PICASSO

His Life and Work

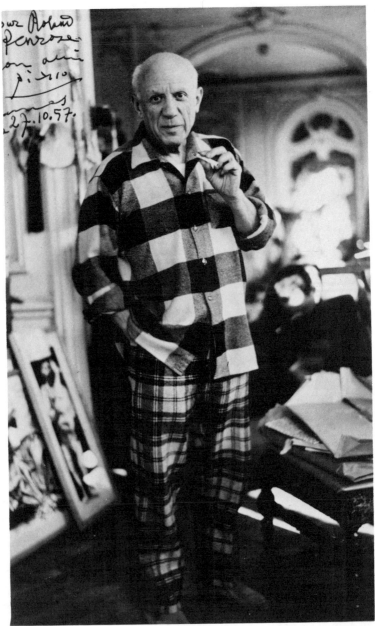

Photo: Lee Miller

PICASSO

His Life and Work

Third Edition

Roland Penrose

UNIVERSITY OF CALIFORNIA PRESS

Berkeley and Los Angeles

Third edition published 1981 by the
University of California Press
Berkeley and Los Angeles

Copyright © Roland Penrose 1958, 1962, 1971, 1981

Library of Congress Catalog Card Number: 80-54015
ISBN 0-520-04207-7

Printed in the United States of America

Contents

List of Illustrations

Plate A

1 Pablo aged seven with his sister Lola
2 Picasso in his studio, 5 bis rue Schoelcher, Paris, 1915
3 Picasso and Fernande Olivier in Montmartre, c. 1906
4 Picasso and Olga Koklova in Paris, 1917

Plate B

1 Picasso as a matador at a ball given by Comte Etienne de Beaumont, Paris, 1924. *Photo: Man Ray*
2 Picasso with his paintings rue la Boétie, Paris, 1931. *Photo: Cecil Beaton*
3 Picasso with Paul Eluard at Mougins, 1936. *Photo: R.P.*

Plate C

1 Picasso painting *Guernica*, 1937. *Photo: Dora Maar*
2 Picasso holding a bull's skull on the beach at Golfe Juan, summer 1937. *Photo: Dora Maar*
3 Picasso presides at the bullfight at Vallauris, with Jacqueline Roque, Paloma, Maïa, Claude and Jean Cocteau, 1955. *Photo: Brian Brake*

Plate D

1 Picasso shows Braque his ceramics in the studio in Vallauris, 1957. *Photo: Lee Miller*
2 Female figure surmounting Picasso's grave: *Woman with Vase. Heirs of Picasso*
3 Picasso and Jacqueline at Notre Dame de Vie, 1965. *Photo: Edward Quinn*

List of Plates

Note: The information given under each reproduction is as follows: title, date, medium and size in inches (unless otherwise marked), height followed by breadth. All other information and acknowledgements to museums, collectors and photographers will be found below. (The abbreviation MOMA is used in every case for the Museum of Modern Art, New York.)

I. 1. *The Picador.* Earliest known painting by Picasso. Heirs of Picasso. 2. *Girl with Bare Feet.* Heirs of Picasso. 3. Diploma drawing. 4. *Science and Charity.* Museo Picasso, Barcelona. Photo: Melich, Barcelona. 5. *Self-portrait.* Collection Mrs E. Heywood Lonsdale. 6. *Scene in a Tavern.* Collection Mrs Howard Samuel, London. 7. *Le Moulin de la Galette.* The Solomon R. Guggenheim Museum, NY, Gift of Justin K. Thannhauser. Photo: MOMA. 8. *The Burial of Casagemas* (Evocation). Musée d'Art Moderne de la Ville de Paris. Photo: Bulloz, Paris. 9. *Harlequin.* Mr and Mrs Charles Payson, NY. Photo: Cahiers d'Art.

II. 1. *Portrait of Jaime Sabartés.* Pushkin State Museum of Fine Arts, Moscow. Photo: Kohlhammer, Stuttgart. 2. *The Blue Room.* The Phillips Collection, Washington, DC. 3. *Self-portrait.* Musée Picasso, Paris. Photo: Cahiers d'Art. 4. *La Vie.* Cleveland Museum of Art, Gift of Hanna Fund. 5. *Two Sisters.* The Hermitage Museum, Leningrad. 6. *Maternity.* Fogg Art Museum, Harvard University. 7. *The Old Jew* (Blind Beggar with Boy). Pushkin State Museum of Fine Arts, Moscow. 8. *The Blind Man's Meal.* Metropolitan Museum of Art, NY, Gift of Mr and Mrs Ira Haupt. 9. *The Courtesan with a Jewelled Necklace.* Photo: Cahiers d'Art.

III. 1. *The Actor.* The Metropolitan Museum of Art, NY, Gift of Thelma Chrysler Foy. 2. *Salomé.* MOMA, Lillie P. Bliss Collection. 3. *Meditation.* Collection Mrs Bertram Smith, NY. Photo: MOMA. 4. *The Jester.* Collection Mrs Bertram Smith, NY. 5. *The Soler Family.* Museé des Beaux-Arts, Liège. 6. *The Old Guitarist.* The Art Institute of Chicago, Helen Birch Bartlett Memorial Collection. 7. *Acrobat's Family with Ape.* Gothenburg Art Museum, Sweden. 8. *La Toilette.* Albright-Knox Art Gallery, Buffalo, NY. 9. *Boy Leading a Horse.* MOMA, Gift of William S. Paley, the owner retaining life interest.

IV. 1. *Portrait of Gertrude Stein.* Metropolitan Museum of Art, NY, Bequest of Gertrude Stein. 2. *Acrobat on a Ball.* Pushkin State Museum of Fine Arts, Moscow. 3. *Self-portrait* (with a Palette). Philadelphia Museum of Art, A. E. Gallatin Collection. 4. *Self-portrait.* National Gallery, Prague. 5. *Woman with a Fan.* National Gallery of Art, Washington, DC, Gift of W. Averell Harriman Foundation in memory of Marie N. Harriman. 6. *Family of Saltimbanques.* National Gallery of Art, Washington, DC, D. C. Chester Dale Collection. 7. *Two Nudes.* MOMA, Gift of David Thompson in honour of Alfred H. Barr, Jr.

V. 1. *Les Demoiselles d'Avignon.* MOMA, Acquired through the Lillie P. Bliss Bequest. 2. *Negro Dancer* (Nude with Raised Arms). Private Collection, London. 3. *Head.* Collection Mrs Wolfgang Schoenborn, NY. 4. *Nude with Drapery.* The Hermitage Museum, Leningrad. 5. *House in the Garden.* The Hermitage Museum, Leningrad. 6. *Two Nudes* (Friendship). The Hermitage Museum, Leningrad.

VI. 1. *Nude on the Beach* (Bather). Collection Mrs Bertram Smith, NY. 2. *Fruit Dish.* MOMA, Acquired through the Lillie P. Bliss Bequest. 3. *Portrait of Clovis Sagot.* Kunsthalle, Hamburg. 4. *Head of a Woman.* MOMA. 5. *Seated Woman* (Femme en vert). Stedelijk van Abbe-museum, Eindhoven. 6. *The Reservoir, Horta.* Collection Mr and Mrs David Rockefeller, NY. 7. *Portrait of Vollard.* Pushkin State Museum of Fine Arts, Moscow. 8. *Portrait of Uhde.* Collection Joseph E. Pulitzer, St Louis. Photo: R. B. Fleming, London. 9. *Portrait of Kahnweiler.* Art Institute of Chicago. Gift of Mrs Gilbert W. Chapman

Paris. Photo: MOMA. 5. *Nude with Night Sky*. Private Collection, Paris. 6. *Grand Air*. Illustration for the first ten copies of *Les Yeux fertiles* by Paul Eluard. Photo: Courtauld Institute of Art, London. 7. *Portrait of Eluard*. 8. *End of a Monster*. Private Collection, London. Photo: R. B. Fleming, London.

XVI. 1. *Portrait of Marie-Thérèse*. Musée Picasso, Paris 2. *Still-life, Le Tremblay*. 3. *Minotauromachie*. 4. *Weeping Woman*. Private Collection, London. Photo: R. B. Fleming, London. 5. *Still-life with Horned God*. Private Collection. 6. *Woman with Cat*. Collection Mme Marie Cuttoli, Paris. Photo: Rossignol, Paris. 7. *Portrait of Maïa*. Musée Picasso, Paris.

XVII. 1. *Guernica*. On extended loan to MOMA. 2. *Dream and Lie of Franco* with Signature. 3. *Man with Lollipop*. Photo: Cahiers d'Art. 4. *Portrait of Lee Miller*. Private Collection, London. Photo: Roger Mayne, London. 5. *Bathers with a Toy Boat*. Collection Mrs Peggy Guggenheim, Venice. 6. *Girl with a Cock*. Collection Mrs Meric Callery, NY.

XVIII. 1. *Woman in a Garden*. Collection Mr and Mrs Daniel Saidenberg, NY. 2. *Still-life with a red Bull's Head*. Collection Mr and Mrs William A. M. Burden, NY. 3. *Woman's Head*. 4. *Cat and Bird*. Collection Mr and Mrs Victor W. Ganz, NY. 5. *Study for a Crucifixion*. Musée Picasso, Paris. 6. *Café at Royan*. Musée Picasso, Paris. 7. *Women at their Toilette*. Musée Picasso, Paris. 8. *Portrait of D. M.* Collection Mr and Mrs Edwin A. Bergman, Chicago. Photo: MOMA. 9. *Fishermen of Antibes* (Night Fishing). MOMA, Mrs Simon Guggenheim Fund.

XIX. 1. *Portrait of Jaime Sabartés*. Museo Picasso, Barcelona. 2. Page from *Royan Sketchbook*. Photo: Cahiers d'Art. 3. *Seated Woman Dressing her Hair*. Collection Mrs Bertram Smith, NY. 4. *Head, Royan*. Painted on the day the Germans entered Royan: 11 June 1940. 5. *Sleeping Nude*. 6. *Still-life with Sausage*. Collection Mr and Mrs Victor W. Ganz, NY. Photo: MOMA. 7. *Portrait of D. M. as a Bird*. Drawn on a leaf of Buffon's *Natural History*. 8. *Self Portrait* from *Desire Caught by the Tail*. 9. *Child with Pigeons*. Musée Picasso, Paris.

Photo: Chevojon, Paris.

XX. 1. *Skull* (Flayed Head). Musée Picasso, Paris. Photo: Chevojon, Paris. 2. *Man with the Sheep.* 3. *Head of D. M.* Private Collection. Photo: Chevojon, Paris. 4. *Head* (paper). Photo: Brassaï. 5. *Paris Landscape.* Musée Picasso, Paris. Photo: Chevojon, Paris. 6. *Bull's Head.* Musée Picasso, Paris. 7. *First Steps.* Yale University Art Gallery, New Haven, Conn., Gift of Stephen C. Clark. 8. *Seated Woman.* Private Collection. 9. *Woman in a Rocking Chair.*

XXI. 1. *Bacchanal after Poussin.* Musée Picasso, Paris. 2. *Pastoral.* 3. (Sleeping) *Nude.* Collection Mr and Mrs Victor W. Ganz, NY. Photo: Chevojon, Paris. 4. *L'Aubade.* Musée National d'Art Moderne, Centre National d'Art et de Culture Georges Pompidou, Paris. 5. *Massacre in Korea.* Musée Picasso, Paris. 6. *The Charnel House.* MOMA, Mrs Sam A. Lewisohn Bequest (by exchange) and Purchase. 7. *Skull and Leeks.* Galerie Louise Leiris, Paris. 8. *Still-life with Pitcher, Candle and Casserole.* Musée National d'Art Moderne, Centre National d'Art et de Culture Georges Pompidou, Paris.

XXII. 1. *Ulysses and the Sirens.* Musée Picasso, Antibes. 2. *Spiral Head of Faun.* Reproduced *Verve*, Vol. 5. 3. *Mother and Children with Orange.* Musée Picasso, Paris. 4. *Owl and Sea Urchins.* 5. *Françoise.* Photo: Courtauld Institute, London. 6. *Night Landscape, Vallauris.* 7. *Portrait of a Painter, after El Greco.* Collection Angela Rosengart, Lucerne. 8. *Chimneys of Vallauris.* Musée Picasso, Paris. 9. *Portrait of Sylvette.* Photo: Galerie Louise Leiris, Paris.

XXIII. 1. *War.* Temple of Peace, Vallauris. 2. *Peace.* Temple of Peace, Vallauris. 3. Woman Vase. Photo: Galerie Louise Leiris, Paris. 4. *Model and Monkey Painter.* Reproduced *Verve*. 5. Vase. 6. *Knights and Pages.* Musée Picasso, Paris. 7. Three Doves. 8. Plate with Bullfight. Photo: Müller, Paris.

XXIV. 1. *Ape with Young.* MOMA, Mrs Simon Guggenheim Fund. Photo: Chevojon, Paris. 2. *Les Femmes d'Alger, after Delacroix.* Collection Mr and Mrs Victor Ganz, NY. Photo: Galerie Louise Leiris. Paris. 3. *Goat.* 4. *Jacqueline Roque in the Studio.* Photo: Galerie Louise

Leiris, Paris. 5. *Pregnant Woman.* MOMA, Gift of Mrs Bertram Smith. Photo: Chevojon, Paris. 6. *The Studio.* Collection Mr and Mrs Victor W. Ganz, NY. 7. *La Coiffure.* 8. *Las Meninas, after Velázquez.* Museo Picasso, Barcelona.

XXV. 1. *Two Nudes.* Musée Picasso, Paris. Photo: Grand Palais, Paris. 2. *Figures and Fountain* (The Bathers). National Trust for Historic Preservation, Bequest of Nelson A. Rockefeller. Photo: Galerie Louise Leiris, Paris. 3. *Portrait of J. R. with Roses.* Collection Jacqueline Picasso, Mougins. 4. *The Bay at Cannes.* Musée Picasso, Paris. Photo: Arts Council, London. 5. *Avant la pique.* Photo: Galerie Louise Leiris, Paris. 6. *Composition with Dalmatian Dog.* Photo: Galerie Louise Leiris, Paris. 7. *Déjeuner sur l'herbe.* Musée Picasso, Paris. Photo: Galerie Louise Leiris, Paris. 8. Paysage de Cannes au crépuscule. Photo Galerie Louise Leiris, Paris. 9. *Tête de femme.* 10. *The Pigeons.* Musée Picasso, Paris.

XXVI. 1. *Still-life with Bull's Skull.* Musée Picasso, Paris. Photo: Arts Council, London. 2. *Man with Sheep.* Musée Picasso, Paris. Photo: John Webb, London. 3. *Woman with Outstretched Arms.* Musée Picasso, Paris. Photo: Arts Council, London. 4. *Man Running.* Photo: John Webb, London. 5. *Femme au chapeau.* Musée Picasso, Paris. 6. *The Painter and his Model.* Photo: Galerie Louise Leiris, Paris. 7. *The Chair.* Musée Picasso, Paris. Photo: Arts Council, London. 8. *The Rape.* 9. *Rape of the Sabines.* Collection Norman Granz, Geneva. Photo: Galerie Louise Leiris, Paris.

XXVII. 1. *Maquette for Chicago Monument.* The Art Institute of Chicago, Gift of the artist. 2. *Chicago Monument.* 3. *Femme couchée au chat.* Photo: Grand Palais, Paris. 4. Engraving. 5. *Artist and Model.* Photo: Grand Palais, Paris. 6. *Mythological Scene.* Photo: Galerie Louise Leiris, Paris. 7. *Raphael and la Fornarina.* 8. *Buste de femme.* Photo: Galerie Louise Leiris, Paris. 9. Sylvette Monument, New York. 10. *Sleeping Girl.* Photo: Palais des Papes, Avignon.

XXVIII. 1. *Amour et Mousquetaire.* Photo: Palais des Papes, Avignon. 2. *Harlequin and Pierrot.* Photo: Palais des Papes,, Avignon. 3. *Le baiser.* Musée Picasso, Paris. Photo: Palais des Papes, Avignon. 4. *Homme au casque et à l'épée.* Photo: Palais des Papes, Avignon.

Foreword

Picasso: His Life and Work was first published by Victor Gollancz in 1958. At the time of Picasso's ninetieth birthday in 1971 a revised edition was published in Great Britain by Penguin Books and two years later in the United States of America by Harper and Row. For this edition I made some corrections and minor alterations and I added three chapters. I have now brought the book up to date by adding a postscript which recounts the circumstances of Picasso's death and burial as well as details of certain important recent exhibitions and the steps that have been taken by the French Government to deal with the prodigious wealth left by him in works of art and personal belongings. This has resulted in the founding of a museum in Paris to house the important collection that the French nation has now acquired.

It is impossible in one volume to deal adequately with the passionate intensity of his life and the torrential flow of work which has made Pablo Picasso a universal celebrity and the outstanding genius of the art of the twentieth century. I have tried to the best of my ability to outline as concisely as possible the essential features of his life and loves as well as his masterly achievements without attempting to claim that my account can be complete. In this endeavour I am particularly grateful for the invaluable help given to me by Picasso himself, particularly during the last twenty years of his life, and the kind assistance of his widow, Madame Jacqueline Picasso.

ROLAND PENROSE
1981

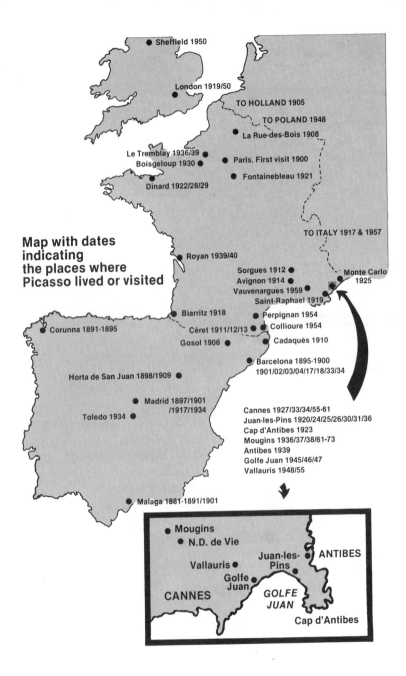

Sheffield 1950

London 1919/50

TO HOLLAND 1905

TO POLAND 1948

La Rue-des-Bois 1908

Le Tremblay 1936/39
Boisgeloup 1930

Paris. First visit 1900

Fontainebleau 1921

Dinard 1922/28/29

**Map with dates
indicating
the places where
Picasso lived or visited**

TO ITALY 1917 & 1957

Royan 1939/40

Sorgues 1912
Avignon 1914
Vauvenargues 1959
Saint-Raphael 1919

Monte Carlo
1925

Biarritz 1918

Perpignan 1954

Corunna 1891-1895

Céret 1911/12/13

Collioure 1954

Gosol 1906

Cadaqués 1910

Barcelona 1895-1900
1901/02/03/04/17/18/33/34

Horta de San Juan 1898/1909

Madrid 1897/1901
/1917/1934

Cannes 1927/33/34/55-61
Juan-les-Pins 1920/24/25/26/30/31/36
Cap d'Antibes 1923
Mougins 1936/37/38/61-73
Antibes 1939
Golfe Juan 1945/46/47
Vallauris 1948/55

Toledo 1934

Malaga 1881-1891/1901

Mougins

N.D. de Vie

Vallauris

Juan-les-
Pins

ANTIBES

Golfe
Juan

GOLFE
JUAN

CANNES

Cap d'Antibes

'*Je parle de ce qui m'aide à vivre.*'

Paul Eluard: 'A Pablo Picasso'

'*Rien de ce qu'on peut dire de Picasso n'est exact...*'

Georges Ribémont Dessaignes

PICASSO

His Life and Work

1

Origins and Youth
(1881-95)

In our time the arts have been in a state of revolution, a battlefield in which tradition has slowly yielded to the onslaughts of a vanguard of innovators who have acted with the conviction of visionaries. Already in the second half of the twentieth century it is difficult for the present generation to understand the violence of this struggle in its early days, the courage of those who led the attack, and the reasons why the battle was fought with such vigour, against such odds. The day has gone in favour of the enlightened, since it is those who had vision, those who were scorned, who have now become the accepted heroes of our age. Among them Pablo Picasso stands out as a leader of undisputed brilliance.

Many factors have combined to make him the most widely known painter today and already his life and achievements are clothed with legends. Paradoxes are so frequent in any statement made about him that the public are bewildered and imagine that he was either a strange and evil monster or an oracle whose wisdom had occult significance. Though he was a Spaniard he lived less than a third of his life in Spain; in his old age he was more vigorous and agile both in mind and body than many men are in their youth; though he persistently outraged the most serious critics by work that seemed incomprehensible, they had to admit their admiration for his talent; though his fame has spread throughout the whole world and his wealth was incalculable he did not change his manner of living. His main desire was to continue his work and, though surrounded by friends and companions whose love for him was great, his magnitude was such that among them he was a solitary figure.

Although Picasso lived as an expatriate for more than fifty years he

was still essentially Spanish. To understand him it is necessary to know something of the country of his birth; a land of strong contrasts, brilliant sun and black shadow, extreme heat and cold, fertility and barrenness. It is a country notorious for violent passion in love and fanatical ruthlessness. Its people have a capacity to exteriorize their emotions and display in a vivid light the drama of human life. Their love of gaiety is accompanied by an insistence on suffering and the macabre, and they find consolation for misery, and relief from anxiety in the arts. Whether it be in the poetry of Góngora, the flamenco music of the gipsies, the bullfight or the painting of Zurbarán, there is always sorrow in the depths of their expression. Tragedy is a reality which must be expressed, and the artist's task is to find a form of realism capable of making it felt acutely. To achieve this, no people know better than the Spaniards that the tragic should be balanced by the comic, and an equilibrium established between the two moods. By giving them equal importance it becomes possible to indulge more profoundly in both extremes.

The work of Picasso is a revelation of the immense variety with which he was able to display this drama between two opposite poles. His life, however, was monolithic in character because of his dedication to a single purpose, his art. The extraordinary vigour, both mental and physical, of Picasso at the age of ninety was a phenomenon similar to the prodigious speed with which he developed in childhood. His progress was so rapid that he denied ever having drawn like a child. Indeed the earliest examples of his work are drawings that contain ideas which preoccupied him all his life. At the age of nine he was already able to paint a scene of a bullfight in which a lively sense of characterization appears in the figures of a *picador* seated on his nag, and of the spectators (Plate I, 1). A composition which is skilful and mature shows also the unselfconsciousness and the originality of a child. The naïve disregard for scale and perspective, the insistence on the main image at the expense of detail, and the arbitrary use of colour – qualities that are typical of the imagination of a child – are to be found. These elements were to be fostered by Picasso rather than disregarded so as to serve him in his work and help him in his discoveries.

On the 25 October 1881, at 11.15 at night, Pablo Ruiz Picasso was

born at Malaga. At that moment both the moon and the sun approached the nadir, and the light that shone on the white houses of the city from the midnight sky came from a strange combination of planets and major stars, whose conjunctions and oppositions have been the cause of much speculation on the part of astrologers. Many attempts have been made by experts to find relationships between these occult influences and the life and character of one so richly endowed with rare talents. Until recently, however, it was inevitable that their calculations should be to some degree erroneous, since none had had access to his birth certificate to verify the hour of his birth. They had all readily believed his own picturesque story that he was born at midnight.

Malaga

Although the plaza de la Merced, where Picasso was born, is the larger of the two squares in Malaga, it is not the more central. In the past it owed its importance to its position outside the gateway to Granada. On the south-eastern side, it is shut in by two steep hills on which stood the citadel, Alcazaba, and the castle, Gibralfaro, two Moorish fortresses which dominate the city and harbour. Little that happens in the narrow streets, paved with cobbles arranged in ornamental design, could pass unnoticed from these formidable ramparts. They had been built on the foundations of a Phoenician fortress. Relics of the Phoenicians and Romans show that the site had been coveted by foreigners long before its conquest in 711 by the Moors, for whom it became the principal port of the Moorish capital, Granada. From the summits above the city a grandiose panorama stretches inland over a plain covered with vineyards to the mountains, while to the south the plain meets the sea in a graceful curve, and out across the Mediterranean can be seen the snow of the Atlas Mountains, a reminder of the nearness of Africa, and of influences much stronger in the past than they are today.

By the end of the nineteenth century the rocky heights that separate the plaza de la Merced from the port had been covered for generations with buildings made from stones pillaged from the Moorish citadel. The terraced gardens and courtyards with their fountains had become unrecognizable. They had degenerated into little more than a huddle of

ruins inhabited by gipsies, the heirs of Moorish music and dancing if not of their splendour. In later years Picasso described this region to Sabartés. 'It is known,' he said, 'as the "*chupa y tira*" ' – which is Spanish for 'suck and chuck' – because the people who inhabited this slum were so poor that they lived solely on a soup made of shellfish. The ground was covered with the empty shells which the inhabitants had chucked out of the windows after sucking them clean. From the sordid hovels that spread down the hillside almost to the tidy gardens of the plaza de la Merced, the night would be enlivened by the sound of guitars and voices singing '*canto hondo*', passionate love songs based on very ancient themes and adapted by the individual singers to the joys and pains of their own hearts.

Ancestry

The sources from which Picasso sprang have now been determined with some certainty, thanks to the work of genealogists, in particular his old friend Jaime Sabartés. The paternal branch of the family tree is not lacking in distinguished ancestors, including men honoured in civic life, on the battlefield and in the Church. It can be traced back to the noble figure of Juan de León, a knight whose lands were at Cogolludo, near Valladolid. Records of 1541 state that his father before him was exempt from all taxes, 'not by a concession from the king, nor because of bearing arms as a knight, not because of his farm lands, nor for any other reason than that he was a gentleman of well-famed nobility'.[1] Chronicles also state that Don Juan set forth 'in good harness as was fitting in his position as a hidalgo' for the war of Granada and Loja, from which he never returned.

 Towards the end of the sixteenth century, the descendants of Juan de León left Castile to settle at Villafranca de Córdoba. Spanish usage in the matter of surnames may cause some confusion, for it is customary to add the surname of the mother to the paternal name, and some such explanation probably accounts for the sudden appearance of the surname 'Ruiz' in this family during the seventeenth century. There is

[1] Sabartés, *Picasso: Documents Iconographiques.*

no doubt, however, that they were in direct descent from the illustrious Juan de León and well known in Cordova until the end of the eighteenth century. It was about 1790 that José Ruiz y de Fuentes settled in Malaga and married a lady of the noble family of de Almoguera. His son, Diego, married María de la Paz Blasco y Echevarria; together they became the grandparents of Picasso. There has been a persistent myth that the origins of the family on this side were predominantly Basque, but Sabartés points out that the name 'Blasco' is Aragonese, and if there is any tendency in that direction it can only be through Picasso's grandmother, María de la Paz Echevarria, a name which is probably Basque.

The ancestors on the side of Picasso's great-grandmother, Maria Josefa de Almoguera, had among them two distinguished priests. The first, the Venerable Almoguera, descendant of a 'very noble' family from the mountains of León, was born in Cordova in 1605 and died in great poverty but in 'the odour of sanctity' in 1676, having in his time been appointed Bishop of Arequipa, Archbishop of Lima, Viceroy and Captain-General of the Kingdom of Peru. The second was Brother Pedro de Cristo Almoguera, who flourished some two centuries later and died in 1855 at the age of eighty-one, having lived for sixty-two years as a hermit in the Sierra de Córdoba. He was a man of faith and courage, who dedicated his life to meditation and to the relief of suffering.

Twenty years after the arrival of Don José Ruiz y de Fuentes in Malaga, an incident occurred. His eldest son, Diego, one day half in play, half wilfully, threw stones at the French soldiers then occupying the city, as they marched by. He was caught by a trooper and nearly beaten to death. Throughout his life Don Diego, Picasso's grandfather, remembered the event, not from shame, but from pride that he had held up the parade. From his photo as an elderly man, tall and thin, with a sour frown and heavy eyebrows, it would be easy to misjudge his real nature, which, we are told, was 'restless, nervous and intelligent, a tireless worker, witty, jovial, with sudden bursts of enthusiasm'.[2] He was ingenious and tactful in overcoming difficulties, and although his

[2] Sabartés, *Picasso: Documents Iconographiques.* p. 294.

business was manufacturing gloves, a trade which kept him at work without respite to provide for his family of eleven children, he managed to indulge his passion for music by playing the double bass in the orchestra of the Municipal Theatre. Also he enjoyed drawing.

Don Diego Ruiz had married María de la Paz Blasco in 1830. Their eldest son, Diego, became a diplomat who at one time travelled in company with the Spanish Ambassador to Russia. He also appears to have become known for his talent in making likenesses of his friends. But the son who took the brunt of caring for the less fortunate members of the family after their father's death was the fourth child, Pablo. He had become a Doctor of Theology and a Canon of the Cathedral of Malaga. He made it his duty not only to look after his four unmarried sisters, but to help to provide for his unbusinesslike younger brother, José, the ninth of the family and the future father of Pablo Ruiz y Picasso.

José, to make matters worse, had decided to become a professional painter, but, unlike his elder brother Diego, he was no dilettante, and his contact with society came with less ease. Since a painter dedicated to his art alone was according to conventional standards a ne'er-do-well, the loyalty and generosity of his elder brother Pablo were factors of great importance to him in early days. However this situation came abruptly to an end with the death of the Canon, after which José was forced to take over his brother's responsibilities towards the unmarried sisters.

Such was the ancestry of Picasso on his father's side. Devotion, tenacity, courage, appreciation of the arts and sincerity in religion were characteristics which recurred among his ancestors, and which could be expected to form part of the inheritance of their descendants. We might hope to trace reinforcements for these virtues on the maternal side, were it not that this branch is less certain of its origins. The name 'Picasso' is not common anywhere, but in Malaga it had attained fortuitous notoriety, not because of its rarity but through an incident that had happened when General José Lachambre, a native of Malaga, in obedience to a higher command, bombarded the city from the near-by hills in order to quell a political disturbance. Such events were not uncommon in the early part of the nineteenth century, but this time the indignation of the citizens was aroused when cannon balls began to fall

in the plaza de la Merced, and on their way lifted some tiles off the house where the Picasso family lived. In popular songs they at once became heroes at the expense of the general.

The family had lived in Malaga for at least two generations. Don Francisco Picasso, maternal grandfather of Pablo, was born there, and was sent to England for his education. Later he became a civil servant in Cuba, where in 1883 he disappeared and was said to have died of yellow fever (*vomito negro*) on the eve of his return to Malaga. This became known to his children only after fifteen years of inquiry.

Little is known of the exact origins of the family, and speculation has centred mainly round the source of the name, which in its spelling appears to be Italian rather than Spanish. This fact has led various writers to believe that the family is linked with the artist Matteo Picasso, a native of Recco near Genoa, who made a reputation as a portrait painter. He was born in 1794 and is best known by a portrait he painted of the Duchess of Galliera, now in the Gallery of Modern Art in Genoa. Picasso himself owned a small portrait of a man painted by Matteo in a pleasing but commonplace style. Recently evidence has come to hand that the grandfather of Doña Maria Picasso was born in a small village near Recco; this would lead to the supposition of a connection between the families.

Sabartés, who has in the past been eager to explode the myths of a Basque origin for the paternal branch and an Italian origin on the maternal side, has however traced a hypothetical source which originates in Africa. He holds this to be a plausible theory and one which would help to offer an explanation for Picasso's feeling of kinship with nomads and gipsies. The chronicles of King Don Pedro, son of King Don Alfonso of Castile, dating from 1591, give an account of a battle fought in 1339 between Gonzalo Martinez de Oviedo, commander of the armies of the King of Andalusia, and the Prince Picaço, son of the Moorish King Albuhacen, who had arrived from Africa at the head of ten thousand knights. The battle went against the fortunes of the prince, who was defeated and slain by the Spaniards.

Since the character of Picasso is one so rare and so original, it is understandable that we should naïvely expect to find extraordinary influences in his ancestry. Spain is a country that owes much of its

inspiration to the Moors and the gipsies, and more than one biographer has suggested that a distant strain either of North African or of Jewish blood is present on his mother's side. A Catalan writer seeks to establish his origin among the gold-workers of Majorca who were Moorish immigrants, and discovers, in the arabesques of their engravings and filigree, the origin of the flourishes and calligraphy that we find in the versatile hand of Picasso.[3] A Castilian poet and early friend, Ramón Gomez de la Serna, has written: 'In the great nation of the gipsies of art, Picasso is the most gipsy of all.'[4] This may be taken figuratively, but there still remains an affinity between the autonomous life, the spontaneity and insight of the gipsies and the Olympian independence, the inspiration and the vision of the great artist.

But leaving conjecture and the implication that we may hope to deduce from heredity, it is safe to say that the ancestors of Picasso on both sides are predominantly Andalusian and sufficiently Spanish from sufficiently far back for us to pay attention, above all, to the characteristics of these people. The artistic tastes and the talent of his father's family were well known locally. In addition, a portrait has recently been discovered of a certain Manuel Harerra of Velez Malaga, seated in a chair, holding in one hand a key and in the other a scroll of verses dedicated to his son. It is signed 'Picasso-Juan' and dated 1850, which suggests that on Picasso's mother's side the family also had leanings towards painting independent of the achievements of the Genoese Matteo Picasso.

Don José Marries

The meeting of José Ruiz Blasco and María Picasso Lopez was not by chance. The Picasso family had lived for many years in the plaza de la Merced in Malaga, a large square enclosing a public garden not far from the centre of the town, whereas José had been living with his elder brother, the Canon Pablo, in the calle de Granada near by. All ten brothers and sisters were agreed that the time had come for José to

[3] A. Cirici-Pellicer, *Picasso avant Picasso*, Cailler, Geneva, 1950, pp. 21-3.
[4] R. Gomez de la Serna, 'Le Toréador de la peinture', *Cahiers d'Art*, Paris, 1932, Nos. 3-5.

marry, partly because no male issue had yet been born to any member of their generation, and partly because they wished to see him settle down and abandon the doubtful life of a young painter, dependent on the charity of his reverend brother. The Canon, in spite of his tolerance, had begun to think 'that the sins of youth towards which a whimsical humour' drew his younger brother had lasted long enough.[5] Having selected a suitable young lady, known to be esteemed by him, they insisted that he should propose to her. But José showed no desire to commit himself, and after keeping the family in suspense, he decided suddenly to marry not this girl but her cousin, whom he had met in her company and who shared the same surname, Picasso. Even after the decision had been made, the suspense was again prolonged by the sudden death of his brother Pablo, and it was not until two years had passed that José Ruiz Blasco and María Picasso Lopez were married in 1880.

In the autumn of the following year, a son was born to them. With due ceremony he was christened in the near-by church of Santiago, and in accordance with tradition the child received the names: Pablo, Diego, José, Francisco de Paula, Juan Nepomuceno, María de los Remedios, Cipriano de la Santisima Trinidad. Sabartés explains that in Malaga it was customary to endow children with a rich choice of christian names, and gives the sources of them all: the only one that has been remembered, however, Pablo, was given as a tribute to his recently deceased uncle.

The tall white block of flats into which Don José Ruiz Blasco moved with his bride was on the eastern side of the plaza de la Merced. His young wife was small and of delicate build. She had the black eyes, sparkling with vivacity and wit, and blue-black hair of the Andalusians, in contrast to her husband, the tall, gaunt painter, whose reddish hair and distinguished reserve caused his friends to call him 'the Englishman'. The jibe was apt in other ways, for he appreciated English customs and English design, especially in furniture. In proof of this, two of a set of Chippendale chairs, which had come to Malaga by way of Gibraltar, were used by Picasso in his house at Mougins until the end of his life.

[5] Sabartés, *Picasso: Documents Iconographiques*.

The new block occupied the site of the ancient Convent of Our Lady of Peace. It had been built by a patron of the arts, Don Antonio Campos Garvin, Marqués de Ignato, who also lived in the same square and enjoyed entertaining the group of poets, painters and musicians of which Malaga could boast at that time. Generous and benign, he collected pictures bought from his friends the artists, and when a crisis arose he was willing to accept paintings in lieu of rent from those who had become his tenants. Thus on more than one occasion Don José had reason to be grateful to his landlord. Life had never been easy, and additional cares such as his new responsibility for his unmarried sisters and his mother-in-law, as well as the arrival of his first child, forced Don José to take on an administrative post in order to add to his scant income as a painter.

Don José exchanged his freedom for a post in the School of Fine Arts and Crafts of San Telmo, and accepted the curatorship of the local museum, which was housed in the Town Hall. These duties should have secured for him an income sufficient to support his family to the end of his days, had not municipal politics caused him to lose his job within a year or two. However, understanding the fickle nature of local government, he held on to his post unpaid until the swing of the pendulum returned again to his favour.

In spite of adversity, the birth of Pablo was the cause of great rejoicing in the Ruiz family. He was the first male heir to have been born to any of the eleven descendants of Don Diego Ruiz de Almoguera, and therefore a triumph over destiny. The birth had been made all the more dramatic by a misjudgement, nearly fatal, on the part of the midwife. The child appeared to her to be stillborn and she abandoned it on a table, so as to give all her attention to the mother. It was due only to the fortunate presence of mind of Don Salvador, one of his uncles and a qualified doctor, that the infant was saved from asphyxia before life had begun. This story, often told to him during childhood, of how death was so forcefully present at birth, lurked in Picasso's imagination throughout life.

An Earthquake

Three years after the birth of Pablo, one evening in mid December, Malaga was shaken violently by an earthquake, and Don José, out gossiping with friends in a chemist's shop, broke off his conversation to race home to his family. On the way he decided that he must evacuate them immediately to the house of a friend, believing that its position, backed by the rock of the Gibralfaro, would make it a safer refuge than his flat on the second floor. Sabartés tells how Picasso, some fifty years later, described to him their flight: 'My mother wore a handkerchief on her head, I had never seen her like that before. My father seized his cape from the coat-stand, threw it round his shoulders, took me in his arms and rolled me in its folds, leaving my head exposed.'6 They had not far to go to reach the house of Antonio Muñoz Degrain, a painter and an intimate friend. Taking shelter there, Pablo's mother gave birth to her second child, a daughter called Lola.

Local Painters and Painting

Muñoz Degrain had come to Malaga to decorate the new Cervantes Theatre. He was one of a group of painters whose work now hangs in the local museum. In his academic canvases the subject matter, whether it be historical, religious, maritime or picturesque, is all-important, though now seriously in retreat beneath heavy coats of varnish. Although he is best known by his conventional scenes from Spanish history, there are traces of influences from abroad in some of his Andalusian landscapes which show an inclination to use colour in a less conventional way. Blue began to find its way into the shadows. The search for light of the Impressionists, and the symbolism of the Romantic painters of the north, were beginning to make themselves felt, replacing historical pastiche even in these remote parts of the peninsula. Degrain had gained a considerable reputation in Spain, which had earned him some limited fame abroad. A story, which was the delight of Picasso for many years, is told of how on one occasion Degrain was returning with a friend from Rome where they had

6 Sabartés, *Picasso: Portraits et Souvenirs.*

achieved some renown. On their arrival they found the city of Malaga gaily decorated, and their friends at the station in ceremonial dress to meet them. The two painters, overwhelmed by the display, were brought home in triumph, covered with laurels and convinced that all had been specially arranged in their honour. But to spoil their ecstasy the King arrived by the next train on a compassionate visit to the areas ruined by the earthquake which had coincided with Lola's birth.

In the small museum where Don José worked, he had the use of a room for restoring pictures. Here he could paint undisturbed, for, it is said, the museum was scarcely ever open. He was a dull though competent painter with a limited range. Dining-room pictures were his speciality: fur and feather, pigeons and lilac, together with an occasional landscape, completed his repertoire. He was happiest when he could make his feathered models symbolic of moral or sentimental drama, as in his painting of a happy couple perched on the threshold of their pigeon house, while a third party ruffled with jealousy spies on them from below. Recently, when a small collection of his work was unearthed in the possession of the de Ignato family in South America – some of those paintings that had been accepted in payment of rent – it was found inappropriate to organize a public exhibition owing to their banality. Don José proved however to be a teacher whose lessons were never forgotten by his son. In spite of his traditional outlook and his unimaginative style, he had inherited the Spanish passion for realism, and was willing to make experiments that a more restrained and conventional temperament would have considered to be in bad taste. The experiments were not always successful, as could be seen from one which used to hang at the house of his daughter Lola in Barcelona. Don José had bought a plaster cast of the head of a Greek goddess whose classical beauty he had transformed into an image of Our Lady of Sorrows by painting the face with the utmost realism, sticking on eyebrows and adding golden tears.[7] He then draped the hair and shoulders in cloth dipped in plaster, so that it stuck to the cast. The head was finally set up on a small eighteenth-century table, which he repainted periodically with shiny paint, varying the colour according to

[7] See *L'Œil*, No. 4, 15 April, 1955.

his mood. In spite of this it was always very ugly, according to Picasso. Other useful tricks were observed by the watchful eye of his son. In his passion for painting pigeons Don José would often attempt ambitious compositions. In order to arrive at the happiest solution in their arrangement, he would first paint individual birds on paper, then having cut them out, he shifted them round until the composition took shape. In fact, from his childhood Pablo became acquainted with the possibilities of using material in unconventional ways, borrowing from any source that came to hand, and making the newly discovered substance obey his wishes. Brushes and paint were by no means the only tools of the trade; knives, scissors, pins and paste all played their part.

One passion above all others dominated Pablo from infancy. His mother was fond of telling how the first noise he learned to make, 'piz, piz', was an imperative demand for '*lapiz*', a pencil. For hours he would sit happily drawing spirals, which he managed to explain were a symbol for a kind of sugar cake called '*torruella*',[8] a word formed from a verb which means to bewilder or entangle. He could draw long before he could speak, and many of his first pictures took their ephemeral shape in the sand where the children played in the plaza de la Merced.

The square itself is spacious, and laid out in a formal way with plane trees, which shelter a crowd of inventive and noisy children from the violence of the sun. Even more numerous than the children in the square are the pigeons. Throughout his life these birds were Picasso's constant companions. Gentle and elusive, they became the symbol of his most tender feelings and utopian desires. The dove of peace drawn by his hand has appeared on the walls of many cities and has been welcomed as a symbol of new hope. From the windows Pablo, encouraged by his father, could watch the movements of these birds in the branches of the plane trees and listen to their crooning. A picture painted by Don José that remained vivid in Picasso's memory was described by him as 'an immense canvas representing a dovecote crammed with pigeons sitting on perches...millions of pigeons'. But Sabartés, who had unearthed this picture in Malaga, was able to count

[8] Further checking with pastry cooks in Malaga reveals that *torruella* was the name traditionally used in the last century for a small cake that is now known by the more descriptive name *caracola* meaning 'snail'.

only nine in the whole composition.

Memories of the first decade of his life in Malaga tend to become confused or incomplete, but often they contain some allusion to later life which seems to give them prophetic significance. Sabartés [9] tells the story of how, sixty years later, when watching a child learning to walk, Picasso said, 'I learnt to walk by pushing a tin of Olibet biscuits, because I knew what there was inside', and he continued to insist on the importance of this motive, priding himself on his artfulness at such a tender age. This early appreciation of simple geometric shapes combined with an interest in what lies hidden beneath is highly appropriate to the future inventor of Cubism.

Visually Picasso's memory always remained extraordinarily clear concerning things both big and small that impressed his imagination. He has described to me in detail the amazing Baroque interior of the church of La Victoria, and on a photograph of himself at the age of four, reproduced by Sabartés, he wrote for me descriptions of the colour of his clothes. They consisted of a vermilion jacket with gold buttons, a kilt, bronze boots and a white collar and bow. On another portrait of himself with Lola, in which he is dressed up as a sailor, with button boots and black stockings, he wrote, 'Lola's costume, black, belt blue, collar white. Me, suit white, overcoat navy blue, beret blue.'

What remained of these early years, more permanent than fragmentary memories, was the hereditary and traditional influence that lay mysteriously deep and well-rooted in Picasso. Qualities that he never forgot are the boisterous wit of the Malaguenians, their passionate love of the glamorous parade of the bullfight or the religious processions of Holy Week. He also understood their fear of the act which completes an object or finishes an event, bringing with it an unbearable finality resembling death. It is symbolized by the unfinished cathedral that dominates the city, which is known as the '*Manco*' (one-handed) because it raises one tower into the air like a one-armed man, its twin never having been completed. Strong contrasts inherent in the environment have had their indelible effect; the comparison between the fertile plain and the arid rock, intense light and heat in the open contrasted with the coolness of shaded avenues and the interiors of

[9] Sabartés, *Picasso: Portraits et Souvenirs.*

buildings, the stench of slums with the sweet perfume of tropical flowers, the dust and grime of the earth with the purifying freshness of the sea. All these influences were present in the heredity and the environment of this child, whose responses to the world of the senses were unusually acute.

Bullfights

The traditional centre of popular entertainment in all Spanish cities is the bull ring. At Malaga it is so close to the southern slopes of the citadel that those who cannot afford seats can get a distant view by sitting on the sun-scorched hillside. Throughout the summer the arena is filled nearly every Sunday with amateurs who come with their families and their friends to applaud the prowess of their champions in the art of tauromachy. Though superficially the crowd may resemble the spectators at a football match their interest is profoundly different. The performance they have come to see is a rite rather than a sport. Its ritual can be traced to early Mediterranean civilizations such as that of Crete; but the continuity of this aspect in Spain, when in other European countries the bullfight has died out or become merely a test of agility, is a sign that it supplies something necessary to the Spanish character. Its pageantry displays to them in a form that they enjoy the fearful drama of life and death. The sacrifice of the bull becomes the symbol of the triumph of man over brute force and blind instinct. Courage and skill are balanced against the tempestuous onslaught of exasperated fury. In the wake of this encounter follow suffering, cruelty and death. The festive costume of the toreador endows him with the qualities of the priest and the athlete. By his courage he becomes the hero admired and reverenced by all; he can equally earn their merciless scorn should he show himself cowardly or incompetent in his dangerous task. In his skill he bears a resemblance to the artist.

Like most Spanish children Picasso was taken to the bullfight at an early age. Don José had a keen appreciation of every detail and took a pleasure in explaining the subtleties of the fight to his son. In Pablo there seemed to be a natural propensity for the 'corrida' which Ramón Gomez de la Serna ascribes to his possible hereditary connection, or at

least to affinities, with gipsies. 'In Malaga, his native town,' he writes, 'I found an explanation. . . of what Picasso is and I understood to what degree he is a *toreador* - gipsies are the best toreadors - and how, whatever he may do, it is in reality bullfighting.'[10] The child watching the display imagined himself accomplishing the daring movements of his heroes within inches of the murderous horns of the bull, and saw with envy the victorious matador in his splendid clothes carried high in triumph by the crowd.

In the centre of the square in sight of the flat where the Ruiz family lived stands a tall elegant obelisk in white stone. It was set up in memory of those who fell in two unsuccessful uprisings during the nineteenth century against the implacable absolutism of Spanish rule. Although Picasso played in its shadow as a child, he has no memory of any gesture on the part of his relatives that would suggest that they were particularly interested in the reformist activities which made themselves felt from time to time in Malaga, or that politics of any description were their concern. The early education he was given was normal for a child in his circumstances; his first school was an ordinary infants' school opposite the museum. His memories confirm the impression given by the family photographs that in politics, religion and their way of living they were a conventional, law-abiding, provincial family.

Departure for Corunna

Ten years after the birth of Pablo, Don José was forced to admit that his struggle to provide for his family was not succeeding. The family had been increased in 1887 by the birth of another daughter, which made the overcrowding at home almost intolerable. Finally the day came when disillusioned and temporarily defeated by financial burdens, he sadly decided to leave his native city and accept the post of art master at the Instituto da Guarda, a school for secondary education in Corunna. This brought to an end the quiet life of well-established habits that he had enjoyed, and severed contacts on which he had come to depend for help and advice. In particular, he was to suffer from leaving his young

[10] Ramón Gomez de la Serna, 'Le Toréador de la peinture', *Cahiers d'Art*, 1932, Nos. 3-5.

brother Salvador, the doctor, who had achieved an important situation as chief of the Sanitary Bureau of the Port of Malaga, and whose influence had enabled him to book a cheap passage by sea to Corunna. It was a dejected Don José who sailed with his wife and the three children in September 1891 for that remote port on the Atlantic coast. Nor was the arrival in Corunna a happy one. The sea voyage had been so rough and tedious that Don José had decided to cut it short by landing the family at Vigo and proceeding overland. At the first sight of Corunna, he decided that he hated the place. Rain and fog replaced the Mediterranean sun, and his isolation from all that he loved in Malaga weighed heavily. Near the rugged granite of Cape Finisterre, Corunna was literally the end of the world to him. An unsurmountable sadness and sense of failure overcame him a few months later when his younger daughter, Concepción, died of diphtheria. She was the only one of his three children who showed some physical resemblance to him, since she was blonde and slender, and he felt the blow bitterly.

But the move to the north had a very different effect on Pablo. To him it was an adventure full of possibilities. They had been fortunate in finding an apartment in the calle Payo Gómez, which was so close to the college that his mother could watch him as he crossed from door to door; and owing to his father's position in the college he was able to spend all the time he liked drawing, painting, and learning under his father's devoted instruction. His concentration was such that in a very short time he was able to master the academic technique of charcoal drawing with its insistence on modelling from light to shade. There are in existence many drawings of this period, which achieve a perfection almost unbelievable in one so young, and also reveal his acceptance of these methods of training which are now considered obsolete.[11] The drawings are faithful copies of the repertoire of plaster casts with which every traditional art school was well furnished. The school at Malaga still displayed for the pupils' benefit scores of lifeless plaster statues of Greek heroes and Egyptian goddesses; fragments of legs, arms, ears and noses, together with stuffed eagles and pigeons. At Corunna it was worse, the casts were drearier and not so varied, but being under the

[11] See *Cahiers d'Art*, II, 1950, pp. 290-91.

supervision of Don José, whatever facilities the Institute could offer were eagerly accepted by his son.

Before leaving Malaga Don José had been very worried by Pablo's backwardness in elementary education, particularly in arithmetic. He dreaded the disastrous situation which he felt would be bound to arise in the atmosphere of a strange city with unknown and unsympathetic schoolmasters. Pablo had always hated school. Even the rudiments of reading, writing and sums gave him great trouble, and he was quick to escape to his father's studio and a form of learning he loved.

Don José realized that something must be done to save his son and himself from disgrace, and approaching a man who was a very good friend and also a very indulgent schoolmaster, he arranged with him for an examination to be held. The description of this memorable event, for which we are indebted to Sabartés, was given by Picasso later and is full of wit and significance.[12] Faced by his examiner, little Pablo could only answer that he knew nothing, strictly nothing. The patient professor insisted that he should write down a column of four or five figures, but even this was impossible, and exhortations to pay attention made the boy all the more nervous and distracted. However, determined to help, the master wrote the figures on the blackboard and told Pablo to copy them. That indeed was precisely what Pablo could do, and forgetting his own way of making figures, he copied stroke for stroke the numbers on the board with delight, thinking all the time of the pleasure he would have when he returned home to his proud parents and of the paintbrush that awaited him as a prize. 'I shall copy the little pigeon,' he said to himself as he finished the row of figures. But his troubles were not over yet. The addition had to be made, and this again would have defeated him had he not noticed that the master, carelessly or on purpose, had written the correct answer on his blotting paper. The opportunity was quickly seized by Pablo, who with great care drew in the figures that completed the sum. 'Very good,' said the kind master. 'You see, you did know. The rest will come in time. You see, my child! Why were you so scared?'

Pablo returned home in triumph, clutching the certificate and

[12] Sabartés, *Picasso: Portraits et Souvenirs.*

feverishly calculating how he would draw his picture. 'The eye of the pigeon is round like zero. Under the zero a six, with a three under that. There are two eyes and two wings. The two legs placed on the table underline it and below that there is the total.' The addition of figures was not the only lesson remembered by Pablo. He had also understood that a symbol can have more than one meaning, as can be seen from a pencil sketch made a year or two later in Corunna, which shows a further development in his discovery. The drawing represents two men standing together. One is a comic gawky man in peasant's costume, with wide-brimmed hat and stick, the other a small creature with an oversize baby face. The tall man's eyes are both drawn in the shape of the figure '8', while the dwarf's are in the shape of '7's. Beside them, scribbled several times, are the numbers from one to nine, and a large seven appears alone, with the stem crossed in continental fashion, showing that it could also be made to represent the lines of the eyebrow and the nose.[13]

Although there may have been some justification for Don José's fears that his son might grow up almost illiterate (Picasso confessed to me that he could never remember the sequence of the alphabet), there were at that time no official regulations to force him to educate Pablo at all, and it is interesting to speculate on what might have occurred in present conditions, when much more of the boy's time and energies would have been diverted into cramming knowledge for commercial reasons into an unreceptive brain. The result might have been a frustrated genius with the approved level of scholastic achievement; in fact, an unbalanced and wasted individual. Don José had understood that where great talent is involved, conventional rules must yield. 'One law for the lion and the ox is oppression.'

Satisfied that his son's talent would continue to gain respect at the Instituto de Guarda, Don José welcomed the help that Pablo could now give him with his pictures. Often he would leave him to finish certain portions, particularly the feet of a still-life of dead pigeons. After dissecting these from the bird, he would pin them to the table in the required position and set Pablo to copy them.

[13] See Zervos, *Picasso*, Vol. VI, p. 7, No. 49.

Don José had grown morose and rarely left the house except to attend
Mass. When not at work he stood at the window watching the rain. One
evening, when the weather was less depressing, he set a task for his son
and went out for a stroll along the Alameda. Among the crowds that
pass slowly up and down, beneath the datura flowers hanging like white
lanterns heavy with scent, he aired his melancholy. On his return, the
pigeons were complete, and so lifelike were their legs that Don José, in a
burst of emotion, abruptly gave Pablo his own palette, brushes and
colours, saying that his son's talent was now mature, in fact already
greater than his own, and that he himself would never paint again. In
this act of renunciation he found some satisfaction; it helped him to
hide his own personal disappointment behind his hopes in the future of
his son. His self-denial was not unlike similar gestures among his pious
Andalusian ancestors.

The four years spent in Corunna were of great importance to Pablo.
The sudden break with Malaga, the family, grandmother, uncles, aunts
and cousins, and the climate of the Mediterranean, was a first step from
the provincial to the universal, from the warm, intimate nursery to a
cold testing ground, where his love of the new and the vital, his eager
appreciation of anything which breaks with traditional habits, suddenly
became strengthened with a sense of independence and confidence in
himself. He had already triumphed over his father, and at the age of
fourteen was sure of his own powers and judgement. But his confidence
had to be proved daily, questioned with relentless courage, until the
game of confidence versus doubt became the everyday rhythm of his
creative spirit, a game in which there is no promise of final victory, and
in which the future is the only judge of how well it has been played.

In the academic drawings he had done for his father, Pablo had
shown that he could copy accurately, and that he enjoyed doing so. It
proved to be a valuable discipline, a training in the coordination of hand
and eye, which made the hand the quick and unerring interpreter of
observation. It became in itself a pleasure, like the athlete's delight in
well-ordered and accurate movement of the muscles, and it also
prepared the way for the flow of the emotions through the same
channel.

But in addition to these exercises, Pablo worked endlessly on sketches

of the people and the objects that he saw around him. His subjects were the fishing boats in the harbour, bourgeois families on the beach and landscapes of the Tower of Hercules, a Roman pharos on a rocky headland above the town. His favourite sitter was his sister Lola, of whom he made many drawings. She appears dressed in schoolgirlish frocks, going about her daily chores, helping the household by fetching water, or sitting happily nursing a doll.

There are in existence a few portraits of friends of Don José, which show remarkable maturity of style and which are certainly excellent likenesses. One of them is an unfinished portrait of Don Ramón Perez Costales, a minister in the first Republican government of Spain, who happened to be a neighbour and friend.[14] The personality of the old politician, with his billowing *moustachios*, his intelligence, authority and wit, stares out from the canvas. There is no hesitation in the brush strokes, and its execution would give satisfaction to many artists as the culmination of a life's work. The most impressive picture is a small painting of a young girl, with tousled hair and bare feet, painted in the last few months in Corunna (Plate I, 2). With a freshness and sureness of touch, the girl is portrayed with strong accents and contrasts that suggest Zurbarán. She is seated in front of a plain wall, gazing at us with large dark eyes. The untidy shawl on her shoulders, her plain dress and bare feet, together with the austerity of the surroundings, speak of poverty. Both feet and hands are coarse, and contrast with the innocence and wonder of her gaze, the classical symmetry of her face and the sadness of her expression. The painting is wonderfully sensitive and cannot fail to impress the most academic judge of art, but already there are elements that betray an individual trend. The exaggeration in the size of the feet, the heavy ankles enveloped by her dress, emphasize her contact with the earth and situate her as one of those born to live humbly. She is at the same time prophetic of the beggars of the Blue period, which was to follow seven years later, and the colossal nudes which Picasso was to paint in the early 'twenties. Picasso always kept this picture close to him. It is one of the many with which he could not part. In it can be seen the great Spanish tradition of Velázquez and

[14] See *Cahiers d'Art*, 25th year, II, 1950, Paris, p. 296.

Goya, but it must be remembered that up to this date Pablo had never seen any paintings beyond those contained in the churches, museums and art schools of the two provincial cities in which he had spent his childhood.

It is said that before the family left Corunna, Pablo exhibited a few pictures for the first time in a shop where various kinds of merchandise were for sale, including clothes and the much-needed umbrella. But in spite of the quality of his work and a short notice in the local press, sales were very few. Connoisseurs became shy of buying when they learned that the artist was only fourteen years old, but Don Ramón Perez Costales as a friend of the family accepted some small paintings as gifts.

The deliverance from this despised Atlantic haven came to Don José by chance. A post became vacant at the Barcelona School of Fine Arts, because one of the instructors there, a native of Corunna, was anxious to return home, and an exchange, financially advantageous to Don José, was arranged.

Summer in Malaga

In the summer of 1895 the Ruiz family packed their trunks and set out for their holidays in Malaga by way of Madrid. There for the first time Pablo had a brief glimpse of some great pictures. With his father he saw the work of Velázquez, Zubarán and Goya in the Prado.

Reunion with the family was a delight to all. Pablo was still the only boy of his generation and in addition had developed to such an extent during the past four years that everyone was now impressed by his talent. He had always been a stubborn child with a will which had been strengthened by the indulgences of his doting parents and relatives, but now his achievements demanded respect. His black hair, cropped short, his round and regular features, protruding ears and burning black eyes gave him a look of devilish vivacity, well suited to his small and compact physique.

The intensity and blackness of Picasso's eyes are noticeable in the earliest photographs, and throughout his life they struck wonder and fascination into all whom he met. They appear to possess a power of penetration which can see beneath the surface of things, pierce their

superficial coverings and lay bare their real identity. Age did not impair their power. At times their blackness suggested a look of fear, a fear of what they might reveal, but they were also like fireworks, throwing out flashes in a dark sky: flashes of wit or anger that struck deep into the person who met his glance.

That other member essential to the artist, the hand, is equally significant in Picasso. Small and well shaped, his hands were the instruments of his invention and the envoys of his sensibility. They could envelop a lump of clay, and transmitting his most subtle intentions, bring it to life in the form of a woman, a bird or whatever his imagination might dictate. They could draw, rub, smudge, tear, squeeze and manipulate with or without the aid of tools, whatever material he might choose to work upon. These two features, eyes and hands, were both inherited from his mother.

Although letter-writing was as irksome to Pablo in these early times as it was later, he had devised a way of keeping the family in Malaga informed and himself amused during the four years of absence. He sent them letters in the form of a minute illustrated magazine, having appointed himself director, editor, illustrator and reporter.[15] He drew out the headings and gave his journal titles such as *La Coruña* or *Azul y Blanco* (Blue and White), in the latter thinking probably of the weekly illustrated magazine *Blanco y Negro* (White and Black), but substituting blue for black with his characteristic preference for this colour.

The journal was copiously illustrated, and each picture given its explanation. The drawings referred generally to the discomfort of the climate. Men and women huddled together, umbrellas and skirts flying in the tempest, are given captions such as: 'The wind in its turn has begun and will continue until Corunna is no more.' Another page with the title 'All in revolt' shows a band of active little thugs with knives fighting each other or threatening old gentlemen whose top hats spring into the air with fright. The sheet finishes with advertisements of his invention, such as 'We buy pedigree pigeons.'

As soon as he had returned, his uncle Salvador at once began to think of ways which could help to promote his nephew's talent, and hopes

[15] See Duncan, *The Private World of Pablo Picasso*, pp. 134-7.

were raised of fame for the youthful Pablo, in which the family could share. Don Salvador had on his hands at that time an old sailor, Salmeron, who was in need of charity, and killing two birds with one benevolent stone, he offered him to Pablo as a model. In addition he gave his nephew an allowance of five pesetas a day and a room in the office of the sanitary authorities. The result of this act is a portrait which is often reproduced, and was seen to the end of his life in Picasso's studio.[16] The old sailor was very successfully portrayed, but what caused consternation to Don Salvador was that the picture was finished far too soon, and he was obliged to search for other sitters.

Josefa Ruiz Blasco, Pablo's Aunt Pepa, was the third of the eleven brothers and sisters. She was the eccentric one of the family and had lived under the protection of the Canon, Pablo, until his death. After that she had moved into Don José's apartment in the plaza de la Merced, and subsequently found a room for herself, which she decorated strangely with religious trophies and exotic bric-à-brac, very seldom allowing any visitors to penetrate her retreat. All agreed that Don Salvador's proposal that she should sit for her portrait was excellent, and Pablo, always eager to paint, consented; the only obstacle was the refusal of Aunt Pepa, who automatically answered 'No' when a question was put to her. It was decided that the request would stand its best chance of success if it came from the young artist himself. Pablo went to call, but found her as usual in interminable prayer, and her 'No' came with even more finality sandwiched between two Ave Marias. However, the unexpected happened abruptly, when all hope had been abandoned. A few days later, in the intense August heat, Aunt Pepa suddenly appeared, dressed in her finest fur coat and resplendent with all the jewellery she possessed. Pablo was summoned from the courtyard where, as often happened, he was playing with his sister and cousins, and reluctantly began the portrait, finishing it with astonishing speed, it is said within an hour. This picture is still in existence,[17] hung in the apartment of Lola, Señora de Vilato, in Barcelona.[18] From a canvas darkened by age the pale wrinkled face of Aunt Pepa watched the

[16] See Zervos, *Picasso*, Vol. I, p. 1.
[17] See Sabartés, *Picasso: Documents Iconographiques*, Plate 9.
[18] Now hung in the Museo Picasso in Barcelona.

entertainments, the singing and guitar playing that the descendants of her family offered to their friends. Her fanatical eyes and quivering lips seemed still to contain the same fervour sixty years later. Also the games from which Pablo had been called to paint the portrait remained as vivid in the memory of his companions, for he could amuse them in extraordinary ways by his skill. With a pencil he could bring to life with one continuous line the figures of people, birds, animals or what you will. They appeared with startling speed and exactness of outline, leaving his onlookers filled with delight. He would then say to them, 'Do you want a little horse? Here it is,' and with scissors he would unhesitatingly cut out of paper the most charming and lifelike animal which he would then present to the two little girls, who were his cousins.

2

Barcelona
(1895-1901)

Catalonia and Spain

It was in October 1895 at the beginning of a new academic year that the Ruiz family set out for the second time towards the north. Barcelona and Corunna are about equidistant from their native city, and both, like Malaga, are active seaports. But instead of an isolated rock-bound harbour, looking bleakly into an uninviting ocean, Barcelona is a Mediterranean port with easy access to France and the rest of Europe. Surrounded by rich country, it does not only make these two other ports appear insignificant, but even rivals Madrid commercially, politically, and as a centre of learning and the arts. Its geographical position gives Barcelona advantages over the capital; its interests lie with foreign neighbours to the north and east, rather than in an exclusive loyalty towards the sovereignty of Spain.

In the last years of the nineteenth century the Castillian grandees surrounding the central government had been shaken in their hereditary power by innumerable political rivalries and disasters, such as the Spanish-American war, but they still showed no sign of wishing to revise their ancient and unbending customs. Catalonia, on the other hand, having suffered less from the war, and being less rigid and conservative in its way of life, presented a more friendly and encouraging atmosphere to those whose traditions were liberal, and whose hopes lay in social progress. A strong separatist movement had linked this province for centuries with Roussillon across the Pyrenees, with which it shared a common language. As the authority of Madrid weakened, Catalonia became rejuvenated by a closer contact with French culture. Once more, in the last decades of the nineteenth

century, the artistic circles of Barcelona were invaded by Frenchmen, who immediately found themselves at home, whereas many Catalan intellectuals who made their way to Paris never returned.

The turn of the century brought with it in Barcelona a thirst for contacts outside the frontiers of Spain, and influences that seemed even more refreshing came from countries farther north than France. Ibsen was widely read and acted in the theatres of the Ramblas. Performances of Wagner helped to satisfy a yearning for romance which had its counterpart in the cloud-capped towers and cypresses of the paintings of Böcklin. The influences were equally popular and as easily digested as the music of César Franck and the painting of Puvis de Chavannes. It would be a mistake to imagine that France, because she is Spain's next door neighbour, is necessarily her next of kin. Germanic and Flemish influences abound in Spain in architecture, painting, and sculpture. There is a kindred feeling for expressionism which is to be found in the early frescoes of the Catalan primitives. Their saints are bucolic and uncouth, and they disturb the usual decorum of the Byzantine formula by outbursts of emotion that appear in their facial expressions and their gestures. The accompanying beasts and birds convey simple feelings of love and fear, symbolizing the forces of life and death, good and evil. Death and the martyrdom of mankind are intolerable, haunting thoughts to all, but the Spaniard has found a permanent way of exorcizing the spectre and depriving it of its obsessional power by exteriorizing it. The invisible terrors of the unknown take shape in art and ritual. Once their appearance has become known and familiar their authority is diminished and they can be greeted, even applauded, like actors in the drama of life. To look death in the face continually, to become familiar with the presence of the unknown and to come to terms with its menace, is one role of art throughout the ages; a contribution eagerly adopted by religion as its adjunct, and accepted by philosophy as a natural medicine for the ailments of the mind.

Throughout Spain, artists of all centuries have delighted in this role. Their work, whether religious or secular, shows unity in a common desire to express the drama of life and death. Symbolism often takes the form of extreme realism in an attempt to bring home with greater force the eternal theme. Precious stones from the tears that stream from the eyes of Christ, blood flows from his livid wounds, trickling over his

emaciated and half-putrefied body. No artifice is spared in order to bring home the horror of his suffering. Other artists with the same end in view, the expression of human suffering, have employed less obvious but not less moving methods. The angels of El Greco mount, stretching upwards in a flight which will tear them away from the agony of those below. The bitterness of the colour and the threatening contrasts of light and darkness convey the anguish of the soul, just as the *Caprichos* and the *Disasters of War* of Goya demonstrate in images the reality of doubt and suffering.

Suffering is not only a permanent reality in Spain, it becomes an essential ingredient in all forms of art and also in the ritual of the Church and the bullfight. Suffering dominates, but its contemplation becomes a channel for an exuberance of expression. The *corrida*, flamenco dances and singing, the processions of Holy Week with their fanatical penitents, and even the convulsions of Iberian Baroque architecture are evidence of this spirit which forms a link with the martyrs and devils of the Gothic north.

The Intellectuals Revolt

In the last years of the nineteenth century the revolt against the dead hand of Church and State was widespread. In Catalonia the 'modern' movement had suddenly gained momentum. Groups of young poets and artists were boldly making their unconventional opinions known to the public. In 1894 the little walled seaside town of Sitges staged a solemn fête in honour of César Franck, Morera (a Catalan musician) and Maeterlinck. At a time when El Greco was shown no consideration in Madrid, two of his paintings, recently purchased in Paris, were carried in solemn procession through the streets, escorted by Catalan poets and painters, and installed in the local museum. Intense excitement continued all day in an orgy of speeches and readings of poetry. Casellas read a Pre-Raphaelite fragment, *The Blessed Damozel*,[1] followed by another poet, Yxart, who delivered a piece called *Impressions of Tuberculosis*. The Catalan poet Juan Maragall then read one of his melancholy poems about the silent flowers that stripped

[1] Presumably a translation of part of the poem by D. G. Rossetti.

themselves of their own petals. Finally Santiago Rusiñol, the painter, playwright, 'intimist' poet and symbolist, who had on his own account bought and presented to Sitges the El Greco paintings, pronounced 'an enflamed speech in which he made disdainful allusion to the great herd, and said, notably: "We prefer to be Symbolists and mentally unbalanced, nay, even mad and decadent, rather than debased and cowardly; common sense stifles us, prudence in our own land is in excess..." '[2]

The fête of Sitges was symptomatic. Such sentiments as those of Rusiñol, prompted by the writings of Maeterlinck, Ibsen and Nietzsche, and well tempered with a native taste for romanticism, anarchism and individual courage, were shared by a vigorous and not untalented group of intellectuals. It was this group that attracted the youth newly arrived from Malaga. Thirsting for company that would help him to free himself from the conventions of the provincial society in which he had been brought up, he was shortly to find among them his most intimate friends.

In the last decades of the century the arts in Spain were being strangled by academic prejudice and incompetence, starved by the decay of popular art and threatened by a world that was taking an increasing interest in commerce and scientific invention at their expense. For those who were conscious of this growing menace, hope lay in closer contacts with northern countries. France had produced the Symbolists and the Impressionists, while in Germany Wagnerian romanticism was in vogue. The influence of England was important both on political and artistic grounds. Liberalism was strong politically, and a liberal and humanitarian tendency pervaded the significant artistic expression of nineteenth-century England, from the works of the Romantic poets to the activities of the Pre-Raphaelite Brotherhood and the writings of Ruskin and Carlyle. In addition the stability of government, much envied in a country that had known continual political upheaval, had its effect in the growing city of Barcelona on various levels of society. The underpaid and undernourished workers sought employment in England, and returned with views on democracy

[2] Cirici-Pellicer, *Picasso avant Picasso*, p. 96.

which they tempered with the Spanish desire for individual liberty of expression. A widespread popular movement that took the form of anarcho-syndicalism, influenced by the writings of Tolstoy, Bakunin, Kropotkin and Ferrer, whose works were still on sale in every kiosk along the Ramblas even in the early days of the Civil War, grew as a parallel to the intellectual revolution and influenced the trend of its development.

Arrival in Barcelona

The city of Barcelona, having outgrown the limitations of its ancient walls in the last decades of the nineteenth century, was expanding with extraordinary rapidity, but the great square, the plaza Cataluña, which is now the centre of the city, was in 1895 still a disordered fairground where booths were set up beneath the plane trees. On the far side of the square, among groups of buildings that began to invade the countryside, there was a hall that harboured a splendid collection of armour. Don José, the newly installed professor of Fine Arts, enjoyed paying visits to these attractions and would stop on the way to examine with envy the cages of rare pigeons always on sale along the Ramblas. Beside him walked his son Pablo, small but well-proportioned, his round head covered with closely cropped black hair, his sun-tanned face lit up by eager shining black eyes that left nothing unnoticed, and his ears of a schoolboy, who has not yet slept enough upon them, protruding beneath his hat.

The pair made a curious contrast, and showed little family resemblance. Don José was tall. He wore a long overcoat and a wide-brimmed felt hat. The ample flourishes of his greying whiskers and reddish beard surrounded a fine straight nose and kind eyes sunk beneath heavy eyebrows. Their expressions were even more dissimilar. The distinguished, middle-aged man, slightly stooping, had a look of disillusionment, a sad resignation, whereas the small heir to his fading talents walked erect, alert like a young lion cub watching all round and ready to seize any objective that might be captured by his intelligence and played with, tenderly or ruthlessly, according to his mood.

The family had found lodgings in the narrow calle Cristina, in the old

part of the city near the docks. The street itself was quiet, but round the corner was the continual coming and going of mule carts, trains, fishermen and white sailing ships that trade along the coast and across to Majorca. Once more they lived near the sea and, since Don José did not like walking, within a hundred yards of the School of Fine Arts.

The school occupied the top floors of an imposing building called the Casa Lonja, the Exchange. It was built on the site of a Gothic palace round the courtyard crowded with groups of statuary and fountains. Though larger and of greater prestige than the school in Malaga, it was no more advanced in its methods. The most rigid traditions and fustian gloom reigned throughout. The outside world was excluded so that the study of the antique, presented to the student in countless plaster casts, could receive all his attention. In the early stages the pupil would sit on a wooden stool in front of a cast hung at eye level above his drawing board, on a wooden screen painted dirty brown. Day after day hours would be spent in making laborious copies in charcoal on white paper of a fig leaf or a detail of classical architecture, until after weeks of careful application, the paper worn thin with continual erasures, he would be allowed to turn his attention to another cast. Finally the reward would be permission to graduate to the life class and full-size plaster statues. This deadly routine could be relied on to paralyse the imagination and the talent of any student who was not a genius.

When Don José Ruiz arrived to take up his post in the school, Pablo was scarcely fourteen, but although much under age he was allowed, owing to his father's pleas, to skip the boring initial stages and try his hand at the examination which would give him entrance to the higher class, known as 'Antique, Life, Model and Painting'.

The results were startling. The test, for which one month was prescribed, was completed by him in exactly one day, and so successfully that in his finished drawings from life he proved to be in advance of mature students who often found difficulty in reaching the required standards. Pablo's drawings for the examination, on paper bearing the official stamp, are still in existence. The undeniable technical ability they show is enhanced by a brutal disregard for the idealized classical canons of human proportions. As in earlier days, when drawing pigeons for his father, he had copied what he saw

accurately and with no thought of flattering his model. The tousle-headed, black-jowled, muscle-bound, squat-legged little model is drawn with simple realism in all his pathetic nakedness (Plate I, 3). There could be no hesitation on the part of the jury. They were at once convinced that they were faced, for the first and perhaps the last time, with a prodigy. Pablo was admitted. But, to quote Molière, 'to know all without having learnt it is one of the characteristics of great artists', and those who expected that a steady and methodical career as a student would follow this brilliant start were to be disappointed. A fever of drawing and painting had taken hold of him, and though he was willing to learn, what more had these conventional professors to teach? Without effort he had proved himself capable of mastering the academic standards required of a fully fledged art student, but the apprenticeship under the rod of academism that they proposed was no more than a step backwards for Pablo Picasso, who began life as a master. His friend Kahnweiler tells us: 'He has confided to me that he does not like his pictures of this period, and considers them inferior to those he made in Corunna under the sole advice of his father.'[3]

Science and Charity

The family soon moved from the calle Cristina to another house in the same quarter, No. 3, calle de la Merced, and Don José, always vigilant over his son's progress, found a studio for him near by, in the calle de la Plata. For the first time, Pablo had a room of his own where he could work undisturbed. The first picture he painted there is said to have been called *The Bayonet Attack*, but, if this is the case, there is no knowing how the future author of the great paintings *War* and *Peace* treated this subject in the first flush of juvenile enthusiasm, for it has totally disappeared.[4] There are, however, many drawing of battles in which the violent onslaughts of hand to hand fighting surrounded by the wounded and dying are vividly described.

[3] Kahnweiler, *Picasso: Dessins 1903-1907.*
[4] One biographer describes this as a large canvas, so big that it had to be lowered into the street from the attic windows with ropes, but Picasso could not remember this happening, and I agree with Barr that it seems probable that it may have been a small picture, inspired by the frequent illustrations in the press of those years, showing scenes from the early stages of fighting in Cuba.

However, another early painting, the first important work from the new studio, exists, well installed in the Museo Picasso in Barcelona.[5] The finished picture has sometimes been given the title *The Visit to the Sick*, but more correctly it is known as *Science and Charity* (Plate I, 4). At a time when the subject matter of a picture was held to be more important than any other factor, Don José chose with care a theme which would do his son credit, and so as to be closely associated with the progress of the picture he sat as a model for a doctor at his patient's bedside. The composition is completed by a nun holding a child in one arm, and offering a cup of comfort to a sick woman. The dimensions of the picture are imposing. Its size and the consistency of its accomplished execution are astonishing in one so young. There is, however, little in the picture to distinguish it, except for its competence and restraint, from a polished work by an academic painter of the period. Other artists of his time would have drenched the same subject in sentimentality. Pablo's version is a triumph of poise and discretion. One touch at least is prophetic of later work: the limp, elongated and graceful hand of the dying woman, against the white sheets and the contrast it makes with the hand that holds it. The acuteness of observation is substantiated by quantities of sketchbook drawings of hands. This speaks in advance of Picasso's feeling for hands, which emerged in the Blue period and remained characteristic of his work throughout. As so often happens when one detail reveals more of an artist's originality than others, it was this hand that was singled out by a scornful critic, who wrote the following verse:

> I regret before such sorrow
> To laugh like a brigand;
> But the reason is overwhelming,
> For does one ever see the doctor
> Take the pulse of a glove?[6]

Science and Charity earned for itself this doggerel, and also an

[5] Here again, a legend has spread to the effect that it was painted over *The Bayonet Attack*. This is proved to be incorrect, since the family well remember the story of the arrival of an immense roll of fresh canvas, and the consequent jealousy of Lola which was only cured when her parents offered her a handsome doll as a consolation.

[6] Sabartés, *Picasso: Documents Iconographiques*, p. 300 (translation).

honourable mention when it was sent to Madrid to the National Exhibition of Fine Arts in 1897. Later it went to Malaga, where it was awarded a gold medal, and afterwards found a home in the main hall of the house of Pablo's uncle, Don Salvador. There it remained for many years until it was installed temporarily in the apartment of Doña Lola de Vilato, Picasso's sister, in Barcelona. When, however, in 1970 it became the major item in Picasso's donation, it was transferred to calle Montcada.

Between the ages of fifteen and sixteen, still influenced by his father and the academic background of his father's friends and colleagues in Malaga and Barcelona, Pablo painted several more subject pictures. *The First Communion*,[7] which was shown in the Municipal Exhibition of 1896 in Barcelona, is now also in the Museo Picasso. In it, as in another large painting, *The Choir Boy*, the influence of his milieu is obvious. *The Choir Boy*[8] resembles in several ways a pompous canvas called *Acolytes' Pranks* painted by Don Rafael Murillo Carreras, the director of the Museum in Malaga who succeeded Don José. When a comparison is made it can be seen how the youth Pablo knew how to purge his subjects of fashionable anecdote and sententious bigotry. Unlike Carreras's painting, Pablo's choir boy stands at the altar with no facetious hints or elaborate detail. He looks you in the eyes instead of glancing with sentimental piety at the altar, and he is clothed in a plain surplice and a red cassock too short to hide a pair of clumping black boots. Pablo has taken Carreras's subject and stripped it to essentials. The figure of the boy stands in the centre of the canvas in a way that recalls the *Expolio* of El Greco, and foreshadows the insistence on a central feature that we find in cubist paintings of fifteen years later.

Independence and New Influences

Pablo soon discovered that the studio of the calle de la Plata was too close to the influences from which it was necessary to escape. Don José could drop in too often and give advice on his way to and from La Lonja. It was not long before he managed to move farther afield and

[7] See Zervos, *Picasso.* Vol. XXI, 23, No. 49.
[8] ibid., Vol. I, p. 2.

develop his own independence in his work. The first outstanding example of a new style is a small painting of 1897. It is a sketch of the interior of a tavern, painted early that summer (Plate I, 6). The murky atmosphere of the room is lighted only by a small and distant window against which the huddled groups of figures are silhouetted. The picture clearly shows new influences from other sources, probably gathered from reproductions of Daumier, and though there was little chance of his being conscious of it at that time, there is an affinity to the early painting of Van Gogh.

The work of a young and enterprising artist is bound to show the influence of other artists. Such influences will multiply with his desire to find new means of expression, and with the degree of his understanding of what he sees. It is in no way derogatory that we should try to link his work with the styles of other painters. Since the beginning of this century a flood of reproductions has widened the field greatly. The history of art is now available to an extent that did not exist at the time of which we are speaking. Sources were then more limited and discoveries of styles hitherto unknown were continually being made. With his insatiable appetite for examining the work of others. Picasso became conscious of new influences. Selecting those that moved him most deeply, he did not hesitate to take from them those elements which he needed, but in his expression the hallmark of his personality dominated. The stolen ideas were transformed and assimilated so thoroughly that there was little occasion for them to be claimed by their originator.

Besides those artists and styles that we know to have been admired by Picasso all his life, there is a host of lesser influences which have been seized on by him because of the way in which they have been a stimulus to his mood. During the period we are speaking of, before he first went to Paris, he knew little of the great movement in art that had been going on for some years in France. What knowledge he had came from a few friends who could talk about what they had seen in Paris, and from magazines that printed the graphic work of artists such as Steinlen and Toulouse-Lautrec. The painting of the French Impressionists, such as Degas and Seurat, remained unknown except from verbal descriptions until he reached Paris. There had, however, been a considerable vogue

in Barcelona for the Pre-Raphaelites, and the young Andalusian had been fascinated in particular by the white-skinned maidens of Burne-Jones, whom he had seen in reproduction. The drawings of Beardsley, Walter Crane and William Morris were also known to him through art journals, and slight flickers of their influences are occasionally to be found in drawings of these years.

In the early summer of 1897 some of Pablo's work was exhibited in Barcelona. Canvases such as the portrait of the *Man in a Cap*,[9] painted in Corunna, and more recent work were shown, but although the press gave notice of the exhibition there was no marked enthusiasm. He was still too young to be taken seriously, a fact which hindered the sales that his father eagerly anticipated.

Excursions along the Coast

During the early years in Barcelona the Ruiz family took several trips in coasting vessels along the coast to Valencia, Alicante, Cartagena, and even as far as Malaga. It is these short journeys which account for several seascapes which can now be seen with a profusion of early drawings and paintings in the Museo Picasso in Barcelona. They give ample proof of great sensitivity and accomplishment in the impressionist vein. The dramatic arrival in harbour at early dawn was remembered vividly by Picasso who told me not so long before he died of the unexpected events that once greeted the family as they went ashore in Valencia. The town was crowded with soldiers, who to their surprise were in an aggressive mood, firing into the air – an action which was answered by a hail of bricks and stones from the roofs. But this local disturbance in no way upset his parents, who made it the occasion for an excellent lunch in a near-by restaurant. It was Pablo's first contact with political violence and an example of the indifference to social events characteristic of his parents.

Visit to Malaga

With great rejoicing Don José and Doña María packed their trunks for

[9] ibid., Vol. I, p. 4.

their return to Malaga for the summer of 1897. Andalusian at heart, Don José had never really taken to Barcelona, where the Catalan language annoyed him, and the general behaviour of the people was too busy and casual in comparison to the leisurely warmth of the Malagueñan.

They were accompanied by Pablo and Lola, who went to stay with their grandmother. The young painter's success at La Lonja had already become known among his relatives. His uncle Salvador again saw the possibility of making him into a successful artist, and at the same time a respectable citizen, who would be a credit to the Ruiz family.

It was soon noticed that he took pleasure in walking out in the cool of the summer evenings under the trees on the Caleta near the beach with his cousin, Carmen Blasco. Smartly dressed, he wore with a flourish a black hat, from beneath which shone eyes so black that they appeared to burn with the reflected lamplight. He carried a cane under his arm with a swagger he had learnt in Barcelona. It seemed to all that he must be in love, and hopes that this, and his loyalty to Malaga, would persuade him to settle down in his native town ran high. The climax came when he presented Carmen with a superb bouquet, not bought at the florist but painted specially for her on a tambourine.

But the family was to be disillusioned. Pablo never did what was expected of him, and in October, when the holidays came to an end, so did the happy idyll. Pablo left his home alone for the first time, bound for Madrid. He wanted to see what this city could provide in the way of new experience, and whether life in the capital could offer more promise than in Barcelona or his native Malaga. This in fact was the last time he was to spend a summer in Andalusia, surrounded by the family circle.

During his stay it was made clear that it was not only his relatives who were impressed by his unusual talents. A fête was organized by a group of Don José's friends who met regularly at a club called El Liceo. Don Joaquín Martínez de la Vega, a successful painter, had been told of the honours paid to the picture *Science and Charity* in Madrid. Another admirer was the old friend of the family, Antonio Muñoz Degrain, who had received as a Christmas present from Pablo two years before a

remarkably lifelike water-colour portrait of Don José[10] which, with its inscription in the hand of the young painter, can now be seen in the museum in Malaga. In the elegant eighteenth-century décor of El Liceo, beneath its painted ceilings and chandeliers, they assembled to baptize Pablo Ruiz Picasso, painter, with libations from a bottle of champagne.

Madrid

The Royal Academy of San Fernando is an austere and pompous building in the centre of Madrid. Its galleries contain several of Goya's great portraits and some superb small paintings by him of dramatic scenes of Spanish life, such as the bullfight, the Inquisition, the madhouse and a riotous procession of masquerading peasants. Velázquez, Zurbarán and other Spanish masters are also represented. The overwhelming weight of Spanish tradition, the forbidding darkness of the corridors, were no more in keeping with the visions of new forms of art than had been the provincial incompetence of the schools which the impatient youth from Malaga had already spurned.

Again his entrance to the Academy was marked by a performance of brilliance equal to that on his arrival at La Lonja. In a single day he excecuted drawings that satisfied the most obstinate of his examiners. By doing so he had, at the age of sixteen, exhausted all the academic tests that the official art schools of Spain could apply.

His arrival in the capital in October 1897 was his second visit to this city. On their return from Corunna two years before, Don José had found sufficient time to take Pablo round the Prado and point out some of its major treasures. But now for the first time he was alone, and desperately restricted in his means. He found humble lodgings at first in the calle San Pedro Martín, in the centre of the city. The life of the streets and the riches of the Prado proved to be of far greater interest to him than the course laid down by his professors at the Academy. 'Why should I have gone there? Why?' he asked his friend Sabartés in later years.

[10] See Sabartés, *Picasso: Documents Iconographiques,* Plate 15.

That he worked is certain. Picasso always worked with the same urgency that he breathed, but his poverty restricted his purchase of painting materials, and in fact very few of the drawings and paintings he made during this stay have survived. It is possible that there may lie buried deep in academic dust, somewhere in the cellars of San Fernando, the works with which he passed his entrance tests, since it was only recently that the Madrid Museum of Modern Art discovered, hidden in its storerooms, a portrait of a girl by Picasso which had won a third prize about 1900.

Lacking further evidence, we can still gather an image of his surroundings and his poverty from a few sheets covered so completely with drawings that it is difficult to disentangle the figures of gipsies, pompous bourgeois, clowns, dogs, horses and scenes of café life. On one sheet, in the centre of which is a sketch of two men preparing for a duel with swords, he has written eight times, 'Madrid 14 de diciembre' in delicate flourishes, as though he were setting himself an exercise in calligraphy.[11] Perhaps this was the result of a moment of boredom, but it again reveals his interest in forming letters and figures, and his delight in watching a well-controlled pen make extravagant flourishes and curlicues. Also the date, which he usually added to drawings before he signed them, had a special significance for Picasso. It records the movement of time and adds the recognition of another dimension to his art.

In another of these rare sketches there is a wooden stool and a makeshift table on which stand two glasses,[12] set against a bare wall, evocative of the series of attics in which he lived, moving from one to another in the busy quarter round the plaza del Progresso.

In the spring of the following year funds were running very low. His ambitious uncle in Malaga did not like the offhand way in which he believed Pablo had shirked his studies. For him, painting should be a profession which would lead to a position of honour among painters and society. What better start could there be to a successful career than the blessing of the Academy of San Fernando? He had before him the

[11] See Zervos, *Picasso*, Vol. VI, p. 11, No. 83.
[12] ibid., Vol. VI, p. 7, No. 53.

splendid examples of his old friends, Moreno, Carbonero and Muñoz Degrain, whose lifelike portraits of the aristocracy and colossal scenes depicting the glories of Spanish history had already won them fame which, he considered, should be eternal. Madrid was recognized to be the only place where an artist could attain the highest glory and fortune. In consequence, since his nephew refused to profit by his generosity in the way he had planned, he showed his disapproval by stopping his allowance. The result was that the hard-pressed Don José deprived himself still further to keep his son alive.

But neither threats nor financial worries could disturb Pablo. Continuing to absent himself from the Academy, he enjoyed his liberty and the life around him in the streets and cafés. He became intrigued by the menacing darkness of narrow alleys and doorways frequented by a mixed bohemian population, men and women who were undaunted by the state of misery in which they lived precariously. Their vitality was such that they were able to laugh, dance and sing in spite of the filth and hunger that would otherwise have swallowed up their lives. The poet Ramón Gomez de la Serna gives us this description: 'Picasso wanders on the raging pavement of Madrid, penetrates it with the soles of his feet, discovers there that which will afterwards be the essential base of all his rebirths, the plasticity of the visible, whose hard entrails he will express in the first cubist nightmare.'[13] In the streets where Goya watched and painted the revolt of the people against French tyranny, Picasso made his first lonely contact with the grim reality of poverty. Goya, a hundred years before, had witnessed revolutions and the end of a period. 'He [Goya] had seen this terrestrial eminence which is Madrid, subtly lit up by the light of two centuries: the eighteenth century coming to an end, while the nineteenth was already announced, and from this he acquired a keener clairvoyance, a kind of double sight...Picasso at the meeting of the nineteenth and twentieth centuries knows the ancient paths and from there discovers new ones.'[13]

The winter had been hard and full of privation. In the spring Pablo fell ill with scarlet fever, and as soon as he was able he left Madrid and returned to his parents in Barcelona.

[13] Ramón Gomez de la Serna, 'Le Toréador de la peinture', *Cahiers d'Art*, 1932, Nos. 3-5.

Though the exact date of his departure is uncertain, it could not have been before 12 June, because he remembered having been present at the celebrations which take place yearly on the eve of the feast of St Anthony. The terraces between the river and the shrine of San Antonio de la Florida are crowded all night with a noisy throng of revellers. The dome of the little chapel had been decorated by Goya with groups of graceful and desirable angels whose models were the ladies of the court of Charles IV, and beneath it lies the artist's grave. Pablo's first exacting separation from his family and his friends, in harsh surroundings and the loneliness of the capital, at least finished with communal festivity in an atmosphere which recalled memories of his great compatriot.

Horta de San Juan: Summer 1898

In Barcelona Pablo had met a youth, Manuel Pallarés, from the borders of Aragon, a painter of some talent with whom Picasso was to have an exhibition in 1900. Their friendship continued in old age. The family of Pallarés lived in a village of stone-built houses, crowded round the massive sun-baked walls of the church. The surrounding country is rich in vegetation; wherever irrigation can bring water to the parched soil it becomes a luxuriant garden. Elsewhere vines and olive trees cover the hills that rise gently from the valley of the Ebro. They are dominated by the angular barren peaks of limestone mountains standing against the sky like the walls of ancient fortresses. The sun relentlessly bakes and gilds the rocks. Lying among the foothills near the great river, the village of Horta de San Juan[14] (Horta in Catalan means garden) enjoys the contrasts of this marriage of fertility and sterile drought. In these surroundings, which were to provide themes ten years later for some of the early cubist landscapes, Pablo found the welcome he needed after the privations and illness he had suffered in Madrid. Here he made the acquaintance of the countryside for the first time, and came into contact with a different kind of struggle for life, the enemy now being the relentless and incalculable behaviour of nature, instead of the severity

[14] There is some confusion about the name of this village. It was called Horta de Ebro in Picasso's letters to Kahnweiler in 1909, but it is now known officially as Horta de San Juan.

and dishonesty of man. But the background of poverty was much the same. Thrift and endless labour, the only means of survival, had bred the taciturn race of peasants who now became his companions.

Pablo understood and even relished the healthy change in his surroundings. He was eager to learn the crafts of farming. The skill required to load a mule or yoke oxen, and the knowledge necessary for the growing of crops or making of wine intrigued him. Owing to his willingness to lend a hand in routine jobs he was able to boast later, 'all that I know, I learnt in the village of Pallarés'.

At Horta he felt thoroughly at home, and he stayed on long after his convalescence was complete. Many sketches are in existence of peasants seated by the roadside, gipsies with shawls and flowers in their hair, playing the guitar, and men and women at work in the fields. They are drawn in fluent curves, with a feeling of tranquil assurance. There is one charming head of a girl, with her name, Joceta Sebastia Mendra, Horta de Ebro, noviembre 1898, inscribed below.[15] It may well be that she was the cause of his long expeditions on foot to the only shop in the neighbourhood that could provide him with sufficiently elegant black velvet trousers.

When the heat became intolerable the two young painters found their way high up into the mountains where they lived together in a cave, buying food from a near-by farmhouse and making sketches of the pine forests while they enjoyed their isolation.

Return to Barcelona

It was shortly after Picasso's return to Barcelona in the early spring of 1899 that Sabartés, according to his own account, first met him at 1 calle de Escudillero Blanco, a narrow street in the heart of the old part of the city. Pablo was using as a studio a small room in the apartment of the brother of the young sculptor, Josef Cardona. The other rooms were occupied as workshops for making ladies' underwear. Sabartés describes how 'Picasso, in idle moments, enjoyed making eyelet holes in the corsets with the appropriate machines.'[16]

[15] See Zervos, *Picasso,* Vol. VI, p. 17, No. 136.
[16] Sabartés, *Picasso: Portraits et Souvenirs,* p. 20.

Into the small room was crowded a mass of canvases, not only *Science and Charity* with its generous dimensions, recently returned from Madrid, but also another important work called *Aragonese Customs*, painted on the suggestion of Pallarés at Horta de San Juan. This picture has totally disappeared for the simple reason that like so many others it was painted over again and again, partly to save the cost of new canvases and partly because in his eagerness to realize a new idea Pablo could not waste the time needed to go out and buy new material. We know, however, that the painting was awarded a third prize in Madrid, and again a gold medal in Malaga, but the only remaining evidence is a caricature of it which appeared in a Madrid paper. The cartoonist had seized on the fact that in the picture a peasant with an axe looks dangerously as though he were about to decapitate a woman bending meekly beside him, and concluded that this was the reason for the title, *Aragonese Customs*.

More than eighteen months had passed since Pablo had been resident in Barcelona, and during that time he had greatly widened his acquaintance with the world by the extreme contrasts of life in the metropolis and life in the depths of the country. He was now ready to start work in earnest and make his way among the seasoned intelligentsia of the modern movements in Barcelona. The everyday life of the city with the ceaseless activity of its harbour again provided him with an endless supply of subject matter. He was living in the heart of a world intensely alive both day and night.

Beyond the Ramblas with their flower markets, cafés and endless stream of people, passing slowly up and down in animated discussion, is the so-called Chinatown of Barcelona, though the Chinese themselves are noticeably absent. On the contrary, nothing could be more Spanish than the narrow streets, crowded with various kinds of necessities, entertainments and temptations. There are restaurants where the smell of rancid olive oil and garlic perfumes the air with an odour peculiar to Spain; *bodegas* where the low vaults, packed with casks, ring with the passionate voices of the impromptu singers of *canto hondo* and the sharp punctuating notes of the guitar; cabarets that open their doors well after midnight, and fill at once to suffocation with those who love to bask in the sentiment of popular songs accompanied by a pianist; music halls

where the girls in low-cut dresses and high pearl chokers, or naked except for an embroidered shawl and jewellery, stand close to the footlights to put across the combined provocation of their voices and actions to a turbulent male audience; and, finally, brothels where in silence, without the accompaniment of song and dance, the most intimate desires can be fulfilled at the smallest cost to the purse if not to the health.

It was to these gay and sordid regions that artists and poets were naturally attracted, and in addition a revolutionary urge made it impossible for them to be indifferent to the lurid drama of life which was present all the time in an intensive form. The intellectual climate also was tumultuous, and above it could be heard the voice of Rusiñol exhorting his companions.

to tear out from human life, not direct scenes, not vulgar phrases, but brilliant visions, unbridled, paroxysmal; to translate into mad paradoxes the eternal evidences; to live by the abnormal and the strange, to arrive at the tragic by frequenting the mysterious; to divine the unknown; to foretell destiny, giving to the cataclysms of the soul and to the anxieties of the world an expression excited by terror; such is the aesthetic form of this art of our time, splendid and nebulous, prosaic and great, mystic and sensual, refined and barbarous, medieval and modern.[17]

These torments were in favour, rather than a carefully balanced, ordered approach to the problem of life. The enemies were commonsense and reason. In the belief that a new form of art should be born from the exaltation of anarchy, the Catalan modernist intellectuals echoed the cry of Rimbaud for a *'déréglement total des sens'*. At the same time his challenge aimed at all existing values and his desire to transform life at its roots became confused in a romantic nostalgia, a *'mal du fin de siècle'*. Rimbaud's anger at injustice and incomprehension became immersed in a torrent of words that bred ridicule rather than terror. The underlying disquietude of the Catalan intellectuals was founded on the reality of a widening gulf between them and an unresponsive society that they felt bound to condemn. The role of the *'Poète maudit'* spread both to those whose suffering was their fate and to

[17] Cirici-Pellicer, *Picasso avant Picasso.*

the dilettanti alike. The poet and bohemian took as their chosen companions the political rebel and the starving tramp.

Els Quatre Gats

A group of paintings surrounded by sketches was the first exhibition to hang on the walls of a new artistic and literary tavern, which was opened in a small street near the plaza Cataluña in 1897 by the genial Pere Romeu. The painter of these works was Isidro Nonell and the tavern was to become the famous cabaret of the Four Cats, in Catalan Els Quatre Gats. Both events were innovations of importance. Nonell's pictures formed a series which he called The Cretins. They were studies influenced by Daumier, of the old peasant women who were to be seen every day squatting on the steps of churches or queuing for alms, their faces shrivelled and their hands worn by hunger and drudgery. That they should appear on the walls at the opening was ominous of the trend for which the tavern was to become famous. They symbolized a new tendency in the art circles of Barcelona.

When Pere Romeu returned from a long trip, which included both Chicago and Paris, he did so with the intention of opening an establishment that would cater for the varied tastes of his intellectual friends. In Chicago, while learning about sport, he had been greatly impressed by the possibilities of that symbol of the new age, the bicycle. Later in Paris, after an apprencticeship in the night life of Montmartre and the Latin quarter, he had evolved the idea of creating in his native city a cabaret on the lines of Le Chat Noir of Aristide Bruant, calculated to foster the most unconventional and creative spirits among poets, painters, sculptors, playwrights and musicians.

He chose for this purpose a new building in the Neo-Gothic style, with heavy beams and elaborations in carved stone and wrought iron. The large room was to serve as a beer garden, cabaret, and concert hall, and also as a theatre for marionettes and shadow-plays directed by Miguel Utrillo. (His name has become more widely known in recent years through his adopted son, the artist Maurice Utrillo.) The painter Ramón Casas and Utrillo were joint editors of the art journals Pel y Ploma (Brush and Pen) and Forma. Small exhibitions were arranged. In

the early days they were chiefly of drawings by Nonell, and clever portrait drawings, in the style of Steinlen, by Casas. The main decoration in the hall was a large mural by Casas of two bearded men, himself and Romeu, in white and black stockings riding a tandem.

The tavern advertised itself as a 'Gothic beer hall for those amorous of the north and Andalusian patio for amateurs of the south, a house of healing'. The founders of the activities for which it became famous were men of Rusiñol's generation. His closest friends were Utrillo, Casas and the Basque painter, Zuloaga. Picasso, who was away at the time it opened, joined the group later as its 'Benjamin' when its leadership had already passed into the hands of a younger generation. His talent more than filled the gap in years between him and his friends, and at once they pushed him into competition with artists of established reputation, in particular Casas, who was the accepted portraitist of the time with no limit to his clientele. As a challenge, Picasso's unflattering but startling sketches of artists, poets and musicians were pinned up on the walls. The spontaneity and strength of his line, the unexpected flourishes, blots and scribbles, so convincing and so revealing of the character of the sitter, filled his friends with admiration. They realized that Picasso could easily surpass the painstaking work of artists ten to twenty years older than himself. But this early demonstration of his powers passed unnoticed by the outside world.

There is in existence a poster for the 4 Gats signed P. Ruiz Picasso which shows a group of elegant customers, ladies dressed in crinolines and gentlemen in frock-coats and top hats, seated with their mugs of beer on the terrace in front of the Gothic façade.[18] It is somewhat in the style of Walter Crane, and a figure resembling John Bull sits with ladies in the background. It is a romantic dream of a bohemia, deliberately northern in feeling and very unlike the anarchist realism that was coming to birth in the paintings of Nonell. Later, in 1902, a much less stylized version was to appear, signed more discreetly with the initial P.[19] It is a pen drawing of a group of the real *habitués*, seated drinking and smoking pipes around a table. In the foreground sits Picasso

[18] See Zervos, *Picasso*, Vol. VI, p. 24, No. 193.
[19] ibid., Vol. VI, p. 24, No. 190.

himself, with black dishevelled hair, an untidy beard, large hat, overcoat and stick. Behind him is the long, sad face of Pere Romeu, smoking a large twisted pipe, and accompanied by the painter Angel F. de Soto, Jaime Sabartés and two others. A large dog completes the group, and above is written 'Drink and Food served at all hours'. Undoubtedly this gives a more accurate picture of the 4 Gats and those who so eagerly visited it, than the earlier version. The style of dress favoured by them was a proletarian dandyism. It consisted of a black hat, stock and high-cut waistcoat, loose dark jacket, and trousers that narrowed towards the ankle, and was derived from the costume of the anarchist agitators who were the heroes of the working class. There is a well-known portrait by Casas of Picasso dressed in this way, for although he was far too preoccupied with his work to take much interest in politics, a form of dress which distinguished him from the bourgeoisie was to his taste. From his earliest days Picasso nurtured a compassionate tendency which united him with the common people and led him to seek the company of those who were dissatisfied with a social system characterized, as they saw it, by the greed and vanity of the rich and the misery of the poor. Beyond this, politics for him belonged to another sphere, and the language of politicians was as foreign to him as the speech of distant tribes. The political theories expounded by those who frequented the 4 Gats were based largely on Catalan separatism. For this reason alone they failed to interest one recently arrived from another province, and Picasso found that the anarchist doctrines which corresponded more closely to his instinctive desires lacked sincerity when they came from a rich dilettante such as Rusiñol, who risked nothing by his inflammatory talk.

The words of Jaime Brossa, a young anarchist writer, however, carried more weight. He called for a 'courageous anti-snobbism in art and life' which would defeat the 'bourgeois and the philistine'. In the review *L'Avenue* of January 1893 he wrote: 'Man. . . comes to the point when he can no longer admit any hindrance to his speculations, and from this exaltation of the individual no myth, idol or entity, divine or human, remains capable of opposing the absolute liberation of individuality – theories qualified by some as disruptive, but in which a negative spirit joins a positive spirit reconstructing and renewing lost

force.' An echo to this war-cry may be heard forty years later in Picasso's remark: 'My works are a summary of destruction.'

In such theories lay the germ of convictions that in later years led the intellectuals of Barcelona to throw in their lot with the Republicans when their ideals became threatened at the outbreak of the disastrous Civil War of 1936, and also induced Picasso to declare his solidarity with them. When revolutions, dictatorships and war became realities he no longer wanted to retain his Olympian independence.

The position of Picasso among his friends of the 4 Gats became firmly established. He is 'said to have been uncommunicative but of rare precision in his judgements. Those who knew him at once became his admirers or his enemies.'[20] His shrewd wit could be devastating but he could also laugh boisterously at good-humoured jokes. Among the younger painters his closest friends were the painter Sebastia Junyer-Vidal, of whom he did many drawings,[21] 'the vigorous and very talented' Nonell, the collector Carlos Junyer, the sculptor Manolo Hugué, the brothers Angel and Mateo Fernandez de Soto, Reventos, the writer of strange tales, the poet Jaime Sabartés, and Carlos Casagemas, who was shortly to accompany him on his first visit to Paris.

The 4 Gats lasted only six years, but during its life it earned a great reputation, not only for the artists who were attracted by its atmosphere, but also for Utrillo's puppet shows and the concerts given by such distinguished young musicians as Albeniz, Granados and Morera. In 1903, after the departure of Rusiñol for Paris, Pere Romeu, who had married an English girl of whom Picasso made a very fine portrait,[22] gave up the management and returned to his passion for the bicycle. Although much loved he did not prosper, and died of tuberculosis in poverty a few years later. His tavern will be remembered for the turbulent and brilliant activity that centred round it where an unforgettable presence was the youth, Pablo Picasso.

In this circle of young intellectuals robustness of spirit was not necessarily accompanied by good health. The distant examples of

[20] Cirici-Pellicer, *Picasso avant Picasso*, p. 41.
[21] See Zervos, *Picasso*, Vol. VI, pp. 30, 31 and 33.
[22] ibid., Vol. I, p. 63.

Baudelaire, Verlaine and Rimbaud had convinced their generation that the artist must of necessity be the prey of poverty and disease. Poverty was by no means unusual but disease was a commonplace and was suffered proudly, particularly when it took the form of tuberculosis or venereal diseases, which carried with them a romantic aura. They were all the more likely to be contracted by those who were determined to live passionately with little consideration for the consequences, and who accepted such doubtful rewards with pride. Neither was the aid of drugs left untried, the aim being to heighten the pitch of the imagination at all costs and if necessary at the expense of all else.

Sketchbooks

Since his return from the borders of Aragon, Picasso had continued to paint with increasing energy. Above all, his appetite for drawing was insatiable and kept him in a fever of excitement all day long; his hand, with amazing precision, was the constant interpreter of the vision of his greedy eyes. His sketchbooks contain an incredible variety of street scenes, bullfights, studies of cart horses, dock-workers, men in boats, toreadors, beggars, coachmen; together with sketches made in cabarets, dance halls, cafés and brothels.[23] There are a few landscapes and views of house tops, some nudes and great quantities of portraits and caricatures of his friends, most of them bearded bohemians, drawn with vigour and undoubtedly extremely lifelike. There are also many portraits of his family; his sister drawn with tender affection as she stands arranging her hair before the dressing-table or poses seated in a chair; or his father, tall, bearded, elegant and distinguished. There are others where he questioned his own face in the mirror or from imagination saw himself standing in the street with friends. From an early date he was not content to see himself only as the reverse image in the glass, and anxious to know how he looked to others he studied his own appearance from all angles. He knew himself and could describe what he knew. Sometimes he delighted in making himself look absurd. In this way some event that had wounded his pride could be laughed off

[23] ibid., Vol. VI, pp. 32, 34 and 35.

by a caricature. He once drew in pastel a scene in the antechamber of a brothel where he shows himself, hat and stick in hand, presenting his excuses to a monstrous harridan seated on a couch, but there is no further explanation of why he should be doing so.

In addition to sketches rapidly taken from life, there are occasional studies for compositions in the classical style, set pieces which were suggested either by his father or his father's colleagues. But the desire to translate these subjects into large-scale paintings had passed, and on the occasions when he was tempted to start on themes such as 'The Last Supper'[24] they were not carried further than preliminary sketches. A scene that never ceased to interest him, however, was the bullfight. Alive with the dramatic movement of men and beasts, the brilliant colour and strong contrasts of sunlight and shade, and the hysteria of the crowd, the arena seemed to contain, framed like a cameo in so small a space and limited time, the actions, the passions and the fears of daily life. Its appeal to Picasso was irresistible. 'People think,' he told me, 'that I painted pictures of bullfights in those days after they were over. Not at all, I painted them the day before and sold them to anyone so as to have enough money to buy a ticket.'

Some of the sketches of these years in which he was still not entirely free of his apprenticeship show evidence of the prevailing sentimentality of the time. Subjects such as the poor girl in a garret, kneeling beside the bed of a sick child, in his hands gain, however, by a tenseness in the pose of the girl and a severity of atmosphere.[25] Picasso even at this age did not shrink from the most harrowing scenes. There are sketchbook drawings now in the Museo Picasso of men dying in hospital that show a great capacity for objective observation. Poverty, anxiety and sickness were real to him, and the reality he could give them as it grew in strength reappeared in his paintings of the beggars and the half-starved mothers with their children of the Blue period. On looking at sketches and paintings of these early years in Barcelona we find signs of an increasing awareness of the painting of others. The styles that attracted him, whether they belonged to the past or the

[24] ibid., Vol. VI, p. 10, No. 77.
[25] ibid., Vol. VI, p. 23, Nos. 180, 182, 184 and 186.

present, were those which were unknown or despised in academic circles. Already in Madrid he had been deeply impressed by El Greco, and the interest that Rusiñol and Utrillo saw in his work added to Picasso's appreciation. In charcoal drawings such as the *Old Man with a Sick Girl*,[26] his adaptation of El Greco's characteristic elongation of limbs and heads becomes clearly visible.

Miguel Utrillo was an art historian as well as a critic with advanced ideas. He had travelled in Italy and at home he had discovered the Catalan primitive, Huguet. Picasso's interest in Gothic or Romanesque frescoes and polychrome sculpture, in which Catalonia is so prolific, dates from the period when Utrillo's enthusiasm was at its height.

About the same time, another influence came into Picasso's work. Barr suggests that Casas, 'a clever and prolific artist in the line of Steinlen and Toulouse-Lautrec...encouraged Picasso and passed on to him the influence of the great French draughtsmen of the end of the century long before the young artist saw their work in Paris'.[27] He also knew, through reproductions from magazines such as *Gil Blas*, the *Studio* and later the *Assiette au Beurre, Le Rire* and *Simplicissimus*, a great deal about the minor painters of France, England and Germany.

First Illustrations

In July 1900 a modest periodical, *Juventud* (Youth), which represented extreme 'modernist and Catalan' views in literature, science and art, reproduced for the first time a drawing by Picasso. Very few illustrations appeared in this paper, and this one was done to accompany a symbolist poem by the now almost forgotten poet, Joan Olivia Bridgman, entitled *The Call of the Virgins*.[28] In the foreground of the charcoal drawing, signed P. Ruiz Picasso, reclines a rather matronlike semi-nude virgin, while there appears in a mist above her the ghostlike visitation of a muscular and desirable male. The following month, another drawing appeared illustrating a new poem, *To Be or*

[26] ibid., Vol. I, p. 183.
[27] Barr, *Picasso: Fifty Years of His Art*, p. 16.
[28] See Zervos, *Picasso*, Vol. VI, p. 30, No. 245.

Not To Be,[29] by the same author. Here, in a stormy sea a man stands alone, steering his boat with a long oar through the tempest. The interest of these youthful drawings, the one symbolic and the other transcendental, lies in the fact that they are the first of so many drawings made by Picasso in later years in collaboration with his friends the poets. Whether or not he was inhibited in this first attempt by the sentimentality of the poems, both drawings are feeble in comparison with other work of the same period which remained unpublished and little known at that time.

Another review, *Cataluña Artistica*, on 6 September 1900 published a charcoal portrait of the poet Antoni Busquets y Punset, and a few weeks later, another illustration to a romantic and melancholy story by Surinac Senties appeared, with the title of the story in Picasso's own lettering and his drawing *La Loca* (the mad woman).

Life was not easy, and the small sums that these illustrations could contribute to his finances were welcome. But, unlike most of his companions, it was very rare that he helped himself out with commercial work. It is recorded that on one occasion he decorated the front of a grocer's shop in the calle Conde del Asalto, and another time he made a poster for a patent medicine. Its qualities, advertised as an infallible cure for 'lymphatism and weakening of the bones', were made unexpectedly attractive by a beautiful drawing of a wasting girl poised beside a seated pierrot.

Gaudí

A large and active circle of friends and a steadily growing reputation did not imply a comparable increase in wealth. On the contrary, even in a city where living was easy, only bare necessities could be afforded. Picasso moved from one studio to another, seeking cheap accommodation for his work, and usually sharing it with a friend. There is a story of how he invaded the studio which was rented by a group including his friend the painter Ramon Pichot, former pupil of Casas and Rusiñol. In a very short time after Picasso moved in, the place became full of his materials, and his friends, including the owner,

29 ibid., Vol. VI, p. 39, No. 317.

gave way before the urgency of his desire to paint and his indisputable authority. It became Picasso's studio. On that occasion all went well, but his egocentric ways did not please all, and murmurings about his obstinacy and his disregard for the work of painters around him came from those who were jealous of his talent.

Later he settled in the calle Conde del Asalto with the sculptor, Mateo Fernandez de Soto, who, it is said, contributed the greater part of the rent. In this narrow thoroughfare near the Central Ramblas, bordering on the Chinese quarter, the architect Antoni Gaudí had ten years before finished a palace of peculiar design that he had built for the Count de Güell, his most devoted patron. Gaudí is best known as the fanatical architect of the gigantic but still unfinished Cathedral of the Holy Family that towers over the modern part of the city. He designed his apartment houses, palace, churches and parks with a desire to free architecture from the imposed rigidity of classical rules. Nature could give him, he believed, direct guidance in the construction and ornament of his buildings. Palm trees with their upright thrust and spreading branches, and snails with the structural economy of their spiral shells, became his models. From their example he devised highly original forms. His early work, such as the Güell palace, is heavily overlaid with decorative art nouveau ornament. Stone, wood, ironwork and mosaic are carved, moulded, beaten and twisted into the shapes of vegetable growth. The parabolic arches of its entrance are filled with heavy wrought-iron screens that suggest seaweed, and above, in the apartments and lofty music-room, there is an atmosphere of a magic palace, isolated from the busy street below. It is lit by windows that are screened from the interior by avenues of columns, and richly decorated in a style that suggests Venetian palaces or the harems of Istanbul. But Gaudí never travelled, and these influences must have reached him through his patron, or more probably Ruskin, who was much read and appreciated by the intelligentsia of Barcelona.

Picasso had no particular love of Gaudí, though he admired his work, and he never met him personally. Gaudí belonged to another set and was thirty years his senior. He was a devout, even bigoted, Catholic, highly conventional in all ideas that did not touch directly on his art. As a member of the rival Cercle de San-Luc he disapproved strongly of the

atheist, anarchist trends of the bohemian 4 Gats. By 1900 his reputation was at its height, and so were his fees. An aura of snobbism cut him off at that time from the younger generation, but in recent years he has been rediscovered as a great inventor by some of the most advanced architects, such as José-Luis Sert and a circle of admirers in Barcelona. It might therefore seem strange that he did not exert more influence over the young painters of his time. We must remember, however, that for painters influences do not usually originate in architecture but in painting. It happens more frequently that architects find inspiration in styles invented by painters. The art nouveau style of which Gaudí is one of the greatest exponents sprang partly from Ruskin and his views on painting, and later the Cubists and the geometrical abstractions were to be the source of inspiration for an international style in architecture. To Picasso, Gaudí, whose work still dominates the skyline in Barcelona, was no more than a curiosity. The architect's problems are not necessarily the painter's problems.

Departure

As time passed and another summer came to an end, Picasso felt more strongly than ever an urge to escape from the surroundings of which he was again feeling the limitations. But there were serious difficulties in the way. Although he had liberated himself effectively from his family ever since he set out alone for Madrid, he still had a deep affection for his parents and his sister. He saw them almost daily, and would often stay to eat with them, making drawings of Lola and the assembled company seated round the table. They were unwilling to see him disappear abroad, thinking of the many painters who had left for Paris never to return, and, what was more serious, his departure would mean a financial sacrifice they could ill afford. To the middle-aged Don José, who had by this time ceased to follow his son's restless search for something he himself found incomprehensible, the project was not encouraging.

However, among Pablo's numerous friends was a young painter, Carlos Casagemas, whose strange appearance can be judged from numerous caricatures. Tall, thin, with an enormous pointed nose dominating a chinless profile, adorned by scruffy side-whiskers sticking

out from a high stiff collar, he is seen in one of Picasso's sketches, shambling along beside his friend, both well wrapped in overcoats.[30] After leaving the calle del Asalto early in 1900 Picasso shared his third studio since his return from Horta with this awkward friend in the calle Riera de San Juan, and, finding its whitewashed emptiness intolerably severe, he decided that they should have every possible comfort and luxury painted realistically on the walls. Appearing with magical speed, sumptuous furnishing soon provided for all their needs and desires. The bookcases were filled with rare volumes, cupboards, tables and easy chairs were spread around, a good-looking maid and a page stood waiting for orders, and fruit and flowers covered the sideboard on which coins had been scattered negligently. All this magnificence, however, was soon forgotten. In October the two friends decided to set out together towards the north to see and to conquer. Not long afterwards the studio was pulled down.

Unlike most of his companions Casagemas had private means which helped to provide for the expenses of their trip, and there is no doubt that Picasso, at least, left Barcelona in high spirits. Convinced of his talents, he had drawn a portrait of himself shortly before, adorning his own brow with the words YO EL REY (I the King) repeated three times.

I say their departure was towards the north, because Picasso assured me, when he stayed with me in London in 1950, that for him Paris was to be merely a halt on a journey which would take him farther north, to London. The chief reason for this plan was that he had conceived a great admiration for England, partly because he appreciated his father's taste in English furniture and clothes, and partly because some English painters, especially Burne-Jones and the Pre-Raphaelites, whose work he had seen in reproductions, had a romantic attraction for him. Above all the project was due to the idea he had formed of English women, whose beauty, strength of character and courage had grown in his imagination to heroic stature. When living in Corunna he had come across the grave of Sir John Moore, and had learned that he died with the name of his love, Lady Hester Stanhope, on his lips. He had read her life, and finding a woman of a type so different from any he had ever met, a woman who had conquered her own liberty and also the hearts of

[30] ibid., Vol. VI, p. 27, No. 219.

men, he decided that he must investigate the country which fostered women of this admirable breed. History would undoubtedly have been very different had he held to this intention, or had the magic of Paris been less potent.

Paris

The visit to Paris, the first to take him into a foreign country, began within a few days of Picasso's nineteenth birthday. It was to be of short duration but of great importance. For the first time he made the acquaintance of the city in which he was to live the greater part of his life, and as usual, first impressions had that incisive quality which lingers for many years. Montmartre, where he was eventually to settle for nearly ten years, was his destination. He was guided by the simple reason that a colony of his friends in voluntary exile had settled there already, and contact with them not only helped to solve the language problem, but also gave him the information he needed to find his way about Paris. They knew the museums and the dealers' galleries, as well as the cafés and the streets. The painters Canals and Sunyer, and the sculptor Manolo quickly introduced him to the exuberant, untidy group of artists that frequented the cafés of La Butte. Manolo, whose wit was irrepressible and ruthless, delighted in introducing his silent young friend as his daughter, and Picasso's vehement protests were inevitably drowned by the chorus of applause that followed.

The studio where Picasso settled down to paint in Paris had belonged formerly to Nonell, who had reached Paris a year or two before. It was in a narrow street[31] near the summit of the hill on which stands Montmartre. This small detached community, which still prides itself on its own customs and its own patois, was in process of being absorbed into the metropolis. Recently crowned with the stark whiteness of the Sacré Coeur, it was slowly being robbed of its independence. The old vineyards, the worked-out quarries and paralysed windmills were vanishing, the slopes were being terraced for apartment houses, hotels, cafés and amusement halls, to accommodate the increasing crowd of visitors, who had been attracted to Paris by the great exhibition of 1900.

[31] 49 rue Gabrielle.

However, La Butte de Montmartre still remained relatively detached and remote from the great city lying at its feet, a refuge for artists, poets and those of all nationalities who valued their independence and enjoyed the unconventional freedom they found there.

The life of Paris by day and by night, the streets glittering under the warm autumn rain, the din from market stalls and the clatter of horsedrawn traffic on the stones, enchanted Picasso and made him feel at home. Except for the climate these new surroundings were not unlike Barcelona and Madrid, but richer in their variety, more vital and more cosmopolitan. Here he recognized an atmosphere which would foster his development. He had come from Barcelona to escape the cramping influence of his family and the burden of provincial life. He was in search of a society which would in the widest sense nourish his ambitions as a painter, and he wished to see for himself the achievements of the past and promise for the future that this much talked-of Mecca of the arts had to offer.

Visits to museums and to dealers' galleries gave him for the first time an opportunity to see the work of Ingres and Delacroix, and to form his opinions on the Impressionists and their successors. He examined eagerly the paintings of Degas, Van Gogh, Gauguin and Toulouse-Lautrec. In spite of the shortness of his visit and innumerable distractions, he found time to paint several pictures which bear signs of the speed with which he could assimilate these new influences.

A few days after his arrival, Picasso paid a visit to Mlle Berthe Weill, who ran a small gallery and who was to become Matisse's first dealer two years later. He was fortunate in meeting there a Catalan industrialist called Mañach, who had recently developed a dealer's interest in drawings. Mañach was immediately struck by the talent and character of the young Andalusian and offered him 150 francs a month for all the work he produced. In addition, Picasso succeeded in selling to Mlle Weill three canvases of bullfights that he had brought with him from Spain. She gave him 100 francs for all three, and was glad to make a quick profit of 50 francs by selling them at once to a publisher, Adolphe Brissen.

Mañach's financial backing, though small, meant a great deal to Picasso, for at least it gave him a small degree of independence and

allowed him to return to Spain when he wanted. Before he left, he painted several pictures of the life of gaiety and elegant debauch he saw around him. *The Can-Can*[32] and more important, *Le Moulin de la Galette* (Plate I, 7) are paintings which show the influence of Toulouse-Lautrec. Since this was his territory, it was particularly difficult to see the same scenes he had painted with such verve without falling under his spell.

The *Moulin de la Galette* is a painting in the impressionist tradition. The subject, a hall crowded with dancers, with ladies wearing large flowery hats, is treated with flowing brushwork as a lively pattern of colour. The light seems to have its source not only in the festoons of gas lamps, but also in the colour of the dancers' gowns and the shine of well-brushed top-hats. The technique of the 'painters of light' had been seen and understood at a glance. Picasso had at once shown his ability to master a new style.

New Year in Malaga

In December the visit came abruptly to an end, though the reasons for the return to Spain remain somewhat obscure. Picasso himself said that the main cause was his companion's despair. On arrival in Paris, Casagemas had fallen in love with a girl who in spite of all his efforts showed no interest in him. Believing that the sunshine of Andalusia might have a good influence, Picasso hastened his melancholy friend by way of Barcelona to Malaga, where they arrived on 30 December.

The New Year celebrations with the assembled family did not have the salutary effect that Picasso had hoped for. From the start everything went wrong. The inn of the *Tres Naciones* took exception to the two long-haired, uncouth bohemians and refused to admit them. Picasso was humiliated by having to ask his paternal aunt, who lived near by, to intercede with the landlord and act as a guarantor. The next blow was when his former patron, his uncle Salvador, expressed violent disapproval of the appearance of his nephew. The long, dishevelled hair and the hat of an eccentric art student filled him with disgust. Picasso

[32] See Zervos, *Picasso*, Vol. I, p. 20.

was quick to realize that a barrier had once and for all blocked the way between the conventional respectability of his family and his own ideas of how he wished to shape his life. He could see also in his father's attitude that there was no further hope of an understanding. The last disillusionment had come for Don José. His son had finally broken loose and would no longer accept the guidance that he felt he ought to give. His last role as a parent had come to an end, and he relapsed into old age, disillusioned and sad.

The last and deciding factor with Pïcasso was the conduct of his friend, who showed no inclination to be shaken from his suicidal gloom by the healing rays of the Mediterranean sun. On the contrary, he sought solace but failed to find it in the obscure depths of taverns, where nothing could remove him from the bottle.

At the end of a fortnight, all hope that any good thing could come from this situation had disappeared. Malaga had lost its charms and the memories of his past delights and flirtations had faded. Picasso once again took the train for Madrid.

That even in this short and unsatisfying visit he found time to draw is proved by a charcoal sketch published six months later in *Pel y Ploma* of peasants sitting in a café concert, enthralled by the music of *canto hondo*. It was in this tavern that he left Casagemas, hoping that the seduction of the guitar might eventually divert his thoughts. Nothing however could succeed and Casagemas, still absorbed in his unyielding misery, returned to Paris and ended the tragedy upon which he could not cease to meditate by shooting himself in a café.

Sabartés has commented on the restlessness that had taken hold of Picasso at this time.[33] He suggests that a reason for leaving Paris so abruptly, deeper than his concern for Casagemas or his former promise to rejoin his parents for Christmas, was his hope that Barcelona, Malaga or Madrid might supply his need of somewhere to settle for a while. He had not yet thought of Paris except as a place to visit; it still seemed too foreign and remote. The climate and his memories had drawn him first to Malaga, his native city. He now wanted to see if Madrid would yield more promise than it had done during his former visit. Whatever his

[33] Sarbartés, *Picasso: Documents Iconographiques,* p. 51.

motives, however, the result was a final break with the family in Malaga, whither he was never to return.

Madrid: Arte Joven

Picasso returned to Madrid no longer a student, but a young man who could already speak with the authority of one who has travelled to Paris. Finding there a friend from Barcelona, Francisco de Assis Soler, he entered into association with him in a short-lived literary project. With Soler as literary editor and himself as art editor, they set to work to produce a review to which they gave the title *Arte Joven* (Young Art). The first number was published on 10 March 1901, and on its first page it announced '*Arte Joven* will be a journal that is sincere.' Soler had managed to become the representative for an invention of his father's, an 'electric' belt which was calculated to cure all ailments. The commissions from this life-giving source were sufficient to launch the review but not to sustain it for long. The last issue, which appeared in June, printed an announcement with a drawing by Picasso of a further joint publication, *Madrid, Notes on Art*. Unfortunately it never matured, for by then funds were exhausted and Picasso, abandoning the project, returned to Barcelona. From there he soon hurried back to Paris in response to the complaints of Mañach, who for some months had not received his promised pictures.

The review, of which only five numbers were published, was copiously illustrated with drawings by the art editor. The sketch-books that he had filled in rapid succession in Paris during the previous autumn, and to which he was adding constantly, served to decorate almost every page. Throughout, the style was reminiscent of Steinlen and Toulouse-Lautrec. There were two self-portraits in charcoal.[34] In both he has kept his long untidy hair, and a lean, hungry appearance. With hands deep in his pockets he looks straight into our eyes with a sad, questioning regard.

The avowed purpose of *Arte Joven* was to implant in Madrid the Catalan modernist movement. It adopted the form laid down by Miguel

[34] See Zervos, *Picasso*, Vol. I, p. 22.

Utrillo in *Pel y Ploma,* which had also been liberally illustrated by its art director, Casas. His clever portraits, highly esteemed by the young Modernists, were, however, now made to look conventional in comparison with those of his younger rival. In *Arte Joven* there was great variety in the subject matter. It contained caricatures of friends, including a rapid sketch of a group standing together like conspirators,[35] and another of listeners to an after-dinner narration by the novelist, Pio Baroja. There were scenes from the streets and cafés, with stiff, fashionable ladies in muffs and furs, gipsy girls and groups of peasants. The women ranged from the idealized Pre-Raphaelite virgin with flowers in her hair to the realism of the whore wrapped in shawls, waiting at the door of her squalid den.

The editors kept a close link with Catalonia. Translations into Castillian from the works of Rusiñol were published, together with a drawing by Picasso of the venerated poet-painter walking in his garden. In addition there were announcements of the activities of the 4 Gats. The tone throughout was revolutionary. Contributions came not only from Catalonia but also from writers such as Miguel Unamuno. A letter by Ramón Reventos to the intellectuals of Madrid was printed, as well as articles, nihilist in tendency, by Martinez Ruiz, who advocated an abstention from the polls with 'Kill the Law' as his slogan. *Arte Joven* proclaimed the revolt of a new generation, who prided themselves on their idealism and violence.

Barcelona: Exhibition at the Sala Parés

In Barcelona the impression that Picasso's talent and the force of his character had left had not been forgotten. Sabartés describes the days after his return in these picturesque words: 'He withdraws for a few days into the calm of his home. He takes the opportunity, meanwhile, of disquieting us, his Catalan friends, who listen to him all agape. He goes around, up and down the Ramblas; he gossips and makes plans. Like fireworks, he lights up imaginary constructions and shows new perspectives to our expectations.'[36]

[35] See Zervos, ibid., p. 18.
[36] Sabartés, *Picasso: Portraits et Souvenirs,* p. 57.

During this explosive visit, his friends, the editors of the review *Pel y Ploma*, organized an exhibition at the Sala Parés, a spacious gallery dedicated to the modern movement. The exhibits were all pastel drawings, most of which he had brought with him from Paris or Madrid. In June, the following month, Miguel Utrillo, the champion of the younger generation, wrote an enthusiastic article in *Pel y Ploma* signing himself 'Pincell'. It was illustrated with a portrait of Picasso by Ramón Casas, which according to Utrillo describes accurately the personality of his young friend. He stands with the skyline of La Butte as his background. 'Under a "*pavero's*" [37] big hat,' wrote Utrillo, 'faded by the intemperate climate of Montmartre, with the quick eyes of a southerner who knows self-control...his personality has suggested admirably to his French fellow artists the name of "Little Goya" with which they have christened him.' The editor of *Pel y Ploma* speaks with approval of Picasso's having left the autumnal influences of 'the ardent country of dried grapes' and of having abandoned the lessons of the School of Fine Arts in Barcelona. 'The art of Picasso', he continued, 'is very young; the child of his observing spirit which does not pardon the weakness of the youth of our time and reveals even the beauty of the horrible, which he notes with the sobriety of one who draws because he sees and not because he can draw a nose from memory.' Having spoken of Picasso's work in Madrid and the attraction of Paris, Utrillo ends his article in this way: 'Paris, criticized for its febrile way of life, has again attracted him, not to make a conquest with the flourish dreamt of when he made his first visit, but rather with the ardent hope of learning from that centre where all the arts definitely flower with more fertility.'[38] At the moment when this appeared in print, Picasso was already installed in Paris and a new epoch had begun for him.

The pastels shown at the Sala Parés had again a warm reception from the small group centred round the 4 Gats. They were mostly remarkable for a light spontaneous touch, and the deep glow of their colour. The *fin de siècle* atmosphere that dominates, suggesting above all the influence of Toulouse-Lautrec, is inclined to blind critics to the

[37] One who feeds turkeys.
[38] Miguel Utrillo ('Pincell'), *Pel y Ploma*, Barcelona, June 1901, No. 77.

ingenuity and originality apparent in a variety of techniques. There is a pastel of a singer just stepping into the picture to make her bow before the footlights (now in the Museo Picasso), in which the background, composition and atmosphere suggest Degas as much as Lautrec, but the way in which he uses as colour for the long gloves of the girl the grey of the untouched paper, shows an ingenuity prophetic of future inventions.[39] There is a wonderful luminosity of colour in these drawings, which are usually focused on a single patch of light. In the *Woman before the Mirror*, the light, which is the mirror itself, glows with brilliant blue, whereas in the *Embrace*, a drawing in which two lovers stand united like one solid tree-trunk, it is the blouse of the girl that lights the whole picture with its ardent red.

Most of the pictures are signed P. R. Picasso, for it was at this time that Pablo decided no longer to sign in the conventional Spanish way, with his father's surname followed by that of his mother. He preferred to drop Ruiz, which is by no means an uncommon name throughout the country, and use only the more unusual Picasso of his mother's family. This gesture also showed a disregard for the feelings of his father, and even more those of his uncle Salvador. Both, not without reason, were proud of their family and wished to give its name every chance to become even more illustrious. But Pablo's affections leaned more naturally towards his mother. From her he had inherited his small well-proportioned and alert physique, his coal-black eyes, and hands so sensitive that they seemed the perfect emissaries of his sensibility, receptive and creative, female and male. With a more subtle understanding of the extraordinary powers of her son, she refrained from advising and cajoling him. She combined patience and understanding with a fiery conviction that he would prove that he was right whatever he might attempt to do, and however mad it might appear. When his urge took him away again to Paris, his mother at least raised no objection.

[39] See Zervos, *Picasso*, Vol. I, p. 15.

3

The Blue Period
(1901-04)

Return to Paris

There is some confusion as to the exact date of Picasso's return to Paris in the spring of 1901, but a drawing by him of his arrival accompanied by his friend, Jaime Andreu Bonsons, shows them standing together on the quay.[1] A bridge crowded with traffic, the Eiffel Tower and a passing Parisian lady form the background. The bearded Bonsons wearing a check cap carries a handbag, and Picasso holds a walking stick and a large portfolio under his arm. The way in which both are heavily clothed in overcoats - in fact nothing but Picasso's eyes and shaggy black hair can be seen beneath the brim of his black hat - suggests that the weather was still chilly.

The portfolio contained the drawings that were owing to Mañach. He had decided that rather than write letters of explanation he would bring them himself in return for the 150 francs which, in principle, he was to receive each month. Mañach, delighted to see his newly discovered protégé, welcomed him and offered to share with him his minute apartment at 130 boulevard de Clichy. The flat, on the top floor looking south over the plane trees across the wide street, consisted of two rooms. The larger of them was to be occupied for the next few months by Picasso.

Thanks not only to a description by Sabartés but also to two paintings by Picasso, we can gain a good idea of the interior of this room and the view from its window. The canvas known as *Boulevard de Clichy*[2] is painted in a free Impressionist style. The tall houses at the corner of the

[1] See Zervos, *Picasso*, Vol. VI, p. 42, No. 342.
[2] ibid., Vol. I, p. 35.

rue de Douai, reflecting the evening sunlight, are visible above the heads of little groups of people sauntering between the trees in the wide *boulevard*. There is space and life in the great thoroughfare below, but it is obvious from the other painting that inside the attic everything happened in a very constricted area.

This picture is known as *The Blue Room* (Plate II, 2) because of a predominantly blue tone throughout; walls, bath tub, water jugs, furniture, the shadows in the bedclothes and round the window are all blue. As we see from the painting, as well as being a studio, the attic was a living-room, bedroom and bathroom, often shared by Picasso with his model or his friends. On the walls above the bed hung pictures; a seascape and a painting copied closely from a poster by Toulouse-Lautrec of the dancer May Milton. A bowl of flowers stands on a small oval table; but the two chairs that Sabartés mentions as completing the furniture are not shown, neither is the disorder which he tells us grew steadily on the floor. Everything that found its way up the six flights of stairs stayed where it was put and each time it was necessary to clear the table for meals, more went on to the floor. The walls were lined with an ever-increasing number of canvases propped against them. None of this, however, appears in Picasso's painting of his room, which leads us to think either that it was painted before the disorder reached such overwhelming proportions or that the sense of order prevailing in his work has dominated the picture in a way which did not entirely correspond with reality.

Disorder in fact was to him a happier breeding ground for ideas than the perfection of a tidy room in which nothing upsets the equilibrium by being out of place. As soon as an object has a place assigned to it, it loses its independence and becomes part of a decorative or utilitarian scheme, but when it is left just where chance has placed it, it can more readily call for attention and startle the onlooker into recognizing its significance. These are the advantages to the observant eye of a practice which is considered slovenly by most people. Once when visiting Picasso in his apartment in the rue la Boétie I happened to notice that a large Renoir hanging over the fireplace was crooked. 'It's better like that,' he said, 'if you want to kill a picture all you have to do is to hang it beautifully on a nail and soon you will see nothing of it but the frame.

When it's out of place you see it better.'

Exhibition with Vollard: June 1901

Mañach took the first opportunity of introducing his young prodigy to a dealer named Vollard, who had a shop in the rue Laffitte, a street that had become known for galleries devoted to the more advanced painters. Two years before, he had exhibited the work of Picasso's compatriot, Nonell. Born in the island of La Réunion, Ambroise Vollard had rapidly made a reputation as a friend of painters whose names are among the most illustrious of the time and whose works in many cases he was the first to show. He is probably best known for sponsoring Cézanne. Many others, however, such as Degas, Renoir, Odilon Redon, Gauguin, Bonnard and Rodin were among those who dined with him in his cellar, where he entertained with good wines and exotic Créole cooking. His activity during his long life was not limited to the plastic arts, and among his many visitors there were not only distinguished clients from many European countries and the United States, but also writers and poets such as Mallarmé, Zola, Alfred Jarry and Apollinaire.

Vollard speaks in his memoirs of a visit he received from his friend Mañach, whose factory he had visited in Barcelona. He brought with him, he tells us, a young unknown Spaniard, Pablo Picasso, 'dressed with the most studied elegance'. Though this youth was only eighteen, Vollard says he had finished about a hundred paintings which he brought with him with a view to an exhibition. When he saw them his usual caution disappeared and he agreed without hesitation. But this time, in spite of the prestige that accompanied exhibitions in his gallery, the experiment was not a success, and, he adds, 'for a long time Picasso got no better reception from the public...I have had in my shop many of his pictures which are the most sought-after today, but for which the artist at that time could not obtain the price of a stretcher.'

For his exhibition, which opened on 24 June, the gallery was shared with a Basque painter of no great interest, named Iturrino, who was nearly twenty years Picasso's senior and whose name preceded his on the printed announcements. However, the works of the younger artist,

which numbered seventy-five, were noticed by Félicien Fagus, the critic for *La Gazette d'Art*.

'Picasso is a painter, absolutely and beautifully; his power of divining the substance of things should suffice to prove it,' he wrote appreciatively.

Like all pure painters he adores colour in itself and to him each substance has its own colour. Also he is in love with every subject and to him everything is a subject; the flowers that gush forth furiously from a vase towards the light, the vase alone, and the table that carries the vase and the luminous air that dances around; the multicoloured seething crowds backed by the verdure of a racecourse or the sunlit sand of an arena; the nudity of the bodies of women... there are discoveries: three little girls dancing, the practical green skirt over white underclothes which are so exactly that stiff boyish white of little girls' starched petticoats; the yellow and white of a woman's hat, etc... Thus just as in a subject everything is his subject, so everything is worth translating, even slang, a Gongorism – that other form of slang – or the neighbour's dictionary. One can easily perceive many a probable influence apart from that of his own great ancestry: Delacroix, Manet, Monet, Van Gogh, Pissarro, Toulouse-Lautrec, Degas, Forain, Rops, others perhaps... Each one a passing phase, taking flight again as soon as caught. It is evident that his passionate surge forward has not yet left him the leisure to forge for himself a personal style; his personality exists in this passion, this juvenile impetuous spontaneity (they say that he is not yet twenty and that he covers as many as three canvases a day). Danger lies for him in this very impetuosity which can easily lead him into a facile virtuosity. The prolific and the fecund are two different things, like violence and energy. This would be much to be regretted since we are in the presence of such brilliant virility.[3]

The enthusiasm of Fagus led him to judge the work of the young painter from the standards he knew and loved best, which were based on the Impressionist point of view. He talks of the 'luminous air' that surrounds the flowers in the numerous flower pieces, a phrase that came direct from his love of atmospheric effects cherished by the 'painters of light'. The shadows he noticed were made mysterious with blue transparency. But also he remarks that Picasso's love of colour led him to insist that 'each substance has its own colour'. The green lawns of Longchamp or the red blouse of a woman were vivid, glowing patches that radiate from their local source a light which permeates the whole picture, reminding us rather of the discoveries of Van Gogh and

[3] Félicien Fagus, *Gazette d'Art*, quoted in *Cahiers d'Art*, 1932, Nos. 3-5, with reference to first Picasso Exhibition, Vollard Gallery, June 1901.

Gauguin than the cloudy depths of Monet.

Picasso had seized eagerly on a mixture of techniques and exploited each in his own way. In the portrait of *The Dwarf Dancer*[4] of 1901 he had applied colour in small spots in a manner that recalls 'pointillism', but the painstaking atmospheric modulations of Seurat were sacrificed for a cloud of speckled brilliance which enlivens the colours of the dwarf's dress and falls in cascades around her, giving both depth and movement to her background. With this the borrowed pointillist discipline was abandoned. In the same picture the face, arms and legs are painted in another style, more in the manner of Toulouse-Lautrec. The result might be expected to present disastrous inconsistencies and surprisingly it does not. Picasso had shown his ability to steal what interested him from different styles and put the loot together so that it became his own harmonious creation.

In the paintings of this period influences abound. Sometimes it is the subject matter of Degas, the racecourse or the nude girl washing in a zinc bath tub that he has seized upon; or an interior that recalls Vuillard; or a cabaret scene with dancers in swirling skirts, their black stockings kicking wildly, which inevitably brings to mind the manner of Toulouse-Lautrec; but always, mixed with his feverish spontaneity, there is a control by which he is able to accentuate contrasts and a sense of order with which he places the accents. Our pleasure is divided between surprise at the originality of their position and satisfaction in the arrangement of the composition.

Work of the Cabaret Period

On his return, Picasso had begun where he had broken off six months before, but with more assurance. The people among whom he lived furnished him with an inexhaustible source of material which he sought to express with tenderness or with cynicism. He made sketches of children sailing their boats, leisurely crowds enjoying the Luxembourg Gardens, the brilliant fashions of ladies on the racecourse, or the prim *midinette* seated on the deck of a *bateau mouche*, and produced pictures full of an atmosphere of pleasant ease.

[4] See Zervos, *Picasso*, Vol. I, p. 31.

A more lurid world of night life also attracted his prying eye and many paintings of the early months of this visit are a continuation of the scenes in cafés and cabarets begun in Barcelona, though with a more developed critical sense and pungency, which attacked the frivolous orgies of the rich. There are several versions of a dinner-table scene with an over-fed opulent rake, seated with a bejewelled woman whose splendour seems to overpower her benefactor. There are scenes in theatres where rows of gaping starched shirt-fronts are faced by the charms of a fragile siren, and many portraits of ladies of the *demi-monde* and young girls. These were often started from rapid sketches made backstage between the acts in the popular music-halls, becoming later magnificent portraits such as the *Courtesan with a Jewelled Necklace* (Plate II, 9). Between the splendid arabesque of her feathered hat and the low-cut curve of the dress, he painted an expressionless mask with drowsy sensuous eye-lids. The head is poised on a trelliswork tower made of gaudy jewellery encircling her long neck. With plump fingers, rounded like the teats of a cow and crowded with rings, she caresses her own bare shoulder. Although there seems no doubt about the apparent firmness of her flesh, Picasso has arrived at this effect without the use of modelling. The roundness of form is conveyed by the bold sweep of the curved outline set between the elliptical shapes of the hat above and the *décolleté* below. Bold, heavy brushwork and outlining show here and in many other paintings of this period that, as Picasso himself said, the influence of Van Gogh was then stronger than that of any other painter. The simplicity with which the head is treated conveys by under-statement the arrogance of the lady. Her vulgar beauty, flattered by its adornments, is treated by the artist with a harshness which gives her an appearance of superb self-assurance – a brazen look amounting almost to innocence.

This capacity to depict character in surprisingly unconventional ways recurs in other portraits. Thanks to the Vollard exhibition, Picasso had met Gustave Coquiot, a shrewd critic and enthusiastic collector, and shortly afterwards he painted two portraits of him.[5] In one, Coquiot is seated in front of pictures from his own collection; and in the other,

[5] ibid., Vol. I, p. 42.

dressed for debauchery, he sits in front of a mirror reflecting a bacchanalian cabaret show. Two other friends of Picasso's also served as models for remarkable character studies, Mateo F. de Soto and Jaime Sabartés. Both had followed him from Barcelona and were his constant companions. The portrait of de Soto is extraordinary for the severity of the expression of the young painter.[6] His eyes, deep, sad and thoughtful, the severe ascetic mouth beneath his neatly trimmed moustache and his small pointed beard give him the sad fanatical expression of Zurbarán's monks.

Sabartés has described at length the painting of two portraits of himself during this visit to Paris. The first, soon after his arrival, came as a surprise. Picasso, arriving late for the *rendez-vous*, had come upon Sabartés without his friend's seeing him from where he sat waiting at a café table, shortsighted and embarrassed. On returning to his studio Picasso painted a portrait (Plate II, 1) which was later bought by Sergei Shchukine, the Russian collector. It is Sabartés, the young poet in a foreign land, nervously fingering his mug of beer while his myopic gaze searches the café for his friends. The portrait was an admirable likeness, but, as happened so often, it was painted by Picasso while the model was absent.

Sabartés had arrived in Paris in the late autumn, some six months after Picasso. When he first climbed to the top floor of the house in the boulevard de Clichy, he was astonished at the quantity of canvases he found there in a style which he could not fathom. When Picasso asked him what he thought,. he answered loyally, 'I shall get used to it . . . ' There was a greater distinction between these paintings and the earlier work done in Spain than any of his former changes of domicile had brought about. 'The canvases that he showed me,' Sabartés explains, 'had violent contrasts in tone and in colour, like the shades of playing cards.'[7] In particular Sabartés was struck by the vivid colouring in the portrait of Coquiot.

Picasso did not let his work exclude visits to the museums, which were one of his chief amusements during these early days in Paris. By this time he knew his way round most of them. He spent long hours

[6] ibid., Vol. I, p. 43.
[7] Sabartés, *Picasso: Portraits et Souvenirs,* p. 68.

with the Impressionist paintings in the Luxembourg and he was often seen in the Louvre, where he was much intrigued by the art of the Egyptians and Phoenicians, which in those days were generally considered barbaric. The Gothic sculpture of the Musée de Cluny called for careful scrutiny and he was aware in a more distant way of the charm of Japanese prints. They had already been in vogue for some years and therefore interested him less. It gave him greater satisfaction to discover things not yet noticed by others.

The summer and autumn of 1901 had been a period of fruitful exploration and experiments in the adaptation of borrowed techniques. He had learned much by copying indirectly and by transposing the work of masters he admired. By the time his twentieth birthday arrived in October he had already accomplished a vast quantity of work of remarkable quality. The stage was now set for the development for the first time of a style which would be thoroughly personal.

Max Jacob

The exhibition at Vollard's gallery, even if it had pleased no more than a few critics and collectors, was the source of new friendships. A young man, whose immaculate top hat and conventional elegance served as an effective disguise for extreme poverty, had called at the gallery. Max Jacob, the poet, painter and art critic, born in Brittany of Jewish parents, was immediately struck by the brilliance of the work of this young and unknown foreigner. He described years later the beginning that same day of an extraordinary friendship between them, which was to continue until his death in 1944 in a Nazi concentration camp. 'At the time of his great and first exhibition, as a professional art critic I had been so struck with wonder at his production that I left a word of admiration with Ambroise Vollard. And the same day I received from M. Mañach, who looked after his interests, an invitation to visit him. Already this first day we felt for each other a great sympathy.' Max Jacob continues: 'He was surrounded by a swarm of poor Spanish painters, who sat on the floor eating and chatting. He painted two or three pictures a day, wore a top hat like me and spent his evenings in the *coulisses* of the music halls of those days, drawing portraits of the

stars... He talked very little French and I no Spanish but we shook hands.'[8]

From that moment a friendship united these two men who were in many ways so unlike, but who found in each other a fundamental and instinctive understanding. Max Jacob, the mystic, was a man stricken with an overwhelming desire to enjoy life and a compensating sense of sin that led him to the severest penances and a final renunciation of the world in a monastery. He was moreover endowed with a sensibility which responded both in poetry and painting to the same human drama which was tormenting the spirit of the young Spaniard. His friend, André Billy, describes the character of Max Jacob in these words: 'Malice, ingenuity, covetousness, melancholy, irony, sweetness, goodness, cruelty, salaciousness; all that you will, except innocence, simplicity, lightheartedness, true gaiety, severity, incapacity to understand. Except saintliness, I should be tempted to add if I relied only on my most distant memories.'[9]

At the first meeting a return visit was planned, and Max eagerly welcomed the boisterous crowd of Spaniards to his small hotel room. By this encounter 'la bande Picasso' had enlisted a new member, one who brought with him the element of French culture which had formerly been lacking. In rooms hermetically sealed against the cold and filled with smoke, he would read to them late into the night his own poems and also those of poets of the nineteenth century, almost unknown to them except by their reputation – Baudelaire, Verlaine and Rimbaud. The barriers of language melted rapidly before their enthusiasm and his eloquence.

Decoration of Le Zut

At night there were frequent visits to the cabarets of Montmartre such as the Chat Noir, and, when tickets could be found, to the Moulin Rouge. Paris seduced the lawless Spaniards by its frivolity and its elegance. The ladies of all classes tried to outdo each other in the width of their hats and the narrowness of their waists, while the men

[8] *Correspondance de Max Jacob*, Editions de Paris, Paris, 1953, p. 24.
[9] André Billy, *Max Jacob*, Pierre Seghers, Paris, 1953.

considered themselves dishonoured to be seen without top hats. Max
Jacob tells us that Picasso wore a top hat like him, and this is borne out
by a self-portrait sketch in which Picasso tries the effect of his evening
clothes, complete with hat, silk scarf and camellia, on a bevy of half-
nude young ladies. But such extravagances were rare; the
establishments where Picasso could usually be found with his friends
were extremely modest. For a while the headquarters of '*la bande*' was a
small bohemian cabaret in the place Ravignan, called Le Zut. Its dim
passages and stained walls lit with candles attracted a mixed bag of
artists of all descriptions, pimps, and girls of varied occupations.
Sabartés describes how night after night they would meet in a small
room where the amiable *patron* Frédé would serve their drinks, usually
beer or cherries in brandy, on a barrel, and entertain them with his
songs and the guitar. They remained aloof from the Parisian sociability
that went on noisily in the room beyond, peering round the corner to
watch when some unusually exciting dancing or fighting drew their
attention away from their own interminable discussions. Picasso would
sit and listen, taking part only when some terse remark of his could give
a startling explanation or add a provocative paradox.

Eventually the squalor of the sweating walls and the cobwebs brought
about a revolt and the Spaniards decided to decorate the room, which
they had named the Hall of the Stalactites. After the walls had been
whitewashed, they each decorated a panel exactly as they felt inclined.
Pichot drew the Eiffel Tower with the dirigible of Santos-Dumont
flying above it, and Picasso rapidly sketched in some female nudes.
'The temptation of St Anthony!' shouted someone as a bright guess at
what was coming. The interruption had the effect of stopping Picasso.
The composition interested him no longer.

Sabartés tells how later he finished the panel by improvising
something quite different with extraordinary speed. His description of
Picasso at work is not the only one given by him or by friends who have
watched him. In general he does not allow others to be present when he
is painting, but all who have been admitted have been impressed by the
completeness of his concentration, whether the work in question is of
importance or relatively trivial. The line becomes visible in the exact
place where it is required with such certainty that it is as though he

were communing with a presence already there. Maurice Raynal, his lifelong friend, speaks of how, in a trancelike state, he 'injects his very life-blood' into the lines drawn by his brush, and Sabartés says, 'he is so wrapped in thought and so intensely plunged into silence that anyone seeing him, from near or from far, understands and is silent'.

Departure for Barcelona

As winter approached Picasso's friends noticed a change in his humour, he became morose. With or without excuses he would disappear from their company, and a coldness between him and Mañach appeared, inexplicable but ominous. Paris was losing its initial charm. He had tasted its glamour and its squalor, and, quick to appreciate the value of such experience without becoming saturated, Picasso decided he needed a change. One day his usual practice of hiding his intentions from even his closest friends – often because he was himself undecided up to the very last moment – broke down, and he announced that he was planning to leave Paris shortly. All he was waiting for was a letter from his father. The moment this arrived and the way was open for his departure he no longer tried to hide his dissatisfaction with the overcrowded lodgings provided by Mañach. Much to his friend's distress, this brought to an end their close association and Picasso's second visit to Paris.

The Blue Period

The picture called *The Blue Room* to which I have referred is one of the first in which Picasso's natural predilection for blue led him, over a period of several years, to choose this colour for the leading role in his palette. About the same time he painted a composition important both in size and content. The subject was one that had been haunting him for some months. It has since been given the title *Evocation*, but to his friends it was known as *The Burial of Casagemas* (Plate I, 8). Sabartés says that when he arrived in Paris this canvas, owing to its ample dimensions, was used as a screen to hide a pile of miscellaneous objects in the corner of the attic studio. It was in consequence the most conspicuous picture in the room and the most permanently on view.

A study for this painting, nearly as large, also exists. The subject is a

group of mourners with bowed heads standing round the shrouded corpse of a man laid out in the foreground. In the larger picture this group, while similar in arrangement, has dwindled in importance, and a stone sepulchre has been added on the right. The grief-stricken figures and the corpse in its winding-sheets, however, are dwarfed by a great expanse of sky. In a vaporous turmoil that recalls El Greco, allegorical figures float among the clouds. The central position is occupied by a white horse, which echoes the whiteness of the shroud below. It carries a shadowy rider, almost entirely hidden by a woman who supports him in her arms. Round about are three detached groups of women: a mother accompanied by her children; two women united in a close embrace; and, seated on a cloud, a group of girls naked but for their red and black stockings. Apart from the manner in which the transcendental trends of the picture are contradicted by details reminiscent of the circus or the brothel, and the awkwardness of the disjointed composition, in which the groups are held together only by the rhythmic turbulence of the background, a feature of more subtle interest is the treatment of the heavily draped figures of the mourners. In both versions their statuesque shapes announce the emergence of a new and more personal style. Their restricted gestures, smothered within the dark blue folds of their robes, emphasize the depths of their sorrow. Static, monolithic, they have the appearance of spirits imprisoned in rocks and trees. The shimmering atmospheric light of the Impressionists has given place to a representation of solid form.

These two pictures are the first that show Picasso's new discovery of plastic form and the beginnings of a symbolism of his own. They mark the final crisis of his adolescence and his triumph over the influences of his family. The subject was one that had affected him personally and deeply. He had watched closely a drama which gave him a brutal sense of the conflict between life and death and raised the question of a resurrection. He had lived through his friend's tragedy so closely that it had become his own, and his new problem was to find adequate ways of expression. Already he knew the pitfalls of sentimentality and romantic symbolism. To avoid them in the painting he had introduced the bawdy detail of the coloured stockings for the celestial chorus girls. As a check to the transcendental flight of his imagination he kept an anchor firmly

fixed in mundane reality, using his sense of the comic as a lifeline. Since he had been led to descend into Hades it was essential for him to discover his own salvation. The rider on the white horse mounting into the clouds and the huddled mourners below were both subconsciously symbols of himself.

The marked duality of his character was early noticed by his friend Maurice Raynal, whom he met in Paris the following year. Years later Raynal wrote

Unfamiliar as we were with the Spanish turn of mind, Picasso seemed to us to move within an aura of mystery. We marvelled at the contrast between the gravity of his art, now brooding, now flaring up dramatically, and the genial good nature of the man himself, his effervescent sense of humour and love of a good joke. It was known, of course, that now and then he fell prey to those typical Spanish fits of depression that usually came when least expected; but not realizing how deep they went, we put them down to the vicissitudes of bohemian life in Paris.[10]

The exuberance of his vitality coupled with the depth of his sensibility made it possible for him to live through misery and create the style which in the next few years was to begin to bring him universal fame.

Certain writers, such as Gertrude Stein, have attributed the change in Picasso's style which resulted in the Blue period to his return to Barcelona and to purely Spanish influences. When they do so, they overlook the fact that besides *Evocation* several important works had been painted during his stay in Paris in 1901. These include some versions of the theme of Mother and Child; the painting *Harlequin Leaning on his Elbow;*[11] the portrait of the *Woman with a Chignon,*[12] with her head resting wearily on both hands; the *Child Holding a Dove,*[13] fresh and tender in its allusions; and also a remarkable *Self-Portrait* (Plate II, 3) in which, hungry, muffled to the chin in his overcoat, Picasso looks straight out with eyes that are sad, disillusioned, but still passionate.

In the autumn, during the period of transition, he reverted at times to Impressionist techniques without entirely sacrificing the new direction

[10] Maurice Raynal, *Picasso,* Albert Skira, Geneva, 1953.
[11] See Zervos, *Picasso,* Vol. I, p. 39.
[12] ibid., Vol. I, p. 47.
[13] ibid., Vol. I, p. 41.

of his work. There is a very expressive portrait of *Bibi la Purée*,[14] in which we perceive the facial gymnastics of the small-time bohemian actor, and are left no illusions as to the pathetic banality of his personality. It is one of Picasso's most brilliant works of virtuosity, but it is also the last of its kind, and perhaps it is not irrelevant that Toulouse-Lautrec died in the same year.

It had become necessary not only to change the technique of his painting and to abandon the gaudy colours derived from the frivolous night-clubs of Montmartre, but also to take a more adult view of society. To quote Professor Boeck: 'The painter has evidently been chastened by his own experience: his earlier irreverent and critical attitude towards society has yielded to one of deep compassion for suffering mankind.'[15]

Barcelona: January 1902

Picasso's return to Barcelona brought with it soothing influences and physical nourishment of which he was in need. Earlier causes of irritation were smoothed over by a recognition of his independence, and he settled again into his home in the calle de la Merced. A room with a terrrace where he could work was found in the calle del Conde del Asalto near the corner of the Rambla del Centro. By means of an agreement with Angel Fernandez de Soto to whom it belonged, and a painter, Roquerol, to whom it had been rented, he found a corner where he could paint without being disturbed, although the sun streamed in perpetually on one side or the other, and the heat in summer was overpowering. With his unfailing capacity for concentration divided only between his canvas and his palette placed on the floor, Picasso began again to develop the themes of the Blue period. The sodden harlot, the penniless but devoted mother, the figures with bowed heads and a look of bewildered resignation that we associate with his work of this period, existed all round him, in Barcelona more persistently than in Paris. It was in the crowded streets of the Catalan capital that he had

[14] *Cahiers d'Art*, 25th year, II, 1950, p. 313.
[15] Boeck and Sabartés, *Pablo Picasso*, p. 123.

first become conscious of their eternal presence. But as usual he was not tied to one subject or even one set of subjects. He was intrigued once more by the view from his windows and by the changing effects of light on the house tops. There is a painting[16] of roofs, terraces and chimneys seen from his studio which is severely architectural and formal in comparison with the earlier Impressionist view, the *Blue Roofs* of the boulevard de Clichy.

In spite of the spontaneity and unpredictable nature of his actions and his apparent disregard for time, Picasso organized his day with a minimum of complications. A monotonous regularity in his working hours always was characteristic of his way of living. Like all Spaniards he went to bed late, sometimes very late, and was not up very early unless, as was not unusual, he had not been to bed at all. His usual round would start from his home; on foot he would pass through the narrow streets of the old city to his studio where he would arrive during the morning round about eleven o'clock. After a late midday visit to the 4 Gats and a lunch accompanied by prolonged and excited talk, he would take leave of his friends and return to his studio. There everything irrelevant to his work was forgotten until the hour came for him to leave his painting and make his way home, stopping at various cafés along the Ramblas or to talk to friends in the street. At night he would walk out again, and if he were alone he would amuse himself by watching the passers-by or by trying his luck at the penny slot-machines. Or he would fall in with friends, and become involved in long, passionate conversations at café tables or under the massive plane trees that line the Ramblas. These would often leave him in a state of excitement which could only be calmed by noting his impressions in sketches on any scrap of paper that came to hand, or in prolonged hours of reading.

Distractions in Barcelona were less absorbing than in Paris. The only dealer's gallery of interest was the Sala Parés, and its exhibitions were insignificant beside the rich variety of the rue Laffitte. The inexhaustible riches of the Paris museums could scarcely be replaced even by the paintings and polychrome sculptures of the Catalan

[16] See Zervos, *Picasso*, Vol. I, p. xcii, No. 207.

primitives, which in those days had not been collected together in the museum in Barcelona. To see them it was necessary to make long excursions into the mountains, where they could be discovered, dimly lit, on the walls and ceilings of the churches. But to Picasso, well stocked at that time with recent memories, this was not important. All he wanted was to be able to paint, and this he continued to do daily, stimulated by the brilliant Mediterranean light and helped by the unfailing though limited support of his family in his material needs.

During Picasso's absence from Paris, Mañach organized an exhibition at the gallery of Berthe Weill. Some thirty paintings and pastels that he had finished the year before were shown. Mlle Berthe Weill was a courageous little woman, 'as tall as three apples', who, thanks to her flair for spotting talent, was in those days in advance of other dealers. She had managed to get the critic Adrien Farge to write a preface to the catalogue. In it he mentioned several pictures such as the *Luxembourg*, the *Still-life*, the *Courtesan with the Collar of Gems*, and he praised these works 'in which our eyes delight, captivated by brilliant painting in tones sometimes crudely brutal, sometimes knowingly restrained'.

As had happened at Vollard's gallery, his friends came and were lavish in expressions of enthusiasm, but no one bought the pictures. The exhibition brought no hope of alleviating the poverty in which he was forced to live. Extravagant living was out of the question, and Picasso's moderate tastes as a dandy were difficult to satisfy. His style of dress remained unchanged, but he enjoyed indulging his fantasy where ties and waistcoats were concerned. Some sartorial improvements were however made possible by his friendship with a tailor named Soler who was later to receive a magnificent portrait of himself and his family in payment. A final and essential adornment to his person was the fashionable walking stick which in Picasso's hands became a rapier to be used in playful tilting with the plane trees.

His energy never faltered and his wit flowed out in rapid, pitiless sketches of his friends at the 4 Gats. Several drawings were often crowded on to the same sheet – friends and enemies were pilloried with equal vigour. Rusiñol and Casas appeared as bearded old women, but the most persistent teasing was reserved as usual for one of his closest friends at that time, Sebastia Junyer, a painter with whom Picasso was

to make his next trip to Paris the following autumn. He was made easily recognizable by a high forehead crowned with black hair and a black bushy moustache – which seemed too big for his small round face – against his pale skin. He is made to appear ludicrous as a toreador,[17] as a romantic painter clad in classical robes and seated on a rock seeing visions of the naiads,[18] or with a harp and scroll declaiming poems to the gulls. In another drawing Picasso parodies the *Olympia* of Manet, in which the odalisque has become a Negress of immense volume to whom the white and willowy Junyer is bringing a dish of fruit. Picasso has added himself to the scene, seated on the near side of the bed; all three are suitably naked.[19]

There is another sheet from a sketchbook on which Picasso had already drawn with unhesitating line some female nudes of extraordinary grace.[20] One of them is lying prostrate with a skull appearing over her heart and a red flower growing out from her sex. But the main theme on the page is a drawing of a beggar seated cross-legged with his dog, to whom a grotesquely fat bourgeois, with top hat, spats and diamond rings, gives a coin as he passes. The drawing has written across it *Caridad* (Charity). At the bottom left-hand corner he has added another strange cloaked figure with a straight black wig crowned with the crown of Egypt, which does not appear to connect in any way with the other drawings. Probably the appearance of these figures all on the same sheet is fortuitous, but the profile, surprisingly, is that of Picasso himself, made unmistakable by the small untidy moustache he wore at that time.

Sabartés tells a story which fits well with allusions to the lighter side of Picasso's life in Barcelona. There was, it seems, a beauty of the music-halls on the Paralelo, '*la belle* Chelito', who was much praised for the grace which 'resided in her gestures, the line of her body, the tints of her complexion and of her hair, her glances and her voice...and when she undressed the public went mad'.[21] Picasso hearing of her from his enthusiastic friends went to see her for himself. When Sabartés

[17] See Zervos, *Picasso*, Vol. VI, p. 61, No. 499.
[18] ibid., Vol. VI, p. 61, No. 495.
[19] ibid., Vol. VI, p. 42, No. 344.
[20] ibid., Vol. VI, p. 54, No. 438.
[21] Sabartés, *Picasso: Portraits et Souvenirs*, p. 99.

called for him at his house next day at noon, his mother showed him into the room where Picasso lay still asleep among a great litter of paper covered with drawings of '*la belle* Chelito'. A precise flowing line had caught the poise of her graceful body from all angles and he had not slept until he had exhausted every memory of her charms.

During this period of eight or nine months in Barcelona Picasso continued to paint pictures predominantly blue in tone, with a subject matter deeply tinged with pathos. Although there is a tendency for the colouring to be brighter, and for the sea rather than the café to be used as a background, there is no discontinuity between pictures such as *Mother and Child on the Shore*,[22] or those of lonely figures seated against the bare walls of the taverns of Barcelona, and their predecessors painted the autumn before in Paris.

It is particularly in drawings that a new freedom and strength appear, with a growing feeling for sculptural form. Apart from wilful caricatures, these sketches contain less obvious cynicism and show a deeper research into the meaning beneath the external expression of the human face. A theme which recurs many times is the meeting of two people, sometimes with decorous gestures of greeting, and sometimes, clothed, or naked, locked together in a passionate embrace which is so close that they stand joined as one living trunk.[23]

As the months passed a desire to return to Paris descended again on Picasso. His dissatisfaction with the lack of understanding he found in Barcelona was augmented by the memory that friends in France, such as Max Jacob, not only understood him and his work but provided him with a new stimulus. He had been quick to understand the difference between the level of intelligence of the painters of Barcelona and of the poets and critics of Paris. Language was rapidly ceasing to form a barrier, as may be seen from the letter he wrote to Max Jacob in an idiom which though it savours strongly of Spanish is clearly recognizable as French. It is illustrated copiously with drawings of incidents at the bullfight, and a self-portrait with wide black hat, tapering trousers and the inevitable cane. The bull ring forms the background. The letter as usual begins with apologies for not writing

[22] See Zervos, *Picasso*, Vol. I, p. 184.
[23] ibid., Vol. I, p. 13.

more often and the excuse that it was because he was working, and when not working 'one enjoys oneself or one is bored stiff'. In confidence he writes to Max:

I show what I do to my friends the 'artists' here; but they find that there is too much soul and not enough form, which is very funny. You know how to talk to people like that; but they write very bad books and paint imbecile pictures. That is life, that's it! Fontbona works a lot; but he does nothing. I want to make a picture of this drawing that I send you [*The Two Sisters* (Plate II, 5)]. It is a picture that I am making of a whore of St Lazare and a nun. Send me something written by you for Pel y Ploma. Adieu, my friend, write to me. Your friend, Picasso. Calle de Merced 3, Barcelona, Spain.[24]

Both the drawing and a painting of the *Two Sisters* are in existence. The picture is a composition of two women facing each other, and similar in this respect to many other encounters of two figures painted earlier and later. Here the contact is not the meeting of lovers or ladies in feathered hats. In anguish the prostitute with closed eyes and bowed head seeks the sympathy of her more serene sister. Both figures are draped, both have bare feet, and their attitudes suggest the simple imagery of the Catalan primitives. There is a restrained pathos in the picture which borders on the sentimental, saved only by the severity of their pose. The idea came to Picasso, however, from a close contact with reality in its crudest form. His curiosity had led him to make frequent visits while he was in Paris to the St Lazare hospital for venereal diseases. He happened to know one of the doctors, who arranged for him to visit the wards as a member of the staff whenever he liked and make drawings of the inmates. The patients were given hoods like Phrygian bonnets, a shape which reappears in many canvases of this period. But Picasso's interest in the women of the street who were constant inmates continued after he had officially left the premises and washed his hands in disinfectant. He would then go to a near-by café which was frequented by the out-patients. There he could watch them and talk to them in a different atmosphere.

Paris

It is clear from the letter to Max Jacob that Picasso was ready again to

[24] See Penrose, *Portrait of Picasso*, p. 28.

cross the frontier to a more inspiring climate. For some months he hesitated, and it was not until the end of the summer of 1902 that he returned to Paris for the third time. At first he took a room in the little Hôtel des Ecoles, in the Latin quarter, but he soon moved to a cheaper room which he shared with a Spanish sculptor known as Sisket. It was a small attic on the top floor of a seventeenth-century house which had become the Hôtel du Maroc – now the Hôtel Louis XV – in the rue de Seine. This is a narrow street near the boulevard St Germain, crowded with bookshops and art dealers. One of the artists was forced to stay in bed most of the time because an enormous iron bedstead occupied almost the whole room. At other times the bed was covered with Picasso's prolific production, but neither of them ever had a square meal.

Before long Max Jacob, who was appalled at Picasso's poverty-stricken way of living, rescued him from this sordid attic. Max had recently been able to ease his own precarious existence by taking a job in a department store. This allowed him to invite his friend to take shelter in a more spacious but otherwise equally modest room that he had rented on a fifth floor in the boulevard Voltaire near the industrial centre of the city. There was only one bed and only one top hat; both had to be shared between them. But Picasso accepted gladly. The company of Max and enough room to work made it worth while. They arranged matters between them in such a way that the bed was never unoccupied. Max slept there by night while Pablo worked, and by day, while Max was away at the store, it was Pablo's turn to sleep.

The simplest necessities were often more than they could afford and although Max Jacob's heart was warm, all that he could offer was a fair share of his poverty. An anecdote frequently retold by Picasso illustrates the real poverty through which they lived. He tells how one day with their last farthings they bought a sausage. It looked so big and satisfying that they hurried back to their attic to cook it. Suddenly as it was warming in the pan, the sausage exploded leaving no trace of any substance, only stinking air, which in no way satisfied their hunger. Some six months later, when Picasso had returned to Barcelona, he wrote to Max saying with a touch of nostalgia: 'I think of the room in the boulevard Voltaire, of the omelettes, the beans, the brie and the

fried potatoes and I think also of those days of poverty and I become sad.'

During his youth Picasso had known many moments of discouragement. Doubt about the ultimate value of his work had often tortured him, but never did he taste the combined cruelty of poverty and disillusionment more acutely than during these months. By the end of the year the exhilaration of Paris had faded; the price it demanded seemed unnecessarily high. No one wanted his work. And as a final disaster Max Jacob, whose temperamental character always made regular employment precarious, lost his job.

On the eve of his third departure from Paris Picasso managed to sell a pastel, *Mother and Child on the Shore*,[25] for 200 francs, and took all the rest of his pictures, which he would in desperation have sacrificed for the same sum, up to Montmartre to be stored by Pichot. Even so they were nearly lost, for when Picasso returned to claim them, they could only be found after a long search, under a cupboard where they had been too successfully hidden. So great was his distress that on the last night Picasso remembers burning a great quantity of drawings in order to keep warm.

The pictures that Picasso had painted during this short visit were not important in size, owing to his circumstances, but a picture such as the *Mother and Child on the Shore*, which was drawn in the overcrowded attic of the Hôtel du Maroc, is of a high quality and deeply moving. Limited by lack of funds and lack of space, he had found drawing the most suitable means of expression. The irresistible desire to make sketches like short visual messages concerning the essential features of what he saw was impeded. It seems most probable that the drawings that were sacrificed to warm him must have been an eloquent part of his production during these months.

Barcelona: *January 1903–April 1904: Blindness and Vision*

The letter to Max Jacob, with its nostalgic reference to the meagre fare they had shared, was written from Angel de Soto's studio in Barcelona. The letter is headed with a drawing of the towers of the Cathedral,

[25] See Zervos, *Picasso*, Vol. I, p. 184.

which could be seen over the house tops. The studio was the same room in the Riera de San Juan that Picasso had occupied in 1900. Again he was forced to share it with his friend, and it was not until the beginning of 1904 that at last he found himself in a position to take a studio on his own in the calle del Comercio.

The rapid changes of domicile during these years between Barcelona and Paris are attributed by Sabartés to the restlessness that continued to pursue him. Between 1900 and 1904 he crossed the Pyrenees eight times. He had also visited Malaga and Madrid in the hope of finding a spiritual climate which would provide him with the inspiration and the stability necessary for his work.

The solitude of those who realize that they must make their path alone, and the doubt that seizes all who venture into the unknown, were already familiar to Picasso. But on this occasion he had decided not to waste his time on fruitless journeys, with the hope of finding more suitable surroundings. As he says at the end of his letter to Max Jacob, he intended to stay in Barcelona through the following winter 'so as to do something'.

The visit lasted over a year, into the spring of 1904, and became memorable for the production of some of the most admirable and most moving of the paintings of the Blue period. Among the many that are typical of this style in their subject and colour, there are two large and exceptional paintings. One is a family group. It shows us the tailor, Soler, out picnicking on the grass with his wife, four children and the dog (Plate III, 5). The gun and the dead hare placed on the cloth before them with wine and fruit show that it was a good picnic. The attitudes of parents and children, halted momentarily in their enjoyment to face the painter and conscious of being watched, seem to give a timelessness to the group without robbing it of its animation. In this way it is not unlike Courbet's portrait groups, intimate and realistic.

After many years this picture has finally found its way to the Liège Museum. The upper region of the picture had been left as bare canvas by Picasso. He had asked a friend to finish it for him with the result that the family found themselves seated in a conventional wooded grove. Nearly ten years later Kahnweiler bought the painting and before he sold it he showed it to Picasso, who on seeing it again, objected to the

background. Painting out the trees, he replaced them with cubist rhythms in keeping with his style at that time. But this failed to please him, and sweeping all other solutions aside he painted in a simple uniform background which does not detract from the interest of the figures.

The other picture, *La Vie*, also painted in 1903 and also of large dimensions, is in some ways the most ambitious painting of this year (Plate II, 4). It is certainly impressive in size, and it is a carefully planned composition, the outcome of many studies. The picture contains a symbolism which links it to the *Evocation*. The allegory that is intended is not easily understood and critics have sometimes been content to dismiss it as a 'problem picture'. The rigid pose of the three figures suggests that they are intended to expound some principle such as the incompatibility of sexual love and daily life. The composition is simple. A naked woman leaning her body against a man is balanced by the draped figure of a woman who holds a child and at whom the man points enigmatically. In the background between the figures two studies of nudes are propped up as though in a studio. The figures in both are huddled up and apparently in great distress. The drawings are placed there, it would seem, as a means of adding symbols of suffering to the picture. This adding of images has a suggestion of the 'collage' technique which led later to the introduction of real objects stuck to the painting in order to introduce different kinds of reality. The picture shows throughout signs of the selfconscious development of a complicated theme which has led the artist away from his original intentions. In a preliminary drawing, we find that the two figures on the left are both stark naked and that the man's face is clearly a self-portrait.[26] In the picture, Picasso has changed the likeness to that of one of his friends and clothed him in a slip. Both these details point to hesitation and a departure from the first spontaneous idea, in a search for an imagery that has not gained in process of elaboration.[27]

But apart from these two large pictures, there are many others, some of which are more successful and certainly more moving. Although they

[26] See Penrose, *Portrait of Picasso*, p. 34.
[27] A penetrating study of the motives involved in this picture is to be found in an essay by Theodore Reff in *Picasso: 1881–1973*, Paul Elek, London, 1974.

are closely related in style and saturated with the mysterious influence of their blue colour, there is a great variety among them and it is possible to find the first appearances of many elements that recur in later periods. There is, for instance, *The Old Guitarist* (Plate III, 6), whose elongated limbs, twisted pose and affected gestures recall the mannerist style of El Greco, but the geometric pattern of the human figure built round the central axis of the guitar points forward to the composition that we find in still-lifes of the cubist period.

Again, the *Woman with a Chignon* is an example of the dramatic effect produced by a deliberate distortion of limbs.[28] Here, as throughout the Blue period, there is a marked interest in the treatment of the hands. The fingers are elongated and sensitive. They seem to be remarkably endowed with power to feel like antennae and to clutch with the swiftness and the strength of an ape.

The emphasis Picasso places on hands has special significance, since it appears at the same time as a series of pictures which show very clearly his speculations about blindness. A case in point is *The Blind Man's Meal* (Plate II, 8). Here a hungry man whose eye-sockets have become lifeless caverns sits at a table feeling with long sensitive fingers the bread and the jug set before him. His hand caressing the jug compensates for a contact with the outer world of which he has been robbed. His visual sense finds a substitute in the touch of his hand, and in the secluded depths of his mind he again sees clearly with his own inner vision untroubled by the vagaries of changing effects of light and colour.

In considering the act of perception, Picasso always was amazed at the discrepancy between seeing an object and knowing it. Its superficial appearance was to him absurdly inadequate. Seeing is not enough, neither is the aid that the other senses can bring. There are other faculties of the mind which must be brought into play if perception is to lead to an understanding. It is somewhere at the point of junction between sensual perception and the deeper regions of the mind that there is a metaphorical inner eye that sees and feels emotionally. Through this eye of the imagination it is possible to see, to understand

[28] See Zervos, *Picasso*, Vol. I, p. 48.

and to love even without sight in the physical sense, and this inner seeing may be all the more intense when the windows on the outer world are closed.

Recently I heard Picasso reaffirm an enigmatic statement made by him some twenty years before when he said: 'There is in fact only love that matters. Whatever it may be. And they should put out the eyes of painters as they do to goldfinches to make them sing better.' Picasso was speaking as one who desired all his life, without counting the cost, a greater intensity in expression and a deeper understanding of the world in which we live. In brutal terms his saying echoes an idea expressed by Pascal: 'Jesus Christ came to blind those who see clearly and give sight to the blind.'

The allegory of the blinded man pursued Picasso throughout life like a shadow, as though reproaching him for his unique gift of vision. It is a paradox that a man who lived so predominantly by his eyes should consider even for a moment the advantages of blindness; but it is also true that love itself is blind, above all in the act of creation, with its unpredictable consequences. In Barcelona Picasso found models at almost every street corner for his paintings of the blind, and he produced many very moving pictures. *The Old Jew* for instance sits expressionless with hollow eyes that have long ceased to be a means of communication (Plate II, 7). Beside him a small keen-eyed boy has been recruited to watch for him and add those essential banalities, money and food, to the self-contained world of the old, lonely outcast seated with his hands clutching his knees, staring upward into a sightless void. His pose seems reminiscent of the seated statues of Egyptian gods, and suggests that he has perhaps a greater gift of sight in him than others who have never known his affliction. In an etching, *The Frugal Repast*, made in Paris a year later, there is the same idea of the blind man using the eyes of his companion, in this case a woman.[29] He holds her tenderly in his long bony hands, sensing her sleeve with his finger tips, while his futile gaze is turned towards a distant corner of the room.

The Blue period also contains other themes less full of pathos; it abounds in pictures of children. Picasso always showed his affection for

[29] See Barr, *Picasso: Fifty Years of His Art*, p. 31.

children of all ages, beginning with his awed fascination with the baby at the breast. His love seems never to have been more acute than at this time, when his other preoccupations were poverty, disease and monstrous deformities. An example is the *Child Holding a Dove*,[30] in the collection of Lady Aberconway. His treatment of a subject in which the pitfalls of sentimentality are so obvious is saved by the boldness of the brushwork and the heavy outlines, characteristics which again evoke the vigour of Van Gogh. The surfaces are free of modelling and there are no shadows in which to introduce a complicated play of colour. By depriving himself of the obvious means of giving solidity to the image he has ironed out those gentle contours that could lead to sentimentality. An apparent harshness of treatment has brought about a marriage of opposites in the technique and the subject. The same process redeems another painting, *The Greedy Child*,[31] where a little girl is helping herself to the bottom of a pudding bowl. Again the subject, without a masterly vigour in the technique, could well merit the reproach made by certain critics that the Blue period is marred by sentimentality.

Certainly some of these pictures, those, for example, of the blind beggars, and the well-known *Old Guitarist* (Plate III, 6), now in the Chicago Art Institute, come within range of this charge. Yet there is a dramatic sense of pathos based on observation of reality which saves them throughout. Picasso's preoccupation was always not how to exclude psychological interest but to discover how it could be included without the usual pitfalls of overstressed and unbalanced sentiment.

The portraits of this period, however, escape these accusations. Beginning with the *Man in Blue*,[32] the portrait of the wife of Pere Romeu and the portraits of Sabartés[33] and Mateo de Soto, he painted later other superb likenesses. These include the portrait of Angel de Soto,[34] in which face, hands and a glass on the table make a succession of incidents admirably contrasted in form and texture. There are two

[30] See Zervos, *Picasso*, Vol. I, p. 41.
[31] ibid., Vol. I, p. 23.
[32] ibid., Vol. I, p. 69.
[33] ibid., Vol. I, p. 43.
[34] ibid., Vol. I, p. 90.

portraits of Sebastia Junyer. In the larger painting of his artist friend he has placed, seated on a café bench behind Junyer, a street-walker, pallid, with heavy eyelids and holding a flower between her thin lips.[35] She haunts the background like a temptation that it would be inhuman to avoid and unwise to accept, alluding to a conflict which is not visible in the smooth, well-groomed face of Junyer. This is the only portrait which is complicated by symbolic allusions. In the other Picasso found sufficient psychological interest in his sitter alone. He enjoyed his mastery of the art of portrait painting as the dancer or the athlete enjoys the ease with which he can accomplish dazzling feats with the controlled strength of his muscles.

It was in the spring of 1904 that Picasso, needing more privacy and more space, moved briefly into a new studio in the calle del Comercio. Thanks to Sabartés, who rented two attic rooms in the same street, we know that he started work at once. His father had carefully prepared a large panel for him with the hope of watching the development of some definitive masterpiece. But Picasso treated it with no more respect than an ordinary canvas and left it with a few rapidly sketched figures and nothing more. His newly acquired seclusion was however exactly what was needed for a fresh burst of creative work. In addition, he visited Sabartés with paints and brushes and decorated his walls with murals 'in the spirit of Assyrian reliefs and of the pictures of the series 1901-1904'. On another wall opposite the window he drew a macabre scene in which a half-naked Moor was hanged from a tree while below him a young and entirely nude couple abandoned themselves 'to the passionate game of love'. Then, using a round window high in the wall as part of his design, he converted it with a few lines into an all-seeing eye with an inscription below that read, 'The hairs of my beard, although separated from me, are gods just as much as I.' The phrase 'just as much as I' reveals both his ambition and the doubt which troubled him. As he had done years before when sharing the studio in the Riera de San Juan with Casagemas, he added the inscription invented on the spot to complete the image he had just sketched out.

[35] ibid., Vol. I, p. 81.

Before he left Barcelona, he changed his studio once more for a more suitable room in the same street. But good accommodation was not enough to satisfy him. Barcelona was not the equivalent of Paris, and in April 1904 he left Catalonia for the last time.

4

Au Rendez-vous des Poètes
(1904-06)

The Bateau Lavoir: the Final Move to Paris

On the south-western slopes of the heights of Montmartre there existed in a small square, now named place Emile-Goudeau, a strange dilapidated building which more than fifty years ago was christened by Max Jacob the Bateau Lavoir,[1] possibly because of the many ways in which it was like the laundry barges anchored along the Seine. It resembles a boat only in that a visitor arriving from street level must embark on the top deck and go down complicated stairways and dark passages to reach the lower floors. Otherwise it is totally unlike a floating laundry owing to the almost complete absence of water and hygiene both outside and within. On the side facing away from the square, large glazed windows announce that the whole building, perilously hanging to the slope of the hill, is in reality a hive of studios.

This strange dwelling, composed it seemed of nothing but lofts and cellars, all in such a sad state of repair that no insurance company would ever accept it as a risk, had become well known at the turn of the century as a centre of bohemian life. It had housed artists and writers of the generation of Gauguin and the Symbolists. It was now to be the destination for which Picasso and Sebastia Junyer y Vidal set out from Barcelona in April 1904. Their progress by rail in the third class and their first encounters with the French are described in a series of lighthearted sketches, called by Picasso 'Alleluias'.[2] With the arrival of the two travellers, Junyer is seen in the first sketch carrying a large trunk under his arm. 'And at nine o'clock they arrive in Paris at last' is

[1] Destroyed by fire in May 1970.
[2] See Zervos, *Picasso,* Vol. VI, p. 60, Nos. 485-9.

the explanation below. The climax comes in the last drawing, which shows Junyer appearing bareheaded and alone, with a framed picture which he exchanges for a bag of gold offered by a bald little man in a frock-coat. The explanation written below is, 'I summon Duran-Rouel [*sic*] and he gives me a lot of cash.' 'Alleluias', it should be explained, is the name given to nineteenth-century Spanish broadsheets, covered with woodcuts describing pictorially a pious anecdote illustrating the adversity of human life. In Spain such tales invariably end in disaster. Skulls, coffins and funerals finish the story with an 'alleluia'. But Picasso's version, ending with a successful visit to the wealthiest dealer in contemporary art of the day, was according to such tradition outrageously optimistic.

Picasso's earlier visits to Paris had been made with the intention of staying no more than a few weeks, but on this occasion cases of paintings and canvases had been sent on ahead to the new address, known in those days as 13 rue Ravignan. It was possible therefore to settle at once into the studio on the top floor, that is to say ground floor of the Bateau Lavoir, where for the next five years he was to live, work and receive his friends.

Experience had warned him of the cruel disregard that the great city could show to a young artist, however talented and full of conviction he might be. This time 'Picasso did not come to Paris to conquer it, nor even to seduce it,'[3] writes Maurice Raynal; 'he came there to find a cure for life.'

Not all writers are in agreement as to Picasso's motives in making a move which was to have such far-reaching consequences and was, in effect, to be the beginning of his exile from his own country. From that time onwards he became virtually a French artist. Slowly and timorously, as his fame began to increase, even the official world was eventually to acclaim his presence as an honour to France and her traditions. Outside Spain, however, Picasso always felt himself to be a stranger. He never asked for French nationality, but he accepted France as his country of adoption at first willingly, and later, since his return to Spain was made impossible by political events, with good grace.

[3] Maurice Raynal, *Picasso*, Crès, Paris, 1922, p. 37.

Certain Spanish writers cannot admit statements such as that made by the poet Pierre Reverdy, when he wrote: 'All his [Picasso's] career as a painter unfolded itself in Paris, and the multiple manisfestations of his talent are part of the history of French contemporary art... Picasso understood that the legendary immobility of his country could only oppose its powerful force of inertia to the development of his imagination.' In reply they point indignantly to all that he had learnt in Spain, and to the Spanish blood in his veins that can never change its colour. But from a more detached angle it would seem probable that the magnetic force of Paris, composed of so many seductive elements equally attractive to a host of artists from all parts of the world, outweighed conclusively the provincial charms of the companions with whom Picasso had grown up at the 4 Gats. To this may be added the presentiment that the revolutionary trends his work was to take would never be tolerated in Spain. He later confided to Raynal his own opinion that 'if Cézanne had worked in Spain he would have been burnt alive'.

'A cure for life' was at the basis of what Picasso sought when he moved to Paris. Painting and life were inseparable. His life was lived daily through his eyes and he needed to see clearly in the deepest sense. Doubts assailed him as to where his vision with its growing discernment might lead him, and how the great talents which he knew he possessed could be used for its expression. The applause of his friends, and the pleasure that arose from the phenomenal ease with which he could communicate his ideas to others graphically, left him still dissatisfied and lonely. To quote Raynal again, 'he felt the troubling solitude of nascent genius and the call to new horizons'.[4]

But his return to Paris after more than a year of intense activity in Barcelona brought no immediate break in his work. The pitiable inhabitants of the streets of Barcelona appear to have accompanied him on his journey: the first images that haunted him on his arrival are closely similar. The hungry beggar watched eagerly by children eats the same bowl of soup in Paris, the madman in rags stirs the air with his

[4] Maurice Raynal, *Picasso*, Skira, 1953, p. 18.

fingers and mutters similar gibberish, and again the blind man crumpled and starving holds out an empty hand for alms. A universal population, irredeemable in its misery, continues to fill his work.

Two outstanding pictures dating from the summer of 1904 must be mentioned. One, a large pastel now in the Museum of Art, Toledo, Ohio, is known as *The Woman with the Crow*.[5] Its colour and the emaciated form of the woman with dreaming eyes, who bestows a kiss on the head of the bird, connect it inevitably with the Blue period, though the form is less sculptural than in many of the earlier pictures. The main emphasis lies in the long thin hand held vertically against the bird, which again recalls the mannerisms of El Greco.

Similar elongated hands appear in the other picture, a large etching known as *The Frugal Repast*, which I have already described. It is recorded that Ricardo Canals, a friend from Barcelona, had five years before encouraged Picasso to make copper-plate etchings, but only one example of this early work is known. It is a small etching of a *picador* standing with his legs apart, and holding a pike in his left hand. Picasso, as a beginner, had forgotten that the image would be reversed in printing, but he quickly covered his mistake by writing at the top, *El Zurdo* (the left-handed man).[6] At the feet of the *picador*, who appears to be posing for his portrait in an interior, is a small owl, the first appearance of this bird, which fifty years later was again to fascinate Picasso and become the subject of a great number of drawings and paintings.

The Frugal Repast is a mature work and masterly in execution, but as copper was too expensive, a zinc plate was used on which the traces of a landscape drawn by a former owner had not been entirely erased. Canals, who had also come to live in Paris, had acted as adviser, and according to Bernhard Geiser, the authority on Picasso's graphic work, 'it was thanks to his guidance that Picasso became accomplished enough in the techniques of etching to be able to get the effects he wanted'.[7]

[5] See Zervos, *Picasso*, Vol. I, p. 107.
[6] Geiser, *Pablo Picasso, Fifty-five Years of His Graphic Work*, Plate I.
[7] ibid., Preface.

Fernande Olivier

Soon after Picasso's arrival, while he was at work on this plate, he noticed in the dim corridors of the Bateau Lavoir a girl who came to fetch water from the one tap in the basement that supplied all the tenants. Her green almond-shaped eyes and regular features, crowned with the wild abundance of her auburn hair, could not be ignored. He spoke to her, and we know from her, as well as from many other sources, of the consequences of this chance meeting, which led to the first important attachment in his life. '*La belle* Fernande' was to become his companion, sharing his privations and the first fruits of his fame, during the next six years. Her version of their first meeting is that one hot summer afternoon she was sitting in the shade of the chestnut trees in the square with a girl friend, when a sudden storm made them run for shelter. In the passage was the young Spaniard whose black eyes she could not escape. He was holding a kitten in his arms and he laughed as he playfully barred her way. She remembers her astonishment, when she agreed to enter his studio. Piled up against the wall there were quantities of great blue pictures and a family of white mice lived in a table drawer.

Even so Fernande did not yield to him at once. She had a secret which she did not dare to tell him. Six months younger than Picasso, she had been born in Paris of parents who ran a millinery business. At the death of her mother she was sent to live with an aunt whom she hated with such violence that at the age of seventeen, to escape from her, she married a sculptor whom she scarcely knew. Shortly afterwards he went mad, and once more she had to flee. Continuing her story, she insisted that while they were living together it was she who refused Pablo's demands that she should marry him, without letting him know the reason. Even Don José, when they visited Barcelona together, could not believe that she could be so obstinate and advised his son to be more persistent.

Fernande Olivier speaks in her memoirs of the day-to-day joys and disappointments in the life of a couple whose combined ages added up to little more than forty. In her original way she also gives a lively picture from her point of view of the bohemian life that went on around

them and the visits of penniless intellectuals and rich collectors of various nationalities.

The exuberant beauty of her youth, her healthy robust figure and her confidence, introduced a new element of optimism and delight which could not fail to affect the life and therefore the work of her lover. He expressed his love for her in innumerable drawings and portraits, and with the jealousy of a Spaniard confined her to his own attentions. She recalls how grateful she was for the piles of secondhand books that passed away the weeks when she could not leave the studio because she had no shoes. Picasso, the Andalusian, in his way treated her as an odalisque. She was never allowed to go out without him. He would sweep the floor himself and go out to buy food. In return, she says, 'with some tea, some books, a couch, little housework to be done, I was happy, very happy'.[8] For although Fernande had the reputation of luxuriating in laziness, she was a good cook and made excellent dishes on the small paraffin stove. With her sense of economy she managed to feed him and his friends on not more than two francs a day.

Fernande's memoirs contain a description of the impression he made on her which is worth quoting. 'He had nothing very seductive about him if one did not know him, nevertheless his strange insistent regard demanded attention. Socially it was difficult to place him but this radiance, this internal fire that one felt in him generated a kind of magnetism, which I could not resist.' Elsewhere she says he was 'small, black, thick-set, restless, disquieting, with eyes dark, profound, piercing, strange, almost staring. Awkward gestures, the hands of a woman, poorly dressed, badly groomed. A thick lock of hair, black and shining, slashed across his intelligent and obstinate forehead. Half bohemian, half workman in his dress, his long hair brushed the collar of his worn-out jacket.'[9] She remembers how in winter when they had run out of fuel it was warmer to stay in bed, until the neighbouring coal merchant generously delivered fuel without even asking for payment, because 'my eyes pleased him'. She tells how they devised ways of getting provisions without paying cash by asking a store to send them

[8] Olivier, *Picasso et ses amis*, p. 9.
[9] ibid., p. 25.

round. When the delivery boy arrived, Fernande would shout through the door: 'Put them down, I can't open now; I'm naked.' By this farce they gained a week in which to find the money. On another occasion their dog Frika returned home like a good Samaritan dragging a string of fresh sausages.

The Bateau Lavoir was dirty, uncomfortable and full of other people's noises. In winter ice formed in the tea cups and in summer the heat was intolerable. The neighbours, who included 'painters, sculptors, writers, humorists, actors, washerwomen, dressmakers and hucksters' shared in the same medley. Picasso remembers the tragic scene when a man, slipping on the snow on one of the roofs, crashed to his death below; and the comedy of the oil stove thrown out of an upper window by its half-asphyxiated and furious owner. But poverty and discomfort were matched by vitality and companionship. This untidy bohemian community in the heart of Montmartre still retained the atmosphere of a village with its intimacy, gossip and passionate drama. The adventure that was being lived by the young Spaniard and his group of friends fitted in with the surroundings. They were accepted by all as an asset even though their neighbours were often incapable of understanding their strange talk and pre-occupations.

Outside, under the trees in the square, Picasso would meet and talk with his friends, mingle with the neighbours or teach the children to trace in the dust with one continuous line the outlines of cocks and hens, rabbits, horses, birds or what you will.

La Bande Picasso

Among those who for diverse reasons had found their way from Barcelona to Paris were Paco Durio, sculptor and ceramist, formerly a friend of Gauguin; the gaunt Ramón Pichot; Zuloaga, who already took the pose of a master; the engraver and painter Ricardo Canals, whose beautiful wife was Picasso's model for one of his most brilliant portraits; and the sculptor Manolo Hugué, who had a great appetite for jokes at the expense of any victim. Manolo was the son of a general and had been left to his own resources on the streets of Barcelona when his father went out to the war in Cuba. He soon learned to live by his wits.

His inexhaustible fund of good humour compelled his friends to forgive even his most brazen and unscrupulous behaviour towards them. There are endless stories of his roguery, beginning with the time when his father ordered the police in Barcelona to bring Manolo to him. The general's speech to his son was so full of admonition and so moving that Manolo wept and asked for one favour only, which was to be allowed to embrace his father. The general was even more astonished when he discovered after his son's departure that his watch had gone too. Manolo would admit with a smile that apart from murder he had done everything. But he was a talented sculptor into the bargain, and his irresistible charm made him the most authentic and lovable of bohemians. Years later, when grave news of a political crisis in Barcelona reached Picasso, I remember his saying that if they tried to shoot Manolo, his executioners would be sure to miss because he would make them helpless with laughter.

The personality of Picasso as well as his talent won admiration and devotion among his friends. They were anxious to come to his help whenever their limited means allowed. Paco Durio, hearing once that Pablo had nothing left, tactfully put down outside his door 'a tin of sardines, a loaf and a litre of wine'. Manolo and de Soto, with Max Jacob's assistance, often set out with packets of drawings under their arms. In the hope of raising a few francs, which would be generously shared out among them, they made a tour of the dealers of the rue Laffitte; or if they failed there they tried bric-à-brac merchants such as the Père Soulier, a former wrestler and a great drinker. This picturesque tradesman kept a shop opposite the Cirque Medrano. Mixed in among the bedsteads and mattresses which were his stock-in-trade, a variety of pictures had accumulated, his choice having been guided by an instinctive love of painting. According to André Level, his flair had helped him to discover pictures by Renoir, the Douanier Rousseau and even Goya. He became indispensable to the artists who lived around, not because he made them rich by his purchases but because he often saved them from starvation. From him it was always possible to raise something to pay for immediate needs. But at what a price! Twenty francs for ten admirable drawings by Picasso was the exchange demanded by him over a drink in the café next door.

Other attempts elsewhere to raise a few francs also met with small reward. A series of fourteen etchings was made by Picasso with the help of a friend, Delâtre, a former Communard, who owned a press and made prints on the rare occasions when they were in demand. The plates, varying in size, were remarkable for the precision of their line and the charm of their subject matter, which consisted chiefly of harlequins and circus folk, or Salome dancing before a monstrously fat Herod (Plate III, 2). They also included the earlier engraving, *The Frugal Repast*, which in this original edition, before the plates were bought by Vollard and re-edited in 1913, is now one of the rarest and most treasured of all Picasso's etchings. The edition was put on sale by a small but enthusiastic dealer, Clovis Sagot, of the rue Laffitte, but it brought no profit to be shared by the artists or anyone else.

Unlike most painters, who lose no opportunity of sending their work to exhibitions, Picasso refused consistently to show his paintings in public. To sell pictures was a necessity rather than a pleasure. He was miserable when they had gone and preferred to give away rather than haggle with a dealer. In fact at this time he gave away more than he sold. His reluctance to exhibit may have been due in some degree to the disappointment of his early exhibitions, which he did not wish to risk again. More probably it came from a mixture of conviction of his own genius and doubt as to the reactions of others. As a result he preferred to remain proudly aloof rather than attempt to display his wares. Even Vollard did not as a rule show Picasso's work to strangers. He kept it hidden to be seen only by a chosen few.

Already in 1905 the names of Matisse, Braque, Vlaminck, Dufy, Friesz and Rouault could be found among the exhibitors in the Salon D'Automne or the more rebellious Salon des Indépendants. But Picasso saw no point in appearing in such mixed company. He had little interest in current theories and preferred to follow his own solitary and precarious path. To ease the pangs of hunger many artists helped themselves by drawing for the *Assiette au Beurre* and other illustrated reviews, but Picasso had neither the time nor the desire to follow their example, although on one occasion, it seems, he did contribute to the satirical review, *Frou-Frou*. Once also he agreed to design a poster for a play, *Sainte Roulette*, by Jean Lorrain and his friend Gustave Coquiot.

The poster being by an unknown artist was not a success and was turned down by the manager of the theatre, the Grand Guignol.

The First Patrons

Although he refused to make a gesture towards the public, visitors and collectors of various nationalities found their way to Picasso's studio and began to buy from him the recent products of his untiring energy. Among those who discovered his retreat were Leo and Gertrude Stein, piloted there by a young author, Henri-Pierre Roché. The Steins were Americans who had recently settled in Paris. They were finding their way rapidly and with passionate excitement into the world of art and literature. Passing through London in 1902, Leo Stein bought his first modern painting, a Wilson Steer. Soon after, with the help of Bernard Berenson, he discovered the Cézannes at Vollard's gallery and bought a landscape. This led to further satisfaction when he added Van Gogh and Gauguin to his collection. At the Salon d'Automne of 1905, he was bold enough to buy, with his sister's approval, a 'brilliant and powerful' portrait by Matisse. This picture had become the bull's-eye for adverse criticisms aimed at a group of violently coloured exhibits by those painters, Matisse, Derain, Vlaminck, Braque and others, who had become known as 'Les Fauves', the wild beasts. Their method was a free and somewhat arbitrary use of pure colours which implied in consequence an even greater disregard for form than that of their predecessors, the Neo-Impressionists. Their exuberance centred round the talented painter, the eldest in this youthful group, Henri Matisse, 'le roi des Fauves'.

The Steins were greatly impressed by the work and the personality of Picasso. The first purchase made by Leo from Clovis Sagot for 150 francs was however against Gertrude's wishes. It was a large upright canvas painted in 1905, predominantly blue in tone, of an adolescent girl holding a basket of red flowers.[10] But on their first visit to Picasso's studio, they spent 800 francs buying paintings, an event without precedent.

[10] See Zervos, *Picasso*, Vol. I, p. 113.

The two enthusiastic explorers of uncouth appearance were not only courageous in their choice but also extremely hospitable. In her books Gertrude Stein has described the dinner parties at their apartment in the rue de Fleurus, where for years they brought together a remarkable assembly of creative talent. It would be true to say that nearly all the young poets, painters and musicians of the brilliant generation that came to Paris in the first decades of this century, from all parts of the world, visited their household sooner or later. But although they had been buying the work of both Matisse and Picasso for more than a year, it was not until the autumn of 1905 that the two painters met for the first time under their roof.

The Studio: Late Blue Period

Fernande remarks that before knowing Picasso she wondered how he could find any time to work during the day, so constant was the stream of his Spanish visitors, but she discovered that in spite of the total lack of gas or electricity he preferred to work by night. Most of his pictures before 1909 were painted by the light of an oil lamp, which he hung above his head while he squatted on the floor in front of his canvas. But often in the early days he could not afford to buy the oil, so he held a candle in his left hand while he worked with his right. André Salmon describes how on his first visit in company with Max Jacob, he found him painting in this way a 'picture that was blue'.

The weakness of the candlelight and its tendency to subdue yellow has been given as a possible reason for the overall bluish tone of this period, but that he should have miscalculated his effects is not credible. His sense of colour and familiarity with his materials were more than enough to compensate for the temporary distortions of artificial light. All such theories become nonsense beside his own words: 'You are that which exists best in the world...the colour of all colours...the bluest of all blues.' His preference for working by night frequently kept him up until six in the morning and for this reason early callers were not welcome. Happily the concierge, whose heart he had won, could be relied on to keep away all visitors except those she recognized as having a possible financial value. When Monsieur Olivier Sainsère, Conseiller

d'Etat, arrived correctly dressed and with his top hat, the concierge would knock on the door shouting: 'You must open, this time it's serious.' At this Picasso would get up in his nightshirt and open for the distinguished collector while Fernande hid behind the canvases. Sainsère, looking round for a suitable place for his hat, would say urbanely to the young painter: 'Please put on a pair of trousers, you will catch cold.' He would then settle down to examine the newly painted canvases.

A visitor arriving at a more convenient hour, however, would find the door opened to him by Picasso with 'the celebrated curl over a black currant eye, dressed in blue, the blue jacket open on a white shirt held in at the waist by a poppy-red flannel cummerbund with fringes...'[11] The visitor was greeted by a strong smell of oil paint and paraffin, which Picasso used as a medium for painting as well as fuel for his lamp, mixed with the heavy smoke of black pipe tobacco. Once the stacks of paintings leaning against the walls had been passed, he would find the canvas on which Picasso had been working propped up at the base of an easel in a clear space in the centre of the room. Picasso often liked to work leaning or squatting over the canvas at an odd angle, but he changed his position with the size of the canvas. On the floor to the right of the easel, paints, sable brushes and a vast collection of pots, rags and tins were spread out close at hand. In spite of the ample size of the studio and the almost complete lack of furniture, the room was overcrowded with objects. In that respect it resembled the attic in the boulevard de Clichy, and in the future, the apartment in the rue la Boétie, the great rooms of the rue des Grands Augustins, the villa 'La Californie' and the *mas* Notre Dame de Vie – in fact wherever Picasso had settled and gathered round him the material that was to feed his imagination and his work. Salmon gives us an inventory of what he remembers having seen on his first visit:

A paint cupboard made of boards, a small bourgeois round table bought from a junk merchant, an old couch used as a bed, an easel. Carved out of the original studio space, a little room containing a thing like a bed. This had become a retreat. Familiarly it was known as 'the maid's bedroom'. All kinds of

11 Salmon, *Souvenirs sans fin*, 1955.

buffoonery went on there behind our host's back and continued to do so until the arrival, not long delayed, of Fernande Olivier.[12]

As Salmon slowly became aware of the impact of the multitude of paintings that surrounded him, he says he was 'bowled over by the revelation of a new universe'.

Certain incongruities in the disorder attracted special attention. In the middle of the floor was a zinc bath tub and in it were books by Paul Claudel and Félicien Fagus. In Fernande's little corner with its tottering floorboards Picasso had placed on the wall, this time deliberately, an object by which she also was puzzled. In the first days after their meeting he had made a drawing of her, which he framed elaborately with a mount made from her blue chemise which he had asked her to give him. With the help of Max Jacob, who supplied two cerulean blue vases filled with artificial flowers, he set up the portrait as an altarpiece, half mocking and half in devotion to the girl he loved. Fernande could never decide whether this display was an echo of what she calls his 'mysticism' or just an elaborate joke placed above her bed to disquiet her.[13]

The arrival of Fernande did not disturb the friendship between Picasso and Max Jacob. In fact, the poet's genuine affection for her even outlasted her liaison with Picasso. Max's company was very entertaining. There was great originality in his wit and he was an untiring entertainer. He would read his own poems with admirable conviction and enchant everyone with songs from comic operas. Of this Picasso never tired. But even with this unfailing flow of drollery and serious thought, as Salmon remarks, 'too much friendship loses its value'. The days of their closest intimacy were already over.

Au Rendez-vous des Poètes

Although Picasso always demanded solitude for the hours in which he worked, he was never able to live without company. In Paris, as in Barcelona, his bias towards the literary world brought about some

[12] ibid., p. 170.
[13] Olivier, *Picasso et ses amis,* p. 53.

significant encounters that were to be of great importance both to him and to his new friends. André Salmon's first visit to the Bateau Lavoir resulted by chance in his first meeting with Max Jacob on Picasso's doorstep. Only a week before Picasso himself had made the acquaintance, in a bar near the Gare St Lazare, of an impetuous and brilliant poet of half-Italian, half-Polish origin, who had adopted France as his fatherland and exchanged his family name, Kostrowitzky, for that of Apollinaire.

On the same evening the two young Frenchmen met at his door, Picasso took them to meet Guillaume Apollinaire. The introduction was made in the same crowded bar, and has been described by Max Jacob in these words: 'Without stopping a quiet but violent discourse on Nero and without looking at me, he absently extended his short strong hand (one thought of a tiger's paw). Having finished his speech he rose, swept us out into the night with great shouts of laughter and so began the most wonderful days of my life.'[14] Not only was this a great event for Max Jacob, but it was this encounter which inaugurated the epoch when these friends, with other painters and poets, were to influence each other in close and fruitful collaboration.

Picasso's interest in the poets was liberally reciprocated by them, and as the circle grew his prestige increased among them. Before his death in 1907 Alfred Jarry became a friend whose talent, wit and eccentric behaviour made a profound impression on Picasso, and his influence was remembered long after his death. Inventions such as Dr Faustroll's Pataphysique and that monstrous, brutish character, the Père Ubu, corresponded to Picasso's growing desire to disrupt accepted appearances by any means he could find valid. Jarry's ability to handle dangerous weapons such as ridicule and obscenity was a stimulus to him, and although the Parisian wit of his plays was meat too strong for French audiences, they whetted Picasso's Spanish appetite for a riotous, full-blooded castigation of conventional ideas.

The young poets Pierre Reverdy and Maurice Raynal, as well as Charles Vildrac, George Duhamel and Pierre MacOrlan, all became frequent visitors to Picasso's studio. He enjoyed their excited and

[14] R.G. Cadon, *Testament d'Apollinaire*, Debresse, Paris, 1945, p. 22.

intelligent conversation and their appreciation of his work. This was in many ways an attraction of opposites. Picasso usually remained silent except for an occasional burst of enthusiasm which took the form of a startling paradox or a monstrous joke. He seemed to be continually on the watch, his eyes shifting rapidly among his companions, listening to their remarks, and readily grasping their meaning. His friends, on the other hand, were for the greater part extremely loquacious, complicated and ebullient. They were attracted by the mysterious ways in which he could control his own talent and youthful ardour with apparent calm, the way he could express himself with such originality in his words and such richness in his work. The increasing frequency of their visits to his studio made one of them remark that there should be a sign over the door, '*Au Rendez-vous des Poètes*'. The first visitors to arrive about midday were usually Apollinaire, Max Jacob and Manolo. During the years spent at the Bateau Lavoir, Fernande remembers very few meals with Picasso alone. She often prepared food for the whole company on her paraffin stove, unless, as sometimes happened, her admirer, the coal merchant, called in and invited them all to come and taste his cabbage soup. 'You should have heard Apollinaire's grateful laugh,' she told me, 'as we trooped off together.'

The Rose Period

Salmon on his first visit had found Picasso painting in blue. The 'blue universe surrounded him'. During the autumn and winter of 1904 the sentiment and mannerisms of the Blue Period still persisted. A large painting in grey blues that departed little from monochrome had for its model a laundress who lived and worked in the same building.[15] With the weight of her weariness she presses on her iron. The accentuation of her long thin arms and the meanness of her empty room suggest a sadness unrelieved except for the trace of a smile on her pallid face. The angle of her shoulder raised above her head conveys a melancholy akin to that of *The Old Guitarist*. In both cases, their antecedents lie in the mannerist distortions of El Greco and his medieval ancestors.

[15] See Zervos, *Picasso*, Vol. I, p. 111.

Another even larger painting, *The Actor*, is equally dramatic in its tension (Plate III, 1). Again the model was a neighbour. With wasted arms and fingers writhing like dead branches in the wind, he gesticulates to his audience. His sinuous, elongated body, clothed in pink with blue trimmings, sways over the prompter's box on an empty stage. Whatever his role may have been, his attitude indicates clearly a state of exalted inner suffering and privation. In this picture the all-pervading blue has yielded to colours reminiscent of the paintings of the earlier days in Paris, though they are more subdued and more skilfully controlled. The form, again Gothic in feeling, is built up without hard outlines, and the freedom of the brushwork has a more personal touch.

Unlike *The Old Guitarist* and the majority of the figures of the Blue period, *The Actor* seems to move within the three-dimensional space created by the depth of the background. For this reason, as well as the introduction of colours unusual in the previous paintings, it heralds new tendencies. For convenience the succession of styles that Picasso developed during the next two years has been labelled the Rose period. Alfred Barr more correctly divides the period chronologically into five short stages beginning with the Circus period of which *The Actor* is a forerunner. Picasso was awakening from the cold, blue world of the pitiable outcasts who had formerly inspired him. He had found new company in Montmartre, and although the life of the circus ring and the stage was precarious, it was not in the same way wedded to despair. The clown and the actor belonged to a race of artists. Their skill and their courage in an atmosphere of uncertainty and danger had an appeal similar to that of the bullfight. They provided the climate in which his next inventions were to grow.

Harlequin

From the early days of the Blue period, taking his place somewhere between the blind beggars and the prostitutes, sharing with them the same café tables, another character makes his appearance. He is a youth disguised for a performance in which, to judge from his fragile looks, he is merely another victim, one of a troupe of players who impersonate the behaviour of a society from which they are outcasts. Whether comic

or heart-rending, his act is calculated to mislead because his particular drama lies less in his miming than in himself.

The image of Harlequin recurs intermittently throughout the work of Picasso (Plate I, 9). Even during the cubist period, shorn of literary allusions, the diamond pattern of his costume still betrays his presence. This persistence has led Professor Jung to claim that the motive for his haunting reappearances is a subconscious desire in Picasso to portray himself in this disguise. The theory is strengthened by the frequency in early years with which we find Harlequin as Picasso's self-portrait. Let us not assume, however, that this is Picasso's only characterization of himself. His love of disguises prompts him to imagine himself in many different roles. It can be said that the bull, the horse, the minotaur, the owl, the dove, the meditating lover, the bearded artist and even the child holding a candle are also symbolic of Picasso himself.

The preference that Picasso shows, particularly in early life, for Harlequin suggests that analogies must exist between him and this legendary character. Picasso's Harlequin is not the elegant flirtatious entertainer loved by Watteau, nor Cézanne's proud youth in fancy dress, nor is he a buffoon. Though he may be a jester he speaks the truth, and though he may be wearing a disguise we detect his identity by his mercurial nature and his elusive ways. It would be legitimate to interpret this Harlequin, with his diamond coat of many colours, as the power to juggle with everything while remaining evasive and irresponsible. He is a thief who gratuitously steals up unperceived to take his prize, to prove himself capable of doing so and to test his luck. His game is ambitious; it is a test of strength with the established order. During the nineteenth century Harlequin was out of favour among painters, but before it ended he made a brilliant reappearance in Cézanne's picture *Mardi Gras*. This painting which had been bought by Vollard was seen by Picasso in his gallery before it was purchased and taken to Russia by the collector Shchukine. Its subject was in consequence the first influence that Picasso acquired from Cézanne. This happened about six years before he was ready to absorb fully the great stylistic changes inherent in Cézanne's work.

Throughout the Circus period Harlequin dominates the scene. He is seen off-stage, lithe and sensitive in physique, with his family and their

attendant pets. In intimacy he nurses a baby while his wife stands nude arranging her hair. In the *Acrobat's Family with Ape* he watches the young mother with her child, in company with another important actor on Picasso's stage, the ape (Plate III, 7). He appears at times as a small boy or wanders in open country with an acrobat and a dog, or again he stands in thought looking into the blind face of one of his companions.

Although these characters, like those of the previous period, are still aloof, living in a world of their own, they have a serenity about them which seems to reflect the new sense of happiness which Picasso had found in his love of *la belle* Fernande. Two water-colours of the autumn of 1904 show a man, in one instance obviously himself, contemplating that one luxury attainable even in poverty, the naked beauty of a sleeping girl (Plate III, 3). This is the first appearance of a theme which has recurred later with innumerable variations.

Throughout the Circus paintings the pervading solemnity of blue, transcendental and morose, was giving way to the warm caressing blush of rose pink. The old untouchables had yielded their place to the tangible presence of youth and affection. The circus folk are no longer solitary in their poverty, they appear surrounded by their companions. The pale emaciated forms of starving cripples are replaced by figures full of the grace of adolescence and often curiously androgynous in their physique.

Circus and Saltimbanques

Being a village within a city, Montmartre was almost self-contained. Within a small distance a great variety of amusements and theatres were at hand. For some years the most popular place of entertainment among artists was the Cirque Medrano, which to this day still continues to enchant successive generations of Parisians. Its clowns, acrobats and horses had delighted Degas, Toulouse-Lautrec, Forain, Seurat and many others. There, behind the scenes and outside among the sideshows of the fair that traditionally occupies the whole *boulevard* during the winter, Picasso made friends with the harlequins, jugglers and strolling players. Without their being conscious of it, they became his models. With their families they camped beside the booths in which

they performed under the warm glare of paraffin lamps. Their wives, their children, their trained pets, monkeys, goats and white ponies squatted among the props necessary for their acts. Detached from the everyday business of the great city, they lived absorbed in rehearsing and giving displays of their agility.

There is an important picture, bought later by the Russian collector Morosov, and now in a Russian museum, of a little girl dressed in blue tights, balancing on a large ball (Plate IV, 2). In the foreground sits the massive figure of a wrestler in pink and blue, while in the distant treeless landscape, baked like the plains of Castile in summer, a woman with her child watches a white horse grazing. The two main figures, the little girl, fragile, ethereal, detached from the soil, and the young athlete, thick-set, muscular, seated squarely on a heavy stone block, are admirably contrasted. They form together a composition which is classical in its ordered simplicity and in which even the spaces unoccupied by the figures are interesting and alive to the eye.

With the numerous paintings and studies that accumulated in the spring of 1905 Picasso had the intention of composing two large canvases, only one of which was achieved. Of the first, *The Circus Family*, only a large water-colour,[16] now in the Baltimore Museum of Art, exists, though component parts appear in many other pictures. The scene is set in the open; Harlequin stands among his troupe watching a child practising on a ball, while the women are occupied with domestic tasks. Two features that recur in other sketches are the white horse and a ladder pointing towards the sky. The second painting, known as the *Family of Saltimbanques* (Plate IV, 6), is now in the National Gallery of Art, Washington. Measuring about seven feet square it was the largest so far painted by Picasso.

It is never necessarily true that a great composition into which an artist crowds all the efforts and discoveries of a period is the most moving and successful product of his work. In the case of *La Vie* painted two years earlier Picasso had allowed allegory and sentiment to cloud the aesthetic impact, and many smaller pictures of the Blue period give greater satisfaction. In the *Saltimbanques* there is no

[16] See Raynal, *Picasso*, Albert Skira, p. 31.

message, no allegory, and a balance between spontaneity and sensitive judgement relieves it of any suspicion of sentimentality. Picasso had assembled the studies of his circus friends and grouped them together under a blue sky with an empty, timeless landscape as their background.

In an early sketch the background was a racecourse scene reminiscent of Degas, with one of the riders taking a fall. All this was finally eliminated and there is in consequence a feeling of detachment among the figures who stand listlessly, apparently waiting for a command. The precarious balance of the composition, with five figures grouped to the left and a solitary figure of a girl seated in the right-hand corner, adds to an expectation of some unforeseen event. The evolution of each of the figures can be traced through the studies. The seated woman was formerly the subject of a painting where she wears a pointed hat covered with a veil such as was worn by the ladies of Majorca. Like a Tanagra statuette she balances it high on her hair. The little girl appeared in the first sketch without her flower-basket, caressing a dog. The elderly jester with a paunch swelling his red tights, who seems to be the father of the troupe or the 'understander', has an extensive background of antecedents. Usually dressed in red and seated on a block, he has as a companion a slender youth. He is first cousin to the sybaritic Herod of the etching *Salome*, and wears the same mock crown as the bronze head of a jester modelled about the same time. He also reappears as the gargantuan king of a bookplate drawn for Apollinaire. But the tall figure of Harlequin on the extreme left of the painting is the most familiar. He stands hand in hand with the little girl facing the old jester. At the last moment Picasso gave him his own profile so as to identify himself even more closely with his wandering companions. The six characters who seem otherwise aloof have a unity of purpose. Together they form a motley troupe. The freshness with which the picture is painted contributes to the mystery of their presence. This mystery haunted the poet Rainer Maria Rilke when in 1918 he asked if he might live in the same room with 'the great Picasso', which then belonged to Hertha von Koenig in Munich. Sharing Picasso's fascination for the wandering circus folk of Paris, he was inspired to write the fifth of his *Duino Elegies* while living, he told a friend, 'with the loveliest Picasso

(the *Saltimbanques*) in which there is so much Paris that for moments I forget'. In these lines he speaks of the wandering players he had beside him:

> But tell me, who are they, these acrobats, even a little more fleeting than we ourselves...[17]

Life in Montmartre

'We all lived badly. The wonderful thing was all the same to live,' wrote Max Jacob, who suffered more than anyone from an extreme poverty that his top hat, immaculate dress and exquisite manners failed to hide. His room in the rue Gabriel was so lacking in any comfort that Picasso presented him with a screen he had decorated to keep off the draught, though in the early years he was not much better off himself. The humiliating bargaining with the Père Soulier brought little satisfaction.

Restaurants where artists of all descriptions met to satisfy their hunger at the least possible expense abounded in the steep narrow streets that led up to the place du Tertre. Picasso and Fernande had picked one that suited them for various reasons – it was next door to the pawnbrokers, and the proprietor Monsieur Vernin was too soft-hearted ever to refuse credit. The '*bande* Picasso' was always to be found there, as well as young actors and actresses. The animation and smell of cooking were both intense, but the final advantage of this *bistro* to Picasso was that he found the conversation so boring that it was an incentive to finish the meal fast and return home to work. Higher up the hill, the bearded Fredé, former owner of Le Zut, had recently opened a small café, Le Lapin Agile, which was later to become famous. It still exists, though it is only in its external appearance that it retains something of its former atmosphere. In its early days the Lapin Agile became one of the favourite haunts of the group of poets and artists which included Picasso. In the evenings they would congregate to exchange ideas and listen to recitals of Ronsard or Villon by Baur and Dullin, or the airs of the 'Caf-conc' sung by Francis Carco. In summer,

[17] Rainer Maria Rilke, *Duino Elegies*, translated by J. B. Leishman and Stephen Spender, Hogarth Press.

on a little terrace under an old acacia they could get an excellent dinner for two francs including wine, and it became a custom to celebrate occasions such as the opening of an exhibition, or even the funeral of a friend, '*chez* Fredé'. Inside the café, in the semi-darkness, could be seen the work of artists accepted by the patron as payment for their debts. There were pictures by Utrillo and Suzanne Valadon, with others by less-known names. Also there was a highly coloured Picasso in the gaudy yellows and reds of the Lautrec period nailed to the wall. This has since become a painting of historical interest (Plate I, 9). The figure seated at a table in the foreground fingering his glass is an admirable portrait of Picasso himself disguised as Harlequin. Beside him in profile sits the pale Germaine Pichot, formerly the friend of Casagemas, listening attentively to Fredé who can be seen seated on a barrel playing his guitar. A tame crow belonging to Fredé's daughter Margot, who later married Pierre MacOrlan, hopped about among the guests. It was the same bird that appeared in Picasso's painting of 1904.[18]

Picasso enjoyed the usual café talk he found at the Lapin Agile, whether it was serious or rowdy, and chance meetings which might lead to new friendships. Certain people, however, he disliked because he felt they were wasting his time: those who insisted on asking questions in a pedestrian attempt to understand his work. He once made this unforgettably clear to three young Germans who came one evening to his studio. After standing a long time politely appreciating his paintings, at his suggestion they climbed the hill together to the Lapin Agile to have a look at the picture nailed to the wall. On the terrace they began earnestly to ask him to explain his theory of aesthetics, but Picasso's answer was as immediate as it was effective. Drawing from his pocket the revolver given him by Alfred Jarry and often used to express his high spirits, he fired several shots into the air. The three earnest Germans disappeared into the night and Picasso went in to explain to Salmon and his startled friends the reason for this outburst.

The same tactics were used one night when Manolo and Picasso were sharing a cab on the way home with a poet who had bored them considerably by insisting on reading his poems to them. This time the

18 See Zervos, *Picasso*, Vol. I, p. 107.

shots were fired through the roof, and the Spaniards slipped out of the fiacre on opposite sides. The bewildered poet, who again happened to be a German, was left to cope with the driver and the police, who locked him up for the night.

A Visit to Holland, and Sculpture

Among the many foreigners whom Picasso had met in Paris was a Dutch writer named Schilperoort, who in the summer of 1905 invited him to visit his home at Schooredam. For one month Picasso gazed in amazement at the flatness of the landscape and the opulent forms of the Dutch girls, head and shoulders taller than himself. At the end of that time he returned with several paintings of these girls, whose ample figures encouraged him to emphasize their sculptural and monumental qualities. In the painting known as *La Belle Hollandaise*, which shows a nude in a lace cap, he used a palette limited to pinks and greys.[19] It is prophetic of the colossal nude figures painted in the early 1920s, but it also had a more immediate influence in guiding Picasso to further serious attempts at sculpture.

The earliest known sculpture of Picasso, a small seated figure of a woman, dates from 1901, and there are two masks, tense and expressive, the *picador* with broken nose and the *Blind Singer* of 1903 modelled with great sensibility and related to Blue-period paintings. Following these (Plate III, 4) in 1905-6 came the dramatic *Jester*, the *Kneeling Girl Combing her Hair*,[20] of gracious yet ample form and heads of *Fernande*[21] and *Alice Derain*, both admirable portraits. Thanks to Vollard the originals were cast in bronze some years later. His excitement was such that for a time it seemed that sculpture might take preference over painting; but with a few exceptions Picasso did not follow up this brillint start until more than twenty years later. *The Jester*, the most accomplished of these bronzes, has a rugged solidity due to its rough modelling, which catches the light and spreads it over the form. The face is sensitive and the jester's cap and crown spring

[19] ibid., Vol. I, p. 114.
[20] ibid., Vol. I, Plate 153.
[21] ibid., Vol. I, Plate 149.

from the head like a flower. It was begun late one evening after returning home from the circus with Max Jacob. The clay rapidly took on the appearance of his friend, but next day he continued to work on it and only the lower part of the face retained the likeness. The jester's cap was added as the head changed its personality.

First Classical Period

It was during the months that succeeded the visit to Holland that the next stage of what is known as the Rose period arrived. The Blue period had already given place to the Circus period with its less morbid but introspective harlequins. They too were now to be forgotten in a more objective approach to the subject matter, in which aesthetic considerations were to grow in importance. The elongations and expressive distortions of Romanesque or Gothic origin were set aside, and Picasso's work began to show the influence of his study of Greek sculpture of the primitive and classical periods in the Louvre, and his continued interest in Egyptian art. Until his death there existed in the collection of Tristan Tzara a sheet covered with delightful sketches which indicate the widespread interests of Picasso at this time.[22] Over the figure of a girl acrobat in the centre of the paper is a woman in the Egyptian style drawn with bold unhesitating outline. Characteristically the eye, placed on the profile face, is seen as though full face. A mixed bag of objects and comic figures fills the rest of the sheet: men naked except for bathing slips and hats; a small elephant; a peacock and a hippopotamus showing both eyes on a head in profile; a vase of flowers; an ink blot transformed into the head of a Negro; and in addition a rough sketch of a gateway surmounted by an oriental dome. The sketches are slight but significant.

A classical tendency is clearly present in two of the earliest paintings of this period, *Woman with a Fan* (Plate IV, 5) and *Woman in a Chemise*. (The latter is now in the Tate Gallery.) Both paintings have a serenity and a stylization of gesture which suggest Egyptian art. In colour both recall the Blue period, but the simple well-rounded forms and elegant

[22] ibid., Vol. VI, p. 85, No. 699.

proportions herald a new epoch which was to last about a year during which all mannerist distortions were abandoned, and a search for simplified form took their place. There is an Arcadian atmosphere in the drawings and paintings of naked boys leading their docile horses or riding bareback (Plate III, 9). A gouache known as *The Watering Place*[23] is a study of boys and horses for an important painting that Picasso was contemplating but which did not mature. It is a splendid composition on classical lines; the horses and their riders form an oval in the centre of the canvas, punctuating it with light and dark vertical forms. The studies in themselves, however, such as the *Boy Leading a Horse* in the Tate Gallery, are sufficient proof of Picasso's mastery of this theme. As Alfred Barr writes of these and of the nudes of the same period, they have 'an unpretentious, natural nobility of order and gesture which makes the official guardians of the "Greek" tradition such as Ingres and Puvis de Chavannes seem vulgar or pallid'.[24]

The Portrait of Gertrude Stein

In the spring of 1906 Picasso surprised Gertrude Stein by asking her if she would allow him to paint her portrait. She had by then become an intimate friend. Although she may not have understood thoroughly his saturnine nature and the many-sided significance of his work, she had been captivated by his genius and the shining blackness of his eyes. Of Leo Stein there are several drawings:[25] he had a bushy black beard, gold-rimmed spectacles, awkward posture and intense professorial look. He had made a collection of rare books in which he took particular pride. As a joke he forbade Picasso to look at them saying that those piercing black eyes would burn holes in their pages. Gertrude was unselfconsciously eccentric in appearance. Her squat and massive figure, regular features and intelligent expression, coupled with a masculine voice, were significant of a strong personality. The proposal that she should sit for Picasso was surprising, since at this time he found the actual presence of a model altogether unnecessary. His

[23] ibid., Vol. I, p. 118.
[24] Barr, *Picasso, Fifty Years of His Art*, p. 42.
[25] See Zervos, *Picasso*, Vol. VI, p. 82.

circus folk lived near by, but never were they asked to come and pose for him in his studio. This practice singled him out once more as an eccentric among painters, while others accused him of causing unemployment among the models.

When, as in this case, Picasso reverted to custom in order to make a particularly careful portrait, he usually made heavy demands on his model. Gertrude Stein describes how she posed more than eighty times for her portrait. 'Picasso sat very tight on his chair and very close to his canvas, and on a very small palette which was of uniform brown grey colour, mixed some more brown grey and the painting began.' Fernande offered to amuse the sitter by reading aloud with her beautiful diction stories from La Fontaine.[26]

Gertrude Stein could only account for his persistence by supposing that a mystic attraction existed between Spaniards and Americans. But although the likeness started to her satisfaction, it failed to please him and little progress was made until 'all of a sudden, one day, Picasso painted out the whole head. "I can't see you any longer when I look," he said irritably. And so the picture remained like that and he left for Spain.'[27] This journey in the summer of 1906 lasted for some months. On his return in the autumn, he painted in the head without having seen his model again and presented the finished picture to Gertrude Stein (Plate IV, 1). She accepted it gratefully and declared she was satisfied. Others, shocked by the mask-like severity of the face, were more critical. In reply to their disapproval Picasso remarked, 'everybody thinks she is not at all like her portrait but never mind, in the end she will manage to look just like it'. In proof of this Gertrude Stein kept the portrait beside her all her life and when she died bequeathed it to the Metropolitan Museum of Art, New York. By then it was acclaimed by all as an admirable likeness. It hangs there as an example of how Picasso could see more acutely and profoundly with the eyes of his imagination than when he was confronted with his subject.

There is only one other portrait of importance dating from this period. It is a self-portrait in a white singlet holding a small palette (Plate IV, 3). The head is treated in the same clear and determined way.

[26] Stein, *Autobiography of Alice B. Toklas,* John Lane The Bodley Head, p. 51.
[27] ibid., p. 57.

From the wide-open eyes which are drawn with unhesitating precision comes a look of assurance and understanding not to be found in the earlier portraits.

Gosol

When the summer of 1906 arrived Picasso again felt an urge to return to Spain, an urge that existed in spite of the fact that Paris was rapidly becoming indispensable to him. His friends, and the recognition that he was beginning to receive from collectors and dealers, made life in the French capital not only more interesting but also financially less difficult. His means were still restricted; as soon as money came in it was spent at once on painting materials and food, or on some extravagance for Fernande. The pinch was becoming less acute, however, and after a sale more remunerative than usual it became possible to buy tickets for Barcelona for himself and Fernande.

Spain was still essential to Picasso. On crossing the frontier he became a very different character. Fernande remarked than in Paris 'he seemed to be ill at ease, embarrassed, smothered in an atmosphere that could not be his', whereas in Spain he was 'gay, less shy, more brilliant, animated, taking an interest in things with assurance and calm, in fact at ease. He gave out an air of happiness in contrast to his usual attitude and character.'[28]

A minimum of time was spent on a duty call on his parents and friends in Barcelona before they set out for a remote village on the southern slopes of the Pyrenees. There once again Picasso could feel at home with the peasants whose company he had grown to enjoy on the Pallarés farm, and he could also enjoy at little expense the space and solitude he needed for work. The French landscape was unsatisfying to him in comparison with the wild rugged mountains of Catalonia. It stank of mushrooms, he said, whereas what he needed was the warm and bitter-sweet odour of thyme, rosemary, cypress and rancid olive oil.

They chose Gosol, a village near the French frontier, which could be reached only on mules. It consisted of a bare market place surrounded

[28] Olivier, *Picasso et ses amis*, p. 115.

by a dozen houses built of stone that became golden as it weathered in the sun, wind and snow. Above the purple earth of the orchards rose the snow-capped Mount Cadi, from which little clouds like boats set out across a sky of sparkling blue. Fernande speaks of the benefit both to body and spirit that this remote and lovely place gave Picasso; of the excursions made with smugglers into the forests; of the long stories of their adventures with the *carabineri*, to which Picasso would listen attentively. An understanding and mutual respect grew naturally between them.

The visit however ended abruptly. According to Fernande, typhoid broke out in the village and Picasso, showing his characteristic alarm when illness appeared on the scene, insisted on crossing the mountains by mule track and reaching France and better sanitation with the shortest delay.

But before they left, in spite of days spent in exploring the mountain slopes, Picasso produced a prodigious quantity of paintings. As usual he chose as his subject matter the people, the objects and the landscape round him. The square shapes of the houses with their small unglazed windows, the peasant women with long straight noses and scarves covering their heads, the weather-beaten faces of the old men, and Fernande in her serene beauty drawn with great tenderness, all these appear in his sketches. But there is also a series of nudes painted with classic purity and sensuous understanding. The warm earth colours of the mountain soil bathe their graceful bodies. A painting which shows the most complete mastery of the 'Greek' idiom is the *Toilette* (Plate III, 8),[29] where two women, one nude looking into a mirror held by the other, stand against a bare background. They have lost all trace of the mannerisms of *The Old Guitarist* or the *Acrobat's Family*. This mood, of which the *Woman with Loaves*[30] is again a splendid example of classical poise, continued its influence for a while after the return to Paris. The paintings of the autumn months repeated in their colour the happy glow of the summer, but a renewed insistence on form and a return to plastic distortions, significant of anxieties which were absent

[29] Albright-Knox Art Gallery, Buffalo. See Zervos, *Picasso,* Vol. I, p. 150.
[30] Philadelphia Museum of Art. See Zervos, *Picasso,* Vol. VI, p. 89, No. 735.

in the remote mountain air, again made their appearance.

A large vertical canvas, *Peasants and Oxen*,[31] is also related to the period though it is curiously unlike it in style. Here a man and a woman run barefoot together beside a pair of oxen. She carries a bunch of flowers while he lifts a basket overflowing with garlands above their heads. There are several reasons why this composition is unexpected and interesting. The proportions of the man with his minute head, great length of body and exaggerated forearms are unlike the elongations of limb that are to be found in the Blue period or the more conventional shapes of the Gosol nudes. The form throughout has angular rhythms that announce a first appearance of geometric shapes, and instead of the static, sculptural forms that had been evolving throughout the Rose period the figures are in agitated movement.

This composition was probably painted on Picasso's return to Paris. It seems symptomatic of the restlessness of his spirit and his constant discovery of new means of expression, often from ancient sources. Barr points out that at the time of his passage through Barcelona on his way to Gosol, his old friend Miguel Utrillo had just published the first Spanish monograph on El Greco. In this book, as well as in two magazines published in Paris that autumn, there were illustrations of El Greco's *St Joseph with the Child Jesus* which show a clear affinity in composition with the *Peasants and Oxen*, though there are no oxen in the El Greco painting and a group of angels takes the place of the garland. The smallness of the saint's head in proportion to his body and the general feeling of the composition seem to bear out Barr's suggestion that after a lapse of some two years, Picasso again had El Greco in mind. There are also three preliminary drawings which help in an attempt to understand the origins of this picture, and Picasso's ability to blend ideas coming from very different directions. The first is a straightforward drawing of a peasant boy leading two oxen down the mountainside.[32] The second is a sketch of a blind man carrying a basket of flowers on his shoulders and shouting his wares.[33] He is led by a

[31] Barnes Foundation, Merion, Pennsylvania. See Zervos, *Picasso*, Vol. I, p. 185.

[32] See Zervos, *Picasso*, Vol. I, p. 159.

[33] ibid., Vol. I, p. 140.

child holding a bouquet; neither figure showing any marked distortion. There is little movement in the figures and the sketch has every appearance of being taken from life. The third, another of the same subject, shows a marked insistence on movement.[34] Both figures are launched in a wild forward rush in which they have lost the plodding realism of the former drawing, and both have greatly elongated bodies. In the step from this to the final painting, the two outstanding changes that have taken place are the addition of the oxen and the angular folds in the clothing. The change from the original drawing of the blind flower seller to the bacchanalian peasants and oxen is complete in spirit as well as style. (It is moreover the last drawing in which the theme of blindness occurs until thirty years had passed.) We can thus trace three different sources which played their part in the final composition: El Greco's *St Joseph*, the peasant boy with the oxen, and the blind flower seller, all seen by Picasso at different times and in different places.

The summer visit to Barcelona and Gosol was of marked importance in Picasso's development. He had again made contact with the Romanesque and Gothic art of Catalonia and had rekindled his passion for El Greco. But even more important to him was the discovery of the pre-Roman Iberian sculpture which had recently been shown in Paris. Bronzes found in excavations at Osuna, not far from Malaga, in 1903 had been acquired by the Louvre. Added to them was another exhibit, the polychrome portrait bust known as *The Lady of Elche*. In his eager search for new forms in art, these sculptures attracted him by their unorthodox style, their disregard for refinements, their rude barbaric strength and their closeness to his own origins. Their influence can be held responsible for the clearly defined sculptural features of the repainted head of Gertrude Stein, and the drawing of certain heads with large, heavily outlined eyes (Plate V, 3). The tranquillity of classical proportions was already threatened by more primitive and vital influences.

But it is the transformation in the human form which is most striking. In female nudes of the Circus and the first Classical periods there is a tendency to idealize the long rounded thighs and exaggerate their length

[34] ibid.

in proportion to the slender body surmounted by virginal breasts; but after Gosol the nudes, often composed as two figures facing each other, are statuesque in the simplicity of their heavy modelling and the suppression of any accidents of extraneous detail (Plate IV, 7). They have moved from the classical into a new atmosphere where preconceived rules of proportion are abandoned. It is these studies of the human form that foreshadow the great events that were about to occur and the birth of a new aesthetic conception – Cubism.

5

Les Demoiselles d'Avignon
(1906-09)

New Tendencies and Matisse

The Paris Salon d'Automne had been founded in 1905 as a protest against the sterile academic control that was stifling the fashionable annual exhibitions. Its only rival was the anarchic, juryless Salon des Indépendants which held its exhibitions every spring. The opening was celebrated by the Nabis, a group of painters led by Maurice Denis, Bonnard, Vuillard and Sérusier, with a large memorial show of Gauguin, their first leader, who had died that year in the Marquesas Islands. The following year, for the first time, a collection of thirty-two paintings by Cézanne was shown to the public, and in each of the two succeeding years ten more were exhibited. In 1907, the year after his death, the Master of Aix was honoured by his friends with a large retrospective exhibition of his work, though in general its significance was little understood.

Apart from these tardy recognitions of the older generation of pioneers, the Salon d'Automne became the stronghold of the Fauve group, who continued to astonish the critics and enrage the public with the wild brilliant colouring of their pictures. In the spring of 1906 their leader Matisse had anticipated the excitement of the autumn Salon by exhibiting with the Indépendants a large and revolutionary picture, *La Joie de vivre*. The brilliant flat colours in which it was painted signified a break with his former style and alarmed the critics. His old friend Signac, a follower of Seurat's theories of pointillism and at that time the domineering Vice-President of the Indépendants, took it as a betrayal that he could never forgive. But in spite of his disapproval, the picture was bought at once by Leo and Gertrude Stein, and it was in their

collection when Picasso saw it for the first time on his return from Gosol in the autumn. What is equally important, however, is that thanks to the Steins' hospitality Picasso met Matisse.

Fernande Olivier, who used to accompany Picasso on his visits, gives a spirited description of the meeting which gave birth to a long if spasmodic friendship. The French painter was then thirty-seven, Picasso's senior by twelve years. 'He was a sympathetic character,' she writes, 'the type of the great master, with his regular features and vigorous red beard. At the same time, behind his big spectacles, he seemed to mask the exact meaning of his expression. Whenever he began to talk he chose his words deliberately...very much master of himself at his meeting with Picasso who was always a bit sullen and restrained at such encounters. Matisse shone imposingly.'[1]

In his orderly restraint, his careful planning and the ease of his brilliant conversation, Matisse was the antithesis of Picasso. He loved to exhibit his work whenever possible, he always wanted to learn from a comparison with other artists, whereas to Picasso exhibitions were distasteful and his learning from others was a secret process. However, in spite of Matisse's avowed love of '*Luxe, calme et volupté*', in spite of rivalry and difference of temperament the attraction between the two painters was one which remained until the last days of Matisse's life. At his flat in Nice, where for some years before his death in 1954 Matisse lay bedridden, Picasso was one of his most constant visitors.

Recognition

Although exhibitions never had great interest for Picasso, he visited those of other painters out of curiosity. It was the act of creation that mattered to him rather than the subsequent means of display. His first question on meeting a friend was 'Have you been working?' and not 'Are you having an exhibition?' or 'What have you sold?' though this last question was not without interest to him.

In Montmartre his closest friends were all in some respect creative artists, but the demonstrations and theories expounded by groups of

[1] Olivier, *Picasso et ses amis*, p. 107.

painters never appeared to him relevant. Then, as throughout his life, he preferred the imaginative and witty speculations of his friends the poets.

By the end of 1906 Picasso, who was then twenty-five, had achieved a position which was unusual and enviable for so young a painter. This was particularly remarkable in that he had refused to compromise in his work in spite of severe hardship. Both Sagot and Vollard were now able to sell his pictures and the demand was increasing. The collection which had already become the most known in Paris, because of the audacious and discriminating choice of the Steins, contained many of his works. The undeniable mastery that he showed in the techniques of painting, sculpture, engraving and drawing in many different media convinced his admirers not only of his present genius but also of a brilliant career in store.

Materially his life had become less precarious. He was better off than most of his friends, and he had as his mistress a spirited girl whose beauty never passed unnoticed. There would appear to have been every reason for him to consolidate his hard-won gains and continue to paint in a style that gained the admiration of his most sensitive and intelligent friends and patrons.

Conflicting Styles

But Picasso was always assailed by the demon of perpetual doubt. His work on his return from the Arcadian summer months at Gosol showed signs of conflict. There were above all two tendencies that had not been resolved. One led towards a jubilant decorative conception. It had produced the tall picture of bacchanalian peasants running with their oxen: here form was sacrificed to the surface design of figures in movement. But the other trend, more static and severe, had as its first consideration a realization of the existence of volume. In it there was an attempt to create the actual presence of an object on the canvas. In paintings done since his return from Spain the human form had become heavy and sculptural. The illusion of a third dimension on the flat surface of the canvas was made increasingly convincing by the conventional use of shading, but with a far greater freedom than

academic standards would have allowed.

Many influences had been absorbed and were apparent in both tendencies. The early delight that Picasso had found in atmospheric appearances derived from the Impressionists and the debauched world of Toulouse-Lautrec had long ago been abandoned. It had been supplanted by a more plastic realization of form during the Blue period. With the appearance of Harlequin and the circus folk, there was a partial return to atmospheric effects, particularly in the backgrounds of great pictures such as *The Acrobat with the Ball*. Later the intense study of Greek sculpture had borne its fruit in the athletic stature of the boys leading their horses and in the rich, fertile quality of the peasant women of Gosol. It had given fullness to their forms and grace to their proportions without a return to academic conceptions. This had never occurred to Picasso. Almost as soon as it had appeared, the classical calm gave way to more expressive means of representing the human form, which were not of the past but essentially of the modern age.

Picasso was alive not only to influences on his style, but to current trends of thought. The new ideas, theories and speculations of science, such as the fourth dimension and the exploration of the subconscious, were topics among intellectuals. From the material point of view the scope of civilized man had recently been enlarged by the use of electricity and internal combustion. There had also been discoveries in the history of the human spirit, such as the finding of the rock paintings at Altamira, and the adventures of men of imagination like Gauguin among primitive peoples, which were bringing about a revaluation of cultures formerly despised as barbaric. Works of art imported from Asia had had a superficial influence on European style since the first voyages of Vasco da Gama, and Japanese prints had caused a stir when they became popular in the nineteenth century. It was not until the early years of the present century that the importation by missionaries and explorers of 'curiosities' made by the 'savages' of Africa and the South Seas gave rise to the view that art and beauty could have a meaning that had been suppressed by the canons of good taste.

Les Demoiselles d'Avignon

The problems that had kept Picasso in a turmoil of uncertainty, and forced him to exploit two almost opposite tendencies at the same time, found a solution in the spring of 1907. After months of work on drawings and studies, Picasso painted with determination and in the space of a few days a large picture measuring nearly eight feet square (Plate V, 1). He took unusual care in the preparation of the canvas. The smooth type of canvas that he liked to paint on would not have been strong enough for so large a surface. He therefore had a fine canvas mounted on stronger material as a reinforcement and had a stretcher made to his specified unconventional dimensions. When he still considered the picture to be unfinished, his friends were allowed to see it, and from that moment he did not work on it any more. A new style, deliberate and powerful, met their astonished gaze.

At first glance this picture has the power of drawing the spectator to it by its atmosphere of sheer Arcadian delight. The flesh tones of five female nudes glow against the background of a curtain, the blueness of which seems to recall the intangible depths of the sky at Gosol, but he is checked in his initial enthusiasm when he finds himself in the forbidding presence of a group of hieratic women staring at him with black wide-open eyes.

Their presence is a surprise, and the small and tempting pile of fruit at their feet, poured out of a melon rind in the shape of a harlequin's hat upside down, seems irrelevant to the scene. The figure on the extreme left holds back a red ochre curtain so as to display the angular forms of her sisters. Her appearance, particularly in the grave profile of her face, is unmistakably Egyptian, whereas the two figures she reveals in the centre of the picture, their tender pink flesh contrasting with the blue of the background, have more affinity to the medieval frescoes of Catalonia.

There is no movement in the three figures. Although singular and lacking in conventional grace, they are poised and serene, making a strong contrast with the two figures on the right, which, placed one above the other, complete the group. Their faces show such grotesque distortion that they appear to have intruded from another world. The

figure above makes a niche for herself in the curtain, while the squatting figure below, opened out like a roast sucking pig, twists on her haunches from back to front, showing a face with staring blue eyes. Both have faces like masks which seem foreign to their naked bodies.

The opinions given by Picasso's friends were of bewildered yet categorical disapproval. No one could see any reason for this new departure. Among the surprised visitors trying to understand what had happened he could hear Leo Stein and Matisse discussing it together. The only explanation they could find amid their guffaws was that he was trying to create a fourth dimension. In reality, Matisse was angry. His immediate reaction was that the picture was an outrage, an attempt to ridicule the modern movement. He vowed he would find some means to 'sink' Picasso and make him sorry for his audacious hoax. Even Georges Braque, who had recently become a friend, was no more appreciative. All he could say as his first comment was, 'It is as though we are supposed to exchange our usual diet for one of tow and paraffin', and the Russian collector, Shchukine, exclaimed in sorrow, 'What a loss to French art!'

Even Apollinaire, who had shown such understanding in his first criticism a year before, could not manage at first to stomach such an incomprehensible change. He had already committed himself by writing in *Lettres Modernes* (1905): 'It has been said of Picasso that his works reveal a premature disillusionment. I think quite differently. Everything enchants him and his undeniable talent seems to me to serve an imagination in which the delightful and the horrible, the low and the delicate, are proportionately mingled.' Apollinaire now watched the revolution that was going on not only in the great painting but also in Picasso himself, with consternation. Picasso's disregard for the reputation he had won with such labour was of no consequence beside the internal struggle that went on within him as he realized that he could no longer be an artist who accepts without a challenge the dictates of his muse. Artists of this kind, wrote Apollinaire, 'are like a prolongation of nature, and their works do not pass through the intellect'. Picasso had become the other kind, who 'must draw everything from within themselves. . . they live in solitude'. It was after five years of pondering over the change that Apollinaire wrote this in

his book *The Cubist Painters*. He finished his statement by saying, 'Picasso was an artist of the first kind. Never has there been so fantastic a spectacle as the metamorphosis he underwent in becoming an artist of the second kind.'[2]

Apollinaire, when he came to see the *Demoiselles d'Avignon*, brought with him the critic Félix Fénéon, who had a reputation for discovering talent among the young, but the only encouragement that he could offer was to advise Picasso to devote himself to caricature. Talking of this later, Picasso remarked that this was not so stupid since all good portraits are in some degree caricatures.

Picasso was not insensitive to the unanimous censure of his friends. It brought not only severe disappointment through the discovery that he had outstripped their capacity to understand him, but also the menace of renewed privations, since no one, not even Vollard, thought any more of buying his recent work. The solitude that his daring brought Picasso was so great that Derain remarked to their new friend, Kahnweiler, 'one day we shall find Pablo has hanged himself behind his great canvas'.

Any man who relied less on his own judgement or who was less conscious of the strength of his own individuality would undoubtedly have done something drastic, turned back or modified the direction of his advance, but criticism was a challenge to Picasso and he used it as a stimulus to further effort along the same lonely and exalted path.

The next months were spent on paintings that Barr classifies as 'postscripts' to his great work, and slowly his friends began to acclaim this picture that had so seriously disturbed them, not only as the turning point in Picasso's career but as the beginning of a new era in the modern movement. All, with the exception of Leo Stein - who could not stand the change and later condemned Cubism as 'Godalmighty rubbish!' - sooner or later admitted its astonishing merits.

There were, however, two exceptions to the first general disapproval. Wilhelm Uhde, the German critic and collector, was at once enthusiastic in his admiration. In agreement with him was his young friend, Daniel-Henry Kahnweiler, to whom Uhde had described the

[2] Apollinaire, *The Cubist Painters*.

picture in advance as a strange painting 'somewhat Assyrian' in style.

After his first acquaintance with the author of this revolutionary work, Kahnweiler became the lifelong friend of Picasso and the authoritative historian of Cubism from its earliest years. At that time he had recently abandoned his prospects of a prosperous financial career in London and had arrived in Paris to try his hand as a picture dealer, attracted by the originality and force that he found among young painters such as Picasso, Derain, Vlaminck and Braque. They were chosen as the first to be exhibited in the gallery he opened in the rue Vignon.

Although there is some doubt about the origin of the title of the great picture, since Picasso himself never invented titles, it is probable that it was first named *Les Demoiselles d'Avignon* by André Salmon some years after it had been painted. The reason was partly the resemblance between these nude ladies showing their charms and scenes witnessed in a brothel in the carrer d'Avinyó (Avignon Street) in Barcelona, and partly a ribald suggestion that Max Jacob's grandmother, a native of Avignon, was the model for one of the figures.

The idea of a large picture of female nudes began at Gosol, where many studies of groups and individual figures were made. The later sketches which led up to the composition itself are of great interest.[3] They show not only the stages of its formation but also the progressive elimination of any incidental story. In the first there are seven figures, two of which appear to be sailors visiting a brothel. One is seated holding a bouquet in the centre of the group of five nudes, while the other enters from behind a curtain holding an object which Picasso has said was intended to be a skull. It has been suggested that 'Picasso originally conceived the picture as a kind of *memento mori* allegory' – the wages of sin, though it is unlikely that he had any 'very fervid moral intent'.[4] It corresponded most probably with his Spanish preoccupation with death.

In subsequent studies the composition begins to take its final shape and all anecdote vanishes. Sailors and flowers have gone, though the fruit remains in the foreground. The figures are backed by curtains

[3] See Zervos, *Picasso*, Vol. II*, p. 12, Nos. 19 and 20, p. 13, Nos. 21 and 22.
[4] Barr, *Picasso, Fifty Years of His Art*, p. 57.
(* denotes the first of two volumes numbered II)

which have no great depth. The scene appears limited to the small stage of a cabaret, but the strong accents in the rhythmic highlights on the folds of the curtains and their bluish colour have the same incalculable depth as El Greco's skies.

The figures on the left are painted with flat surfaces of pink with only a slight variation of tone. None of the conventional devices of shading or perspective is used to give them volume, but in spite of this their forms are not limp or empty. This effect has been achieved by the firm and sensitive way in which they are drawn. Their volume is realized in a manner reminiscent of the Catalan primitives. Lines, dark or light, outline the essential shapes with great economy of means. The features of each face are drawn unequivocally: eyes, ears and noses are unmistakable. They are seen in full face or in profile irrespective of the position of the head to which they belong. They are not merely symbolic nor are they fleeting or accidental in appearance. They belong organically to each head and give it life.

These methods could never have been tolerated by the Impressionists or their followers, the Fauves. It was their belief that the limitation of form by line was a falsehood. It imprisoned the form and isolated it from its surroundings. Objects therefore should not be drawn but painted with differences of tone and colour so that they bathe in atmospheric light. But Picasso thought otherwise. His appreciation of objects was passionate and clear like his native climate. By his use of line, colour and modulations of tone he established the presence of the object. He was willing to sacrifice all former rules and prejudices and use whatever means seemed to him appropriate. By taking these risks he discovered new methods closer to the expression for which he was searching.

In this sense the *Demoiselles d'Avignon* is a battlefield. The picture itself contains evidence of Picasso's internal struggle. It can be seen at a glance that the two right-hand figures are totally different in treatment from the others. Ghoulish and sinister, they make the already forbidding features of their companions appear dignified, almost gentle. The upper face is dominated by a wedge-shaped nose of enormous size. Heavy shading with green hatching spreads from its crest almost to the jaw. The structure of the face below depends on the strong sweeping

curve of a monstrous snout which divides a terra-cotta-coloured cheek from the heavy blue shadow on the side of the nose – a contrast which gives solidity to its flat surface. With astonishing economy and the use of revolutionary means the awful asymmetry of this mask-like face comes to life.

There has been much controversy about the impulses that combined to give birth to these two heads. Until recently it was supposed that Picasso painted the whole picture after being greatly impressed by his discovery of African sculpture. This however is obviously untrue, for the three nudes to the left show no such tendencies. Their ancestry lies without doubt in the Iberian bronzes and Catalan murals, with which certain Egyptian influences have been assimilated. Further, Picasso has stated firmly that when he started the picture he was not conscious of any particular interest in Negro art. The other two faces, so different in spirit, have, however, some genetic resemblance to the barbaric simplicity of Negro masks, and it also appears that they were painted in after the rest of the picture had already taken its present form in the spring of 1907.

It is well known that Vlaminck and Derain, a year or two before, had bought African masks, and Vlaminck is said to have discovered two Negro statuettes among the bottles in a bar and brought them home under his arm as far back as 1904. Their enthusiasm for primitive sculpture was shared by Matisse, but Picasso was not struck by its significance until one day that spring while he was painting the *Demoiselles*. He paid a visit to the Museum of Historic Sculpture at the Trocadero, and found by chance that the ethnographical department contained a splendid collection of Negro sculpture. Negro art in the Trocadero was esteemed only for its scientific value. There was then no attempt to present the objects as works of art; on the contrary they were piled into badly lit glass cases with complete disregard for those who might be interested in the startling originality of their form. This in some way made their discovery all the more exciting, and Picasso always remembered the emotion he felt at this first contact. It is significant that while the other painters who had already made this discovery continued to show no sign of its influence in their work, Picasso understood its importance and saw the profound implications

that could be used to bring about a revolution in art. Shortly after this, he too began to buy from a dealer in the rue de Rennes. His first finds were not necessarily pieces of great value but they possessed vitality and a freedom from academic conventions that excited his imagination. With complete disregard for stylistic unity he completed his picture with two heads that sprang from his delight at his new discovery.

Like many of Picasso's most powerful works, this painting is an organized and wilful sum total of inconsistencies. It is as though a dramatic change in his attitude to art and its relation to beauty had taken place while he was at work. The commander had changed his tactics while the battle was in progress, but rather than suppress the evidence of conflict between two stages of his thought, he left it unfinished, allowing us to see clearly the evolution of ideas in his own mind. It is in fact our best clue in bridging the gulf that seems to separate the bewitching charm of the Rose period from the severity of the task on which he was about to embark. The barbarous appearance of the heads on the right and their disregard for all classical canons of beauty give the lie to statements such as 'Beauty is truth, truth beauty', because no human face, and these must be recognized as human, could ever assume such monstrous proportions, and yet their powerful presence speaks profoundly and truthfully to our sensibility. 'Such faces, compounded so of hell and heaven,' to borrow from Herman Melville words that seem prophetic, 'overthrow in us all foregone persuasions and make us wondering children in this world again.'[5]

Picasso had finished working on the *Demoiselles* within a year of the appearance of Matisse's picture, *La Joie de vivre*, to which it bears certain superficial resemblances. The subsequent history of the two pictures was however very different. Matisse according to his custom exhibited his canvas to the public almost before the paint was dry, and within a few weeks it had entered into an important collection where for many years it was constantly admired by a large international group of appreciative visitors. Picasso's painting remained in his studio almost unseen. It was shown to the public once at the Galerie d'Antin in 1916

[5] Herman Melville, *Pierre, or, The Ambiguities,* first published 1852. New American Library Signet Classic, p. 67. A French translation of this novel made an unforgettable impression on Picasso when he discovered it in the 1930s.

but for many years it lay rolled up on the floor in his studio and it was in this condition when it was bought without being seen beforehand by Jacques Doucet soon after 1920. Doucet, realizing its importance, gave it a place of honour in his collection. Although it was acclaimed by the Surrealists who reproduced it in *La Révolution Surréaliste* in 1925, giving it for the first time its present title, few people even knew of its existence until it was shown at the Petit Palais in 1937. It was bought shortly afterwards by the Museum of Modern Art of New York. Lent by the trustees of this museum it has twice been shown publicly in London, by the Institute of Contemporary Arts in 1949 and again at the Tate Gallery in 1960.

This history, as Barr points out, should be sufficient to refute those who have maliciously claimed that Picasso never acted without an eye to publicity.

Even during the early days of its seclusion, the influence of the picture on those who saw it was profound. Derain and Braque chose this moment to abandon Fauvism and turn their attention to a search for plastic values. As for Braque, after his first resentment, he quietly shook off his antagonism and became Picasso's close companion in the Cubist adventure that was to follow. Even Matisse showed signs in his painting of the following year of a swing away from the flat colour patterns of *La Joie de vivre* towards a realization of form.

A vital reason for insisting on the importance of the *Demoiselles* is that in this picture Picasso for the first time became entirely himself. Out of the many influences that affected him he created with his intuitive deliberation a painting which combined discipline and vitality. Antecedents for the general scheme of the composition can be found in Cézanne's groups of female nudes which are organized into the great compositions of bathers. The central nude figure with its raised arm and drapery of his *Temptation of St Anthony* may have provided a suggestion, and the idea of a closed interior bordered by curtains occurs in the *Olympia* of the same artist. But the economy of means, the strong decisive line, accentuated only where necessary, and the elimination of ornament, virtuosity and the picturesque give the *Demoiselles* a strength which is unparalleled in the work of any other artist of that period. There is a mastery of scale derived from the diminutive proportions of the fruit

grouped in the foreground that gives a towering sense of authority to the figures standing above it. The control of colour which is based almost entirely on the contrasts of pinks and blues, the simplified, unmodelled shapes of the female form which are at the same time flat and voluminous, and the monstrous distortions of the two Negroid heads, challenge our former conceptions of beauty and widen the horizons of our enjoyment.

Negro Period

There were many aspects of African sculpture that intrigued Picasso. The simplified features of Negro masks express with force the primeval terrors of the jungle, and their ferocious expressions or serene look of comprehension are frequently a reminder of the lost companionship between man and the animal kingdom. In more formal ways the able use of geometric shapes and patterns produces an abstract aesthetic delight in form. The simple basic shapes created by the circle and the straight line, the only unchanging features of beauty, are applied with startling aptitude. But above all it is the rich variety in which these elements exist and the vitality that radiates from Negro art that brought Picasso a new breath of inspiration.

The paintings that followed the *Demoiselles* added to his discoveries. Many of them were direct 'postcripts' in which the sculptural appearance of the two wry heads was developed with a passionate fervour. A new architecture of the human form came to life in which classical proportions were a hindrance. Even the expressive distortions of El Greco and the Catalan primitives gave way to a more violent mode based on form that was essentially sculptural.

The head, that culminating feature of our human architecture, occupied Picasso's thoughts most profoundly during the spring and summer of 1907. Heads such as the upper one of the barbaric pair in the *Demoiselles*, which appear in several studies where the nose is heavily shaded with strong parallel lines coming down across the cheek, leaving a prominent cheekbone to catch the light, are held by most critics to be derived from the masks from the Ivory Coast. It is for this and other similar reasons that the period beginning with the *Demoiselles* has been

labelled the Negro period. Negro influences are undoubtedly present at this stage and continue to show themselves in other more subtle ways throughout the Cubist period, but the receptive sensibility of Picasso embraced many sources in addition.

Sympathy for the violent expression and primitive strength of Negro sculpture came at a moment when Picasso was again preoccupied with the realization of solid forms on a two-dimensional surface. His thoughts were inspired by sculpture, but it was not until two years later that he turned his hand again to modelling. Before this happened, though he thought as a sculptor, he acted as a painter. Even in a still-life such as *Flowers on a Table*,[6] the flowers are endowed with such solidity as to suggest the possibility of making a reconstruction in bronze. The planes, luminous with colour, are determined by strong outlines and heavy shading, a technique which suggests the fronds of a palm or the tattooed patterns on the naked bodies of Negro statues. In the large *Nude with Drapery* (Plate V, 4) which is now in Russia, he combines his sculptural sense of form with a vigorous and exciting surface pattern accentuated by heavy hatching like light filtered through jungle vegetation.

These influences were assimilated and combined with the persistent love that Picasso had for archaic Iberian bronzes. Their resemblance can still be traced in paintings such as the *Woman in Yellow*.[7] To label all paintings of this period as 'Negro' is in fact to oversimplify the problem of their origins and diminish their significance. Raynal suggests that it would be less misleading to call this period 'prehistoric' or 'prehellenistic', but if the period must have a label it would be more exact to use the term 'proto-Cubist' invented by Barr, since all these tendencies led consistently to the birth of the new style.

Already by the end of 1907 the fireworks in the surface pattern of the *Nude with Drapery* have died down, and more solid constructions take their place in paintings such as *Friendship* (Plate V, 6), a composition of two nudes, now also in Russia.

This picture, painted in the spring of 1908, was again the result of a

[6] See Zervos, *Picasso*, Vol. II*, p. 17, No. 30.
[7] ibid. Vol. II*, p. 23, No. 43.

number of studies, large and small. It is painted with rich, warm earth colours and combines angular patterns with sculptural solidity almost as though the figures were constructed from wooden blocks. *Friendship* was one of fifty paintings by Picasso bought by the Russian merchant Shchukine, who paid frequent visits to Paris and established before 1914 the finest and most comprehensive collection of contemporary French painting in Europe. With magnificent examples of the work of Monet, Degas, Toulouse-Lautrec, Van Gogh and Gauguin already in his possession, he made the acquaintance of Matisse, from whom he bought freely. As a proof of his fundamental esteem for Picasso, Matisse had introduced him also to the Russian collector. From then until the war and the Russian Revolution put a stop to his coming and going, Shchukine was a frequent visitor to Picasso's studio, following his evolution with enthusiasm and buying many examples of his work. At an early date he recognized Matisse and Picasso as the greatest of their generation.

Literary Friends

The scandal caused by *Les Demoiselles* did not interfere with the visits of Max Jacob and Apollinaire to Picasso's studio. With the increasing necessity to see people by day and live more normal hours, he worked less frequently by night. In the morning he rose late and his ill humour was showered, as always, on anyone except his best friends or serious amateurs who inadvertently called too early. None the less he was always glad enough to receive visitors in the evenings when he was not working. Together they talked, sang and consumed large quantities of wine and spirits, as they explored the unknown together to the limits of their imagination, and tore to pieces anything or anybody they hated. Fernande tells of experiments with drugs, of nights when curiosity led them into the gentle dreams of opium. 'Friendship,' she says, 'became more confident, more tender, all indulgent. The next day, on waking, having forgotten this communion we began again to snap at each other, for there has never been a circle of artists where mockery or malicious and wounding remarks were more honoured.'

These soothing but dangerous expedients came to an end, however,

when a young German painter, Wiegels, was found hanging in his studio as a result of excessive doses of ether. His funeral and his memory were celebrated in horrified remorse at the Lapin Agile. 'Opium,' says Picasso, 'has the most intelligent of all odours', but it was not only the suicide of Wiegels that put a stop to its use. While under the influence of the drug Picasso found that his imagination and his vision became more acute but that his desire to paint what he saw diminished seriously. This threat of blissful sterility influenced him most.

Although Montmartre was in itself almost self-sufficient, the brilliance of the literary group which gathered at the Closerie des Lilas tempted Picasso to cross the Seine and join its noisy discussions. Wrapped in a heavy shapeless overcoat that covered him to the ankles to keep out his enemy the cold, he would cross Paris on foot every Tuesday with Fernande. In spite of the distance she found that 'it does good to walk when one carries youth on one's face and hope in one's heart'.

Two poets, Paul Fort and André Salmon, were the organizers of these weekly reunions known as 'Vers et Prose'. Their friends who came regularly were poets, writers, painters, sculptors and musicians, young and old, boisterous and eccentric, but all talented. Picasso enjoyed breathing this air charged with intellectual fireworks. It was a delight to talk to poets such as Jean Moréas, who in spite of their lack of understanding of the problems that Picasso had at heart, provided a subtle commentary on a general human footing. He understood them: it mattered little if they misjudged him. In addition the circle included intimate friends: Apollinaire, Raynal, occasionally Braque, and, until his death, Alfred Jarry. The meetings were warmed by lavish drinking animated by passionate or witty discussions. Not infrequently they ended in protests from the *patron* of the café and the expulsion of the whole company.

Picasso's taste coincided in general with the literary extravagance of these reunions, but when it was a question of a closer understanding, no one among the poets could share his humours or his ideas more closely than Apollinaire. This man, whose origins were a matter of legend rather then certainty, had travelled, and his knowledge of foreign

languages and of the more obscure and erotic paths of literature was vast. His love of the picturesque was tempered with a profound appreciation of reality and a desire to liberate man from hypocrisy and sterile, self-made limitations. 'Picasso certainly possessed the same kind of sensibility, but Apollinaire helped him to become convinced of it himself. And it is in this way that by dint of listening to the dictates of his heart, Picasso perceived the emptiness of the absolute rules of Art.'[8] In writing this, Maurice Raynal also quotes a saying that 'man spends the first part of his life with the dead, the second with the living and the third with himself'. Picasso's first years had been passed with the great examples that religion, history, literature and art presented in idealized form. He had aimed at a kind of ideal and conventional perfection, and this youthful dream continued until in a moment of clarity he perceived that it led rapidly back to the dead. He needed new and wider horizons, and these he found not through the tiresome and confused arguments of painters, but by confidence in his own imagination, nourished by his understanding of poetry and his love of the shapes it took before his eyes.

The many books that littered his studio were of a variety that would baffle anyone who expected Picasso to make a coherent study of art and metaphysics. Mixed with volumes of the poetry of Verlaine, Rimbaud, and Mallarmé, and works by eighteenth-century philosophers such as Diderot and Rétif de la Bretonne, were adventure stories – Sherlock Holmes, Nick Carter and Buffalo Bill. On the other hand a type of book that was completely absent was the contemporary psychological novel. These books, shorn of imagination and drama, lacked all interest for him. They were an applied art rather than art itself.

The Douanier Rousseau

For some years the Salon des Indépendants, thanks to its policy of welcoming all who wished to exhibit, had shown the strange paintings of a humble little man, Henri Rousseau, a retired employee of the *octroi* or City Toll and in consequence nicknamed '*Le Douanier*' by

[8] Maurice Raynal, *Picasso*, Crès, p. 39–40.

Apollinaire. He had had no training as a painter, although as far back as 1895 Jarry had made his acquaintance and admired his work. Jarry had even published a lithograph of a large painting of Rousseau called *La Guerre*. The naïve skill with which the little man painted, and the intensity of his imagination, brought him increasing popularity among the small group of young painters who were searching for an art unsullied by academic requirements. His sincerity was unquestionable and he enjoyed company. In his modest studio in the remote rue Perrel he entertained his friends with conversation and airs played on his violin. Up to his death in 1910 he lived in poverty, but the company that attended his soirées was by no means undistinguished.

The Autumn Salon of 1905 had accepted three paintings by the Douanier including an enormous jungle scene. Two years later Picasso discovered at the Père Soulier's shop an immense portrait of a woman. All he could see was the head, peering over stacks of grimy paintings. This was enough however to tell him that it was a most accomplished portrait painted with conviction and originality. He asked Père Soulier if he could buy it for five francs, to which the dealer replied: 'Certainly, it is by a painter called Rousseau but the canvas is good and you may be able to use it.' As they pulled it out from the rubbish Picasso was delighted to find that it was a full-length portrait of a woman in a black dress with blue collar and belt, standing in front of an open window. Beside her hung a long striped curtain, and between the bars of a balustrade behind her was a landscape of flowers. When Picasso showed it to Rousseau later, the old man explained that it was the portrait of a Polish school teacher that he had painted years ago; the curtain had been put in to give the picture an oriental look and the landscape was the fortified zone round Paris which he knew well. Picasso had in fact found one of the Douanier's masterpieces. Always afterwards he kept it beside him and said that it was one of the pictures he loved above all.

Partly in order to celebrate this discovery and the hanging of the picture in his studio, and also from a desire shared with his friends to honour the old painter, Picasso invited a large and brilliant company to a banquet given to pay homage to Rousseau. The 'Banquet Douanier' has become legendary. Three accounts by eye-witnesses describe the festive enthusiasm with which the little elf-like genius was welcomed

and the ecstasy with which he received the rowdy, disorganized compliments paid to him. But the events of the evening were so packed with riotous gaiety and confusion that there are many discrepancies between the various versions. Maurice Raynal, who was the first to record the evening, admits that 'it was difficult to determine exactly how the party ended'.[9] However, on the outstanding events and the memorable success of the banquet, Fernande Olivier and Gertrude Stein agree with him. The whole story is too long to tell here, but the following outline is based on their accounts and those of other eye-witnesses.

No ostentatious preparations had been made, but the studio was transformed with decorations that hid the untidy barnlike appearance of the room and gave the long trestle tables, laid for some thirty guests, a mysterious and festive air. A throne for the guest of honour, placed at one end, was surmounted by a banner with '*Honneur à Rousseau*' written across it, and his painting was displayed above, surrounded by flags and lanterns. Among the numerous surprises perhaps the most important was the failure on the part of the caterer to send the food, and the host's sudden remembrance that he had made a mistake and ordered it for the following day. This disaster acted as an encouragement to the guests to heighten their festive spirit by a liberal consumption of wine, which they made a substitute for food. Fortunately the prompt action of Fernande and some friends saved the situation by an improvised meal of sardines and a '*riz à la Valencienne*' cooked by her in a friend's studio. Nobody regretted the absence of the dinner. On the contrary, certain guests who had lost their way in the interminable corridors of the Bateau Lavoir were thankful for it when they arrived on the following day.

It had been arranged that Apollinaire should introduce the guest of honour when everyone was seated, and in spite of some preliminary mishaps, such as Marie Laurencin's fall, due to an overdose of aperitifs, into a tray full of jam tarts, this part of the ceremony was accomplished.

The old man, clutching his violin and bewildered by the festive splendour of the scene, was overcome with emotion. His face lit up with

[9] ibid., p. 52.

joy as he mounted his throne, and all evening his delight never diminished except for moments when, overcome by sleep, he dozed, violin in his hand and a candle from a lantern above dripping unerringly on his bald head. Otherwise he sang his repertoire of popular songs including his favourite, '*Aïe, aïe, aïe, j'ai mal aux dents*', and made the ladies dance to his music.

Among the guests of many nationalities were Spaniards, such as the tall gaunt Pichot, who danced a ritual Spanish dance. There was also a strong contingent of poets, including André Salmon, who unexpectedly leapt on the table and recited an improvised ode to Rousseau; and Apollinaire, who found it a good moment to catch up with the arrears of his correspondence, also wrote a spontaneous poem which he delivered in his impressive voice. The last verse ran:

> We are assembled to celebrate your glory.
> These wines which Picasso pours out in your honour
> Let us drink, since this is the hour to drink them,
> Shouting in chorus, Live! Long live Rousseau![10]

Through the thick clouds of smoke and the excited chatter of the guests there burst sudden explosions of violence, such as the incident caused by Salmon who began in his cups to hit out indiscriminately. His host, however, aided by Braque, disentangled him from his neighbours and locked him away in a near-by studio. Good humour was quickly restored, and visits from local friends, including Fredé from the Lapin Agile with his donkey, added to the entertainment throughout the night.

The banquet was a tremendous success. Rousseau drank in, in every sense, the honours showered upon him and with touching simplicity. His own vanity made him incapable of questioning the sincerity and wholehearted admiration of all present, whereas a more sophisticated artist in a gathering composed partly of strangers might have feared a hidden element of playful mockery.

Picasso became deeply attached to this strange and lovable man, and Rousseau, who was incapable of discriminating between the sentimental academic fantasies of Bouguereau and work diametrically

[10] ibid., p. 50.

opposed to it in tendency, recognized none the less the genius of
Picasso. This is clear from his famous remark: 'Picasso, you and I are
the greatest painters of our time, you in the Egyptian style, I in the
Modern.'

Picasso appreciated this admiration and reciprocated it. He kept
beside him permanently, wherever he lived, a small self-portrait of the
Douanier and a companion portrait of his wife. The influences of his
work kept on reappearing in unexpected ways at unexpected times,
particularly in paintings of children and fishermen, as late as 1936-8.

Picasso was never slow in recognizing originality of vision and talent
even in unlikely places. With these qualities the portraits, jungle scenes
and landscapes of Rousseau are strongly endowed. They also possess
another quality which makes them essentially contemporary. Cocteau
has commented on this quality in his preface to the catalogue of the
Quinn Sale, in remarks about the Douanier's great painting, the
Sleeping Gipsy. This picture, now in the New York Museum of Modern
Art, was bought by the collector John Quinn on Picasso's
recommendation nearly thirty years after it was painted in 1897.
Cocteau wrote: 'We have here the contrary of poetic painting, of
anecdote. One is confronted rather by painted poetry, by a poetic
object...by a miracle of intuitive knowledge and sincerity... The
gipsy...is the secret soul of poetry, an act of faith, a proof of love.'[11] It
is this conception of a picture being a 'poetic object' that was liberating
painting from the bonds that had required it to be a description of a
scene. Painting could claim again its ancient right to exist as an object
in itself, radiating its own associations and undiminished by being
merely the reflection of something else.

A Duel

Perhaps on account of his own small but well-built physique, Picasso
had always shown an admiration for the size and the well-developed
muscular bodies of athletes. Apart from Apollinaire, whose proportions

[11] From Cocteau's introduction to the catalogue of the Quinn sale. Alfred Barr
(editor), *Masters of Modern Art*, Museum of Modern Art, New York, 1954, p. 13.

were not mean, three of Picasso's friends, Derain, Vlaminck and Braque, formed an imposing trio. All three were well built and proud of their strength. Braque especially, with his handsome features, was easily recognized by the cowboy-like swagger of his walk. In the early days of their friendship Picasso made comic drawings of an imaginary school for physical culture which they were to found.[12] Overwhelming two-legged monuments of muscle with ludicrously small heads were designed to advertise their venture. In reality Picasso limited his athletics to boxing, in which sport, as Fernande remarks, he preferred hitting to being hit. Even so, one lesson from Derain sufficed to complete his career in that form of sport.

There is a story of an event that took place a year before the banquet which would have caused serious anxiety had it not ended in inoffensive comedy rather than violence. Apollinaire, who believed himself insulted by three fairly harmless lines in an article by Max Daireaux, challenged the writer to a duel. Soon afterwards he appeared on Picasso's doorstep with a worried look, asking for advice. It was decided that he should choose as his seconds Jean de Mitty, a journalist and swordsman of repute, and Max Jacob. For weeks outside the Bateau Lavoir the place Ravignan apprehensively discussed the outcome of the encounter until at last Max Jacob, superbly dressed with a new top hat and monocle, called on the opponents. Negotiations took place between the opposing forces each installed in their favourite cafés, while Apollinaire waited in suspense in Picasso's studio. Finally the literary ability of those concerned and a free exchange of aperitifs allowed them to draw up a document that was satisfactory to all concerned. Without loss of honour by either side the bloody encounter was avoided.

There was no lack of invitations for Picasso whenever he felt he wanted a change of air. Apollinaire was delighted to receive a visit from him and other friends at his mother's house in Le Vesinet, in spite of her disapproval of their unaccountable habits. On other occasions he invited them to his apartment in Paris. Here they were ceremoniously offered tea with a lavish accompaniment of wit. On Saturdays the Steins kept open house, and Picasso was a frequent visitor with Fernande in

[12] See Zervos, *Picasso*, Vol. VI, p. 81.

elegant and flowery hats. There were dinner parties given by Vollard in the cellar beneath his gallery. Distinguished artists of the older generation and collectors were often present to meet the young Spanish painter and eat the fiery rice dishes of colonial origin. The Germans also were pressing with their hospitality; a rich painter and friend of Uhde gave sumptuous feasts at which Picasso found himself surrounded by admirers.

In his domestic life, in spite of moments of violent disagreement, Picasso continued to cherish his companionship with Fernande. In common they enjoyed the close contact of their friends. Van Dongen, the Dutch painter whose portraits later became fashionable, had a little daughter for whom Picasso enjoyed drawing and making paper dolls. His love of children, like his love of animals, gave endless pleasure and refreshment to his imagination. There was an understanding between them that went deeper than language. They provided that link with the primitive and the instinctive that becomes lost in a world based on reason and practical considerations.

The studio, already hopelessly overcrowded with paintings and objects that never ceased to accumulate, also became the home of various pets. Though it would have pleased Picasso to have had more exotic birds and beasts around him, he contented himself with cats, dogs, a tortoise and a monkey. These were among the many generations of creatures that he kept beside him, watching and fondling them with wonder and affection, wherever he lived. Max Jacob recounts how in his early days in Paris, Picasso paid frequent visits to the Jardin des Plantes by night, where one of his friends, the son of the curator, gave him access to the rarest and most fascinating animals.

The Beginning of Cubism

The spring in France and even more the summer have an irresistible tendency to draw painters away from Paris to the great varieties of landscape in the provinces. Early in 1908 both Braque and Derain left for the country with the troubling memory of Picasso's great picture, *Les Demoiselles*, and the two monstrous faces it contained. Braque, following in Cézanne's footsteps, went to l'Estaque near Marseilles and

returned in the autumn with a number of landscapes, six of which he submitted to the Salon d'Automne. But the jury were upset by a tendency they had not seen in his work before. Colour, instead of being the supreme factor, had become subdued and there was an insistence on simplified geometrical forms. Matisse as a member of the jury pointed out to the critic Louis Vauxcelles, inventor of the term 'Fauve', the predominance of what he called '*les petits cubes*'.

Two of the pictures were refused and Braque in annoyance at once withdrew the others. Happily Kahnweiler was unperturbed by the new style and gave Braque a show in his gallery in November, which has rightly been claimed as the first Cubist exhibition. Encouraged by this, Braque sent two more paintings to the Indépendants the following spring. The critics now had their full opportunity to show their scorn. Vauxcelles had already quoted Matisse's remark about '*les cubes*' in his criticism of the show at Kahnweiler's gallery, and now in an unsympathetic review which would otherwise have been long ago forgotten, he followed it up and facetiously labelled the style 'Peruvian Cubism'. From then on the sadly inadequate title 'Cubism' has been used as a label and was sanctioned by Apollinaire in his first articles in defence of the new style in 1913.

La Rue des Bois

During the same spring, Picasso, nervous and turbulent, stayed in Paris pushing his discoveries further. According to Fernande, he was still haunted by the death of Wiegels, the second suicide of a friend that had touched him closely and reawakened a sensation of the disquieting nearness of death. Rather than make a long journey to the south, he decided, late in the summer of 1908, to overcome his prejudices and try the soothing influences of the French countryside. Having heard by chance from a friend of a vacant cottage on a farm situated between the forest of Hallatte and the river Oise, he set out with little knowledge of where he was going, accompanied by Fernande, a dog and a cat to cure his melancholy in the hamlet known as La Rue des Bois, some thirty miles north of Paris. Although their lodgings were primitive, with a farmyard at their doorstep, there was just enough room to work and to

entertain friends from Paris for a few days at a time. Picasso was soon immersed in the refreshing influences of meadows and forest. For the first time since his early sketches at Corunna, and later at Horta de San Juan, he became interested in the subject matter offered by the landscape on its own merits and not merely as a background for figures.

The verdant countryside of the Oise influenced his palette. Green become so predominant as to suggest to some that the work of these months should be called the Green period. In any case, with a violent thirst for wider horizons, a new experience had begun, and the paintings he produced at La Rue des Bois form a group to themselves.

In contemplating a landscape the eye has the ability to extend the sense of touch so that it seems possible to caress the surfaces spreading out into the distance. The walls of a house or the slope of a distant mountain can become as tangible to the imagination as a matchbox held in the hand. The great landscape painters in the past had none the less neglected this sensation in favour of atmospheric effects. Strong contrasts of tone and colour were situated in the foreground while a blue haze was reserved for the farthest distance. A system of perspective in which the size of objects tailed off to vanishing points in the horizon completed the illusion of space. The image obtained according to these rules, however, made objects too intangible and indeterminate for Picasso. Just as he had taken liberties with the human form to enable the eye to embrace its shapes more completely, so now he began to treat landscape as sculptural form. All unnecessary detail was sacrificed so as to emphasize salient features, and the time-honoured rules of perspective were abandoned, together with any attempt to give an effect of immeasurable distance in the background. In fact, in the landscapes of La Rue des Bois (Plate V, 5), background and foreground are merged together in a play of surfaces which seem to touch each other. The eye is invited to travel among them and enjoy the definite though subtle way in which it can be led into the depths of the picture, exploring paths as they disappear into recesses and returning over angular planes that push forward into the light. In the three-dimensional pattern made up of definite planes, the eye is never allowed to lose itself in awkward holes which could break the continuity of the surface of the picture and destroy the coherence of the composition. Trees, houses and paths

belong to each other and invite the eye to feel and wander among them, enjoying their homely solidity. A house is without doubt a house, and a tree a tree. They present themselves as objects to be felt and to be loved.

The same objective spirit that affirms the presence of each object is not limited to landscapes. It appears in a series of still-lifes painted on Picasso's return to Paris.[13] They are composed in general of bowls and bottles set together on a table, and the presence of these simple utensils seems to be completely established. They exist as familiar objects and also as the component parts of a pattern in which nothing can be added or subtracted without destroying the effect of perfect balance.

Before leaving La Rue des Bois, Picasso amused himself by painting two pictures strongly reminiscent of the two painters upon whom he was meditating most at the time. In one the central object, placed on a crumpled patterned cloth with fruit in front of it, is the tall black hat so characteristic of the later paintings of Cézanne.[14] The other is a flower piece[15] in which the central placing and simple formal shapes of blossoms and leaves are reminiscent of the style of the Douanier Rousseau – a spoon on one side is a characteristic sign of the more complicated sensibility of Picasso.

The same drastic elimination of detail and massing of form into sculptural units appear in several powerful studies of heads painted during the autumn. There is also a figure, 'ponderous and static', called *The Peasant Woman*,[16] in which, owing to a desire to emphasize the solid ample proportions of the figure, colour has again been reduced nearly to monochrome. The hieratic qualities of Negro sculptures once more become apparent.

During the winter the tendency to keep colour subservient to form continued. Compositions of female nudes, aglow with an overall warmth of reddish brown, were acquired by Shchukine for his collection.

There is also a notable picture of a figure, *Nude on Beach* (Bather) (Plate VI, 1). Flat angular shapes in this case are softened. Each part of

[13] ibid., Vol. II*, p. 48.
[14] ibid., Vol. II*, p. 44, No. 84
[15] ibid., Vol. II*, p. 45, No. 88.
[16] ibid., Vol. II*, p. 46, No. 91.

the woman's body is modelled into curved shell-like volumes, linked together at their joints. The articulations, ornamented with flourishes that recall arabesques, resemble the knots between the trunk and branches of a tree. To increase the sensation of volume, back and front are shown simultaneously. Breasts and shoulder blades, belly and buttocks are together in view. The tall structure of the human form grows from large flattened feet planted on the sand. We are presented with a new architectural view in which the living units have been torn to pieces and built up again into a statuesque image. The limitations of a two-dimensional medium have been overcome by hiding from us neither front nor back but at the same time uniting both into a convincing whole.

Horta de San Juan: Summer 1909

By the time the next summer arrived it was impossible for Picasso to resist his desire to return to Spain. For a painter, travelling is difficult. He is in close contact with the material world which he contemplates, enjoys with his eyes and feels with the sensibility of his entire body, also he is to some extent impeded by paraphernalia needed for his work. As he is so essentially influenced by his visual surroundings, concentration is easily dissipated if he moves too often from one region to another. If he is to find time to penetrate the mysteries of the objects that surround him and develop all the potentialities of his talent, he will be unlikely to risk blurring his perception by frequent kaleidoscopic changes in his surroundings. But by adopting a life of comparative immobility, when he does travel he finds his reward in the fresh impact and excitement of unaccustomed scenes.

Picasso travelled very little outside the limits of his favourite regions in France, which are confined to Paris and the Mediterranean coast. In consequence each place keeps its associations intact and is remembered for its own local population of beings both real and imaginary. In his last years, at Cannes, after finishing a bold and evocative drawing of a bearded head, wearing horns like some ancient pastoral king, beside whom was seated a faunlike creature piping to the stars, Picasso said, 'It is strange, in Paris I never draw fauns, centaurs or mythical heroes like

these; they always seem to live in these parts.'

A change often occurs in Picasso's style when he moves to new surroundings and influences remain localized because of the intensity of his perception and his capacity to differentiate clearly between sensations.

It was ten years since he had visited his friend Pallarés in the remote countryside of the province of Tarragona and made his first acquaintance with Spanish peasants, ten years since he had smelt the wild landscape that rises into the arid mountains of Teruel, whose angular shapes close the distant horizon. On the way through Barcelona he paid a brief visit to his family. Accompanied by Fernande he lunched daily with his father and mother, but as soon as the meal was over he preferred to go out with his friends in excursions to the heights of Tibidabo or places in the near-by mountains from where they could look down on the great city below. These were passing pleasures: as usual it was the remote calm of the countryside that was the object of his journey, and so, with Fernande, he was again installed in the little village of Horta, in the blazing heat of mid-summer.

As was to be expected after the experience of Paris and the immense discoveries that had been made since his first visit, Picasso saw his surroundings in a new light. If we turn back to the talented sketches of ten years before, we find there the inquisitive delight of a youth watching the life of the peasant folk and conscious of his ability to seize its detail in rapid fragmentary descriptions of what he saw. But during the ensuing years Picasso had learned to see with other eyes, and to demand from his work, not the mirrored image of ever-changing appearances, but the construction of a reality that he could now perceive more clearly in his imagination – an exteriorization of his deepest feelings about the world in which he lived. With new insight he could now give a timeless quality to his work and endow each picture with a life of its own. This relationship between objective reality and the work of art was beginning to be resolved by the hazardous experiment of Cubism. His interest still lay along the path that had been opened up to him the year before in the wooded slopes of the Ile de France. But the Oise had been exchanged for the Ebro, the northern forests with their dense green patterns reminiscent of the jungle scenes

of Rousseau, for the feathery Mediterranean pines and olive trees dear to Cézanne. Pastures were replaced by terraced vineyards and the close damp atmosphere of the north vanished in the hard light and the vast clear skies of Spain.

The first landscape to be completed shows the conical shape of an arid mountain.[17] It is sufficiently representational for us to be able to trace, above the roofs of the square stone houses, a path bordered by cypresses that leads up a granite slope to the Grotto of Beato Salvador. A severe analysis of the scene has however been made, and the forms are reconstructed with geometric simplicity. Picasso had taught himself to see beneath the bewildering detail of the surface. His intelligence had intervened and overruled his former pleasure in making copies of nature. He now deliberately stated the emotions conveyed to him by what he saw and what he knew. All liberties were permitted if they could help in this aim.

In the composition of this first landscape, the central position and shape of the mountain peak is in itself reminiscent of Cézanne's paintings of the Mont Ste Victoire. The insistence on simple forms to the exclusion of all irrelevant detail is proof that Picasso was conscious of the views expressed by Cézanne in his frequently quoted letter to Emile Bernard: 'You must see in nature the cylinder, the sphere, the cone.' The underlying principles of form must be analysed, otherwise the confused surface detail of natural appearances will obscure its real nature.

A succession of six or more landscapes admirable in their clarity followed *The Mountain,* of which the best known are *The Factory*[18] and *The Reservoir* (Plate VI, 6). In the latter the little town itself, set on a hill, is the focus of forms crystallized round a central tower. In others the houses unite with the angular solidity of the mountains or the spreading branches of palm trees whose regular rhythms are repeated in the sky. Picasso had found the landscape he required to verify what he had already begun to discover in his analysis of the human form. The shapes he saw in nature became the hard shimmering facets of an agglomeration of crystals or cut stones. The light is no longer cast upon

[17] ibid., Vol. II*, p. 76, No. 151.
[18] ibid., Vol. II*, p. 78, No. 158.

them from one given arbitrary position but seems to radiate from beneath each surface. It is used not as a temporary illumination of the scene, but to accentuate the form of each object and become an integral part of its existence.

In these paintings colour, which had been set aside as a problem which should not at this stage be allowed to interfere with the realization of form, creeps in again. It is used to enhance the solidity of the form in the same way that Cézanne employed it, that is to say by shading one surface with a warm brownish colour and contrasting it with the adjoining surface shaded with a cool blue or green. The shading serves to accentuate the relief by making a strong edge between them. Cézanne still used colour for atmospheric effects, whereas Picasso's first consideration was to create the appearance of a reality in solid form.

During this time Picasso applied these principles in a remarkable series of heads.[19] They have the same monumental qualities as the landscapes but beneath their enduring rocklike appearance they are not lacking in expression. Emotion shines through the alternate rise and fall of the luminous planes with which they are constructed. The human face and human form are reorganized with a rich variety of invention. In some we seem to recognize the pointed vaults of Gothic cathedrals, in others the wooden features of a Negro fetish chipped out by an adze. But formal considerations have not obliterated the human expression, which often reappears with more intensity than at any other time during the Cubist period. We are reminded of the anguished faces of Zurbarán. Spanish expressionism was still apparent in spite of new techniques.

It is not surprising that after these heads Picasso should have wanted to work out the relationship between the painted head and its three-dimensional counterpart in a first attempt at cubist sculpture. The bronze *Head of a Woman* (Plate VI, 4) was modelled after his return to Paris in the autumn. It follows closely the same conception of a surface broken into planes whose ridges catch the light.

[19] ibid., Vol. II*, p. 84.

Return to Paris

It was by a strange coincidence that Braque had returned from the Mediterranean in the autumn of 1908 with landscapes that were to be labelled 'Cubist', and that Picasso coming from La Rue des Bois also brought with him paintings which, independently, showed a parallel tendency. From that time until they were separated in 1914 by the war there was a close association between the two painters. They watched each other's work and vied with each other in invention. The authorship of their paintings at the height of the Cubist period is often difficult to determine, especially when they were working in close collaboration, though in Picasso's own words Braque, true to his origins in the Ile de France, 'always has the cream', which a Spaniard would find too rich and unnecessary. It is impossible, however, to know which of them was the originator of each idea that created the new style. That in the formative stages they should independently achieve similar results suggests that a community of ideas was ripening in an atmosphere alive to the urgent need for a new form of expression. At the same time it must not be forgotten that the *Demoiselles d'Avignon* in 1907 was in advance of any other creative achievement.

The friendship between Picasso and Braque, though not without rivalry, was genuine and fruitful. Born the year after Picasso, Braque had come to live in a studio near by in Montmartre, and he brought a methodical and questioning spirit into discussions on their new ideas. His first reactions had been of stubborn disapproval, but he had quietly abandoned the Fauve group, which was already in disruption, and alienated himself from them by paintings that met with the disapproval of Matisse and his old friends Dufy, Friesz and Marquet.

To Picasso, the company of Braque was stimulating. Together they shared each other's thoughts and entertainments. In his generous moments Picasso was always anxious that his friends should share his own happiness, and in early days he thought it fitting that Braque should be found a suitable wife. The choice was the daughter of the *patron* of a Montmartre cabaret, Le Néant, who happened to be a cousin of Max Jacob. One evening it was decided that Braque should be introduced formally to her, in company with Max and other willing

friends. For the occasion they all hired the most splendid dress and set out complete with top hats, cloaks and elegant canes. The effect was overwhelming. Both the *patron* and his daughter were conquered at once by their distinguished guests, but it was difficult for their high spirits not to spoil the desired effect, and as the night went by the atmosphere deteriorated seriously. When the time came for them to leave, the engagement was still not concluded and their presence was no longer desired. In the cloakroom they found that it was impossible to recognize their hired disguises, but adopting the easiest way out they all helped themselves to the hats and cloaks they fancied, an action which unfortunately made their return for further negotiations impossible. As it proved, this was just as well, for Picasso introduced Braque shortly afterwards to a girl of great charm who lived in the quarter, and who became his wife and lifelong companion. It is said also that Derain owed his marriage to Picasso's good services, and it was he who introduced Apollinaire to his wild and talented muse, Marie Laurencin. With unexpected concern he interested himself in the happiness of his friends.

6

The Creation of Cubism
(1909-14)

Move to Boulevard de Clichy

The summer months spent in the arid rocks and vineyards of Spain had an excellent effect on Picasso. He returned to Paris with a large number of paintings that showed a persistent development in the new style. Vollard, having recovered from his earlier misgivings, at once exhibited them in his gallery, and in spite of the hostility of the critics and guffaws from the public, the small group of enlightened admirers led by Gertrude Stein and Shchukine continued to buy.

Picasso at last found himself in a position to move from the squalor and inconvenience of his old surroundings, and with Fernande and their Siamese cat he installed himself in the same quarter in a studio apartment at 11 boulevard de Clichy near the place Pigalle. The increasing volume of his work and his need for seclusion had already induced him to spread into a second studio used exclusively for work at the Bateau Lavoir, and this he kept as a store for several years until Kahnweiler moved all his belongings for him to Montparnasse.

The contrast was so marked between the sordid surroundings in which there was nothing that could be described as comfortable and the bourgeois splendour of a great studio with a north light and its adjoining apartment looking south over trees, that the men who shifted their scant furniture and the heavy loads of canvases thought the young couple must have drawn a lucky number in the National Lottery.

Fernande says she felt misgivings about the new surroundings. She thought that their new way of life, with a maid in apron and cap to wait at table and the custom of Sunday afternoon receptions, which for a while they adopted as a means of returning hospitality, could not

replace the spontaneous, disorganized enchantment of the early days of their life together.

The furniture Picasso acquired was a mixture of any styles that took his fancy. Among heavy oak pieces with simple lines, an immense Louis-Philippe mahogany settee upholstered in plush, and a grand piano, there stood a delicate piece in Italian marquetry, a present from his father. To Picasso, 'good taste' and interior decoration were obstacles to his imagination, a stagnation of the spirit. On the walls of the dining-room he had hung as a joke chromo-lithographs framed in straw which Fernande says were more worthy of a *concierge*'s parlour. In the studio the fear that dust raised by a broom might get stuck to fresh paint forbade dusting and sweeping, and the usual splendid disorder was quickly established. It was added to daily by a collection of chosen pieces of junk such as glass, picked out because of the intensity of its blue, curiously shaped bottles, princely pieces of cut glass, fragments of old tapestries from Aubusson or Beauvais, musical instruments, old gilded frames, and above all, an ever-growing collection of African sculpture. Competition between him and other painters such as Braque, Derain and Matisse in the discovery of rare pieces and necklaces had reached a high pitch, and ivory bracelets from the same source made an exotic display on the arms of their girls.

Picasso continued to make the round of visits to his friends, always protesting to Fernande before they set out that it was a boring waste of time, always remaining taciturn while he was there, but nevertheless unable to live without these contacts which he enjoyed in his own way. The Saturday visit to the Steins at their studio in the rue de Fleurus was a regular event. There he always met Matisse to whom he invariably paid a visit on Fridays. At the Steins' they were both among the most honoured guests, Matisse with his brilliant flow of conversation and Picasso sardonic and reserved, inclined to look down on those who failed to understand him. He was particularly unhappy when asked for explanations of his work which he always tried to avoid, and which became all the more irksome in his broken French.

To Picasso the all-important activity was the continuous rhythm of his work. Locked into his new studio, he pursued every afternoon and again at night, the development of the new style that was steadily taking

shape. The stage was now set for an unparalleled flow of invention and the establishment of a revolutionary movement in which he was without premeditation to become the prime mover.

The group which formed in Montmartre consisted in the first place of Picasso and Braque. Derain, a painter of great talent and an attractive personality, appeared at one time to be following the same path, but there are two other artists whose names are more closely linked with those of Picasso and Braque as creators of Cubism. They are Juan Gris and Fernand Léger. Gris, a Spaniard from Madrid, lived in poverty in the Bateau Lavoir. He earned just enough to keep alive by drawing caricatures for illustrated reviews such as the *Assiette au Beurre*. But his friendship with Picasso opened for him new horizons and he began to explore the possibilities of the Cubist style as early as 1910. Fernand Léger had arrived in Paris a year before, coming from Normandy, and soon after his meeting with Picasso and Braque he began to invent his own cylindric simplifications of form which earned for themselves the nickname of 'tubism'.

Interest in Cubism spread with astonishing speed from Paris to other countries. It was as though the new generation of painters had everywhere been waiting for an orientation. The simplification of form at the expense of representation was the fundamental step taken simultaneously by artists in countries as distant from each other as France and Russia, Italy and America.

Their motives were not necessarily the same. Painters such as the Russian, Malevich, and the Dutchman, Mondrian, after their first contact with Cubism in Paris, pursued paths that led them to disregard all associations with objects in their desire to arrive at pure abstraction in colour and form. They sought for Platonic perfection based on the indisputable beauty of simple geometric shapes such as the circle and the rectangle. This road, which led to complete suppression of subject matter and a search for absolutes, was foreign to the instincts of Picasso. Whatever merit their almost fanatical research may have had, it tended to narrow the role of painting to decorative and intellectual aspects. To deprive painting thus of all subject matter and hence of all poetic allusions and symbols always seemed to Picasso a form of castration. He is not concerned with purity except in relation to impurity.

Perfection does not interest him because it implies a finality which is static and deprived of life. Art and life are inseparable to him, and inspiration comes from the world in which he lives rather than from a theory of ideal beauty. However abstruse his work may appear, it has always as its origin passionate observation and the love of a given object. It is never an abstract calculation.

Other painters, stimulated by the discoveries of Cubism, formed groups, such as the Futurists dominated by Marinetti in Italy, and the Vorticists in England. Amazed by the inventions of our age, they based their theories of aesthetics on the shape and movement of machines and the repetition of mechanical rhythms. In their desire to incorporate movement into the static art of painting, they showed the consecutive positions, for example, of the leg of a runner. But here they differed from the Cubists, who by totally different and more subtle means managed also to introduce the fourth dimension, time, into the representation of an object.

Cubism, however, did not begin with theories. There was no question in Picasso's mind of creating a system any more than of founding a school. His urge was to make a break with the past, to substitute a living object for the fleeting sensual images of the Impressionists – who, he said sarcastically, merely showed you what weather it was – and to render to the work of art its own internal life. To do this, new means had to to be invented. The history of Cubism reveals the discovery of these means.

The decade that followed the *Demoiselles d'Avignon* was to witness a revolution without precedent in the arts, the consequences of which are still not fully understood. No sooner had Cubism made its appearance than its influence began to spread to other arts. It is true to say that the art of this century took its shape from the cubist paintings of Picasso and Braque, and that sculpture, architecture, the decorative arts, ballet, theatre design and to a lesser degree, literature, were all modified either profoundly or superficially by the cubist conception. The influence was bound to be far-reaching because Cubism challenged fundamental assumptions concerning the role of the arts. It rescued art from idealism and from the belief that it should have as its purpose the creation of absolute beauty. It was not a campaign directed against any particular

art form, but it had the effect of restoring to art its preoccupation with the complex nature of reality. Former movements of revolt such as Impressionism had been limited to visual problems, but Cubism pursued its inquiry into the very nature of the objective world and its relationship to us. It is for this reason that it can claim to be the most significant revolution in the history of art since the Renaissance, and that it continues to influence all branches of the arts in our time.

But there is no final solution in art, or rather, in the words of Kant, art is a 'finality without end'. The artist can never completely visualize the final state of his production while he is at work on it, nor is he able to judge with certainty where his work will lead him. In order to succeed, he must make discoveries as he travels along the path he has chosen. This is the essential condition for his continuous inspiration. Picasso and Braque did not, as has been suggested, base their work on calculations as a guide to new laws of aesthetics. André Breton has stated that Picasso used measurements and mathematics to clarify his work.[1] Though this is far from the truth, the assertion may be derived from the friendship between Picasso and a mathematician, Princet, who frequented the cafés of Montmartre while earning his living as an actuary for an insurance company. Princet aroused the interest of Picasso and Braque by the exquisite way in which he laid out mathematical problems on paper, and he reciprocated their enthusiasm by theorizing on the relationship between Cubism and calculations developed from the golden section and current theories of the fourth dimension. But there is no doubt that his speculations were of little interest to Picasso or Braque and that they were subsequent to their inventions in painting. These speculations, however, inaugurated a spate of theorizing, which was followed up by other mathematicians and by some of the more pedestrian followers of the cubist movement, such as Gleizes and Metzinger. Science inevitably arrives after the *fait accompli* to rationalize and elaborate the discoveries we owe to art.

Whatever calculations may have been made by others, Picasso himself joked about his own complete inability to understand mathematics. His use of geometry is as instinctive as that of the first

[1] See Barr, *Picasso: Fifty Years of His Art*, p. 260.

caveman who drew straight lines and circles long before the scientific faculties of man were sufficiently developed to make deductions and theories. But although mathematical calculations are absent, there is nothing haphazard about his work. It is prompted by an unerring sensibility and an intense desire to penetrate and understand reality in relation to human consciousness. It is in other words a search for truth. Art had been content to accept and enjoy appearances, but to the inquisitive spirit of Picasso this was not enough, and his dissatisfaction led him to inquire more deeply into the nature of our perception of the world around us. If superficial appearances were insufficient, the object had to suffer a dissection, an analysis which could enhance our understanding and appreciation of its presence.

The Cubist Portraits: Analytical Cubism

The first important canvas to be painted in the new studio, *La Femme en vert* (Plate VI, 5), still shows a formal structure reminiscent of the technique of Cézanne. The contrasted greens and reddish browns come from his Provençal landscapes. But particularly in the face of the seated woman there is a more severe analysis of form and a further restriction in the choice of colour. The rigours of the new discipline were in future work to limit the range of colour still further, until subtle passages from ochre to brown or grey were all that relieved it from monochrome. Even the greens of the Horta landscapes, which appear for the last time in this picture, were afterwards banished. It was necessary to create a clear conception of space before enhancing it with colour.

At the same time, while the processes of demolishing the object so that normal appearances became scarcely recognizable and abandoning the use of colour were at their height, Picasso produced some portraits for which paradoxically he demanded, as he had done for Gertrude Stein, the frequent presence of the sitter. The first of the series was a portrait of Clovis Sagot (Plate VI, 3) painted in the spring of 1909. Although cubist influences are apparent in the form, its colour and treatment in general make it an obvious descendant of Cézanne. The second was painted during the visit to Horta the following summer. It is a portrait of his friend Pallarés and in it the colour has become greatly

attenuated. The third, known as the portrait of Braque,[2] followed on Picasso's return to Paris that autumn. It is a lighthearted, almost grotesque caricature showing little concern for a likeness to its subject. This however is not the case with the three great portraits that followed in the next year. In them a resemblance to the sitter is one of the most surprising and easily recognized virtues, in spite of the dissection of the form and the angular rhythms with which it has been reconstructed.

The first of the three was the portrait of Ambroise Vollard (Plate VI, 7), painted in the winter of 1909-10 and bought shortly afterwards by Shchukine. In spite of rigorous cubist treatment it is a remarkable likeness. Vollard himself relates that though many at the time failed to recognize him, the four-year-old son of a friend said without hesitation, on seeing the painting for the first time, 'That's Vollard.' The bulldog-like snout of the picture dealer and the high bald dome of his forehead detach themselves in warm tones from the grey monochrome and the continuous angular rhythms of the background. In spite of strong accents, there is nowhere an awkward interval or hole. The crystalline surface of the picture is unbroken.

The same qualities are present in the portrait of Wilhelm Uhde which followed (Plate VI, 8). There is a more austere consistency in the subdued colour, maintained here throughout with no concessions to flesh tones and a unity between the figure and its background, filled appropriately with a chimney-piece and books. The treatment is admirably fitting. It expresses with unexpected eloquence the dry, loyal personality of Picasso's scholarly friend. So true is the likeness that, more than twenty-five years later, although I had never met Monsieur Uhde in my life, but knowing the picture well, I was able suddenly to recognize him sitting by chance in a crowded café.

The style in the last of these three portraits has evolved still further. The patient sitter was Kahnweiler (Plate VI, 9), who well remembers the innumerable hours he had to pose. Here the analysis of form has been so uncompromising that although the features can be distinguished, the resemblance to the sitter is not so easily understood. The whole surface of the picture is organized as a pattern of small

[2] See Zervos, *Picasso*, Vol. II*, p. 89, No. 177.

planes that recall the intricate honeycomb design of the Moorish vaulting in the Alhambra, though here they seem to float in the vertical plane of the picture. Each facet lends to its neighbour a continuous play of recession and intrusion like ripples on the surface of water. The eye wanders among them picking up here and there landmarks such as eyes, nose, well-combed hair, a watchchain and folded hands, but in its passage it can continually enjoy moving over surfaces that are convincingly real, even though they are not intended to present an immediate resemblance to any given object. The imagination is confronted with a scene which though ambiguous appears undoubtedly to exist, and, excited by the rhythmic life of this new reality, it devises with delight its own interpretations. The passage round the neck and shoulders can seem like a promenade among streets and houses glowing with light and clearly defined in their spatial relations to each other. Picasso is reported to have said: 'In the paintings of Raphael it is not possible to measure the exact distance from nose to mouth: I want to paint pictures in which this can be done.' In this way his end has been achieved, there is a convincing precision in these three-dimensional recessions, though to the imagination they may suggest a depth of one inch or one hundred yards. The new sense of reality detached from representation creates a poetic ambiguity.

The portrait of Kahnweiler is one of the best examples of the style that has come to be known as analytical Cubism. The desire to penetrate into the nature of form, to understand the space it occupies itself and the space in which it is situated, brought about a searching analysis in which the familiar contours of its surface have all simultaneously forfeited their customary opaqueness. The screen of outward appearances has been made to undergo a crystallization which renders it more transparent. Each facet has been stood on edge so as to allow us to appreciate the volumes that lie beneath the surface. Instead of being invited to caress with a glance a smooth outer skin we are presented with a transparent honeycomb construction in which surface and depth are both visible.

Another picture which was painted earlier in 1910 and which has not evolved quite so far on the road of analytical Cubism, *The Girl with a Mandolin* (Plate VII, 1), can in some ways also rank as a portrait. In this

case also, contrary to an increasing tendency to paint wth the eye of his understanding rather than direct from nature, Picasso demanded many sittings from his model. A girl named Fanny Tellier, who had posed for many of his friends, offered her services to him and came persistently to pose. He found her presence, to which he was unaccustomed, somewhat embarrassing, but did not let it interfere with prolonged concentration on his work, until finally it was the model who lost patience. After more sittings than she was in the habit of giving for a single painting she announced that she was indisposed and could not come the following day. 'I realized that she meant not to come back at all,' Picasso told me, 'and subsequently I decided that I must leave the picture unfinished. But who knows,' he added, 'it may be just as well I left it as it is.'

If he had carried the painting further, it is reasonable to suppose that the process of elimination of resemblance to the outer appearance would have continued. As it is, there are signs everywhere of metamorphosis, although the upright figure of the girl holding her mandolin can be recognized without difficulty. Her head, her hands and her breasts have suffered the artist's wilful transformation, and there are arabesque flourishes that soften the hair that flows down her neck and find their echo in the detail of the frills of her dress and the ornamented frames against which she stands. Her right breast hangs like ripe fruit with a candour which appears both naked and clothed, while her head, which is partly merged into the background, evokes a different kind of ambiguity. It has been simplified into an undivided block with no features but the eye drawn as a sign on its surface, and it is extended by a rectangular shape which can be taken for the frontal surface of the face or a transparent shadow. That such ambiguity should be tolerated is an outrage to all classical standards of painting, but Picasso was discovering the importance of this mode which was to become one of the main assets of twentieth-century painting and pervade all manifestations of the new style. The simplification or elision of form in the head is repeated in the hands holding the musical instrument. But in spite of the economy in their shapes he has mysteriously managed to show their precise and sensitive activity as they play over the strings, merging into the discipline of his new conceptions, a tender regard for female charm which is made apparent above all by the elegance of her

poise. The picture is in fact such a bewildering combination of those qualities of elegant poise, classical proportions, selection of essential features, sober and subdued colours, that in spite of its revolutionary concept it has the serenity and inevitability of the architecture of the Greeks or the music of Bach. The human form has rarely been dissolved and recreated with more consummate skill.

Summer in Cadaqués

During the next eighteen months Picasso continued to push even further his analysis of form, sacrificing relentlessly the superficial appearances of objects but never losing touch with the origin of his inspiration. The summer of 1910 was spent at Cadaqués on the coast of Catalonia, in the company of Fernande and André Derain. His friend Pichot had asked him to share his house, and though Picasso found time for the pleasures of bathing and dancing the Sardana, he continued to organize his painting with the same severe discipline. Unlike his visit the year before to Horta, the landscape did not claim his attention, though as usual on arrival at a new place he acknowledged the change of scene with a few drawings, in this case of the black angular prows of fishing boats.[3] The work he produced was inspired in general by the human figure and the objects – musical instruments, fruit, glasses and bottles – that ornamented Pichot's interior.[4] He chose the most familiar forms, those close at hand, since they corresponded to his desire to touch as well as to see.

Derain, in spite of his close association with Picasso during these months, never felt tempted to carry out an analysis with the same rigour or to look so persistently behind the surface; but Braque, who had returned south to spend his summer at L'Estaque, continued at a distance to share Picasso's preoccupations, and independently he made important discoveries. The summer of 1910, according to Kahnweiler, was one of the richest in new developments for both painters. In the autumn Picasso, still doubting and dissatisfied with his achievements, returned from Spain with a large number of unfinished canvases.

[3] ibid., Vol. VI, p. 133, No. 1112.
[4] ibid., Vol. II*, pp. 109, 110.

However, it soon became apparent that a great step had been made towards establishing the new language of Cubism. The change can be seen most clearly in a comparison of the portraits of Uhde and of Kahnweiler, one painted before and the other after the visit to Cadaqués. The former still plays with arrangements of the surface, whereas the latter treats the sitter as a three-dimensional structure, existing as disrupted elements plotted in space in a transparent honeycomb, which is viewed from several angles and yet is welded together into a comprehensive whole. To quote Kahnweiler, 'he had taken the great step, he had pierced the closed form'.

The same development can be noticed from the *Seated Nude* (Plate VII, 3) of early 1910, now in the Tate Gallery, to the tall *Nude Woman*[5] painted a few months later at Cadaqués. In the former, deep cavernous greens make a background to a figure which seems to be overlaid or loosely boarded up with shingles. It still presents a solid graceful mass, while the *Nude Woman* has disintegrated into a scaffolding built with powerful angular rhythms, recessions and transparencies, almost unrecognizable as the female form. Direct reference to outward anatomical appearance or to the play of light on swelling volumes of skin-covered flesh has entirely vanished. The remaining structure owes its reality to the invention of a new architecture which is beautifully human in its proportions and convincing as a three-dimensional 'ideographic' sign.

There is no doubt that the new system, though logical, was becoming progressively more difficult for the layman to understand. The danger of its becoming a hermetic exercise, an aesthetic delight for the few who cared for abstruse metaphysical problems, was felt by both Braque and Picasso. The obvious risk was that in analysing the object, all reference to its recognizable reality might vanish completely, and it was to avoid this that Braque, while at L'Estaque, had introduced into one of his pictures a nail painted with its cast shadow in a naturalistic way, as though it were pinning the canvas to the wall. Thus he brought together two different levels of reality, the nail functioning as an explanatory aside made by an actor or a footnote to a poem. Then, pleased with the

[5] ibid., Vol. II*, p. 115, No. 233.

effect of this shift from one level to the other, he began to introduce lettering. These elements from another sphere had their own reality and brought with them into a style, in which all other reference to reality had become difficult to interpret, wide associations which could enlarge the scale and the signification of the picture. The problem of retaining a line of communication with the objective world had been relatively easy when it was a question of dealing with the human form, in which associations are so strong that a slender resemblance to an eye, a moustache, a breast or a hand is sufficient as a clue; but when less familiar objects are in question, a sign such as the tassel on the fringe of a tablecloth, the double curve of a guitar, the circular top and cylindrical stem of a wine glass, the bowl of a pipe, the suit of a playing card or the first three letters in heavy type of the word '*journal*', could be used to give the spectator an entry into the conception behind the picture.

There are many sequences of drawings by Picasso which start from an easily recognizable seated figure, and then proceed to eliminate appearances and to render shapes in simplified rectilinear planes, but always some clue remains as a symbolic link with the world in which the idea of the drawing originated.[6] However at this period, so great was the artist's desire to dissect form and recreate an object according to his own inspiration, that Kahnweiler was moved to plead that 'cubist pictures should always be provided with descriptive titles, such as *Bottle and Glass, Playing Cards and Dice* or *Still-life with a Guitar.*'[7] There should then be no danger of the paintings becoming merely an abstract decoration.

The Heroic Days of Cubism

When the summer spent in Cadaqués came to an end there was the usual long journey back to Paris. Talking towards the end of his life of these repeated arrivals after months of absence, Picasso insisted that they were very unlike our present-day rapid return to work after the

[6] ibid., Vol. VI, pp. 144, 145.
[7] Kahnweiler, *The Rise of Cubism.*

holidays. He remembered that on one occasion at least it took him two days to get from the station to Montmartre. When the night train drew in at the Gare d'Orsay in the morning, friends were on the platform to meet him. The whole band then set off on a sort of triumphal progress through a series of bars, cafés, galleries and studios, exchanging items of news and gossip, and indulging in noisy arguments. Finally, exhausted more by his welcome than by the journey, Picasso unlocked the dusty silence of his own studio.

As soon as he was reinstalled, the flow of production and invention continued without check during the winter months. Braque was living near by, and frequent visits to each other's studios kept them closely in touch, so much so that it was impossible in many cases to know who could claim to be the inventor of any given idea.

It would now be impertinent to attempt an exact chronology or to give credit exclusively to one or the other. Braque describes this fruitful collaboration in these words: 'Closely linked with Picasso in spite of our widely different temperaments we were guided by a common idea...Picasso is Spanish, I am French...but we said together during those years things that no one will ever say again...things that would be incomprehensible and that have given us so much pleasure.... It was rather like being roped mountaineers.' The austere fervour with which they worked together was such that for a time neither signed his paintings, wishing rather to share anonymity, and 'there was a moment', Braque has admitted, 'when we had difficulty in recognizing our own paintings.'[8]

This should not lead us to imagine, however, that there was no difference in style between the two artists. Their divergent national characteristics, the subtle nuances of the French on the one hand and the dramatic precision of the Spanish on the other, help to give to each painting its identity. But both were searching along the same path, and both revolutionaries had in their blood the great traditions of European painting that they were seeking to revitalize. Both laid their new discoveries in the severe classical framework of a composition based on a central feature supported by receding planes. Closely woven into this

[8] Braque–Dora Vallier, 'La Peinture et nous', *Cahiers d'Art*, October 1954, XXIX^e Année, No. 1.

foundation and contrasting with it are tilted parallel lines and curves placed with economy so as to give them their maximum significance. The dominating importance that the central figure acquires in pictures such as the *Jeune Fille à la Mandoline* (Plate VII, 1) is a reminder, coming when it might be least expected, of the composition of El Greco's *Expolio*. Braque found that the rectangular composition often became irksome towards the corners of the canvas and often enclosed his pictures in an oval. A rectangular composition within a rectangle was dull, it led nowhere; whereas placed in an oval – which, as Picasso pointed out to me, can signify a circular plane seen in perspective – the whole picture gained a three-dimensional effect. One of Picasso's earliest oval pictures is a nude dating from 1910.[9] In it the total effect of the picture is almost spherical. 'In the early days of Cubism,' he told me, 'we made experiments, the squaring of the circle was a phrase that excited our ambitions...to make pictures was less important than to discover things all the time' – but he warned me again not to think it was ever a question of exact calculations. The aim was rather to create space in a convincing way and therefore a new reality. For this reason, he said, he had always hoped to make a painting that was literally spherical, and always kept at hand some large balls of clay with which to make experiments in three-dimensional and two-dimensional effects.

The Subject Matter in Cubism

Cubism, which appeared to many to be detached from reality, used as subject matter the most common objects of everyday use – pipe, newspaper, bottle, glass, or the human form – and neither Picasso nor Braque was in any way detached from the daily events of the world around him, and which in turn influenced them both in the work. Just as the street and the circus had been the climate of the Blue and Rose periods, the world of science and mechanical invention was often in the background of Cubism.

Two inventions in the early years of this century did a great deal to alter our relations with the force of gravity – the use of ferro-concrete in

[9] See Zervos, *Picasso*, Vol. II*, p. 114, No. 228.

building, and the airplane. Both made it possible to carry heavy masses in the air without visible means of support, and both inventions were in consequence of interest to the Cubists. By means of ferro-concrete the ancient conception that a building must be supported laboriously by columns and caryatids disappeared, thanks to a feat of engineering which could make great masses of concrete float in the air in a way hitherto impossible. At the same time a favourite slogan in the French press was 'our future is in the air'. Braque and Picasso were quick to see its importance. 'We were very interested in the efforts of those who were making airplanes,' said Picasso. 'When one wing was not enough to keep them in the air they joined on another with strings and wire.' In a letter to Braque we find him addressing his friend as '*Mon cher Wilbur*', a joke referring of course to Wilbur Wright.[10] In fact the resemblance between the angular shapes of Monsieur Bleriot's flying machine held together by struts and cables and the overlapping facets and tenuous lines of an analytical cubist painting is not fortuitous. It is the result of observation and a discerning interest in the changing form of life, in particular in efforts to conquer another dimension in space.[11]

In this connection also the superimposed planes of analytical Cubism that often suggest the wings of a biplane or the overlapping wing feathers of a bird give the effect of a recession in space. They are like the treads of a staircase seen from above and can create a sense of depth as convincing as the old methods of linear perspective.

Céret

When summer came round again, instead of returning to Spain Picasso stopped short at Céret, a small town with great charm at the foot of the Pyrenees on the French side. It had been discovered by Manolo who continued to live there for many years, and before the outbreak of war

[10] Kahnweiler is sceptical about the extent of the influence of the inventor of aircraft on Cubism. He holds that the reason why Braque was nicknamed 'Wilbur' was simply that in their efforts to pronounce the name 'Wright' it took an unexpected resemblance to 'Braque'.

[11] This is in fact the only direct influence that modern technological inventions had on Picasso. The machine which has been the source of inspiration or of cynical mistrust for so many twentieth-century artists never captivated Picasso.

in 1914 it became the spiritual home of Cubism. Shaded by gigantic plane trees, its narrow streets are crowded with peasants from the mountains, leading mules whose bells echo as they pass by the fountains buried in moss and the crowded terraces of the cafés. In the luscious green of irrigated meadows, apricot groves and vineyards outside the town, a friend, Frank Havilland, had bought a small abandoned monastery where Manolo was already installed. It was a noble-looking eighteenth-century house surrounded by a large garden full of ancient trees and watered by a mountain torrent. Picasso took over the whole of the first floor and installed himself with Fernande. Four or five rooms of splendid proportions with a wide terrace overlooking the park gave ample scope for his work. Céret was close enough to the frontier for a frequent interchange between its population and the Spanish mountain folk, whose anarchist theories of justice and liberty were of the same fiery brand that Pablo had known in earlier days in Barcelona. On both sides of the mountain they were one race, Catalan, and Picasso could introduce his French friends, Braque and Max Jacob, who joined him there, to the people to whom he was closely akin. Max Jacob, though essentially fitted for Parisian elegance, was quickly acclimatized and began even to enjoy the perpetual choruses of frogs, toads, and nightingales that prevented him from sleeping. He managed to charm the elderly bourgeois whom he met in the café with his distinguished conversation and his horoscopes which earned him a few francs.

On the terrace of the Grand Café in the main street could be found most evenings the group of artists and poets who had come from Paris to pass the long pleasant days of summer in the company of their friend, whose dark piercing eyes seemed always to be discovering and absorbing new material for his work, and who was just as likely to be morose and reserved as witty and unexpectedly affectionate. They made a contrast with the local folk by the freedom of their dress, the gay colours worn by their stockingless girl friends and the variety of accents with which they spoke. The conversation rarely became dull. If there was any tendency in that direction, Picasso would remain silent and start drawing on the marble table top for the amusement of the girls or the wives of his friends. With one continuous line he drew animals, birds or portraits of people they knew. He could describe anyone he

wished in this way, even upside down, so that the person sitting opposite was presented with a portrait the right way up. Even the most conservative among the inhabitants quickly grew to understand them and they were only mildly surprised when Picasso asked for such unusual things as the heavy red curtain from the butcher's shop for an ornament for his studio.

Picasso was the only one among the artist friends to have enough money, but this mattered little as living at that date, in the depths of the country, was cheap anywhere in France, and the *patron* of the hotel was a good friend of artists. During the three years before the war broke out, those who had adopted Céret, including Manolo and his wife Totote, were the composer Déodat de Severac, Braque, Max Jacob, Kisling, Pichot, Herbin, Juan Gris, Havilland and later Matisse. Picasso made several visits but it was only during the first that he was accompanied by Fernande. There was much that pleased him in these surroundings – the weather, the warm wrinkled faces of the old folk, the healthy, well-built girls, the mountain landscape and the variety of vegetation that surrounded the solid stone houses of the little town; and, above all, ample space for work in a delightful setting, and the company, whenever he wanted it, of some of his most entertaining friends. There was no reason why Picasso should not have been happy except that pleasure was fundamentally of no interest to him and a prolonged state of undisturbed happiness was inconceivable.

Among the paintings produced at Céret during this first visit, landscapes are again very rare. There is one which is purely cubist in style although the broken shadows on the houses are painted with small short brushstrokes reminiscent of pointillist technique.[12] Characteristically there is a complete absence of colour, but without it this painting still evokes the deep shady streets of the little town. Otherwise there is no acknowledgement in any picture of the delights of the countryside. In company with Braque he was absorbed by further discoveries in the language of Cubism. Two pictures, *The Bottle of Rum*[13] and *The Aficionado* (Plate VII, 2), are examples of how rigorous the new discipline has become. The disruption of the object is

[12] See Zervis, *Picasso*, Vol. II*, p. 137, No. 281.
[13] ibid., Vol. II*, p. 132, No. 267.

complete. In the three-dimensional pattern composed of its dis-membered elements it is still recognizable, however, thanks to certain clues. In both cases, heavy capital letters forming parts of relevant words anchor the picture to its subject.

The Poet[14] and *The Accordionist*[15] are two large pictures painted at Céret. In both cases a single figure fills, in diamond fashion, the centre of the canvas. It is improbable that at the first glance the artist's intention will be understood: in fact it is said of the latter that its first owner in America enjoyed looking at it for years with the conviction that it was a landscape. There is no reason why a picture should not be enjoyed wrong way up, but if we wish to follow the artist's intentions, a cubist picture usually contains a clue. In this case on inspection the folds of the accordion are clearly visible near the centre of the picture, just where they would be expected. The armchair can be recognized by the spiral curls of the arms that protrude from behind a structure in the form of an obelisk which is the body of the musician. Pleasure can be found in a superficial excursion over these intricate broken surfaces whichever way up they may be placed, but there is additional satisfaction when the dignity and the convincing reality in space of this monumental figure is understood.

First Reactions to Cubism

While the stimulus of the Cubist movement spread among painters, its vitality and the significance of its implications made themselves felt among poets. Its influence assisted in clearing the ground of the romantic *fin de siècle* nostalgia which was already half strangled in its own pessimism. Although Cubism was the invention of painters, and therefore difficult to define in literary terms, its form and many of the ideas that it contained tempted certain poets to make experiments on similar lines. Max Jacob and Apollinaire, captivated by the visionary assurance of Picasso, were the first to attempt to incorporate the influence of Cubism into their literary style.

It is possible that Max Jacob was swayed by his deep affection for

[14] ibid., Vol. II*, p. 139.
[15] ibid., Vol. II*, p. 135.

Picasso. Although his limited visual sense did not permit of a change of style in his attempts at painting, in his poetry the form of his imagery shifted away from Symbolism to the complex and at the same time more ambiguous style of Mallarmé, purged of all sentimentality. In his earlier days he had said: 'In poetry interest will be born of the doubt between reality and imagination... Doubt, that is art.'[16] Doubt remained, but his mood, stimulated by the vitality of Picasso, had become more positive. In spite of his lack of understanding as a painter he was intrigued by Cubism, and he was delighted when Kahnweiler as the publisher asked Picasso in 1910 to illustrate a poetic novel he had written entitled *Saint Matorel*.[17] Already in 1905 Picasso had made a drypoint sketch for a little book of poems by André Salmon, but *Saint Matorel* was honoured with four etchings. The announcement of the book was written by Max Jacob himself. From it Picasso's reputation would appear already to be widespread. 'The authority of the name of Picasso dispenses with any necessity to present him to the public,' he writes, but had it not been intended for a cosmopolitan public such terms would at that date have appeared to be unjustified flattery.

The engravings were completed during the summer at Cadaqués. The Cubist technique in painting found its equivalent without difficulty in etching, the short brushstrokes of analytical Cubism being replaced by short lines or dots to shade certain planes and place them in relief.

This was the first of five books of poems by Max Jacob published during the next nine years to contain illustrations by Picasso. A second book, *Le Siège de Jérusalem*,[18] which appeared three years later, was also published by Kahnweiler. It was illustrated with three etchings and drypoints. The evolution of cubist painting is transferred to this medium: the introduction of lettering, wood-graining and paradoxically naturalistic detail again presented no difficulty to Picasso.

The fascination of the Cubist idiom spread later to other poets, in particular to Pierre Reverdy, who after the war became a close friend of Juan Gris; but it was Apollinaire, the first apologist of the new style,

[16] Jacob, *Correspondance*, p. 31.
[17] ibid., p. 52.
[18] Jacob, *Le Siège de Jérusalem*, Kahnweiler, Paris, 1914.

whose work as a poet was more affected than any by his close association with Picasso. Although his experimental revival in *Caligrammes* of the old conceit of constructing a poem in the shape of an image is an obvious link in technique between poetry and the new style in painting, the more profound influences must be looked for in the forms and structure of his poetry. He was essentially a visual poet who could use Cubist methods in the multiple images that are conveyed in a poem such as '*Lundi rue Christine*'. He delights in the ambiguity of dreams rather than a stark, limited vision of reality.

Apollinaire was not only an excellent poet but also a great animator. He had been called by Picasso the Pope of Cubism, and among the many caricatures there is one of Apollinaire seated as the Pope with triple crown and crozier and also pipe and wristwatch.[19] Anything that was modern and part of the movement which had as its intention the liberation of the human spirit was worthy of his enthusiasm. But this quality, for which many had reason to be grateful, also led him into trouble with others who found him too eclectic and lacking in discrimination.

L'Affaire des Statues

In his search for new values Apollinaire was willing to take risks. His hope of finding talent in unexpected places, and his interest in rare and exotic forms of art, however, caused him temporarily considerable embarrassment in an incident that has come to be known as '*l'affaire des statues*'. The painful events would have been unlikely to occur had they not happened to coincide with the spectacular theft from the Louvre in the summer of 1911 of *La Gioconda*. The story has been told on many occasions. The press has at one time or another given a variety of sensational versions, but an authentic account is presumably the one to be found in a letter written by Apollinaire in 1915 to his friend Madeleine Pagés. He explains that it all started with his employment as secretary, more from kindness of heart than for any practical sense, of a young Belgian adventurer called Géry-Pieret, who had a gift for

[19] See Pascal Pia, *Apollinaire par lui-même*, Aux Editions du Seuil, Paris, p. 89.

entertaining people with extravagant stories. In 1907, it seems, Géry stole two Hispano-Roman statues from the Louvre, and with bombastic talk from which it was impossible to decipher the truth, he persuaded Picasso to buy them from him. Apollinaire, when he asked Picasso some years later to return them, was told enigmatically that he, Picasso, had 'broken them up in order to discover the secrets of the art, both ancient and barbarian, from which they had sprung.'[20] In 1911 the young Belgian again turned up penniless on Apollinaire's doorstep and, to increase the poet's embarrassment, he had with him another statue from the Louvre. He had stolen this not only as a joke, he claimed, but also to show how badly guarded were the nation's treasures. There was indeed some reason to draw attention to this. Thefts of the despised exhibits of African art in the Trocadero by those who were becoming aware of their value were not infrequent. Apollinaire, again out of the warmth of his heart, did not turn him away but tried without success to get him to return the statue. A few days later, on 21 August, the incredible news was broken to Paris that the *Gioconda* was missing from its place in the Louvre.

Suspicion at once fell on the Belgian ne'er-do-well, though of this last crime he was in fact innocent. In panic he went to *Paris-Journal*, to which paper he managed to sell his story. He left the statue with the editor and then fled from Paris on the proceeds of his deal. As he crossed France he sent letters daily to the police from new addresses, boasting that it was he who had stolen the *Gioconda* as a job done to order.

Meanwhile Apollinaire, who was thoroughly aware of the danger of the situation, went to Picasso, who had returned that very day from Céret, to warn him. After a search the two statues were unearthed at the bottom of a cupboard where they had been lying forgotten, and the two friends, scared and uncertain as to what they should do, wandered all night carrying with them this embarrassing treasure in a bag. They even contemplated washing their hands of the whole affair by dropping their incriminating load into the Seine. Finally they decided to follow Géry's example and take the statues to *Paris-Journal* so as to ensure

[20] Marcel Adéma, *Apollinaire*, p. 144.

their anonymous return. Unfortunately, however, before Géry fled from Paris he had returned at the last moment to beg for more money from Apollinaire, who as a last act of kindness and also as a means of getting rid of him had taken him to the Gare de Lyon and put him on a train. This gave the police sufficient evidence to suspect the poet, and on 7 September the papers announced the arrest of a thirty-year-old Polish writer, Kostrowitzky alias Guillaume Apollinaire, as the thief of Leonardo's masterpiece. A section of the press was quick to remember that he had been heard to declare at the *Closerie des Lilas* that 'all museums should be destroyed because they paralysed the imagination', and that he had published new editions of erotic classics in order to make a little money. This was enough to convince the police that they had unearthed the leader of a dangerous international band.

Two days later Picasso, unaware of his friend's plight, was awoken at seven o'clock in the morning by a plain-clothes policeman who demanded his immediate presence before the judge for interrogation. The two friends were confronted with each other at the Préfecture. Both were untidy, unshaven and terribly shaken by the appalling consequences they believed might fall upon them – prison, exile, and every other form of disgrace. Their highly emotional behaviour seems to some extent to have baffled even the judge, who allowed Picasso to go free but bound him over to return if required as a witness, and sent the unhappy Apollinaire to prison. This happened in spite of their loyalty to each other, Apollinaire saying that Picasso did not know that the antiques he had bought came from the Louvre and Picasso declaring to the judge that he had before him 'the greatest living poet'.

Fortunately Géry, more mad than vicious, when he read in the papers of Apollinaire's arrest, sent a full and at last sincere confession to the police before fleeing the country. The affair came to an end with the release of Apollinaire after a week in prison, with a crowd of friends acclaiming him as he left La Santé. The story however though irrelevant to the creative work of both men was not easily forgotten. In spite of the doubtful distinction of being the only man to have been arrested in connection with the theft of *La Gioconda*, Apollinaire suffered greatly from the indignity he had undergone and was avoided by some of his more cautious friends. Picasso also was worried for many

weeks. He was haunted by the feeling that there was trouble still in store and that he was being continually watched. As they were foreigners, their position in France might have become difficult and they could have been expelled, a prospect dreaded by both. As it was, Apollinaire's naturalization as a Frenchman, when he tried to enlist on the outbreak of war, was retarded for many months because of the affair.

Changes at Home

It was about this time, though perhaps not as a direct result of his anxieties, that Picasso began to suffer from ill-health which obliged him to follow a strict diet without salt and pepper. Max Jacob remembers this as 'magnificent stoicism', but although Picasso delighted in the pleasures of the table he was never greedy and always considered his health before his enjoyment. If normal food was likely to threaten his ability to consecrate every part of his being to his work he was happy enough to eat boiled macaroni and drink water rather than take a risk.

Though his work continued to evolve with undiminished strength, the winter brought other changes. Picasso's life with Fernande had not always gone smoothly. Intimate friends such as Gertrude Stein could read well enough the signs of temporary storms between them. Often Fernande would appear without her earrings owing to their absence at the pawnbroker's, and be glad to give French lessons to the Steins' American friends to earn a few francs. But although quarrels were mended countless times it seemed less probable as time went on that the liaison could be permanent, especially after the move to the boulevard de Clichy. Fernande's own wistful explanation is that having been the faithful companion of the years of misery, she had no idea how to be the same in prosperity. In six years her dishevelled penniless lover, whose insistent looks radiated fire, had become a painter whose reputation commanded the respect of all connoisseurs of the modern movement in France and whose fame was spreading across the world. But the fire in his eye was no longer meant for her alone. The jealousy with which he had held her to him in early days had given way to a freer attachment which in turn came to a sudden end when the confidence that had

become established between them vanished before proofs of infidelity.

Picasso always had a taste for an abrupt ending to an awkward situation. It happened in this case without recrimination and left the way open for him to form an association with a girl of a more tender and placid nature, who although lacking the impetuous beauty of Fernande had a quiet charm that suited his more contemplative mood.

The maiden name of Eva – Marcelle Humbert – was Gouel. Picasso enjoyed calling her Eva, an allusion to her becoming the first woman in his affection. In company with the Polish painter Marcoussis, her former lover, Fernande had met her at the Steins' before realizing that they were to exchange places in Picasso's favour. Since Eva entered his life at a time when naturalistic drawing had been abandoned for Cubism, there are no portraits of her to which we can refer, though a few indifferent photos have been preserved. Her name however appears, perpetuating her memory, in many Cubist pictures. '*J'aime Eva*' is a testimony of Picasso's love, written on the picture like a lover's inscription in the bark of a tree. With similar intent the title of a popular love song of the time, '*Ma Jolie*', is often inscribed in paintings together with some notes or other musical signs (Plate VII, 5). This harping refrain had become familiar from visits to the near-by Cirque Medrano. The song, '*O Manon, ma jolie, mon cœur te dit bonjour*', became an obsession. It makes its reappearance in many different forms, incorporated into drawings and paintings as a tribute to the newly kindled passion for Eva.

During the winter of 1911-12, before this new attachment, Picasso had made a habit of frequenting with his friends, particularly Kahnweiler, the many more or less sordid night-clubs whose signs illuminated the streets of Montmartre outside the seclusion of his studio. The attempt to squeeze more entertainment from an atmosphere which had already become too familiar, and his liaison with Fernande that had grown stale, came to an end in the spring. With the arrival of Eva a change became imperative. New surroundings and solitude were again necessary in order to enjoy his newly found love and combine his delight with his inner compulsion to pursue the discoveries of Cubism.

Already in May he decided to leave Paris. Avignon was the first destination, but soon the charm of Céret drew him back to the Pyrenean

countryside in spite of its recent associations with Fernande. The break had been sudden, and the escape to these remote surroundings would have been a guarantee against recriminations had not his old friends the Pichots, whom he found at Céret, raised a storm by tactless references to his rupture with the girl whom they admired and who by chance was staying with them. Picasso packed his bags and returned with Eva and an enormous Pyrenean dog to Avignon.

But in this city he could find nowhere to stay, and with his usual disregard for local charm or any other consideration apart from adequate space for work, he took the train to Sorgues, a small nondescript town in the fertile plains six miles north of Avignon. This place on the main road towards Orange and Paris would no longer be likely to attract artists or lovers who wished to find solitude, but in those days, before the roar of heavy traffic had disturbed the shade of the avenues of plane trees, and before the swift flow of the irrigation channels had become contaminated by factories, Sorgues-sur-l'Ouvèze was a quiet place to which to retire, and the Villa les Clochettes that Picasso rented for the sum of ninety francs a month an appropriate though charmless dwelling. They were joined by Braque and his wife Marcelle, who rented part of the Villa Bel Air on the outskirts of the town, and in the bleak shelter of their hired villas they lived in close proximity for one of the most brilliant and productive epochs of Cubism.

With his health restored and the seclusion he needed, Picasso's energy was again fabulous. His newly formed ideas took shape with innumerable variations but with a dominant reference to Eva, '*Ma Jolie*'. On 12 June he wrote to Kahnweiler, '. . . I love her very much and I shall write her name on my pictures.'[21]

As so often happens in the midi, the bare whitewashed walls of hired rooms tempted him to use them for sketches. On one occasion in later years when this happened, a furious and short-sighted landlord made him pay fifty francs for a new coat of paint. 'What a fool,' said Picasso referring to this years later. 'He could have sold the whole wall for a fortune if he had only had the sense to leave it.' But at Les Clochettes

[21] Picasso, Catalogue, Musée des Arts Décoratifs, Paris, 1955.

the story was different. Picasso had painted on the wall an oval picture which he did not want to abandon when he returned to Paris in the autumn. The only way to avoid doing so was to demolish the wall with great care and send the whole piece intact to Paris. This was carried out on Kahnweiler's orders and later the painting was remounted on a wooden panel by experts. Sabartés managed to find the man who actually packed the piece of wall with the painting, and who remembered that he noticed in it a mandolin, a sheet of music with '*Ma Jolie*' as its title and a bottle of Pernod. The picture still exists as a proof that a simple artisan was capable of reading the hermetic signs of Cubism at the time it was painted.

The Beginning of Collage

When Braque first came to Paris, he had been sent there by his father, a house painter and decorator, to learn the technique of making *trompe l'œil* surfaces of marble or grained wood. He had abandoned this to become a landscape painter and later he evolved through Fauvism to Cubism, but his skill in the craft of the painter-decorator never left him. At the height of analytical Cubism, soon after he and Picasso had begun to add lettering to their paintings, he started to introduce *trompe l'œil* surfaces into his pictures using the combs and varnishes that he had learned to employ in his early training. His purpose was the same, again he wanted to introduce elements which would identify themselves easily with reality.

Picasso at once saw the possibilities in this innovation, and the use of graining combs appears in a picture called *The Poet*,[22] painted in the summer of 1912. In this case the combs are used to make a formalized representation of hair and moustaches. But even before, in an oval still-life, there appeared a use of *trompe l'œil* which was still more revolutionary. Short-cutting Braque's painted imitations of wood and marble, and remembering his father's habit of pinning cut-out pieces of paintings on to his canvases to try out new ideas, he took a piece of oilcloth on which the pattern of chair-caning was very realistically

[22] See Zervos, *Picasso*, Vol. II*, p. 152, No. 313.

reproduced, cut it to the shape he required and stuck it on the canvas. This recollection of his father's technique must not be allowed to imply that Picasso had the same temporary process in mind. On the contrary, he affirmed that the *papiers collés* which followed 'were always intended to be what they are: pictures in their own right'.[23]

By sticking on pieces of oilcloth or paper, Picasso violated one of the canons of aesthetics which for centuries had required a homogeneity in the surface of the picture. Cézanne had scandalized the critics by leaving bare patches uncovered by paint in his canvases. They had argued that the paint should cover the entire area of the picture, and indeed since the earliest days of the Renaissance, when painters abandoned the embossed and gilded crowns and haloes dear to the Middle Ages, no break in the continuity of the painted surface had been tolerated.

The process of combining two different versions of reality which had begun with Braque's painted nail now became more involved. The *Still-life with Chair-caning* (Plate VII, 9), a small oval picture painted in May 1912, is rich in inconsistencies which have been organized so that they form a unity. On the right there is an analytical version of a glass goblet and a sliced lemon, while on the left a clearly discernible pipe stem protrudes through the letters 'JOU' of the word '*Journal*'. Though the first letter, J, lies flat on the paper to which it belongs, the U appears to peel off in an independent movement. Below, pasted to the canvas, is a piece of oilcloth realistically patterned with chair-caning. Its edges are camouflaged and it is partly over-painted with shadows and stripes so that at the bottom of the picture it does not appear to lie all in the same plane. This curious mixture of techniques however holds convincingly together within an oval frame made of a coil of good hemp rope. If we consider the implication in the picture and 'stop to think which is the most "real" we find ourselves moving from aesthetic to metaphysical speculation'.[24] The chair-caning which looks real is false. The letters copied from a newspaper are given a different and independent meaning; instead of being informative their purpose is aesthetic and symbolic; while the pipe, the glass and the lemon attain a cubist reality

[23] Barr, *Picasso*, p. 260.
[24] ibid., p. 79.

in their own right because of their lack of imitation.

In all painting the artist requires us to become the willing dupes of our eyes, to enjoy for aesthetic reasons without question the reality of the object or the image offered to us. Here, Picasso wilfully disturbs us by combining within the same frame various degrees of deception which at different times and in different places we have already accepted, but put together in this way, they set up a play of contradictory or complementary meanings. In addition he presents us with a picture which by its composition, its self-contained light and its sober colour is a delight to the eye whether its deeper implications are understood or not.

It is an object with a reality of its own that lightheartedly poses disturbing questions about reality itself – a metaphysical pun. The austere aesthetic research of analytical Cubism is grinning at its former sobriety, 'adding insolence to paradox'.

Papiers collés *and the Return of Colour*

During the short visit to Céret in the spring of 1912 Picasso made a series of charcoal line drawings in which he used patches cut out from the coloured patterns of nineteenth-century wallpapers and pieces of newspaper to enrich the content of his picture. Braque at the same time was at work on a similar trend, and from then onwards the technique of *papier collé* began a career which spread into many different spheres, ranging from the poetic collage of superimposed images invented by Max Ernst and the Surrealists, to commercial advertising.

The cut-out piece of paper as used by Picasso and Braque imposed a new discipline and enabled them to reintroduce, at first with great economy, colour.

The flat definite shape of a piece of coloured paper could be used as a unit in the design. It could play its part as a patch of shadow or a change of texture, or, if it had words printed on it, like a visiting card or a label from a packet of tobacco, it could enrich the picture with these associations, becoming an ideogram, or a visual joke or metaphor.[25]

[25] See Zervos, *Picasso,* Vol. II**, p. 226, No. 490.
(** denotes the second of two volumes numbered II)

Deflected from its original meaning and made to describe something different, a piece of newspaper could be the shadow or the body of a guitar. By juggling with our conceptions and our symbols of reality, Cubism transposes abstract ideas into the plane of the plastic arts.

Colour now came back in its own right as an abstract value, not as something that belonged to an object and hence the victim of form and light. To quote Braque, 'colour acts independently of form...colour could give sensations that upset space and that is why I had abandoned it... The Impressionists...had sought to express atmosphere, the Fauves, light and the Cubists, space... It was therefore necessary to bring back colour into space... The adaptation of colour came with the *papier collé*... There it became possible to dissociate colour clearly from form and see its independence in relation to form... Colour acts simultaneously with form but has nothing to do with it.'[26] As later in abstract painting, colour was to be enjoyed for itself, but it was also to act simultaneously with the form of objects as their complement.

The Widening Influence of Cubism

From Sorgues Picasso wrote to Kahnweiler asking him to move all his belongings from the studio flat in the boulevard de Clichy, as well as what remained at the Bateau Lavoir, to a studio he had taken in the boulevard Raspail, Montparnasse. His new life with Eva was to be marked by a break with all the habits he had formed in Montmartre. He was exchanging the bohemian charm of La Butte for the more banal surroundings of Montparnasse, which was however a quarter newly discovered by artists from all parts of the world. Intellectuals of all sorts were to be found at the Closerie des Lilas, as well as at the two famous cafés, La Rotonde and Le Dôme, where political exiles such as Trotsky joined in passionate discussion with poets and painters. The new address, 242 boulevard Raspail, was however temporary. A year later Picasso moved again to a dreary though well-lit studio in a modern block of flats at 5 bis rue Schoelcher, overlooking the trees and tombs of the Montparnasse cemetery.

[26] Braque-Dora Vallier, 'La Peinture et nous', *Cahiers d'Art*, October 1954, XXIXᵉ Année, No. 1.

Cubism had by now become the most important and controversial topic in discussions of the arts, but Picasso remained remote from all manifestations that savoured of group activity, though many were ready to acclaim him as the leader of the new movement. Such an idea was entirely foreign to him, and he began to give rude answers to trite questions about the importance of Negro sculpture in the Cubist revolution, and continued to refuse to exhibit in the Salons. In the summer of 1911 his absence was already conspicuous in the first great manifestation of Cubism at the Salon des Indépendants, which included Delaunay, Gleizes, La Fresnaye, Léger, Metzinger, Picabia, Le Fauconnier, Archipenko, Marie Laurencin and Marcel Duchamp. But neither that, nor the Salon de la Section d'Or organized by the Groupe de Puteaux who met in the studio of Jacques Villon, held any attraction for him.

The critics who attacked this show as well as the Salon d'Automne of the same year, which included many of the same painters, could not however forget the absent originator of the new style. Gabriel Mourey wrote in *Le Journal*: 'May I be permitted to avow that I do not believe in the future of Cubism, no more in the Cubism of its inventor Picasso than of. . . his imitators. Cubism, integral or not, has already had its last word.' Only Apollinaire in *L'Intransigeant* and Salmon in *Paris Journal* continued to defend the movement.

In foreign countries, thanks to isolated enthusiasts, Picasso was slowly becoming known. The Thannhauser Gallery in Munich, where a first exhibition had been held in 1909, showed his works again in 1911. In the winter of 1910-11, thanks to the disinterested enthusiasm of Roger Fry, two Picassos were included in an exhibition entitled 'Manet and the Post-Impressionists' at the Grafton Galleries in London.[27] The pictures chosen were Gertrude Stein's *Nude Girl with Basket of Flowers*[28] of 1905 and the pre-Cubist *Portrait of Clovis Sagot* (Plate VI, 3). Even these pictures which would now appear simple for anyone to understand raised a storm of abuse and were bitterly parodied in an exhibition at the Chelsea Arts Club put on in haste to demolish

[27] '. . . two of his paintings, six drawings and a piece of sculpture were shown there'. Thomas Bodkin, *Birmingham Post*, 25 November 1958.
[28] See Zervos, *Picasso*, Vol. I, p. 113.

the foreigners by ridicule. A certain wit, signing himself François Rotton, sent in a caricature of the portrait of Sagot entitled *Portrait of the Artist (painted with his left hand)*.

In his second Post-Impressionist Exhibition in 1912, however, Fry included thirteen paintings and three drawings by Picasso, among which were a number of important analytical Cubist pictures. In the same year the Stafford Gallery held an exhibition of drawings, mostly of the Blue and Pink periods, with prices ranging from £22 to £2 10s. But in spite of his courageous showing of the Cubism of Picasso and Braque in London at an early date, Roger Fry failed to follow the significance of their work. This can be judged from the preface to the catalogue, in which he says: 'The logical extreme of such a method would undoubtedly be the attempt to give up all resemblance to natural form – a visual music; and the later work of Picasso (e.g. *c.* 1911-12) shows this clearly enough. . . '[29] With the advantage of knowing what followed we can now see that this was never Picasso's logical or illogical aim.

Although the first appearance of the paintings of Picasso across the Atlantic was in 1911 at the Photo Secession Gallery of New York, it was not until the great Armory Show,[30] long remembered for the scandal it caused, that Cubism made its impact on the United States, first in New York and later in Boston and Chicago. In these exhibitions the work of Picasso was dispersed among that of other painters, Braque, Duchamp, Gleizes, Marie Laurencin and Picabia, but all the same it did not fail to make an unforgettable impression.

Collectors from abroad continued to buy Picasso's paintings. His reputation was steadily increasing and in the future he was never again to feel anxiety about how he was to make enough money. Little by little the problem changed to how to use it and how to deal with the incessant demands of his less fortunate friends. A second Russian collector, Morosov, began to buy paintings with admirable discrimination, but confined himself to pre-Cubist work, and Shchukine, never having been seriously affected by the shock that, according to Gertrude Stein, he had suffered from the *Demoiselles d'Avignon*, continued to take back with

[29] See Benedict Nicolson, 'Post-Impressionism and Roger Fry', *Burlington Magazine*, January 1951, p. 11.
[30] New York, 1913.

him to Russia after his frequent visits some of the finest examples of Cubism. Even in Spain, though Madrid showed no interest at all, the Dalmau Gallery in Barcelona organized an exhibition of Cubist art which seriously upset those friends of Picasso who had considered themselves pioneers of the modern movement at the time of the 4 Gats. They were frightened by the incomprehensible inventions of the man they had formerly considered a genius.

It was not until 1913 that the first book to defend Cubism against the scorn of the critics and the indignation of the public was published in Paris, although in Munich Max Raphael had spoken favourably of Cubism in the book *Von Monet bis Picasso*. Guillaume Apollinaire, the untiring champion of the modern movement, however, was more thorough. In *Les Peintres cubistes* he wrote lyrical passages which continue to arouse the sympathy of all who are sensitive to poetic criticism. 'The modern school of painting,' he says, 'seems to me the most audacious that has ever appeared. It has posed the question in itself of what is beautiful.' In his eagerness to include all who are young and active he praises the work of painters of minor talent as well as the great creators of the movement, yet we owe to him the famous observation that Picasso 'studies an object as a surgeon dissects a corpse', and his profound admiration for his friend appears in a sentence such as 'his insistence on the pursuit of beauty has since changed everything in art'.[31]

Synthetic Cubism

I have already mentioned that the *papier collé* was the source of the next development in Cubism. The large coloured surfaces cut out of paper reintroduced colour in the form of a coloured patch rather than a painterly suggestion of colour created by the touch of a paint-brush. Colour had been kept in reserve; its relative scarcity during the analytical period had made the subtle nuances of tone all the more important, but now it was to return, not to describe the lighting or the relief of an object but as a delight in the sensation of colour itself. In a

[31] Apollinaire, *The Cubist Painters.*

large picture, the *Card Player* (Plate VIII, 7), painted in the winter of 1913-14, the old techniques of analytical Cubism have taken a new breadth, the breaking up of surfaces is now handled by means of a large flat coloured area each given a relationship in space to its neighbours and fitted securely into a three-dimensional pattern. The arabesques of decorative designs borrowed from wallpaper are here painted imitations in *trompe l'œil*.

But the spirit of the *papier collé*, the desire to return to the object itself, and incorporate it into the picture, so as to witness with enjoyment the metamorphosis that it could be made to suffer, had other consequences. To quote Cocteau:

He [Picasso] and Georges Braque, his companion in miracles, debauched these humble objects...that one finds on the slopes of Montmartre, the models which were the origin of their harmonies: ready-made ties from the drapers, imitation marbles and woods from bar counters, advertisements for absinthe and Bass, soot and paper from houses that are being demolished, chalked kerbstones, the emblems of the tobacco shops where two Gambier pipes are naïvely held together by sky-blue ribbon.[32]

With a preference for the humblest, all materials were now to be pressed into the service of these alchemists. The silk purse must be made from the sow's ear. The magic lies in giving value to that which is usually despised. What virtue can there be in making a gold nugget out of gold?

But the transition from analytical to synthetic Cubism was not abrupt. As early as 1912 the *papiers collés* of Céret and Sorgues show a preference for large flat surfaces, but at the same time they often incorporate objects treated analytically. Throughout the following year there are many pictures in which the two styles exist side by side.

At the same time there is an increasing appreciation of the sensuous pleasure of surface textures. The use of sand stuck to the canvas offered an invitation to touch the rough coloured surfaces and enjoy their existence quite apart from any representational meaning. Also the way in which rough surfaces catch the light made them a lively ground for colour lightly brushed on.

[32] Jean Cocteau, *Picasso,* p. 12.

Cubist Constructions

In the late autumn of 1913 Apollinaire became editor of a monthly review, *Les Soirées de Paris*. In his first number[33] he published four reproductions of cubist constructions made by Picasso.[34] Their appearance caused such disapproval among its forty subscribers that all but one of them cancelled their subscriptions. The constructions were made out of the most unconventional and humble materials, built up so as to form a bas-relief. The materials consisted mostly of wood, tin, wire, scraps of cardboard and paper, with or without patterns, images and colours. The theme in most cases centred round the guitar. None was made with much regard for permanence. They were fragile and very little remains of them except their photos. It is possible to detect in them influences derived from Negro sculpture that assert themselves here more obviously than in painting. There are certain African masks from the Ivory Coast in which the eyes are made as cylinders sticking out ferociously from the face, and an echo of this exchange of a dark hole for a protruding circle, negative for positive, is introduced into some of the constructions, when for instance the hole in the centre of the guitar is transformed into a projecting cylinder.

Picasso was here making a statement which challenged the nature of existence. The conception of substituting negative for positive became a diverting exercise which appealed to the imagination of his friend Apollinaire. It was a favourite habit of the poet to give special names to his friends. For Picasso he had found one suggested by a bronze bird from Benin that he had discovered. This strange creature held a butterfly in its beak and was attended by two rampant snakes. Picasso's name henceforth became the '*Oiseau de Bénin*' or the '*Ucello noir*'. In *Le*

[33] *Les Soirées de Paris*, No. 18, 15 November 1913.

[34] See also Zervos, *Picasso*, Vol. II**, pp. 356, 357, 361, 362, 363 and 387. Although this seems undoubtedly to be the first publication of reproductions of Cubist constructions, Picasso in conversation with William Rubin in February 1971 made it clear that the constructions originated before rather than after the adoption of collage and that the *Guitar* which he presented to the Museum of Modern Art on this occasion, formerly dated 1912, was in fact made before the *Still-life with Chair-caning* (Plate VI, 9) dated correctly 1911-12. This implies that the Cubist constructions were invented independently of collage, in which it has been thought that Braque had an important share.

Poète assassiné, a poetic tale published in 1916, Apollinaire describes how, after the poet's death, his friend the painter, 'dressed in blue linen and bare feet' whom he names '*l' Oiseau de Bénin*', builds a monument in honour of the dead hero. The government having refused to grant a site he chooses a spot in an opening in the forest where he hollows out of the ground an exact likeness of the poet 'so perfectly that the hole was full of his phantom – a profound statue in nothing, like poetry and like glory'. Again in a poem entitled 'Pablo Picasso' published in *Sic*[35] the author of *Caligrammes* arranged the typography of the page so as to leave spaces in the form of the objects that appear in Picasso's Cubist still-lifes, framed by the words of the poem.

The constructions have none of the meticulous care with which certain artists, fascinated by the abstract beauty of geometric forms in space, have realized their ideas in metal and plastic materials in more recent years. They were put together roughly. The materials were chosen with a feeling for their texture. Here and there a few boldly painted lines or circles enhance the strength and the sensuality of this composite object and add a reminder of the plastic strength of primitive sculpture. The simultaneous multiple image is at the basis of each construction. Each object within it is invariably seen from more than one viewpoint. In order to understand the roundness, flatness, fullness or hollowness of the object, as well as what goes on in space around it and behind it, every liberty is taken.

The first constructions were built up in deep relief on a background. From them Picasso evolved a remarkable example of polychrome Cubist sculpture in the round known as the *Glass of Absinthe* (Plate VIII, 5). Using Cubist and collage techniques he again established a play, a joke between varying degrees of reality, by placing on the glass, which was modelled out of wax, a real absinthe spoon and an exact replica of a lump of sugar. The glass, scooped out so as to show the surface of the liquid within, is poised on its saucer and the whole, with the exception of the spoon, is cast in bronze and painted. The painted patterns and the elegant poise of the little object give it a gay and vaporous look which

[35] No. 17, May 1917.

brings to mind the top-heavy slanting hats and the tight-fitting lace chokers of the ladies of those times.

The Woman in a Chemise (Woman in an Armchair)

During the autumn of 1913 Picasso produced one of those works which in later years stand out among other paintings of the period as being prophetic of trends of development. It is a large canvas in which ochre and purple tones have been allowed to invade the restrained palette of analytical Cubism. The picture has had several titles but is usually known as the *Woman in a Chemise* (or *Woman in an Armchair*), (Plate VIII, 3). I once had the good fortune to have it lent to me for some months after it had been acclaimed by the Surrealists and shown in their exhibition in London in 1936 as a splendid and powerful example of fantastic art. It was in fact so powerful that a friend to whom I had let my house for a month during its visit complained that it gave her nightmares and endangered the future of her expected child. I also was deeply moved by it. The references to reality are direct and highly sensual. In describing this picture after he had known it for twenty years, Paul Eluard wrote: 'The enormous sculptured mass of the woman in her chair, the head big like that of the Sphinx, the breasts nailed to her chest, contrast wonderfully...with the minute features of the face, the curl of hair, the delicious armpit, the lean ribs, the vaporous petticoat, the soft and comfortable chair, the daily paper.'[36] New and disquieting relationships between abstraction and sensuality, between the sublime and the banal, between stark geometric shapes and allusions to organic reactions are brought into being. I have not only been moved by the familiar flesh pinks, greys and purples of this great female nude, by the enveloping arms of the chair which embrace and protect the seated figure, not only loved the cavernous depths that surround the strong central pillar round which is built the enveloping egg-like, womb-like aura of her body and its culmination in the cascade of dark hair which seems at times to transform the upper part of the picture into a landscape by the sea, but also I have been haunted by those pegged-on breasts hanging like the teeth of a sperm whale strung on

[36] Eluard, *A Pablo Picasso*, p. 36.

the necklace of a Fijian king, germinating sensations of tenderness, admiration and cruelty.

With masterly authority of line and composition, the erotic content of this picture, which is almost unbearable in the completeness of its implications, becomes laden with poetic metaphor. The act of creation is situated in one symbolic seated figure surrounded by the newspaper, the armchair and the linen of our everyday existence. The dream and reality meet in the same monumental statement.

Avignon

Picasso again spent the summer of 1913 in the exhilarating company of his friends and the relaxing heat of Céret. Again a prodigious amount of work was produced, but in addition, the nearness of Spain tempted him to cross the frontier with Max Jacob so as to see a bullfight. In a letter to Apollinaire, dated 2 May, Max Jacob mentions this, and also says that they were all deeply upset by the news of the death of Pablo's father in Barcelona and adds that Eva's health was not good. However they found entertainment in a small travelling circus where they made friends with the girl performers and the moustachioed clowns 'who seemed to have been painted up as a cubist studio joke'.

The following year it was again Provence that attracted Picasso. With Eva he went to stay for several months at Avignon, and was joined by Derain as well as Braque. Again he worked with his usual untiring vigour. A flow of paintings and *papiers collés* of increasing brilliance was the product of this visit, but before the summer ended the situation had changed. On 2 August 1914 war was declared, and Picasso said goodbye at the station to Braque and Derain, who both left hurriedly to join their regiments. The break had come at the moment when Cubism was in full development, when its creative impetus backed by the sensibility of Braque, Gris, Léger and many others gave promise of a great future. There appeared to be no limit to the consequences of its challenge in the spheres of poetry and philosophy as well as art.

Picasso stayed on at Avignon with Eva, sad, worried and solitary. It was not his war. Even when surrounded by friends he had always been alone, taking refuge in his work. Now he was more isolated than ever.

Though he did not realize it at once, the farewell he took of his friends was to be final, for although they returned from the war, he himself said that after their parting in the station at Avignon he never found Braque or Derain again.

The pictures of these summer months however contain a gaiety of colour and an exuberance of form that have tempted critics to label them 'Rococo Cubism'. There is a still-life called *Vive la France* (Plate VIII, 4) because one of the goblets standing on a table, among the vases of flowers, playing cards, fruit and bottles, has written on it the words '*Vive la*' above crossed French flags. The background is an ornate flowered wallpaper. Here, as in the large green canvas *Portrait of a Young Girl* (Plate VIII, 2), the technique of the *papier collé* is imitated in painting. Even the edges of certain areas are given *trompe l'œil* shadows to give the impression that they are actually or partly stuck to the surface. Picasso obviously enjoyed the joke and he has enhanced some patches with bright coloured dots giving a pointillist effect like the texture of sand. Both pictures, typical of this period, betray a lively, almost frivolous mood. Gentle curves describe the forms and the elaborate patterning covers large areas of the pictures, adding to their exuberant charm.

This mood extended to constructions made of the most varied materials and to drawings of a wildly grotesque nature in which realist details are introduced into a cubist structure. In the drawings, features in themselves recognizable as part of the human form, such as eyes, breasts, hair, hands and feet, are the clues in an orgy of distortions which surpass all liberties formerly taken with anatomy. Yet in spite of the outrageous proportions and grotesque expressions, which could suggest that they are no more than a joke, a communication is established. The drawings become clear to a sense which bypasses all logic and belongs to the world of dreams.[37] In this way they can be said to be prophetic of the discoveries of the Surrealists, Max Ernst and Miró, ten years later. They are a truthful account of the reality of the subconscious. 'Surprise laughs savagely in the purity of light.'[38]

[37] See Zervos, *Picasso*, Vol. II**, p. 358.
[38] Apollinaire, *The Cubist Painters*.

7

First World War – Paris and Rome
(1914-18)

Cubism at the Outbreak of War

Since the appearance of the *Demoiselles d'Avignon* the new style had had only seven years to evolve, but the pace of its development had been vertiginous. Its influence had spread in all directions. Even painters of established repute, such as Matisse, who could not endorse its discoveries, found themselves adopting certain of its principles, until it could be said that no artist sensitive to the problems of painting could escape being influenced to some degree. At the same time the storm of anger that Cubism had aroused among academicians and philistines was equally significant. No one in fact who professed an interest in the arts could ignore it. A new conception of the role of painting and the relationship between art and life had come into being.

The accumulation of ideas that had found expression in Cubism and in consequence enlarged the sphere of the arts is too vast in all its implications to be described in a few pages and has not yet been fully understood, but I shall try to make clear some of the most important factors. A primary condition was the disregard for the photographic image of objects. Art was no longer required to copy nature or even to interpret it. Instead it was made to intensify our emotions and associate us more profoundly with nature by endowing the work of art with new powers. These powers however are not the fruit of intellectual speculation; they are closely akin to the primeval heritage of art that had become overlaid with convention and forgotten.

Cubism though revolutionary was not a rupture with the past. It was a positive creation which again brought into the field of our sensibility values well known to primitive man. The insistence on the objective

power of the work of art in its own right has its distant echoes in the wonderful and formidable appearance of Negro masks and fetishes, as well as the ritual images and sculptures of the cave dwellers. Picasso enjoyed making the claim that 'some day we shall paint pictures that can cure a man of toothache', a claim which was also made for the icon and the miraculous images of saints, though other forces considered by us as foreign to the arts such as faith or superstition had to come to their aid. In this case the arts made their appeal independently of religion, forfeiting the advantages and despising the charlatanism that can be part of such alliances.

Every aspect of painting had undergone an inquisitorial revision. Form, colour, light, space, surface textures, signs, symbols and the meaning of reality had all been stripped of their former conventions and reinstated and developed with fresh significance.

Under the rigorous dissection of analytical Cubism objects had lost their momentary superficial appearance; they had been made to reveal their existence as entities plotted in time and space. The new sense of objects conceived in three or even four dimensions seen from many angles had surpassed the narrow convention which required the single viewpoint of Vitruvian perspective. The limited view of an object seen from one given place was inadequate and the new conception introduced two factors of interest: movement on the part of the spectator rather than the object, and knowledge of the object based on more than a limited glance.

Following the ascetic intensity of the analytical period which owed much of its passionate seriousness to Cézanne's long contemplation of nature, the introduction of the *papier collé* came with a disconcerting burst of lightheartedness. Two different conceptions of reality were brought together in the same picture, and just as words can change their meaning according to the context in which they are used, so objects were made to vary in significance, playing more than one role in the manner of a visual pun. I have already mentioned the visiting card or the piece of newspaper which when pasted on to a painted still-life played its part in the composition as an area of colour, light or shade but also retained its own identity. Similarly a piece of black paper cut in the shape of the shadow of a guitar could give the illusion of substance to

the guitar itself. The Cézannean endeavour, which dominated analytical Cubism to give to an object a plastic form, led in synthetic Cubism to the form's becoming an object. Form began to dominate for its own sake and its appearances and implications were examined so as to emphasize its greatest significance; optical effects were exploited; concave forms could be made to become convex; positive and negative were interchangeable. To live in the imagination forms had to achieve a metamorphosis and attain a new reality of their own.

But in spite of its revolutionary trends, Cubism retained an instinctive attachment to classical tradition in more than one respect. With his love of things as entities in themselves, Picasso was never tempted to mutilate an object by cutting it off mercilessly at the edge of the canvas, a habit often exploited by Degas and the painters of atmosphere to whom the plasticity of an object was less important. With the desire of a sculptor to handle things and feel all round them, Picasso, however much he may distort, never makes an arbitrary cut which would leave an object incomplete. Even when it is partly hidden by something else in the picture we are made aware of its presence by transparency or linear implication.[1] In addition to this, whatever it may be, head, figure, guitar, pipe or glass, the object is an entity bathed in the aura of its own reality.

The composition of Cubist pictures owes throughout another important debt to tradition. They are invariably built round a central mass in a manner which recalls the Byzantine icon or such pictures as the *Expolio* of El Greco. The characteristic recurrence of egg-shaped compositions is also reminiscent of the ancient symbol of the universe and the germ of life, the almond-shaped *vesica piscis* which frames the figure of God in Byzantine art.

The far-reaching discoveries of Cubism become a coherent style thanks to the fundamental simplicity of their conception. Geometric simplifications adopted instinctively by the artist allowed him to create new harmonies with the same precision whereby crystals form with the frost.

[1] There is an interesting exception to this general tendency which occurs when words are introduced. For instance the first three letters of the word 'journal' in many Cubist paintings are sufficient to establish a kind of shorthand as evocative as a laborious use of the whole word. Words and shapes require different treatment.

That the creation of the Cubist style is due to the genius of Picasso working in close collaboration with Braque is beyond question, but as Salmon points out, 'the founders of schools, if really they are masters, surpass the framework of the school itself. Picasso had already in 1918 a right to say he knew nothing and wanted to know nothing of Cubism. He playfully asserted that imitators did much better than inventors.'[2] Regardless of the theorizing and stylization inflicted on Cubism by minor followers the work of its originators remains as a source which will continue to fertilize the arts and a revelation which will influence the thought of generations to come.

At the outbreak of war in 1914, however, the great majority of critics on all levels were hostile. A few writers such as Rémy de Gourmont and Anatole France admitted that the Cubists were serious and resolute, even though the public imagined them to be purely frivolous and interested only in the scandal they caused. Even so Jules Romains, after years of reflection, thought that 'the activity of Picasso was no more than a perpetual imposture and that his Cubism roused our illusions'.[3]

In spite of incomprehension and violent opposition, Cubism took root. Although in literature its influence was indirect and interior, it changed the face of the modern world by the power it exercised over painting, sculpture, architecture and the applied arts. Interior decoration, advertising and commercial design imitated its geometric rhythms. But the farther it flowed from its source the less was it understood and the more adulterated it became. Feeble imitations of its angular patterns appeared like a shadow of modernism which spread over textiles, furniture and even female fashions. Though Cubism remained in itself incomprehensible to the public its ghost became popular. In another respect, its origins in African sculpture linked Cubism inevitably with Negro spirituals and jazz. Two very different sources, one the dark primitive communities of the jungle and the other the highly developed society of our civilized cities joined together inadvertently to produce a new musical style with Cubism as an unexpected link.

At an early date during the war the influence of Cubism entered into

[2] André Salmon, *Souvenirs sans fin*, Vol. I.
[3] See Zervos, *Picasso*, Vol. II (Preface), 1942.

the public domain in another way. Gertrude Stein tells the story of how she was walking one cold autumn evening in the boulevard Raspail with Picasso. A convoy of heavy guns on their way to the front passed them, and they noticed to their astonishment that the guns had been painted with zig-zag patterns to disrupt their outlines. 'We invented that,' exclaimed Picasso, surprised to see that his discoveries in the breaking up of forms should have been pressed so rapidly into military service. Realizing the possibilities of using Cubist technique to make recognition of an object less easy in warfare, he said later during the war to Cocteau: 'If they want to make an army invisible at a distance they have only to dress their men as harlequins.' Harlequin, Cubism and military camouflage had joined hands. The point they had in common was the disruption of their exterior form in a desire to change their too easily recognized identity.

Paris Goes to War

Mobilization and war brought with them inevitable confusion and the dismemberment of the various groups of intellectuals who contributed to the modern movement. It struck a blow that threatened to paralyse the movements for ever, leaving irrefutable evidence only in the achievements of the Cubists that a new style had come to life. The disruption and desolation of the next four years were such that it is surprising that all was not lost. As it happened, it was the older and more traditional habits of society that suffered most. The younger generation was able to regroup its energies. The survivors, once freed from the army and reinforced by new blood, became more than ever determined to change the old order which had been responsible for a disaster of such catastrophic consequence.

In common with all Frenchmen of military age, the artists found themselves mobilized and many foreigners who had settled in Paris volunteered in the Foreign Legion. Braque, Derain and Léger were drafted at an early date to the front. To escape internment, Kahnweiler and his German compatriots fled to neutral countries, while others such as Gris found themselves stranded and almost penniless in France. Apollinaire, however, wishing to prove his love of France and to share to

the full the ordeal of his friends, applied for French nationality. Having finally overcome bureaucratic objections arising from '*l'affaire des statues*' he was accepted in the artillery. The same zeal he had shown for the arts and the same loyalty to his friends were now transmitted into the comradeship and the ordeal of battle.

Picasso returned, accompanied by Eva, to his studio in the rue Schoelcher. He found Paris a changed city, robbed of its gaiety and anxiously watching the approach of the German armies. The life as he had known it a few months before was almost eclipsed by the brutal and immediate exigencies of war. To him, whose preoccupation had always been his work, the present upheaval was a heart-breaking display of human stupidity, but he did not, like Apollinaire, feel it to be his responsibility to take an active part in the quarrel. His idea of war was that it was a business for soldiers.

Max Jacob and the Death of Eva

Among the few friends who had not been forced for one reason or another to leave Paris was Max Jacob, whose health made him ineligible for military service. Emotional and delicate, he continued to live a life of passionate disequilibrium. He related to his friends how some years before, while he was in a state of trance in his squalid lodgings in Montmartre, a vision of Christ had appeared to him. As time passed his exalted sense of guilt increased his desire to withdraw into monastic life. As a Jew he could not do this until he had been baptized.

Picasso showed no surprise at his friend's intention but neither was he able to associate himself with the increasing fervour that led Max to his conversion. During the first winter of the war Max had discovered in Montparnasse a priest who was willing to baptize him, and not long after in the presence of Pablo Ruiz Picasso whom he had chosen as godfather, he was admitted into the Christian faith. He received the name of Cyprien, one of the many saints who are to be found in the birth certificate of his Malaguenian friend. Much to the distress of the new convert, Picasso had wanted him to be baptized 'Fiacre' after the patron saint of gardeners, but he was quite willing to give up his joke in favour of this closer and more conventional link. At the ceremony he

ʒave his godson a neatly bound copy of *L'Imitation de Jésus-Christ* in which he wrote 'To my brother Cyprien Max Jacob, Souvenir of his Baptism, Thursday, 18 February 1915, Pablo'.[4]

A letter received by Max Jacob a few months later proves that although Picasso did not take his role of godfather seriously he did not mock either. He wrote: 'My dear godson Max, I am sending you the money you ask for and I shall be very happy to see you again soon. I am deep in house-moving and you will arrive just right to give me a hand such as you have always offered as a friend. You know how little I ask on these occasions: only your moral support, encouragements, in short the friendly hand of Max Jacob. Meanwhile, here is mine, your old friend Picasso.'[5]

There is no certainty that the money referred to in this letter was for Max Jacob himself. The war was causing great hardship to many artists, and about the same time as this undated letter, Max wrote to Salmon asking him to subscribe to a fund he was trying to raise for the Futurist painter Severini who was in danger of dying from hunger and tuberculosis.

In the winter of the same year tragedy came nearer. Eva, 'small and perfect', finally wasted away and died after a short and terrible illness.

In a letter written in November to Gertrude Stein, who was at that time in Spain, Picasso speaks of spending half his time in the metro on his way to and from the nursing-home. Even so he had found time to paint a harlequin and he ends the letter by saying, '. . . in short my life is very crowded and as usual I never stop'.[6] When the end came a month later, a very small group of friends accompanied Picasso to the cemetery. Juan Gris who was among them said in a letter to Raynal at the front: 'There were seven or eight friends at the funeral, which was a very sad affair except, of course, for Max's witticisms, which merely emphasized the horror.' He adds coldly, probably referring to the jokes: 'Picasso is rather upset by it.'[7] We find Picasso writing to Gertrude

[4] See Penrose, *Portrait of Picasso*, p. 41.

[5] Jacob, *Correspondance.*

[6] Elisabeth Sprigge, *Gertrude Stein,* p. 110.

[7] *Letters of Juan Gris,* collected by D. H. Kahnweiler; translated by Douglas Cooper. Privately printed, London, 1956, p. 34.

Stein on 8 January 1916: 'My poor Eva is dead...a great sorrow to me...she has always been so good to me.' He continues, 'I would also be very happy to see you since we have been separated for so long. I would be very happy to talk to a friend like you.' Gertrude Stein, the determined, egocentric materialist pagan seemed a possible source of comfort. She was connected with his past and his nostalgic memories of Montmartre, and was at the same time a refreshing influence on account of her liberty of thought and vigour in action.

Neither the conversion of Max nor the untimely death of his mistress did anything to change Picasso's attitude to religion. He remained detached from its problems and avoided its rites just as he kept aloof from the war which surrounded him but was not his war. There is however a drawing of Christ on the Cross, dated 1915, which is an isolated but very careful study rather in the style of El Greco, which we may choose to associate with his personal feelings at this time. It was not until a new interest in myths and primitive rituals was awakened by his association with the Surrealists in the late twenties that the theme of the crucifixion again appeared briefly but with unparalleled violence.

The Crystal Period

It was impossible for the atmosphere of pessimism shared by so many of his friends not to affect Picasso's work. The exuberance that had crowned pre-war days and at the last moment produced the rococo pictures painted at Avignon was past, doubt once more penetrated his spirit and made it impossible for him to continue in the same vein. Deprived of the company of Braque, Picasso found no other painter with whom he could share in such intimacy the excitement of new discoveries. Matisse spent most of the period of the war in his apartment on the Quai St Michel, but though they met frequently the war did nothing to soften the old rivalry. Minor Cubist painters who followed in Picasso's wake, such as Gleizes, Metzinger, Severini and many others, had developed nothing which could be of interest to him out of their theoretical approach.

The crisis that arose was not due only to the war. The exclusivity of the new style demanded that it should either be pushed even farther

towards the abstract and the decorative or that it should yield, and combine with other modes of expression. The theorists claimed that any return to a more representational art was reactionary and a sign of defeat. Picasso, however, refusing as usual to hedge himself in with rules, continued on the one hand to paint pictures with even greater severity and geometric precision, and on the other to surprise and anger the more consistent but less talented artists by making drawings which were almost photographic in their naturalism.

During the first autumn and winter of the war there was no abrupt change, only a tendency towards a more rigid structure. Space and form began to spread into larger simpler shapes bounded more often by straight lines. Curves became all the more emphatic owing to their rarity. Large rectangular shapes were filled with flat colour or illuminated with dots, often lined up in rows like a pattern on a fabric. In most cases the compositions were based on a central object which could be a man, a guitar, a woman seated in a chair, or a still-life group on a table. The identity of figures and objects was often merged in playful ambiguity.

There are photographs that show the young painter in his studio in the rue Schoelcher, standing in front of some large canvases on which he had been at work for some months, constantly repainting and changing their appearance. In one he wears his working clothes - old patched trousers rolled up at the ankle, a creased jacket and a conventional English cap. His expression is relaxed except for his penetrating stare and in his right hand he clasps firmly that constant companion of those days, his pipe. Another photograph shows him in shorts stripped to the waist. His costume and his well-built muscular physique would suggest a boxer were it not obvious from the background that the ring in which he fights is his world of canvas and paint, his only antagonist being doubt in his mind as to how to express his passionate imaginings.

Before the spring of 1916 a few large pictures were painted of which the *Man with his Elbow on a Table*[8] and the *Guitarist* (Plate VIII, 9) are the most important. They are imposing in their size as well as in the

[8] Zervos, *Picasso*, Vol. II*, p. 255, No. 550.

angular strength of their design. The *Guitarist* is remarkable for a new dramatic organization of light. The simplified rectangular head illuminated by a small circular eye stands out fiercely in front of a light background. Below, the dark mass of the body gains a sense of towering height from tall rectangles which seem to be lit up with spots like the windows of skyscrapers at night. At their base in a horizontal patch of light is a hand holding a guitar. But to realize the complete detachment from atmospheric painting that the new style had attained we must look at pictures such as the *Harlequin* (Plate VIII, 8) painted in 1915, now in the Museum of Modern Art, New York. The clear flat colours are bounded almost entirely by straight lines making contrasts which would be intolerably harsh were not their relations to each other in tone and their proportionate sizes so miraculously balanced. The nervous touches of the brush of the analytical period have been entirely eliminated, as have all other concessions to Impressionist technique. The *Girl with a Mandolin* (Plate VII, 1) of 1910 appears almost sentimental when compared with the calculated severity of this canvas.

It is these qualities, developed with even greater precision in the still-life paintings of the following years, that suggested to Raynal the name 'Crystal' for this period. Such pictures reach their culmination in the two versions of the great composition *Three Musicians* (Plate X, 1),[9] painted in 1921, which I shall discuss later. It was at this moment, however, during the early years of the war, when Picasso had reached a high degree of purity in his style, that he produced a new surprise for his friends.

'Back to Ingres'

It was often said, not without malice, that Picasso would steal anything from anyone if it intrigued him sufficiently. There are those who claim that during his close collaboration with Braque he would hurry home after a visit to his friend's studio to exploit ideas suggested by the work he had just seen. These rumours spread to such a degree, says Cocteau (who was himself not averse from the habit of borrowing, especially from

[9] ibid., Vol. IV, p. 127.

Picasso), that minor Cubist painters would hide their latest pet inventions when he paid them a visit from fear that he would carry off some trivial idea on which they had staked their hopes of fame. It is not the theft however that is important – the world of ideas should have no frontiers – it is what is made of it afterwards. A worse practice which can lead to complete sterility is indicated by Picasso when he says: 'To copy others is necessary but to copy oneself is pathetic.'

During the years when Picasso was discovering Cubism his faculties were fully occupied; he was completely dedicated to his new-found invention, and allowed himself no deviations. At the same time he was conscious of other modes of vision. His admiration for the work of great masters such as Ingres, and his careful study of their paintings in the Louvre during his early years in Paris, may at first sight appear incongruous with his Cubist discoveries. But even during the most hermetic period of Cubism he shared with all great artists a desire to keep in close touch with reality, and knew that there has been more than one way of doing so.

To the surprise of those who were not intimate with Picasso's ways of thinking and working, he again revealed his extraordinary ability as a conventional draughtsman by an increasing number of naturalistic drawings. The subjects were varied; sometimes apples or a bowl of fruit, sometimes a man seated in a chair or a couple dancing. In the summer of 1915 he once more astonished his friends with a careful and exquisite pencil drawing of his old dealer Vollard[10] in which the outline and shaded forms produce an almost photographic likeness, making an extraordinary contrast with the Cubist portrait painted five years before. It is a masterly portrait, irreproachable by academic standards. The line is so sensitive and precise that critics immediately drew a comparison with Ingres.

It is certain that Picasso always had a great admiration for the master of Montauban, but it was not only the faithful likeness of the model traced with sensitive strokes of a pencil that enchanted him. Ingres with his horror of anatomy had been content to think of the curved surfaces of his models without regard for the inner structure. He elongated their

[10] ibid., Vol. II, p. 384.

limbs and rounded their joints in ways that earned him the censure of contemporary critics. His eroticism and his understanding of the female form urged him to include more surfaces of flesh than can be seen from one point of view. It is in fact surprising that this painter who, unlike the Cubists, had a horror of penetrating beneath the surface was close to them in the need he found for distortion, and in his tendency towards a multiple view of the same object. In another way also he anticipated them. His use of colour, in which he denied himself atmospheric effects and used flat unmixed colour, was closer to Picasso's taste and more comparable to the *Harlequin* of 1915 (Plate VIII, 8) than was the complicated mixing of colour practised by Delacroix and the Impressionists.[11]

Several other pencil drawings of friends were to follow the portrait of Vollard. In January 1915 Max Jacob wrote to Apollinaire, who was at that time a sergeant in the artillery at the front: 'I pose at Pablo's and in front of him. He has a portrait of me in pencil which is very much the old peasant, it looks at the same time like my grandfather, an old Catalan peasant, and my mother.'[12] Yet if it offended the vanity of the poet it was acclaimed by all who had not become too fanatically Cubist, as an admirable likeness and a masterly drawing (Plate IX, 1). A year later it was Apollinaire's turn to sit for Picasso. After accepting a commission in the artillery he had returned to Paris with a serious head wound, for which he was trepanned. Picasso did several drawings of him. One in particular (Plate IX, 2) shows him seated, dressed in his uniform, the Croix de Guerre pinned to his breast and his forage cap crowning his head, bandaged as a result of his wounds to which he was eventually to succumb. The criticism of the more bigoted followers of Cubism failed to affect Picasso. He continued to go his own way, working at the same time on conventionally realistic drawings and developing in painting an even more rigorous Cubist technique.

Life during the War

The perilous military situation which had brought the front line close

[11] See J. T. Soby, *Modern Art and the New Past*, University of Oklahoma Press, 1957.
[12] Jacob, *Correspondance*, Vol. I.

to Paris had at least one compensation for those who were suffering the infernal misery of the trenches. They could escape when on leave and find themselves quickly in a very different atmosphere. Montparnasse had by this time superseded Montmartre as the centre for intellectual life, and artists and poets returning from the battlefield gathered where they were certain to meet their friends. The café terraces which were only a short walk from the studio apartment of Picasso in the rue Schoelcher were thronged with those who had arrived unexpectedly from the front. The company was widely international; those in uniform such as Léger, Raynal, Braque, Derain, Apollinaire and many others mixed again with painters, sculptors and writers such as Mòdigliani, Kisling, Severini, Soffici, Chirico, Lipchitz, Archipenko, Brancusi, Cendrars, Reverdy, Salmon, Dalize. There was no lack of talent among them and such encounters were a welcome contrast to the ceaseless roar of cannon and the stench of death not more than fifty miles from the gates of Paris. The dominating mood was one of careless bravado – few while on leave troubled themselves with political or social issues. With death so close their reaction was to joke. Gertrude Stein quotes Picasso as having said cynically: 'Will it not be awful when Braque and Derain and all the rest of them put their wooden legs up on a chair and tell about the fighting?'[13]

Apollinaire with his talent for story telling, mixing fact with fantasy, describes this atmosphere in *La Femme assise*. 'Today,' he writes, 'Paris solicits me; here is Montparnasse, which has become for painters and poets what Montmartre was fifteen years ago, the refuge for their simplicity.' Among his characters in this book is one, Pablo Canouris, 'the painter with the blue hands', who has the eyes of a bird and speaks 'French and Spanish'. Attributing to him both charm and great talent comparable to Picasso's, he leaves the reader in doubt as to what is legend and what is truth. But Picasso did not enjoy the description of a passionate and frustrated love affair with Elvire, a young woman painter, which appears to be a caricature of one of the ephemeral attachments formed by him in the two years that followed the death of Eva.[14]

[13] Stein, *Everybody's Autobiography.*
[14] Stein, *Autobiography of Alice B. Toklas,* p. 183.

Among those who remained in Paris and continued to entertain their friends were Roch Grey (Baronne d'Oettingen) and Serge Férat, who had formerly vigorously supported the review *Les Soirées de Paris* and who continued to participate in its successor, *Sic*. A record of their conviviality is preserved in a drawing made by Giorgio di Chirico which shows, seated at table around a frugal meal, the painter Léopold Survage, Roch Grey, Picasso and Serge Férat, while on the wall above them hangs Rousseau's full-length portrait of himself.[15] Chirico's view of Picasso in this as in other drawings is not flattering. He insists on his short stature and his tough impertinent look, but above all he cannot resist exaggerating the blackness of his eyes which he draws as enormous excrescences ready to drop out of their sockets. It is observation rather than love that emerges from these sketches.

The departure of Kahnweiler from France owing to the war brought several young painters into serious financial difficulties. He had been their friend and a sincere advocate of their work. Fortunately for them a Parisian dealer, Leonce Rosenberg, a convinced supporter of the modern movement, became the wartime centre for their sales. Picasso transferred to him the care of all such transactions until 1918 when his brother, Paul Rosenberg, with whom he had formed a new friendship, became his official dealer, an arrangement which lasted for many years.

In the spring of 1916 Picasso was seized with a desire to move into a house of his own, which he could now well afford. The gloomy atmosphere of the rue Schoelcher with its view over a sea of tombs had continued for long enough, and he decided to move to a small suburban house with a garden in Montrouge. He soon discovered the rashness of this change, for although he was waited on by a faithful servant and there was little to interrupt him in his work, he still needed contact with his friends. In consequence he found that he was scarcely ever at home. Owing to the war, all forms of transport were slow and rare. Whenever he visited his friends in Montparnasse their conversations continued until late in the night, so that a long walk home through dark, deserted streets became almost a nightly event.

These nocturnal wanderings were in fact an old habit. Picasso

[15] See Penrose, *Portrait of Picasso*, p. 42.

enjoyed the sensation of being conscious when others were asleep; it felt like a triumph over death. The absence of noise and movement left more room for his own imagination. He enjoyed the loneliness of the night with its sparse and ghostlike population. It seemed like an echo of his own loneliness, the solitude of genius. But these solitary thoughts were at this time often willingly sacrificed for the company of another mind of great originality. Erik Satie, the composer, lived at Arceuil, in the same direction as Montrouge, but even farther from Paris. His wit, and the highly imaginative and inventive turn of his thought, made him an excellent companion with whom Picasso could enjoy his long trek from the café back to bed.

The Russian Ballet

While he lived in the rue Schoelcher Picasso had often received the visits of an agitated and brilliant poet who, on leave from the front, would dash up the stairs when he came to call with his eyes closed so as to avoid seeing the large plaster moulds of the Parthenon frieze that were its permanent decoration. He plunged eagerly into the unfamiliar atmosphere of Picasso's studio, where again, but for different reasons, he felt uneasy among the Negro masks and strange objects that hung haphazard on the walls. Jean Cocteau, the elegant and talented youth who had already become known for his precocious association with the Russian Ballet, rapidly perceived that even if he could not understand the full significance of Picasso's enormous paintings and the bizarre collection of objects that littered the studio, he had yet some astonishing things to learn. 'Picasso's admiration,' he wrote, 'favours much more what he can use than beautiful accomplishments. It is due to him that I lose less time in gaping contemplation at what cannot be of use to me and I understand that a street song listened to from this egotistical angle is worth "The Twilight of the Gods".'[16]

Cocteau had been working for some months on his second project for a ballet. The first, *Le Dieu bleu,* had been presented in Paris in 1912, and in London a year later, by Serge Diaghilev, the impresario and

16 Cocteau, *Picasso,* Stock.

producer of the Russian Ballet. It was neither good nor successful but during the early years of the war, in spite of the exigencies of military service, Cocteau had evolved rapidly. With the intention of becoming ultra-modern, he made the acquaintance of Erik Satie and obtained his promise to write the music for a ballet which was to astonish the whole world by its originality. The plot was well advanced when he invited Picasso, in the spring of 1917, not only to design the costumes and scenery but also to come with him to Rome, whither the ballet company had returned from America for rehearsals, and there to meet Diaghilev.

Picasso's aversion from travelling and the fact that the ballet, though reputed for its high standard in dancing, had little connection with the modern movement in the arts, seemed to make it hopeless for Cocteau to succeed in dragging Picasso away from Paris. However to the astonishment of all and with the insistent disapproval of serious-minded Cubists, Picasso accepted. In February he started for Italy on a journey which was to have lasting consequences for him and for the future of the ballet.

Since the first season of the Russian Ballet in Paris in 1909, Diaghilev had entertained his audiences with displays of oriental grandeur in the costumes and scenery of Bakst, whose taste for lascivious opulence had a savour of the romanticism of the nineties. Diaghilev, however, with admirable judgement, realized that the unrivalled talent of his dancers and musicians must be brought into contact with the contemporary movement in western European painting. This was to become all the more important when the return to its native land of the ballet loved by the Tsar became impossible owing to the Revolution. The acceptance of Cocteau's project, in which two such revolutionary figures as Picasso and Satie were to take part, was an adventurous step for Diaghilev, the first which later was to classify his ballet in every way as the spearhead of the *avant-garde*. It opened the way for many other productions which were to make it one of the most important manifestations of the modern movement for the next ten years.

Cocteau had devised a theme which was eminently suitable to Picasso. Its title *Parade* at once conjured up ideas of the circus and the music hall with their glamour, their illusions and their garish entertainment. Formerly in Montmartre and Barcelona Picasso had

watched theatrical performances with keen eyes from the auditorium or the wings. His paintings of the lean harlequins were comments on life behind the scenes, but on this occasion he had been asked to join the company and work with them. All these circumstances added to the enthusiasm with which he set to work in Rome. There he at once made the acquaintance of Diaghilev and those who surrounded him. These included two brilliant young Russians who were to become close friends of Picasso, Stravinsky and Massine.

'We made *Parade* in a cellar in Rome where the troupe rehearsed...we walked by moonlight with the dancers, we visited Naples and Pompeii. We got to know the gay Futurists,' wrote Cocteau. Picasso had in fact met Marinetti in Paris as early as 1909. The leader of the Futurists and his disciples had watched keenly every new development in Cubism and had worked out their divergent ideas of painting. Futurism differed from Cubism fundamentally in the way it stressed the importance of movement and the machine. Picasso, as we have seen, had not neglected the idea of movement in painting, but the methods he favoured were more subtle and indirect. He did not despise their efforts, but the only painter among them whose talent he really admired was Boccioni, who was killed on the Italian front. Differences of opinion, however, did not interfere with their friendship, and the Italian painters were willing to lend a hand in the making of the framework of some of the more extravagant costumes and in helping Picasso to paint the enormous drop curtain.

The visit to Italy was quickly over. After a month in Rome and a few days in Florence and Milan, Picasso was back in Montrouge. Work between the trio, Cocteau, Satie and Picasso, did not always continue smoothly. On several occasions the patient Satie was on the point of abandoning the project. Had it not been for his admiration for Picasso, to whom at one time he wished to dedicate his music, it is unlikely that *Parade* would ever have been produced. In a letter to his talented young friend Valentine Gross (afterwards Valentine Hugo) Satie unburdened himself. 'If you only know how sad I am,' he wrote; '*Parade* is changing, for the better, *behind* Cocteau! Picasso has ideas that please me better than those of our Jean! And Cocteau doesn't know it! What can be done? Picasso tells me to continue with Jean's text, and he, Picasso, will

work on another text, *his own* – which is astounding! Prodigious!

'I am getting frantic and sad! What can be done? Knowing the wonderful ideas of Picasso, I am heartbroken to be obliged to compose according to those of the good Jean, less wonderful – oh! Yes! Less wonderful! What can be done? What can be done? Write and advise me. I am frantic. . .'

Fortunately the crisis passed and a week later Satie wrote again from Paris: 'It's settled. Cocteau knows all. He and Picasso have come to understand each other. What luck!'

The first performance of *Parade* was fixed for 17 May 1917 at the Théâtre du Châtelet where in spite of the war the Russian Ballet was to give its first wartime season. At the appearance of the great drop curtain (Plate IX, 4) accompanied by Satie's sombre music for the overture there was a sigh of pleasure and relief. The audience who were expecting to be outraged, instead found themselves bewildered by the fact that the inventor of Cubism should present them with something that they could understand. The curtain was a delightful composition in a style which was only indirectly Cubist; it owed its inspiration rather to the popular art of the circus poster. Its subject resembled a backstage party among the harlequins and circus folk of pre-Cubist days in a happy tranquil mood. A large white mare with wings attached by a girth quietly licks her foal while it nuzzles up under her for milk. A ballerina with budding wings standing on its back reaches up to play with a monkey above on a brightly painted ladder. In the foreground are familiar circus objects such as an acrobat's ball and a drum lying near a sleeping dog, while in the distance behind the folds of the tent can be seen a romantic landscape of ruined arches. The colours, mostly greens and reds, are reminiscent of the tender melancholy light in which the *saltimbanques* appeared ten years before. In their reappearance they seemed less soulful, having gained new vitality in a style strengthened by the disciplines and inventions of Cubism.

The delightful hopes offered by the drop curtain were however to be shattered as the curtain rose. The music changed; sounds 'like an inspired village band' accompanied by the noises of dynamos, sirens, express trains, aeroplanes, typewriters and other outrageous dins broke on the ears of the startled audience. The technique of collage and the

puns of Cubism suggested to Cocteau the name of 'ear deceivers'
noises. They announced, together with rhythmic stamping
anized accident', the entry of the gigantic ten-foot figures of
rs'. Only the legs of the performers showed beneath
ctures built up of angular Cubist agglomerations. The
r carried at the end of a grotesquely long arm a long
e his other, real arm, pounded the stage with a heavy
erican manager, crowned with a top hat, carried a
a poster showing the word 'Parade'.[18] Both were
rms in silhouette appropriate to their native scenery;
enchman was outlined with shapes suggesting the
ds and the figure of the American towered up like a
d manager was a horse. Its head held high on a long
the fierceness of an African mask. Two dancers
ly pranced about the stage with perfect realism. It
lour that the audience was shocked. The backcloth
, it represented houses in perspective with a
ke an empty frame in the centre. The costumes of
...agers, including the horse, were also sombre. Among the other
dancers the dazzling Chinese conjuror, with his angular movements,
seemed like some brilliant insect.

In addition to the managers there were only four dancers. The
Chinese conjuror, danced by Massine, wore a costume of brilliant
yellow, orange, white and black with bold patterns symbolizing a rising
sun eclipsed in wreaths of smoke; his headdress in the same colours
looked like flames or petals of a flower. Cocteau's directions for his
miming were: 'He takes an egg out of his pigtail, eats it, finds it again
on the end of his shoe, spits out fire, burns himself, stamps on the
sparks, etc.' With the conjuror appeared a little girl who 'runs a race,
rides a bicycle, quivers like the early movies, imitates Charlie Chaplin,
chases a thief with a revolver, boxes, dances a rag-time, goes to sleep,
gets shipwrecked, rolls on the grass on an April morning, takes a
Kodak, etc.' The other two dancers were acrobats, their tight-fitting
costumes were decorated in blue and white with bold volutes and stars,

17 See Zervos, *Picasso*, Vol. II**, pp. 404, 405.
18 ibid., Vol. II**, p. 406.

'simpleton, agile and poor...clothed in the melancholy of a Sunday evening circus' they danced a parody of a *pas de deux*.[19]

The managers fulfilled the function of scenery. Their size reduced the dancers, whom they introduced to the unreal proportions of puppets. As they stumped about the stage they complained to each other in their formidable language that the crowd were mistaking the preliminary parade of the actors for the real show which was to go on inside their theatre, and for which no one had turned up. Finally their fruitless efforts brought them to a state of exhaustion and they collapsed on the stage, where they were found by the actors, who in turn also failed to entice an imaginary crowd inside for their performance.

The plot was simple and inoffensive enough but Cocteau managed to mystify and outrage the audience by calling it a '*ballet réaliste*'. To them the deliberate confusion of real and unreal was inadmissable in a ballet just as it was incomprehensible in Cubist paintings. The same conception had penetrated Satie's music. He had formerly annoyed an audience by calling some of his compositions for the piano '*petits morceaux en forme de poire*'; and in this case, to explain the strange mixture of sounds, he said modestly, 'I composed a ground for certain noises that Cocteau found indispensable to determine the atmosphere of his characters'.

As the ballet came to an end the mounting anger of the audience expressed itself in an uproar. The Parisian intelligentsia were incensed, believing that they had been made a victim of a farce produced to make them look ridiculous for having sat through it. Cries of '*Sales Boches*' (the worst possible insult in the wartime atmosphere of Paris) were shouted at the company. The audience rose to their feet in an ugly mood menacing the producer as well as Picasso and his friends. The situation was saved however by the presence of Apollinaire. The black bandage on his head and his Croix de Guerre commanded respect. Patriotism and sentimentality finally prevailed over the audience's conviction that they had been insulted.

Parade was an event of importance in the growth of the new spirit in the arts. Apollinaire had written an introduction in the programme with

[19] Cocteau, *Le Coq et l'Arlequin*, p. 74.

the title '*Parade et l'esprit nouveau*'. It described the ballet with enthusiasm and spoke of its significance in the dawn of a new era. There was hope that the modern movement, which was proving that it could survive the disruption caused by the war, would soon blossom into new wonders. He claimed that the fusion of the designs of Picasso and the choreography of Massine produced a kind of super realism (*surréalisme*) which heralded the New Spirit. It was to him 'the starting point of a series of manifestations... which should completely alter both arts and manners'. He added that 'the spectators will certainly be surprised, but in the most agreeable way; and charmed, they will learn to understand all the grace of the modern movement of which they have no idea'. Apollinaire was right. In spite of the uproar at the first performance, Diaghilev produced *Parade* again. With each production it won more respect but the total number of its performances was not great. It remained a ballet for the élite and a victory in the campaign of the *avant garde*.

Picasso stepped into his new role as theatrical designer with the same assurance that had won for him his entrance to the academies of Barcelona and Madrid. Léon Bakst, who had until then been the most popular stage designer for the ballet, wrote a generous introductory note for *Parade*. In it he praised the way in which Picasso had discovered a new branch of his art, and showed how the collaboration of the great painter with Massine had led to a new choreography and a new form of truth.

Picasso had influenced the ballet, but the ballet was also to have its influence on him. Not only did it give him a chance to paint on a larger scale than had been possible hitherto, and to see his costumes and construction realized, and moving in space and light, but also it brought him into a close relationship with the human form. Since 1906 his constant interest in the natural beauty of the figure had been overlaid by the stylistic problems of Cubism, in which the still-life composed of a quota of domestic objects had furnished the greater part of the subject matter. But humanity is the inexhaustible source of Picasso's inspiration, and the ballet accelerated his return to a less exclusive repertoire.

Rome, and the exhilaration of a troupe of dancers of amazing talent,

provided the first stimulus which was to dissolve the melancholy of the early war years and the loss of Eva. Unable to live without the company of women, Picasso had indulged in a few passing flirtations since her death; but it was not until he set eyes on Olga Koklova, one of Diaghilev's dancers, in Rome that a new influence of lasting importance came into his life. During the war he had introduced several of his temporary mistresses to Gertrude Stein at her apartment in the rue de Fleurus – all of them girls of intelligence, beauty and often of talent, but none managed to win his heart.

The dancer Olga Koklova, who attracted his attention among so many, was not a great ballerina. She had taken her part in the *corps de ballet*, and as one of the four girls in *The Good-Humoured Ladies*, in which she made her first star appearance in 1917, she had reached the high standard demanded by the tyrannical Diaghilev. Olga Koklova was the daughter of a Russian general, it was in her tradition to be associated with fame, and the ballet, which she had joined against her father's wish, was her first step on this path. She was captivated by its glamour. Even when she had ceased to be part of the troupe she kept in close touch with her Russian friends and continued to practise her dancing. But with the arrival of Picasso in Rome her career as a professional ballerina came rapidly to an end.

A Visit to Barcelona

When after the Paris season Diaghilev took his ballet to Madrid and then to Barcelona, Picasso went with him. In the Catalan capital it was received with enthusiasm, though experiments such as *Parade*, considered too advanced for a more provincial Spanish audience, were omitted. Joan Miró, who was then a student at the art school of Francisc Gali, remembers how he watched every performance from the gallery, and, what was even more important, how he heard of Picasso for the first time.

On his return to his home, Picasso was welcomed by his old friends. They once more gave him a generous reception and entertained him at the music halls of the Parallelo during long nights with flamenco dancing and parties given in his honour. A photo taken in the studio of

a friend shows him surrounded by his admirers, such as Miguel Utrillo, Iturrino - the painter with whom he had shared Vollard's gallery in 1901 - Angel de Soto, Ricardo Canals and more than a dozen others.

It was five years since Picasso had been in Barcelona; during that time his father had died and his mother had gone to live with her daughter Lola who had recently married a doctor, Don Juan Vilató Gomez. Though he did not neglect his family, Picasso preferred to escape from their admiration and affection. He stayed in a hotel near the harbour. From the window he painted a landscape with the monument to Columbus which stands at the end of the Ramblas as its central feature.[20] The picture is the forerunner of a series of variations on the theme of a window looking into the brilliant light of the Mediterranean, flanked by shutters, with a table loaded with objects and backed by the silhouette of the ironwork balcony. In this case, however, the central feature, the table, is missing.

There is also a portrait of a girl with a mantilla,[21] painted in pointillist technique, which is both the first realistic portrait in oils for many years and one of the last examples of a systematic use by Picasso of Seurat's methods. These with a dozen other paintings he left with his mother when he returned to Paris. When she settled in her daughter's home she had taken with her the large crumpled canvases of his youth. *Science and Charity* and *The First Communion* covered the walls on which they remained for many years guarded jealously since the death of Señora de Ruiz Picasso by Señora de Vilató and her sons and daughter.[22]

It is perhaps of some significance that during this short stay in Barcelona, those paintings which are the more traditional in style are the more accomplished. Cubism had relaxed its rigour and given way to a manner which, although less exciting to the intellect, was more readily a vehicle of his present emotions. This can be seen in the still-life and figure paintings, which, though Cubist in style, contain a flow of curves or an angular movement not unlike the stylized gestures of

[20] See Zervos, *Picasso*, Vol. III, p. 19, No. 47.

[21] ibid., Vol. III, p. 17.

[22] These and many other paintings and drawings from early years and the visit in 1917 to Barcelona were presented by Picasso in 1970 to the Museum in that city established in his honour. See pp. 469-71.

marionettes.[23] It is still more evident in the realistic painting of a harlequin,[24] now in the New Museo Picasso of Barcelona. The picture in which he seems to have concentrated the maximum of his emotion, however, is a painting of Olga wearing a mantilla (Plate IX, 5). This portrait, the first of Olga, is painted with conventional consideration for the beauty of his young love. It presents her with great tenderness and a realism which surpasses even that of the pencil drawings of Max Jacob and Vollard. Those who see in Picasso the enemy of classical beauty are here obliged to admire his power to master the conventional idiom in its most human and unambiguous form. Yet beneath the smooth oval of the young and sensitive face we can divine a temperament already formed and unwilling to compromise. The dark discerning eyes appear to have settled on the object of their adoration with a possessive intent, and the straight delicate mouth set firmly above a well-developed chin hides its resolution behind a faint smile. Picasso gave the portrait to his mother, who treasured it for many years.

In addition to this evidence of a strong amorous preoccupation there exists a series of drawings of the bullfight, made during these same summer months (Plate IX, 6). Among the varied and significant events of the *corrida* it was the battle between the bull and the victim of its outrageous bestial courage, the horse, which interested Picasso. Plunging its horns deep into the horse's belly the bull holds its dying prey disembowelled and pinned to the ground. The agony of the horse, its neck stiffened in a final ejaculation, can be taken to be symbolic of the supreme act of love and of death. Its towering phallic head searching for a release from its mortal destiny is a symbol which recurs later in the painting of Picasso. It finds its most dramatic expression nearly twenty years later in the studies for *Guernica*.

The image of the horse gored by the bull is too complex for a simple sexual interpretation. It cannot be dismissed merely as a sign of brutish domination. It is rather the uncontrollable escape of the spirit, symbolized in the death throes of the horse, its neck stretched as though in a final orgasm. It is the gesture of the victim, analogous in Picasso's memory with the awful appearance of his friend the German painter

[23] Zervos, *Picasso*, Vol. III, pp. 18, 20.
[24] ibid., Vol. III, p. 11.

who was found hanged from the rafters of the Bateau Lavoir. Was this similarity between the act of creation and the giving-up of the ghost a meaningless coincidence?

Marriage and the Move into Paris

When the Russian Ballet left Barcelona on a tour of South America, Olga Koklova stayed on with Picasso. The attachment between the Russian ballerina and her Spanish lover had grown rapidly. She spoke French fluently and enjoyed the long fantastic stories that he told her in his thick Spanish accent. In the autumn of 1917 they returned together to his suburban villa at Montrouge, where she settled in with the faithful servant, the dogs, the caged birds and the thousand and one objects that had followed Picasso from one abode to the next in ever-increasing numbers. But this temporary solution satisfied neither Olga nor Picasso himself. Montrouge had been useful as a retreat. He had worked there spasmodically and often at night, sometimes kept awake against his will by bombardments. On one occasion, finding the din too great, he searched the house for a canvas on which to work, and finding none he picked on a painting by Modigliani which he had acquired. Setting to work on it with thick paint which allowed nothing to show through, he produced a still-life with a guitar and a bottle of port.

On 12 July 1918 Picasso married Olga Koklova. Those who came to the wedding were his friends rather than hers. In compensation, the civil wedding at the Mairie of the 7th Arrondissement was followed by the long rites of the orthodox Russian ceremony. Apollinaire, Max Jacob, and Cocteau were the witnesses. Only two months before, Picasso had similarly paid his respects to Apollinaire at his wedding which had taken place at the church of St Thomas Aquinas, near where the poet lived in the boulevard St Germain.

The wedding was soon followed by a move towards the centre of Paris. The rue la Boétie is a busy thoroughfare in a fashionable quarter with shops dealing in carpets and expensive semi-antique furniture. About this time art dealers such as Paul Guillaume, one of the first to collect African sculpture, were moving into this neighbourhood. In his gallery in the Faubourg St Honoré he held, early in 1918, a joint

exhibition of Matisse and Picasso. The public were again mystified, as they had been by the drop curtain of *Parade*, to see among work they still failed to understand a few paintings showing a return to realism. In the catalogue Apollinaire explained almost apologetically: 'He changes direction, comes back on his tracks, starts off again with firmer step, always becoming greater, fortifying himself by contact with unexplored nature or by the test of comparison with his peers from the past.'

Close to this new gallery Picasso took a two-storey apartment that had been found for him by his new friend, Paul Rosenberg, whose brother Leonce had opened a gallery in a neighbouring street. Paul Rosenberg had dealt chiefly in the old masters. He quickly recognized, however, the genius of the creator of Cubism, although he had no use for his brother's idealism in shepherding the whole Cubist flock. In the rue la Boétie he opened his own gallery next door to Picasso, who now became surrounded by dealers as formerly he had been by artists. But Paris is a concentrated city and the move away from the bohemian cafés of Montmartre and Montparnasse did not mean that he was cut off from his friends, though one of them wrote, 'Picasso now frequents "*les beaux quartiers*".'

Olga took an active part in seeing that the new drawing-room on the street and dining-room giving on to a garden were furnished according to her taste, and that there were sufficient good-looking chairs to seat the numerous visitors whom she intended to entertain in correct style. Picasso made his studio on the floor above, taking with him his hoard of objects that had found their way into his life by choice or by chance. The pictures by Rousseau, Matisse, Renoir, Cézanne and others were hung haphazard or propped against the walls, recreating the favourable atmosphere of disorder.

Guillaume Apollinaire

After months of treatment in hospital, Apollinaire had recovered from his wounds sufficiently to take up his literary activities again. New books and articles from his pen once more appeared in the *avant-garde* publications of Paris, while an exchange of ideas went on between him and writers who had taken refuge in Switzerland and America. *Les*

Mamelles de Tirésias, a light-hearted drama, had its single stormy performance soon after the scandal caused by *Parade.* Apollinaire had called it a 'surrealist' drama, but a critic referred to it as a 'Cubist play'. This annoyed the more purist followers of the movement he had formerly championed. They sent to the press a letter of protestation against Apollinaire, claiming that he had made them look ridiculous.

At the moment of Apollinaire's wedding in the summer of 1918 there was a feeling of optimism, which proved to be short-lived, that his health was improving. The severity of his wound had reduced his vitality and in the autumn of the same year he fell a victim to the virulent epidemic of Spanish influenza that accompanied the Armistice. He died just at the moment when the streets of Paris were decked with flags and the crowds beneath his window were shouting 'Hang Guillaume!' Hearing the cry from his deathbed he had to be reassured by his wife that the 'Guillaume' they were out for was the German emperor.

The same day Picasso remembered walking at dusk along the windswept arcades of the rue de Rivoli. As he passed in the crowd, the crêpe veil of a war widow blew across his face, wrapping his head so that momentarily he was blinded. This was the prologue to the news which he learned by telephone shortly after, that Apollinaire whom he loved had just died. The call came while he was drawing a portrait of himself in the mirror, a portrait which marks the end of an epoch for two reasons. A great friend had gone and Picasso, with this drawing, abandoned his habit of making frequent lifelike self-portraits. With the death of Apollinaire Picasso lost the most understanding of his youthful friends. He was overcome with grief. The suddenness with which the end had come paralysed his thoughts. At his request Cocteau wrote to Salmon saying: 'Poor Apollinaire is dead – Picasso is too sad to write – he has asked me to do so and deal with the notices to the press.' For the large circle of devoted friends and those others who admired Apollinaire for his courage and patriotism, the frenzied rejoicing at the victory of the allies was eclipsed by their sorrow.

Three years later a committee of the friends of Apollinaire asked Picasso to design a monument to be set up on the grave of the first champion of Cubism. Sufficient funds were finally raised, but for

reasons which remain obscure the monument failed to be erected. Certain writers claim that Picasso never made a suitable design,[25] but in spite of his aversion from producing anything to order, Picasso did make a series of drawings and small sculptures in 1927-8 which he showed to the committee. His ideas varied from a monument of massive anthropomorphic shape (Plate XII, 1) to elegant linear sculptures made of metal rods (Plate XII, 3) which drew in space three-dimensional outlines based on the human form. Picasso told me that the committee turned all these down as unsuitable. 'But what did they expect,' he added. 'I can't make a muse holding a torch just to please them.' Although a partial solution was found in the monolith designed by Serge Férat which now marks Apollinaire's grave in the Père Lachaise cemetery, there was a strong feeling that some day a sculpture by Picasso should commemorate the greatness of his friend.[26]

The Armistice

With the end of the war Paris at once regained its position as the centre of attraction for artists, poets and philosophers throughout the world. It was largely the prestige of the modern movement and the widespread influence of Cubism that drew to it again the younger generation, now disillusioned and angry at the madness to which life had been reduced during the past four years. They blamed society for its blindness and violently opposed the pious hopes that there should be a return to tradition and pre-war values both in art and life. The war, it had been claimed, was to end war, with the result that victory became an excuse for self-complacency.

In reaction to these tendencies small groups had sprung up during the war in Switzerland, Germany, England and the USA. Although the difficulty of communication hampered their contact with each other they showed remarkable affinities in their ideas. In Switzerland, sheltered by neutrality, a group led by Tristan Tzara and Jean (Hans) Arp came into being. There was a close similarity between their contempt for the rules that should supposedly govern art and the ideas

[25] Marcel Adéma, *Apollinaire*, p. 271.
[26] See p. 430.

making themselves felt in New York in the work of Marcel Duchamp, Picabia and Man Ray, and later in the more political attitude of Richard Huelsenbeck in Berlin.

The first sign of the new movement in Europe was the opening of the Cabaret Voltaire in Zürich in May 1916. Hugo Ball, its founder, was a pacifist and a poet, fanatically devoted to the movement in which the names of Picasso and Apollinaire stood out as the main sources of inspiration. He inaugurated his premises as a place to exhibit the work of contemporary artists and hold debates. The catalogue of his first exhibition contained poems and other contributions by Apollinaire, Arp, Cendrars, Kandinsky, Marinetti, Modigliani, and Tzara. The exhibition contained four etchings and one drawing by Picasso. This was followed in July 1917 by the first number of the review which took the name of the new movement, *Dada*. In its desire for a clean sweep of the hypocrisy of the past, Dada wished to destroy everything, even that which had so recently been considered admirable. To the Dadaists 'Cubism, marvellous in certain aspects...was drifting towards an odious estheticism'.[27] A new, more violent attack was to gather force in Paris as soon as the way became open.

The outcry of the Dadaists had however no immediate effect on Picasso. That they should attack his less inspired followers who were attempting to create a 'school' from their superficial understanding of his inventions did not trouble him, any more than did the tendency towards abstraction of painters such as Arp and Kandinsky, and the more distant theories of the Russian constructivists. He had already sown the seed of many conflicting tendencies. Two such opposite styles as the pure design in line and colour of Mondrian on the one hand and the poetic imagery of Max Ernst on the other both owed much to his work. With his perpetual curiosity he watched the new movements and continued on his own course.

Biarritz

For the first time since he had said good-bye to Braque and Derain at

[27] Georges Hugnet, 'Dada and Surrealism', *Bulletin of the M.O.M.A.*, New York, November–December 1936.

Avignon at the outbreak of war, Picasso returned to the south of France in the late summer of 1918. This time it was in response to the invitation of a rich Chilean lady, Madame Errazuriz, who had taken a villa at Biarritz as a refuge in the early days of the war. It was in her salon in Paris that Picasso had begun to work on *Parade* with Satie and Cocteau in the autumn of 1916. Now, with a feeling of relief that the war was coming to an end, he and his young bride spent several weeks enjoying the luxury of the villa, and revelling in the sea which from his childhood in Malaga and Corunna had always been one of his loves.

The ocean beaches and new company provided a relief from the noise and the dust of Paris at war. Picasso showed a sociable interest in his holiday surroundings by drawing portraits of his friends and their children. It was here that he˙met Paul Rosenberg, who lived with his family near by, and one picture he found time to paint was a portrait of Madame Rosenberg seated in a decorative chair with her child on her knee;[28] another is a small painting of girl bathers with the Biarritz lighthouse in the background.[29] The artificial poses of the girls relate them more closely to the mannerist pictures of 1902 to 1904 than to Cubism, but the standing figure that dominates the composition is twisted in such a way that both her front and back are visible, a liberty in distortion which does not occur elsewhere at that early date. More important than this painting is a drawing of girls on the beach (Plate X, 6). The delicacy of the line, and the ease with which subtle distortions in the manner of Ingres can be accepted, puts this drawing among the highest classical achievements of graphic art. The movements of the girls are so balanced and the space so organized that the fifteen nude figures that enter the composition are nowhere crowded by each other. Several other complex drawings of figures were done during these weeks, the main theme being the serenade. Picasso clothed his guitarists in the costumes of the commedia dell'arte, which had impressed him in Rome. Accompanied by cherubs and barking dogs, they perform to

[28] See Zervos, *Picasso*, Vol. III, p. 85. Alexandre Rosenberg remembers a story of his mother's displeasure at Picasso's version of her charms. She told him firmly that she would rather have been painted by Boldini, the fashionable Parisian portrait painter of the day. Silently Picasso took another canvas and a few minutes later presented her with a perfect example in the style she desired, signed Boldini.
[29] ibid., Vol. III, p. 83.

reclining odalisques in a series of charming studies.[30]

Besides these idyllic drawings Picasso found time to paint murals appropriate to his amorous mood on the whitewashed walls.[31] In a space between two nude female figures, over a drawing of a vase of flowers, he wrote a verse from '*Les Saisons*' of Apollinaire:

> *C'était un temps béni nous étions sur les plages*
> *Va-t'en de bon matin pieds nus et sans chapeau*
> *Et vite comme va la langue d'un crapaud*
> *L'amour blessait au cœur les fous comme les sages.*

On hearing of this, Apollinaire, who was living at that time in Paris, wrote back, just two months before he died, to Picasso, 'I hope your wife is well...I am very happy that you have decorated the Biarritz villa in this way and proud that my verses should be there.' He then continued by describing a new trend in his thought which coincided with Picasso's return to classical realism. 'The poems I am writing now will enter more easily into your present preoccupations. I try to renew poetic style but in a classical rhythm... On the other hand, I do not want to slip backwards and make a pastiche.' He then explains his intentions further by making a contrast between authors: 'Is there today anyone more fresh, more modern, more exact; more laden with richness than Pascal? You appreciate him I believe, and rightly. He is a man we can love. He is closer to us than a Claudel who only dilutes with some good romantic lyricism vulgar theological generalities and political or social truisms.'[32] Apollinaire was referring to conversations he had had lately with Picasso in which they had both agreed that thought and intuition could be more illuminating than obedience to reason. But this was as far as Picasso went in his appreciation of Pascal. Neither then nor at any other time did he share the religious convictions of the philosopher of Port Royal. Firmly and persistently he repeated, '*Il n'y a pas de bon Dieu.*'

[30] ibid., Vol. III, pp. 72, 73.
[31] ibid., Vol. III, p. 80, Nos. 229, 230.
[32] Lettre inédite d'Apollinaire à Picasso, 11 September 1918, *Cahiers d'Art*, 1947, pp. 142-3.

8

'Beauty Must be Convulsive'
(1918-30)

The Ballet in London

In September 1918 the Russian Ballet arrived in London and stayed there for nearly a year, ending with a season more brilliant than ever before. Diaghilev again sought the cooperation of Picasso. During the season in July at the Alhambra Theatre in Leicester Square he risked a second production of *Parade*, and put on a new ballet, *The Three-cornered Hat*, for which Picasso had designed the costumes and scenery.[1] The music was by De Falla and the theme a Spanish tale, in which an old grandee tries to use his authority to seduce the wife of a young miller and fails lamentably, much to the delight of the village folk and the audience. Nothing of the revolutionary nature of *Parade* was involved, but the theme gave Picasso admirable scope to utilize and enjoy the atmosphere of his native country in the costumes and scenery.

Another new production during the London season was *La Boutique fantasque*, for which Derain had been asked for the first time to design the costumes and scenery. He accomplished this with admirable charm, contributing a ballet as French as Picasso's was Spanish to Diaghilev's repertoire. Picasso was once more persuaded to leave Paris. Both he and Derain came to London to supervise the painting of the scenery, which was done skilfully by Vladimir Polunin and his English wife Elizabeth.

The Three-cornered Hat proved to be a most popular ballet from the start. The simple outlines and dry colour of the backcloth, with its gigantic pink and ochre archway against a pale blue sky filled with stars, showed little trace of Cubism except in the organization of the angular walls of the houses. Like De Falla's music, it was saturated with the

[1] See Zervos, *Picasso,* Vol. III, pp. 107, 109, 110 and 111.

warmth and excitement of the Spanish night. The rhythms of flamenco dancing, which Massine had learnt during his visit to the Peninsula, were given a masterly interpretation by the cast dressed in costumes admirably adapted to the action. In his designs Picasso had instinctively drawn on the curves and zig-zags characteristic of the flourishes and patterns used by Spanish peasants as decorations for their wagons and mule-harness, rhythms that probably descend from the calligraphic arabesques of the Moors. The acid contrasts of greens, pinks, scarlet and black were equally evocative of Spain. 'All the costumes are, without exception, full of warmth and strength but tempered with a taste for dignity which is very Andalusian,' wrote the critic Jean Bernier. The drop curtain, for which many sketches are in existence, had also been greeted with applause. In the foreground a man and a group of women in Spanish costumes look over a balcony. In the arena is seen the end of a fight from which the dead bull is being dragged off by mules, but here again the technique of Cubism was not in evidence and the audience were put to no strain in their enjoyment.

It was now nearly twenty years since Picasso had originally dreamt of crossing the channel to the city that had inspired him in his youth. But since the day he had left Barcelona as a hungry youth in search of a country of bold, beautiful and emancipated women and a society in which the aristocrats were eccentric poets and the beggars wore top hats, much had happened to modify his hopes. He arrived instead as an artist already famous, and with Olga at his side he chose to stay at the Savoy Hotel where the ballet company had made their headquarters.

As was to be expected, Picasso worked hard on the last-minute preparations of the *Three-cornerd Hat*, supervising the painting of the scenery and adding final touches to the costumes at rehearsals. He even appeared in the wings on the opening night with paint and brushes to add his last ideas to the costumes on the dancers before they appeared on the stage. The dancers themselves were enchanted with the results. Karsavina, who danced the role of the Miller's wife opposite Massine, said afterwards that the costume he finally evolved for her 'was a supreme masterpiece of pink silk and black lace of the simplest shape; a symbol more than an ethnographic reproduction'.

The arrival in London of the Russian Ballet came at the moment after the war when it had suddenly become fashionable to take an interest in the arts, and in particular those which could be styled *avant-garde*. The ballet provided a combination of the prestige of great dancers and the scandal caused by young revolutionary artists, which both pleased the snobs, and on another plane, attracted the attention of the intellectuals. The painstaking work of Roger Fry, seconded by Clive Bell, had persuaded the élite of Bloomsbury to open an eye towards modern painting. With rare exceptions these pioneers failed to arouse a genuine appreciation of the modern movement in art even in their own circle. The general admiration for the perfection of the ballet, with its music and its dancing, helped them however to bring to the attention of an otherwise unreceptive public the work of painters such as Picasso, Derain and later Matisse. It was a roundabout way of convincing London, which in those days was always ten years late in its appreciation of the modern movement, of their importance; but it bore its fruits when three years later the first important exhibition of over seventy of the works of Picasso was held at the Leicester Galleries with a preface to the catalogue by Clive Bell.

The social life that accompanied the success of the ballet drew Picasso and his wife into a round of rich parties. Olga was delighted at these attentions and Picasso, unlike Derain, who took his applause in a plain blue serge suit and sought more bohemian society, ordered himself suits at the best tailors and appeared at fashionable receptions immaculately dressed in a dinner jacket.

Clive Bell describes a party given in honour of the two visiting painters by Maynard Keynes in the house they shared in Gordon Square. They had invited, he says, to meet Picasso a few unfashionable friends. Other guests from the ballet were Ansermet, the conductor whose famous beard is well known from the drawing Picasso made of him in Barcelona, and Lydià Lopokova, a friend of Olga's, whose dancing had won the hearts of many Londoners and in particular of Keynes himself whom she was later to marry. Waggishly the hosts placed Ansermet at the head of one table with Lytton Strachey to match with his beard at the head of a second. To meet the distinguished guests they invited 'some forty young or youngish painters, writers and

students – male and female'.[2]

The compliment was returned by Picasso more than once in the rue la Boétie where Clive Bell was invited to call on him whenever he felt inclined, and on one occasion after lunch Picasso lined up his guests, who were, according to Clive Bell, Derain, Cocteau and Satie, on a row of chairs and drew their portraits as a conversation piece.[3] The drawing has been reproduced more than once but in it the place attributed to Derain is occupied by Olga. Although frequently there were guests to lunch and invitations to excellent meals at gourmet restaurants, Picasso was in fact seeing less of his old friends since his move to '*les beaux quartiers*'. Braque, on his return from the war with a serious head wound, had been precariously ill and in a difficult mood. All thoughts of a renewal of the pre-war relationship between him and his former friend and collaborator vanished. He disapproved of Picasso's new manner of living and despised the way he appeared fashionably dressed at the theatre. In his work, after a few strictly cubist paintings, he abandoned the rigours of his former style for a more fluid, perhaps more personal, mode, from which however the influence of Picasso never entirely faded. Years later Picasso used to say, with affection of his own brand, 'Braque is the wife who loved me most.'

Pulcinella *and* Cuadro Flamenco

In 1920 and 1921 Diaghilev produced two more ballets with Picasso's designs. The idea for the first had been broached as early as 1917 when Picasso was in Rome. From a newly discovered manuscript of 1700 Diaghilev had evolved the idea of a ballet inspired by an episode from the commedia dell'arte called *The Four Polichinelles who Look Alike*. Picasso with his early love of Harlequin at once found this hook-nosed companion a suitable character for his attention, and in the many drawings done during the next three years he had the idea of adaptations for the new ballet in mind. In the sketches of naked odalisques serenaded by Pierrot and Harlequin done at Biarritz the masked face of Pulcinella first appears, though it is not until January

[2] Clive Bell, *Old Friends.*
[3] See Penrose, *Portrait of Picasso*, p. 50.

1920 that we find the projects for the stage sets.[4] The first ideas for the backdrop were based on the baroque decorations of the Italian theatre. It was composed of a false proscenium opening on to a false stage with a chandelier and richly decorated pilasters and ceiling. In the centre was a further false opening with a long perspective flanked by arcades which opened on to a harbour with ships, somewhat reminiscent of the silent piazzas of Chirico. Though the forced perspective and asymmetric angular *trompe l'œil* showed its cubist origins, the whole effect was of 'unabashed romanticism'. But in the final version these complicated extravagances were suppressed, and the form was highly simplified. The perspective giving on to the night sky between houses, with a large full moon above a boat in the harbour, was treated in a rigorously cubist style. The romanticism had been boiled down, the baroque décor had vanished and only these symbols of the Neapolitan scene remained, strengthened and made more monumental in scale. The white costumes and shiny black masks of the pulcinellas and the simple white bodice, apron and short red skirt of Pimpinella stood out clearly in the moonlight and gave full scope to Massine's immense talent for mime.

There was trouble during the rehearsals of this ballet. Diaghilev criticized the designs and was discontented with the music of Stravinsky. The composer had looked forward to this collaboration with Picasso, who had recently designed the cover for the piano score of his *Ragtime*,[5] but it seemed to be resulting in failure, although Stravinsky had said: 'The prospect of working with Picasso, who would do the décor and costumes and whose art was infinitely precious and suited to me, the memory of our walks and our many impressions of Naples . . . all this succeeded in conquering my hesitation.'[6] There had been some muddle about dates and insufficient liaison between Picasso and Massine. In spite of all this, the first production was a success. Stravinsky's fears were allayed. He says: '*Pulcinella* is one of those spectacles – and they are very rare – where everything holds together and where all elements, subject, music, choreography and decorative scheme form a coherent and homogeneous whole . . . As for Picasso he

[4] See Zervos, *Picasso*, Vol. IV, pp. 6-9.
[5] ibid., Vol. VI, p. 160, No. 1344.
[6] William S. Lieberman, *Dance Index*, Dance Index Ballet Caravan, New York, Vol. V, No. 11, 12. November–December 1946.

performed a miracle and it is difficult for me to say what enchanted me most, his colour, his plastic expression or the astonishing theatrical sense of this extraordinary man.' Cocteau also was full of praise. 'Think of the mysteries of childhood', he wrote, 'the landscape it discovers in a blot, Vesuvius at night seen through a stereoscope, Christmas chimneys, rooms seen through a keyhole, and you will feel the soul of this décor.'

The next ballet for which Diaghilev again demanded Picasso's help was the *Cuadro flamenco*. In a letter to Kahnweiler in April 1921 Gris, who had been invited to go to see Diaghilev in Monte Carlo, complains that he was originally asked to design the décor and that 'Picasso had stepped in and taken it for himself'.[7] As a Spaniard Gris was an equally appropriate choice. But the idea had been born four years earlier when Picasso was in Spain with the Ballet. However, we learn from Gertrude Stein that there was a coldness between Gris and Picasso at this time, which had not thawed when Gris died in 1927.

With his flair for recognizing talent and his immediate enthusiasm for flamenco dancing, Diaghilev had found a troupe of gipsy dancers during his visit to Seville. It included girls of unusual beauty and passionate matrons who danced and sang as though they were possessed. Among the male dancers was an old toreador, who, having lost his legs below the knee, danced with additional fury on his stumps until the more squeamish London public demanded his withdrawal. Their orchestra consisted of two guitarists. On the stage the troupe sat in the conventional way in a semi-circle in front of a drop curtain that had been designed by Picasso.[8] He was able to use here the idea which he had abandoned for *Pulcinella* of a curtain that showed not only the proscenium with gay rococo ornament but also the adjoining boxes filled with dandyish couples watching the performance. The romantic effect of the surroundings, rich in Spanish bravado, gave without effort the perfect atmosphere for this type of performance.

[7] *Letters of Juan Gris,* collected by D. H. Kahnweiler. Privately printed, London, 1956.
[8] See Zervos, *Picasso,* Vol. IV, pp. 87-9.

Mercure

The last ballet in which Picasso took part was not originally produced by Diaghilev – the last, that is, if we except *Train bleu*, for which an enlargement of a small painting by him, of two colossal partially draped women striding across a beach, was used as a drop curtain. Massine had parted company from his former impresario to produce a ballet for Comte Etienne de Beaumont in a series of private entertainments known as Les Soirées de Paris in the summer of 1924. With the collaboration of Satie and Picasso the strangest ballet and the most original since *Parade* was put together. Between them 'they composed a short work in three tableaux crowded with mythological incident and spiced with mundane fantasy. The ballet was in part deliberately scatological. It attempted to shock as well as to amuse.'[9] The theme, which was a skit on the stories of the Greek gods, was the least interesting feature. But Picasso used the occasion to realize some new and interesting ideas.[10] The drop curtain in subdued browns and greys had as its theme two musicians. In its atmospheric softness of tone the striking feature, which was repeated in the costume designs, stage effects and backcloths, was the use of line. From childhood, as I have already said, Picasso had enjoyed accomplishing the feat of drawing a figure or an animal with one continuous line. His ability to make a line twist itself into the illusion of a solid being, without taking pen from paper, had become an amazing act of virtuosity and a delight to watch. The costume drawings for *Mercure* are a masterly example of this kind of calligraphic drawing. With characteristic inventiveness, he had foreseen how they could be carried out on the stage. Remembering the success of the Managers in *Parade* he devised with Massine a variety of constructions. The chariot for the rape of Persephone in which Pluto rides with his prize, and the horse he drives, were drawn in iron wire set on large simplified white shapes. The result in terms of form and movement achieved with such simple means was a triumph. But somehow the ballet was not a great success, either at its first appearance or later in 1927 when Diaghilev took it over. The critic Cyril Beaumont

[9] William S. Lieberman, *Picasso and the Ballet,* Dance Index Ballet Gravas, New York, Vol. V, Nos. 11-12, 1946.
[10] See Zervos, *Picasso,* Vol. V, pp. 92-103.

thought that the 'whole thing appeared incredibly stupid, vulgar and pointless', and if it had not been for the music of Satie and Picasso's innovations in the décor it would soon have been forgotten. In the great retrospective exhibition of Picasso in Paris in 1955, however, the drop curtain was exhibited as one of his major works. Though lacking in intensity in an exhibition consisting mainly of easel pictures, it provided an important example of his style in the early twenties.

Portraits and Drawings

The Russian Ballet with its circle of musicians, dancers and painters had inspired Picasso with the desire to make drawings of his friends from life. A series of line portraits drawn with a fine lead pencil show boldly and faithfully the features of Stravinsky (Plate IX, 3), Satie, De Falla, Diaghilev, Bakst and Derain.[11] There are more complicated shaded drawings of Cocteau, Ansermet and Massine. All of them recall the perfection of Ingres. However, they also contain a touch of caricature in the features, emphasized particularly in the hands, which makes it impossible to attribute them to anyone but Picasso. With discernment he recognized the essential features and acted on that counsel of Van Gogh's in a letter to Theo: 'exaggerate the essential'.

The portraits of friends connected with the Ballet began in Rome, where Picasso made rapid and humorous sketches of Diaghilev, Massine, Bakst and Cocteau paying him visits in his studio. Later in London he made drawings during rehearsals of groups of dancers in various poses. The tendency towards the sentimental in the sketches of these sylphs is held in check again by a slight well-judged dose of caricature. The tenderness of their gestures is made gently ridiculous by the enormous size of their hands placed delicately against their cheeks. In one drawing the sense of arrested movement of Lopokova poised on Massine's knee while dancing in *La Boutique fantasque* becomes the major consideration.[12]

As a result of Picasso's desire to use his talent in this way we have a magnificent portrait gallery which extends beyond the circle of the

[11] See Penrose, *Portrait of Picasso*, p. 47.
[12] See Zervos, *Picasso*, Vol. III, pp. 114-15.

ballet in the early twenties. Poets often came to him asking for a frontispiece for a book of poems they were publishing. His willingness to comply is evident from the long list of those whose portraits he made between 1920 and 1925. It includes Aragon, Huidobro, Salmon, Valéry, Parnak, Reverdy, Breton, Max Jacob, Cocteau, and Radiguet.

Picasso's renewed interest in realistic drawings led him often to make copies of photographs and picture postcards that he picked up by chance. A postcard of a young couple in Tyrolean national costume was transformed into a large and splendid pencil drawing which is no slavish copy, but rather a noble and inspired study, drawn with such vitality and freshness that the original photo would look a travesty of reality beside it.[13] There is similarly a well-known drawing of Diaghilev and Seligsburg taken· from a photograph for which they had dressed themselves with the greatest care (Plate IX, 7). In this case the photograph still exists. In comparison with the direct simplicity of the drawing, in which all superfluous detail is eliminated and only a pure unhesitating line remains to describe their features, the photograph is a poor, insufficient likeness of the two men. Just as Picasso had delighted in showing even as a child that he could rival the masters, here it gave him great satisfaction to show that he could beat the camera. The handsome swagger of Diaghilev with his top hat perched at a slight angle and a debauched twinkle in his left eye exists with an extraordinary economy of line. Beside him the figure of his portly seated companion attains more volume by the perfect placing of a few lines than by all the detail of modulated tones from which line is absent in the photograph.

Another example of the same process of translation from a photograph is a portrait of Renoir[14] – a painter who is not readily associated with Picasso, though a large and very fine painting of a nude by Renoir hung for years in the dining-room at the rue la Boétie.

The interest in line drawings, so well demonstrated in the portraits, continued in many compositions of nude bathers. The sensitivity with which Picasso controls line can be a prolonged source of delight to those who care to enjoy its subtlety. It varies from a certain deliberate coarseness, as in parts of the portrait of Stravinsky (Plate IX, 3), drawn

[13] ibid., Vol. III, p. 143.
[14] ibid., Vol. III, p. 137, No. 413.

soon after the first night of *Pulcinella*, which is 'curiously modest, without inflection or accent, as prosaic and casual as the sack suit which it describes',[15] to graceful perfection in the exquisite composition of *The Bathers* drawn in 1918 at Biarritz. In all cases the miraculous effect brought about is that the form enclosed or suggested by the line is convincingly present, whether it is in the strong nervous interlocked hands of the musician or the full and tender shapes of naked girls. By implication the eye sees what is not there, the white paper is transformed into living flesh.

Le Midi

After his visit to Biarritz in the summer of 1918 Picasso scarcely ever spent a summer without visiting the sea, either on the Brittany coast or more often his native Mediterranean. These places, not yet overcrowded with the holiday makers who now besiege the coast everywhere during the summer months, were a refuge from the fashionable life into which he was being drawn in Paris. Though such contacts pleased and flattered the worldly side of his nature, a nostalgia for a freer, more bohemian life such as he had known and in which his imagination had thrived before the war remained. Even the Côte d'Azur was still unfashionable in summer. The beaches were almost deserted and he could fully enjoy the refreshing influences of the sea, and the tranquillity of the company of his young wife and the son she bore him in the summer of 1921. He could benefit from this atmosphere to devote most of his time and thought to his work.

The first visit after the war was to St Raphael in the summer of 1919. Picasso installed himself in a large hotel looking out to sea. In his room he painted several versions of a theme he had begun at Barcelona (Plate X, 5). Just as Matisse had been doing in Nice, he used the window with its shutters and balcony as the background for objects seen against the light outside. But unlike Matisse, instead of evoking the atmosphere of the harem with odalisques reclining in cool shadows, he placed against the light a table piled up with familiar objects, guitars, bottles and fruit,

[15] Barr, *Picasso: Fifty Years of His Art*, p. 110.

using the open window as the proscenium of a stage.

He continued to elaborate these cubist still-lifes after his return to the rue la Boétie. They differed from pre-war compositions chiefly in the treatment of light, which now invaded them and illuminated the still-life, so that it belonged both to the brightly coloured objects and to the limitless depth of their background. Also the strict observance during the analytical period of the picture plane as a continuous shallow surface, which had already been abandoned in synthetic Cubism, now gave way to the introduction of a realistic background of the sea or the sky line of Parisian roofs. This renunciation of a homogeneous Cubist style for the still-life and its background, implied that Cubist and realistic treatment of objects was not incompatible.

Monumental Nudes

In addition to the still-lifes Picasso continued to develop his interest in the female form. The summer had produced many studies of girls running, dancing and swimming, with a clear expanse of sea and sky as their background. They are the prologue to paintings covering a great variety of moods, sometimes idyllic and sometimes sinister, which were to follow during several years. In these early days there appear for the first time figures from classical mythology, such as the centaur and the satyr, who in a gouache of 1920 are seen fighting together for a naked girl held in the centaur's arms.[16] Here again, just as in line drawings, it is the plastic solidity of the form that is emphasized. In spite of the overpowering light of the Mediterranean sun, form has not been allowed to dissolve into atmospheric effects. Picasso's instinct has urged him towards a more tactile sensation of the human form and a feeling for the physical weight of bodies and limbs. To the dismay of those who had begun to look to him for a renaissance of graceful classical discipline founded on the influences of the paintings he had seen at Pompeii and the voluptuous smoothness of flesh in Raphael and Ingres, his preoccupations led him to a new and disquieting version of female nudity. These conventional influences were too sweet to confine his

[16] See Zervos, *Picasso*, Vol. IV, pp. 62, 63.

turbulent spirit. Distortion was again in demand as an emotional necessity. This time it was not the elongated, emaciated, El Greco-like distortion of the Blue period but that of a more earthy, ponderous conception that emerged.

The appearance of the robust and fleshy type of female, reminiscent of the Dutch girls of 1905, came as a surprise. As usual when there is an abrupt change in Picasso's work we are tempted to look for some enlightenment close at hand. That the series should have begun at the time of his wife's pregnancy seems not without importance. The fertile promise of her distended form and his recognition of his own intimate part in the creative process must have awakened his wonder. Another association linked with his childhood can also be brought into account. Picasso once told me how, when very young, he used to crawl under the dinner-table to look in awe at the monstrously swollen legs that appeared from under the skirts of one of his aunts. This childish fascination with elephantine proportions always impressed him. Such exaggeration seems both frightening and supernatural and both sensations were recaptured by him in these paintings. The first of these monumental figures, such as the *Two Female Nudes* of 1920, often lean their heads together sentimentally.[17] Patient and statuesque, they seem to dream of a coming ordeal. Their fleshy bodies, their growing breasts, their strong enveloping hands and heavy feet firmly rooted to the ground are preparing for the future tasks of maternity.

Three Musicians

At the same time, Picasso true to his nature did not pursue exclusively one particular trend. Concurrent with the colossal women he painted Cubist pictures of increasing purity – still-lifes and harlequins whose simplicity in form and economy in colour provided the appropriate material. They culminated in the summer of 1921 in a great composition known as the *Three Musicians* (Plate X, 1), of which there are two versions painted both at the same time. The more resolved of the two, now in the Museum of Modern Art, New York, is one of

[17] ibid., Vol. IV, p. 16, No. 56.

Picasso's major achievements. In describing it Maurice Raynal says: 'Rather like a magnificent shop window of Cubist inventions and discoveries, the *Three Musicians* is a masterpiece of wit and poetry. With it Picasso summed up his long series of figures from the Italian Comedy, which he had treated in increasingly abstract fashion, reaching the limit here.'[18]

A composition of three figures in the rigorous technique of synthetic Cubism was a feat Picasso had not attempted before. The flat coloured shapes, simple and rectilinear in form, are arranged so that everywhere their significance is legible. Each shape becomes an ideogram, a significant 'sign' of reality. But it is the hieratic appearance of the masked figures, apparent even in a small reproduction, which is astonishing. Their monumental scale is wittily created not only by the construction of their masses but by comparison with tiny spider-like hands with which the musicians play their instruments. We have noticed Picasso's preoccupation with hands before. At this particular period, remembering his father's saying 'it is in the hands that one sees the hand', he made a great number of drawings of his own hands seen from all angles, and also of the plump graceful hands with fruit-like fingers of his wife. In portraits such as that of Stravinsky he had usually been tempted to exaggerate the size of the hands. They become ponderous and expressive of their tactile sense, but in the *Three Musicians* on the contrary the hand is reduced so as to become the smallest unit, thus giving a key to the gigantic size of the figures.

Fontainebleau: Mother and Child

After the birth of his son Paul (known as Paulo) in February 1921, instead of returning to the sea, Picasso rented a large and comfortable villa at Fontainebleau. From the point of view of the health of his wife and son it was a considerate action to forego the delights of the coast for a bourgeois residence within a reasonable distance of Paris. But Picasso was not entirely happy about his new role as pater-familias. Although the size of the villa allowed him to keep aloof from the exigencies of the

[18] Maurice Raynal, *Picasso*, Skira.

nursery, and although his love of Olga is evident in the drawings he made of her suckling her child or playing the piano among the genteel furniture, he remarked to friends who visited him that he was thinking of ordering a Parisian street lamp and a *pissotière* to relieve the neat respectability of the lawn.

It was during this summer that he painted the two versions of the *Three Musicians*; the *Three Women at the Fountain,*[19] a large composition in his neo-classic style; landscapes of the near-by lanes; the gate of his villa; still-lifes; and in addition made pencil sketches of the villa both inside and out and of his wife and child. The variety of subject was only equalled by the variety of his style.

But stressing that Picasso was mainly interested in the reality of the life that went on round him, the major theme that he developed at this time and which, with the sole exception of the portrait of Madame Rosenberg and her daughter, he had neglected since the Blue period, was the 'mother and child'. There are a number of variations of paintings of a mother playing with her naked infant on her knees, in which the neo-classical figures and the colossal females of the previous months reveal a new look of contentment, a sense of fulfilment (Plate X, 3). This sentimentality which he had allowed to filter into his youthful pictures of maternity was eliminated by a severe sculptural simplification of form which has as its basis a sense of banality rather than of idealism. Refinement and grace are banished, with the result that a splendid image faces us, a vital picture of human life.

More gigantic nudes with placid expressions appeared during the same year. They are painted with the same brutal sense of realism which seems to be inspired by the naïve retouching and tinting seen in the enlargements of cheap photographers, combined with the simplifications of late classical sculpture. The twilight colours of the Blue period had given way to the broad prosaic light, the grisaille of an overcast midday. The pose taken up by the nude figure is often made all the more formal by the addition of a cornice to support the elbow.[20] Picasso took a perverse pleasure it seems in taking subjects of voluptuous delight and in denying himself any of the aids he had

[19] See Zervos, *Picasso,* Vol. IV, p. 119.
[20] ibid., Vol. IV, p. 122-3.

formerly used to evoke sympathy and emotion. They confront us in their stark banality, and yet these females seem to carry about them the timelessness of goddesses, indestructible and reassuring as an eternal symbol of the female form. In this instance the sublime owes its life to the commonplace.

Exhibitions

Picasso's friendship with Paul Rosenberg was increased by the dealer's usefulness as a protector of his interests and the organizer of exhibitions in his fashionable gallery. In October 1919 Picasso decorated the invitation card which announced an exhibition of drawings and water-colours with the first lithograph he had ever made, and added a second drawing of Olga as a cover to the catalogue.[21] During the following two years exhibitions were held in Rosenberg's gallery, and in 1921, as has already been mentioned, London saw for the first time an important collection of the work of Picasso: twenty-four oil paintings and forty-eight drawings, water-colours, and etchings dating from 1902 to 1919 were shown at the Leicester Galleries. The picture that dominated and greatly impressed Londoners was the *Woman in a Chemise* (*Woman in an Armchair*, Plate VIII, 3), and there were other fine examples of Cubism. The catalogue had as its preface a reprint of an article by Clive Bell, in *The Athenaeum*, in which he compares the talents of the two painters who had emerged as the leaders of the modern school: Matisse and Picasso, and analyses 'why the latter' and not Matisse, 'is master of the modern movement'. His argument is that 'besides being extraordinarily inventive, Picasso is what they call "an intellectual artist" '. This needed some explanation since the word intellectual can imply something very foreign to the creative artist. 'An intellectual artist is one who feels first...and goes on to think,' he says, and continues later: 'Matisse is an artist; Picasso is an artist and something more – an involuntary teacher if you like.' Clive Bell, like many others, was struck by the power that Picasso possessed to feel and to analyse his emotion. Though he tends to separate dangerously the emotional and

[21] ibid., Vol. VI, p. 163, Nos. 1371, 1373.

the intellectual processes, Clive Bell is undoubtedly right when he draws attention to the vast influence that, already in the early twenties and in spite of himself, Picasso had on other artists. To this day no one can claim to be the pupil of Picasso; he never had the time or the patience to teach systematically, but such was his capacity to set others thinking by his work, by his chance remarks in conversation, by his writings and by his way of living, that he became one of the greatest teachers of our time.

Although the prices asked for these pictures seem now absurdly low they represented at the time a high level for a painter who was just reaching his fortieth year. Picasso was in fact becoming rich with the proceeds of what he sold, and could afford all the comforts he and his family wanted. He was not much perturbed when, owing to the law that gave the French Government the right to take possession of all property belonging to enemy aliens, the two great collections of Uhde and Kahnweiler were put up for sale by auction. The Kahnweiler sale was held in four sections spread over the years 1921 to 1923. Apart from a mass of less valuable drawings, collages and objects, it offered to the public 381 cubist paintings by Picasso, Braque, Gris and Léger of which 132 were by Picasso. The three other painters were nervous about the effect of having such a large part of their former work put up for public auction. Braque even appeared at the first sale and protested loudly at the ineptitude of exposing the work of French painters, Léger and himself, to such unnecessary risk supposedly in the interests of the French State. He felt so strongly about it that seeing Léonce Rosenberg, one of the organizers of the sale, he walked up to him and slapped him in the face.

In the light of the subsequent appreciation in value of these works the prices they fetched seem trivial. Very few foreign buyers were attracted, and it was chiefly those collectors, such as Roger Dutilleul and André Lefèvre, who had already bought paintings from the Cubists before the war, joined by Alphonse Kahn and the Belgian collector René Gaffé, who were able to add judiciously to their possessions. Kahnweiler, who had returned from Switzerland, bought back what he could of his former stock. The expected setback in the value of cubist and post-cubist painting owing to this glut on the market was only temporary. It

did not seriously affect Picasso's sales of his current work which were being ably handled by Paul Rosenberg.

The Dinard Still-lifes

After one of his lengthy summer absences from Paris, Picasso returned to find as he opened the cupboard where his winter suits used to hang that the moths had been hard at work. Nothing of his best suit remained except the framework of its seams and the buckram linings, through which could be seen, as in an X-ray, the contents of his pockets – keys, pipe, matchboxes and the other things that had resisted the attack of the insects. The sight delighted him and still made him chuckle when he told me the story years later. Transparency had been a problem since the early days of Cubism when the desire to see behind the visible surface of objects had led him to dissect their form. Here nature had given a demonstration of how it could be done by other means.

In 1922 Picasso went for the summer not to the Mediterranean but to Brittany. The nature of the coast with estuaries and rocky headlands jutting out into the ocean was reminiscent of the windswept beaches of Corunna where he had made his first independent discoveries in the cold, stormy light of the Atlantic. Just as he had sketched the over-dressed Galicians on the beaches and the Tower of Hercules thirty years before, so now he made contact with his new surroundings by making line drawings in pen and ink of Dinard, where he rented a villa for his wife and child, and of St Malo as it appeared across the water.[22] But the paintings which characterize this visit to the ocean are still-lifes, Cubist in tendency. They rely on a new use of heavy straight lines of stripes superimposed on clearly defined patches of bright colour. This method of introducing light into the picture appeared first two years before in a composition of a guitar set on a table. The stripes give an interlocking transparency like a net or ribbed glass to the solid shapes that they imply (Plate XI, 4).[23] Fish lying on torn sheets of *Le Journal*, bottles of wine, fruit dishes, glasses and an occasional guitar are the basis of a number of fascinating transparent pictures which suggest light filtered

[22] ibid., Vol. IV, pp. 152, 153.
[23] ibid., Vol. IV, pp. 166–78.

by slatted shutters or the ripples chasing each other across the estuary. The paintings vibrate with a luminous *joie de vivre*, but this well-being ended abruptly when Olga was taken seriously ill and Picasso was obliged to rush her to Paris, nursing her with ice-packs on the journey, while little Paulo was violently car-sick all the way. An operation followed and Olga's health was restored.

Varied Styles

In a statement made to Marius de Zayas, Picasso said: 'The several manners I have used in my art must not be considered as evolution, or as steps towards an unknown idea of painting.'[24] He did not change his style in the hope of finding an ultimate solution, changes happened because of his urgent desire to cope with the flood of ideas that were continually being born within him. 'I have never made trials or experiments,' he continued. 'Whenever I had something to say I have said it in the manner in which I have felt it ought to be said. Different motives invariably require different methods of expression.' So we find in the rapid changes from one style to another, which from this time on became characteristic of Picasso's work, the signature of his personality.

For the next two years the neo-classical trend continued simultaneously with pure cubist still-lifes. In these there is a brilliance of colour, expressive of an enjoyment of life, which had never appeared formerly in such an unrestrained manner. Surface textures made with sand, which had begun some ten years earlier, were now exploited with a sensuous delight in the contrast between rough and smooth which gave a variety of tactile sensations to the whole canvas.

After the unhappy ending of the visit to Dinard the next five summers were spent on the Mediterranean. The visit to Juan-les-Pins in 1924[25] is particularly memorable for forty pages of sketchbook

[24] Published in *The Arts*, New York, May 1923; quoted by Barr, *Picasso, Fifty Years of His Art*, p. 270.
[25] Barr attributes these drawings to Juan-les-Pins 1926, Zervos to 1924, Boeck 1924 and 1926. Evidence comes from the publication of some of the drawings in No. 2 of the *Révolution Surréaliste* of 15 January 1925 and the fact that Picasso spent the summer of 1924 at Juan-les-Pins, but did not return in 1925.

drawings (Plate X, 7).[26] These were done in addition to gay, almost frivolous landscapes in which the mock-gothic towers of the Villa la Vigie, in which he was staying, appear in the foreground. The drawings were afterwards used to embellish Balzac's story *Le Chef d'œuvre inconnu* which Vollard published in 1931, illustrated with thirteen full-page etchings. At first sight they appear to be abstract doodles made up of lines which form dots like the knots in a net whenever they cross, making clever concave or convex patterns. But as I have insisted before, abstraction, that is insistence on form for its own sake without reference to any associations, is completely foreign to Picasso. If we compare these arabesques, which resemble diagrams of constellations of black stars, with the still-lifes of the same period, we find that they are mostly variations on the same themes. The original subject matter of most of the drawings reveals itself as the shapes of musical instruments, while others, evoking the resemblance between the guitar and the human form, are more anthropomorhic. In some of the most complicated kind a large black circle is made to suggest both the head of a female figure holding a guitar and a black sun spreading over the sea. With such simple means Cubism had been coaxed into an evocative mood, prophetic of further developments. It had happened unexpectedly, in the manner of the genius who could say: 'In my opinion to search means nothing in painting. To find is the thing.'[27]

The Great Still-lifes

Throughout these years of changing styles the still-life remained a constant theme to which Picasso could return. The subject matter remained much the same, and in general they were variations on a theme which gave scope each time for new subtleties. They served as a touchstone with which he could sort out, as Raynal puts it, 'his ideas and technical finds'.[28] But Picasso with his profound interest does not easily exhaust a theme; on the contrary the deeper he goes the more he

[26] See Zervos, *Picasso*, Vol. V, pp. 130, 132, 134, 136, 138, 142, 144–6.
[27] 'Picasso Speaks' (statement made to de Zayas), *The Arts*, New York, 1923; quoted by Barr, *Picasso: Fifty Years of His Art*, p. 270.
[28] Raynal, *Picasso*, Skira.

finds. So in the years 1924-5 the still-life took new proportions in his hands. The brilliancy of colour and the masterly compositions of these paintings give them great distinction in the whole panorama of his work (Plate XI, 1). He also found ways of extending the subject matter beyond the usual cubist repertoire. He included classical plaster casts of heads, or the clenched fist holding a scroll which has an air prophetic of the more tragic setting of *Guernica*. In the great composition *The Studio (with Plaster Head)* of 1925 other, less conventional material was introduced (Plate XI, 3). The picture became a synthesis of classical motives: the bearded head, the open book and the clenched fist, together with an architectural landscape reminiscent of the scenery for *Pulcinella*, which had its origin in a toy theatre he had made to amuse his son.

Surrealism

Although Picasso had been living aloof from the bohemian world since his marriage, he was not unaware of the many divergent movements that were making Paris once more the centre of the arts. The war had had various influences; in some it brought about, as a reaction to the violence of movements such as Cubism, Futurism and Expressionism, a longing for a return to a more orderly way of living and thinking, a reasoned return to tradition. 'Back to Raphael, Poussin, Ingres and Seurat', seemed in the light a cry of hope, echoed in Apollinaire's wish to 'renew poetic style but in a classical rhythm', a cry to which Picasso had responded in his neo-classical painting. The proof of his conversion seemed convincing when he helped to design the scenery for Cocteau's adaptation of *Antigone* when it was performed at the Théâtre de l'Atelier only five years after the scandal that had been caused by *Parade*.

But Picasso recognized other influences that were closer to his nature. He had never denied his discoveries and had continued to paint Cubist pictures side by side with others in the neo-classical style. There was no question of antagonism between the two. When, after the war, the Dadaists assembled from the various countries in which they had begun their activities, Picasso was eager to see what would ensue, and while remaining aloof he frequently attended their rowdy manifestations.

Paris owed much of its esteem among the younger generation in France and abroad to its revolutionary traditions. In addition it had the prestige of having been adopted as their home by those such as Apollinaire and Picasso who already had a worldwide influence. As an example of Picasso's magnetic appeal, I mention that as far back as 1911, the first sight of his work in an exhibition in Cologne induced Max Ernst, then only twenty, to forsake the conventional means of earning a living for which he was being trained and to become a painter. Among many of his generation, hope for the future (for which Picasso was the symbol) did not lie in a return to the past. On the contrary, the violent protests of Dada coincided closely with what Ernst had learned in his youth from Picasso and later from the war. As soon as possible after the armistice he left Germany for good and settled in Paris under the roof of the poet Paul Eluard.

In company with André Breton, Philippe Soupault, Louis Aragon and Eluard, Max Ernst linked his activities as a painter with the group of young poets who had begun to publish their work in a review of Dadaist tendency, *Littérature*. The group was joined by Tzara and Arp on their arrival from Zürich and by Picabia, Duchamp and Man Ray when they reached Paris from America. The Dadaists were soon in a position to express themselves. They edited reviews, held exhibitions and gave performances calculated to insult and enrage the public, who in revenge always crowded to see them, because Dada was all the talk of the day and because they were completely mystified about its aims. The scandal more than once caused an uproar which brought in the police. The Dadaists were uncompromising in their violence not only against the bourgeoisie but also against the Futurists, and the members of the Section d'Or, a group supported by those who hoped to steer Cubism on to rational lines.

Before long, however, factions in the heart of the movement itself began to give trouble. The nihilism of Dada could not continue, and it so happened that the last of its manifestations was attended by Picasso. This was a performance that Tzara, the most uncompromising among them, put on at the Théâtre St Michel in 1922, called the *Soirée du cœur à barbe*. At the beginning of the performance hostile demonstrators from the newly formed Surrealist group, led by Breton

and Eluard, leapt on to the stage, and in the riot that followed Picasso was heard shouting from his box, 'Tzara, no police here'. In the confusion the sound of the word 'police' linked with the name of Tzara made Breton jump to the conclusion that the arrival of the *gendarmes* in the theatre, which happened immediately afterwards, was the deliberate and unpardonable act of Tzara, engineered against him and his friends. Tzara in consequence claims that Picasso was the unwitting cause of his prolonged estrangement from the Surrealists, whose ideas in reality were not far from his own. But it is clear that Picasso did not intend to be drawn in on one side or the other. He returned to the rue la Boétie, to his wife and his work, intrigued by ideas but uninterested in quarrels.

Having shaken off the purely destructive influence of Dada, Breton and his friends began the work of forming a group which would interpret the thought of the modern movement. The slogan: 'A new declaration of the rights of man must be made', appeared printed on the cover of their new review *La Révolution Surréaliste*. It contained declarations of policy, Surrealist *'textes'* by Eluard, Péret, Aragon, Reverdy and others, and among the illustrations was a reproduction of one of Picasso's 1914 constructions, photographed by Man Ray. In the following number two pages of the previous summer's drawings from Picasso's sketchbook of Juan-les-Pins were given, and in the fourth published on 15 July 1925, the *Demoiselles d'Avignon* was reproduced for the first time, eighteen years after it was painted. It was in fact due to Breton that the painting was unearthed where it lay rolled up in Picasso's studio, and set up in a place of honour in the Paris house of Jacques Doucet who bought it for his collection.

The brilliant and turbulent poets and painters who formed the Surrealist group had in common a desire to probe the origins of the creative process in art; an investigation which had begun on the one hand with poets such as Rimbaud and Mallarmé and on the other with Freud's examination of the subconscious. When the term 'surrealist' invented by Apollinaire was adopted as the name of the new movement, Breton wrote in explanation: 'This word...is employed by us with a precise meaning. We have agreed to refer by it to a certain psychic automatism, which more or less corresponds to the dream-state.'[29] An

[29] *Littérature*, No. 6, Second Series, November 1922. Translated by D. Gascoyne, *Surrealism*, Cobden-Sanderson, 1935.

appreciation of the importance of the subconscious was essential to the Surrealists. In the work of Picasso they stressed its influence at the expense of aesthetic considerations. 'Picasso', they claimed, 'is Surrealist in Cubism', but they had a horror even greater than his of tendencies that led to abstraction.

Picasso was in general more attracted by the activities of the poets of the Surrealist group than by those of the painters. He always asserted that of all that was going on during the twenties their activities were the most interesting. Though he never allowed himself to be drawn into the deliberations he let them reproduce his work in the *Révolution Surréaliste*; and for the first time his antipathy to exhibiting in a group was overcome when paintings of his were hung, with his permission, in the first Surrealist Exhibition at the Galerie Pierre in 1925. This however was a very different matter from the professional scramble, characteristic of all 'salon' exhibitions. The Surrealist movement owed its strength to an alliance between poets and painters and an attitude towards human conduct which transcended purely artistic considerations. Picasso had found again, in association with the poets, the climate he had known before the war.

In the fourth number of the *Révolution Surréaliste*, Breton published a long illustrated article on Picasso in which he analysed his reasons for his great admiration. Reality, he claimed (speaking of what is understood vulgarly as real), is not just what is seen, and the painter should in consequence refer to a model which is purely interior. He realized that this had been the achievement of Picasso in Cubism, and praising his clairvoyance and courage he wrote: 'That the position held by us now could have been delayed or lost depended only on a failure in the determination of this man.'[30]

The Surrealists were severe in their condemnation of fashionable society and included ballet in their censure. When Max Ernst and Miró accepted the proposal made to them by Diaghilev at the instigation of Picasso that they should design the décor and scenery for the ballet *Romeo and Juliet*, Breton and Aragon protested and attempted to exclude them from the group for their collaboration with 'the international aristocracy'. This was surprising since only a year before

[30] André Breton, 'Le Surréalisme et la Peinture', *La Révolution Surréaliste*, No. 4, 15 July 1925.

Breton had praised Picasso's designs for *Mercure*. The row, which was smoothed out by Eluard, was typical of the attempts on the part of Breton to enforce a purist discipline on other members of the group. In his aloofness Picasso held a position of unassailable authority which he used generously as in this case for the benefit of younger artists who had impressed him by their talent.

'Beauty Must be Convulsive'

The association with the Surrealists had the effect of bringing out in a sudden burst a new and disquieting manifestation of the underlying restlessness of Picasso's mind, which had been for a while partially overlaid by domestic happiness. Breton's dictum that 'beauty must be convulsive or cease to be' coincided with this new torment that had begun to disturb Picasso. In the spring of 1925 he joined Diaghilev and Massine for a short season with the ballet in Monte Carlo and it was not surprising that the great picture he painted early that year was of three dancing figures; but the mood of this painting known as the *Three Dancers** (Plate XI, 2) has nothing in common with the elegant snobbism of the Russian Ballet. Here it is evident that the post-war hopes of a new Golden Age, shared by so many, had vanished and yielded to a desperate ecstatic violence, expressive of frustration and foreboding. When in 1964 the painting was acquired by the Tate Gallery,[31] Picasso told me that he had never approved of the title it had acquired, that for him it was above all connected with his misery on hearing of the death of his old friend the painter Ramón Pichot, whose profile appears as a shadow against the window on the right of the canvas.

The *Three Dancers* in this way becomes a nodal point in the work of Picasso. It is the first to show violent distortions which have no link with the classical serenity of the preceding years. It heralds a new freedom of expression. During the following years the human form was to be torn apart, not with the careful dissection practised during the years of analytical Cubism, but with a violence that has rarely been

[31] See Ronald Alley, *Picasso: The Three Dancers*, Charlton Lectures, University of Newcastle-upon-Tyne, 1967.
*also called *The Dance*.

paralleled in the work of any artist. Picasso, however, does not only decompose and destroy, he invents new anatomies, new architectures and a new synthesis, incorporating the world of dreams with mundane realities.

It is the dancer on the left of the composition who combines the greatest intensity of physical and emotional violence. The wild movement of the body, her breasts thrown upwards and her back arched, culminates in a head convulsed and disquieting in its demoniac expression. Yet on her brow, forming part of her head, there is a separate profile like the thin crescent of the waning moon, looking with serenity into the centre of this scene which has the character of a delirious invocation. It has been noticed by critics that although the composition seems to be derived from the group of voluptuous dancing figures by Carpeaux in front of the Paris Opéra it is fundamentally more related to the anguish of a crucifixion. It is at the same time a frenzied dance of life and a ritualistic dance of death. Livid pinks, reds and blues suggest the colour projections of a night-club, though in the background is a window looking out into the blue empty space of sea and sky.

Picasso's necessity to express his rage could no longer be contained. The convulsions of the ecstatic dancer are prophetic of new anatomies. She inaugurates a new epoch in which monsters are to play a major role.

Social Contacts

Picasso's mood was changing. The routine of the smart set in which he had become involved began to pall. His appearance with Olga at first nights, made conspicuous not only by his fiery black eyes but by the bullfighter's cummerbund worn beneath his well-cut dinner jacket, had become familiar to the snobbish society who frequented the sumptuous parties and performances of the Paris season. For a ball given by Comte Etienne de Beaumont, Picasso, with his delight in disguises, had found the magnificent suit of a matador, and on more than once occasion he was asked to design decorations for the festivities. Like the majority of Spaniards he had an insatiable appetite for good entertainment and good company. The night was never long enough to tire him. He had no

need of the stimulus of alcohol. When he was in a festive mood his reserve at moments broke down. The unexpected comments interjected into conversations, the apt stories told in an eager voice finishing with an inquiring '*n'est-ce pas?*' and a high-pitched resounding chuckle, made his company both delightful and disturbing.

During his long visits to the Mediterranean the sources of his inspiration were varied and often unconventional. André Level speaks of seeing him in the market at Cannes suddenly seduced by a cardboard plate on which some fruit he had bought was handed to him. After enjoying the feel of its texture, he quickly made a sketch on it of fruit, squeezing the juice out of flower petals to colour it. Having signed it he exchanged the decorated plate for a pile of empties with which he returned home, delighted at his find. Alive to his surroundings, he would absorb the colours of the landscape, the light reflected from the sea and the athletic movement of the bathers who played on the beaches. He could be equally enthralled by such chance discoveries as a strangely shaped piece of driftwood, a bit of rusty iron or bamboo roots which had been modelled into grotesque shapes by the waves.

Visitors to France, including Hemingway, were among the friends with whom he spent the hours when he was not working, in conversation by the sea or at table. There are photos of beach parties where instead of sunbathing the guests diverted themselves by dressing in strange costumes. One of these shows the Comte and Comtesse de Beaumont in gay disguises, with Olga dressed as a ballerina. Among the party is Picasso's mother, who was paying her son a visit, sitting on the edge of a canoe with a strange hat fringed with beads. The only one in the group who is not disguised is Picasso himself who sits in the centre in a conventional felt hat and white shirt buttoned up to the neck.[32]

Renewed Violence

Enjoyment of such pleasures was only a part of Picasso's life. In the world of his thought he was still isolated and lonely. At the same time, though he never seemed to despise those around him for not being able

[32] Penrose, *Portrait of Picasso,* p. 51.

to follow his meaning, a desire to mystify the public in general was not foreign to him. The outrageous joke of making a collage out of his own unlaundered shirt tails was both an intentional insult and at the same time a miraculous feat in transforming so mean a thing into an object that gave pleasure to the eyes. Another example of his 'malicious art' is the large collage of the same year, 1926, called *Guitar* (Plate XI, 8), in which the main element is a coarse dishcloth perforated by nails whose points stick out viciously from the picture. Picasso told me that he had thought of embedding razor blades in the edges of the picture so that whoever went to lift it would cut their hands. There are no decorative curves to soften the cruel impact of the picture and there is no charm of colour. It is an aggressive and powerful expression of anger in a language which makes it painfully plain. Though it has been shown in major exhibitions in Paris, New York and London, Picasso usually kept this picture in his studio like a curse which he stored for his own satisfaction. Other paintings of the years that follow show the growing violence of his mood in more elaborate form.

The Anatomy of Dreams

The liberties that Picasso now chose to take with the human form seem unbounded. Even the most daring rearrangements of features and revision of proportions did not however prevent the recognition of the human head and human form. The cubist method of describing an object simultaneously from more than one viewpoint had induced Picasso, as early as 1913, to inscribe a profile on a head seen full face. But in 1926 the same idea was carried further in paintings of violently distorted heads (Plate XI, 7) in which the recognizable features – eyes, mouth, teeth, tongue, ears, nose and nostrils – are distributed about the face in every position, with the bold line of a profile making a central division of the head. In some cases both eyes appear on the same side of the face, in others the mouth takes the place of an eye – every imaginable permutation is tried but miraculously the human head survives as a unit powerfully expressive of emotion. In this process of re-assortment the spherical mass of the head itself begins to disintegrate and token hairs are made to sprout from anywhere they may be required by the artist. Nothing remained unviolated, but the power of

this sign language lies in the discovery that the association these vestiges of resemblance to our own features hold for us is undeniable, and it gives a new and strange fascination to find that we can reconstruct our own image from such complete and improbable distortions.

The human body was subjected to the same wanton rearrangement of its form. In Cannes during the summer of 1927 Picasso suddenly broke away from the flat patterning derived from synthetic Cubism, which still exists in pictures such as the *Three Dancers*, and began to draw fantastic reconstructions of the human form, with heavy modelling. The bathers he saw every day on the beach passed through a metamorphosis into elephantine sculptural shapes, skipping lightly across the beach (Plate XI, 5) or attentively turning the key of a bathing hut.[33] The anatomy of these females is extremely droll. Their swollen forms have no immediate resemblance to anything in nature, but they are still convincingly organic, and bear out Picasso's remark that: 'Nature and art are two different things. Through art we express our conception of what nature is not.'[34] But if they are not recognizable as conventional human forms, the habits on the beach of these massive creatures are touchingly human; especially those who finger the tiny key set in the lock of a hut they are trying to open. A sexual metaphor can have many interpretations: the locked hut is in the first place a symbol of privacy which in this case seems in danger of being invaded by powerful female or hermaphrodite monsters of Picasso's own creation.

This series of charcoal drawings, together with pen sketches and a maquette for a monument in similar terms made at Dinard the following summer, were among the suggestions that Picasso showed to the committee for the Apollinaire memorial without gaining their approval.

Picasso returned to Dinard for two successive summers. It was a retreat from the place where he could be too easily interrupted by his increasingly numerous friends. The large, ugly Art Nouveau villa with a garden that he rented was close to the quay where the ferry from St Malo landed its passengers. From his window he could hail the arrival

[33] See also Zervos, *Picasso*, Vol. VII, pp. 38-47.
[34] 'Picasso Speaks', quoted, Barr, *Picasso: Fifty Years of His Art*, p. 270.

of the young poet Georges Hugnet who lived across the water, and with whom, after announcing to his wife that he was going out, he would spend long hours wandering on the crowded beaches. He was glad to escape from the family, the English governess who had been engaged to give Paulo a good orthodox education and the villa whose only attraction was the space that it afforded for the creative disorder that surrounded his work. In addition to pen and ink drawings which were more elegant versions of the anthropomorphic forms of the previous summer, the pictures he painted were mostly scenes of bathers tossing a ball (Plate XI, 9). Again the liberties taken with the human frame were extraordinary. Their limbs and bodies, now flattened out like broken matchboxes and clothed sometimes in striped bathing costumes, are in violent, concerted movement in front of a brilliantly coloured background of sea and rocks.

During the first of these visits to Dinard, colour and agitated movement were the main preoccupation, but in Paris Picasso worked with stricter discipline on large compositions with a rigid construction of flat coloured surfaces with straight black lines giving an architectural feeling of space. Pictures such as *The Studio*[35] and the *Painter and his Model* (Plate XII, 8) make a sober contrast with the dynamic exuberance of the summer months. Though capable of a restraint which can be seen in other simple sculptural images of serene metamorphoses of the human form, he also had visions of more diabolical changes for the female body. A woman seated in a chair could resemble the convulsed tentacles of an octopus (Plate XII, 5), and another seen against the sea could look like a bloodless monument made of bones and driftwood, her hollow frame composed of pieces balancing precariously on each other (Plate XIII, 1). In many of these inventions there is a striking contrast between the aggressive bonelike structure of the head, with a vertical jaw, its teeth opposing each other like a trap for vermin, and the ethereal pale blue sky against which it is seen. These excursions into realms formerly forbidden by a canonical respect for beauty were more profoundly disturbing than the attacks made by Cubism on academic conceptions of painting. They upset man's vision of himself which had

[35] See Zervos, *Picasso,* Vol. VII, p. 64, No. 142.

sprung from classical tradition. But we were to discover, thanks to Picasso, that the image of man did not reside only in an ideal conception but that in its nature it should be organic and alive.

During this period the image of one person for whom his tenderness remained unaffected was not submitted to such violent disruption. From the day his son was born Picasso often enjoyed the pleasure of drawing portraits of him, and during these years, among pictures of monsters, we find several delightful portraits of Paulo in fancy dress: as Pierrot, as Harlequin holding a wand and a bunch of flowers, or wearing the gold-braided suit of a toreador (Plate XI, 10).

At the same time there appears in another picture, violent in colour, a profile easily recognizable as a self-portrait, set in juxtaposition to a sharp red-tongued monster. A bright green strip runs down the front of its long neck as though it lived by drinking poison. For more than ten years Picasso had ceased to make the portraits and drawings of himself that were so frequent in his early life. In several paintings of 1929 however we find the same profile. Here it is disconcerting to find it in such close association with this powerful and aggressive head, an obvious symbol of the emotional stress which was leading him towards a crisis. He was becoming daily more deeply dissatisfied with the life of a successful and fashionable painter into which he had been enticed by his wife. Her possessiveness was the cause of growing antagonism. Picasso's reaction was to translate the torment that Olga caused him into new and powerful symbols, some of which can be clearly traced to his own personal feelings, whereas others became universal in their meaning. The irrational psychological cruelty that is an integral part of sexual relationships was receiving the close scrutiny of the Surrealists. Their research into the processes of the subconscious was also accompanied by a passionate investigation of the myths and religious rites of widely dispersed primitive tribes. Both trains of thought, the personal and the universal, acted on Picasso as a stimulus.

A Crucifixion

The turmoil that was at work came to a focus in a small and unique painting, the *Crucifixion* (1930) (Plate XII, 7) that Picasso produced after

making several preliminary drawings.[36] Owing to extreme violence in the distortions of the human form and the disconcerting changes in scale, even within a single figure, the picture is not easy to decipher. Also there is a paradoxical brilliance in the yellows and reds that dominate, enhanced by vivid blues and greens. Most critics have in consequence dismissed it as a study for a larger unachieved painting or as a picture which is too personal to have any wide significance. More recently, however, a very thorough and illuminating study of its sources and links with other works has been made by Ruth Kaufmann.[37] She gives this small neglected painting a key position between the *Three Dancers* (1925) (Plate XI, 2) and *Guernica* (1937) (Plate XVII, 1) and finds a continuity in Picasso's use of symbols and the development of his thoughts on the subject of myths and the drama of love, life and death, important factors having been at this time his association with Georges Bataille and the Surrealists.

As usual the iconography of the painting is a synthesis of legends and myths drawn from many sources. Exceptionally for Picasso the dominating theme is Christian and the traditional emblems of the crucifixion are clearly present. Around the central figure of Christ nailed to the cross are two more distant crosses from which the thieves have been removed. Their mangled corpses lie on the ground in the bottom corner on the left. There are also in the foreground the two soldiers playing dice for the garments of Christ and the ladder at the top of which a small figure nails the right hand of Christ to the cross.

But as Ruth Kaufmann points out there are other less conventional references involving pagan and primitive religions which add another dimension to the painting, making it also a commentary on the primeval sacrifice of the king god conducted here with 'human irrationality in the form of hysteria, brutality, and sadism'.[38]

The picture is dated 7.2.1930 and in the spring of the same year Georges Bataille published in a special number of *Documents* – *Hommage à Picasso* – the first preliminary drawing of 1926 and an

[36] ibid., Vol. VII, p. 14, No. 29; p. 114-16.
[37] Ruth Kaufmann, 'Picasso's Crucifixion of 1930', *Burlington Magazine*, September 1969.
[38] ibid.

article entitled 'Soleil Pourri'[39] which has some interesting analogies with Picasso's preoccupations. Bataille was particularly interested in primitive worship of the sun and moon and in Mithraic rituals to which Picasso in his enthusiasm for the bullfight was particularly drawn. This was later to reveal itself in the Minotaur engravings and in Guernica.

There is doubt among some as to Picasso's intention and the significance of the symbols he used. Should we see in them a universal meaning or should we believe that they are limited to an expression of his personal torments? Fortunately it is here that the drawings are of help. A few months before embarking on the painting he made several drawings of unusual violence in which his main preoccupation centres round the strangely distorted figure of Mary Magdalene.[40] Her naked body is bent backwards in a gesture that recalls the bacchanalian figure of the Three Dancers but here she bends towards us in a convulsion so violent that the inverted head seems to touch the buttocks with the result that her inverted eyes and nose resemble the male organs and become at the same time confused with her own genitalia. The other distinctive feature is her arms stretched upwards in supplication.

In the painting this personification of frenzied grief has been simplified. The Magdalene stands high up to the right of the cross but her arms have been transferred to a tall figure, a symbol of invocation, near the right edge of the picture. The naked hysterical Magdalene of the drawings has been given a more stylized form but the powerful emotional effect is generated elsewhere with no concessions to religious decorum. By all conventional standards this painting must be considered blasphemous. But blasphemy is by its very nature an acknowledgement of the power of religion, especially when it attains great violence. Religious subjects, excluding the Choir Boy and the Burial of Casagemas, had never in the past developed beyond rare sketchbook notes, and Picasso's belief that there is no such thing as religious art as distinct from art itself makes it clear that he is using a language of his own to express fundamental and timeless truths in his own idiom.

[39] See pp. 304-05
[40] See Zervos, Vol. VII, p. 114, Nos. 279, 280.

But also in his blasphemy there are undeniable signs of reaction against the strict Catholic régime of Spain in which he was brought up. This is even more evident in another figure whose appearance in the drawings is mild and compassionate in comparison to the Magdalene. In the painting however this figure has a central position for its ambiguous and awe-inspiring presence. There is a drawing dated June 1929[41] where we find at the feet of Christ three women closely entwined. On the left is the convulsed figure of the Magadalene while on the right there are two heads with long flowing hair, gazing up with eyes full of sorrow. They turn their back on the ghoulish faces of a crowd of onlookers.

In the painting it is the upper head with open mouth prophetic of the women of *Guernica* that has been elevated to a central point against the breast of Christ. If we suppose, as the drawings indicate, that this is the figure of the Virgin Mary a disconcerting ambiguity follows owing to the complete lack of tenderness in her face at the very moment that we would most expect it, a circumstance which contradicts her look of compassion in the drawing.

It would be easy to suspect that the head belongs to a harpy menacing Christ and to connect it with the monster in the painting of 1929 (Plate XII, 2) which is superimposed on the profile of Picasso himself, but if this is the case it would be limiting his motives to his own private affairs and so obvious a literal solution does not tally with the character of Picasso, nor with the universality of the surrounding symbols. In consequence the central female figure is undoubtedly the Virgin. The teeth which have now become sharp and menacing and the open jaw are indications of a violent gesture motivated by ungovernable suffering rather than spite, and the immediate cause of this ferocity is to be found in the presence of the centurion mounted like a *picador* who plunges with his lance into the defenceless body of Christ. He is inserted into the composition on a much smaller scale and has a more realistic appearance than any other figure making his identity and purpose unmistakable. The movement of the Virgin is a last desperate attempt

[41] ibid., Vol. VII, p. 115, No. 281.

to protect her son, described in an idiom which is primitive and dramatic.

The language invented by Picasso is subtle and profound. The descriptions of both women, the Magdalene in her nakedness and the Virgin in her passionate maternal love, reveal a characterization which owes its power to signs that are both disturbingly original in form and appropriate. In its ambiguity the sacred and most reverenced image of woman comes within an ace of being mistaken for the devil and the Magdalene, the redeemed sinner, is reminded in her agony of the omnipotence of sex.

As is usual with all major creations, the interest in this theme did not end with the painting of 1930. Two years later Picasso became absorbed by the emotional qualities of the Isenheim altarpiece of Matthias Grünewald.[42] In the earliest of the drawings he made as variations of this theme, there is a resemblance between the tortured face of Christ and the Virgin of the 1930 painting, but he rapidly became more interested in bonelike structures which resemble the woman seated on the beach (Plate XIII, 1) of 1929 rather than the mythical content of the subject, and the drawings have close affinities with the sculptures in which he was absorbed during the same period.

But there are other revealing references that appeared in more recent years. In a drawing of 1938 (Plate VIII, 5)[43] Picasso returns to the idea with new symbolic violence. In an explosion of cynical despair at the outrageous cruelty of which man is capable, made evident in the Spanish Civil War, which had not yet reached its climax, we find the same scene with Mary Magdalene in a paroxysm of agony described in Rabelaisian terms. She is at the same time farting and clutching at the genitals of her redeemer, symbolically giving up the ghost and desperately clinging to life. But the Virgin, standing beside the cross, severs the umbilical cord of her son with her teeth, an astonishing reference to rebirth in a scene devoid of any vestige of hope and in which Christ pierced by the lance of the mounted centurion utters heavenwards his last reproachful cry of despair.

[42] ibid., Vol. VIII, pp. 22-5.
[43] See Zervos, Vol. IX, p. 92, No. 193.

Finally a series of twenty-five drawings of March 1959[44] comes as a surprise and reminds us again of the analogy that Picasso always found between the crucifixion and the bullfight. In this series the scene is set in the bullring and the Virgin herself presides over the rite. Christ instead of being the passive victim of an outrage has detached his right hand from the cross, a gesture which is found in certain Catalan sculptures of the twelfth century, where it appears to be the preliminary act of the deposition. Picasso, however, interprets this as an active attempt to divert the onslaught of the bull, which has already unhorsed a rider lying in agony at the foot of the cross. Snatching his loincloth he plays the bull as the toreador would do with his cape. This troubling version of the ancient drama underlines the close connection in Picasso's thought between the legendary ritual of the bullfight and the theme of the sacrificed king-god. In this he sees perhaps a hope of resurrection and immortality in the desperate effort to divert the course of uncontrollable violence or an underlying despair at the futility of heroism.

Sculpture

Just as in 1906 when Picasso's desire for a fuller representation of form had resulted in modelled heads and figures carved in wood, so after a lapse of over twenty years he began again in 1928 to realize in three dimensions the sculptural forms of his drawings. Except for the *Glass of Absinthe,* none of the cubist constructions had been sculptures in the round. They were intended to be viewed like a picture from one side only. In painting during the twenties Picasso had alternated between representing form by modelling or by line. To use modelling when it came to solid three-dimensional sculpture would appear to be the normal solution, and in fact that was the method he first adopted when early in 1928 he began to make what was virtually a copy of his charcoal drawings in solid form (Plate XII, 1). But the inventive genius of Picasso was not long to see that three-dimensional figures could also be drawn in other ways. In the autumn he made a construction in iron wire which

[44] See Zervos, Vol. XVIII, p. 100, Nos. 333, 334 and pp. 102-5, Nos. 336-59.

was related to the big architectural still-lifes painted the same year, and also to line drawings (Plate XII, 3). It was like a simplified diagram of the strange sketchbook drawings reproduced later in the *Chef d'œuvre inconnu*. The idea of diagrams in space may be traced back to the Russian constructivists ten years earlier, and more recently to the wire portraits of Calder, but Picasso managed to evoke in his new linear sculpture a lyrical sense of the human form which was his original invention and one which has been exploited widely since the war by younger sculptors.

Other sculptures followed, always linked with his painting and sometimes themselves painted in black and white. There was no separation between the two activities which are usually classified as different arts. With Picasso they were both his children and, like the hen and the egg, who could tell which came first? There are sculptures which seem to originate from elements in a painting, like the *Head* of October 1928[45] which stands on a tripod and resembles closely the figure of the artist in the painting of the same year called *The Painter and his Model* (Plate XII, 8). On the other hand, it was a common practice with Picasso to construct a sculpture out of material he picked up around him, and soon after to paint a picture in which the shapes of his sculpture appeared. Again, after that he often decorated the sculpture with new ideas that were discovered while making his picture. This continual interchange of ideas from one medium to another gives the work of Picasso a homogeneity that echoes from one method and one style to another.

[45] See Barr, *Picasso: Fifty Years of His Art*, p. 157.

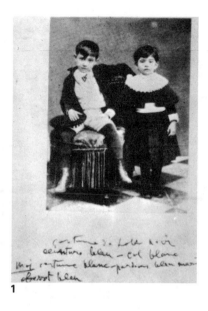

1

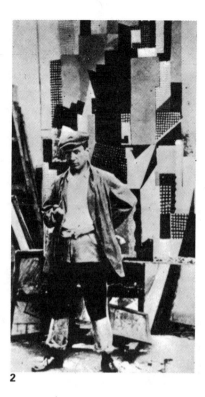

2

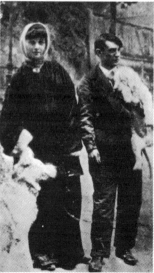

3

PLATE A
1. Pablo aged seven with his sister Lola
2. Picasso in his studio, 5 bis rue Schoelcher,
 Paris, 1915
3. Picasso and Fernande Olivier in Montmartre,
 c. 1906
4. Picasso and Olga Koklova in Paris, 1917

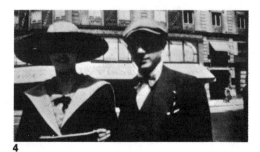

4

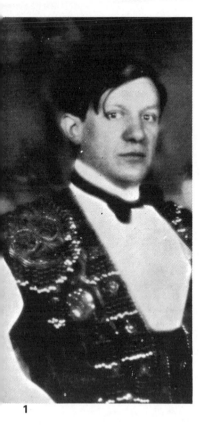

1

2

PLATE B
1. Picasso as a matador at a ball given by Comte Etienne de Beaumont, Paris, 1924
2. Picasso with his paintings rue la Boétie, Paris, 1931
3. Picasso with Paul Eluard at Mougins, 1936

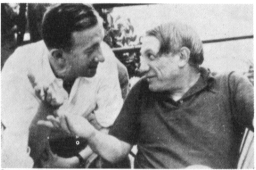

3

PLATE C

1. Picasso painting *Guernica*, 1937
2. Picasso holding a bull's skull on the beach at Golfe Juan, summer 1937
3. Picasso presides at the bullfight at Vallauris, with Jacqueline, Paloma, Maïa, Claude (only just in the photograph) and Jean Cocteau, 1955

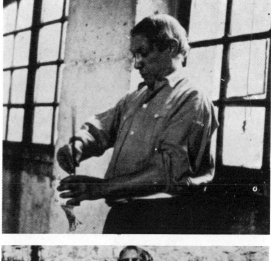

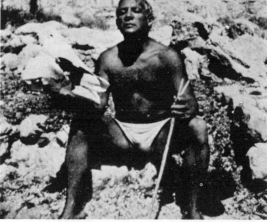

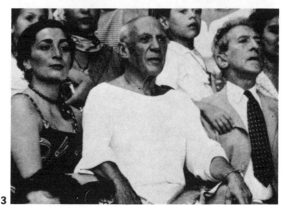

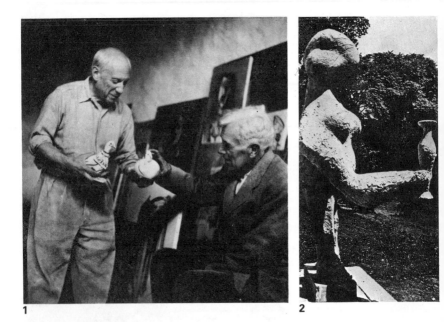

1 2

PLATE D
1. Picasso shows Braque his ceramics in the studio at Vallauris, 1957
2. The massive female figure, now surmounting Picasso's grave at Vauvenargues: *Woman with Vase*. 1933. Bronze (86½ high)
3. Picasso and Jacqueline at Notre Dame de Vie, 1965

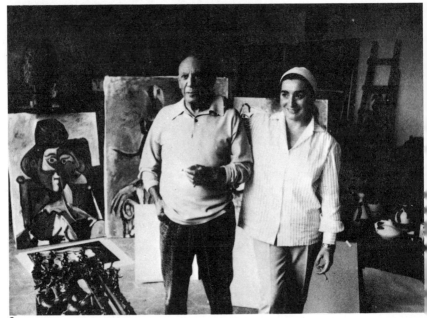

3

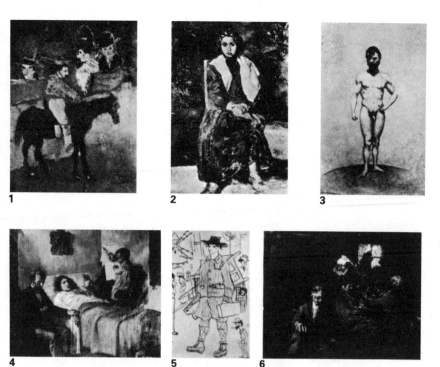

PLATE I

1. *The Picador.* Earliest known painting by Picasso. 1889-90. Oil on wood
2. *Girl with Bare Feet.* 1895. Oil (29½ × 19½)
3. Diploma drawing. 1895. Pencil (19¾ × 12)
4. *Science and Charity.* 1896. Oil (77⅝ × 98¼)
5. *Self-portrait.* 1901. Pen and coloured crayon (7 × 4½)
6. *Scene in a Tavern.* 1897. Oil (7 × 9½)

7. *Le Moulin de la Galette.* 1900. Oil (35¼ × 45¾)
8. *The Burial of Casagemas (Evocation).* 1901. Oil (58¾ × 35½)
9. *Harlequin.* 1905. Oil (39½ × 39)

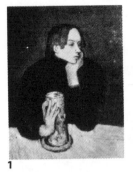

1

2

3

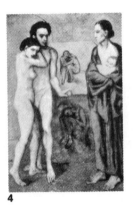

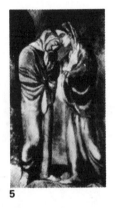

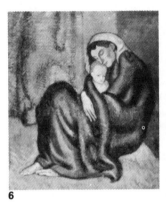

4

5

6

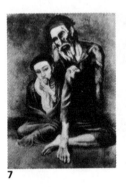

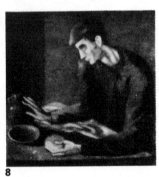

7

8

9

PLATE II

1. *Portrait of Jaime Sabartés.* 1901. Oil (32¼ × 26)
2. *The Blue Room.* 1901. Oil (20 × 24½)
3. *Self-portrait.* 1901. Oil (31½ × 23⅝)
4. *La Vie.* 1903. Oil (77½ × 51)

5. *Two Sisters.* 1902. Oil (59⅞ × 39⅜)
6. *Maternity.* 1901. Oil (44¼ × 38½)
7. *The Old Jew.* 1903. Oil (49¼ × 36¼)
8. *The Blind Man's Meal.* 1903. Oil (37½ × 37¼)
9. *The Courtesan with a Jewelled Necklace.* 1901. Oil (25¾ × 21½)

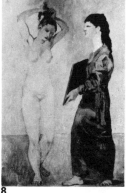

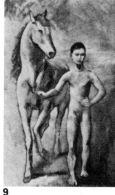

PLATE III

1. *The Actor.* 1904-05. Oil (76³/₈ × 44¹/₈)
2. *Salomé.* 1905. Drypoint (15⁷/₈ × 13³/₄)
3. *Meditation.* 1904. Watercolour and pen (13⁵/₈ × 10¹/₈)
4. *The Jester.* 1905. Bronze (15³/₄ high)
5. *The Soler Family.* 1903. Oil (59 × 79)
6. *The Old Guitarist.* 1903. Oil (47¹/₂ × 32)

7. *Acrobat's Family with Ape.* 1905. Gouache, watercolour, pastel and India ink on cardboard (41 × 29¹/₂)
8. *La Toilette.* 1906. Oil (59¹/₂ × 39)
9. *Boy Leading a Horse.* Early 1906. Oil (86³/₄ × 51¹/₂)

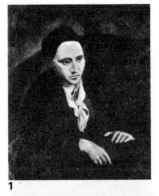
1

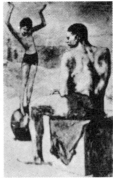
2

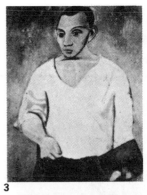
3

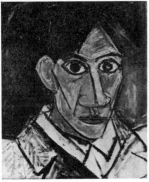
4

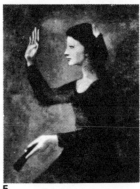
5

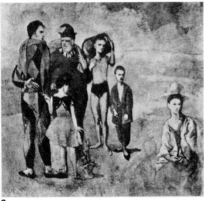
6

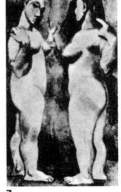
7

PLATE IV

1. *Portrait of Gertrudé Stein.* Completed 1906. Oil (39½ × 32)
2. *Acrobat on a Ball.* 1905. Oil (57½ × 37)
3. *Self-portrait with a Palette.* 1906. Oil (36 × 28)
4. *Self-portrait.* 1907. Oil (19¾ × 18⅛)

5. *Woman with a Fan.* 1905. Oil (39½ × 32)
6. *Family of Saltimbanques.* 1905. Oil (83¾ × 90½)
7. *Two Nudes.* 1906. Oil (59¾ × 36½)

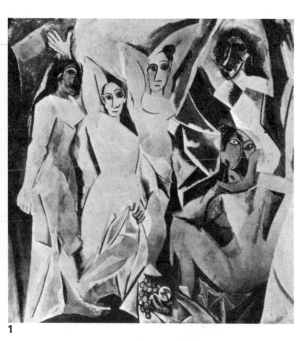

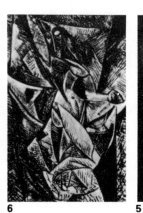

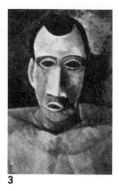

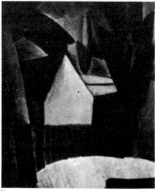

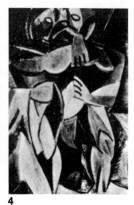

PLATE V

1. *Les Demoiselles d'Avignon.* 1907. Oil (96 × 92)
2. *Negro Dancer (Nude with Raised Arms).* 1907. Oil (24 × 17)
3. *Head.* 1908. Oil (24½ × 17)
4. *Nude with Drapery.* 1907. Oil (60 × 39¾)
5. *House in the Garden.* 1908. Oil (28 × 23½)
6. *Two Nudes (Friendship).* 1908. Oil (59¾ × 39¾)

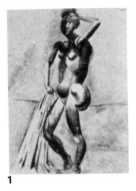

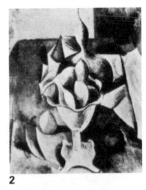

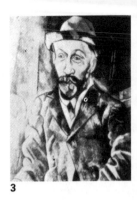

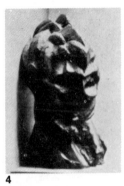

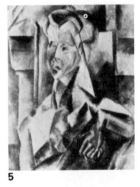

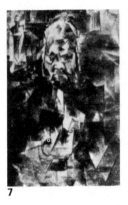

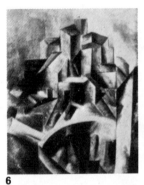

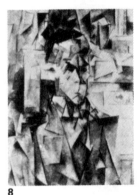

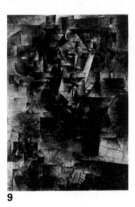

PLATE VI

1. *Nude on Beach (Bather).* 1908. Oil (51¼ × 38⅛)
2. *Fruit Dish.* 1908-09. Oil (29¼ × 24)
3. *Portrait of Clovis Sagot.* 1909. Oil (32¼ × 26)
4. *Head of a Woman.* 1909. Bronze (16¼ high)
5. *Seated Woman (Femme en vert).* 1909. Oil (37¾ × 31½)
6. *The Reservoir, Horta.* 1909. Oil (23¾ × 19¾)
7. *Portrait of Vollard.* 1910. Oil (36¼ × 25½)
8. *Portrait of Uhde.* 1910. Oil (31⅞ × 23⅝)
9. *Portrait of Kahnweiler.* 1910. Oil (39⅝ × 25⅝)

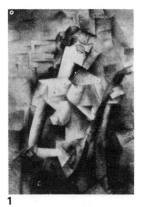

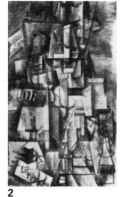

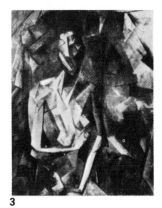

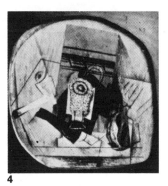

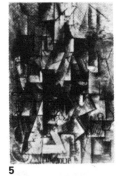

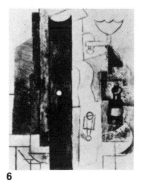

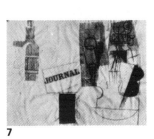

PLATE VII

1. *Girl with a Mandolin.* 1910. Oil (39½ × 29)
2. *The Aficionado.* 1912. Oil (53⅛ × 32¼)
3. *Seated Nude.* 1909 or 1910. Oil (36¼ × 28¾)
4. *Pipe, Glass and Apple.* 1913. Oil.
5. *'Ma Jolie' (Woman with Zither or Guitar).* 1911-12. Oil (39⅜ × 25¾)
6. *Still-life with Gas-jet.* 1912. Oil (27 × 21)

7. *Violin, Bottle and Glass.* 1912-13. Charcoal and pasted papers (18 × 24¾)
8. *Head.* Early 1913. Charcoal and pasted papers (16⅛ × 12⅝)
9. *Still-life with Chair-Caning.* 1912. Oil, pasted oilcloth paper on canvas, surrounded with rope (10⅝ × 13¾ oval)

1

2

3

4

5

6

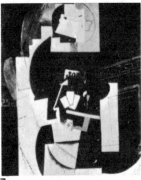
7

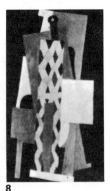
8

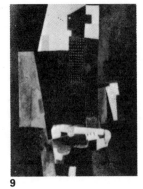
9

PLATE VIII

1. *Guitar on a Table.* 1913. Oil on wood with plaster reliefs (29½ × 17¾)
2. *Portrait of a Young Girl.* 1914. Oil (51¼ × 38)
3. *Woman in an Armchair (Woman in a Chemise).* 1913. Oil (58¼ × 39)
4. *Vive la France.* 1914-15. Oil (21½ × 25¾)
5. *Glass of Absinthe.* 1914. Painted bronze and silver sugar strainer (8 high)
6. *Still-life.* 1914. Painted wood with upholstery fringe (18⅞ long)
7. *Card Player.* 1913-14. Oil (42½ × 35¼)
8. *Harlequin.* 1915. Oil (72¼ × 41½)
9. *Guitar Player.* 1916. Oil (51¼ × 38⅛)

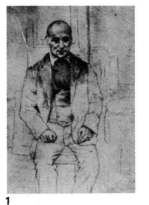

1

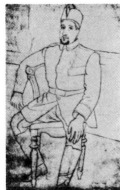

2

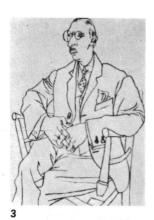

3

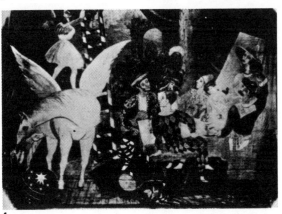

4

5

6

7

PLATE IX

1. *Portrait of Max Jacob.* 1915. Lead pencil (13 × 9¾)
2. *Portrait of Apollinaire.* 1916. Lead pencil (19¼ × 12)
3. *Portrait of Stravinsky.* 1920. Lead pencil (24⅜ × 19⅛)
4. *Drop Curtain for Parade.* 1917 (11yds × 17yds)
5. *Olga Picasso in a Mantilla.* 1917. Oil (25¼ × 20⅞)
6. *Horse and Bull.* 1917. Lead pencil
7. *Diaghilev and Selisburg.* Summer 1919. Charcoal and pencil (25 × 19½)

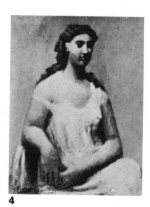

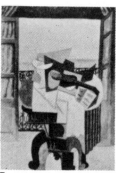

PLATE X

1. *Three Musicians.* 1921. Oil (79 × 87¾)
2. *Two Seated Women.* 1920. Oil (76¾ × 64¼)
3. *Mother and Child.* 1921. Oil (38 × 28)
4. *Seated Woman.* 1923. Oil (36 × 28)
5. *Table in front of Window.* 1919. Gouache (8¾ × 12¼)

6. *The Bathers.* 1918. Pencil (9¼ × 12¼)
7. Drawing. 1924. Pen and india ink (11½ × 9) Illustration for *Le Chef-d'oeuvre inconnu* by Balzac

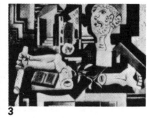

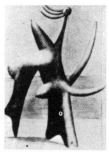

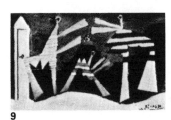

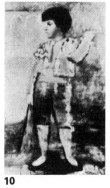

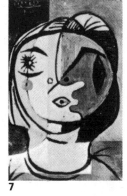

PLATE XI

1. *Mandolin and Guitar.* 1924. Oil with sand (55³/₈ × 78⁷/₈)
2. *Three Dancers (The Dance).* 1925. Oil (84⁵/₈ × 55⁷/₈)
3. *Studio with Plaster Head.* 1925. (38⁵/₈ × 51⁵/₈)
4. *Still-life, Dinard.* 1922. Oil (13 × 16¼)
5. *Bather (Cannes).* 1927. Charcoal
6. *Painter and Model Knitting.* 1927. Etching (7½ × 11¼) Illustration for *Le Chef-d'oeuvre inconnu* by Balzac published Paris 1931
7. *Head.* 1926. Oil (8½ × 5½)
8. *Guitar.* 1926. Floorcloth, string, nails and newspaper on painted canvas (38¼ × 51¼)
9. *On the Beach (Dinard).* 1928. Oil (7½ × 12¾)
10. *Paulo as a Toreador.* 1925. Oil (63¾ × 38¼)

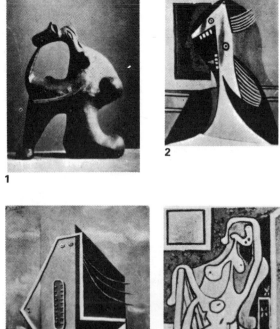

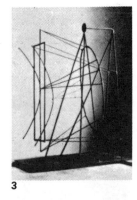

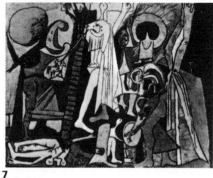

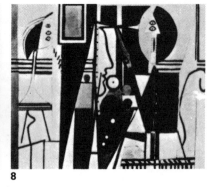

PLATE XII

1. *Metamorphoses (Bather, Metamorphosis II).*
 1928. Bronze (8 high)
2. *Bust of a Woman with Self-portrait.* 1929. Oil
 (28 × 24)
3. *Sculpture.* 1928. Iron wire (c. 20 high)
4. *Project for a Monument (Woman's Head).*
 1929. Oil (25¾ × 21¼)

5. *Woman in an Armchair.* 1929. Oil (76¾ × 51)
6. *Head of a Woman.* 1931. Iron and found
 objects (39 high)
7. *Crucifixion.* 1930. Oil on wood (19¾ × 25⅞)
8. *Painter and his Model.* 1928. Oil (51⅛ × 64¼)

1

2

3

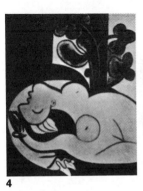

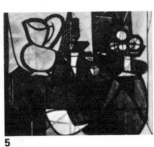

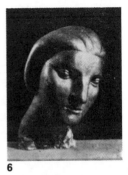

4

5

6

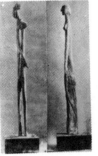

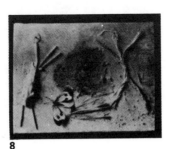

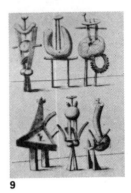

7

8

9

PLATE XIII

1. *Seated Bather*. Early 1930. Oil (64¼ × 51)
2. *Girl Seated in a Red Armchair*. 1932. Oil (51 × 38¼)
3. *Girl before a Mirror*. 1932. Oil (64 × 51¼)
4. *Nude on a Black Couch*. 1932. Oil (63¾ × 51¼)
5. *Pitcher and Bowl of Fruit*. 1931. Oil (51¼ × 63¾)

6. *Head*. 1931. Bronze (19⅝ high)
7. *Figures*. 1931. Wood, later cast in bronze (17 and 20 high)
8. *Composition with Butterfly*. 1932. Matches, drawing pin, leaf, butterfly, etc, (9½ × 13)
9. *Anatomy*. 1933. Pencil

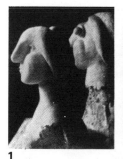

1

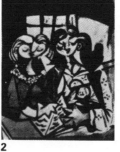

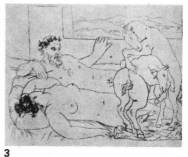

2

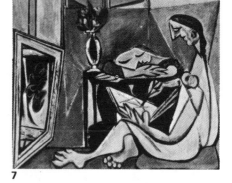

3

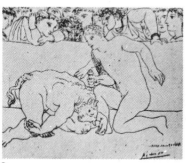

4

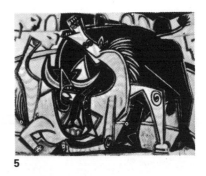

5

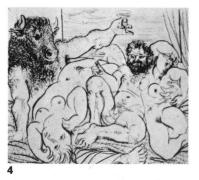

6

7

PLATE XIV

1. *Heads.* 1932. Plaster, later cast in bronze (34 and 30¾ high)
2. *Two Girls Reading.* 1934. Oil (32 × 27½)
3. *Sculptor's Studio.* 1933. Etching (7½ × 10½) From *The Sculptor's Studio*, Vollard Suite
4. *Bacchanal with Minotaur.* 1933. Etching (11½ × 14½) From *The Minotaur*, Vollard Suite

5. *Bullfight.* 1934. Oil (38 × 51)
6. *Vanquished Minotaur.* 1933. Etching (7½ × 11¾) From *The Minotaur*, Vollard Suite
7. *The Muse.* 1935. Oil (51¼ × 63¾)

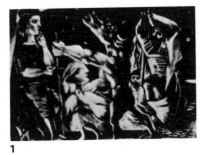

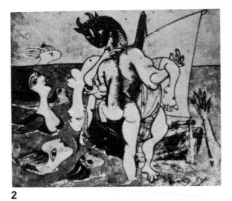

PLATE XV

1. *Blind Minotaur Guided by a Little Girl in the Night.* 1934. Mixed process (9¾ × 13¾) From *The Minotaur,* Vollard Suite
2. *Minotaur with a Boat.* 1937. India ink and Ripolin on cardboard (9 × 11)
3. *Portrait of Nusch.* 1937. Oil
4. *Dora Maar seated.* 1937. Oil (36¼ × 25⅝)

5. *Nude with Night Sky.* 1936. Oil (51¼ × 63¾)
6. *Grand Air.* 1936. Aquatint (16½ × 12¼) Illustration for the first ten copies of *Les Yeux Fertiles* by Eluard
7. *Portrait of Eluard.* 1936. Pencil
8. *End of a Monster.* 1937. Pencil (15 × 22)

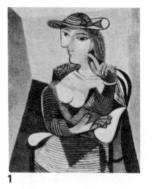

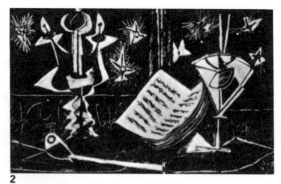

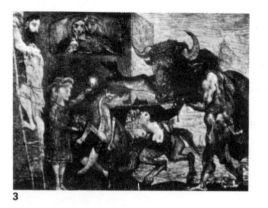

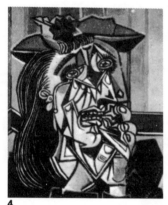

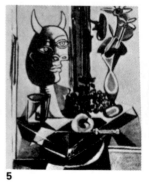

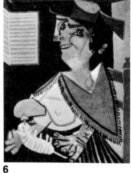

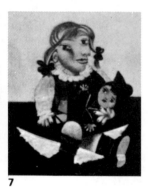

PLATE XVI

1. *Seated Woman. (Marie-Thérèse Walter).* 1937. Oil (39⅜ × 31⅞)
2. *Still-life, Le Tremblay.* 1937-38. Oil
3. *Minotauromachie.* 1935. Etching (19½ × 27⁷/₁₆)
4. *Weeping Woman.* 1937. Oil (23⅝ × 19¼)
5. *Still-life with Horned God.* 1937. Oil (27¾ × 23½)
6. *Woman with Cat.* 1937. Oil (c. 32 × 23)
7. *Portrait of Maïa.* 1938. Oil (28¾ × 23½)

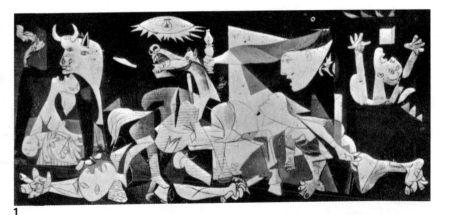

1

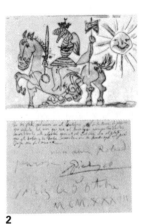

2

3

4

5

6

PLATE XVII
1. *Guernica.* 1937. Oil (11′ 5″ × 25′ 5¾″)
2. *Dream and lie of Franco.* 1937. Etching and aquatint (12⅜ × 16⁹/₁₆) *AND* Signature to ditto, 1937
3. *Man with Lollipop.* 1938. Oil (24 × 19)

4. *Portrait of Lee Miller.* 1937. Oil (32½ × 23½)
5. *Bathers with a Toy Boat.* 1937. Oil, charcoal and chalk (51 × 76¾)
6. *Girl with a Cock.* 1938. Oil (57¼ × 47½)

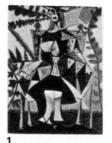

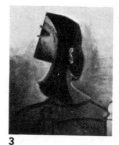

1
2
3

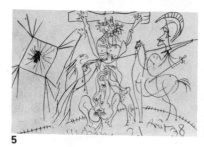

4
5

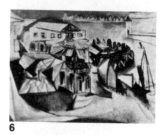

6
7

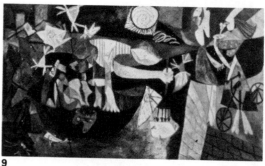

8
9

PLATE XVIII

1. *Woman Seated in a Garden.* 1938. Oil (51 × 38)
2. *Still-life with a Red Bull's Head.* 1938. Oil (37¾ × 51)
3. *Woman's Head.* 1939. Oil (25½ × 21½)
4. *Cat and Bird.* 1939. (38¼ × 50¾)
5. *Study for a Crucifixion.* 1938. Ink on paper

6. *Café at Royan.* 1940. Oil (38 × 51)
7. *Women at their Toilette.* 1938. Oil and pasted paper on canvas. (117¾ × 176⅜)
8. *Head of a Woman with Two Profiles (DM).* 1939. Oil (36 × 28½)
9. *Fishermen of Antibes (Night Fishing).* 1939. Oil (6' 9" × 11' 4")

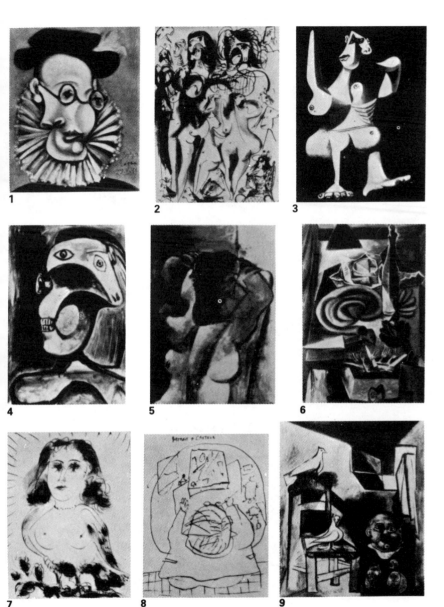

PLATE XIX

1. *Jaime Sabartés*. 1939. Oil (18½ × 15)
2. Page from *Royan Sketchbook*. 1940. Pen, ink and wash (16 × 11¼)
3. *Seated Woman Dressing her Hair*. 1940. Oil (51 × 38¼)
4. *Head, Royan*. Painted the day the Germans entered Royan, 11 June 1940. Oil on paper (25 × 18)
5. *Sleeping Nude*. 1941. Oil (36 × 25½)
6. *Still-life with Sausage*. 1941. Oil (36 × 25½)
7. *Portrait of DM as a Bird*. 1943. Pen, ink and wash. Drawn on a blank leaf of Buffon's *Natural History*
8. *Self-portrait* from *Desire Caught by the Tail*. 1943. Pen and ink
9. *Child with Pigeons*. 1943. Oil (64 × 51)

1

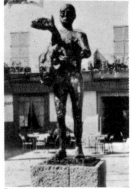

2

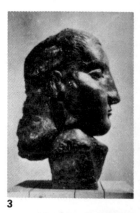

3

4

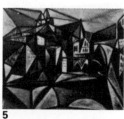

5

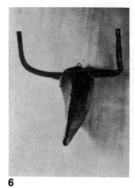

6

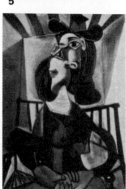

7

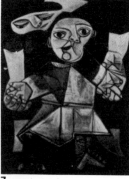

8

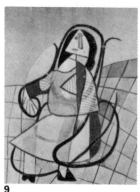

9

PLATE XX

1. *Skull (Death's Head)*. 1943. Bronze and copper (12¼ high)
2. *Man with the Sheep*. 1944. Bronze (7' 2" high) Vallauris
3. *Head of DM,* monument to Apollinaire, in graveyard of St. Germain-des-Prés, Paris. 1941. Bronze (31½ high)
4. *Head*. 1943. Paper (5 high)
5. *Paris Landscape*. 1945. Oil (28¾ × 36¼)
6. *Bull's Head*. 1943. Bicycle saddle and handlebars (17 high)
7. *First Steps*. 1943. Oil (51¼ × 38¼)
8. *Seated Woman*. 1941. Oil (51 × 38)
9. *Woman in a Rocking Chair*. 1943. Oil (63¼ × 51)

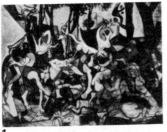

1

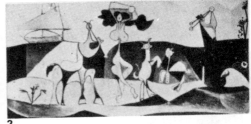

2

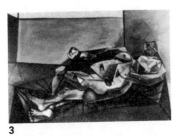

3

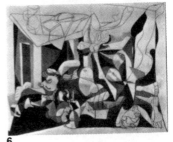

4

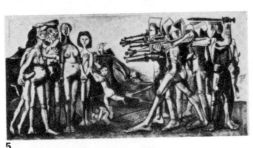

5

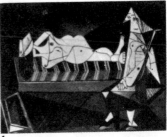

6

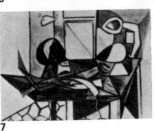

7

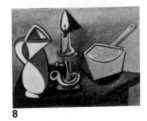

8

PLATE XXI

1. *Bacchanal after Poussin.* 1944. Watercolour and gouache (12¼ × 16¼)
2. *Pastoral.* 1946. Oil on fibro-cement (47¼ × 98¼)
3. *Sleeping Nude.* 1942. Oil (51 × 76¾)
4. *L'Aubade.* 1942. Oil (76¾ × 104⅜)
5. *Massacre in Korea.* 1951. Oil on plywood (43¼ × 82¾)

6. *The Charnel House.* 1945. Oil and charcoal (78¾ × 98¼)
7. *Skull and Leeks.* 1945. Oil (35 × 51)
8. *Pitcher, Candle and Casserole.* 1945. Oil (32¼ × 41¾)

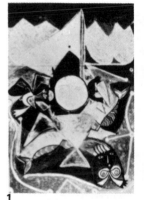

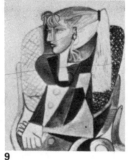

PLATE XXII

1. *Ulysses and the Sirens.* 1946. Oil on fibro-cement (*c.* 177 × 118)
2. *Spiral Head of Faun* (*c.* 12 × 10) Reproduced *Verve*, Vol. 5, Nos 19 and 20
3. *Mother and Children with Orange.* 1951. Oil on wood (45¼ × 34¾)
4. *Owl and Sea Urchins.* 1946. Oil on wood (31½ × 30¼)

5. *Françoise.* 1946. Lithograph (24¾ × 19)
6. *Night Landscape, Vallauris.* 1951. Oil (57½ × 45)
7. *Portrait of a Painter, after El Greco.* 1950. Oil on plywood (39⅝ × 31⅞)
8. *Chimneys of Vallauris.* 1951. Oil (23½ × 28¾)
9. *Portrait of Sylvette.* 1954. Oil (39¼ × 32)

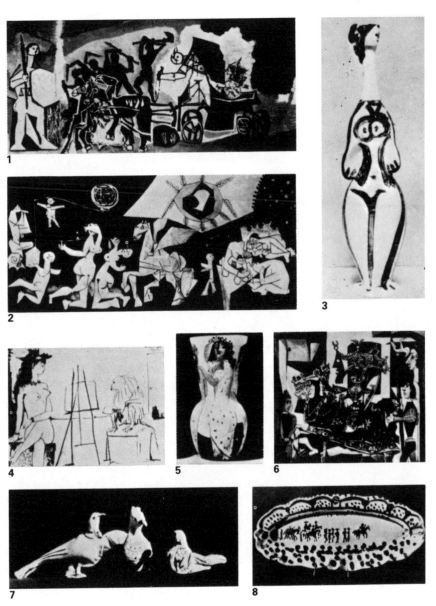

PLATE XXIII

1. *War.* 1952. Oil on isorel (15′ 5″ × 33′ 6″)
2. *Peace.* 1952. Oil on isorel (15′ 5″ × 33′ 6″)
3. Woman Vase. 1948. Ceramic (*c.* 18¾ high)
4. *Model and Monkey Painter.* 1954. Ink and wash (9½ × 12½) Reproduced from *Verve*

5. Vase. Ceramic. *c.* 1951 (*c.* 18 high)
6. *Knights and Pages.* 1951. Oil (18 × 24)
7. Three Doves. 1953. Ceramic (8-12 long)
8. Plate with Bullfight. *c.* 1957. Ceramic (11 × 26)

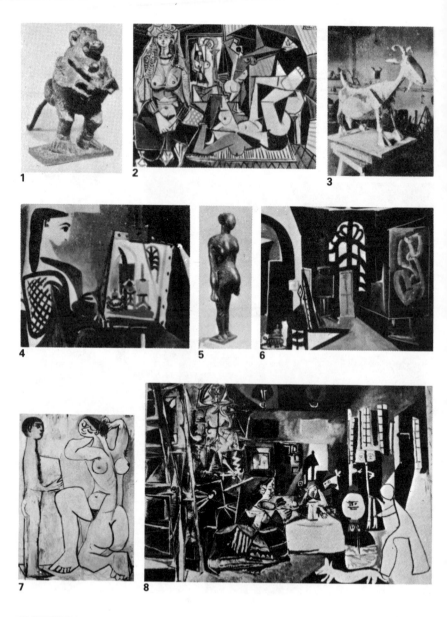

PLATE XXIV

1. *Ape with Young.* 1951. Bronze (21 high)
2. *Les Femmes d'Alger, after Delacroix.* 1955. Oil (45 × 57½)
3. *Goat.* 1950. Plaster, later cast in bronze (46⅜ × 56⅜ × 27¾)
4. *Jacqueline Roque in the studio.* 1956. Oil (18 × 21½)
5. *Pregnant Woman.* 1950. Bronze (41¼ high)
6. *The Studio.* 1956. Oil (28½ × 36)
7. *La Coiffure.* 1954. Oil (51 × 38)
8. *Las Meninas, after Velázquez,* first version. 1957. Oil (5′ 10″ × 8′ 6″)

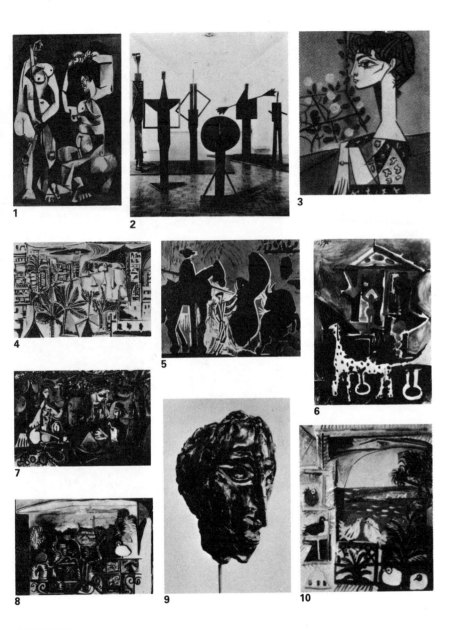

PLATE XXV

1. *Two Nudes.* 1956. Oil (76¾ × 57¼)
2. *Figures and Fountain (The Bathers).* 1956. Bronze (Max. height 8′ 8″ × 3′ 5″)
3. *Jacqueline aux Fleurs.* 1954. Oil (39¼ × 31⅞)
4. *The Bay at Cannes.* 1958. Enamel on canvas (50¼ × 76¾)
5. *Avant la pique.* 1950. Lino-cut (24½ × 29½)
6. *Composition with Dalmatian Dog.* 1959. Oil (76¾ × 55)
7. *Déjeuner sur l'herbe.* 1960. Oil (51¼ × 76¾)
8. *Paysage de Cannes au crépuscule.* 1960. Oil (51¼ × 76¾)
9. *Tête de femme.* 1961. Bronze (27 × 11 × 23)
10. *The Pigeons.* 1957. Oil (39¾ × 31½)

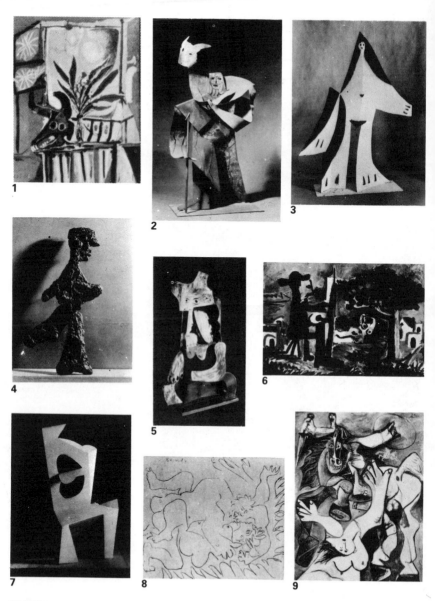

PLATE XXVI

1. *Still-life with Bull's Skull.* 1958. Oil (63¾ × 51¼)
2. *Man with Sheep.* 1961. Metal cut-out, folded and painted (20⅞ × 11)
3. *Woman with Outstretched Arms.* 1961. Metal cut-out folded and painted (72 × 69¾ × 28)
4. *Man Running.* 1960. Bronze (117 × 64 × 8/ 25½ × 3½)
5. *Femme au chapeau.* 1961. Sheet iron (50½ high)
6. *The Painter and his Model.* 1963. Oil (35 × 51¼)
7. *The Chair.* 1961. Metal cut-out, folded and painted (43⅞ × 45⅛ × 35)
8. *The Rape.* 1963. Lino-cut (20¾ × 24¾)
9. *Rape of the Sabines.* 1962. Oil (63¾ × 51¼)

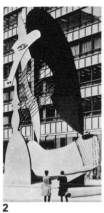

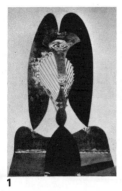

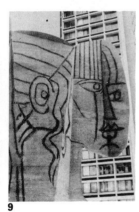

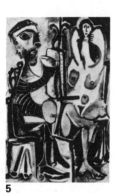

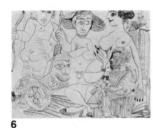

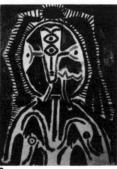

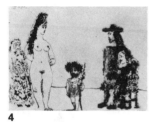

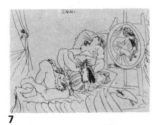

PLATE XXVII

1. *Maquette for Chicago Monument.* 1964. Steel (41¼ × 27½ × 19)
2. *Chicago Monument.* Corten steel. (50' high)
3. *Femme couchée au chat.* 1964. Oil (51 × 76¼)
4. Aquatint. 1968 (9¼ × 13)
5. *Artist and Model.* 1963. Oil (76¾ × 51)
6. *Mythological Scene.* 1967. Pencil drawing (22¼ × 29½)
7. *Raphael and la Fornarina.* 1968. Engraving (11 × 16¼)
8. *Buste de femme.* 1963. Oil (36¼ × 28¾)
9. Sylvette Monument, New York
10. *Sleeping Girl.* 1969. Pencil drawing (20 × 25¾)

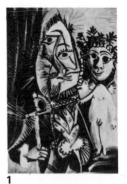

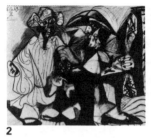

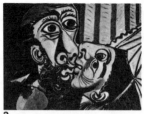

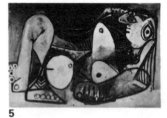

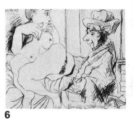

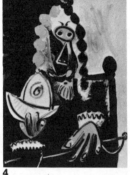

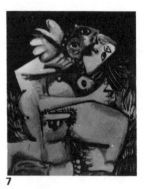

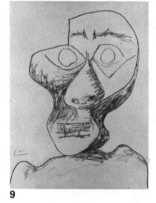

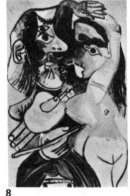

PLATE XXVIII

1. *Amour et mousquetaire.* 1969. Oil (51 × 35)
2. *Harlequin and Pierrot.* 1969. Coloured chalk and crayon (12¾ × 16)
3. *Le Baiser.* 1969. Oil (38¼ × 51)
4. *Homme au casque et à l'épée.* 1969. Oil (57¼ × 44¾)
5. *Nude.* 1969. Oil (51 × 76¾)

6. *Nude Girl and Companion.* 1969. Blue crayon (17 × 21¾)
7. *The Couple.* 1969. Oil (63¾ × 51)
8. *Peintre et modèle.* 1969. Oil (57¾ × 44¾)
9. *Self-portrait.* 2/7/72. Drawing in pencil and white chalk (27½ × 22½)

9

Boisgeloup: Sculpture and the Minotaur
(1930-36)

Le Chef d'œuvre inconnu *and Ovid's* Metamorphoses

'There ends our art on earth,' solemnly exclaimed the friend of the old mad painter in Balzac's story *Le Chef d'œuvre inconnu.* He and the young Poussin were looking for the first time at the picture on which the aged artist had been working for over ten years. In his attempt to arrive at the perfect image of his imaginary model he had hidden all resemblance to reality beneath endless improvements. To him the confused daubs of colour and the multitude of bizarre lines which formed a thick wall of paint was a masterpiece, more alive and more beautiful than the woman it was supposed to represent. Balzac's story raises the problem of comparative realities which had occupied Picasso since the early days of Cubism. When confronted with the living model, the work of art is not in competition. It is a fiction, 'a lie that makes us realize truth, at least the truth that is given us to understand', to quote Picasso's own statement. The fiction becomes valuable when its power is sufficient to compel us to see in it a new vision of reality.

It was this story that Vollard chose for Picasso's illustrations when in 1931 he published a volume which puzzled book collectors by its diversity of styles (Plates XI, 6, and X, 7). Vollard used as an introduction sixteen pages from the enigmatic Juan-les-Pins sketchbook, which I have already described, executed as wood engravings by Aubert. Besides these cryptic inventions he inserted in the text over sixty engraved drawings and thirteen etchings which have the clarity and the sensitivity of line drawings by Ingres. The opposition of two such different styles was well chosen. Apart from the visual excitement it produces, it reaffirms the necessity for multiple

reactions between art and reality. Here, just as in the cubist *Still-life with Chair-caning*, the drawings that imitate nothing, those of Juan-les-Pins exist with an autonomous reality of their own and in this way outshine the seductive charm of those that have a clear resemblance to a subject. A second book, Ovid's *Métamorphoses*,[1] was published in Lausanne by Albert Skira the same year, illustrated with thirty etchings. In this book there was no inconsistency of style. The astonishing perfection of line in the drawings that describe the struggles of the naked heroes and heroines continues in the same classical manner throughout.

The *Chef d'œuvre inconnu* started Picasso on a series of etchings known as the 'Vollard suite' which is one of the greatest triumphs of his graphic art. A few years earlier Vollard had introduced Picasso to an engraver, Louis Fort, who was an expert in the preparation of copper plates and who owned a stock of 'wonderful old Japanese paper whose mellow pulp inevitably excited his [Picasso's] taste'.[2] The incentive of working with an expert craftsman often led Picasso into new paths, and was the means on this occasion of bringing him back to engraving in a way which proved more fertile than ever before.

Boisgeloup: New Activities

Outside Paris in the direction of Rouen, two miles from the little town of Gisors, Picasso found in 1931 a small seventeenth-century château lying at the edge of a village named Boisgeloup. At the gate-way, leading into a spacious courtyard, stands an elegant little Gothic chapel. The grey stone château with its well-proportioned slate roof and windows is backed by the luxuriant growth of great trees. The long row of stables which faces the main building across the courtyard affords ample space for studios of every description. Louis Fort's press for etchings was brought there and installed and the more spacious coach-houses were transformed into sculpture studios, for this acquisition coincided conveniently with a new urge to make large sculptures for which there

[1] Ovid, *Les Métamorphoses*, Skira, Lausanne, 1931.
[2] Level, *Picasso*.

had been no space in the apartment studio in Paris.

Just as the meeting with Fort had facilitated the return to engraving, so a renewed contact with Picasso's old friend, the sculptor Gonzalez, opened the way to a period of activity in plastic creation which continued with varying intensity to the end of his life. One of the virtues of Gonzalez was that he was an excellent craftsman in metal, and as well as being an accomplished artist himself, he was quick to appreciate the ways in which he could put his talent at Picasso's disposal. He realized that sculpture was the nerve-centre of Picasso's work. Picasso had told him that in early cubist paintings 'it would have sufficed to cut them up – the colours after all being no more than indications of differences in perspective, of planes inclined one way or the other – and then assemble them according to the indications given by the colour, in order to be confronted with a "sculpture" '. Picasso was referring here to the paintings of 1908 and the bronze *Head of a Woman* (Plate VI, 4) of the following year which had been modelled by him in Gonzalez's studio. He had succeeded there in translating the portraits of Fernande painted at Horta into a three-dimensional head. Gonzalez said of Picasso in 1931 that 'he must be conscious of a true sculptor's temperament since. . . I have often heard him repeat "I find myself once more as happy as I was in 1908." '[3] The result of this recaptured delight was the appearance of a number of pieces of sculpture, some of them six feet or more high, made of pieces of iron welded together. Sometimes they were painted and most of them were later cast in bronze (Plate XII, 6).

Ideas for sculpture had appeared at frequent intervals, and from time to time in later years Picasso had made cubist constructions similar to those of 1913. In the summer spent at Juan-les-Pins in 1930 he took advantage of a heterogeneous collection of objects picked up on the beach to make designs in low relief which were glued to the back of a canvas and unified by means of sand stuck to the surface. The fortuitous encounters of objects normally unrelated to each other, of which the Surrealists were at that time exploring the advantages, suited Picasso's taste for metamorphoses. 'The chance meeting on a dissecting table of a

[3] J. Gonzalez, 'Picasso sculpteur', *Cahiers d'Art*, II, Nos. 6–7, pp. 189–91, Paris, 1936.

sewing-machine and an umbrella', praised for its strange poetic consequences by Lautréamont, was at the source of these bas-reliefs which contained anything from an old glove and a child's toy to fragments of roots or palm branches. In addition to the effect of the bizarre encounter there were masterly qualities of composition and frequent touches of humour (Plate XIII, 8).[4]

These objects of intimate charm were at one end of the scale. Other projects for sculpture in the round, such as the monument to Apollinaire, were emerging simultaneously, though, like the idea he had at one time of monumental constructions to be placed along La Croisette, the sea front at Cannes, many of them never materialized. 'I have to paint them,' he told Kahnweiler, 'because nobody's ready to commission one from me.' There is for instance a painting of a monument (Plate XII, 4), the scale of which can be judged from the figures standing beside it. The severe boxlike outlines suggest a skyscraper whose walls have been decorated by a geometric construction like a gigantic woman's head from which spring three long strands of hair. In the centre is a long mouth placed vertically and showing two rows of sharp teeth. It is a powerful image which inspires fear rather than love, analogous to the 'malanggans' from New Ireland, those strange ceremonial carvings that are reputed to cause instant death to any woman who sees them.

At Boisgeloup with Gonzalez beside him and the necessary facilities, sculpture in iron began to show new possibilities. The cubist collage had already revealed the unexpected things that could happen by using actual objects as the raw materials and combining them in a new entity. Pieces of scrap iron, springs, saucepan lids, sieves, bolts and screws, picked out with discernment from the rubbish heap, could mysteriously take their place in these constructions, wittily and convincingly coming to life with a new personality. The vestiges of their origins remained visible as witnesses of the transformation that the magician had brought about, a challenge to the identity of anything and everything.

In a different mood Picasso took a penknife and whittled out of long slender pieces of wood human figures which later he had cast in bronze

[4] See also Kahnweiler-Brassai, *The Sculptures of Picasso*, Nos. 79-83.

(Plate XIII, 7). With his ability to give volume and monumental scale to an object of trivial size, he gave these figures dignity and vitality. The most impressive sculptures of the Boisgeloup period, however, are the great heads with protruding noses and eyes that were modelled in clay and plaster. They date from a year or two after his arrival (Plate XIV, 1).

At Boisgeloup Picasso found a retreat where he would work with concentration amounting to frenzy, a condition which was essential to him if he were to find prolonged happiness. Gonzalez was astonished at the excitement and pleasure that he took in his work. The rare visits from friends were a delight to him. These included Braque, whose friendship had been rekindled through the overwhelming passion they both had for painting and an underlying warmth of affection; also Kahnweiler and his brother-in-law the poet Michel Leiris, with their wives.[5] These companions provided moments when it was possible to enjoy the shade of the great trees and examine at length Picasso's various creations. There are a number of delightful landscapes painted from the windows, in which the little church and the adjoining houses appear in sun or rain.[6] The grey walls and fine masonry of the house pleased Picasso's sense of the monumental, which was also evident in things with which he surrounded himself, such as the St Bernard dog of which he was very fond, the skull of a hippopotamus that was placed in the hall, and a very fine example of Baga sculpture of majestic proportions from French Guinea. This piece, with an exaggerated arched nose and a head almost detached from the neck, found its echo in the monumental plaster heads in the stables across the courtyard.

Still-lifes

There are still-lifes painted in 1931 which depend on colour and transparency for their effect rather than an insistence on form. Shapes are indicated with an arabesque of heavy lines giving rather the effect of a stained-glass window (Plate XIII, 5).[7] The decorative leaves of the philodendron are a characteristic of many paintings of this period, and

[5] See Penrose, *Portrait of Picasso*, pp. 58, 59.

[6] See Zervos, *Picasso*, Vol. VII, pp. 141–2.

[7] ibid., Vol. VII, p. 133, No. 326.

also appear on some of the iron sculptures. Picasso had been impressed by the overwhelming vitality of this plant. He once left one that had been given him in Paris in the only place where it would be sure to have plenty of water while he was away in the south. On his return he found that it had completely filled the little room with luxuriant growth and also completely blocked the drain with its roots.

Anatomy Reshaped

The liberties that Picasso had taken with the human form might be held to be a sacrilege. The distortions had surpassed what could be considered as a legitimate means of expression. They had gone beyond the not uncommon device of exaggerating the gestures by which emotion becomes manifest, and had become a declaration of rage against humanity itself, a vengeance in which the victim was hanged, drawn and quartered. But the contrasts in Picasso's work and in his nature were such that while perpetrating this violence he found it necessary to present us with a new anatomy of his own invention, constructed with ingenuity, grace and humour (Plate XIII, 9).[8] In sheets of drawings set out like a catalogue he offers a great variety of solutions. He replaces limbs, breasts, bellies, heads, eyes, noses, ears and mouths with forms of varied qualities: some are rigid and elegant, some soft and bloated, some tenuous and fragile, some massive and tough: pieced together these elements make new creatures that have each an individuality and a droll resemblance to the infinity of shapes that healthy or deformed humanity, stripped naked, can present.

With precision and without repetition Picasso devised a great number of plausible solutions in paintings as well as in the sheets of drawings. In two-dimensional art, figures could be balanced according to any whim, but in sculpture the problem was different, the laws of gravity imposed their restrictions. In spite of this, Picasso found the means of converting the ideas of his invented anatomies into plaster and succeeded in constructing heads in which the various elements hold together as though by magnetism.

[8] See also *Minotaure*, No. I, Albert Skira, Paris, 1933.

Moonlike Heads: A New Model

In the spring of 1932, with another of his periodic bursts of energy, Picasso produced a series of large canvases, some of which were exhibited that summer in the great retrospective exhibition at the Galerie Georges Petit. He had discovered a new highly sensuous version of the female nude (Plate XIII, 2). Most of these figures painted with flowing curves lie sleeping, their arms folded round their heads. In several paintings the boisterous philodendron sprouts up in the background (Plate XIII, 4). The sleeper's breasts are round and fruitlike and her hands finish like the blades of summer grass. The profile of the face, usually with closed eyes, is drawn with one bold curve uniting forehead and nose above thick sensuous lips. Its outline, easily recognizable, recurs in all the nudes and gives a clue to their origin.

Picasso's new model whose voluptuous influence is so strongly marked in these canvases, mostly of large dimensions, was Marie-Thérèse Walter, a young girl whom he had met by chance some while before and who attracted him by her firm, healthy figure, her blonde nordic looks and her strange aloofness. She always behaved according to her own inclination, changing her mind or her manner of living in an inconsequential way as though controlled by the influence of the moon or by some even less calculable force. She had a robust coarseness and an unconventionality about her which formed a complete contrast to Olga and the world into which she had drawn him, a world which curtailed his freedom and attempted to inflict on him a life which he found boring and fundamentally despised. The massive plaster heads made at Boisgeloup were also inspired by Marie-Thérèse (Plate XIV, 1 and XII, 6). Set high on a long tapering neck they seem to be detached from the earth and float like the moon racing through clouds. The eyes are sometimes drawn on the surface with a deep incision or in other cases modelled like a ball and added to the cheek like a satellite.

Talking to me one day, Picasso said he was sorry that in working on these heads he once spoilt his original intention. Working at night in the studio at Boisgeloup he had first built up a very complicated construction of wire which looked quite incomprehensible except when a light projected its shadow on the wall. At that moment the shadow

became a lifelike profile of Marie-Thérèse. He was delighted at this projection from an otherwise indecipherable mass. But he said, 'I went on, added plaster and gave it its present form.' The secret image was lost but a more durable and splendid version, visible to all, had been evolved. And he added: 'When you work you don't know what is going to come out of it. It is not indecision; the fact is it changes while you are at work.'

Widespread Recognition

Barr lists fifty important exhibitions of Picasso's work held in various countries between 1930 and the outbreak of war in 1939. The vast number of paintings he had produced were becoming scattered all over the world. Besides those in the great collections of Shchukine and Morosov in Russia, many had found their way into collections in Germany until that country under Hitler's régime became, like Russia, hostile to modern art. At the same time Picasso's reputation grew steadily in America, Switzerland and England as well as in France. An exhibition entitled 'Abstractions of Picasso' held in New York in January 1931 was followed by a retrospective collection of thirty-seven paintings at the Reid and Lefèvre Gallery in London, which was hailed as one of the main events of the summer season. Pictures from the Blue period, such as *La Vie*, hung on the walls, with recent still-lifes and invented anatomies. In New York two other exhibitions were held the same year. But the most important exhibition of this period was the great retrospective held at the Galerie Georges Petit in Paris in June–July 1932. Among the 225 paintings, seven sculptures and six illustrated books that were shown were many important early works, as well as the *Crucifixion* and the most recent paintings of the sleeping nudes. There were many remarkable pictures, including the *Burial of Casagemas*, of which the public knew nothing. The choice of the exhibits was made with the help of Picasso himself.

To coincide with this manifestation, Christian Zervos published a number of his review *Les Cahiers d'Art* almost entirely dedicated to Picasso, containing many reproductions and articles in French, English, German and Italian by a long list of distinguished poets,

painters, musicians, and critics.

The Sculptor's Studio

Picasso's brilliant career of discovery in the arts was not accompanied by the same success in his family life. He found in himself strong desires for a tender relationship with a woman who would remain at his side as the inspiration of erotic pleasure and the traditional pillar of his household. In his youth Fernande's bohemian nonchalance had failed to bring this about, and Eva, patient and perhaps too well-ordered, had died. With Olga there was no lack of possessive urge to found a family but it soon became obvious that the Spanish desire to observe custom was not strong enough in Picasso to conquer his mercurial nature. The many exquisite portraits of Olga and Paulo, alone or at play together, speak eloquently of Picasso's devotion in early years. The conflict that followed was due to Picasso's instinctive horror of being trapped and forced to act in ways that interfered with the flow of his creative work. His success in wooing her, resulting in the birth of their son, was the only creative side to their marriage. Once that was accomplished the incongruity of their ambitions led slowly to the situation in which she became a menace to the liberty of spirit that he could not live without.

Olga was beautiful, passionate and insistent. She was tenacious but she did not covet the wealth that was now theirs, nor was she annoyed that the possibilities of enjoying it in conventional ways left Picasso indifferent. His tastes remained simple. Though he had enjoyed complying with Olga's choice in buying the most expensive clothes, he himself usually wore the same threadbare suit. The large range of silk ties bought in Bond Street remained at the bottom of a trunk. He was more in the habit of spending money on unusual objects that excited his fancy or of giving unobtrusively and generously to his less fortunate friends. But to Olga, it was necessary to be respected and well thought of in high society, and to her the recognized methods by which this should be attained were inflexible. Years later when Picasso was asked why he could not share the same life, he replied with simplicity, 'she asked too much of me'.

The growing estrangement between Picasso and his wife lay upon

him heavily. There is more than one indication in his activities during the years from 1932 to 1936 that he was seeking ways that would liberate him. It has been said in a way that is misleading that for a while he even gave up painting. Indeed it is true that the canvases dated 1933 are less numerous than usual. This may be taken as an indication of the emotional agony through which he was passing, but Picasso's work was his life, and as usual in moments of crisis his resourcefulness allowed him to discover new methods of expression.

In the summer of 1933, after a short visit to Cannes, he returned for a few weeks to Barcelona, and the following year he made a longer journey to San Sebastian and Madrid, whence he again visited Toledo and the Escorial. He came back to Paris from the second journey stimulated once more by the atmosphere of his native country, and as had happened before after his visit in 1918, the bullfight became again the theme of a series of paintings more full of movement, colour and violent significance than ever before.

Although there were moments when he could not find in himself the habitual urge to paint, Picasso never ceased to draw. Over a period beginning in 1927, Vollard had commissioned him to make a series of etchings which numbered finally in 1937 a hundred plates.[9] They began with the illustrations of the *Chef d'œuvre inconnu*, but it was in 1933 that Picasso arrived at his most fertile production. Between 20 March and 5 May he engraved forty etchings on a theme which had been close to him since he had been at Boisgeloup, *The Sculptor's Studio*. The set was completed the following spring with six more.

An early water-colour painted by Picasso in 1904 shows a pale young man poorly dressed in contemplation of a girl asleep on a bed in their mean lodging (Plate III, 3). As was not unusual then, the profile of the man is recognizable as a self-portrait. The subject is one in which Picasso felt himself involved through his life, and one to which he gave an extraordinary variety of interpretations beginning with this emotional water-colour. In the late twenties the theme reappears as a formal cubist composition divested of all trace of emotional weakness.

[9] The 'Vollard Suite' consists, apart from 27 miscellaneous plates, of the following groups: (i) *L'Atelier du sculpteur*, 46 plates; (ii) *Le Viol*, 5 plates; (iii) *Le Minotaure*, 11 plates; (iv) *Rembrandt*, 4 plates; (v) *Le Minotaure aveugle*, 4 plates.

The direct amorous relationship between two lovers has been complicated by the girl's becoming the artist's model, and still greater changes have taken place in the manner of their presentation. The subject is hidden beneath the scaffolding of a severe geometric composition, and the emotion it conveys is based on a less obvious appeal. It no longer tells a tender and easily interpreted story, on the contrary with rigid machine-like forms, the couple face each other imbued with a passion which amounts almost to hatred. Strangely enough, however, in the version dated 1928, between the geometric shapes of the two antagonists, active and passive, a conventionally realistic profile is drawn on a canvas on which the artist is at work (Plate XII, 8). Picasso has gone beyond formal considerations and, not without wit, places this reminder of the comparative realities of nature and art reversing their accepted relationship a degree further than had happened in Balzac's story.

In the series of etchings known as *The Sculptor's Studio* this same riddle is the main theme, treated with a richness of variety. Drawn in the neo-classical style with an unhesitating line, the bearded sculptor is intent on his work which stands enthroned before him. At his side is his lovely companion who shares his passions and his anxiety. Their anxious looks are directed towards a third presence; the work that she has inspired and he has created. In this situation, unlike that which occurs in family life, the artist is sole master of his own creation. His eye watches with astonishment the life and movement that has come into his marble children, crowning the results of his conscious labour, while in his arms he holds tenderly the soft white body of his muse. In almost every image we find the drama of the lovers between whom a third presence has appeared, breaking into their unity like a nightmare as they lie together. In the plate dated 3 April the sculptor lies beside his companion, his hand on a window which looks out on an Arcadian landscape, and raises himself to contemplate the apparition that he has made (Plate XIV, 3). Standing on its base at the edge of their couch is the statue of two young horses struggling together in amorous play. It is their life and movement that fills the gaze of their creator. Lying immobile, his bald head crowned with ivy, his thoughts are far from the girl beside him. With limp fingers he caresses her as she lies asleep,

gloriously naked to his touch, her wreath of flowers tangled in her hair.

Other images show them both awake, but still their glances never meet. It may be that the violence of the sculptured group of a bull attacking two horses, or the bacchanalian abandon of a naked girl entangled in garlands, led in by a youth who has thrown her over the back of a young bull, engrosses too completely their attention;[10] they sit or lie, their bodies entwined together but their thoughts apart.

The Horned God

Picasso had found a way in the Vollard series of revealing his sense of drama in the form of a new mythology, which enriched by its references to the classics was at the same time the mirror of our daily thoughts. For, as he has said, 'there is no past or future in art'.

As early as 1913, at a time when cubist discoveries were an all-absorbing interest, Apollinaire spoke of Picasso's 'hybrid beasts who have the consciousness of the demi-gods of Egypt.'[11] But it is not always possible to trace the origins of the actors on Picasso's stage, several of whom have followed him through his life, reappearing in different circumstances but always keeping their personality. We can watch Harlequin from the days when he appeared as a self-portrait of the half-starved artist, disguised in carnival dress, to his robust, self-confident look as he carouses with his companions of the commedia dell'arte. We can remember the innocent child holding a dove of the Blue period, her reappearance in the troupe of the *saltimbanques*, and again as a mock angel standing on the back of the winged mare in the drop curtain of *Parade*. Now in the Vollard series she makes a new entry fearlessly leading a terrifying character, the Minotaur stricken with blindness, his arms searching in darkness, his muzzle bellowing to the sky and his eyes white and dead (Plate XV, 1).

The bull-headed man had made his entry in the arena of Picasso's imagination at the time when the female form was being submitted to the most monstrous distortion. There is a small painting, *Composition*, dated 1927,[12] of a nude seated in an armchair with a body which has

[10] See *Picasso: Suite Vollard,* Editions Parallèles, Paris, 1956, No. 56.

[11] Apollinaire, *Les Peintres cubistes*, p. 34.

[12] See Zervos, *Picasso*, Vol. VII, p. 34, No. 78.

suffered such distortions that it is not easy to decipher. The head tossed back convulsively has a distinctly bovine form and on either side in patches of light on the figured wallpaper appear two realistic human profiles, one made of shadow, the other of light. Although this appearance of the human beast may be fortuitous, for it is rarely combined elsewhere with the female form, it is drawn with complete clarity in a collage dated 1 January 1927,[13] which nine years later was made into a Gobelins tapestry. Here, in an abbreviation of the whole figure, the bull's head runs nimbly, mounted on a pair of human legs.

But in the etchings of the Vollard suite we are introduced to the Minotaur as a powerful and well-defined character who revels with the sculptor and his lascivious models (Plate XIV, 4). He takes his place in their orgies as one of the guests. He drinks with them and enjoys caressing their tender flesh. There is an innocent gentleness in his eye that is belied by the strength of his muscles and the horns that crown his head. The human beast or horned god, in spite of his excesses, is accepted as one of the family. The patriarchal head of the artist becomes interchangeable with that of the demi-god, as if they both wore masks. But treachery, violence and lust are hidden beneath his ingenuous mien, forming an essential part of his bestial destiny.

The strange fellowship between Picasso and animals is astonishingly clear. As we have already seen, he is never without their company. They take their place in his household as familiar spirits, their animal nature is a symbol of lovable and hateful qualities shared by human beings. The Minotaur joins the family with the same intimacy as the canine dynasty that has always reigned under his table, and Picasso admitted that in drawing the head of the bull he had more than once had in mind the head of his favourite Airedale, Elft.

There are two etchings, in the series known as *The Sculptor's Studio*, of the Minotaur dying in the arena before the gaze of awestruck spectators (Plate XIV, 6), in which the mystery and anguish of the death of the brute is powerfully present, but none is more troubling than those of the blind Minotaur (Plate XV, 1). As he strides along by the boats leaning on his staff he spreads terror among the fishermen. Only

[13] ibid., Vol. VII, p. 58, No. 134.

children are without fear. The little girl clutching a dove to her breast leads him with confidence. The blind beggars that impressed Picasso so profoundly in his youth and seemed to him the symbol of that which is the most appalling state of man, and at the same time the condition which could give birth to a new form of vision, are closely akin to the more complex image of the stricken Minotaur. Blinded like the goldfinches of Picasso's own parable, so that he shall sing better his lament, he proclaims like Oedipus the crimes that are his fate.

It is perhaps significant that the arrival of the Minotaur in the imagery of Picasso coincides with a renewed interest in sculpture. He needed to identify himself with a creature for whom he had sympathy. The nature of the Minotaur, half man, half beast, seemed to correspond in certain ways to Picasso's vision of himself in the role of the sculptor. The Greek demi-god is a being of a more earthbound quality than the ethereal vagrant, Harlequin, to whom Picasso had felt so akin as a painter in his youth. In the Vollard suite of etchings the perplexed artist crowned with laurels appears to be a caricature of the true spirit of the sculptor. The powerful, carnal nature of the Minotaur, his spontaneous instinctive behaviour, outrageous and yet endearing, brings him closer to Picasso's mood and associates him with the more terrestrial magic of sculpture. Even in the blindness of the Minotaur we can find an allusion to the supremacy of the sculptor's sense of touch. There are however two characteristics shared by both these mythical beings; their amorous devotion to women and their reputations as rogues and outcasts from society, qualities that endear both Harlequin and the Minotaur to Picasso. Finally there is a drawing in the pure line of his pencil dated '6.D.37' (Plate XV, 8) which was given by Picasso to Paul Eluard and which inspired his friend to write a poem 'La Fin d'un monstre'.[14] The Minotaur is seen meeting his end. He has collapsed on the beach transfixed by an arrow and a girl arising from the sea like Venus presents the monster with the *coup de grâce,* his own image in a mirror that she holds before him. Eluard saw in this legend the ritual sacrifice of the demi-god and his inevitable immortality.

[14] Eluard, *A Pablo Picasso.*

The poem begins:

> It is necessary for you to see yourself die
> To know that you still live[15]

In this way he honoured the ancient belief that the sacrifice of life is a condition of immortality, that the hero or the monstrous demi-god must die in order to continue to live, a belief that Picasso also shared.

Picasso the Poet

For years it had been Picasso's habit to leave Paris during the summer, usually for the Mediterranean, but the summer of 1935 was an exception. He stayed at home. He was in no humour to return to places where he would be surrounded by the frivolous holiday atmosphere of fashionable acquaintances. In a letter to his old friend Sabartés, who had returned to Spain after many years in America, he wrote significantly, 'I am alone in the house. You can imagine what has happened and what is waiting for me...'[16] To add to the sordid complications which were bound to follow his break with Olga, one consolation had arrived which was also not without difficult consequences. Marie-Thérèse gave birth to a daughter whom they named María Concepción, or, as an abbreviation, Maïa.

Confronted by these two events Picasso took the course, always distasteful to him, of consulting lawyers. The solution that appealed to him then was to divorce Olga and try to realize once more his desire for a family, this time with Marie-Thérèse. But legal procedure proved to be so complicated, owing to Picasso's Spanish nationality which he had no desire to forfeit, that after long exasperating consultations the idea was abandoned. For months he was plagued by these abortive proceedings, so much so that for a while he could not bear to go upstairs to his studio where everything reminded him vividly of the past and the ways in which he had sublimated his melancholy.

In the autumn he escaped from Paris to the seclusion of Boisgeloup

[15] *Il faut que tu te voies mourir*
 Pour savoir que tu vis encore.
[16] Sabartés, *Picasso: Documents Iconographiques*, p. 28.

where he could work without interruption on his sculpture, paint, and draw without the same weight of past memories to depress him, and above all indulge secretly in a form of expression which brought new satisfaction to the days when he had not the heart for his usual work. Some months later the news that Picasso was exploring yet another path reached his mother, whom he had visited in Barcelona both in 1933 and the following year, but to whom he rarely sent more than verbal greetings by friends. '...They tell me that you write. I can believe anything of you,' she said with her usual confidence in him in one of her letters. 'If one day they tell me that you say mass, I shall believe it just the same.'[17] But for many months Picasso let no one know what he was jotting down in the little notebooks that he hid as soon as anyone came into the room.

Slowly the desire to communicate his thoughts to others induced him to read scraps of his writings to a few close friends. He was always haunted by substituting one art for another, writing pictures and painting poems, and in some of his first attempts, which have never been published, made at Boisgeloup, he had used blobs of colour to represent objects in his poems. Abandoning this idea he started to write again, stressing visual images in words and using his own form of punctuation which consisted of dashes of varying length to separate the phrases, but this concession to the rules of grammar soon seemed to him too conventional. As he explained to Braque who had come to lunch one day at the rue la Boétie, he found that 'punctuation is a *cache-sexe* which hides the private parts of literature'.[18] In consequence he suppressed all forms of punctuation so as to let the words stand by themselves, fitted together like stones in a dry wall.

Picasso's reticence in showing his poems was due partly to the fact that he had no pretensions about the quality of his poetry. He therefore suffered to an even higher degree from the same bashfulness that he still had, even in his old age, in showing anything on which he had just been working, largely because he hated to admit that it was finished and resented having anyone see what he was doing while he was still at

[17] Sabartés, *Picasso: Portraits et Souvenirs,* p. 19.
[18] ibid., p. 125.

work. Another difficulty was that his poems could not be understood by the majority of his friends because they were in Spanish. It was fortunate therefore that in November 1935 Sabartés should have been free to accept the invitation of his companion of the 4 Gats to come to Paris and join him in the half-deserted apartment. His old friend could understand better than anyone not only the poems but also the circumstances that had driven him to explore this new medium of expression. Soon after his arrival Picasso began to read out loud his private meditations to a few Spanish friends and then to translate them word for word to others. Among the first who came eagerly to hear them were the surrealist poets among whom this kind of poetry, spontaneous and free in form, was highly appreciated. Sabartés had typed the poems out clearly but Picasso had rapidly made each sheet his own again by covering it with corrections made with pencils of various colours.

One of the first to acclaim the poems with enthusiasm was André Breton, whose admiration for Picasso's work in other media was already known. The result was that several of them were published a few months later in a special number of *Cahiers d'Art*, with a preface in Breton's most eloquent style. He draws attention to Picasso's eagerness 'to represent all that belongs to music' in his work as a painter. 'We learn from this,' he says, 'the necessity of a total expression by which he is possessed and which compels him to remedy in its essence the relative insufficiency of one art in relation to another.'[19]

Sabartés tells similarly how one morning while he was unobtrusively laying the table for their bachelors' lunch Picasso appeared from the next room saying 'Look! Here is your portrait.' But on this occasion, unlike the earlier portraits, it was painted with words.

To Picasso the new discovery was not a sideline or a hobby. It was a means of translating into words his intimate visual life. Like the relationship he had created between painting and sculpture, it was in close liaison with his varied means of expression. The poems are like monolithic slabs made up of words, each sparkling with meaning like separate crystals: 'Poetry that cannot help being plastic to the same degree that [his] painting is poetic.'[20]

[19] A. Breton, *Cahiers d'Art*, 10th Year, Nos. 7-10, Paris, 1935, p. 186.
[20] ibid.

Again we can see through the brilliant kaleidoscopic flow of images how close Picasso is to his surroundings. 'The point of departure', Breton writes, 'is immediate reality.' In the torrent of words there is continual play between the object at hand and its poetic image. Their paradoxical behaviour comes to life in proverbs such as 'the knife that leaps with pleasure has no other resource than to die of pleasure'. Colour plays an important role with violence or tenderness. From the following fragment we can judge how words have been applied as a painter uses colour from his brush:

listen in your childhood to the hour that white in the blue memory borders white in her very blue eyes and piece of indigo of sky of silver the white glances run cobalt through the white paper that the blue ink tears away bluish its ultramarine sinks so that white enjoys blue rest agitated in the dark green wall green that writes its pleasure pale green rain that swims yellow green in the pale forgetfulness at the edge of its green foot the sand earth song sand of the earth after noon sand earth[21]

Hermetic and personal in that Picasso does not stop to explain his images, they are a direct transcription of his thoughts, inspired·equally by the sensations gathered from his immediate surroundings and memories often going far back into the past and traceable in some cases to events in his childhood. His memory is long, but it is the automatic flow of sensation from the subconscious freely transmitted in words which is even more important.

Mingling with unpremeditated imagery are echoes of his lasting dissatisfaction with society in general. In a language of authority which seems prophetic of what was shortly to come he starts a poem with these words:

give wrench twist and kill I make my way set alight and burn caress and lick embrace and watch I ring at full peal the bells until they bleed terrify the pigeons and make them fly about the dovecote until they fall to the ground already dead from fatigue I shall block up all the windows and doors with earth and with your hair I shall catch all birds that sing and cut all the flowers I shall rock in my arms the lamb and give him my breast to devour I shall wash him with my tears of joy and sorrow and I shall send him to sleep with the song of my solitude, *soleares*[22]

[21] ibid., p. 187.
[22] ibid., p. 190.

The Return of Jaime Sabartés

The solitude of Picasso had become more than the inevitable solitude of genius. To escape the fashionable world into which he had been drawn during the past ten years he had hidden himself away with his work as the only possible solace. Friendship to him was an indispensable asset to life and it was his memory for those who had shared his thoughts and affection in the past that had prompted him to write to Sabartés asking him to come to Paris and help him with the growing menace of unanswered letters and official chores. Sabartés describes with shrewdness and affection Picasso's welcome at the station and their arrival at the half-deserted flat in the rue la Boétie. 'Since that day,' he writes, 'my life follows in the wake of his'[23] – for Sabartés remained until his death Picasso's closest confidant and devoted friend. Author of books written with modesty and the authority of one who shared intimately the anxieties and the joys of his great compatriot, he remarked to those who came to him asking enthusiastically for further information: 'Ah! you also, I see, have caught the virus.'

The discomfort and disorder of the apartment had been increased by the fact that for days together Picasso shunned the idea of going up to his studio on the floor above. The two friends camped among indescribable piles of objects, paintings, documents and unanswered letters which had accumulated like geological strata. The process had gone on for years, because of Picasso's intense dislike of tidying things up and his conviction that some precious object would be lost if this should be attempted. For hours they talked. Late into the night Picasso would keep his companion awake discussing people and life in cynical terms or talking amiable nonsense rather than letting him fall asleep. The dry humour and picturesque originality of Sabartés's remarks, his complacent pessimism and his quiet enthusiasm for Picasso's genius, his unobtrusive competence and complete devotion made him the best possible medicine for his friend's troubled spirit.

As he had done in the past, Picasso found endless ways of teasing him. In the mornings he would lie in bed as long as possible and annoy Sabartés by continually asking him the time, sometimes repeating the

23 Sabartés, *Picasso: Portraits et Souvenirs*, p. 110.

question before Sabartés had finished his answer. 'Wouldn't it be better for you to get up?' Sabartés would say. 'Why?' asks Picasso. '*Mon vieux*, if only to get this obsession out of your head', and Picasso would go on, 'Let's talk of something else . . . What time is it?'[24]

Paul Eluard

Picasso's affinity to Surrealism had brought him in touch with Paul Eluard soon after the young poet had returned to Paris from the war and recovered from the illness brought on by a gas attack on the western front, but there had been no intimacy between them until more than ten years later. At this time Eluard like Picasso had gone through the misery of a separation from his wife, Gala, who by a coincidence was also Russian.

One of the first things that marked the beginning of a friendship which was to be long and full of consequence was a portrait drawn in pencil and dated by Picasso '*ce soir le 8 janvier xxxvi*' (Plate XV, 7). Six months later it was used as a frontispiece to the first translations of Eluard's poems to be printed in London and at the same time Picasso agreed to illustrate *La Barre d'appui*, a book of poems that Eluard was about to publish with Zervos in Paris.[25] With Eluard watching he took a copper plate and divided it equally into four parts. Three of them he filled with etchings. In the first he drew the head of Nusch, the beautiful fragile girl whom Eluard had just married; next to her in heavily patterned arabesques he made a birdlike woman watching the flaming edge of the sun as it literally burst through a wall. Below in the third quarter was the sleeping head of Marie-Thérèse merged into a landscape of houses and the sea, and to complete the four quarters Picasso printed the impression of his right hand on the plate.

Eluard delighted in his new intimacy with Picasso. He said at the time with candour that he was happy to be alive in this troubled century above all because he had met Picasso. On the other hand the poetry of Eluard, lyrical, passionate and rich in images was of the kind that

[24] ibid., p. 115.
[25] See Barr, *Picasso: Fifty Years of His Art*, p. 194.

Picasso admired most in surrealist literature. Eluard loved painting with an understanding rare among writers. He had collected round him far more pictures and objects than he could ever hang on the restricted wall space in his apartment. They were acquired in the same way that he lived, with vision and enthusiasm. Max Ernst, Miró, Dali and other surrealist painters were then among his closest friends, and of all the poets that Picasso had known it was Eluard who had the most complete appreciation of his work. A poem dedicated 'To Pablo Picasso' dated 15 May 1936 begins:

> What a fine day when I saw again the man I can't forget
> Whom I shall never forget
> And fleeting women whose eyes
> Made me a hedge of honour
> Wrapped themselves in their smiles

and finishes:

> What a fine day a day begun in melancholy
> Black beneath green trees
> But which steeped suddenly in dawn
> Entered my heart by surprise.[26]

Touched by Eluard's insight and sympathy Picasso found it easy to collaborate with him. In the early days of their friendship Eluard had completed a book of poems, *Les Yeux fertiles,* which gave Picasso the idea that one of the poems, 'Grand Air' (Plate XV, 6), should be engraved on a plate and illustrated by him. It was possible by means of a process invented by Lacourière for Eluard to write his text on the plate and for Picasso then to illuminate it with drawings. The clear bold hand in which the poem is written does not betray for a moment the disability from which Eluard suffered since his war wounds, which made his hand tremble violently as though with some deep emotion until his pen actually touched the paper. Under the signature of Eluard is the date *3.6.36, 3 heures 15* while in the opposite corner Picasso dated his *4 juin xxxvi.* The finished plate is a testimony to the sensitive and confident understanding that had sprung up between poet and painter. The text and its illuminations combine with consideration of each other's

[26] Eluard, *Selected Writings.*

meaning. Picasso surrounded a poem of lyrical optimism with an atmosphere of high-spirited amorous enjoyment.

Picasso Acclaimed in Spain and Paris

In the spring of 1936 Eluard accepted the invitation of a group of young Spanish artists and poets to go to Barcelona and make a speech at the opening of a retrospective exhibition of Picasso's work that was to be held there, and later to travel to Bilbao and Madrid. Members of the ADLAN[27] group had been to Paris, and thanks to their youth and enthusiasm they had managed to get Picasso's co-operation in assembling what was to be the first exhibition of his work in Spain since 1902. The demands for photographs, values for insurance and other ancillary scraps of information which inevitably accompany such activities bored Picasso and often put him in bad humour. He was likely to put off making the decisions which his visitors needed by saying anything – 'perhaps', 'we shall see', 'come tomorrow' or even 'yes' in order to get rid of them. But he was inclined to be well disposed towards his own compatriots, especially when they were young and genuinely interested in his work.

In Barcelona Eluard arrived for the opening and speeches were made by him and others on the radio. 'I speak of that which helps me to live, of that which is good,' were the opening words of his address. 'Picasso wants the truth,' he continued. 'Not that fictitious truth which will leave Galatea inert and lifeless, but a total truth which joins the imagination to nature, which considers everything as real and which going ceaselessly from the particular to the universal and from the universal to the particular comes to terms with all variety of existence, of change, provided that they are new, that they are fecund.'[28]

As it travelled through the three Spanish cities, the exhibition was hailed by the younger generation with enthusiasm. In Barcelona Ramón Gomez de la Serna gave a recital of Picasso's poems. Later, when it opened in Madrid, Guillermo de Torre wrote a preface to the well-

[27] Amigos de las Artes Nuevas.
[28] Eluard, 'Je parle de ce qui est bien', *Cahiers d'Art,* 7 October, 1935.

documented catalogue, in which he proclaimed that 'Picasso is without doubt the supreme contemporary example of. . .an inventive spirit in continuous eruption'. But Picasso, true to his habit of keeping away from such manifestations, did not follow his exhibition to Spain.

In Paris also the fame of Picasso was once more established by three exhibitions of recent work. Zervos showed his sculpture and the Renou and Colle Gallery held an exhibition of drawings, while Paul Rosenberg, in his gallery next door to Picasso's apartment, filled the great room and the entrance with the splendid canvases that he had painted intermittently during the last two years. The two main themes that were visible in the brilliantly coloured pictures made a strong contrast. One series was of girls either reading, their eyes demurely lowered in concentration, or asleep, their heads resting on their folded arms (Plate XIV, 2 and 7). The reds, purples, greens and yellows that shone in these great canvases had the quality of stained glass heavily outlined with sweeping black curves. They radiated a warm luscious tranquillity unlike the wildly distorted females of the preceding years. The other theme dated from Picasso's return from Spain in 1934 where he had once more renewed his contact with the drama of the bullfight. As in the other paintings the colours were generally brilliant, but here there was violent movement, and fury and agony reigned among the dying animals (Plate XIV, 5).

In the apartment next door to the gallery Sabartés found it difficult to keep well-meaning friends from annoying Picasso with their effusions. Those who attended the private view had been overawed by the strength of the new work. Picasso had again taken them by surprise. The twenty-eight paintings and eight gouaches spread their light and their emotion throughout the gallery like 'windows through which could be seen images of flame and crystal'.[29] At the opening '*le tout Paris*' was there breathless with excitement, only Picasso himself was not to be seen among the crowd. Such enthusiasm was taken by him at its just value. When later he went to see the exhibition and received extravagant congratulations from a friend, he explained afterwards to Sabartés that this same man had visited him at Boisgeloup and on

[29] Sabartés, *Picasso: Portraits et Souvenirs*, p. 129.

seeing the paintings there had told him, Picasso, in private that 'he was scandalized and found himself obliged to give him some friendly advice: the paintings were decadent and unhealthy, his style revealed exhaustion, which was deplorable'.[30]

Fame had always been suspect, 'hollow like glory' in Apollinaire's phrase. Even the prize awarded him by the Carnegie Institute in 1930 for the portrait of Madame Picasso painted in 1918 had not impressed him. When the French Government sent representatives to choose one of his paintings about the same time, he described the visit to his friend the dealer Pierre Loeb in these words: 'Four of them came; when I saw them, with their striped trousers, their stiff collars, their looks at the same time timid and distant, I thought again of my youth which was so tough. I thought that those people could have been of more help in the past with a few hundred francs than today with some hundreds of thousands. I began to show them some paintings, my best paintings, but I felt they wanted the blue period. We arranged vaguely another rendezvous to which I shall not go.'[31]

Secret Visit to Juan-les-Pins

After the acclamations of the early spring Picasso became more restless. The constant stream of well-wishers interfered with his thoughts and his work and on 25 March he disappeared to Juan-les-Pins, taking with him Marie-Thérèse. Sabartés describes putting him on the train and receiving instructions that his mail should be forwarded to him addressed to Pablo Ruiz as soon as he had found where he wanted to stay. For six weeks Sabartés received regularly letters of varying humour. On 22 April things went well, 'I work, I paint, I write and I begin to go to bed later. . .' but the next day it was different: 'I write to you at once to announce that from this evening, I am giving up painting, sculpture, engraving and poetry so as to consecrate myself entirely to singing. A handshake from your most devoted friend and admirer – Picasso'; but again by the twenty-seventh things had changed for the better. 'I continue to work in spite of singing and all. Your

[30] ibid., p. 133.
[31] Loeb, *Voyages à travers la peinture*, p. 54.

faithful servant who kisses your hands. Your friend – Picasso.'[32]

Such frequent letter writing in itself was so unusual as to be disquieting, and a certain sign of restlessness. Sabartés's misgivings were therefore justified when little more than a fortnight later he received a telegram announcing Picasso's return. He brought with him more drawings of extraordinary scenes in which the main characters were the Minotaur and naked girls who watch or motivate his actions, illustrations of new unwritten stories that he had been inventing in his Mediterranean retreat. Among them was a pen drawing of the Minotaur moving house, in which the innocent smile of the monster makes him almost lovable, in spite of his crimes.[33] He marches along briskly dragging a cart into which he has piled his furniture, consisting of nothing but a mare and her foals disembowelled by his own hands. In other drawings the monster lies on the grass gleefully watching the dance of a distracted nymph, or in agony he falls to the ground transfixed with a spear while the maidens with detachment watch him die.

To another drawing dated *27 avril xxxvi* he gave the title *Two Old Men Looking at Themselves in a Mirror.*[34] Their fat bodies and hairy, toothless faces are convulsed with laughter as they sit together naked looking straight into the mirror which, in this case, can be nothing other than the eye of whoever looks at the drawing, a disconcerting and significant way of involving himself and all concerned in the ribald grimace of old age.

Summer in Paris

Almost at once after his return, Picasso began work on a commission from Vollard that he had shelved for an unknown period, the illustrations for the *Natural History* of Buffon.[35] To do so he went to the studio of Roger Lacourière, high up on the slopes of Montmartre, where many painters have worked, helped by the excellent equipment

[32] Sabartés, *Picasso: Portraits et Souvenirs,* p. 135.
[33] See Zervos, *Picasso,* Vol. VIII, p. 130, No. 276.
[34] ibid., p. 130, No. 277.
[35] Buffon, *Histoire Naturelle,* Fabiani, Paris, 1942.

and the skill of the master-printer and his craftsmen. Picasso enjoyed working once more with technicians who welcomed the inventive way in which all processes were questioned by him, and frequently new and startling results were obtained. He worked with great freedom, choosing from the animal kingdom those that interested him for the illustrations and producing a set of aquatints which are surprising in the gentle fluency of their treatment and their profound likeness to birds and beasts that were nowhere to be seen in Montmartre. Though the thirty-one illustrations were completed at the rate of one a day, the book was not published until 1942, three years after Vollard's death.

Other activities crowded in on Picasso as well as the aquatints for the Buffon, illustrations for Eluard and drawings for the poet René Char. Friends persuaded him to design a drop curtain for a play by Romain Rolland with which they intended to celebrate the 14 July in 1936 on the great stage of the Alhambra.[36] As usual time went by and the maquette was still not done. Indeed it is very unlikely that the curtain would ever have materialized had it not been possible to find in the abundance of Picasso's production a recent water-colour of the Minotaur series which fitted as though it had been specially designed for the purpose.

Picasso was in a more sociable mood since his return, and could be found almost every evening at one of the cafés at St Germain-des-Prés, where he spent long hours talking with his friends and usually leaving untouched his glass of mineral water. Paul Eluard and the elegant and charming Nusch, with her irresistible laugh, joined often by Zervos and his wife, were constant companions.

The surrealist group had extended its activities into many different countries, and in the summer of this year the first international exhibition was opened in London by Breton and attended by Eluard, as well as a number of painters and poets from Paris. It was thanks to the intimacy which had grown up between them that Eluard was able to persuade Picasso to allow nine of his works to be shown, including some of the large canvases which had appeared at the Rosenberg gallery earlier in the year. Other companions who frequented the same cafés

[36] See Zervos, *Picasso*, Vol. VIII, p. 136, No. 287.

were the Braques, Man Ray, Laurens the sculptor, Pierre Loeb, Michel and Zette Leiris, and the faithful Sabartés. Paulo, now old enough to be included in adult company, was astonished at his father's ability to see so many friends. Going from one café to another until well after midnight he would not infrequently walk home. Sometimes he stopped, alone or with friends, to visit the Gare St Lazare to watch the night trains leaving, before finally going to bed.

At St Germain-des-Prés early in the year, Paul Eluard had introduced to Picasso a young girl with black hair and dark and beautiful eyes who was a friend of his and of the poet Georges Bataille. Her quick decisive speech and low-pitched voice were an immediate indication of character and intelligence. She was a painter and an experienced photographer and had found her way into surrealist circles because of her interest in their work and their revolutionary attitude to life. Thus there were many reasons why Picasso should pay special attention to Dora Maar, among the numbers of attractive young women who were always seeking to make his acquaintance. Although she had been brought up in France, her father was a well-to-do Yugoslav who had lived for many years in the Argentine. His real name, Markovitch, had been abbreviated by his daughter. Owing to her South American connections, she had the advantage of being able to talk to Picasso in his own language as well as in French.

Civil War in Spain

About the same time that Picasso was planning to leave with Eluard for the south of France, news reached Paris of the military uprising under General Franco in Spain. In surrealist circles with their strong left-wing bias and their insistence that the artist should not seek refuge in an ivory tower but rather take a militant part in social revolution, there was no doubt from the first on which side their sympathies lay. Those like Maurice Raynal who could remember Picasso's 'bitter outspoken indignation in 1909, early in the reign of Alfonso XIII, when Ferrer, one of the anarchist leaders of an uprising in Barcelona, was hailed before a military court and summarily executed',[37] were not surprised

[37] Raynal, *Picasso*, Skira, p. 99.

to see him share the same view as his more politically conscious friends, a view that became more definite as time went on. On their side the Spanish Republican Government, urged by the group of young intellectuals who had so recently planned the exhibitions in Spain, were not slow to appreciate the importance of Picasso's worldwide reputation, and as a gesture of recognition he was made Director of the Prado Museum in Madrid by the Republican Government.

August at Mougins

The departure for Mougins, a little hilltop village a few miles inland from Cannes, took place in early August. Picasso went alone in his spacious Hispano-Suiza in which he could transport all the material he needed and have room on the return journey for the many objects – pebbles, shells, bones, driftwood, pottery or frames – that had taken his fancy on the beaches or in the shops during the summer. He preferred to travel by night but never had any inclination to drive. As he once remarked, 'I prefer the carrier pigeon to the compass.' His chauffeur, Marcel, in consequence had to be prepared to pack everything into the car and start at once as soon as the final decision to leave had been made. The road was covered at great speed and dawn broke on a landscape of white rocks, cypresses and olive trees. By midday he had exchanged the grey streets of Paris for the brilliant sunlight of the Mediterranean.

This time the village that Picasso chose for the summer was suggested by Paul Eluard, who had taken the apartment of a friend in the ramparts of the old town of Mougins close to an unpretentious hotel with the exalted and well-justified name, 'Le Vaste Horizon'. Here he was met by Zervos and his wife and shortly afterwards others arrived, the summer visitors including Man Ray, Paul Rosenberg and René Char, and others who stayed for periods varying in length from one meal to several weeks. On the terrace shaded by vines and cypress trees the tables were joined at every meal to seat a large company of friends.

The morning bathe was a daily ritual. Picasso usually went with Eluard and others to the beach, returning refreshed from the sea to a late lunch which was always enlivened and prolonged by unfailing wit

and enthusiasm, engendered by the contact of poet and painter. During these meals, which rarely passed without some anxious comments on the news from Spain, Picasso's humour was a series of contrasts. Dressed in a striped sailor's vest and shorts, at times he would enchant the whole table with boisterous clowning. Holding a black toothbrush to his upper lip and raising his right arm he would give them an imitation of Hitler's ranting, or he would enjoy telling of the grotesque adventures of Manolo whose safety in the present crisis was on his mind. At other times, using whatever material was at hand such as burnt matches, lipstick, mustard, wine or colour squeezed from flowers and leaves, he would quietly draw portraits on the tablecloth taking quick glances at the youthful smiling face of Nusch or at Eluard's daughter, Cécile, with eyes that seemed to devour what they saw. At other times his restless fingers would fold the paper napkins and with delightful skill, tear all sorts of creatures out of them. Bulls, horses and men in paper, wire or cork roamed between the wine glasses and were swept away when the three dark-eyed daughters of the house came finally to clear the table.

Returning by the main road from Cannes one day at noon under a scorching sun, Picasso was the victim of an accident which he describes with its consequences in a letter to Sabartés. The Ford in which he was sitting in the back was driven by me. At a bend we collided with a car that was coming towards us on the wrong side of the road. The shock was sufficiently violent to shake up everyone in the car without doing them serious damage, but Picasso was thrown against the bodywork and bruised in the chest so badly that it took him several weeks to recover completely. However, his tact was such that in spite of my anxiety and frequent inquiries I never discovered how much he had been hurt until I read the letters to Sabartés published over ten years later. He wrote: 'A secret...the other day, coming from Cannes by car with an Englishman, I had an accident which left me bruised all over almost incapable of movement, broken and reduced to dust. I thought at first that I had some ribs broken, but yesterday I had an X-ray taken and it seems that it is nothing; but I am still stiff at least for some days. Don't be frightened...' Four days later, 3 September, he wrote reassuringly, 'I am all right.' It took considerably longer, however, for the effects of

shock and bruising to wear off completely.

Some days before the accident an expedition along the coast to St Tropez had been arranged to visit the writer Madame Lise Deharme, who was spending the summer in a farmhouse close to the sea. Picasso had learned that Dora Maar was one of her guests. After lunch they disappeared together for a walk along the beach. He talked to her with candour, telling her of the complications in his life and the existence of his small daughter, Maïa. He also asked her to accompany him back to Mougins. In a drawing dated *1 août xxxvi* Dora Maar, dressed as though for a journey, can be seen opening a door, on the other side of which she finds a bearded patriarch sitting with a staff in one hand and a dog on his knee, a comment on Picasso's sense of his advancing years in contrast to Dora's youth.[38]

Throughout this summer painting was not in great favour with Picasso. It seemed as if he were remaking his contacts with a world from which he had been excluded, now opened to him again by the casual enjoyment of the healing atmosphere of the Mediterranean and the lyrical company of his friends. Together with Eluard and Nusch he enjoyed making trips by car to the villages along the coast or in the mountains behind. One of these expeditions took them by chance to the little town of Vallauris, whose main industry since the time of the Romans has been ceramics. Leaving the Hispano by the roadside, they wandered into one of the many potteries where vessels of many kinds were being thrown on the wheel in traditional style. The ease with which the craftsman could make the clay obey his manipulations delighted them. Picasso understood at once that he had come across a new field to explore, but he did not begin there and then. The hope that was born that day was in fact to be realized, but not until ten years later. On their return to Mougins the same evening, Eluard added the following verse to the poem 'à Pablo Picasso' on which he was at work:

> Show me this eternal man always so gentle
> Who said fingers make the earth rise higher
> The knotted rainbow the coiling serpent
> Mirror of flesh in which a child is pearled
> And these peaceful hands that go their way

[38] See Zervos, *Picasso*, Vol. VIII, p. 139, No. 295.

> Naked obedient reducing space
> Charged with desires and images
> One following the other hands of the same clock[39]

Other new ideas were to interest Picasso on his return to Paris in the autumn. The example of Man Ray's discoveries in making photographic prints from shadows thrown on the sensitized paper by objects or textiles, combined with the technical skill of Dora Maar, and her understanding of these processes, offered Picasso the chance of mastering yet another art. Again the wilful defiance of rules combined with a sense of what after all was possible produced some fascinating prints made from a combination of shadow printing and drawing on the photographic plate.[40]

New friends, new thoughts and new techniques reinforced Picasso's energy. Never before had he been in possession of such power. Talent, knowledge and experience combined to nourish him during these months of relative idleness which, however, by the standards of other artists, must still be counted as fertile. But as Picasso's morale improved, the political situation in which as a Spaniard he was involved became daily more threatening.

[39] Paul Eluard, 'à Pablo Picasso', *Les Yeux Fertiles*, selected writings; translated by Lloyd Alexander, Routledge & Kegan Paul, 1952.
[40] *Cahiers d'Art*, Vol. XII, 1937.

10

Guernica

(1936-39)

Le Tremblay

In the late autumn of 1936, Vollard told Picasso that he had been seduced by the rustic masonry of an old farmhouse at Le Tremblay-sur-Mauldre, not far from Versailles, and that he had bought it with the intention of offering it to Rouault so that he could paint in the country. Unhappily Rouault disliked the place and refused to use it, in spite of the fact that there was a fine barn which could serve as a studio, with a large window looking on to the garden. Picasso on the contrary at once appreciated the possibilities of this new retreat which was free from associations of his separation from Olga, which haunted Boisgeloup. It would enable him to spend a few days each week in seclusion, far enough from the inquisitive attentions of his friends in Paris. He accepted Vollard's invitation and began to work during his visits here on a series of still-lifes (Plate XVI, 2). These paintings are characterized by brilliant colour and by the charm of homely objects, such as jugs, plates, saucepans, cutlery, fish, fruit and flowers, among which we find the not infrequent intrusion of the head of the horned god or the bull (Plate XVI, 5). Several are night scenes, lit by the flame of a candle or by stars that have found their way in through the window.

These pictures breathing an atmosphere of rural charm are, according to Sabartés - one of the few to have seen them all - 'the refrain of a marvellous period in Picasso's pictorial production and even in the history of art'.[1] Since few of Picasso's friends were invited to Le Tremblay, more than half of the paintings he made there during the

[1] Sabartés, *Picasso: Portraits et Souvenirs*, p. 150.

next two years remained unknown even in reproduction, though in 1939 thirty-three of them were exhibited at Paul Rosenberg's gallery.[2]

Among those that have been seen by the public are some large paintings of nudes on the seashore (Plate XVII, 5). Constructed with Picasso's invented anatomy, they are not unlike the bonelike *Seated Bather* of 1929 except that they are purged of its threatening looks, and flesh completely hides their bones. The swelling forms of these females resemble ripe fruit. They sit on the sand absorbed in a book, or in the extraction of a thorn from the foot. Others enveloped in the blue haze of a calm sea play together with a toy boat, while from behind the horizon rises the immense head of a companion, like an inquisitive cloud covering the sun, to spy on them. There are also some revealing drawings of Marie-Thérèse with Maïa on her knee, and a portrait of Marie-Thérèse seated in a chair reading, wearing a red hat and a gay striped dress (Plate XVI, 1).

Dream and Lie of Franco

At Le Tremblay Picasso was happily detached from the disquieting pre-occupations of Paris. His short visits gave him the opportunity to enjoy a replica of family life; but on returning to Paris he again became involved in the growing anxieties of his friends. The news from Spain was bad, and as in all civil wars, where even brothers can be divided against each other, the situation was vexed by mixed loyalties, suspicion and hate. His mother in Barcelona sent news of the burning of a convent within a few yards of the apartment in which she lived with her widowed daughter and five grandchildren. For weeks the rooms had reeked with the stench, and her keen black eyes, the model for her son's, ran with tears from the smoke.

To the group of young poets, painters and architects who had recently organized the exhibitions of his work, the defence of demo-cratic liberty had become a matter of life and death. Many had hastily taken up arms and departed for the front. Others, disproving fascist propaganda, which claimed that the art treasures of Spain were being

[2] See Zervos, *Picasso*, Vol. VIII, pp. 166-71.

pillaged and burnt by unruly mobs of anarchists, set to work on surveys of neglected ancient monuments and the organization of new museums. In Paris also there was a remarkable unity among intellectuals in support of Republican Spain, which, as Soby suggests, was unparalleled since the days of the war of Greek independence, a hundred years earlier.[3]

It was this year that had been chosen by the French Government for a great International Exhibition, and it was of great importance to the Spanish Republicans that their Government should be well represented. A young architect, formerly an active member of the ADLAN group, José Luis Sert, had been charged with the propaganda service. With Luis Lacasa he was asked to design the Spanish Pavilion. Picasso had already consented to produce some manifestation which would make his sympathies clear to the world, and there was much speculation as to what form it would take.

Already in January he had begun to engrave two large plates divided into nine spaces, each the size of a postcard (Plate XVII, 2).[4] It was originally intended that the prints should be sold separately for the benefit of Spaniards in distress. When the work was finished, however, on 7 June, the sheets of etchings shaded with aquatint were so impressive as a whole that it was decided to sell them intact with an additional sheet which was the facsimile of Picasso's manuscript of a long violent poem. To these three sheets were added French and English translations and a cover designed by Picasso giving the folder the title *Sueño y Mentira de Franco* (Dream and Lie of Franco).

The story of violence and misery inflicted by the arrogant leader of the military rising reads from picture to picture like a strip cartoon or the popular Spanish 'Alleluias' Picasso had known as a child. To personify the dictator he invented a grotesque and loathsome figure crowned with headdresses symbolic of his pretensions as the hero of Christianity, the saviour of Spanish tradition and the friend of the Moors. He carries a banner in which the Blessed Virgin takes the shape of a louse. He attacks the noble profile of a classical bust with an axe.

[3] See James Thrall Soby, *Modern Art and the New Past,* University of Oklahoma Press.
[4] See also Larrea, *Guernica,* Plates 24 and 25.

He kneels protected by a barbed-wire fence in front of a monstrance in which is displayed 1 Duro. Riding a pig, he tilts at the sun. The horse he mounts with pomp drags its entrails on the ground and later, slaughtered by his own hand, lies writhing at his feet. Women lie stretched out dead in the fields, others flee with their children from their burning houses or raise their arms in gestures of despair. Only one creature can hold evil at bay, the bull who in its innocent strength disembowels the monster with its horns.

'...cries of children cries of women cries of birds cries of flowers cries of timbers and of stones cries of bricks cries of furniture of beds of chairs of curtains of pots of cats and of papers cries of odours which claw at one another cries of smoke pricking the shoulder of the cries which stew in the cauldron and of the rain of birds which inundates the sea which gnaws the bone and breaks its teeth biting the cotton wool which the sun mops up from the plate which the purse and the pocket hide in the print which the foot leaves in the rock' – with this torrent of verbal images Picasso finishes his poem, the preface to his visual account of the calamity of which Franco was the originator.

The Spanish war had made itself felt so acutely to Picasso that he could not avoid becoming personally involved. The loathsome shape he had invented for Franco came from a personal image of a monster which he understood as lurking within himself. Not long after he had finished the series, I asked him to sign a copy I had bought (Plate XVII, 2). He did so, but when he had written my name beginning with a small p, I was astonished to see that the capital letter with which he commenced his own signature had fundamentally the same form as the twisted grotesque head that he had invented for the man he hated most. The strength he gave to the image borrowed subconsciously from so intimate a source was an indication of the degree to which he felt himself involved. The desire to implicate himself by means of his own initial could not be more convincing. Just as formerly he had often based the image of the hero, Harlequin, on an idealized self-portrait, here the subconscious origin of the shape he gave to the man he most hated was equally personal. It must be remembered, however, that when he engraved the monster on the plate it was the reverse image of what he saw in the print when he signed it. Even so the similarity is

surprising and significant.

A Mural for the Spanish Pavilion

When, in the first winter of the civil war, Picasso promised to make an important contribution to the Spanish Pavilion, it became obvious that it would be necessary to find a studio which would give him sufficient scope. By good fortune Dora Maar knew of a large empty room which had been used by the poet Georges Bataille for the lectures and discussions of a group he had founded named 'Contre-attaque'. It was on the second floor of a seventeenth-century building which before the Revolution had been the residence of the Dukes of Savoy. By a coincidence it was situated in the rue des Grands Augustins near the river, the same street in which Balzac had set the scene of his story of the mad painter.

The spring passed, however, without any sign that Picasso had discovered what form his contribution to the Spanish Pavilion should take. The problems that arose were complex and their solution greatly intrigued those who looked to him for a valid expression of the feelings of millions of people outraged by the civil war. Since the painting was to be used as the main feature in one of the pavilions in an international exhibition which would be visited by people from all over the world, it was hoped that its appeal would be couched in a style which would deeply affect the masses. Was it possible that the inventor of Cubism and strange distortions, styles which the public in general considered abstract or even demented, could make an appeal to ordinary people? The Spanish Government had asked Picasso to take on this task, knowing that his reputation was in itself an attraction; but of those responsible it was only his younger and more ardent admirers such as Sert and the writer Juan Larrea (then in charge of the Information Office in Paris) who had complete confidence in the results. As usual Picasso decided to tackle the problem in his own way. Trusting his inspiration, when the time came he painted a picture whose strength could be ignored by no one. Its impact on the thousands of visitors to the exhibition came as a shock even to those who could not fathom its meaning. But as later the public grew slowly more familiar with its

idiom, it came to be recognized as a lasting protest against war, surpassing the limitations of partisan propaganda and remaining valid even after the cause for which it had been painted had met with defeat.

Premonitions

The preparation for the great mural had come about unperceived. In the spring of 1935, soon after he had drawn a series of engavings of the Minotaur, Picasso produced an etching which has since become famous not only for its unusual size and splendid quality but also because of suggestions in it which now seem prophetic of the catastrophes which were soon to follow (Plate XVI, 3). The engraving is dominated by the sinister entry from the seashore of the Minotaur, his eyes reflecting the light of a candle held by a fragile little girl who, greeting him with a bunch of flowers, fearlessly halts his advance. His right arm stretches forward in a menacing gesture, while beneath it, slipping from a horse which has become hysterical with fear, lies the figure of a dying woman dressed as a matador, her sword helpless in her hand and her white breasts stripped and defenceless. From a window above, two women with their tame doves contemplate the scene, while at the extreme edge of the picture a naked man mounts a ladder in an attempt to escape.

Other etchings of the preceding months are also based on the theme of the horse and its lovely rider who, decked out in the borrowed finery of the matador, becomes herself the victim of the bull's onslaught. In a sudden violent encounter the monster triumphantly exposes her exquisite and ill-disguised weakness.[5]

Taken as a series, these scenes often show ambiguity about the intentions of the beast. In some cases, in a paroxysm of anger and with irresistible force, the bull blindly rapes innocence and destroys virtue. At other times, though always characterized as a creature of overwhelming strength, the monster is innocent of such crimes. Elsewhere, in some earlier versions, the bull is more playful. Rather than destroy the fair amazon he wrests her from his rival, the horse, and with fire in his eyes, seeks her lips with his bovine muzzle.

[5] See *Picasso: Suite Vollard*, Editions Parallèles, Paris, 1956, No. 22.

In his use of mythical and symbolic creatures Picasso could indulge his predilection for ambiguity, as a means of approaching truth. There are certain animals and birds whose behaviour and appearance make them appropriate symbols of human passions, but in his desire to use this vital and universal link with antiquity, Picasso did not limit himself to over-simplified conventional interpretations, nor did he arbitrarily draw parallels between their actions and moral issues in the manner of La Fontaine. By encouraging a sense of ambiguity he left the spectator the liberty of choosing his own interpretation.

Picasso Furioso

On 29 April 1937 news reached Paris that German bombers in Franco's pay had wiped out the small market town of Guernica, the ancient capital of the Basques. This gratuitous outrage, perpetrated at an hour when the streets were thronged with people, roused Picasso from melancholy to anger. Acting as a catalyst to the anxiety and indignation mingled within him, it gave him the theme he had been seeking. He had at hand the factors necessary for his task, and his recent work, more than ever a mirror of the Spanish scene, was an appropriate prologue. His exceptionally visual memory, which kept fresh the observations and discoveries he had made throughout his life, nourished his imagination. The experience gained from the many styles he had used gave him technical assurance. The more recent introduction into his work of the myths born in the Mediterranean and revitalized by him gave a new plane on which he could present this drama. Finally the atmosphere around him of friends who shared his thoughts, and his own unparalleled energy intensified by the horror of the war, armed him with great strength and the vision of genius.

The first characters to appear on his stage in hasty sketches were the horse, the bull, and a woman stretching out from a window with a lamp in her hand to throw light on the calamity in which they were all suddenly involved.[6] In successive versions, some drawn rapidly in pencil, numbered and dated, and others painted on canvas, the

[6] *Cahiers d'Art,* 1937, Nos. 4-5.

personalities of the actors began to evolve, while at the same time they appeared together in compositions. From the beginning Picasso chose the stricken horse as a central feature.

Ten days after the first sketch, a canvas eleven and a half feet high and nearly twenty-six feet long had been set up at one end of the room in the rue des Grands Augustins (Plate XVII, 1). It was stretched from wall to wall, and from the tiled floor below to the massive oak beams supporting the rafters. The room, though it seemed vast, was not quite high enough for the width of the canvas, and it could only be fitted in by sloping it backwards, which meant that the upper part had to be reached with a long brush from the top of a ladder. In spite of having often to climb to this perilous position Picasso worked fast, and the outline of the first version was sketched in almost as soon as the canvas was up.

Thanks to the presence of Dora Maar a continual photographic record of the development of the painting was kept.[7] It is a unique and vivid account of the changes in the composition as it evolved. 'It would be highly interesting,' Picasso commented, 'to fix photographically, not the successive stages of a painting but its successive changes. In this way one might perhaps understand the mental process leading to the embodiment of the artist's dream.'[8] As had always been his practice, Picasso lived with his work and allowed his ideas to evolve with it as though it were in itself alive. 'At the inception of each picture someone is working with me,' he said, referring to this secret dialogue between the artist and his creation. But he continued: 'Towards the end I have a feeling of having worked all by myself and without a collaborator.'[9]

Simultaneous with the great canvas, a large number of studies, very moving in their intensity and often carried as far as a finished picture, formed part of an output which continued daily, except when with great regularity he paid his weekly visit to Le Tremblay. There for a while his fury lay dormant and he continued with equal energy to paint the series of still-lifes and portraits of Marie-Thérèse and Maïa, saying,

[7] ibid.
[8] Quoted by Larrea, *Guernica*, p. 13.
[9] ibid., pp. 52, 53.

'You see, I am not only occupied with gloom.'

As the painting developed it was possible to watch the balance that Picasso kept between the misery caused by war, seen in the anguish of the women, the pain of the wounded horse or the pitiful remains of the dead warrior; and the defiant hope of an ultimate victory. Many writers have tried to interpret Picasso's symbolism and often they have committed the error of over-simplification. Juan Larrea, in an extensive and otherwise authoritative study of *Guernica,* states surprisingly that the horse transfixed with a pike represents Nationalist (Franco) Spain.[10] To others the horse and its rider are the heroic victims of a brutal attack from the bull; but on examination we find, particularly in the early versions, nothing to suggest that the bull is in this case the villain. On the contrary he appears to be searching the horizon for the enemy, who is in fact not present in the scene at all. His enemy is the common enemy of all mankind, too vile and too universal to be contained in a single image. What we see in the painting is the effect of his enormity: the dead child, the house in flames, lacerated bodies, hysterical cries of agony and looks of astonishment that such things are possible.[11] The omission of the evil spirit that has caused this disaster is a more effective insult than its introduction, as in *Dream and Lie of Franco,* in the shape of a loathsome monster. Also it makes prophetic reference to the impersonality of modern warfare which allows the victims increasingly little chance of knowing who is their aggressor.

Symbols of hope come and go at various stages during the progress of the work, as though Picasso were debating how to give them undeniable authenticity. In the first version, across the centre of the picture the dying man raises high his clenched fist, the challenge given by anti-fascist fighters. Soon after, we find him holding a handful of corn in front of the round disc of the sun while his other hand still grasps a broken sword. Later the warrior 'is again transformed and arrives at his

[10] ibid., p. 34.
[11] Jerome Seckler who interviewed Picasso in 1945 reports him to have said: 'The bull is not fascism, but it is brutality and darkness...the horse represents the people...the *Guernica* mural is symbolic...allegoric. That's the reason I used the horse, the bull and so on. The mural is for the definite expression and solution of a problem and that is why I used symbolism.' 'Picasso explains', *New Masses,* 13 March 1945.

final position. Now the head lies where his feet were before. His defiant arm is obliterated and only the hand grasping the sword remains unchanged. In the same process the disc of the sun has been contracted into an oval shape like an eye without a pupil. The *vesica piscis,* which was used in Byzantine art to make a transcendental frame round the image of God, is rolled over on its side, empty. The bull also, which dominated the left half of the painting, watching the horizon as though ready to attack intruders, becomes reversed in position and looks over his shoulder in a more bewildered attitude. Only the lamp with its welcome light, the light of truth shed on a scene of havoc, which had been present in every drawing, held by the outstretched arm of the woman at the window, remains. The other symbols of hope have one by one disappeared. Even the sun is finally degraded and its source of light made artificial by its centre being filled with an electric light bulb. To compensate for the warrior, now torn to pieces, the distraction of the bull and the insult to the sun, a bird perched inconspicuously on a table in the background flaps its wings and with open beak shrieks to the sky. The introduction of the table, with its domestic reference, into what was formerly an entirely outdoor scene, adds to the universality of the image.[12]

The evolution of the horse to its final state, in which it dominates the centre of the composition, is also of interest. There are many sketches, sometimes of the head only, reaching upwards with gnashing teeth and a tongue thrust out of the deep cavity of the mouth like a dagger, at other times the animal writhes on the ground with outstretched neck reminiscent of the bullfight drawings of 1917. An early drawing dated 2 May (1937) shows the dying horse with the bull, the woman with the lamp and a prostrate figure with a Greek helmet. From a wound in its

[12] In an article entitled 'Soleil pourri', published in a special number of *Documents - Hommage à Picasso* in 1930, Georges Bataille drew attention to ambiguities inherent in the sun as a symbol. He points out that the midday sun which is too bright for the eyes is beautiful but that when obstinately looked at it becomes 'horribly ugly'. 'If. . . in spite of all it is observed with enough concentration this supposes a kind of madness and the notion changes its meaning because in light it is no longer the production which is apparent but the waste, that is to say the combustion, expressed well enough, psychologically, by the horror which is seen in an incandescent arc lamp.' He goes on to describe the Mithraic rite in which 'the initiate was spattered with the blood of a slaughtered bull'. The bull itself is also in this case an image of

belly springs a small winged horse, which might be taken as an allusion to an after life of the soul, and recalls the *Burial of Casagemas.* This simple optimism, however, does not reappear anywhere. In the early stages of the painting the animal in its death throes lies curled up on itself as though returning to the womb. As the composition suddenly reached its final shape early in June, the horse's head was raised high in the centre of the picture, rivalling in importance the sun and the arm holding the lamp. Instead of reaching upwards in a final ejaculation towards the sky, the open mouth spits defiance like the last salvo from a fortress that will not surrender: a gesture which echoes the cry of the defenders of Madrid: 'They shall not pass.'

The most moving figures in the picture are very naturally the four women. Their attitudes and expressions are significant of astonishment, fear, and the agony of overwhelming grief. They have much in common with the drawings of the Virgin Mary and the Magdalene for the *Crucifixion* but are even more powerful in their expression of anguish. The success with which Picasso conveys these emotions is clearly due to his long experience in the distortion of the human form. The distortions are skilfully controlled so as to accentuate gestures and movements which reveal tense emotion. The stretching upwards of the arms and neck of the woman falling from the burning house convinces us of the reality of her plight and accelerates the speed with which she will crash to the ground. The feet of her terrified companion below are eloquent of their need to cling to the earth as she runs out half-dressed and crouching from the danger that threatens from the sky. By looking again at the drawings we can see how carefully Picasso had studied the anatomy of grief and the primitive animal-like movements that come to the surface under the influence of uncontrollable fear. Many of the drawings go beyond what he needed

the sun but only when slaughtered. It is the same as the cock, 'of which the horrible cry, particularly solar, is always close to the cry of a creature whose throat is being cut'. It is of interest that Picasso's image of the degradation of the sun shows some analogy and that it was painted in the same room in which previously Bataille had held his discussions with the group *Contre-attaque.* The references to the mythological significance of the bull and the cock are also particularly important when it is remembered that before 1930 there are few references to these creatures in Picasso's painting and that the *Crucifixion* was painted in the spring of that year with its allusions to the sun-moon myth and Mithraic rites (see pp. 256-61).

for the final composition and date from after its completion. The richness of Picasso's invention overflows the limits of any single painting however great its proportions. The decomposition caused by sorrow in these figures and heads can hardly be surpassed. Each feature is interpreted with astonishing freedom. Both nostrils, both eyes and ears are crowded on to the same profile so that their testimony shall not be lost, and yet it is not the distortion that surprises us, nor the tears that stream across the cheeks, it is rather the fact that we can read so plainly the intention of the signs he makes and accept with such conviction the reality of the emotion he describes.

The discoveries of Cubism, the purity of line of the neo-classical period and the unbridled distortions of the later nudes had all united to give Picasso powers which permitted him in the summer months of this year to create this 'monument to disillusion, to despair, to destruction'.[13] As he worked on it not only was he discovering new ways of expression, he also never ceased to question the validity of what he had already done. Returning to his opinion in the early days of Cubism he felt that colour would distract him in his aim. In the *Crucifixion* he had obtained a dramatic effect of contrast between the dazzling colours of the pictures as a whole and the black and white figures of Christ and the Virgin Mary: here he decided that his message would carry more weight without the distractions of colour. In the studies he used from the beginning a combination of colour - greens, purples, pinks and yellows - which added to their emotional quality. They contain an acrid bitterness in their contrasts which recall Spanish images of saints.

During the weeks in which the great painting evolved through such startling changes, Picasso at times reverted to his former practice of pinning pieces of patterned wallpaper to the canvas so as to introduce colour and the presence of another kind of reality. When visitors arrived he discussed with them the movements of the figures as though the painting were alive. Once when the picture was nearly finished I called with Henry Moore. The discussion between us turned on the old problem of how to link reality with the fiction of painting. Picasso

[13] Herbert Read, 'Picasso's Guernica', *London Bulletin*, No. 6, October 1938.

silently disappeared and returned with a long piece of toilet paper, which he pinned to the hand of the woman on the right of the composition, who runs into the scene terrified and yet curious to know what is happening. As though she had been disturbed at a critical moment her bottom is bare and her alarm too great to notice it. 'There,' said Picasso, 'that leaves no doubt about the commonest and most primitive effect of fear.'

Universality of Meaning

It is the simplicity of *Guernica* that makes it a picture which can be readily understood. The forms are divested of all complications which would distract from their meaning. The flames that rise from the burning house and flicker on the dress of the falling woman are described by signs as unmistakable as those used by primitive artists. The nail-studded hoof, the hand with deeply furrowed palm, and the sun illuminated with an electric light bulb, are drawn with a child-like simplicity, startling in its directness. In this canvas Picasso had re-discovered a candour of expression which had been lost, or overlaid for centuries with the refinements of artistic skill. He had proved such excellencies to be unnecessary, even a hindrance to an understanding of reality. When visiting an exhibition of children's drawings, some years later, he remarked: 'When I was their age I could draw like Raphael, but it took me a lifetime to learn to draw like them.'[14] It was only this profound humility which could open to him the secret of instilling life into myths and symbols.

Again in his choice of symbolism he had realized the strength of simplicity. Herbert Read points out: 'His symbols are banal, like the symbols of Homer, Dante, Cervantes. For it is only when the widest commonplace is inspired with the intensest passion that a great work of art, transcending all schools and categories, is born; and being born lives immortally.'[15]

In his eagerness to press on rapidly in his work and concentrate only

[14] Herbert Read, letter to *The Times*, 26 October 1956.
[15] Herbert Read, 'Picasso's Guernica', *London Bulletin*, No. 6, October 1938.

on essentials, he allowed the wet paint to run down the canvas here and there, and, as though by a secret agreement, such accidents as the trails of white that run like saliva from the teeth of the horse, appear to be carefully premeditated effects. Again when he altered the position of the bull's head, he did not trouble to paint out entirely a redundant eye, with the result that the animal has now three eyes with which to scan the horizon even more effectively.

The structure Picasso chose for his composition can be seen traced on the canvas in the first of Dora Maar's photos. Its main feature is a triangle, the apex of which goes beyond the top of the picture, leaving space for a vertical column in the centre which originally contained the vertical arm with its clenched fist and later the sun and the horse's head. There is nothing revolutionary in basing a composition on a triangle, it recalls Cézanne's great composition *The Bathers* or, as Barr suggests, the pediment of a Greek temple; but as we have already noted, Picasso often uses the simplest and most traditional forms as a frame for the most revolutionary inventions, beneath which the firm basic structure tends to disappear. In the case of *Guernica* the sharp angular patterning and strong contrasts of light and shade purposely suggest rather the calamity and chaos brought about by an explosion than a well-balanced composition.

The Public and Picasso

Before two months from the day Picasso made his first sketch had elapsed, the great canvas *Guernica* was ready to take its place in the Spanish Pavilion at the Paris Exhibition. Economies enforced by the war had required their plans to be modest, but the architects had reserved a place of honour for it, and near by they set up two of the large statues made four years earlier at Boisgeloup. In the courtyard in front was a mercury fountain designed by Alexander Calder, and Joan Miró also contributed a mural which was placed at the head of a stairway leading to a gallery above.

The immediate reactions of the public were confused, and the press was divided on political grounds. The less numerous critics of the right wing had no hesitation in condemning it for its intention as well as its

appearance, while the left wing supported it, though the less enlightened among them would have preferred a painting which was an obvious call to arms. Others with an equally grave misconception of the poetic nature of the painting hailed it as a form of social art or 'social realism' with a predominant political purpose. Those who appreciated its true nature at once were the intellectuals from many countries, who recognized in it a great work of art and a crystallization of their feelings about the horrors of war and Fascism, which for them had become almost synonymous.

Zervos produced a number of the *Cahiers d'Art* almost entirely devoted to the painting, and including Dora Maar's admirable photos of its progress, as well as the preliminary studies and small canvases.[16] It contained articles by Zervos himself, Jean Cassou, Georges Duthuit, Pierre Mabille, Michel Leiris, a poem by Paul Eluard and an important contribution by the Spanish Catholic poet José Bergamin. Throughout, their praise for Picasso, who had put on record with such majesty the calamity of Guernica, is tempered with a sense of foreboding. 'In a rectangle black and white such as that in which ancient tragedy appeared to us, Picasso sends us our announcement of our mourning: all that we love is going to die, and that is why it was necessary to this degree that all that we love should embody itself, like the effusions of a last farewell, in something unforgettably beautiful.' These words of Michel Leiris reveal the gratitude felt towards Picasso for expressing the despair of those who knew themselves and their hopes to be menaced, realizing that they were incapable of extricating society from its approaching doom. He had interpreted their forebodings and so made their anxiety more bearable.

Guernica has been compared with other great works such as *The Massacre at Chios* by Delacroix, Géricault's *Raft of the Medusa* and Goya's *Madrid 2 May*. In the scale of its monumental appeal it has much in common with these paintings, but whereas they all used the recognized idiom of their time to portray catastrophes that had occurred, in *Guernica* Picasso found a more universal means of conveying the emotion centred round a given event, and in consequence

[16] *Cahiers d'Art*, 1937, Nos. 4-5.

arrived at a timeless and transcendental image. In addition, the symbolic use of the familiar and humble enabled him to present disaster in an emotional way without overstatement. It is not the horror of an actual occurrence with which we are presented; it is a universal tragedy made vivid to us by the myth he has reinvented and the revolutionary directness with which it is presented. The power of *Guernica* will grow.

Return to Mougins

With *Guernica* finished Picasso closed his studio and set out once more to join Paul and Nusch Eluard at the Hôtel Vaste Horizon at Mougins, taking Dora Maar with him. A third passenger in the Hispano was Kasbec, an Afghan hound Picasso had acquired not long before. The drowsy oriental dignity or sudden alertness of this slender animal earned him a considerable amount of attention. He never left his master's side, and his profile with its sharp sensitive nose became traceable for several years among the human heads that Picasso invented. In fact Picasso told me jokingly that his two most important models in these years before and during the Second World War were Kasbec and Dora Maar.

An early appearance of the beautiful and distinguished features of Dora Maar in drawings by Picasso was a pen and ink sketch which has the inscription '*Mougins 11 Septembre xxxvi fait par cœur*'.[17] His memory did not fail him. It is easily recognizable and has captured a vision of her fresh intelligent looks, her dark eyes and boyish windswept hair. Many other highly realistic sketches followed, including an early one in which the lifelike appearance of her head grows majestically from a body half human, half bird;[18] and in the spring of 1937 her profile becomes recognizable in a drawing of mermaids peering from the sea at the Minotaur as he loads on to his boat the body of a girl, nude and limp (Plate XV, 2).

Not long after this, Picasso painted a portrait which glows with rich and appetizing colour (Plate XV, 4). Dora Maar is seated and holds her right hand to her cheek. The painted fingernails prod gently into the

[17] See Zervos, *Picasso*, Vol. VIII, p. 137, No. 289.
[18] ibid., p. 140, No. 297.

flesh and hold back her hair, the blackness of which glistens with blues and greens. There is a smiling expression of relaxed happiness in her face and her eyes sparkle with animation. So natural does the likeness seem that it comes as a surprise to realize that the two eyes, one of which is red and the other blue, are painted both on the same side of a face which is drawn in profile. They swim together in reds, pinks, greens, yellows and mauves; colours which are far too brilliant to be thought of usually as flesh tones but which joyously convey the radiance of her youth. It is interesting to compare this portrait with that earlier version of the lover's homage, the portrait of Olga painted twenty years before. The new idiom, in which colour and form are charged with poetic associations, surpassing the mere fact that it is also a remarkable likeness, adds qualities which are lacking in the masterful but conventional technique of the earlier painting. Even in his desire for a literal expression, Picasso had found the means of using the discoveries of Cubism to great advantage.

During the next weeks at Mougins Picasso's energy, in no way sapped by the ordeal of *Guernica*, expressed itself not only in his physical enjoyment of the unfailing sunshine but also in the constant invention of his mind. Unlike the previous visit, when he had been content to make drawings in a small room with no more than the strict essentials, he installed himself in the only room with a balcony in the hotel. When he emerged on to the terrace for meals he would tell his friends, who were then occupying the entire hotel, what he had been doing. Sometimes he had painted a landscape of the little town with its towers and houses grouped against the sky, but more often he would announce that he had made a portrait. As a reaction to his recent preoccupation with tragedy, he was seized with a diabolical playfulness. The 'portraits' were most frequently of Dora Maar, but at other times he would announce that his model was Eluard or Nusch or Lee Miller (Plate XVII, 4). The paintings were strangely like their models but distorted and disguised by surprising inventions. Eluard first appeared in the traditional costume of an Arlésienne, and a few days later, in a second painting, he was dressed as a peasant woman suckling a cat (Plate XVI, 6). Nusch had been given the hat of a Niçoise and her eyes, so often half closed with laughter, had become bright-coloured

Mediterranean fish. In each case, beneath the buffoonery, there was a masterly handling of colour and form as well as a likeness, the reasons for which were almost impossible to define. The profile of Lee Miller seemed all the more recognizable when combined with large liquid eyes that had been allowed to run with wet paint and an enormous smile from a pair of bright green lips. It was by a combination of characteristics set out in hieroglyphic shorthand that the person in question became ludicrously recognizable.

Picasso was again happy in the unpretentious surroundings of Mougins. He was able to enjoy at his leisure the warmth of affection and animation which Eluard infused among his friends. 'The poet is he who inspires far more than he who is inspired' was Eluard's favourite way of describing that uncalculating generosity of spirit of which he himself was an example. Again the association between two characters, poet and painter, who each had so much to give was fertile, and it was reinforced by Eluard's contempt for the ivory tower and his interest in the cause which Picasso had particularly at heart.

Though Picasso always enjoyed company he also needed independence and solitude. Not infrequently he would disappear. Sometimes Marcel the chauffeur would take him to Nice to pay a call on Matisse, and sometimes he would wander all night with Dora Maar along the deserted promenades of Antibes or Juan-les-Pins.

In the morning the beaches provided the main attraction. Sunbathing with the party of friends from Mougins and frequent dips in the sea would be the prelude to searches along the beach for pebbles, shells and roots or anything that had been transformed by the action of the waves. The small, neat, well-built physique of Picasso was at home in these surroundings. His well-bronzed skin, his agile controlled movement, his athletic figure and small shapely hands and feet seemed to belong to the Mediterranean scene as though he were the reincarnation of the hero of an ancient myth. During one of his wanderings with Dora they found among the rocks, not far from an old refuse dump, the bleached skull of an ox which had been scoured by the sea. With his usual delight in disguises Picasso, closing his eyes, posed for Dora to take his photograph, holding in one hand the skull and in the other a staff such as he had put into the hand of the blind Minotaur.

On another occasion Picasso returned to the hotel with a monkey, which for a while became such an absorbing companion that Dora finally grew jealous. The animal had joined them as one of the family and was taken everywhere with them until one day it became extremely nervous in company with Kasbec on the beach and bit Picasso's finger. By a coincidence it was reported the same day in the local paper that the king of some small state had died of poisoning from a monkey's bite. With his usual prudence in face of a threat to his health and in deference to Dora Maar, he promptly returned the monkey to the shop it had come from.

Picasso's love of monkeys was permanent. Watching these animals one day in the Jardin des Plantes in Paris, Dora Maar remarked to him that she thought she saw a connection between their looks and the distortions of the Blue period, such as the elongated limbs and fingers, the crossed arms and the attitude of crouching in fear. 'Oh yes!' he replied, 'so you have noticed that!' Certainly among the harlequins of the circus period, the ape appears as one of the family and later reappears climbing the ladder in the drop curtain for *Parade*.

To Picasso it is not only the appearance and the anatomy of monkeys that counts, he enjoys them as caricatures of human beings. On some occasions when he found himself in company with friends, after the first polite formalities had been exchanged he would say, as an aside, 'so here we are in the monkey cage'. Again he does not spare himself in this comparison: in a lithograph of 1954 of the artist and his model the painter has become a monkey (Plate XXIII, 4). Man Ray tells how one day he was present when a Swiss psychiatrist asked Picasso what he thought was the relationship between the drawings of some of his patients, which he had brought with him, and modern tendencies in art. The reaction of Picasso was to say nothing. Turning his back he proceeded to mime with convincing realism the gestures of a long-armed ape, and with a crayon he produced a meaningless scribble which he thrust at the professor with a chuckle.

The Autumn in Paris

Finally, late in September, the modest room which had served as

bedroom and studio was emptied of the accumulation which had piled up during the summer. This consisted of painting materials, easels, a great number of canvases including portraits and landscapes, drawings and sketches, pebbles and shells carved or engraved with a penknife, and strange objects of many kinds, including the skull of the ox. All these were packed carefully into the Hispano and the return trip to Paris began more reluctantly than the journey south. The day before, Paul Rosenberg, who had also been staying on the coast, had called, and was shown the brilliant canvases from which he had the right to take first choice. He reserved a large number without hesitation.

The relaxation of Mougins had not deadened Picasso's anxieties nor had it made him forget the train of thought that had developed during the painting of *Guernica*. Before going south but after the picture was finished he had made a large etching and some drawings of the head of a woman weeping, with tears streaming across her cheeks and a handkerchief stuffed between her teeth. On his return he took up the same theme again. As had happened at the time of the *Demoiselles d'Avignon*, he continued for some months to add postscripts to his major work. On 26 October he finished the last version of the theme of the woman weeping (Plate XVI, 4). In colour it is very different from the studies made before going to Mougins. The lurid acid effects had been exchanged for brilliant contrasts – red, blue, green and yellow. The result of using colour in a manner so totally unassociated with grief, for a face in which sorrow is evident in every line, is highly disconcerting. As though the tragedy had arrived with no warning, the red and blue hat is decked with a blue flower. The white handkerchief pressed to her face hides nothing of the agonized grimace on her lips: it serves merely to bleach her cheeks with the colour of death. Her fumbling hands knotted with the pain of her emotion join the teardrops that pour from her eyes. Simultaneously they are her fingers, her handkerchief and the tears that fall like a curtain of rain heralding the storm. Her eyes like those of Dora Maar are rimmed with black lashes; they nestle in shapes like small boats that have capsized in the tempest, emptying out a river of tears. As the stream follows across the contour of her cheek it passes her ear, the form of which is not unlike a bee come to distil honey from the salt of despair. Finally as we look into the eyes themselves we

recognize the reflection of the man-made vulture which has changed her delight into unbearable pain. This small picture contains some highly complex images. Its intensity is due again to the clarity with which each statement is made and to the strength and pertinacity of contrasts. Picasso sometimes obtains a dramatic effect by reversing the order to which we are accustomed, as he has done in the centre of the woman's face. Here above the handkerchief there is a jagged black hole between the eyes where we would expect to find them divided by the bridge of the nose. Instead of a ridge he makes a cavity. The breach that he has made in such a vulnerable spot, torn open as though by some projectile, makes a formidible contrast in a face which, though tortured in its expression, shows no sign of being moribund.

Paul Eluard and the Spanish War

In Picasso's varied moods, saturnine despondency or sullen rages were most often dispersed by the arrival of a friend. Paul Eluard had been the most frequent visitor throughout the painting of *Guernica* and his ideas, more defiant towards the gathering storm than those of most other poets, were a continual stimulus. To the poem he wrote in the summer of 1937, which has become an almost inseparable companion to Picasso's painting, he gave the title 'The Victory of Guernica'. This was meant ironically and also as a sign of stubborn optimism in the final outcome of a struggle in which, Eluard was convinced, human rights and human love would finally triumph.

To contradict the errors, often deliberate, that were being circulated in the press both in Europe and America, Picasso made a statement in May 1937. It was issued at the time of an exhibition of Spanish Republican posters in New York, where it had previously been reported that he was pro-Franco. It began:

The Spanish struggle is the fight of reaction against the people, against freedom. My whole life as an artist has been nothing more than a continuous struggle against reaction and the death of art.... In the panel on which I am working and which I shall call *Guernica,* and in all my recent works of art, I clearly express my abhorrence of the military caste which has sunk Spain in an ocean of pain and death.... Everyone is acquainted with the barbarous bombardment of

the Prado Museum by rebel airplanes and everyone also knows how the militiamen succeeded in saving the art treasures at the risk of their lives. There are no doubts possible here. . . . In Salamanca, Milan Astray cries out, 'Death to Intelligence!' In Granada Garcia Lorca is assassinated. . . [19]

Six months later a second statement addressed to the American Artists' Congress was published in the *New York Times*. The last paragraph contained this even more definite confession of faith: 'It is my wish at this time to remind you that I have always believed, and still believe, that artists who live and work with spiritual values cannot and should not remain indifferent to a conflict in which the highest values of humanity and civilization are at stake.' These words were borne out by Picasso's generosity towards his less fortunate compatriots. He gave large sums for Spanish relief and often sold pictures specially with this aim.

Visits from Paul Eluard and Nusch were a pleasure to Picasso. As a proof of friendship he frequently drew or painted the exquisite charm of Nusch. The drawings were often done while sitting together on the terrace at Mougins. Sometimes in the paintings he would playfully elaborate the portrait, adding allusions to things they had noticed together. These portraits, like many made in the intimacy of his family and those closest to him, were often kept by Picasso to remind him of moments of happiness. With her usual taste for originality and elegance, Nusch one day appeared at the rue des Grands Augustins in a new black dress and hat. On the lapels were two gilt cherubs and the top of the hat was ornamented by a horseshoe. The pale, fragile face of Nusch, with her combination of ethereal charm and simple candid high spirits, looked all the more enchanting in the severity of these clothes. Picasso remarked that the hat was shaped like an anvil with the horseshoe in position to be hammered into shape. In the portrait he painted as soon as she had gone he traced the base of the anvil in transparent shadows vertically across the oval shape of the face (Plate XV, 3). The gilt cherubs appeared on the lapels and her dark hair surrounded her head with the movement of clouds.

[19] Quoted by Barr, *Picasso: Fifty Years of Art,* pp. 202 and 264

Visit to Paul Klee

In the autumn of 1937 an unforeseen event made it necessary for Picasso to pay a short visit to Switzerland. As he found himself in the neighbourhood of Paul Klee, he called on him with his friend Bernhard Geiser. After the closing of the Bauhaus, Klee had taken refuge from Nazi tyranny and was living in a surburb of Berne. Although he had watched Picasso's extraordinary career and appreciated the growing influence of his work for many years, the two men had never met. Klee was so modest and retiring in temperament that when he had visited Paris in 1912, attracted by the inventions of the Cubists, he had not dared to call on either Braque or Picasso though he greatly admired their achievements. Picasso's talent in particular affected him so deeply that he tended to avoid seeing too much of his work from fear of being caught in its spell.

Living in exile and harassed by political events, Klee's health had already begun to suffer, but he greeted Picasso with great warmth. 'He was magnificent, very dignified and worthy of respect for his attitude and his work,' Picasso told me. The studio was pleasant and, unlike his own, very tidy and meticulously arranged; in fact to Picasso it was more like a laboratory than a studio. Frau Klee entertained them by playing Bach, and the two painters parted with their mutual esteem greater than ever.

Picasso's description of Klee as 'Pascal-Napoleon' which has been reported[20] is not, as might be thought, a cryptic reference to the character or achievements of either of these great men, but, he assured me much later, rather a comment on his looks which reminded him of them both. He also denied having made to Klee the trite remark which has been attributed to him: 'You are the master of the small size, I am the master of the large.'

Mougins: 1938

In the summer of 1938, with the Eluards, Picasso again sought the

[20] See W. Grohmann, *Klee*, Lund Humphries.

secluded hospitality of Mougins. He painted portraits of Nusch, sometimes producing more than one in the same day.[21] The now familiar arrangement of two eyes in the same profile was applied with tenderness and respect for the beauty of her features. At the same time he made portraits of the three dark-eyed daughters of the house, the youngest of whom, Ines,[22] accompanied Picasso to Paris and remained at the rue des Grands Augustins with her husband for many years as his housekeeper. In addition, he showed ceaseless interest in the features of Dora Maar, which he saw with untiring freshness of vision, giving them a rich variety of interpretation. The portraits he made of her ranged from lifelike drawings in the classic style to distortions based always on observation of the ever-changing light and expression in her face.

Picasso was also impressed by the bucolic look of the village youths who sat in the cool shadow of the plane trees in the village square. It was they who inspired a series of grotesque heads of men sucking lollipops (Plate XVII, 3).[23] Always enjoying the absurdity of such contrasts which corresponded to the underlying uneasiness in his thoughts, he accentuated the uncouth coarseness of their features and the greediness with which they took their childish pleasures.

This uneasiness became most apparent in a large picture completed in February of the same year. The *Girl with a Cock* (Plate XVII, 6) painted in vivid blues, pinks and greens, is a striking though indirect reflection of the violence of the Spanish war, which was then going from bad to worse. To quote Barr: 'Through the power of Picasso's imagery what might seem perverse and minor sadism takes on the character of hieratic ritual, perhaps even symbolic in significance.'[24] The moronic ruthlessness of this female holding on her knees a trussed cock she is about to slaughter is highly disquieting. There is no feature in the picture to attenuate the brutality of the scene, yet surprisingly, as Meyer Schapiro has pointed out, there is something in the outline of the girl's face and the straight black hair that perhaps suggests Picasso's own profile, in which case this is another, though less convincing,

[21] See *Cahiers d'Art* 1938, Nos. 3-10, pp. 180-8.
[22] ibid., p. 187.
[23] See also *Cahiers d'Art*, 1938, Nos. 3-10, pp. 163-6.
[24] Barr, *Picasso: Fifty Years of His Art*, p. 212.

example of the subconscious process of identification that we have already noticed in the monster of *Dream and Lie of Franco.*

During 1938, a year of great activity, Picasso began to decorate forms with small lines that suggest basketwork. In certain drawings the whole surface of the paper is covered with tracery which gives angular crystalline shapes to the figures and their surroundings. As in the earlier 'anatomies' the human form is dislocated and pieced together again with great freedom. Often the breasts of the women are accentuated by spirals which recall Picasso's predilection as a child for drawing these curves which resembled his favourite form of cake (Plate XVIII, 1). Among shapes that are mostly rectangular the spirals attract the eye and gain a significance in addition to their association with food.

Guernica *Travels*

After the close of the Paris exhibition *Guernica* was shown in Norway in the summer of 1938. On its return an exhibition was planned in London, sponsored by a strong committee of left-wing politicians, scientists, artists and poets. When the moment arrived for the painting to be shipped to London with sixty-seven of the preparatory paintings, sketches and studies, the political situation, culminating in Chamberlain's visit to Munich, looked so sinister that I telegraphed to ask Picasso what he wished us to do. His reply was immediate and definite. I was to continue with the arrangements. The purpose of the picture was to draw attention to the horrors of war and it must take its chance. The exhibition opened at the date planned, announcing itself as under the auspices of the National Joint Committee for Spanish Relief.

For the first time those who were not endowed with an understanding of his work joined enthusiastically with others who had been convinced for years of the greatness of Picasso and who admired this monumental proof of his genius. In general the studies made a more direct appeal than did the picture itself, which demanded a greater effort to be understood. Yet the people who came to see the exhibition in large numbers were deeply impressed: very few went away without something of its emotional power making itself felt to them. When it closed in the West End, a second exhibition, this time opened by Major

(the late Earl) Attlee, was held in the Whitechapel Art Gallery. Here the workers of the East End had their first chance of seeing original works by Picasso, and for this reason as well as their interest in the cause of Spain the gallery was constantly crowded.

The New Burlington Galleries, where the picture was shown in the West End, consisted of two large adjoining halls. By coincidence the larger of the two, which had been available for *Guernica*, turned out to have been booked by Franco's supporters for an exhibition of a large painting by Zuloaga who by then had become the champion of academic art in Spain. A large, dull and conventional composition, whose purpose was to exalt the military prowess of Franco, hung at the end of the room; its subject was the defenders of the Alcazar of Toledo. Flags, guns, uniforms and religious images, adding arrogance to incompetent painting, made a contrast with the lack of any such bombast in the room next door where the naked tragedy of war revealed itself through women and children. It was gratifying to the promoters of the *Guernica* exhibition that the rival show remained nearly empty throughout.

After two additional exhibitions in Leeds and in Liverpool the great picture left for New York, where it was shown in the most complete retrospective exhibition of Picasso's work that had till then been collected together, at the Museum of Modern Art. Here it joined that other great picture painted thirty years before, *Les Demoiselles d'Avignon*, which had been bought by the same museum a few years earlier. As the outbreak of the European war made it impossible to return the painting to Europe, Picasso was glad to leave it where it could be seen and appreciated. It remained in America on loan until it was brought back to Europe for the great exhibition at the Musée des Arts Décoratifs in Paris in 1955. After a tour of European cities it was then returned to New York.

Illness and Recovery

Sabartés gives an intimate account of the weeks of misery spent by Picasso in the icy winter of 1938, when a prolonged attack of sciatica kept him immobilized in bed in great pain. Sabartés described Picasso's

restlessness, his sleepless nights, the procession of visitors who all knew of some certain cure, and finally the appearance of a doctor who managed almost miraculously to cure him instantaneously by the cauterization of a nerve.

A few days before the attack, he painted two still-lifes. These are similar in subject matter, except that the first contains two sources of light: a candle, and a version of the sun resembling the white rectangle of a paper kite with a fringe of black rays. The other objects are the same in both; on a table which fills the lower part of the picture, a palette and brushes lie on an open book, and beside on a pedestal stands the head of a bull. In the first version the head is black with lines scratched into the paint to define its eyes and snout.[25] In the second painting, done a week later, the bull's head has the appearance of having been flayed alive (Plate XVIII, 2). Its unprotected eyes stare from a livid mass of red flesh, exposed relentlessly to a crude light which is too strong and too universal to come from the candle.

Picasso soon recovered after his illness and continued to create images of people and of animals with great violence and frequent allusions to cruelty, such as the painting of a ferocious cat carrying a lacerated and fluttering bird (Plate XVIII, 4). The half-human face of the cat with its shifty eyes is a terrifying vision of calculated brutality made all the more powerful by the direct, childlike manner in which it is drawn.

In the spring Picasso had worked in the evenings at the studio of Lacourière. His project was to reproduce in coloured engravings the texts of poems he had written not long before, decorated with drawings in the margins. The difficulties of this complicated technique were exactly what he needed to excite his inventive powers. Sabartés tells us how his ideas became steadily more ambitious as he became enthralled by his work. Vollard was called in as publisher. He willingly offered his services, leaving Picasso an entirely free hand in the choice of paper, layout and every other point in the production. To make his work easier, the press was brought back from Boisgeloup and installed under Lacourière's supervision in a wing of the apartment in the rue des Grands Augustins, which was at that time being made more habitable

[25] Raynal, *Picasso,* Skira, p. 102.

with central heating. Even with all these preparations it would have been a long time before the project could have been completed. As it happened, Picasso became interested by other means of expression which prolonged the process, until one day, irritated by the technical problems of putting his work together as a book, the calculations involved and the interminable length of the whole process he announced to Sabartés that there was no question of the book being finished. The engravings were then unpublished and remained stacked away for many years in the rue des Grands Augustins.[26]

In July the usual urge to leave Paris drew Picasso to the Mediterranean coast. He took an apartment in Antibes, but hardly had he settled in when he heard of the sudden death of Vollard. The next morning Sabartés was surprised to find him back in Paris. Picasso, however, did not stay long. A few days after the funeral a telegram from a friend in the *Midi* arrived announcing a bullfight at Fréjus. This was the decisive fact that started him on another hasty all-night road trip with Marcel at the wheel. For the first time Sabartés, overcoming his distaste for travelling, went with him.

The first few days after their arrival at Antibes were spent in showing the attractions of the coast, such as Monte Carlo, Nice, Cannes and Mougins, to his old friend. After that Picasso started work. In bourgeois style the apartment was crowded with tea tables and depressing ornaments. These suddenly became offensive to him, and with the help of Sabartés and Marcel, the imitation antiques, bibelots and pictures were stacked away, leaving room for him to crowd the room with his own kind of disorder. The large walls stripped to the flowered wallpaper were an incentive to paint another picture of great

[26] In a conversation in Cannes between Picasso and Dr Bernhard Geiser (the editor of the *catalogue raisonné* of Picasso's graphic art), Dr Geiser asked how he could have access to these and other works which he needed to photograph so as to make his catalogue complete. Picasso with charming nonchalance said: 'how is it possible, they are all in Paris, many of them stacked away in a bank, even here I have difficulty in finding things and there no one could do so without me? It would be easier', he added, 'for me to do them all again. How often has it happened that someone has called for a drawing that I had promised to do for him and although it was done, it has been impossible for me to find it, so to put matters right, while out of the room looking for it, I have quickly done another which has been accepted just the same.'

dimensions. He bought an enormous roll of canvas which he pinned up and began to cover at an incredible speed with a subject that he had found near by (Plate XVIII, 9). His evening walks with Dora Maar had led him to discover the little fishermen's harbour where they prepared their boats for the night fishing, which was done at that time with strong acetylene lamps. The purpose of the lamp shining on the water was to attract fish that could be speared with a trident from the boat. By this means, even close in among the rocks, the sea yielded creatures of wonderful colour and strange shapes glistening under the powerful light, while insects such as beetles and large moths flapped about in its glare. This was the scene that Picasso chose for the big canvas and every day he concentrated his energies on its realization.

The painting did not however hinder him from taking his morning bathe. As I was also in Antibes, we met daily on the beach and exchanged views on the political situation. The surrender of Barcelona and the defeat of the last faint hopes of the Republicans had filled us all with an intense depression, which was in some degree relieved by the arrival of Fin and Javier Vilató, two of Picasso's nephews, who after crossing the Pyrenees with the defeated army, had escaped from internment by the French. Their joy at finding their uncle and the antics they played on the beach in their irrepressible high spirits helped temporarily to disperse the increasing gloom.

Although no one could be mad enough to feel optimistic about the future, the news of ultimatums and mobilization came as a sudden shock a few days later. Picasso came every evening to sit with his friends at the café in the main square of Antibes, and enjoy for an hour or so in the cool air his abstemious choice of coffee or mineral water. The conversation which formerly had been varied and amusing from then on had only one theme. Plans for departure were being discussed on all sides. Within a day most of our friends had gone and the town began to fill with troops, while on the rocks close to the fashionable hotels and bathing pools Senegalese soldiers had already set up their machine-guns.

Picasso remained undecided. He was particularly irritated to have been interrupted just as he had begun to see more clearly the path his new work was to take. Joking with us he said they must be making a war

just to annoy him when he was starting on a good line. As Sabartés said pertinently: 'What he dreaded in war was its menace to his work; as though peace were indispensable to this being who cannot live without mental strife.'[27]

The evening after the announcement of Hitler's invasion of Poland I went up to Picasso's flat. The new painting of the night fishing seemed finished but other large panels of canvas pinned to the walls remained untouched. In the centre of the picture two fishermen in a boat, one peering with a hideous grimace into the water and the other making frantic efforts to secure their catch, were being watched by two girls in gay frocks. One of them, wheeling her bicycle along the quay, licked a double ice-cream cone with a sharp blue tongue like a bee drinking honey from a flower. The decoy lamp, to the fish a treacherous substitute for the sun, hung ambiguously on the horizon. Over its yellow surface Picasso had drawn a red spiral, his early symbol for a source of nourishment. As I looked out of the windows, the towers of the palace of the Grimaldi stood out faintly, coloured with tenebrous blues, purples and greens, against the sky, just as they were in the picture. From the balcony could be seen the old town with its street lighting partly dimmed as a first measure of defence. The angular shapes of the stone walls lit from the street corners had a striking resemblance to analytical Cubist paintings. The architecture of these ancient buildings seemed to have grown to look like these pictures, just as Gertrude Stein was said to have grown to look like her portrait.

We said good-bye, consoling ourselves with promises to keep in touch, and left Picasso to his packing. He had decided to risk a crowded train journey back to Paris, leaving Marcel to return with the car loaded with extra petrol, trunks, boxes and the picture, *Night Fishing at Antibes*, rolled up on the back seat. Six years were to pass before Picasso saw the Mediterranean again.

[27] Sabartés, *Picasso: Portraits et Souvenirs*, p. 148.

Second World War - Royan and Paris
(1939-45)

Royan

When Picasso reached Paris after the discomfort of an all-day journey in a desperately overcrowded train in intense heat, he found a changed city, and for the second time in his life a war with Germany imminent. Again his French friends were on the point of being mobilized. Some like Eluard had already left Paris to join their regiments. Faced with the terrors of immediate bombing, upon which he had meditated so thoroughly in painting *Guernica,* and realizing the futility of staying in a city where rumours and preparations for hostilities occupied everyone's thoughts, he set out by road for Royan. Three days of anxious conversations with friends had convinced him that he had better seek shelter outside the city. This little port at the mouth of the Gironde some seventy-five miles north of Bordeaux seemed a place sufficiently remote and yet near enough to keep in touch with Paris.

Sabartés describes how after leaving in the Hispano about midnight they arrived at Saintes, close to their destination, in the early morning to find there the same preoccupation and anxiety. After a breakfast served by waiters already in uniform they continued to Royan. Picasso was relieved to find himself back in the sunshine and again by the sea. They found rooms for his party, which included Dora Maar and the hound Kasbec, on the outskirts of the little port near the station. In the haste of their departure it had been impossible to bring the materials required for painting, but unable to remain idle Picasso ransacked the local shops for paper and sketchbooks until he had found what he wanted. The following day, returning to the only activity that could bring him some comfort, he was again at work.

The first drawings he made were of horses. In traditional style France mobilized her forces from the fields as well as her manpower. Everywhere on the road they had seen processions of requisitioned horses, which, as Picasso remarked to Sabartés, certainly understood that they were not going towards their usual work, in spite of their air of submission. Once more the horse was the victim of a calamity brought upon it by the incomprehensible behaviour of its masters.

But Picasso was not allowed to find tranquillity even at this distance from Paris. Within a few days he was troubled by the announcement that as a foreigner he required a special permit to stay in Royan. His fear of finding himself in the wrong with official regulations induced him to hurry back to Paris with Sabartés to obtain the permits that had become necessary. During the day they spent there Picasso had his first taste of an air-raid warning which kept him immobilized for at least an hour. Even so he had time to collect the permits and a few precious objects from the rue la Boétie before taking the road back to the coast.

The rooms in which he lived for the next few months were cramped and badly lit. The town itself apart from its harbour had few attractions. Accepting the situation, however, he settled down to a regular routine in which the main factor, work, was punctuated with meals and walks round the town, accompanied by Dora Maar, Sabartés and the docile Kasbec. As they visited the harbour and explored the markets one of their main pleasures was to search among the mysterious piles on the stalls of the junk merchants, an endless occupation which yielded unexpected finds.

The spasmodic preparations for the defence of the town were watched by them during their wanderings along the beaches. When Sabartés remarked one day that they had begun at last to dig trenches as shelters against bombardments, Picasso answered mockingly: 'It's only you who would imagine such things. No, *mon vieux*, no . . . you don't understand. These are excavations to see if they can find trenches, nothing else. You'll see all right. As soon as they find one, they'll take it off to the museum and if there's no museum for it, they'll make one especially.'[1]

[1] Sabartés, *Picasso: Portraits et Souvenirs*, p. 222.

The same lack of respect for those who were professionally in charge of the fortunes of the state was expressed more tersely in a conversation with Matisse, whom he met by chance some months later in Paris, when the war had suddenly taken an alarming turn for the worse. It was in May 1940 and the two painters, who had not seen each other for some months, looked anxiously into each other's faces. Matisse reported their conversation in these words:

' "Where are you going like that?" said Picasso.

' "To my tailor," I [Matisse] replied. My reply surprised him, he seemed scared.

' "What! but don't you know that the front is completely broken through, the army has been turned upside down, it's a rout, the Germans are approaching Soissons, tomorrow they will perhaps be in Paris?"

' "But even then, our generals, what about our generals? What are they doing?" I said.

'Picasso looked at me very seriously: "Our generals, they're the professors of the Ecole des Beaux Arts." '[2]

From the experience of both artists, no more complete condemnation of the military leaders as stubborn and slavish followers of a decayed tradition could have been made.

Discomfort and the shortage of painting materials had not hindered Picasso during this first autumn while the war hung fire. Squatting on the floor for lack of an easel, as he had done in the days of the Bateau Lavoir, he painted on planks or hardboard when canvas was lacking; and for palettes used ready-made wooden seats of chairs, which he liked better for the purpose than the conventional type. The paintings could not be large in their dimensions, but before the end of October he had produced an astonishing portrait of Sabartés in a ruff as a courtier of Philip II (Plate XIX, 1); a portrait of Dora Maar, powerful in its arrangement of simultaneous profile and full face; paintings of nude women and women seated in chairs; and still-lifes of fruit and fish. He had also filled many sketchbooks with drawings, including some careful studies

[2] André Verdet, 'Picasso et ses environs', *Les Lettres Nouvelles,* Paris, July–August 1955.

of the skinned heads and jawbones of sheep.

The portrait of Sabartés was again full of ironical good humour, a mixture of teasing and affection which was a well-established relationship between the two friends.

'The next one,' he told Sabartés, 'will be bigger, full length, life size and in oils of course, to season this kind of frizzled lettuce collar round your neck, as well as salt, pepper &c. to taste, [there will be] the nude woman, the greyhound, and the complete costume you wore when you strutted valiantly in the corridors of the Escorial. That's a long time ago, but we can still picture it.'[3] The patient unassuming Sabartés quietly enjoyed these extravagant but lifelike versions of himself in fancy dress.

The melancholy of autumn in a small seaside resort, thoughts which continually took him back to his friends, and the vast quantities of pictures and other things precious to him that he had left in Paris, compelled Picasso to return once more to the rue la Boétie in October. On this occasion he took the time necessary to sort out the canvases and objects he valued most and to place them in the strong rooms of a bank, where they were housed in safety during the rest of the war. Some in fact remained there very much longer owing to his reluctance to bring out all his treasures and his uncertainty as to where to store them.

When he returned to Royan after that visit, bringing with him a heavy load of canvases and an easel, he found that his quarters were hopelessly inadequate, and after further search he rented rooms on the top floor of a villa called 'Les Voiliers' which later in the war was destroyed by Allied bombs. Looking out to sea, it had a splendid view over the port. His motive in taking this apartment was not however the view – 'that would be fine for someone who thought himself a painter', he explained to Sabartés – but rather the light which had been lacking in his former lodgings. Although he spent hours watching the coming and going of the ferry boat, the changing reflections on the water and the long curving sweep of the bay with its hotels and villas gilded by the sun, he felt uneasy about being the only one to enjoy a scene which was not essential to him for his inspiration.

<hr>

[3] Sabartés, *Picasso: Portraits et Souvenirs*, p. 212.

Hardly had he installed himself in his new quarters and got used to the more spacious, well-lit room he had taken over as his studio, than he was seized by a fresh desire to return to Paris and arrange his affairs. The greater part of the month of February 1940 was spent there, and after a fortnight in March when he was in Royan, he settled in again at the rue la Boétie until 16 May. The war had slowed down all intellectual activities in Paris. Although in April some water-colours and gouaches by Picasso were shown at the Galerie M.A.I., very few exhibitions were being held, and publications such as the one Eluard had planned with Picasso, of a book of his poems called *Fleurs d'obéissance,*[4] failed to materialize. In America, however, the great retrospective exhibition planned by Alfred Barr at the Museum of Modern Art for the autumn of 1939 opened in New York. This impressive collection, which included *Guernica,* made a great impression on the thousands of visitors who saw it there and later in other cities throughout the United States.

A few friends still remained in Paris. Zervos continued his activities in a limited way. Man Ray, Georges Hugnet and a few other Surrealists, who for one reason or another had not been called up, remained engrossed in their work and met Picasso frequently on his daily visits to the cafés of St Germain des Prés.

A review edited by Hugnet and published by Zervos[5] appeared during the winter. To the third and last number, in company with Miró, Arp, and Chagall, Picasso contributed a vignette as a decoration to poems by Pierre Reverdy. These small consolations, and occasional visits to Paris from Eluard and others on leave, provided moments when Picasso could renew his friendships. They were however of short duration. Hitler's *Blitzkrieg* was at hand. Having already occupied Denmark and Norway in April, on 10 May the Nazi troops marched into Holland, Belgium and Luxemburg and the military situation rapidly became catastrophic for the Allies. From day to day the German divisions drew nearer to France until on 15 May news of the break-

[4] In a letter to me dated *31 Mai '40* Eluard, then stationed at Mignères (Loiret) says: '*Je comptais publier les* Fleurs d'Obéissance *avec Picasso. Cela paraît compromis, c'est le moins qu'on puisse dire.*'
[5] *L'Usage de la parole,* Cahiers d'Art, Paris, December 1939–April 1940.

through at Sedan made it obvious that Paris was in danger. The day after, which was the same day he had met Matisse in the street, Picasso left on the night train for Royan.

The German Occupation

After the disastrous ending of the Spanish Civil War hardly a year before, Picasso was now to witness the defeat of his adopted country, France, by forces similar to those that had overcome the Republican Government of Spain. The chaos brought about by military defeat and the misery of thousands of refugees culminated for him with the arrival in Royan of the German troops. From the windows of *Les Voiliers* Picasso saw the arrival of the round steel helmets of their scouts followed by the sinister paraphernalia of tanks, guns and dust-covered lorries. They filed past to their new headquarters on the quay near by. As he watched he said to Sabartés: 'At bottom, if you look carefully, they are very stupid. All those troops, those machines, that power and that uproar to get here! We arrived with less noise.... What nonsense!... Who was preventing them from acting like us?'[6]

The absurdity of the arrogance that led these invaders to believe that because they had conquered the French armies they had also conquered the spirit of France served as a stimulus to Picasso in taking the only path left open. By returning to his work with even greater concentration he affirmed his contempt for those who had openly declared that they considered his influence to be 'decadent' and evil. During the two months after his return to Royan on 17 May, he filled many sketch-books with drawings which contained a new violence and a power equal to that of his fury over *Guernica*. One such book, reproduced later by the *Cahiers d'Art*, contains some very moving pen-and-wash drawings, in which the head of a girl inspired by Dora Maar goes through a series of permutations. The head is in varying degrees split in two, seeming to look both out into the world and into itself with apprehensive tear-filled eyes. While one part of the face is full and tender, with soft lips and cheeks, the other, with its long-drawn-out nose ending in curling

[6] Sabartés, *Picasso: Portraits et Souvenirs,* p. 229.

nostrils, resembles Kasbec's elegant snout.[7]

This marriage of woman and beast in one image culminated in a large canvas, for which there are drawings in this same book, known as *Seated Woman Dressing Her hair* (Plate XIX, 3). In spite of an earlier date on the back of the canvas the picture was actually painted between 4 and 19 June. By restricting his colours severely to mauve, purple and green, Picasso presents us with a firmly constructed, monumental form of aggressive appearance. The nude female squatting on the floor has a sphinx-like presence. The anatomy is built of shapes that, like petrified fruit, are both swollen and hard. Two monstrous feet in the foreground are thrust out in front of a body in which belly, buttocks, and breasts make the four corners of a construction which seems to pivot like a swastika round a point on the breastbone. Above it towers a ruthless head, with human lips on one side and on the other the snout of a beast. Its double personality is united at its apex into a small forehead with two insensitive squinting eyes and two hands tugging behind at its black mane of hair.

Other drawings express a mood of increasing vehemence. On 28 June, four days after the last fighting had taken place not far from Royan, Picasso filled a page with diabolically distorted female nudes and heads (Plate XIX, 2). At the top is a row of skulls constructed with his own invented anatomy. The fleshless bones of one, crowned with a luxuriant shock of black hair, make one of the most ghastly and heartbreaking images he ever produced. Skulls, scenes of rape and demented faces, distorted with diabolical invention, fill the rest of the book nearly to the last pages. Here towards the end of August there are signs of a more gentle mood. Distortion is allied to charm and the smiling eyes and lips of Dora are again recognizable. From these days also dates a landscape, the *Café at Royan* (Plate XVIII, 5), which glows with sunlight, a reminder of his previous saying that he was not always occupied with gloom.

[7] *Carnet de dessins de Picasso* (Facsimile), ed. Cahiers d'Art, Paris, 1948, 24 July 1940.

Return to Paris

With the signing of the armistice between Hitler and Pétain there was no further reason for Picasso to remain in voluntary exile at Royan. Invitations came from the United States and Mexico offering an escape from the uncertainty of life in occupied France. He refused them all, however, and as soon as travel was again permitted, late in August, he left Royan for good and returned to Paris.

To begin with he settled in at the rue la Boétie, returning daily to the rue des Grands Augustins to work. The great room where he had painted *Guernica* was now emptied of all that could be safely stored away, and the monumental stove with its complicated chimney standing in the centre was the only remaining ornament; a feature which as fuel became scarce was to turn into a useless relic. The difficulty of finding any means of transport between the rue la Boétie and the rue des Grands Augustins, however, soon induced Picasso to shut up the apartment and install himself as best he could in the rooms adjoining his studio. He remained living and working in these surroundings, noble in proportions, but lacking in comfort, for the duration of the war.

Throughout the Nazi occupation Picasso was unmolested by the invaders. His reputation as a revolutionary could alone have been enough to condemn him. He was the renowned master of all that Hitler hated and feared most in modern art, the most formidable creator of the 'Kunstbolschewismus' or 'degenerate art' which for years the Nazi régime had tried to suppress. In addition, though at this time he had made no allegiance to communism, he had clearly shown his hatred for Franco, the dictator whom Hitler hoped to gain as an ally. However, the invaders took no action against him. Possibly from fear of criticism from America or from French intellectuals, whom the Nazis at that time believed they must make some attempt to woo, Picasso was allowed to return to Paris and to live there with the same limited degree of freedom as the French. The policy was to attempt a liaison with French artists, but any such ill-timed advances as offers of tours of Germany or even extra allowances of food and coal were steadfastly refused by Picasso, though in some cases they were accepted by artists

who had formerly been his friends. He told them, 'a Spaniard is never cold'.

It is significant that Picasso was forbidden throughout the occupation to show his work in public. The most serious attacks that were made on him came not directly from the Nazis but from those collaborationist critics who under the new régime found places of authority and ample encouragement for their reactionary thoughts. To quote André Lhote, who had been a cubist from early days and who now took a stand with Picasso: 'Never, never was independent art...exposed to more idiotic annoyance or ridiculed in terms more absurd... "To the ashcan with Matisse!" and "To the loony-bin with Picasso!" were the fashionable cries.'[8]

Picasso remained unmoved, nor was he overawed when members of the Gestapo searched his apartment and Nazi critics and officers called on him. During one visit a remark from an inquisitive Nazi officer brought a retort from Picasso which has become famous. Seeing a photo of *Guernica* lying on the table the German asked: 'Did you do this?' Answer: 'No...you did.'

Of other callers, Picasso said later, 'Sometimes there were some Boches who came to see me on the pretext of admiring my pictures. I distributed among them postcards reproducing my canvas *Guernica* and I told them, "Take them away. Souvenir! Souvenir!" '[9]

Towards the end of the occupation high-ranking officers who before the war had visited Paris to collect impressionist paintings called on him. They arrived in civilian clothes and announced themselves politely, although they were fully aware of Picasso's reputation and sympathies. They asked suspiciously after Paul Rosenberg, whom Picasso said he believed to be in America, and made him uneasy by commenting on the bronzes they saw in the studio. Picasso said

[8] The attacks on Picasso came notably from the painter Vlaminck in an article in *Comoedia* 6 June 1942; from Vanderpyl in the *Mercure de France*, authorization No. 64460/9–42; from the old art critic Camille Mauclair in *La Crise de l'art moderne*, *imprimerie spéciale du C.E.A.*, Paris, 1944; and from the aged American pro-fascist expatriate, John Hemming Fry.
[9] '*Picasso n'est pas officier dans l'armée française*', interview with Simone Téry, *Lettres Françaises*, Paris, 24 March 1945, quoted in Barr, *Picasso: Fifty Years of His Art*, p. 226.

nervously, 'They won't help you make your big guns.' 'No,' one of them answered, 'but they could make little ones.' Nothing, however, ever came of this threat, and Picasso's clandestine supply of bronze through loyal friends continued.

Picasso as Playwright

One effect of Pétain's armistice was that some friends could now return to Paris to help refill the void caused when others had fled. With the demobilization of the French army, Eluard was released, and with other poets and painters he found his way back. Picasso's uncompromising yet detached attitude made him the centre of their activities and their hopes. Without taking an active part himself, he became a symbol to those who secretly and precariou\mathring{s}ly, in face of constant dangers, began to think of the future and organize a resistance which would lead eventually to the liberation of France.

Restriction of movement and shortage of food heralded a period of severe privation. Thrown on their own limited resources and obliged to invent a new way of life within the artificial boundaries of occupied France, many artists remained for a while stunned and inactive. For Picasso, however, the necessity to react against an atmosphere which oppressed him urged him to find ways in which he could create, even though destruction was the order of the day. His zeal to create was in a sense dependent upon destruction. Who had dared to dismember the human form more completely than he? Yet such acts of violence in art led to a new creation. They gave to Picasso the destroyer the means to evoke life. And so when disillusionment and despair were in the ascendant they too had to be destroyed by the healing power of his art.

Although Picasso claimed that he wrote only when for some reason he was unable to draw or paint, at Royan he wrote poetry in spite of his fertile production as a painter. Again, on Tuesday 14 January 1941, during the long cold evening which followed a vigorous day's work on his canvases, he picked up an old exercise book and started to give his friends a surprise such as none had dreamed of. Systematically he began with the title *Desire Caught by the Tail*, and, as a frontispiece, a pen and ink portrait of the author, seen as a fly on the ceiling would see him,

seated at his table, his glasses protruding from his forehead and his pen in hand (Plate XIX, 8). He then began to write a play which he had conceived either as a tragic farce or a farcical tragedy. Act I scene I begins with a drawing of a table laid for a meal which consists of ham, fish, wine and a man's head on a plate. Beneath the table dangle the legs of the characters whose names are inscribed down the side of the page. The hero of the play is a certain Big Foot, writer-poet who lives in an 'artistic studio'. His friend called the Onion is also his rival in his passion for the heroine, the Tart. She has a Cousin and two friends, Fat and Thin Anxiety. The other singular characters are Round Piece, the Two Bow-wows, Silence and the Curtains.

This strange company is almost entirely preoccupied with three things - hunger, cold and love. Their conversation, which is often charged with poetic metaphor, is at other times brutally crude. The action which centres round love and feasting ends inevitably in disappointment. For instance, their great '*déjeuner sur l'herbe*' ends badly. Here are the stage directions.

The two Bow-wows, yelping, lick everybody. They jump out of the bath-tub, covered with soap suds, and the bathers, dressed like everybody of this period, come out of the tub. The Tart alone gets out stark naked except for her stockings. They bring in baskets of food, bottles of wine, tablecloths, napkins, knives, forks. They prepare a great picnic lunch. In come some undertakers with coffins, into which they dump everybody, nail them down and carry them off. Curtain.

But the play does not end here. All the characters reappear in the next act as though nothing had happened. A similar anticlimax comes at the end of the last act when after a prizegiving Big Foot says these last heroic words: 'Light the lanterns. Throw flights of doves with all our strength against the bullets and lock securely the houses demolished by bombs.' Then follows the entry of 'a golden ball the size of a man which lights up the whole room and blinds the characters. . . . On the golden ball appear the letters of the word: NOBODY.'

Cold, hunger and love make themselves felt in a variety of ways. One scene is set in a corridor of 'Sordid's Hotel' where 'the two feet of each guest are in front of the doors of their rooms, writhing in pain'. In turn they wail a monotonous chorus: 'My chilblains, my chilblains, my

chilblains...' There are frequent mentions of stoves and chimneys and icy temperatures which serve merely to increase the pangs of hunger. Food is their main preoccupation. In the last act a splendid feast is served 'in the main sewer-bedroom-kitchen-bathroom of the Anxieties'. The sisters boast of the fantastic viands they have prepared. Thin Anxiety exclaims: 'I shall help myself to the sturgeon; the bitter erotic flavour of these delicacies keeps my depraved taste for spiced and raw dishes panting eagerly.' Big Foot, as he writes love poems, meditates: 'When you think it over, nothing is as good as mutton stew.' Even his desire for the Tart is translated into such terms as 'the melted butter of her dubious gestures', or when he addresses her, 'your buttocks a plate of cassoulet and your arms a soup of sharks' fins'.

Finally with her infatuation for Big Foot leading nowhere, the Tart speaks these moving lines from her heart: 'You know, I met love. He has all the skin worn off his knees and goes begging from door to door. He hasn't got a farthing and is looking for a job as a suburban bus-conductor. It is sad, but go to his help...he'll turn on you and sting you. Big Foot wanted to have me and it is he who is caught in the trap...'

Picasso's habit of finding his material close at hand or from memories that spring up again vividly in his imagination provided the flood of images with which the play is inundated. Fat Anxiety talking of some newly born kittens says: 'We drowned them in a hard stone, to be exact a beautiful amethyst.' This strange evocative metaphor was inspired by a large amethyst belonging to Picasso and of which he was particularly proud, because in a cavity enclosed within it water can be seen. His characters also have similarities with those around him, but it would be fruitless and impertinent to search for consistent descriptions. Just as in his painting he enjoys seeing his models in mirrors that distort them so thoroughly that only certain features are recognizable, so he destroys or decomposes his characters before building them again. When Big Foot soliloquizing says of the Tart: 'the roses of her fingers smell of turpentine', we can see an allusion to Dora Maar who spent much of her time painting. He continues, 'I light the candles of sin with the match of her charms. The electric cooker can take the blame.' It would be impossible to explain the last sentence unless it were known that the

electric cooker installed in Dora Maar's flat was, jokingly, always given credit for any specially good dish cooked by her.

Raymond Queneau notices that there are surprisingly few allusions to painting in the play.[10] Apart from a mention of the *Demoiselles d'Avignon* who 'have already had a private income for the last thirty-three long years', there are frequent phrases which are obviously from a painter's or a sculptor's vocabulary, such as 'the blackness of ink envelops the saliva of the sun's rays', or 'I beat my portrait against my brow', or again 'the whiteness and hardness of the gleaming marble of her pain'. The purely visual images are possibly outnumbered by those which appeal to other senses. The predominant appeal to the sense of taste is followed closely by that of smell, which wafts its way in, not only as the fumes from chip-potatoes which completely suffocate the actors at the end of the fourth act, but in reference to the Tart who melts 'into the fragrant architecture of the kitchen' and attracts Big Foot by 'the sweet stink of her tresses'. Sound also is by no means absent. 'The noise of unfastened shutters, hitting their drunken bells on the crumpled sheets of the stones, tears from the night despairing cries of pleasure', or again, 'the feasting will burst all the strings of the violins and guitars' - such passages clearly result from an enjoyment of music.

There is one short act which brings in numbers in an extravagant way. The entire cast are trying their luck at the big wheel of a lottery. As it comes to a stop, each of them shouts out in turn the fantastic sum that has become his prize. In the end they all, even the Curtains, win the jackpot, but this avails them nothing for it is at this moment that the fumes of fried potatoes asphyxiate the lot. As well as making appeal to all the senses and to erotic desire, Picasso here adds the unaccountable fascination that numbers always had for him, which was noticed as early as his first examination in Malaga.

On Friday 17 January 1941, four days after he had started, Picasso drew a line at the bottom of the last act and wrote: '*Fin de la pièce*'. The friends he allowed to read it found its humour irresistible. The contrasts between Rabelaisian wit, evocative imagery and macabre situations were unlike anything they knew. Three years later, in the spring of

[10] Raymond Queneau, 'Une Belle Surprise', *Cahiers d'Art,* Paris, 1940-44.

1944 when the Nazi occupation still made such things dangerous, a reading was organized in the apartment of Michel Leiris who lived near by. Leiris read the part of Big Foot while other parts were taken by his wife, Louise Leiris, Jean-Paul Sartre, Simone de Beauvoir, Raymond Queneau, Georges and Germaine Hugnet, Jean and Zanie Aubier and Dora Maar. Camus offered his services as producer. It would have been difficult to find a cast who could interpret Picasso's intentions with more understanding and delight. The rendering of the play was so excellent that this single performance in occupied Paris is talked of by those who were there as an event as memorable for its accord between poets and painter as the banquet in honour of the Douanier Rousseau some forty years before. In addition it savoured of a clandestine orgy, an insult to the preposterous invaders who had imagined that they could govern Paris. 'Never has our freedom been greater than under the German occupation', wrote Jean-Paul Sartre, '. . . since the Nazi poison filtered even into our minds, every just thought was a victory; since the omnipotent police tried to force us to silence, every word became as precious as a declaration of principle; since we were at bay, our very gestures had the weight of vows.'[11, 12]

Portraits of D. M.

Since Picasso began to draw portraits of Dora Maar when he was staying at Mougins in 1936, her face became more and more an obsession at the basis of his inventions and reconstructions of the human head. Among the early versions there are many lifelike portraits,

[11] *Les Lettres Françaises,* 9 September 1944.

[12] After the war, performances were given in London. The most successful were those which did not attempt any staging. The stage directions in some Rabelaisian details are impossible to act, and since they are eloquent in themselves they are best understood when read. A reading such as this, in which Dylan Thomas took part, was organized by the Institute of Contemporary Arts. *Desire Caught by the Tail* shared the bill with *The Island in the Moon* by William Blake, making an unexpected parallel between the two plays written by painter-poets. Picasso's play was first published in *Messages II Paris, Risques, travaux et modes,* 1944, with four illustrations, and later as *Le Désir attrapé par la queue,* Gallimard, Paris, 1945 (Collection Métamorphoses, XXIII), without illustrations. A facsimile of the manuscript was also made for private distribution.

exact studies of the first direct impression of her features. Treating her appearance with great tenderness and often combining her features with poetic fantasies, he explored every line and every surface, watching her expression and her gestures. Dora Maar, as I have said before, appears as a water nymph, as a chimerical birdlike creature with the regular oval of her head crowned with horns, or in more distorted forms, with her features composed of flowers.

The faces of other women and small children whom he saw frequently during these years also appear in portraits. Nusch Eluard, Ines the maid who had come from Mougins to keep house for him, his daughter Maïa, and friends who called frequently at the rue des Grands Augustins were often his models. However, paintings in which the features of Dora Maar can be traced are the most numerous, though the degree in which they can be said to be portraits varies greatly. For Picasso the subject, ever since the revolution which occurred in the *Demoiselles d'Avignon,* has been the victim of his will to destroy appearances. Vision rather than subject matter becomes supreme. The Cubists had all destroyed the form of objects such as guitars, bottles and even the human body when reorganizing their shapes in still-lifes or figure compositions, but none had had the same courage as Picasso to demolish the human head. What is more, he did not confine this disruptive process to his male friends, as he had done in the early Cubist days, when he had scrupulously avoided making any reference to Eva except as a symbol. The face of his closest and dearest woman friend was eligible to suffer the same violence. The face of Olga had not been exempt, nor was the face of Dora Maar.

Picasso uses the features of a face as raw material. He knows them intimately from long observation and from frequent studies made either from life, or from an equally visible mental image. Sometimes they become complicated by the intrusion of features of another origin, as when he creates composite heads of dog and woman, or, as in the Minotaur series, heads which are the aggregate of features from man, bull and dog.

As early as the autumn of 1939 we find a 'portrait' of Dora Maar in which distortion is carried so far that it might be expected that all resemblance to the human head had been forfeited and in consequence

no trace of likeness to the model could possibly remain. However, in this painting (Plate XVIII, 7) which Dora Maar had seen for several weeks in the studio, she suddenly realized that an isolated bulbous shape between the eyes had an uncanny likeness to her own forehead.

The vision of Picasso seems to know no prejudice and no taboo which will limit its penetration. He does not allow sentiment, tenderness or any convention to stand in the way of his creation. Such liberties will be considered by some an unpardonable indiscretion, an outrage on what is sacred and beautiful, whereas for Picasso it is a necessary process, a process which makes his creation fertile with associations.

To describe the variety of ways in which the presence and intelligence of Dora Maar nourished Picasso's inspiration exceeds the scope of this book. There are some portraits painted during the war which however must be mentioned. The first dates from the autumn of 1939 (Plate XVIII, 3). In a small, simple and yet monumental painting Picasso has seen his model from the least advantageous angle, from behind. With the desire characteristic of the Cubists to see her from more than one viewpoint, he had given the head two profiles, one on either side of a black torrent of hair. Later he used the same device in his treatment of a nude (Plate XIX, 5), where although the sleeping figure lies prone, the face and body are opened out in such a way that both profiles and breasts are made visible at either side of the back. The frustration caused by never being able to see both back and front at once has been subtly overcome. Once more he had preferred a cubist solution to the old problem; which, if we consult history, we find had caused long discussions during the Renaissance. In comparing the relative merit of sculpture and painting, sculptors claimed that the superiority of their art lay in the fact stressed by Cellini that sculpture does not confine itself to one, but can give eight different views of its subject. Giorgione according to Leonardo, in answer to this, 'to the utter confusion of certain sculptors...painted a Saint George in armour standing on the banks of a stream and between two mirrors reflecting the figure at various angles.'[13] Picasso was not ignorant of this method. He had used the reflection in the mirror in the moon-like nudes of 1932. Those were

[13] Leonardo da Vinci, *Paragone*, note by Irma A. Richter, Oxford University Press, 1949.

purely visual solutions; the splitting of forms such as he was practising here had a more tactile quality. It was closer to the conception of a sculptor, who wishes to manipulate form as well as merely contemplate it with his eyes.

Another painting, a gouache, of the Royan period is powerful in invention though small in size.[14] A gnarled, twisted female nude stands with windswept hair against the void of a grey sky. It would be verging on an insult to call this, as Paul Eluard does, *Portrait de Mademoiselle D. M.*, were it not that even in this extreme case, there is still in every detail a reference to the life Picasso was sharing with his friend and to the experiences, visual and emotional, they had in common. Though I am unable here to clarify this suggestion any further it is undoubtedly true because the intimate communion between Picasso, his friends, his surroundings and his work is always at the root of its variety and its success.

There is one more portrait of Dora Maar which should be mentioned because it differs from all others.[15] The stark almost naïve appearance of the sitter against the plain background of a blue wall, as she stares with troubled eyes from the canvas, seems in this case reminiscent of certain portraits of the Douanier Rousseau. She is wearing a green dress with red stripes and in the flesh tints of the face are echoes of these colours. The red glows in her sensitive nostrils and the green and blue shade her cheeks in Cézannesque modulations. In spite of a pronounced asymmetry in the drawing of the nose, which evokes a profile though it is seen full face, there is a relentless realism about the portrait which classifies it as a more austere descendant of the portrait done five years earlier, to whose flowerlike charm I have already referred.

This portrait is dated 9 October 1942. Three months later, in the depths of a bitter wartime winter, Picasso was visiting Dora Maar in her near-by apartment one Sunday afternoon. He had with him a copy of Buffon's *Histoire Naturelle* which, in spite of the war, Fabiani had managed to publish. It contained Picasso's thirty-one illustrations for which the first aquatints had been made five years before. On other occasions Picasso had amused himself by transforming the spots of

[14] Eluard, *A Pablo Picasso*, p. 61.
[15] ibid., p. 156.

paint flicked accidentally from Dora Maar's brush on to the white walls of her studio. He had made of the little stains a population of insects – beetles, moths and flies – which were so realistic that visitors tried to squash them. This time, however, he settled down with ink, pen and brush to decorate the copy of the book he had brought as a present. Turning the pages, he added in the margin the bearded heads of classical heroes, horses, donkeys, cats, rams, bulls, eagles, or doves. When he came to a blank sheet he took the opportunity to fill it at random with a large head of a man or woman or a creature suggested by the text. As a frontispiece he again drew Dora as a bird, her eyes sparkling and her talons grasping a leafy branch (Plate XIX, 7). Then on the page opposite he signed and dated his dedication, written round the name Buffon with his usual delight in puns – 'per Dora Maar tan rébufond!'[16] On several blank pages the drawings were significant of grim preoccupation with external events. On one of these, round a skull crowned with the skeletons of snakes, he drew two shrieking gorgons' heads and on another the skeleton of a bird flapping its wings, its head again being a skull. The drawings were made one after the other with unchecked energy. By the end of the afternoon he had filled the book with forty drawings in which he had gone through moods ranging from macabre fantasies or buffooneries to drawings which prove his acute understanding of the animal kingdom.[17]

Still-life and Figure Paintings

The same sinister background of war and privation makes itself felt in many of the still-lifes of this period. Just as music in the form of guitar-playing and songs had been the theme of many cubist paintings in the days before the First World War, so food in its more humble forms, such as sausages and leeks, together with the skulls of animals and the dim light of candles and shaded lamps recur throughout Picasso's paintings of the Second World War. Even the cutlery, sharp-pointed gleaming knives and hungry forks, repeats the same uneasy theme

[16] 'For Dora Maar so very nice!'
[17] The sheets of this copy of Buffon, edited by Henri Jonquières, have been published in facsimile by Fabiani, Paris, 1957, *40 dessins de Picasso en marge de Buffon.*

(Plate XIX, 6). There are two terrifying paintings of the skull of a bull set on a table in front of a closed window, painted two days apart in April 1942.[18] In the earlier one, raw flesh still hangs to the bone and the horns are silhouetted against the crude, dead light of the glazed window. In the other it is night, the whitened bare bone of the skull grins horribly beneath the semi-circle of the horns set against the darkness outside. The hollow grimace echoes the news of the death of Gonzalez that had reached Picasso the same day. Both are deeply moving in their expression of death, but there is no sense of putrefaction and deliquescence of form, as there is in the *Still-life with Bull's Head* of 1938. The emphasis is rather on the crystalline durability of structures that lie beneath a perishable surface. There is geometric order in death, which appears in these still-lifes and gives them a distinction which is fundamentally Spanish. It is totally unlike the painting of the German expressionists, in which both form and colour are subjected to palpitating feverish decomposition.

As the kitchen table became deserted by palatable foods, there appeared in Picasso's still-lifes that reminder of our own mortality, a human skull, its bared teeth grinning among the clawing roots of vegetables, the black sockets of its eyes looking blankly at the swollen belly of an empty pitcher (Plate XXI, 7). The menace of disaster was continually on the threshold. News frequently arrived that friends, because they had the misfortune to be Jews, had been deported to the supreme horror of concentration camps or that others had been tortured or put to death because of their clandestine activities in the resistance movement. With all the evil uncertainty that goes with military occupation, Picasso, however, kept his buoyant, cynical sense of humour. In paintings such as the *Child with Pigeons* (Plate XIX, 9), *Seated Woman with Cat*,[19] *Woman with Bouquet*,[20] *Woman in a Rocking Chair* (Plate XX, 9), *Little Boy with a Crawfish*[21] *Woman Seated in an Armchair with a Hat Adorned with Three Feathers*,[22] and the mother and

[18] *Skull of Bull on Table*, 5 April, 1942, Janis, *Picasso: The Recent Years*, Plate 101.
[19] ibid., Plate 71.
[20] *Cahiers d'Art*, 1940–44, p. 54.
[21] ibid., p. 22.
[22] ibid., p. 71.

child (Plate XX, 7) in which an anxious mother teaches her son his first steps, there is a mocking and yet compassionate attention to the familiar fundamentals of human life.

Sculpture

Among the diverse resources in his nature Picasso found the means of balancing the angry bitter mood evident in much of his painting with a new outburst of activity in sculpture. The open space afforded by the studios on two floors of the rue des Grands Augustins was highly suitable for this purpose.

Since the period fecund with new inspiration at Boisgeloup, he had contented himself with making small sculptures often inspired by lucky finds among bones and pebbles. On these he had engraved classical profiles or the heads of horned gods and monsters. At Royan he made some small-scale painted bas-reliefs in cardboard on the backs of cigarette boxes which are astonishingly successful as *tours de force* with limited means, but it was not until 1941 that sculpture again became a major activity. The first works of this period show a great variety of methods. There are small female figures in clay; a gigantic plaster head of Dora Maar;[23] and a bird made of a broken piece from a child's scooter placed so aptly on a tall metal stand that the illusion of a tall bird of dignified bearing is a delight.[24] After some contemplation it suddenly becomes apparent that the beak of the bird is nothing more than the fork that once held the front wheel. Again with no visible effort Picasso has made a magical transformation from an insignificant piece of scrap to a creature endowed with the nervous tension of life. In the same way, bent wires or lead caps from wine bottles or old cigarette boxes come to life as dancing forms, a cockerel, a fish or a fluttering dove. Even something as fragile as a piece of soiled paper with holes burnt by a cigarette for eyes gains the strength to claim attention as an evocation of the face of someone (Plate XX, 4).

Of all these discoveries, that which has become the most famous

[23] This portrait bust now cast in bronze was erected as the monument to Apollinaire in the graveyard of St Germain des Prés in Paris (Plate XX, 3).
[24] Kahnweiler-Brassaï, *The Sculptures of Picasso*, Plate 119.

because of its disconcerting simplicity is the object made out of the saddle and handlebars of a derelict bicycle, which when put together by Picasso became a lifelike head of a bull (Plate XX, 6). The metamorphosis is astonishingly complete. Such transformations are a simple game, but for them to become significant it requires a rare perception of the varied and subtle implications in the form in question. Picasso once told me after the war that people frequently brought him stones of curious shapes and interpreted them in various ways, 'but,' he said, 'they often make mistakes – two boys arrived yesterday with a pebble which they said was the head of a dog until I pointed out that it was really a typewriter.'

When seen in this way the identity of objects becomes uncertain and changeable. This possibility prompted Picasso to question the shape of things around him. Borrowing their forms, he found the means of using them in ways such as I have described, or by making an impression of their surfaces on clay or plaster he captured their surface patterns. He used a lemon-squeezer pressed into clay to make a head, round like a sun, for the figure of *The Reaper*;[25] a leaf printed on the body of a cock gave the texture of feathers;[26] the impression of corrugated paper served as a woman's dress.[27] Picasso's ingenuity, combined with his sense of the right time and the right place, worked together to bring to life from the humblest sources a new kind of sculpture, in fact, a new art. Eschewing craftsmanship, he gave life with a magic touch where life, to casual observers, was apparently absent; and with bewildering assurance he succeeded at a time when such a miracle was most precious to all. Those who came to his studio laughed from a profound sense of joy and gratitude that someone could halt the general march towards destruction. When Michel Leiris congratulated him on the complete transformation he had achieved in the *Bull's Head*, he replied with modesty: 'That's not enough. It should be possible to take a bit of wood and find that it's a bird.'[28]

In the summer of 1942 Picasso began to draw a subject which held his

[25] ibid., Plate 173.
[26] ibid., Plate 174.
[27] ibid., Plate 168.
[28] ibid., Preface.

attention for over a year and resulted in the most important work in sculpture that he had yet completed. Zervos has reproduced a choice of fifty of the preliminary drawings from the vast quantity that were produced.[29] In general, the reputation that Picasso gained for rapid spontaneous creation and the speed with which he could pass from one manner to another lead us to forget the continuity of his effort and the thoroughness of his preparation. The theme of the bearded shepherd carrying a frightened restive sheep began with a series of sketches. The two bodies, the one captive and dependent on the other, which stand in firm equilibrium, are studied in general terms, contrasting their volumes and relationship to each other. They are given detailed attention individually, together and from a great variety of angles as Picasso pursued his intention of developing the idea into a life-size statue.

The following summer Picasso asked a Spanish friend to bring him sufficient modelling clay, which at that time was not easy to find, so that he could start on his project. The Spaniard, however, in his zeal to help the master, arrived with a mountain of clay, which was more than sufficient for ten life-size statues. When he had removed the greater part, Picasso set to work one morning, and with energy intensified by the knowledge of his subject, he completed the statue before night (Plate XX, 2). With Paul Eluard, who happened to be there, sitting beside him at a table writing, he began to construct his statue with incredible speed. As he worked it became top-heavy for the fragile armature on which it was being built. It began to topple and had to be steadied with ropes. Later the lamb fell out of the shepherd's arms and had to be wired back in position, but with ingenuity which overcame these minor calamities as they occurred, the figure continued to come to life and at nightfall it was complete. Seeing that the reinforcement was hopelessly weak, soon afterwards he got a friend to make a plaster cast from the clay figure. When the plaster had set Picasso made some modifications and it remained in this condition dominating all else in the studio until after the war, when it was cast in bronze. The startling rapidity with which the *Man with the Sheep* was finally made, after a

[29] *Cahiers d'Art,* Paris, 1945-6.

long period of reflection, is typical of many of Picasso's major works. In this way he never sacrificed his spontaneity.

The *Man with the Sheep* stands alone in the canon of Picasso's work. It is difficult to define its style since there are no obvious influences that can be traced, nor has he profited from the inventions and metamorphoses which abound in other sculptures of the same year. Its appeal is largely due to its humble simplicity. The naked man stands rigid, grasping the sheep firmly by its legs and looking resolutely straight ahead, wheras the sheep with hysterical struggles is an unwilling captive. The theme is ancient and archetypal, and similarly the manner is readily understood by all. It is as though Picasso had wanted for once to speak directly to his human family in familiar terms, and to do so he used the vast wealth of his experience and talent. When at the end of the war visitors of all nationalities crowded into his studio, the tall white figure greeted them as a symbol of Picasso's love of humanity.

Among the other outstanding sculptures that marked his wartime activity there is a skull, or rather a flayed head, which contrasts strongly with the serenity of the great statue (Plate XX, 1). Its appearance is particularly arresting owing to the macabre hollows of the eyes and nose and the absence of any suggestion of bone on the surface. There is a frightful implacable hardness about the smooth surface of this head. Whereas the *Man with the Sheep* attracts the light by the lively irregularities of the surface, beneath which there seems to exist a muscular tension, in the *Skull* the light is reflected from the hard lustre of the bronze as though nothing but death lay below. It was thanks to the devotion of certain friends, who enjoyed secretly diverting the metal from the German war effort, that the skull and several other modelled sculptures were cast in bronze.

Death of Max Jacob

'Picasso paints more and more like God or the Devil,' wrote Paul Eluard in his first letter to me after the liberation of Paris in 1944. 'He has been one of the rare painters who have behaved well and he continues to do so,' he added. He referred to the way in which certain artists had allowed themselves to be seduced by honours or consolations

offered by the Germans, and to how Picasso had always been willing to help the resistance movement by sheltering anyone sent to him by his friends, whether he knew them or not.

Though in general he made no display of his loyalties, Picasso did not hesitate to appear in public at the memorial service for Max Jacob in the spring of 1944. The poet had been arrested, for no other reason than that he was born a Jew, at the Abbey of Saint-Benoît where he had lived as a lay brother for many years. He was sent to a concentration camp at Drancy where he died shortly after. There had been little in common between him and Picasso for many years except their memories, and an enduring respect which was kept alive before the war by visits Picasso paid him in his retreat on the Loire. However the death of a friend, particularly in such atrocious circumstances, always affected Picasso deeply. It robbed him slowly of his links with the past and, as it were, tolled in his ears the hated remembrance of his own mortality.

Landscapes of Paris and a Still-life

As the four years of misery drew to their close, the studio became once more overcrowded with canvases piled high against the walls, and sculpture which had invaded most of the floor space. To add another activity to the richness of his production, he had painted landscapes of Paris. The buildings that he passed daily as he walked along the river where it flows past the Ile de la Cité were his subjects. Notre-Dame seen from the quay, framed by the arch of one of the stone bridges (Plate XX, 5), or the statue of Henri IV among the trees at the end of the island, were his favourite motifs. Still nearer home, he painted the window of his studio looking out across the roofs, sometimes placing in front of it one of the tomato plants grown for its welcome fruit.[30] These familiar scenes were painted with sober feeling for the grey stones and angular patterns of walls and roofs which in his hands gave to the city the facets of a diamond.

A little restaurant a few doors away in the rue des Grands Augustins, named 'Le Catalan' in honour of its distinguished neighbour, was the

[30] See *Cahiers d'Art*, 1940-44, p. 60.

daily *rendez-vous* of painters, poets and friends. For some Picasso showed his interest in their work by making drawings to accompany their poems. For Georges Hugnet, who came there frequently for his meals, Picasso made drawings for three books published between 1941 and 1943; and for Robert Desnos, who was killed by the Germans shortly afterwards, he made a remarkable etching as a frontispiece to *Contrée*, a collection of Desnos's poems. The seated nude that it represents, seen from both front and back, is built up in line by a pattern of arabesques which give her monumental volume.[31] Throughout the book, sections of the plate are used again as tail-pieces for each poem. Even so, the disconnected fragments are so strong and rhythmical in their detail that, cut up, they reappear with new significance.

Robert Desnos, formerly a Surrealist, had written brilliantly about Picasso more than ten years before. In his last essay before he died he recounts a story Picasso told him: 'I had lunched at the Catalan for months,' Picasso said, 'and for months I looked at the sideboard without thinking more than "it's a sideboard". One day I decide to make a picture of it. I do so. The next day, when I arrived, the sideboard had gone, its place was empty.... I must have taken it away without noticing by painting it.' 'An amusing story, of course,' Desnos remarks, 'in spite of or rather because of its veracity; but it illustrates like a fable or a proverb the relationship between the work and the reality. For Picasso what matters, when he paints, is "to take possession" and not provisionally like a thief or a buyer, just for a lifetime, but as himself the creator of the object or of the being.'[32]

Liberation

On the morning of 24 August 1944 the whole of Paris was roused by the noise of sniping from the roofs and gunfire from the retreating German tanks. A fever of excitement ran through the city as Parisians realized that their day of liberation had at last come, and as they took a hand to

[31] Robert Desnos, *Contrée*, Godet, Paris, 1944.
[32] *Picasso peintures*, 1936-46, Editions du Chêne, Paris, 1949; also see *Cahiers d'Art*, 1940-44, p. 61.

hasten it. Divided from the Prefecture only by the Seine and a few roof-tops, Picasso found himself in the centre of a battle. Friends crept in and out telling him of its progress while explosions and gunfire shook the windows of his studio. In this tense atmosphere Picasso chose to forget the immediate danger by submerging himself in his work. He returned to methods he had used at the end of the 1914–18 war. Taking photos or reproductions as his models, he could draw from them with less strain and yet continue to work. First he made a careful interpretation of a photo of Maïa,[33] whom he had installed with her mother some while before in an apartment overlooking the Seine at the far end of the Ile St Louis. Later, as the noise and the anxiety increased, he took a reproduction of a painting by Poussin and began to make from it in gouache a version of his own (Plate XXI, 1). While he worked he sang at the top of his voice to drown the din in the streets. The picture he chose was a scene of wild bacchanalian revelry, *The Triumph of Pan*, which hangs in the Louvre. Its spirit of ritualistic abandon in an Arcadian setting was in keeping with his optimistic mood. Retaining the essentials of the composition and the movement of the ring of dancers, he reinterpreted the figures with freedom and gave the colour a gaiety which makes Poussin's revellers look demure. Once more he was working with a brother from the past, one of his familiars from the *Chef d'œuvre inconnu*, for the poets and painters with whom Picasso shared a timeless intimacy are situated in the past as well as the present, united with him in a brotherhood of genius.

Hardly had the rattle of automatic weapons ceased when friends serving with the Allied armies began to arrive. The news that had reached the outside world about Picasso had been scarce and unreliable. Even those who knew him only as a name were anxious to find out what had happened to him. It was a race to see who could find him first. A few who had the advantage of having known him before the war hurried through streets littered with smoking tanks and hilarious crowds who sang and wept for joy, to the rue des Grands Augustins in the hope of finding him still there. The first to climb the narrow winding staircase and reach the door of the studio was Lee Miller, who was at that time

[33] See Barr, *Picasso: Fifty Years of His Art*, p. 242.

war correspondent for *Vogue*. With tears in his eyes he welcomed her, astonished to see that the first Allied 'soldier' he should meet was a woman. Every day more friends crowded in and news was eagerly exchanged about those who were absent or dead. Picasso's survival through the perils of war became a symbol of victory; applied to him the word 'liberation' was synonymous with his work and his life.

The excitement was so great at finding what seemed to be a miracle - Picasso not only alive but unimpaired in his vigour - that the number of the visitors who pressed around him became almost overwhelming. Every day old friends reappeared to express to him their admiration and affection. Every morning the long narrow room leading to the studio on the lower floor became an antechamber filled with dozens of new arrivals crowding together and waiting for him to appear. They were invited in groups into the sculpture studio on the same floor, and when he felt inclined they were taken up to the floor above, which he used for painting.

This unsolicited homage Picasso was forced daily to receive. He was besieged by enthusiasts in a variety of uniforms and often unable to make themselves understood in either French or Spanish. Standing firmly with a cigarette perpetually smoking, small but radiating vitality from his black eyes, his voice, his gestures and his inquiring smile, he left a deep impression on the thousands who visited him during the first months of liberation. Even when they were insensitive to or shocked by the paintings, the sculpture and the atmosphere of an alchemist's den, they were never disappointed in him.

In the first months of liberation the novelty of finding he had so many admirers, after the solitude of four years of musing, fascinated him. He even allowed himself to be invaded by organized parties of forty to fifty service men and women who bombarded him with questions, and shot thousands of views of him and his studio with their cameras. But even so he managed to arrange his life so that he could think his own thoughts and see his own friends. The rejoicings, and the abundant presents of food and other necessities of life that had become rare, were offset by long conversations about more lasting problems. After all, the liberation of France had not brought about the liberation of his own country. His friends in Spain were still the prisoners of Franco. It

would take more than the spectacular victories of the Allies to make him forget that injustice and stupidity were still rampant.

Picasso: the Communist

The majority of those who had shared with Picasso the years of anxiety and suspicion and who had shown the greatest courage in the resistance movement were members of the French Communist Party. The party had grown greatly in strength. Its members had earned admiration for their courageous devotion to the cause, even among their former political enemies in France. Among the new adherents who had joined, believing that communism was the only path which could lead the world away from catastrophes such as they had witnessed, and found a new society based on human dignity and the rights of man, was Paul Eluard. He had taken this step in 1942, at a time when it needed special courage to do so, since with Hitler's attack on the USSR communism was an unforgivable crime to the Nazis. His motives were idealist and humanitarian; he acted not as a politician but as a poet, a philosopher, and one who was willing to fight to the death for the liberation of his country. To this end, he accepted a party discipline which formerly his love of the rights of an individual would not have allowed him to tolerate.

The prestige of the French Communist Party was very high. Many intellectuals and artists of distinction had joined its ranks. Soviet Russia herself was a gallant and victorious ally. As an act of faith, and with the fervent hope of creating a better world, Eluard had become a member, and burying his former animosity he even became reconciled to the poet Louis Aragon, who also had been occupied in dangerous underground activities.

'I have great news for you,' Eluard whispered in my ear when I was visiting Picasso in his studio a month after liberation: 'in a week it will be announced publicly that Picasso has joined the Communist Party.' Indeed when this became known it aroused speculation on all sides as to what would be the consequences. The question of greatest importance was whether Picasso would retain his right to paint as he wished or whether he would find himself obliged to change his style and adopt a

form of 'social realism' palatable to Soviet doctrines. In addition a strange confusion between art and political creeds had become apparent. The diehards of academic art, who were almost without exception the enemies of communism, had for many years realized that the modern movement was revolutionary and in consequence they ignorantly labelled it 'bolshevik'. Soviet ideology had in this matter seen eye to eye with Hitler in condemning the modern movement and with it Picasso as its greatest leader. Who would now win? Would the Communist Party accept the unpalatable style because of Picasso, or would he be compelled to denounce his former discoveries?

If the scene had been laid in Russia the outcome might have been very different. In France, however, the situation was influenced by the great traditions of French art and culture. It was not the politicians but the intellectuals, proud of the liberties they had won by their own revolution in the past and had regained by their recent courage, who now tempted Picasso to join. It was the politicians, however, who had convinced the party leaders that the prestige gained by his acceptance would be immense.

Untroubled by the dangers that others saw for the future of his art, Picasso willingly accepted the invitation. The offer coincided with many of his deepest humanitarian hopes. He was taking the same step as many of his closest friends, and it was a further gesture of defiance against his old enemies, Franco and Hitler. So far as his painting was concerned he was not surprised that Soviet doctrine did not approve. 'From past experience I would have been suspicious,' he said, 'if I had found they did appreciate my work.' Wishing to make his motives clear to the world at large he made a statement to Pol Gaillard which was published in New York and Paris almost simultaneously[34] late in October 1944.

With simplicity he said many things which help to explain not only his feelings towards humanity and his art, but also his loneliness as a person and the unity between his work and his life.

[34] Pol Gaillard's interview was published in a condensed form in *New Masses* (New York) on 24 October 1944 and, appeared in the original in *L'Humanité* (Paris), 29–30 October 1944. This version is printed in Barr, *Picasso: Fifty Years of His Art*, p. 267.

My adhesion to the Communist Party is the logical outcome of my whole life. For I am glad to say that I have never considered painting simply as pleasure-giving art, a distraction; I have wanted, by drawing and by colour since those were my weapons, to penetrate always further forward into the consciousness of the world and of men, so that this understanding may liberate us further each day.... These years of terrible oppression have proved to me that I should struggle not only for my art but with my whole being.

He then speaks of his friends who had long known of his convictions and with whom he was happy to prove his allegiance to the same cause, adding, 'I was so anxious to find a homeland again. I have always been an exile, now I am one no longer; until Spain can at last welcome me back, the French Communist Party has opened its arms to me, I have found there all those whom I esteem the most, the greatest scientists, the greatest poets and all those faces, so beautiful, of the Parisians in arms which I saw during those days in August, I am once more among my brothers.'

There is no doubt from the emotional tone of these words that Picasso's action came from a profound desire within himself to enter into a pact of friendship with those around him. His art had led him often into isolation; the rare atmosphere of the heights, to which his genius had climbed, could not readily be shared by more than a few. Others if they were to understand needed time to become accustomed to the significance of his discoveries. His hopes of establishing a family had grown dim, but here he could enter into a new comradeship, sharing the same idealism as his friends and those who worked and fought in the streets. He had in his own words found his family.

Exhibitions

Six weeks after the liberation of Paris the Salon d'Automne opened its doors. Instead of following its usual routine, which had been despised by Picasso in the past so that he had always refused to participate, it became a great manifestation of French art after four years of German domination. Traditionally a well-known French painter was invited to exhibit in a gallery allotted exclusively to him. On this occasion, however, as an unprecedented tribute to a foreigner, Pablo Picasso was honoured, and for the first time in an official *salon*. Seventy-five of his

paintings and five of his sculptures were shown, most of them being those he had been compelled by the animosity of the Nazis and the partisans of Vichy to paint behind closed doors.

The effect of this tribute to Picasso on a public whom the Germans had attempted to train to admire only Hitler's choice in art was electric. It aroused violent protests from those who considered that the honour should have gone at such a historic moment to a French painter, and from those who disapproved not only of his art but also of his new allegiance to the communists. On 8 October, two days after the opening of the exhibition, a party of hotheads shouting: 'Take them down! Money back! Explain!' besieged the gallery and threatened to destroy Picasso's work. It was not clear, however, whether they were more influenced by the political issue or by their hatred of Picasso as an artist. André Lhote, who was present, described it as a royalist manoeuvre, but it is also possible that the demonstrators were students from the Ecole des Beaux-Arts, who, like their masters, had a thorough dislike for Picasso's work. There were, however, plenty to stand by Picasso and praise his work with even greater enthusiasm in face of the attack.

The following spring there was a similar exhibition of paintings at the Victoria and Albert Museum in London. The recent work of Picasso was shown with a retrospective exhibition of Matisse. With the exception of the great painting of the *Night Fishing at Antibes,* which, together with several other important pictures, had been hidden throughout the occupation in Zervos's apartment in Paris, all Picasso's work dated from the spring of 1940. This gave an atmosphere of violence and anxiety to his part of the exhibition which was overpowering in comparison with the '*luxe, calme et volupté*' of the Matisse paintings.

The London public was greatly disturbed by this exhibition. Daily it was crowded by people who found themselves divided into those who were passionately appreciative and those who felt themselves insulted at being exposed to such powerful and unaesthetic expression. Many still in uniform who had so recently been trained to commit acts of violence saw an interpretation of the world that startled them. They had expected from the arts a soothing influence and were unwilling to admit that these pictures should be allowed to have such power over them.

Whether they liked what they saw or not, Picasso was teaching them to see.

The Charnel House

In the summer of 1945 Picasso began another great painting reminiscent of *Guernica* – *The Charnel House* (Plate XXI, 6). The picture was exhibited at the Salon d'Automne in the following autumn, after the war had at last come to an end. It had been painted at the time when the appalling horror of Nazi concentration camps had been revealed to the world. It was unfortunate that it was unfinished at the time of the London exhibition, for it would have helped the public to understand more clearly that Picasso's distortions were the outcome of his state of mind and not of a frivolous desire to shock the public.

Unlike *Guernica*, it is not a symbolic picture, prophetic of coming events, but rather an epilogue to the catastrophes that had lately occurred. A heap of mangled, trussed and putrefying humanity has collapsed beneath a table on which are placed empty vessels for food and water. Their plight, unrelieved by the few symbols of hope that still remain hidden in the explosive violence of *Guernica*, makes this picture the most despairing in all Picasso's work. Again he avoided the aesthetic distraction that colour might have brought, and restricted the whole painting between the limits of white and black.

Painted in the hour of victory, the picture shows us nothing but the stark reality of our murderous, suicidal age. 'This picture', says Barr, 'is a *pietà* without grief, an entombment without mourners, a requiem without pomp', and quoting Picasso he continues: ' "No, painting is not done to decorate apartments. It is an instrument of war . . ." against "brutality and darkness". Twice in the past decade Picasso has magnificently fulfilled his own words.'[35]

A dialectic process made itself felt; Picasso had been led by his daemon through dark channels, not easily understood even now, in which his art could give expression so completely and comprehensively to a current disaster.

[35] Barr, *Picasso: Fifty Years of His Art*, p. 250.

12

Antibes and Vallauris
(1945-54)

Return to the Mediterranean

It was not for many months that the exaltation of liberation began to fade, and a stocktaking of losses as well as gains could be made in a more sober light. The ravages of the war and Nazi terror had been appalling in the sufferings they had caused. So many victims had disappeared unaccountably that it was an intense pleasure, a triumph, to welcome the unexpected reappearance of an old friend. Among those who had survived, many found their health weakened by anxiety and privations. In the last months before liberation Dora Maar herself suffered acutely, and Nusch Eluard, whose health had always been precarious, died suddenly of exhaustion in the autumn of 1946. Victory and the future were stained with the blood that had flowed.

In August 1945 Picasso at last managed to escape for a while from Paris. He returned to the Mediterranean for the first time since the flight from Antibes six years before. At Golfe Juan he found a small hotel overlooking the port that suited his habits, and once more he was able to enjoy the sun and the beaches. From here he made an expedition inland to visit an ancient house which had taken his fancy in the Provençal village of Menerbes. A friend in Paris had recently shown him a photograph of this house, built into the ramparts of the little town. It stood perched up above terraces of vines and olive trees looking out across the valley of the Durance. This had been sufficient to persuade Picasso to barter one of his recent still-lifes for the property and as soon as the deeds were signed he handed them to Dora Maar as a present.

For the purpose of seeing the new acquisition they set off together

accompanied by Madame Cuttoli, the collector and patron of the arts, who was staying at her villa at Cap d'Antibes. To their satisfaction they found that it was all they had hoped for, and Dora Maar was happy to find in this remote place a landscape which was to offer inspiration to her painting and a future retreat.

A New Medium and a New Model

Since making the invitation card for his exhibition with Paul Rosenberg in 1919, Picasso had made no more lithographs. The scope offered by etching and aquatints had been sufficient for his graphic art. In the autumn of 1945, however, he found a printer in Paris, Fernand Mourlot, whose efficiency in his craft and amiability tempted Picasso to start again on a technique which since became one of his favourite means of expression. Among his first lithographs appeared the portrait of a girl in full face. The regular olive-shaped outline of the head, and the straight nose, have classical proportions, and the well-formed mouth set in the cup of a firm but graceful chin is the clue to an independent character (Plate XXII, 5).[1] The model was Françoise Gilot, whom he had met through other painters in Paris. Her youth and vivacity, the chestnut colour of her luminous eyes, and her intelligent and authoritative approach, gave her a presence which was both Arcadian and very much of this earth. Another quality which attracted Picasso was her interest in painting, for which she already showed considerable talent. The following spring, when he left Paris for a prolonged stay on the Mediterranean coast, he took Françoise Gilot with him.

The disorganization caused by the war made it difficult to find a suitable place for him to work. The little hotel on the harbour at Golfe Juan, to which he returned, was far too cramped to paint as he wanted. A chance conversation on his return led however to an offer which solved this problem for the moment at least and provided him with as much space as he could desire. The conversation was with Monsieur de la Souchère, the director of the Antibes Museum, which is housed in the ancient palace of the Grimaldi, an old Genoese family. It is a

[1] See also Mourlot, *Picasso lithographe*, Vol. I, pp. 110-20.

splendid medieval building whose towers crown the small fortified town and harbour. Before the war it had contained a dusty collection of plaster casts and objects relating to local history. In his desire for improvements the director hoped originally to obtain from Picasso a painting such as the *Fishermen of Antibes* which could hang appropriately on its walls. Picasso agreed vaguely that he would do something, and then began to complain that he had never been offered large surfaces to work on. At once, seeing his chance, Monsieur de la Souchère made a generous offer, which, as it turned out later, was to be highly profitable to his museum. Picasso was given the keys of the old palace and was asked to use it as his studio.

No time was wasted in ordering large sheets of hardboard, since canvas was still unobtainable, and in laying in stocks of whatever paint could be found. For the next four months the ancient fortress became his headquarters. With its high ceilings, pink tiled floors, and the sunlight reflected from the sea piercing the closed shutters, it provided an atmosphere which inspired him. Stones with bold Roman lettering and dusty casts of Michelangelo's slaves were his companions as he started work on the new panels, painting pictures which contained, more than those of any other period in his life, an atmosphere of Arcadian *joie de vivre*. The medieval splendour, the elegance of the Renaissance and the glory of Napoleon which lurked in the surroundings did not influence him. His attachment to his native Mediterranean was rooted deeper in antiquity. He found echoes of ancient Greece around him in the landscape and the people. The mythical population of nymphs, fauns and centaurs lived again among his friends, and the fishermen and other local inhabitants he met in the harbour, the market and the cafés. They were again the daemons and the demi-gods. The centaurs now walked on two legs instead of four and the nymphs and satyrs were decently dressed, but they were the same population who had lived among the same pine trees, rocks and dwelling-places when the same winds filled the sails of the Argo.[2]

The new pictures and their accompanying drawings reflect the classical Mediterranean tradition with a new vision, both childlike and

[2] *Cahiers d'Art*, 1948, No. I, and *Verve*, Paris, 1948, Vol. 5, Nos. 19 and 20.

complex. The colours are tender; blues, pinks, ochres and greens dominate, and their dancing, flute-playing mood gives the great panels an echo of a golden age. One of the largest paintings, *Ulysses and the Sirens* (Plate XXII, 1), in soft colouring, is like an allegory in which the sun bathes in the sea among those to whom it gives life – fish, men and sea maidens.

Few visitors came to disturb Picasso in this new-found happiness in which the presence of Françoise Gilot was a factor of great importance. Earlier in the year he had made a series of lithographs, large in size and splendid in the precision of their line. They all showed the lovely oval of her face and her gleaming eyes; all were extraordinarily true portraits and yet no two were alike. In the eleven portraits made on 14 and 15 June 1946 (ten in one day, and the eleventh on the next) he had many different versions of her; he saw her as woman or flower or the sun with her face as the source of light.

In the first half of 1947 Picasso continued his spate of lithographs, completing over fifty in eight months. His subjects were still Arcadian, fauns and centaurs, naked dancers, bulls, goats and the recurring theme of the two lovers, the one seated in contemplation while the other lies asleep. A new or rather very old appearance is that of the owl.[3] This bird is to be found at the feet of the *picador (El Zurdo)*[4] – Picasso's first etching – but for years it had been absent from his work. During his stay in Antibes an owl had been brought to him slightly injured, and keeping it beside him he began once more to be fascinated by its strange aloof behaviour and to introduce it into his paintings, his lithographs and later his ceramics (Plate XXII, 4). When, ten years after this, he had another small owl in a cage in his studio in Cannes, he told how once, while he was painting at night, a large bird of the same race flew in at the window and after battering itself against the glass, perched on top of the canvas on which he was at work. It had come, he thought, to prey on his pigeons that flew at liberty from the terrace outside the window during the day. Owls and doves, two birds of such different nature, were his lifelong companions. They both had a significance for him

[3] Mourlot, *Picasso lithographe.*
[4] See Geiser, *Picasso: Fifty-five Years of His Graphic Work*, Plate I.

which bordered on superstition. The owl with its rounded head and piercing stare seems to resemble Picasso himself. As a joke once he took an enlargement of a photo of his eyes and placed over it a white sheet of paper on which he drew the face of an owl, cutting out holes to fit his eyes like a mask. Nothing unnatural seemed to have taken place except that the bird now possessed the vision of a man whose eyes could not only see but also understand.

Picasso and the Museums

While Picasso was in Paris in 1947, he was approached by a friend, Jean Cassou, who had recently been made the director of the new Musée d'Art Moderne. He was anxious to fill serious gaps in its collection owing to the lack of works by the greatest living painters. As Cassou realized, an absurd situation had grown up in France. In early days the rebels, Picasso, Matisse, Braque, Léger, and others had been banned from all official collections by their enemies in the academic world. But for this, in those days when they were relatively little known, their paintings could have been bought even with the limited funds at the disposal of the museums; now that fame had raised the prices, the museums found that neither did they possess any important works nor had they the money to purchase them. In his determination to build up an important collection, Cassou had visited the artists whose work he needed and bought to the limit of his funds, still keeping enough in hand for essential purchases from Picasso. When it came to his turn to be asked, Picasso welcomed the idea, but with the astuteness in such matters which came to his aid at the appropriate moment, he offered ten paintings as a gift rather than allow them to be bought and find later that he owed the purchaser, in this case the French Government, taxes rivalling the price he would have received. The cubist paintings had already passed into private hands, but Picasso was able to save the French museums from their embarrassment by presenting them with important works of more recent years.

In Antibes for other reasons something similar happened. The Palais Grimaldi had become the Musée Picasso. When he found other places to work, he decided to leave on permanent loan the entire production of

the idyllic months spent there, and later he added a collection of his ceramics, drawings and lithographs which transform the museum into one of the most enchanting places to visit anywhere in France. In a fresh and luminous atmosphere the walls display delight, humour, play-fulness and a timeless image of human love and human life.

Since the war, other provincial towns have also made efforts to gather together Picasso exhibits. The little town of Céret, where the memory of cubist days was kept alive by the former museum curator Pierre Brune, has a room devoted to ceramics and drawings, and the new curator is Picasso's old friend, Havilland. In addition to permanent collections, exhibitions have been arranged in provincial galleries, notably in Lyon in 1953 and in Arles in 1957.

Outside France, in countries where the purchase of works of art for museums is on a more lavish scale, competition has greatly increased in recent years. Paintings of the cubist period are very much in demand, so much that the rise in their value over the last fifteen years is the envy of all speculators. Some pictures of this period are now worth more than one hundred times their value twenty-five years ago, which was then about ten times the price that Picasso would have been paid for them when they were painted. The United States has acquired the largest quantity. No important art gallery and no collection of modern art throughout the world considers itself complete without an example of Picasso's work.

Ceramics at Vallauris

In a valley surrounded by pine forests there lay, among vineyards, olive groves and terraces, where lavender, jasmine and other sweet-scented plants were cultivated, the small town of Vallauris. From its pink tiled roofs smoke had risen for a thousand years. It belched intermittently in great black clouds as the potters lit pine faggots to fire their kilns (Plate XXII, 8). The town itself had no particular charm and there was no view out to sea to attract the tourist. Its main industries were the manufacture of scent and ceramics, but although the perfume was still sweet, the ancient traditional style of the ceramists had become so debased and the demand for their produce so reduced that at the end of

the war Vallauris was far from prosperous.

Remembering his visit with Eluard to the old potter before the war, Picasso again took the three-mile trip up the hillside behind Golfe Juan where he was then staying, and made friends this time with the ceramist Georges Ramié and his wife, whose enterprise 'Madoura' defied the general decadence around it. On his first visit he took some clay in his hands and amused himself by modelling a few small figures. It was not however until a year later, in the summer of 1947, that he returned, and was delighted to find that his work had been fired and carefully preserved. From that moment Picasso began to interest himself seriously in ceramics, and round him grew up a new activity in which a host of young artists followed his lead. Within ten years prosperity came back to the little Provençal town, thanks to the presence and example of Picasso; for ten years he lived in a small villa on a hill near the town and made Vallauris the centre of his activities.

The idea of conquering new territory, or rather of finding a new medium of expression, once more enthralled Picasso. In this case the art of the ceramist offered scope for various urges that he had always had in mind. Traditionally it combined the arts of painting and sculpture and in addition it had a basis of utility. Picasso's love of the esoteric, which found its culmination in analytical Cubism, was balanced by a desire for his art to enter into life in the most humble sense as well as the highest. Pots, jugs, compotiers and plates, formerly the subject matter of his still-life paintings, were now to be made by him not as rare treasures but as things which could be of daily use or serve as familiar objects in the house. The collaboration of Georges Ramié and his expert potters opened a wide field of possibilities. Picasso's original designs could be copied faithfully by them and sold like etchings, although they could never have the exactness of prints since they were copies each made by hand. The project for reaching a wider public made Picasso enthusiastic. It gave employment to the local craftsmen and greatly increased the numbers of those who could enjoy his work. However, as time passed, the utilitarian aspect of ceramics was submerged by delight in the medium as a form of art which combines the elements of polychrome sculpture, painting and collage. In the exuberant vitality of his later works, there was little or no attention given to the possibility of

their practical use in the household.

He astonished, even terrified those around him by his bold treatment of the material. Madame Ramié warned him day after day that in the firing such unreasonable experiments were bound to fail, but as she had to admit, he proved almost every time that he could do things that were impossible to others. Taking a vase which had just been thrown by Aga, their chief potter, Picasso began to mould it in his fingers. He first pinched the neck so that the body of the vase was resistant to his touch like a balloon, then with a few dexterous twists and squeezes he transformed the utilitarian object into a dove, light, fragile and breathing life. 'You see,' he would say, 'to make a dove you must first wring its neck' (Plate XXIII, 7). It was a delicate process; if the squeeze went wrong there was no remedy but to roll it all up and start again, but Picasso's touch was so sure that such a thing scarcely ever happened. Squeezing firmly but gently with his thumbs he could convert a vase more than a yard high into the most graceful female form with only a few touches. With extraordinary speed he learnt to judge what it was possible for him to do in using clay, glazes and fire. Always he listened to the advice of experienced craftsmen and then always acted in his own way.[5]

Rapidly there appeared on the shelves of the Madoura storerooms rows of pitchers in the form of doves, bulls, owls, birds of prey, heads of fauns and men with horns or beards, their surfaces decorated with an incredible variety of patterns; some fierce and barbarous in their rhythms, some orderly and classical. Other shelves were spread with casseroles whose traditional Provençal form had been untouched but on which Picasso had painted animals, bullfights or Arcadian scenes. From the bottoms of others stared grotesque faces, which often made children shriek with delight as he did a dance for them, holding one of these casseroles as a mask in front of his face.

In Vallauris Picasso had found a new playground where anything could be seduced by him into becoming a delightful toy. The long solitary concentration necessary for painting could be relaxed among his family of craftsmen who were his friends. Every morning he would

[5] *Cahiers d'Art*, 1948, No. I, and *Verve*, 'Picasso à Vallauris', 1951.

appear dressed in shorts, sandals and singlet. His small, muscular, well-shaped body tanned by the sun and his alert carriage showed little sign of his age. Only his hair now thinning and becoming white, so that his eyes seemed even blacker than before, and the deep furrows in his face which emphasized his expression, gave indications that he was approaching his seventieth year. Otherwise, at work or bathing, he expressed in every movement the agility and strength of youth. To see his hands as he moulded the clay, small and feminine yet strong, gave a pleasure akin to watching a ballet, so complete was the coordination in their unhesitating movements. It seemed impossible for the clay not to obey: in such hands its future form was certain to become impregnated with life.

Among all Picasso's inventions, those into which he instilled a maximum of life and emotion were inspired by the female form, and since in pottery the ovoid form of pitchers and jugs prevails, he readily found materials which lent itself by modelling or decoration to a great variety of representations of women. As scale never presented any difficulty to Picasso he was equally happy to transform small pots only a few inches tall with a few rapid squeezes into little goddesses, or to mould great vases a metre high into a female form. The handle and spout changed into the braided hair of a girl. A simple egg-shaped bulge became her head, poised on a long thin neck springing from a base in the shape of breasts. The unity between the form of the vase, the painted lines that portray the features and the idea that lies therein is of startling perfection – the hidden internal void being an essential contribution to its form.

Vallauris suited Picasso admirably in that it offered wide facilities and an atmosphere in which he could indulge his wish to experiment with everything that came into his hands. Picking up tiles he turned them into owls; the supports used by potters to stack the biscuit pots in their kilns became limbs, trumpets or bones. The amusement of giving life to banal objects never failed because it was so often the origin of new discoveries which led to new achievements. The origin of his inspiration is in fact in play, and his never-ending game with objects and ideas is an essential part of the process of creation.

Picasso and the Cause of Peace

In his retreat in Vallauris Picasso was not isolated. He received visits from Paul Eluard and kept closely in touch with the activities of the Communist Party, particularly in its efforts to organize international opinion against war. In spite of controversy that sprang up as to the value of their endeavour and the sincerity of their aims, a large number of intellectuals in all countries joined forces, and Picasso was asked to support them. He had already made his position clear in the press at the end of the war. Meetings of intellectuals for Spanish relief and for peace had taken place in his studio in Paris. He was now asked however to appear in public and throw in the weight of his reputation in favour of the communist-sponsored Peace congresses, the first of which was held in Wroclaw in August 1948.

It is a proof of Picasso's sincerity that, with his distaste for travel, he should have left Vallauris in the height of summer for Paris and embarked from there with Paul Eluard on a flight to Poland. Public demonstrations of this nature were completely foreign to him, and in addition, he was expected not only to make his appearance as a distinguished delegate but also to deliver a speech. His arrival was acclaimed with great enthusiasm, and before he left Poland, where he remained for a fortnight visiting Warsaw and Cracow, he was decorated by the President of the Republic with the 'Cross of a Commander with Star of the Order of the Polish Renaissance'. This was not the first of such honours. The day before he left France he had received the 'Médaille de la Reconnaissance Française' for services rendered to France, a sign that there was no disapproval of his action in support of the congress on the part of the French Government.

The following year a similar congress was organized in Paris in April. Picasso was asked to design a poster for the event, and choosing a subject familiar to him, a white pigeon such as he kept in a cage at the entrance to his studio in the rue des Grands Augustins, he made a lithograph which has since become famous for more than one reason. Not only was it used to advertise the congress at the Salle Pleyel which was attended by Picasso and his friends, but afterwards it was reprinted and appeared on the walls of many cities throughout Europe, acclaimed by some as a time-honoured symbol of peace and sneered at by others as an

inept form of communist propaganda. Later in the same year the Phila-
delphia Museum of Art, leaving politics aside, awarded his lithograph
the Pennell Memorial Medal.[6] In more recent years, Picasso's doves of
peace literally flew all round the world. Versions of several of his
drawings have been reproduced on postage stamps in China and other
communist countries.

In November 1950 the third congress which Picasso attended as a
delegate was held at Sheffield. Although the former assemblies had
incurred nothing worse than hostile criticism, in this case the British
Government decided, since war had recently begun in Korea, that it
was a dangerous form of propaganda and that it must be kept in check
by refusing entry to a large number of delegates from abroad. As there
were many distinguished intellectuals among the party arriving from
the Continent, including Professor Joliot-Curie, the president of the
congress, the discourtesy of this decision and of the manner in which it
was carried out was remarked on in Parliament, by no less an anti-
communist than Winston Churchill.

It so happened that at the same time an exhibition of recent paintings
and ceramics by Picasso, organized by the Arts Council, was being held
in London, and either for this or for some other reason never yet
divulged, Picasso was allowed into the country. Having been warned
that he was on his way, but not yet knowing what had happened to his
companions, I hurried to Victoria Station to meet him. The night-ferry
was unaccountably late and to my surprise, when I finally caught sight
of the small figure of Picasso dressed in a grey suit and a black beret and
carrying his suitcase, he was alone. As soon as we met he explained that
his friends, almost without exception, had been turned back from
Dover as dangerous revolutionaries, 'and I,' he said with anxiety, 'what
can I have done that they should allow me through?'

Picasso's stay in England was brief. Plans for the congress had been
thrown into confusion and the press was anxious to ridicule any victim
connected with the affair as a deluded pawn of communist propaganda.
To dodge the reporters I invited Picasso to come with me for the night
to the country, a plan which suited him because, thinking that he would

[6] Mourlot, *Picasso lithographe*, Vols. I and II.

be with his friends, he had sent his car over with Marcel, the chauffeur, by way of Newhaven which is near my home. The following day we returned to London and Picasso left next morning by train for Sheffield, where the emasculated congress was to be held in spite of its unfortunate start. The City Hall was filled to overflowing and among the speakers Picasso received by far the greatest ovation, although his speech was the shortest. Speaking in French for not much more than a minute, with a delivery which showed his lack of experience in elocution, he characteristically made no reference to politics. Instead he explained how he had learned to paint doves from his father and from that beginning had taken his place in 'the family of painters'. He finished with the single declaration: 'I stand for life against death: I stand for peace against war.' His personality made him popular and his presence as the only delegate carried weight.

On his return to London he was met by a large party of art students who welcomed him with wholehearted enthusiasm, but this was not enough to soften his annoyance at the action of the Government and he refused to accept an invitation that afternoon to visit his exhibition, which was crowded with hundreds of expectant admirers. In this case politics strengthened his habitual desire to keep away from such manifestations. It might have been thought that once the congress was over, or rather transferred to Warsaw, Picasso would be allowed to disappear from England without further comment. This would probably have been the case had not a section of the press considered that this was the moment not only to ridicule him but also to attack those who wished to honour the visit to London of a great artist. Comments were made on the presence of a cabinet minister at a studio party given to welcome him. 'It is an odd thing that a British Minister should wish to honour Picasso,' the paper announced, and added, 'it is now becoming well known that out of the money he receives for his works, the wealthy Picasso makes large contributions to the communists.'[7]

There was nothing however that could upset Picasso in attacks and distortions in the press. He was used to such things. They were not limited to one section of the press nor to England. During his visit he

[7] *Evening Standard,* Wednesday 15 November 1950.

had been greeted by hundreds of his admirers and although he was not at his ease in the crowds around him whose language he could not understand, the novelty of finding himself isolated from his own circle of friends and the excitement of being back in England, the country which had inspired his earliest dreams of adventure, was sufficient to please him. He was astonished and awed by the scars of the blitz in London, and he enjoyed the English countryside as he saw it in the cold autumn sunlight, saying, 'I am surprised young English painters do not paint more of it.'

The rebuff to the congress that Picasso had witnessed in London did not, however, deter him from attending a fourth congress held in Rome in 1951. He spent four days performing his duties, and found time to visit the Sistine Chapel, about which he later remarked to Kahnweiler that it was like a vast sketch by Daumier. On his way home he stopped to admire the Piero della Francescas at Arezzo and enjoyed, but without much enthusiasm, the Giottos at Assisi. This, however, was his last journey as a delegate. These episodes in a life which was so little occupied with group activities were remarkable proof of Picasso's disinterested loyalty to a cause in which he believed.

Family Life

The ungracious little pink villa, 'La Galloise', perched on the terraced hillside near Vallauris, had been chosen by Picasso, for lack of something better, as his home. Two mulberry trees too small to screen the childish geometry of its gable front shaded a small terrace, and its bleak rooms provided enough space for Françoise and their newly-born son, Claude. At the bottom of the garden was a garage where the new Chrysler given to Picasso by an American friend could be kept side by side with the old pre-war Hispano – the only car of which he ever was really proud. After some adventurous years, Paulo had settled at Golfe Juan, and with his passion for cars, he turned out to be an excellent chauffeur for his father at a time when there was an urgent need for someone to replace Marcel.

Two years after the birth of Claude, a daughter was born in 1949. In accordance with her father's passion for doves she was appropriately

named Paloma. Yan, a boxer puppy, joined the family and took his place in paintings of the children at play with their mother. With the advent of the new dog, the first to replace Kasbec, the elongated features of the Afghan hound appeared no more in Picasso's paintings. The shape of the children's faces in the new pictures reflected rather the round snub-nosed head of Yan (Plate XXII, 3).

Picasso became very much absorbed in his new family. There are many drawings and paintings in which the children can be seen intent on their toys and games, clothed in gay colours, fearless, ruthless and overflowing with energy.[8] He entered into their play, and made them happy with dolls fashioned from scrap pieces of wood decorated with a few lines in coloured chalk; or taking pieces of cardboard he tore out shapes of men and animals and coloured them, giving them such droll expressions that they became fairy-tale characters not only for Claude and Paloma but for adults as well. He had amused himself in the same way before at Le Tremblay with Maïa and earlier had entertained Paulo with similar delights, even painting decorative themes with a few touches on his nursery furniture. Paulo, however, remembered one disconcerting occasion when his father took his toy motor-car after he had gone to bed. In the morning he found it painted in bright colours, with imitations of cushions on the seats and a gay check pattern on the floor. But to everyone's surprise Paulo burst into tears saying that his motor-car had been ruined – that cars never had check patterns on their floors.

At Vallauris throughout the summer the near-by beach was the main playground. The morning bathe would extend into the afternoon, while Picasso taught Claude how to swim and how to pull gruesome faces. It became widely known to friends who were spending their holidays on the coast that the whole family could be found on a certain beach at Golfe Juan nearly every day, and in consequence there was usually a large party to lunch with Picasso at the beach restaurant before he returned to Vallauris to work.

In spite of this apparent idleness the Madoura pottery overflowed with his production in all its rich variety, and it became necessary at an

8 Boeck–Sabartés, *Picasso*, pp. 293, 307.

early date to find a studio where Picasso could paint and continue his sculpture. The solution presented itself in the shape of a disused scent factory near by, with vast tiled workrooms providing all the space required for the time being. The large barnlike workshops could serve as studios for painting or for sculpture and still leave room for future expansion. There was even a place for another painter, Pignon, to live during the summer in one of the rambling outhouses.

In this fertile and friendly atmosphere Picasso inevitably resembled the chief of a tribe – a tribe which had as its nucleus the family at 'La Galloise' and extended to the community of craftsmen at the potteries, not only the Madoura potters but also many other young ceramists who had started their own kilns, as well as painters who came from Paris to try their hand. The tribe also embraced many local tradespeople and artisans, the barber, the carpenter, the baker, and the fishermen from Golfe Juan joined the throng, all sharing admiration and affection for the little man with black eyes and white hair who had come to live among them and to whom the new celebrity of their town was due. He became a legend among them. A roll which the bakers of Vallauris had made for longer than can be remembered, with four points like short stubby fingers, became known as a 'Picasso' because he amused everyone by placing it at the end of a sleeve. The clan ate its 'Picassos' daily.

In Vallauris the legend was based on his daily presence, but elsewhere in France the name Picasso was also to become symbolic just as at one time in Spain the name of the poet Góngora had been. The obscurity of his sonnets made his name a byword even among the illiterate. Particularly if the sky became black or the darkness impenetrable the peasants would call it a 'Góngora'. Similarly in France today the name of Picasso has come to signify a force that is incomprehensible and capricious. In a crowded street in Paris a taxi driver who has nearly come into collision with another car has been heard to shout '*espèce de Picasso!*' For those who judge him from a slight knowledge of his painting and from the disapproval, tempered with astonishment at his success, that they read in the press, the legend is less benign than at Vallauris. The name for many has become synonymous with anything grotesque, which can provoke the remark, '*On dirait un Picasso*'. But

those who met him and got to know him thought of him otherwise. Even if they did not understand his work they were conquered by his personality.

The Man with the Sheep *and the Vallauris Chapel*

To complete the collection of his works at the Palais Grimaldi in Antibes, Picasso made the generous suggestion that he should add a cast of the *Man with the Sheep* (Plate XX, 2). But difficulties arose, and in annoyance at the delay he withdrew the offer. Having done so, he had the idea of offering it instead to the Municipal Council of Vallauris. The councillors were at first taken aback. They asked with some alarm what sort of a statue it was, and when told that it really looked like a man with a sheep, only the blacksmith was heard to say, 'What a pity if it looks just like any other statue!' Apart from its value as a work of art, and even the reputation of its author which was not yet fully appreciated by all of them, it was in itself a valuable piece of bronze and would help to attract tourists, as they realized after some persuasion. They were grateful for the solidarity Picasso showed in supporting their interests, but again they had some misgivings when Picasso told them that he wanted to see it set up outdoors in a square where the children could climb over it and the dogs water it unhindered.

Finally the offer was accepted and the statue set up in the central square of Vallauris. A leader of the Communist Party, Laurent Casanova, was invited to unveil it in the presence of the mayor and a large gathering of friends which included Paul Eluard and Tristan Tzara. As a sign of gratitude the town of Vallauris made Picasso a citizen of honour. In the local press it was acknowledged that 'Picasso is not only a great artist, he is also a man with a heart', and after speaking in general terms of the artistic value of the gift the article went on '. . . the permanent presence of this statue in our town will draw a new influx of visitors for the great good of the economy of our city'.

Picasso's popularity in Vallauris was assured. In addition, the municipality offered him a deconsecrated chapel of the twelfth century to decorate as he thought fit. The invitation came at a time when several painters of repute had been using their talents for religious decorations.

Léger had made a large mosaic for a mountain church at Assy in the Jura, and Rouault had designed a stained-glass window for the same church. Matisse was at work decorating his chapel at Vence, while Braque had contributed to the restoration of a small church near Dieppe. To Picasso, however, in agreement with his communist friends, the idea at that time of seeing his work introduced as an ornament to the Catholic faith was distasteful. 'What do they mean by religious art?' I have heard him say. 'It is an absurdity. How can you make religious art one day and another kind the next?' However, with the Vallauris chapel the same objection did not arise, since it had been turned over to secular use during the French Revolution. He was therefore free to practise his art as he liked and to develop an ideology of his own in which the cardinal factors could be his profound desire for peace and his horror of war. He always insisted that it was not a chapel that he undertook to decorate but a Temple to Peace.

During the summer of 1950 a clash between communism and the Western powers brought about the war in Korea. Picasso, primarily for humanitarian reasons, as one who hated war, again felt himself involved. His communist friends had grown to expect a gesture from him condemning this new outbreak of violence, and it was hoped that he would paint a picture which could be used to blame the Western powers as aggressors. The painting Picasso produced was one of the few pictures to which he deliberately gave a title, calling it *Massacre in Korea* (Plate XXI, 5). It shows in unmistakable terms a squad of semi-robots receiving the order to fire on a group of naked women and children, but there is no clue as to which side is guilty of massacre. Picasso remained faithful to his hatred of military force used against defenceless human beings, and by so doing he saved himself from becoming a partisan propagandist and proved the validity of his painting. At the time it was first exhibited in the Salon de Mai of 1951 the communists made free use of it for their cause, but five years later in Warsaw a large reproduction of it was set up in the streets as a symbolic protest against the action of the Soviet armies in Hungary.

After *Guernica* and the *Charnel House,* the *Massacre in Korea* makes an appeal which is more easily understood by the public in general. In its composition it owed something both to Goya's execution scene of

1808 and to Manet's *Execution of Maximilian*. Picasso had never been closer to anecdote in any of his major works since the Blue period. Even so, the picture attains universality by leaving undetermined the identity of the aggressor.

War *and* Peace

It was during a banquet given in honour of his seventieth birthday by the potters of Vallauris at tables spread in the nave of the little chapel, that Picasso, looking once more at the masonry of its vault, promised finally that he would decorate it. The nave consists of a solid stone barrel-vault without windows, open at one end to the chancel which for many years had been used as an olive press, and at the other to the street. Picasso's idea was to cover it completely with a great painting which on one side would have for its subject war, and on the other peace (Plate XXIII, 1 and 2). To do this a prepared surface had to be insulated from the damp stones. The task was put into the hands of the local carpenter. Skilfully he fixed an armature to the rough stone which was to receive the painted panels when they were ready. Picasso's first problem was to find a studio large enough and to erect a movable stage from which he could work on the panels. Fortunately an adjoining part of the scent factory provided sufficient space, and with the aid of Mr Batigne, an American who had a house in Vallauris, the technical difficulties of lighting and scaffolding were overcome.

In the summer of 1952 Picasso began his task. He had already made great quantities of drawings, but contrary to his practice in painting *Guernica* he made no sketch for the whole picture. Two themes had been occupying his attention. The first he described as centring round 'the tattered, jolting procession of those provincial hearses, miserable and grimacing, that one sees passing in the streets of small towns'.[9] In the drawings the funereal chariot took a variety of shapes, its black plumes were transformed into the turrets of engines of war, and the macabre vehicle was drawn sometimes by decayed nags, at other times by camels or even pigs. The images made it clear that in his view war is

[9] Roy, *La Guerre et la paix*.

not only ugly but also stupid and insane. During the previous year Picasso had made a series of lighthearted drawings and paintings of knights in armour, sallying forth from castles, accompanied by their pages (Plate XXIII, 6). He had amused himself by elaborating the armour of the knights with fantastic excrescences and draping their Rosinantes in rich trappings. These same inventions now took a sinister appearance and medieval skirmishers gave way to the demons of modern war.

In contrast to the preparations for the panel, *War*, Picasso had also been indulging himself at the same time in a very different theme, a series of idyllic drawings of girls dancing. Decked in garlands, with graceful charm they joined hands, skipped and turned somersaults, tossing flowers in the air and abandoning themselves to their games.[10] He had also found the time to write a second play in six acts which he named *The Four Little Girls* (see my translation, Calder & Boyars). With the same verve that he had expended on *Desire Caught by the Tail*, but in a more lyrical mood he worked on to the music of the crickets during the summer nights of Provence. It was begun at Golfe Juan in 1947 and, unlike the earlier play which was written in forty-eight hours, it took some months to complete. It is a fantastic rambling picture of the desires and antics of four charming and precocious children. In the spontaneous joy of their games, their ecstatic dances and their erotic songs the instinctive violence of their desires breaks through. Disquieting screams season the sweetness of their kittenlike play, in which the claw is scarcely hidden beneath the softness of the fur.

As a painter, Picasso makes continual references to colour and to its ambiguous nature: 'The yellow of blue, the blue of blue, the red of blue.' The little girls speak a language which reflects on one side the invented words and puns made by Claude and Paloma and on the other his own thoughts about vision, life and death. For instance, with innocent wisdom they speak in turn like a Greek chorus:

Little girl II	Only the eye of the bull that dies in the arena sees.
Little girl I	It sees itself.
Little girl IV	The deforming mirror sees.

[10] ibid.

| *Little girl II* | Death, that clear water. |
| *Little girl I* | And very heavy. |

As in the earlier play soliloquies are important, and the action is described in stage directions which, as in the earlier play, would often cause trouble if they were to be carried out literally. For instance, at the end of the fourth act we read: 'Enter an enormous winged white horse dragging its entrails, surrounded by wings, an owl perched on its head, it stands for a brief moment in front of the little girl and then disappears at the other end of the stage.'

Picasso's imagery continues with persistence. Characters that appeared at the time of the curtain for *Parade* or before, like the white horse dressed up as Pegasus, reappear in new circumstances. Images that he had formerly realized in his paintings change their medium and become poetry.

When the new studio with its scaffolding was ready, Picasso shut himself off from everyone and only emerged, locking the door behind him, for meals and sleep. For two months the only person who was allowed in was Paulo. His instructions were that if at any moment his father should weaken and inadvertently invite someone to see what he was doing, Paulo, like the crew of Ulysses, was to turn a deaf ear and refuse to let the visitor in. Picasso's days began with a visit to the pottery. He would make two or three pots as a start until he felt in the right mood, then he would disappear into the studio.

Finally one day in October, apparently on the pretext of fetching some cigarettes, the doors were opened and a few friends were allowed in for the first time. The panels were finished. On a table by the door stood an alarm clock and a calendar on which the date of his beginning was marked and two months mapped out in advance. To the astonishment of all, for no one had ever realized that he was capable of such precision in timing, he had kept his programme to a day. In addition to the two great panels, there was a large number of drawings round the studio and also some six or seven portraits, as well as landscapes and still-lifes, created as a sideline to vary the tension of his work.

Speaking later of *War* and *Peace* Picasso said: 'None of my paintings has been painted with such speed, considering its size.'[11] Starting with

[11] ibid.

War he allowed the compositions to grow. 'The laws of composition', he said, 'are never new, they are always someone else's', and to work with the liberty he needed he preferred to trust the storehouse of his own experience to furnish him with solutions when the time came. Like a matador who must judge the right moment and the correct movement for his pass, Picasso said, to explain his method: 'In modern painting each touch has become a task of precision.'

The Temple of Peace

As the great panels faced each other in the studio it was difficult to appreciate Picasso's ultimate intention. During their visit to Italy for exhibition in Rome and Milan they were shown separately, and it was not until they finally returned to Vallauris in the autumn of 1953 to be installed in the chapel, that anyone but Picasso realized the conception he had in mind. They had been planned to fit the low vault, lining it from floor to floor, so that, meeting at the top, they made one picture. When at last they were put together, although he had taken no measurements, the joints in the painting met exactly as he had intended. This faculty of judging distances precisely by eye was frequently put to the test. Picasso told proudly how during the war, when making a drawing for the *Man with the Sheep*, he found that his paper was too small for his intentions. Having drawn the figure to the waist he took a second sheet, and without looking at the first he drew the rest of the figure. When he put the two halves together, not the slightest adjustment in either drawing was necessary. The same accuracy in his judgement was commented on by his producer when a few years later he was at work on a film with Georges-Henri Clouzot.

With the closing of the west door from the street, the vault of the old chapel, lit only from the chancel, had the effect of a cave. Picasso had toyed with the idea that visitors should see his murals by the flickering light of torches, in the same way that primitive man saw the magic paintings hidden in the depths of the caves of Lascaux. He wanted the time-honoured theme of *War* and *Peace* to be seen in intimacy; its universal appeal was also to be personal. He had contrived that the two contrasting subjects should meet overhead with the menacing sword of

war balanced by a multicoloured diamond-shaped sun rising to the zenith, thus enclosing the spectator in two contrary worlds which are one.

Picasso had begun his great panorama with *War*. Its demons breathing fire, burning books and distributing loathsome poisonous insects formed a symbol of the insidious incalculable horrors engendered by war. The tawdry pomp and insane clamour moving from right to left were brought to a halt by a serene god-like figure facing them with the image of the dove on his shield.

The task of creating the image of peace after such spectacular material could have defeated a less resourceful painter. Picasso based his thoughts on what he knew to be the most enjoyable and most permanent in human society, the love that he knew in his own family. For *Peace* he painted a scene in which Pegasus driven by a child is harnessed to the plough. Amidst dancing figures there are feats of equilibrium in which a juggler balances a rod supporting at either end a goldfish bowl full of swallows and a cage containing fish. Thus he makes it clear that happiness is not easily maintained, that like the acrobat the happy man runs a daily risk of calamity. With scathing violence on the one hand and gentle, enigmatic humour on the other, Picasso in this microcosm created the symbols of his philosophy. As Eluard wrote: 'He wants to defeat all tenderness with violence and all violence with tenderness.'

Today the vault of the Temple to Peace is complete, and a lighting system has been installed, but for some years the semi-circular space at the end of the vault remained empty. Finally it was filled by a single panel of four figures in flat primary colours stretching their arms upwards towards a large rising sun. After some misunderstandings and complaints about the indifference of the authorities in Paris, the old Gothic vault with its new concentration of allegoric imagery covering it entirely, was opened to the public as a national monument.

Paris: Books and Paul Eluard

During these years Picasso's activities extended beyond Vallauris. His visits to Paris were frequent. The house in the rue des Grands

Augustins became animated each time with visitors. At times he painted, but much of his energy went into his graphic art. More than a dozen books published by his friends contained lithographs or etchings by him, and he also illustrated several important volumes. The most remarkable of these are the *Twenty Poems* of Góngora, illustrated with etchings and marginal drawings in the text, which is written in his own hand;[12] *Le Chant des morts*, a volume of poems in manuscript by Pierre Reverdy, boldly illuminated with 125 lithographs;[13] and Mérimée's *Carmen* with Picasso's engravings.[14] Shortly after these he produced with Iliazd, the poet and typographer, an illustrated edition of the sixteenth-century poems by Adrien de Monluc;[15] a book of poems by Tristan Tzara;[16] and another by the Guadeloupean poet Aimé Césaire.[17] In 1950 Paul Eluard brought to him a book of short poems he had written, for which Picasso made page by page drawings of the human face, to which he gave the form of a dove. It was published with Eluard's title, *Visage de la paix*.[18]

In the production of these books, many of which were published as de-luxe editions, expert craftsmen from the workshops of Lacourière and Mourlot were eager to give their help. Shifting with ease from one medium to another and keeping them constantly employed, Picasso still found time between their visits for his friends. Kahnweiler had again taken his place after many years as the main agent for Picasso's sales, and Sabartés continued to be his faithful support in business matters. The younger generation was also constantly around him, not only members of his own family but young painters and sculptors in whom he took an interest and to whom his encouragement was precious. Picasso was generous in his praise, he continually looked for talent and was delighted when he found it. Even on those not infrequent occasions when he found himself trapped by an uninteresting young painter asking for advice, he was considerate, knowing how deeply heartless

[12] Góngora, *Vingt poèmes*, Les grands Peintres Modernes et le Livre, 1948.
[13] Reverdy, *Le Chant des morts*, Editions Tériade, Paris, 1948.
[14] Mérimée, *Carmen*, La Bibliothèque Française, Paris, 1949.
[15] de Monluc, *La Maigre*, Editions Degré, Paris, 1952.
[16] Tzara, *De Mémoire d'homme*, Editions Bordas, Paris, 1950.
[17] Césaire, Corps perdu, Editions Fragrance, Paris, 1950.
[18] Eluard, *Visage de la paix*, Editions Cercle d'Art, Paris, 1951.

criticism can wound. I have heard him say firmly and finally to a young man who showed no originality in his work: 'But what does it matter what I say? The essential thing in all this is inside you; it's for you to decide if you should continue to paint or not.'

The political activities to which Paul Eluard devoted an increasing amount of his energy were shared in a more detached way by Picasso, who continued to enjoy his company. To him the great value of Eluard above all other poets, including even Apollinaire, was his under- standing of painting. Eluard was as passionate about painting as he was about poetry and he saw in Picasso the man who had liberated the arts and brought them again into contact with reality. In a lecture that he gave in London in 1951 entitled 'Today, Pablo Picasso, the youngest painter in the world, is seventy', he spoke of the way in which he was affected by his work. Describing some of the night landscapes lately painted by Picasso at Vallauris (Plate XXII, 6) he said:

He copies the night as though he were copying an apple, from memory, the night in his garden at Vallauris – a sloping garden, ordinary enough. At one side of the house there is a reservoir, lit by a lamp, and plenty of grass and weeds. I realize from the start that these nights at Vallauris will have nothing of the facile grace of Provence, but I am certain that after seeing them I could never live through a Provençal night without feeling it in the way it exists in his pictures. All Picasso's models resemble their portraits. In a drawing by Picasso, things are reinstated in their true light; from an infinitely variable appearance, with a thousand considerations he releases a constant, he renders permanent a sum total of images, he totalizes his experiences.[19]

On 14 June 1951 Picasso with Françoise Gilot attended the marriage of Paul Eluard and Dominique Laure in the town hall of St Tropez. Together with the Ramiés they had come over from Vallauris as witnesses of an event which, after the death of Nusch, was at last to bring happiness back to Eluard. His new life with Dominique however was to last little more than one year, for in November 1952 Eluard died. His death brought to an end the longest of the intimate friend- ships between poet and painter that Picasso had known.

At the time of the wedding no one could have suspected such an

[19] Extract from a lecture delivered by Paul Eluard at the opening of a retrospective exhibition of drawings by Picasso at the Institute of Contemporary Arts, London, 11 October 1951.

abrupt finish for a man who overflowed with energy and enthusiasm, in spite of his precarious health. The celebrations had been enlivened by the gift of a tall and magnificent vase, decorated with nude girls and acrobats, from Picasso (Plate XXIII, 5), who at lunchtime made drawings of those round the table. Soon afterwards he returned several times to St Tropez to enjoy the company of Eluard and visit other friends. Françoise, however, was not always with him on these occasions and it was whispered than an estrangement between them had begun.

Towards the end of the summer Picasso was forced to return to Paris. Owing to the shortage of housing the authorities were evicting him from his apartment in the rue la Boétie, which, since he had left it to live in the rue des Grands Augustins during the war, had become no more than a storehouse where everything remained in a state of abandon. Picasso however resented being told to move out; as he said, if he had been running a conventional business he would have been allowed all the space he needed to store his wares, and he felt it unjust that painters were not treated with the same respect. In any case, the idea of delving into the disorder that had accumulated over so many years and been covered so deeply in the grime of Paris was more than he could bear. In consequence he delegated Sabartés and Marcel, the chauffeur, to do it for him while he waited at the rue des Grands Augustins for reports of their progress. The housing of Françoise and the children, who had outgrown the little rooms above the studio, was however solved by taking another apartment in the rue Gay-Lussac.

The size of Picasso's family and those dependent on him was by now considerable. Olga, whom he saw occasionally, was in poor health and had settled in Cannes. Although the tension which had led to such violent encounters and made her unwelcome in the thirties had died down with time, Picasso's new family and new friends had made a final barrier, and Paulo was now the only link between them. In 1953 she died, but according to Alice B. Toklas, who had always remained her friend and who visited her in hospital, she spoke with great emotion of both Picasso and her son, who, she said, had been very good, doing all they could to comfort her in her illness. Before his wife died Picasso had become a grandfather and Paulo had affectionately named his son Pablo.

Sculpture and Painting at Vallauris

The great empty spaces of the old scent factory were rapidly filled in every corner with paintings and sculpture. Among them stood the piece of sculpture that has become the most widely known of those made since the move to Vallauris in 1948 – the *Goat* (Plate XXIV, 3). Like most of the others, it is a composite construction pieced together from objects in which Picasso found new possibilities. When we examine it we find that its fertile belly is a wicker basket, its back-bone and ribs are a palm branch, pieces of scrap iron protrude from its shoulders and its udders are made from clay pots. At the same time it is so essentially a goat, so much the quintessence of goat, that it becomes surprising to think that goats can be made otherwise. It is the sleepy, brooding heaviness of the animal soon to give birth that makes it impressive. This greedy friend of man, capricious and yet generous with its gifts, is set solidly before us. Compared with the black and white animal that grazes beside it in his garden, with its chain attached to its sister's bronze tail, it is more permanent and can evoke a more lasting vision of a goat in our minds than the millions made of flesh and blood that come and go.

Other sculptures of animals, constructed in the same collage technique, are also impressive. There is a life-size monkey with her baby hanging at her chest which provokes a sense of astonishment when it is realized that its head is a toy motor-car (Plate XXIV, 1). The shock it causes is more than a passing joke. Similar means recur in other sculptures; the tail of the *Crane*[20] is a spade and its crest a small tap, the horns of the bull, in the *Still-life with Bottle and Candle,*[21] are handle-bars, and the rays of light from the candle are long carpenter's nails which metaphorically pierce the night. In each case the metamorphosis is complete and appropriate. The joke is not dismissed at first sight in an instantaneous guffaw; it lives on as the inexplicable comedy played between forms which apparently have no affinity, and which yet, in juxtaposition, sacrifice their former identity. By doing so they give birth to a new and vital image, just as when he equates the motor-car with the ape's head Picasso creates a modern version of the Minotaur – the

[20] Boeck–Sabartés, *Picasso,* p. 439.
[21] ibid., p. 480.

animal with a machine for a head. This is one of the very few references to the machine in the work of Picasso and it is significant that it is not the precision of the mechanical perfection of the car that interested him but rather its undeniable likeness to an organic form, the monkey's head. The effects of these metamorphoses which begin as a joke are profound since they challenge our sense of reality. They remind us of the *Temptation of St Anthony* of Hieronymus Bosch, where we are shown a confusion of identity which has become universal and so dangerous that the saint hides his face from it. Picasso however is not frightened to approach the frontiers of madness, knowing that without taking this risk it is impossible to question the reality of what we see.

I was once at Vallauris when Braque paid him a visit. At that time Picasso had begun a sculpture, the first elements of which were a child lying in a derelict baby carriage. Again it was made up from the most unlikely material: he amused us by adding to it pieces of pottery, a gas ring or anything that came to hand that could make the effect more surprising, and finally taking the infant in his arms, he kissed it. Braque who was inclined to be shy of Picasso's buffoonery laughed with us all and then said: 'We laugh, but not *at* you, we laugh *with* you, in sympathy with your ideas.' Our laughter had not been trivial. It was of the kind of which Baudelaire said '. . . laughter caused by the grotesque has about it something profound, primitive and axiomatic, which is much closer to the innocent life and to absolute joy than is the laughter caused by the comic in man's behaviour'.[22] The alliance of the grotesque with Picasso's ability to metamorphose objects at will is a key to the power of these composite inventions.

Some other sculptures of this period do not necessarily rely on the collage technique. There are several versions of owls cast in bronze, some of them painted so that their cantankerous scowls are accentuated and their feathers made light and fluffy. The application of bold patterns in black and white on the bronze completely eliminates the heavy quality of the metal. This mixing of the effects of painting and sculpture has come about through Picasso's desire to speak simultaneously in more than one medium and reduce the conventional

22 Baudelaire, *The Mirror of Art,* Phaidon, p. 144.

barriers between them. In the figure of the *Pregnant Woman* (Plate XXIV, 5), however, his preoccupation is different. In this case it is the swollen forms to which he draws attention by polishing the bare bronze surfaces of breasts and belly as though they had been caressed by devotees like those who polish St Peter's toes with their kisses. Two versions were made after Françoise Gilot's second pregnancy. The breasts and belly were built up internally with three water pots found on a scrap heap. In the first cast there are nipples, a protruding navel and large clumsy feet which have been eliminated in the second giving great importance to the smoothness of the tightly stretched skin. This figure standing stark and proud of her fruitfulness is one of Picasso's most human and moving achievements. For many years he kept a plaster cast high on a table, presiding over the corner in his studio where he was most often at work.

More Paintings and New Versions of Old Masterpieces

Among the many paintings that crowded the studios in Vallauris, the winter landscapes, the scenes of his children at play with their mother and the paintings of the summer nights, there was the series of twelve portraits, painted in the spring of 1954, of a blonde girl, Sylvette Jellinek, whose nordic beauty attracted him as he saw her walking with her English husband round Vallauris. Although in fact she was French, he enjoyed thinking of her as an incarnation of his dream of English beauty, and taking her as his model he painted many versions of her seated with her blonde pony-tail coiffe crowning her head (Plate XXII, 9).

Yet another diversion had become increasingly important in his recent work. His continual interest in the work of others had tempted him on several occasions in the past to take as his theme a painting that he admired, such as Poussin's *Bacchanale,* and reinterpret it according to the feelings it provoked in him. At this time two great paintings, the *Demoiselles de la Seine*[23] of Courbet and El Greco's *Portrait of a Painter* (Plate XXII, 7), had attracted his attention, and he painted two large

[23] Boeck-Sabartés, *Picasso*, p. 428.

canvases, rearranging them in his own manner. In both cases it is possible to trace in detail the original work, but by the way in which they have been transformed they have become completely his own. A careful comparison between Picasso's versions and the works of his predecessors is the best possible guide to the revolution he brought about in painting and to the changes which gave it its significance.

In the portrait by El Greco, for instance, his admiration for the master of Toledo and his interest in the fact that it is probably a portrait of the artist's son have not restrained him from making fundamental changes, although at the same time he has kept faithfully to the spirit of the work. He has treated his subject, the original painting, as formerly he treated a guitar, analysing it and making a statement of its essential qualities without failing to take every detail into account. The head of El Greco, surrounded by a white ruff, is greatly enlarged, and the features, instead of presenting an almost photographic likeness, are formed, rather than deformed, in a way which changes their static appearance into one of movement. El Greco's right hand, with little finger raised, holding the brush, is spread out nervously like a flower and El Greco's small rectangular palette, held in his left hand, is unchanged in shape, but it becomes unmistakably the less tidy palette of Picasso. El Greco's portrait with its Renaissance conception of realism prepared the ground for photography. Picasso's version some 350 years later opens our eyes to a new vision in painting, and a new attitude towards reality in which photographic realism plays a minor role.[24]

The Death of Friends

The death of Paul Eluard was the first of several blows in quick succession that carried off old friends. André Derain had for many years ceased to be an intimate friend, but the news that he had died from the effects of an accident was disturbing to Picasso, especially as the news of the death of another companion of the days of the Bateau Lavoir, Maurice Raynal, who had recently completed his second book about Picasso, came soon afterwards. Picasso told a friend who was staying

[24] See John Lucas, 'Picasso as a Copyist', *Art News*, New York, November 1955.

with him when he heard the news of Raynal's death that he had a habit of going over the names of his most intimate friends every morning, and added with a sense of guilt that that day he had left out Raynal. 'But you didn't kill him,' said his companion. 'No,' said Picasso, 'but I forgot him this morning.'

Shortly afterwards came more bad news. Matisse was dead. Since the war Matisse had been living in Nice and, although bedridden most of the time, had continued to work on plans for his chapel at Vence and produced large compositions made of pieces cut out from coloured papers. Picasso had made a habit of paying him frequent visits and they exchanged paintings and other objects, including an alarming life-size female figure from the New Hebrides which Matisse presented to Picasso. Unfortunately no one was present to make adequate notes of their conversations, for Matisse was a fascinating talker and any exchange of views between them after long years of experience could not have been without interest.

A year later, in 1954, yet another death, that of Fernand Léger, came as a further shock. Picasso was outliving his generation. One of the four great names in the evolution of Cubism, Léger had developed his own vigorous interpretation. In his attempt to popularize his art he applied strictly formal limitations. His paintings were so indicative of his strong, simple personality that Picasso's verdict on seeing an exhibition of his work a year before his death was: 'Léger can't be wrong.'

Separation

The winter of 1953 was one of extreme bitterness for Picasso. The situation between him and Françoise Gilot had become increasingly difficult, and at the end of the summer she returned to Paris with the children, leaving him alone in Vallauris. A saying that she did not want to spend the rest of her life with a historical monument gained wide publicity and was not meant to appeal to Picasso's sense of humour. It would be indiscreet to try to establish the reasons for the break-up of a liaison which to all appearances should have been a very happy one for her and for Picasso in his old age. That he had been in love with her is obvious from the many tributes he paid to her beauty in his work. The

children she had borne were adored by them both and their life in common as painters brought satisfaction, though the talent of Françoise was bound to suffer a partial eclipse in his proximity.

The isolation in which Picasso found himself was to some extent relieved by the arrival of an old friend, the widow of the sculptor Manolo who had died a little while before, with her daughter. They saw to his domestic needs, but the bitterness of his solitude could be relieved only by his own efforts.

A Season in Hell

It was in mid December that Picasso found the outlet he needed for his troubled spirit. In quick succession he made a series of drawings on which he worked with feverish concentration through the lonely nights until the end of January. 'Picasso and the Human Comedy' is the title that Michel Leiris gave to the brilliant preface he wrote for the volume in which these drawings, 180 in number, were reproduced.[25] The artist had turned to the universal reality of his own particular plight to free himself from his obsession, and sometimes making as many as eighteen drawings in a day he set down a visual account of his own thoughts. It became an autobiography in which we find reappearing the actors – clowns, acrobats, and apes – his companions in the work of his early years. Like him they have aged, and holding masks in front of their wrinkled faces, they try to enchant or deceive us with an appearance of classical serenity or obscene grimaces.

The theme of the painter and his model recurs in masterly style with new and more intimate implications. It is still primarily the theme of love; the love of the artist for his model and by transference the love of his own creation, the painting. The ageing artist crouching over his work becomes more absorbed than ever in his picture and takes only fleeting glances at the beauty of his model. The fierce wit with which old age is belaboured and exposed in its ugliness, dotage, and myopic stupidity speaks of Picasso's own consciousness of the approach of the

25 'Suite de 180 Dessins de Picasso', Nos. 29-30, Paris, 1954, *Verve*, Vol. VIII. English edition, A. Zwemmer, London.

'last enemy'. At the same time he pays generous homage to youth in the most moving terms. Old age and fatuity stand dazed by its radiant beauty as with leering eyes or the obscene grin of Silenus they contemplate the naked body of a girl standing before them.

It is Picasso's most complete confession of his love for women. Drawn with a rapid unerring line, which shows no trace of an after-thought, they appear triumphant and integral in their female nature, not within the frozen limits of classical beauty but with movement that brings them to life and hides nothing of the irregularities and the imperfections which can make their attraction even more personal and compelling. Picasso's remark, 'you don't love Venus, you love a woman' is borne out in these drawings by the accuracy with which he has noted the variety of their charms. To those to whom he said that he had never yet fallen in love this may be the answer. It gives an indication of the depth and quality of his love. It may be a generic love of women more than the love of one particular woman, but his passion proves to be so intense that one fraction of it may be of greater richness than the entire affection of another man.

The painter's problem, which springs fundamentally from the same source and becomes in its own right the rival of erotic emotion, received equal attention. The place usurped from reality by the image grows in importance through this enthralling series. We are shown the old, bearded, dry-as-dust painter scratching away at his canvas, oblivious of the model and intent on his 'chef d'œuvre inconnu'. The critics around him examine every detail of his work, and return to admire the least blot made by him on the canvas, just as in other drawings they watch the lady painter who regards the youthful body of her model with a jealous eye. The whole world of the painter's studio is passed in review, and then the make-believe of painting is transferred to games between the artist and the model themselves as they hide their own features, hers behind a bearded mask and his covered by the profile of a beautiful girl. The last drawing, added as a final comment, shows us the model wearing a mask of classical beauty sitting before her muddle-headed bewhiskered painter, who discovers on looking at his canvas a portrait, not of her but of himself mocking him with a toothless grin. Picasso had exorcized the misery which was threatening him by remembering what he had always

known, that art being a product of sadness and pain could rescue him from his melancholy because suffering lies at the root of life.

'La Californie'
(1954-58)

Tauromachia

After the First World War the more sophisticated art of the ballet had superseded the circus in Picasso's affection, but later on, after the death of Diaghilev in 1929, his interest waned. His only contribution since that date was a drop curtain he designed for *Le Rendezvous,* a ballet written by Jacques Prévert for the Roland Petit company in 1945. He found once more, however, that the bullfight, as a spectacle of agility and rich colour, could more than compensate for his former passion for the ring and the stage. Moreover, it brought back memories of his early youth.

In the years after the war, a new interest in bullfighting had sprung up in Provence, and *corridas* in which famous Spanish matadors took part had become frequent in the ancient Roman arenas of Nîmes and Arles and elsewhere in the neighbourhood. On such occasions it was rare not to find Picasso occupying a place in the front row, surrounded by a party of his friends and receiving the ceremonial honours of the fight. Not infrequently, improvised entertainments offered by his Spanish friends prolonged his visits. Toreadors, gipsies, and the guardians of herds from the Camargue would celebrate the event till dawn with flamenco singing and stories which, if they ceased to be concerned with bullfighting, at once took on a Rabelaisian flavour.

At such times, warmed by the animation of his compatriots, Picasso's voice seemed to conceal a laugh. Its tone became more robust as he grew more eloquent in his native language. When suddenly he did break into a laugh it was high-pitched and so infectious that it inevitably spread to his companions. His enormous eyes, which even in daylight

showed scarcely any difference between the iris, which in fact was of a very dark chestnut colour, and the jet-black pupil, became almost swamped by the deep furrows of his smile, and from the corners of his eyes wrinkles radiated like black rays from two black suns. His sparse crop of short white hair bristled and sparkled like hoar frost. Smaller in stature than those around him, he was always the centre of the group. With tense expression they listened as he talked eagerly, leaning forward to prod the arm of a friend to whom he wished to emphasize his meaning. His moods however, could change rapidly with instant effect on his expression. The exuberance would fade and a look of sadness cross his face, seeming to reveal some deep incurable disquiet, or again a penetrating look of inquiry, often tinged with anxiety, would demand a reply to restore his composure.

During the spring of 1954 he had been absorbed by his portraits of his new model, Sylvette. When summer came he stayed on as usual in Vallauris, where he was joined by Claude and Paloma who had been brought by their mother from Paris in spite of their parents' estrangement. The holiday season culminated in a bullfight which Spanish friends, experts in this matter, organized in his honour. In the main square of the town an arena was built specially for the occasion. The *corrida* that followed was locally a much-publicized event, known to all Picasso's friends on the coast. Jean Cocteau, Jacques Prévert and André Verdet, frequently to be seen in Vallauris, were among the first to arrive, and they found Picasso in a festive mood. Taking part in a procession to rouse the town, he was perched on the back of a car playing a trumpet. Accompanying him were Paulo and his friend Pierre Baudouin who had distinguished themselves by shaving one half of their heads from front to back and dressing up in women's clothes.

In the grandstand Picasso took the seat of the president of the *corrida* with Cocteau on one side and Jacqueline Roque on the other. He had recently met Jacqueline in Vallauris, and had painted portraits of her during the summer, emphasizing the beauty of her regular profile and her large dark eyes. Round him also were Maïa, now a handsome girl of eighteen, and Claude and Paloma watching eagerly as their mother, Françoise, rode into the ring on a fine horse to perform the ceremony of asking the president's permission for the *corrida* to begin.

From the point of view of the *aficionado* the proceedings that followed had little interest. They were no more than comic games in which the bull suffered no harm, but the intimacy among the spectators and the buffoonery of the performers made it memorable. So great was its success that for a time it became a yearly event, at which Picasso presided over the festivities like a chieftain surrounded by his tribe.

Apart from these public demonstrations of fraternity, there was a bond between Picasso and the artists, potters and craftsmen of Vallauris. His visits to their workshops were not only an encouragement to them but a meeting between craftsmen. For some years the master potters showed their gratitude and affection by offering him a banquet on his birthday which was attended by thirty or more of them with their friends.

Whatever Picasso enjoyed usually found an echo in his work. Bulls, matadors and *picadors* are transferred from the arena to the surface of a plate (Plate XXIII, 8). Large dishes have their oval shape converted into the grand panorama of the bull ring, with its crowds in sun and shade watching the fight. Reminiscent of cubist discoveries, the oval once more aptly places the circle in perspective.

Large lithographs and aquatints, patiently carried through many stages, have been the means of producing vivid images of bullfights in the arena of Arles. At other times his method is to make a great number of rapid drawings in which each stroke of the brush is final. In the summer of 1957 he returned from a disappointing *corrida,* and with astonishing energy produced some fifty aquatints one after the other. They were in fact inspired not by the *corrida* he had just seen but by a seventeenth-century book on tauromachia by José Delgado (known as Pepe Illo) which for years he had thought of illustrating. Suddenly something had happened to make it possible for him to realize this long-standing project in one creative outburst.[1]

Shortly after the Vallauris *corrida* of 1954, Picasso took Jacqueline Roque and the two children to Perpignan to stay with friends he had known for many years. Comte Jacques de Lazerme had been interested in the arts since his boyhood. Through Manolo, the sculptor, he had known Picasso and the 'Parisians' who had made the near-by village of

[1] Duncan, *The Private World of Pablo Picasso.*

Céret the centre of Cubism for several summers before the First World
War. Jacques de Lazerme and his attractive wife lived in a spacious
seventeenth-century house in the middle of the town. They welcomed
Picasso by giving him several large rooms in which he could live and
work as he felt inclined.

Bullfights at Céret and bathing with Claude and Paloma at Collioure
were his main pleasures. He enjoyed the change in his surroundings,
the coast, and the treeless foothills of the Pyrenees, but he was
tantalizingly near his native country. He could see plainly the mountain
frontier he had vowed never to cross so long as Franco remained
dictator of Spain.

The local people of all ranks greeted him warmly. They hoped he
might settle in the region, and as an inducement offered him the old
castle at Collioure to use as a studio, as he had used the Palais Grimaldi
in Antibes. They proposed that he should build a temple to Peace on
top of a near-by mountain, which could be seen from great distances on
both sides of the frontier. Picasso toyed with these ideas, and explored
the mountain site which he found magnificent, but although he seemed
to agree and talked with enthusiasm of these plans, after he returned to
Paris in the autumn they were eclipsed by other more immediate
work.

Les Femmes d'Alger

Because of his extraordinary visual memory and his familiarity with the
arts in all their variety, Picasso's visits to museums were infrequent.
However, when the paintings he had presented to the State in 1946
were assembled in the Louvre before being sent to the Musée d'Art
Moderne, George Salles, the Director of the Louvre, asked him to come
to see them side by side with 'the Masters'. He arrived, feeling acutely
anxious, to be confronted by his own paintings set round the walls of
the gallery where David's great classical scenes of mythology and
heroism are hung. These vast canvases are much larger than Picasso's
paintings, which themselves are by no means small, for among them
were the *Milliner's Workshop* of 1926,[2] *La Muse* of 1935 (Plate XIV, 7),

[2] See Zervos, *Picasso*, Vol. VII, p. 2.

the *Aubade* of 1942 (Plate XXI, 4) and several important still-lifes. After a disquieting pause for comparison between two such different styles, Georges Salles was the first to pronounce with conviction that they stood up to the test, and to suggest that they should be moved into the Spanish gallery where they could be seen beside Goya, Velázquez and Zurbarán. Picasso was even more worried this time as his pictures were placed beside the work of his countrymen, but again they held their own through the vigour of their execution and the reality of the life they contain. Having regained his confidence he repeated excitedly 'You see it's the same thing! it's the same thing!'

A few years after this single-handed encounter with the masters, he began in 1954 a series of fifteen variations on the theme of Delacroix's masterpiece, *Les Femmes d'Alger*. This picture haunted his memory. He had not seen it for years, though he had only to cross the Seine and enter the Louvre to do so. I suspect that Picasso was encouraged in a feeling of intimacy with the exotic scene by a striking likeness between the profile of Jacqueline Roque and of one of the seated Moorish women.

Working from memory, he first painted a composition which in its essentials bore resemblance to the picture in the Louvre. There was only one obvious difference: the Negress carrying a coffee pot in Picasso's picture appears only in the Delacroix version in the Montpellier museum. In quick succession he painted a number of variations on the same theme, some in monochrome and others with brilliant colour. A suggestion of the tranquil atmosphere of the harem with its ladies seated round a hookah in decorous conversation can still be felt in the first paintings. Soon, however, the scene became more orgiastic. Stripped of their silks and jewellery the nude bodies of the women are drawn with bold curves indicating the fullness of their breasts and the roundness of their buttocks. One of the two figures in the foreground lies on her side in abandon with her entwined legs lifted in the air, while the other, in contrast richly clothed, sits erect in hieratic indifference. The discreet eroticism of Delacroix's harem has vanished. In Picasso's summary treatment of anatomy, the seduction of the female form is no longer veiled and segregated, it floods the whole picture, affecting every corner and opening up the scene from a shadowed confinement to the light of the sun.

The more conventional representation of the first paintings made them easy to interpret, but as the series continued Picasso became interested in more abstract qualities of colour and form which were the outcome of his former discoveries. In the last brilliant composition to be painted, he introduced both styles in the same picture (Plate XXIV, 2). Instead of incongruity he succeeded in achieving an even greater unity, holding the picture together by strong overall patterns of bright colour. The two different styles instead of clashing became complementary, offering different versions of the same reality. The more representational seated figure had the effect of spreading its influence over its neighbours whose forms are less easy to interpret at first sight, humanizing their geometric severity and supplying the key to their metaphorical eroticism.

This great canvas had just been painted when, one day in February 1955, I climbed up the narrow stairs of the old house in the rue des Grands Augustins. The glow of colour from the paintings was warm enough to make me forget the bleak, grey atmosphere of the streets. The stacked canvases left little space, but in the centre of the room he stood there friendly and smiling. Bringing them out one after another he showed me the rich variety of style and fantasy to which *Les Femmes d'Alger* had been subjected. My first sight of the Moorish interiors and the provocative poses of the nude girls reminded me of the odalisques of Matisse. 'You are right,' he said with a laugh, 'when Matisse died he left his odalisques to me as a legacy, and this is my idea of the Orient though I have never been there.' As he continued to bring out more canvases I remarked upon the variations between the representational and cubist styles. I could discover no direct sequence leading in either direction. With an enigmatic smile he told me that he himself never knew what was coming next, nor did he try to interpret what he had done. 'That is for others to do if they wish,' he said, and to illustrate his point he brought out a large recent aquatint: a group of several figures, some old and grotesque and others young, watching an artist at work at his easel. '*You* tell me what it means, and what that old naked man who turns his back to us is doing there. Everyone who's seen it has his story about it. I don't know what's going on, I never do. If I did I'd be finished.'

The planned, methodical development of a theme is as foreign to Picasso as a reasoned explanation. Each painting as it arrived had served as a gateway to the next, the suggestions that had come each time he was at work had not been forgotten, and each had widened the theme rather than narrowed it towards a limited solution. In his perpetual turning over of his ideas, every solution had to be questioned, for the reverse might be equally near the truth. When I asked if he intended to continue to work longer on one of the large canvases towards a résumé of the whole series, he said: 'The fact that I paint so many studies is just part of my way of working. I make a hundred studies in a few days while another painter may spend a hundred days on one picture. As I continue I shall open windows. I shall get behind the canvas and perhaps something will happen.' This was not an answer but the metaphor suggested that the solution was already present in what he had done. New aspects of it were revealed by each change he had made as if he were turning over a precious stone before our eyes. This in fact became clear when a few months later the fifteen paintings were exhibited together, and their homogeneity as well as their variety became apparent.

However, to guard against giving the impression that he was working with the hope of ultimate perfection, he added: 'Pictures are never finished in the sense that they suddenly become ready to be signed and framed. They usually come to a halt when the time is ripe, because something happens which breaks the continuity of their development. When this happens it is often a good plan to return to sculpture.' And to express his satisfaction in changing to another medium, he added: 'After all, a work of art is not achieved by thought but with your hands.'

A few days after this visit, the interruption in his work, which he had sensed as a possibility, occurred. He had to leave for Vallauris where complications in the ownership of property had arisen. The unwelcome break in his work upset his temper, and when he left his face was clouded. Once more, however, the climate that he enjoyed and his new love restored his energy.

Exhibitions

Since the last war the demand for exhibitions, great and small, of the work of Picasso has surpassed that for any other artist. A summary of the situation may be useful. Before the war was over a retrospective exhibition was shown in Mexico City, and paintings shown in Paris soon after its liberation were sent shortly afterwards to the Victoria and Albert Museum in London. Smaller exhibitions, less systematic in their selection, abounded during these years.

In 1948 the Maison de la Pensée Française in Paris presented to the public for the first time 149 ceramics of Picasso, which amounted to no more than a tenth of his production up to that date, though he had only begun to work at Vallauris the year before. The following year sixty-four canvases painted during the four previous years, mostly portraits of Françoise Gilot and Claude, were shown at the same gallery. The Venice Biennale of 1950 organized a relatively small retrospective showing of his work.

Nineteen fifty-one was the year of Picasso's seventieth birthday, and in addition to the celebrations in Vallauris, exhibitions were planned in widely distant parts of the world. In Tokyo drawings and lithographs were shown. In London the Institute of Contemporary Arts opened an important retrospective exhibition of drawings, to which he himself had lent more than half the exhibits. But the most memorable event was the large exhibition of sculpture, accompanied by drawings, most of them shown for the first time, at the Maison de la Pensée Française. It was then that the world at large began to realize the greatness of Picasso as a sculptor.

In 1953 an important retrospective exhibition of paintings opened in June in Lyon, and most of the pictures shown there went on in the late summer to Rome and afterwards to Milan. In Italy the display, already considerable in size, was enlarged by work that came direct from Vallauris, including the murals *War* and *Peace*. The same winter an exhibition was held independently at São Paolo in Brazil.

A third exhibition at the Maison de la Pensée Française opened in the summer of 1954. The unusual interest it offered was the presence of thirty-seven paintings loaned by Soviet Russia from the collection

which had been taken over from Shchukine. These had been shown the previous autumn in a small private gallery in Rome. They were now augmented by some early pictures such as the 1903 portrait of *Celestina*,[3] lent by the artist, and seven paintings ranging from 1905 to 1914 from the collection of Gertrude Stein. This exhibition, including the paintings from Russia, the earliest dating from 1900, was the finest collection of Picasso's early work that had ever been seen. All the pictures were in excellent condition, for although the Russian authorities had kept them hidden from the public as dangerous specimens of Western decadence, they had seen that they were well cared for. Among them were the great melancholy paintings of the Blue period, the *Harlequin and his Companion* of 1901,[4] the portrait of Sabartés caressing his *bock* of 1901 (Plate II, 1) and the great paintings, *The Old Jew* of 1903 (Plate II, 7) and the little girl balancing on a ball –*L'Acrobate à la boule* – of the *saltimbanque* period of 1905 (Plate IV, 6). These were followed by some of the most powerful examples of the Negro period such as the *Draped Nude* of 1907[5] and the *Farmer's Wife* painted at La Rue des Bois in 1908.[6] As we know from Shchukine's reactions to the *Demoiselles d'Avignon,* he had sometimes been hesitant in his choice, particularly towards the close of his career as a collector. But seeing this collection, no one could question his remarkable discernment. One of the greatest pleasures was to be face to face with the astonishing cubist portrait of Ambroise Vollard.

Unfortunately this unique opportunity to see these splendid pictures in Paris lasted only a few days. A daughter of Shchukine who lived in France claimed them as belonging legally to her, and in order to avoid any possible complications, the Russians preferred to close the exhibition and ship their paintings immediately back to Moscow. With the political changes that have happened in Russia a number of them are again on view in museums in Moscow and Leningrad; and in more recent years the authorities have been more generous and have lent to important exhibitions in Brussels, London and Paris where the works

[3] ibid., Vol. I, p. 5.
[4] ibid., Vol. I, p. 46.
[5] ibid., Vol. II*, p. 25.
[6] ibid., Vol. II*, p. 46, No. 92.

have been major representatives of Picasso's early periods.

In 1954 Picasso was in Vallauris. He told friends who were interested to know if he would like to have seen his early work again, that he had no intention of making the journey to Paris and that they must understand that he still disliked seeing exhibitions of his own work. 'In the past I refused for many years to exhibit and even would not have my pictures photographed,' he said in a conversation with Pierre Baudouin. 'But finally I realized that I had to exhibit – to strip myself naked. It takes courage. Even a whore when she strips naked needs courage. People don't realize what they have when they own a picture by me. Each picture is a phial with my blood. That is what has gone into it.'

The exhibitions continued. Two were held in Paris in the summer of 1955, in honour of his definitive arrival in Paris fifty years before and of his seventy-fifth birthday in the following year. In the Musée des Arts Décoratifs, a retrospective exhibition of one hundred and forty-three works was to show Picasso's fabulous career from 1900–1955; that is from the Blue period to the studies for *Les Femmes d'Alger*. From America came many important pictures belonging to private collectors, and also *Guernica,* which had been on loan since 1939 at the New York Museum of Modern Art. The *Demoiselles d'Avignon* unfortunately was lacking in this important manifestation; though, as we know, this picture had been seen in London in an exhibition organized by the Institute of Contemporary Arts in 1948, and, more recently, in Paris at the Cubist Exhibition.

The second exhibition in Paris in the summer of 1955 was held in the Bibliothèque Nationale. It was a very ample survey of the graphic art of Picasso, in which for the first time the public could see the rare prints of the Vollard suite. The same exhibition was shown the following spring in London by the Arts Council. Many other exhibitions of drawings and ceramics, and of the great canvas of *Guernica* with its studies, were organized throughout Europe during these years. They included a small exhibition in Barcelona in the autumn of 1957, the first in this city for more than twenty years. However, the most important display of Picasso's painting and sculpture held up to then was arranged in 1957 by Alfred Barr at the New York Museum of Modern Art. From there it travelled to Chicago and Philadelphia.

Cannes

Throughout these years and ever after, Picasso's fame weighed lightly upon him. His thoughts had always been sufficiently occupied with his work and his daily contacts with his family and friends for him not to be burdened by it. He did not grudge the pleasure it gave to visitors to take his photograph and he was sometimes surprised if he was not asked for an autograph. But he became increasingly hostile to attempts to film him or in particular to make tape recordings, which he insisted were absurd distortions of a conversation. In general he accepted with dignity the position he earned. However the time taken up by visitors in the summer, or on the contrary a lack of visits or inquiries as to whether a caller would be welcome, always worried him.

In Paris, however, in the spring of 1954 he found himself being over-whelmed by callers and family affairs. In addition, he began to find it impossible to visit cafés and restaurants without being pestered by tourists. One day when he walked to the end of the rue des Grands Augustins to see the floods, which were then reaching alarming pro-portions, he was trapped by journalists who asked senseless questions and wanted to take photographs when he was not in the mood. Feeling depressed at the changed atmosphere in Paris and seeing no other solution, he set out again for the Mediterranean. The little villa at Vallauris, however, had lost its attraction since the break with Françoise and also it was far too small for his needs.

He therefore decided to move house, and with Jacqueline Roque, he started looking about in the neighbourhood. One evening, in the hilly inland part of Cannes, they were seeing over a large ornate villa, 'La Californie'. He knew suddenly in the dusk that it would suit his purpose. Its clumsy 1900 style, its pretentious wrought-iron staircase and the stylized carvings round the windows, did not deter him. He was not looking for an old house of fine proportions, nor did he want an artist's studio. He remembered how once before he had taken a villa with a studio in Cannes for the summer, the only time he had ever done such a thing, and as a result, he said, he hardly did any work at all. He knew that what he had found was ugly, but its vulgarity was something that he could dominate and even use, for the house had the attraction of

well-lit rooms with high ceilings and space which would take even him some years to fill. A high back iron fence with a lodge for a guardian at the gate provided the defences needed to keep the curious and the unwanted at a distance. Terraced gardens with some fine trees, including palms and a gigantic eucalyptus, isolated the house from neighbouring villas and a view out to sea gave a pleasant feeling of space.

Picasso soon cleared the house of curtains, carpets, grand pianos and the furniture of the rich industrialists who had used the villa before for their sumptuous entertainments. The drawing-rooms, bathroom suites, kitchens and extensive basement were now to be used very differently. The mirrored doors of the entrance halls soon became hidden behind cases of belongings brought out of store in Paris. Bronzes, ceramics, canvases, easels and furniture, including the eighteenth-century English chairs left to him by his father, crowded the ground floor, while the kitchens were transformed into workshops for lithography and engraving. Into the first-floor bedrooms were brought the bare necessities for comfort and the top floor remained relatively empty. The rugs and curtains were not replaced, and he preferred to let the worn-out silk covers on the armchairs, which brought with them an echo of the rue la Boétie, continue to split until they looked like the slashed doublets of medieval knights. No thought was given to redecoration – such considerations did not interest Picasso. His house had always been his workshop and a place to store his belongings rather than something to be admired for its elegance and comfort. On the walls unframed canvases and rare specimens of masks from the South Seas and Africa found themselves hanging between the ornate plaster mouldings wherever there happened to be a nail, interspersed with photos or scraps of paper with messages written boldly in crayon. With haphazard finality objects took their places round the rooms.

In spite of the attentions of Jacqueline Roque, the disorder grew. Incongruous objects, crowded together, became more deeply hedged in by a forest of new arrivals. Packing-cases were opened to see what was inside, then left. Flowers remained desiccated in their vases. Food, clothing, toys, books, lamps, presents of all descriptions, and *objets d'art* piled up on top of each other like the crusts of the earth.

Yet strangely enough, in spite of all this, there was no squalor. As the

visitor grew used to the disorder, details of fascinating interest caught his eye. A Sicilian marionette in golden armour hung from a lamp standard, a cage of noisy tropical birds could be seen among books and papers, a small self-portrait of the Douanier Rousseau and a night land-scape by Max Ernst emerged from piles of ceramics. These were a few of the finds that became visible to the prying eye, but there were still a thousand treasures locked away in a back room or submerged and forgotten.

The quality essential to every object in this heterogeneous collection was its value to Picasso in his work. Everywhere there were signs of his activity, everything had gone through his hands and been scrutinized by him before taking its place in this jungle. Canvases, ceramics, tiles, plates, bronze and plaster sculptures, bulging portfolios crammed with drawings and engravings mingled with things that had been brought there intentionally or by chance. Everything had its significance and its place in the alchemist's den which he had created around him.

The ground-floor rooms were connected to each other by wide doors. Large french windows, open in summer, brought the scent of pine and eucalyptus in from the garden. In this atmosphere Picasso worked, received his friends, played with his goat or his dogs and amused himself as he felt inclined. Meals were cleared from the dining-room table to make space for him to draw or to work on his ceramics. His life, his work and his play were never separate. Picasso the painter, the sculptor, the engraver, the ceramist, the poet, coincides with Picasso the friend, the sage, the magician, the father, and the clown.

In this multifarious dwelling Picasso had the company of Jacqueline Roque, whose presence had become permanent, attentive and charming. She could quickly assess his wishes and provide for rapid changes of plans. She could guard jealously against intruders, see to his comforts and provide excellent meals. During the hours that Picasso wanted to work, if she were not with him she would enjoy herself listening to music, reading or playing with her daughter, Catherine, who lived with them. Inspired by the variety of subjects at hand she became also an observant and successful photographer.

Many of the paintings produced at 'La Californie' were portraits of Jacqueline. In some of them she wears a Turkish dress reminiscent of

Les Femmes d'Alger. The classical lines of her profile and the large dark eyes that Picasso has given her are impressive in their likeness. In others representation has been sacrificed to gay improvisations with flat brilliant patches of colour, which recall the most daring inventions of Matisse.

In the winter of 1955-56 the portraits of Jacqueline were accompanied by paintings of nudes (Plate XXV, 1), in particular two large canvases in which the figures are constructed in monochrome geometric facets. Their proportions are monumental and they appear to be so solid that one figure, crouching, seems to offer shelter like a cavern, her breasts hanging like spherical lamps from its roof. There are other smaller nudes quite different in their effect. Their realism is more direct and the appeal of their voluminous forms so strong that they seem to convey even the odour of flesh.

When Picasso bought 'La Californie', though he had seen it only by twilight, he realized that its most precious asset to him, in addition to its nearness to Vallauris, was the light that penetrated into every corner of the house. He was happy at once in the luminous atmosphere of the lofty rooms, and as he had done before, he began to paint pictures inspired by the objects that lay around and the tall windows with their art nouveau tracery, through which a warm green light was filtered by the branches of the palm trees. Day after day he saw his studio anew. Sometimes the main feature to be placed in the composition was Jacqueline seated in a rocking-chair in front of stacked canvases on which could be seen former versions of the same studio (Plate XXIV, 4). In other paintings the pattern of the windows dominated everything, towering high like a cathedral nave; or again cool recesses led the eye deep into the picture, past chairs, sculptures, easels and the Moorish charcoal-burner which looked like another relic of Matisse.

The last paintings of this series have an austerity of colour and arrangement which strongly recalls the atmosphere of Spain (Plate XXIV, 6). Picasso explains that they were begun on Easter Sunday 1956 when torrential rain prevented him from going to a bullfight. Strong contrasts of black and luminous white give a sensation of the white-washed passages and the solemn seclusion of Spanish houses. They evoke a bittersweet taste, and the contrast between the burning sun and

the freshness of sheltered interiors, of white wine and black olives. From the magnificent disorder of his surroundings Picasso has resolved in these paintings a masterly plan of light and space in which everything takes its place with serenity.

Although the general rhythm of his life was the same from day to day, Picasso kept changing the forms of his activities. There was the constant coming and going of ceramics brought by car from Vallauris for him to paint or ornament with designs incised or in relief. On the large platters he made bold images of owls, goats, bulls or the calm profile of Jacqueline, and then without warning he would transfer his attention to the tall thin sculptures that stood like sentinels watching over the turmoil. These strange figures built by him with material such as planks, driftwood and canvas stretchers were then sent to be cast in bronze in Paris, so that their hybrid nature became unified and transformed in the more permanent material.

With such variety around him and such mastery in so many techniques it was impossible for him to be idle. The passionate energy which went into his work always infected those who came into contact with him. Although he never had pupils, his example spread to others and gave them the means of producing works of art themselves. It is not only the engravers with whom he worked, the publishers, the ceramists, the makers of tapestries and mosaics, the bronze-casters and iron-founders, but also those who work in gold and silver who have been provided with new and unconventional ideas. It was not in the rue de la Paix that Picasso was introduced to the jeweller's craft but in that fearful place, the dentist's chair. His capacity for detecting new resources led him to discoveries in regions where others would find it absurd or indiscreet to look. As he noticed the dentist's instruments, the idea came to him of engraving in gold with dental drills and making gold ornaments from models with the same precision with which the dentist crowned his teeth. As a result, by using dental material, Picasso made a necklace so magnificent in its effect that it rivals the gold ornaments of ancient Mexico.

Among those who found a new impulse in their craftsmanship was the designer of jewellery, François Hugo. The finesse of his work induced Picasso to commission him to make a series of fifty large

platters in *repoussé* work, beaten out of solid silver. The idea sprang from Picasso's ceramic dishes but in devising new techniques together Hugo soon found that Picasso was thinking in silver rather than clay. As the work progressed the dialogue between artist and artisan resulted in a series of great magnificence. Made usually from drawings, these splendid dishes were never slavish copies but contained the sensitivity of the hand of the craftsman. When Picasso one day pulled one out from under the divan where they were hidden away and gave it to the American dealer Sam Kootz who had just bought from him a hundred recent paintings, Kootz at once balanced the gift with an Oldsmobile of the latest design.

Although the infectious influence of Picasso both as a man and as an artist was immense, it is not surprising to find that there are those who reacted violently against it. His power is also recognized by those who disapprove. One day I was present when he opened a letter addressed to him by a French painter, in which the author, who remained anonymous, began by saying: 'Monsieur, the harm you have done is incalculable.' As he read it, Picasso said quietly, 'Who knows? Perhaps he is right.' In the impulse of his creation Picasso was not conscious of doing good or evil. Power is inherent in his work, and we are in the habit of judging the greatness of a painter by the strength he has to affect ourselves and others.

Films

When the producer H.-G. Clouzot came to Cannes during the summer of 1955 to propose to Picasso that they should make a long film together, several films of his work had already been released to the public. The first had *Guernica* as its title and a commentary by Paul Eluard. The story of the great painting was seen in relation to Picasso's work from his earliest years and the tragedy of the bombing was accentuated by Eluard's poetry. Later the Belgian producer Paul Haesaerts produced a film in which the most interesting sequence was made in Vallauris. It showed Picasso drawing on a sheet of glass so that his movements could be seen like a dance through transparent images of smiling mythical creatures, fauns and goats. Haesaerts later made a

second film, *From Renoir to Picasso,* which makes comparisons between these two modern masters and a third, Seurat. He stressed the emotional violence of Picasso in contrast to the sensuality of Renoir and the intellect of Seurat. These other qualities are, however, so evident in Picasso too that the argument at times seemed oversimplified.

In 1953 Luciano Emmer, known for his films on Carpaccio, Bosch and other old masters, came to Vallauris to take pictures of Picasso at work. He needed scenes taken from life to complete an ambitious film describing the evolution of his art from the Blue period to the present time. Two sequences of considerable interest were filmed. In one Picasso is shown making a huge drawing on the vault of the Temple of Peace in Vallauris (the panels of *War* and *Peace* were away on exhibition). The agility with which he moves about on ladders to complete the drawing is impressive, and even more astonishing is the precision of the long sweeping curves that never lose their meaning in spite of this acrobatic feat. Climbing from one position to another, he completes before our eyes a drawing covering the whole wall, representing a gigantic birdlike demon meeting its destruction at the hands of a hero of classical nobility. In the second episode Picasso constructs on the floor of his studio a statue made up of a great variety of materials discovered while the work is in progress. As a description of his methods in making collage sculpture it is of value, but the feeling that his actions have been rehearsed haunts the whole sequence. The film as a whole is important as a record of Picasso's work. Emmer took advantage of the presence of the paintings assembled in Rome for the exhibition of 1953, including the pictures from Moscow that later had their brief showing in Paris. The colour reproduction is as faithful as possible; the commentary, however, is biased by theories of social realism which seriously distort Picasso's motives. It is only the most representational paintings that meet with the author's approval, the others are shown with condescension as the temporary aberrations of a great man.

Picasso himself experimented with film-making on a small scale. He used paper cut-outs of animals and figures, animating them with coloured chalk, but he was modest about the results, which have never been shown in public. Although he was intrigued by the possibilities of

the cinema as a medium he was nervous of appearing to the public on the screen. In 1950 I went with him to see a film about Matisse. The producer had induced the artist to say a few halting phrases about his own work, and had later suggested to Picasso that he might be able to do something similar. But the reply was emphatic. 'Never will you make an ape of me like that,' said Picasso, and in spite of further attempts at persuasion the film was never made.

This made it all the more surprising that when Clouzot came to Cannes to suggest making a long colour film in which Picasso was to be the only star, his proposal should be taken seriously. The idea was to record the actual creative process of Picasso, in so far as it can be watched, by filming him making drawings and paintings from start to finish. Its success, however, would depend on making a sequence out of the action and on its presentation to a public without specialist knowledge or even an interest in painting, in such a way as to capture the imagination. A vital factor was Picasso's reaction to the exacting and complicated demands of cinema technique. He would be obliged to work surrounded by technicians instead of alone, to start and stop drawing as they required, and to work long hours in the scorching heat of the lamps. All this, it seemed, would combine to kill spontaneity. Discussing it beforehand, Picasso remarked that he would feel like a matador about to enter the arena, a sensation that he knew already in some degree every time he started a canvas, but this time it would be much more intimidating with a crowd of spectators and technicians watching him.

Clouzot had both the tact and the imagination to make it possible for Picasso to go through this ordeal. Contrary to his habits, Picasso was forced to rise early every day for two months during the summer so as to get to the film studios in Nice. There he had to work with great patience and persistence in a heat which 'made the sun outdoors seem like Iceland'. As time went on, he became more and more interested and cooperated fully in the awkward processes demanded of him, such as stopping after each stroke of a painting for it to be photographed and announcing in advance when he would be ready to start again.

It was not until late in the following spring, at the Cannes Film Festival, that the film was shown publicly. Meanwhile Picasso had

spent a whole winter suffering at intervals from the fatigue that his exceptional effort had caused. When he was ailing, Picasso went through great mental torment and his thoughts turned to old age and death, two facts with which he refused then to make his peace. The idea that he was not feeling well enough to work used to torment him and his dejection increased when he was told by the doctor that the best cure was rest. His motto could have been, like Don Quixote's, 'my combat is my repose', for unless he was able to work he became miserable and began to brood. Yet that winter, work, the one cure which he knew would be effective, was forbidden him.

It was some weeks before he managed to break completely out of this vicious circle. The day of the private view of his film, *Le Mystère Picasso*, he was going through another spell of despondency. He stayed in bed all day and insisted that he could not go to the opening. Everyone was unhappy and in particular Clouzot and his old friend, Georges Auric, who had composed the music. At the last moment, however, thanks largely to the tactful persuasion of Jacqueline, Picasso appeared dressed in an elegant dinner jacket which still fitted perfectly although he had not worn it for more than twenty years, and another relic, his favourite hat, an English bowler.

To the delight of all, his drawings spread across the screen as if by magic. Clouzot had devised a technique by which the drawings could be filmed from the back of an absorbent paper through which the coloured inks penetrated immediately, with the advantage that the artist's hand did not hide his work. Each line as it appeared seemed right and inevitable once it was made, and there was a feeling that it was pre-destined, in fact that it had already been there, but invisible to all but the artist. I have had this sensation before when watching him make a drawing, though in the film it is accentuated because he is hidden. The movement of his crayon in obedience to an unseen presence and the lack of hesitation give proof of complete accord between the inner eye of the artist and the realization of the vision on the paper. Picasso had overcome his misgivings and was enjoying the wonderful display that he could give of the visible side of his creative process.

The film also is tense with the excitement of wondering what he will do next. His actions are enthralling, like the actions of a tight-rope

walker who compels his audience to follow every movement of his peri-
lous dance and applaud his prowess when it comes successfully to an
end. At one dramatic moment, after a long sequence in which he has
made many astonishing changes in a large painting of a beach scene, he
exclaims to Clouzot: 'This is going wrong – all wrong', and then
proceeds to wipe out the composition and start again, this time
benefiting from his failure. His performance throughout is a triumph
not only of his artistic talent, but of his personality, unassuming,
powerful and sincere. With Clouzot's ability to hold his audience in
suspense added to Picasso's brilliant display, the film becomes a rare
and valuable account of the workings of genius.

Politics

In his retreat, Picasso often received visits from officials of the French
Communist Party. Frequently they came to ask him to contribute a
drawing to some party cause, or to add his signature to a manifesto. He
considered them as politicians and assumed that as such they were
capable in their own profession. He knew that they did not have much
understanding of his painting nor did he expect that of them. So long as
they allowed him his freedom in his art he was willing to support them
for ideological reasons. This mutual arrangement worked reasonably
well in spite of a temporary disagreement arising from a portrait of
Stalin, which he had made as a 'bouquet of flowers', at the death of the
man who was then their hero. This gesture met with official dis-
approval because it was said that the drawing was not sufficiently
realistic.

In the autumn of 1956 the brutal suppression of the rising in
Hungary troubled many intellectuals in the French Communist Party.
Picasso was greatly disturbed by the news and signed a letter with nine
others, including his friends the painter, Edouard Pignon, and his wife,
Hélène Parmelin, addressed to the central committee of the party. In it
they complained that although 'the weeks that have just passed have
posed burning problems of conscience for communists, neither the
Central Committee nor *L'Humanité* [their newspaper] have helped to
resolve them', and they demanded the summoning of a special party

congress. The reply, published in *L'Humanité*, was not reassuring. It gave a lengthy defence of the official line and concluded by saying: 'The signatories...may have another opinion! They may even become obstinate in spite of the facts, but they have not the right to attempt to impose their point of view on the party by illicit means.' Here the public exchange of views came to an end though Picasso received further visits from the highest-ranking members of the party, who were anxious not to lose so distinguished a member.

Later Picasso explained his attitude to the American journalist, Carlton Lake, who had told him in an interview that he thought many admirers would be happy to hear that he had resigned from the party. 'Look,' said Picasso, 'I am no politician. I am not technically proficient in such matters. But communism stands for certain ideals I believe in. I believe communism is working towards the realization of those ideals.'[7] He went on to make it clear that though he had no intention of resigning from the party his attachment to communism was not political. So long as the party in France continued to represent the aspirations of a large portion of the working classes it would have been unlikely that he would resign. He felt that by remaining a member he kept a link which he needed with the common people. He met them in his contacts with the artisans, craftsmen and technicians with whom he enjoyed working, and his communism helped to establish confidence between them. His faith in them was part of his fundamental humanism. Also this attitude underlined his lasting disapproval of the Franco régime.

Visitors and Friends

All the year round in Cannes, but particularly during the summer months, there was a continuous flow of visitors wishing to call on Picasso. 'La Californie', however, was well hidden among trees on the hillside, and its remoteness helped to check an invasion which might easily have become intolerable. Among others in a different category

[7] Carlton Lake, 'Picasso Speaking', *The Atlantic Monthly.*

who paid visits in or out of season were his old and intimate friends, Sabartés and Kahnweiler. Their help in business matters combined with a lifelong understanding of his habits continued to make them welcome. Since he had not returned to Paris for nearly three years his Parisian friends were compelled to make the journey to see him. As in the past he enjoyed the company of poets. Michel Leiris and his wife Zette, Jacques Prévert, Tristan Tzara and André Verdet enlivened his voluntary exile. Jean Cocteau was still unfailing in his attentions. '*Mon Maître Picasso*' was the title he gave to an article in the press. When in 1955 Cocteau became a member of the Institut Français, Picasso playfully made burlesque – even scatological – designs for the sword hilt which is part of the insignia of an academician.

Musicians such as François Poulenc and Georges Auric would call from time to time, while dealers from all parts of the world, collectors, publishers, film stars, fashion experts, photographers, and architects swelled the numbers of those who came to pay their respects. Many painters spend their summer on the coast but few of them could share Picasso's intimacy. There were those in consequence who accused him unreasonably of making himself inaccessible. When he met young artists, as he did frequently, he was always tolerant, and if he found talent in their work he was generous with suggestions and recommendations. At times Picasso was depressed by the lack of under- standing of his own discoveries and the lack of revolt and individuality among the young. As he said: 'There are miles of paintings in the manner of. . ., but it is rare to see a young painter work according to his own style.'

A painter whose company he enjoyed after the last war was Edouard Pignon. During his stay in Vallauris, working near by in the old scent factory, Pignon remembers one day leaving an unfinished study for a picture of a mother and child. During his absence Picasso came in and painted another version of the subject in the same manner, which he left on the easel. His exit was followed by the arrival of friends looking for Pignon, who became enthusiastic about this latest painting. When they met shortly after they congratulated him warmly and Pignon innocently told them it was just a small study of no importance. It was not until they returned to the studio that they all realized what had happened and

that the new Pignon was in fact a Picasso.

An understanding grew between the stolid good-natured painter who had broken loose from the mining areas of northern France and the unfathomable, volcanic Andalusian. Pignon is a talented painter and a good talker, his knowledge of the arts is wide and his tastes are decided. While he spoke in the language of painters of his latest intentions in his work, Picasso would listen intently and break in suddenly with ideas which excited and surprised at the same time. Pignon would try to explain his motives with clarity, whereas Picasso always spoke in metaphors without any thought of justification. The listener would realize that Picasso appreciated that truth is never easily accessible. Direct statements imply falsehoods too often for them to be trusted. The truth can be better understood by subtle manœuvres which catch it alive instead of trampling it to death. His short, eager interruptions were like well-aimed gunfire which not only tore breaches in conventional defences against possibly disconcerting revelations, but also pierced a way to a more profound understanding of life and the arts.

To record such conversations would be difficult. They rely on glances, expressions, gestures, a quick laugh which introduces a relevant absurdity, and above all on the reactions of his listeners to ambiguities and paradoxes which can become the threshold of new ideas. The pleasure Picasso took in presenting the reverse side of a problem could reduce the over-serious questioner to despair. 'You mustn't always believe what I say,' he once told me. 'Questions tempt you to tell lies, particularly when there is no answer.' Friends sometimes offered to make recordings, but Picasso laughed at their naïvety. Divorced from its surroundings such talk loses its meaning.

The ambiguity of words warmed Picasso's sense of humour. Their insufficiency as labels and their variety of interpretation tempted him to juggle with them. French words, Spanish words, even English words exchanged meanings with each other just as colours can change in value according to their surroundings. You can play with words and make puns just as you can play with colours and shapes. 'After all,' he enjoyed saying, 'the arts are all the same; you can write a picture in words just as you can paint sensations in a poem. "Blue" – what does "blue" mean? There are thousands of sensations that we call "blue". You can speak of

the blue of a packet of Gauloises and in that case you can talk of the Gauloises blue of eyes, or on the contrary, just as they do in a Paris restaurant, you can talk of a steak being blue when you mean red. That is what I have often done when I have tried to write poems.'

Paterfamilias

It is easy to see from his work and his way of living that Picasso was always very fond of children. For many years there were often children, his own or those of friends, around him. More than once he was tempted with the idea of establishing a family, but this does not mean that he ever accepted willingly the role of father – except when his children were very young. Paulo, who provided him with grandchildren, lived his own life, though he frequently returned to visit his father. At one time Maïa somewhat grudgingly sacrificed her freedom for long visits to 'La Californie' before deciding to live in Spain, and Claude and Paloma, after their mother had left Picasso, spent their holidays enjoying the enchantment of their father's company. They were perhaps the only people alive who could switch his attention from work to play with such ease. They would pass hours together on the beach or devise fantastic games in which Jacqueline, Cathy, the dogs, the goat, the doves and the owl quite naturally all took part.

In Picasso's earliest self-portraits is to be found his love of disguise. The game of changing one's personality continued at 'La Californie'. His son Claude was shown how to wear the hat and cloak of a toreador and with Paloma they would try out the effects of faces made by their father from a torn sheet of paper or a ceramic tile. On the sideboard was a store of comic masks, hats of all descriptions and even a cutlass, which provided for any emergency that might arise.

Picasso Entertains

The moment when disguises were called for most urgently was on the arrival of visitors, especially those from abroad. The less known or the more intimidating the guest might be, the more likely it was that he

would find himself confronted by Picasso not as he expected to find him but as a burlesque little figure wearing, perhaps, a yachting cap with horn-rimmed spectacles, a red nose and black side-whiskers and brandishing a sabre. When his grotesque appearance had effectively removed the first embarrassment of meeting, Picasso would emerge from behind his mask, his eyes shining with laughter and his expression still enigmatic.

A visit to Picasso was always a new adventure. Those who called expecting any fixed routine were disappointed. At the same time those who managed to penetrate the defences of the front gate were well received, and when they left their pulses have been quickened and their thoughts set moving by the presence of the little white-haird man whose black eyes have stirred their emotions like a redhot poker sizzling in a pot of mulled wine.

With Picasso the trivial and the serious lived well together. During a visit that could begin with clowning and progress to an improvised performance on an African musical instrument, the final reward could often be a showing of some of his latest canvases. The visitors would stand round or sit on the floor for lack of chairs, while Picasso himself did all the moving. Choosing among the paintings that were stacked deeply round the walls, he would bring them out one by one and prop them against each other, fitting big and small together into a patchwork. Their appearance would be greeted with signs of admiration by the cosmopolitan group of spectators in languages often incomprehensible to him, while those who were most deeply moved by the power and the rich variety of the display often waited for some time before expressing their enthusiasm. With their approval the look of anxiety which was always in his face when he began to unveil his recent creations disappeared, and he listened intently to their remarks.

That Picasso usually enjoyed such visits while they lasted and even found them necessary seems certain. When friends who knew his taste for strange objects arrived with presents, such as a Western six-shooter and a cowboy hat from Gary Cooper, or an elegant photometer and comic spectacles from Alfred Barr, his pleasure would be obvious. His power of astonishing everyone with the variety of his talents and the profusion of his work gave him equal satisfaction. At the same time

these visits often set up a conflict within him. He found it difficult to put up for long with anything that distracted him from his work and interrupted the atmosphere in which his own inclinations were unchecked. Yet when one day I remarked that none the less he had done an extraordinary amount of work during the summer, he answered, 'Yes, who knows? It may be *because* of the interruptions.'

The Unesco Mural and another Project

In 1957 Picasso accepted an invitation to make a gigantic mural for the new Unesco building in Paris, and although he gave some thought to this, for a long time nothing materialized. Finally, delegates arrived to talk the matter over again. They measured out on the front of the house a space comparable to that offered to him in the building in Paris. The area, 33 feet square, was so vast that Picasso became worried about the physical effort involved in covering the surface. 'I am no longer twenty-five,' he said. 'It can't be done.' At the same time, refusing to admit defeat, he began discussing methods which might make it feasible. The idea of providing a design which would be executed by an expert in murals or a scene painter did not please him. He said, 'I want to *live* this picture myself just as I do all my other paintings, otherwise it will become a mere decoration.' Then, turning to the delegates who were searching their brains for fruitful suggestions, he said firmly '*Au revoir!* There is a solution, but I must find it myself.'

Talking about the problem later, he pointed out a fundamental difference between the methods of the fresco painter and his own. The Renaissance artists painted a small area on a newly prepared surface every day, and knew from their sketches where the joins were to come, but he himself liked to extend his painting at any time over the whole surface and without restriction, working either on details or on the over-all effect as he felt inclined. The sheer size of the Unesco mural forced him to invent other methods.

It was only after a pause of some months during which he was entirely absorbed by his series of variations on Velázquez's painting *Les Meninas* that Picasso found in the spring of 1958 his own solution. Seeing that it was impossible for him to complete the whole mural in one piece he

decided to divide it into panels small enough to be placed on the floor of his studio in groups of some dozen at a time. This amounted to forty panels in all. Relying on his ability to imagine it as a whole, he was able to complete the painting and coordinate the colour, the drawing and the composition throughout, without ever seeing all the panels together. Finally the work was assembled and set up under a temporary roof with special flood-lighting in the courtyard of the municipal school at Vallauris. With due ceremony Picasso presented it to a deputation from Unesco headed by Georges Salles who came to receive it officially from the hands of the artist.

Exposed by day to the brilliant light of the sun, away from the architectural surroundings for which it had been conceived, the painting had a disquieting effect. Once more it did not turn out to be what the public had expected. There were however those who understood. Georges Salles, who had followed with enthusiasm the mural in process of creation, showed in an inaugural address his confidence that once installed it would take its place triumphantly in the setting for which it was intended.

This indeed proved to be the case. In September 1958 the great painting was placed in the hall leading to the Conference Rooms, well lit and framed by rough concrete walls and massive columns. It could now be seen that in spite of the unusual difficulties with which he had to contend, Picasso, although he had been given only a small model of the building, had found brilliant solutions. From such sparse indications Picasso had understood the problem and discovered dramatic possibilities in what seemed to be an extremely awkward site. As the visitor approaches he does not see the mural as a whole until he has passed the columns and a low footbridge, which hides its central area, and has arrived within a few yards of it. But his movement round these obstacles seems to give movement to the composition itself, in particular to the sinister black shape near the centre of the painting, like the shadow of a man head downwards on which his blanched bones are traced. This tattered apparition seems to drop headlong out of a white-hot sky into a mountainous blue wave, while bathers basking on the beach near by remain indifferent to its dramatic downfall.

It was this suggestion of allegory that tempted Georges Salles to give

it as its title: *The Fall of Icarus.* The unexpected way in which this gigantic painting enhances its surroundings and demands the spectator's participation without Picasso having been able to see it in place is a convincing proof of his intuitive understanding of visual problems.

Las Meninas

In the centre of the ground-floor studio at 'La Californie', enthroned on a chair, sat one of Matisse's last gifts to Picasso; a monstrous female effigy from the New Hebrides. Her presence was made especially imposing by the startling stripes, blue, white and pink, with which she is painted from head to foot. This ugly goddess stuffed with straw became the presiding genius in a room where a live occupant also sat, immobile all day – a small owl in a cage, to whom Picasso paid periodic visits with food. Although the walls were lined with canvases, some finished and turned to the wall, others, of enormous size, still virgin, awaiting his attention, he was not working there in the autumn of 1957.

Since midsummer the work in progress began to take place on the top floor, hitherto uninhabited except by the tame pigeons. Even the pet goat was not allowed to go higher than the corridor of the first floor where at night it slept outside Picasso's bedroom door. The pigeon house, looking not unlike a cubist construction, was built by him on the balcony of the largest of the empty rooms that he now invaded. There was nothing to distract him but his doves and the view over the palm and eucalyptus trees towards the Lerins Islands that lay there in full view. Here, he could work isolated and undisturbed by day or late into the night.

None of the treasures from the rich haphazard assortment below had been elevated to this level, nothing broke the bleak severity of torn and faded wallpaper and the marble mantelpieces of abandoned luxury. He worked at night by the light of a high-powered electric bulb hung from the middle of the ceiling. 'What does it matter?' Picasso said, 'if it looks good by that light it will look good at any time.' Furniture was absent except for two small tattered armchairs and a packing-case turned upside down surrounded by a mob of paint tins. Scraps of smooth board

or tin lying on top of the case served for mixing his colours. His brushes were mostly worn to a stump with the violent scrubbing on the canvas they received and the great distances they were made to travel while he was painting. Though in many cases hardly a bristle remained he still found no difficulty in making them perform exactly as he wanted. By day, to the accompaniment of the cooing and fluttering of piegons, or by night with Jacqueline silently watching every movement, he covered canvases of various sizes with tremendous speed and astonishing control.

Two themes developed concurrently. One was a series of jubilant paintings of his immediate surroundings, in which the chief actors were the pigeons flying from the shelter of the improvised dovecote, tumbling into the blue sunlit air with the sea as their background. All that was visible from the room where he worked was eligible for a place in the pictures. If we compare the paintings and their subjects it can be seen how each detail, pigeons, palm trees, islands, dovecote and terrace has been considered on its own account before being knitted together into the unity of a composition, like flowers of different kinds arranged in the same bouquet. Each has found its place in the sparkling sunlight and yet everywhere there is an exuberance of movement. Not only do the pigeons strut and flutter, but we feel also the movement of the painter himself as he shifts his viewpoint and looks behind walls and round corners. The sense of life, of an airborne dance, that animates the subject is transposed directly into the pictures.

For the second theme on which Picasso was at work, his model was not present in the same way. Once more he took a subject from the work of one of the great fraternity of painters who lived permanently in his thoughts. After using paintings by Le Nain, Poussin, Cranach, Courbet, El Greco and Delacroix, he now turned to *Las Meninas* (The Ladies-in-Waiting) of Velázquez as the picture which was to feed him with new ideas and to become the source of innumerable variations.

This painting was known to Picasso ever since he visited Madrid with his father at the age of fourteen. He learned then to admire it for the qualities of its composition, drawing and lighting and for the acid harmonies of its colour. Since then he considered the virtues and understood the anatomy of this masterpiece, and with time his love of

the painting grew for many reasons. 'What a picture! what realism!...what a marvellous achievement!' he said to Kahnweiler more than twenty years before he decided to make a thorough investigation of the complicated scene that it presents.

Veláquez's painting contains some very strange and subtle relationships between the painter, the model and the spectator. 'Look at it,' said Picasso one day when we were discussing *Las Meninas*, 'and try to find where each of these is actually situated.' Velázquez can be seen in the picture, whereas in reality he must be standing outside it; he is shown turning his back on the Infanta who at first glance we would expect to be his model. He faces a large canvas on which he seems to be at work but it has its back to us and we have no idea what he is painting. The only solution is that he is painting the king and queen, who are only to be seen by their reflection in the mirror at the far end of the room. This implies incidentally that if we can see them they are not looking at Velázquez but at us in the mirror. Velázquez therefore is not painting *las meninas*. The girls have gathered round him not to pose for him but to see his picture of the king and queen with us presumably standing beside – not them but the king and queen.

Such complicated relationships between the reality implied inside the picture and its relationship with the reality of the world outside raise problems which delighted Picasso. He always enjoyed involving the spectator in the web of his picture, and here in fact the spectator finds himself caught in no ordinary sense. He has been drawn into the royal apartments of the King of Spain, and Picasso intends to keep him there and show him not only a whole gallery of incongruous associations but also how the great traditions of Spanish painting can find a new orientation in his hands. Into such surroundings anyone might stray. Don Quixote might appear, or El Greco, burying the Count of Orgaz. Goya could stroll in, dressed in his trousers with stripes which are horizontal instead of vertical like those worn by Courbet in the well-known self-portrait, *L'Atelier*. Picasso had had made a similar pair to complete the trio, while now taking up residence with Velázquez and his other companions in this lofty Spanish palace into which the sunlight was only allowed to penetrate with discretion. From the hooks in the ceiling to which the chandeliers were hitched at night, he hung

hams and sausages. The painted characters entered as his companions into his disrespectful games.

A large canvas, six feet by nearly nine feet, painted in monochrome, occupied most of the wall in Picasso's top-floor studio (Plate XXIV, 8). It was the first of the *Meninas* series. All the main features of the original painting by Velázquez remain, though the composition had been changed from vertical to horizontal. Picasso had opened the shutters of the royal apartment to let in more light, at the same time he had not diminished the dramatic effect of the chamberlain's silhouette in the open doorway at the far end of the room. Velázquez had organized the effects of lighting and perspective according to the established rules, convincing us of the great distance between us and the chamberlain. Picasso also succeeds in convincing us, but by quite different methods. He creates a sense of space so great that you feel you would have to shout to call the chamberlain's attention. It is done in the later versions by means of angular facets of cubist origin, planes which link together and disappear into the depths of the scene aided by strong contrasts of light and dark. The light no longer comes from a fixed direction, it spreads throughout the picture and the eye is led from facet to facet deep into the painting, as if it were exploring the inner depths of a crystal. Velázquez, tall and lost in thought, is given the authority of an inquisitor. The two ladies-in-waiting, standing in the shadow, become rigid and observant like two sinister officers of the *guardia civil*, their features outlined in red, like warning signs on the road. The Infanta and her two attendants receive special attention. Many studies of them of various sizes were made in greens, yellows, whites and greys, the figures treated individually and as a group. A combination of tenderness and violence used in close proximity in their treatment plays on the emotions. He transformed the carefully modelled surfaces of flesh and silk of Velázquez into a language of signs, a calligraphy in which, however, flesh and silk are still present. We recognize at once their qualities, incorporated into a new and powerful reality, brutally and yet lovingly portrayed. By these bold devices we are drawn in to enjoy and to share the life and surroundings of these children.

For two months during the summer Picasso worked in isolation. Again he refused to allow anyone but Jacqueline to see what he was

painting. The canvases multiplied rapidly during the long summer evenings and the nights when the curtainless windowpanes reflected his work, their uneven surfaces changing and distorting his pictures as he moved. Such ready-made deformations proved once more to be an amusement to him, just as a distorting mirror in his bedroom never failed to make him laugh at its weird versions of reality.

When in the early autumn Michel Leiris and Pignon were finally allowed up to Picasso's sanctuary they were confronted with an astonishing sight. He had taken possession of *Las Meninas* in some twenty paintings, large and small. The realism of Velázquez that he had so much admired had been transformed into the life of Picasso and his surroundings. Even the phlegmatic dog of Velázquez had been changed for the dachshund Lump that Picasso had received not long before as a gift from the photographer, David Duncan, and other more significant exchanges had taken place.

The game Picasso played with reality led him to question everything and to place even those things that are held most in respect in situations which can make them seem ridiculous. It is a risk taken in the interests of penetrating the complex ambiguities of the world rather than a heartless mockery. By a reversal of standards even those things which we love can gain in value rather than lose. The ruthless parody to which *Las Meninas* has been subjected cannot fail to bring a smile, and the laughter that it provokes is of the kind defined by Baudelaire when he wrote: 'Laughter is satanic, it is thus profoundly human and...essentially contradictory; that is to say, it is at the same time a sign of infinite grandeur and infinite misery.'[8] In his study *Of the Essence of Laughter,* Baudelaire went on to define national characteristics, saying: 'The Spaniards are very well endowed with the comic. They are quick to arrive at the cruel stage and their grotesque fantasies usually contain a sombre element.'[9] The story that Picasso imagined for the little Italian buffoon who enters the right of Velázquez's picture is an example. As he pokes the good-tempered dog with his foot the boy's hands seem to flutter nervously. This tempted Picasso to think that he might be playing an invisible piano, and to

[8] Baudelaire, *Œuvres*, N.R.F., Paris, 1939, Vol. II, p. 171.
[9] ibid., p. 177.

paint a study of him seated at a piano well lit with candles. He also noticed in the original a black line in the panelling that rises from the nape of the boy's neck. This in turn suggested to him a cord by which the young pianist was hanged like a helpless tinkling marionette.

'I saw the little boy with a piano,' he said to me. 'The piano came into my head and I had to put it somewhere. For me he was hanged so I made him hang. Such images come to me and I put them in. They are part of the reality of the subject. The Surrealists in that way were right. Reality is more than the thing itself. I look always for its super-reality. Reality lies in how you see things. A green parrot,' he continued, 'is also a green salad *and* a green parrot. He who makes it only a parrot diminishes its reality. A painter who copies a tree blinds himself to the real tree. I see things otherwise. A palm tree can become a horse. Don Quixote can come into *Las Meninas.*' Velázquez's picture had become the pretext for a new human comedy in which Picasso had many unforeseen roles for the actors.

'And yet the "subject" ', Picasso went on, 'no longer exists in our time. When you look at the *Last Judgement* of Michelangelo you don't really think of the subject, you think of it as a painting. When people look at devils in medieval sculpture they are no longer frightened.'

The subject as such has indeed lost much of its significance for us. Now it is no more than a nucleus clothed with assets which belong more strictly to the domain of painting. The treatment of the subject rather than the subject itself has become increasingly important. It is not the haystack in Monet's painting that makes his picture a good one, any more than the presence of the figures of Apollinaire and his Muse made the portrait by the Douanier Rousseau a masterpiece. Even if we take the example of *Guernica,* the greatness of the picture does not depend entirely on the subject matter. Then Picasso had adopted a symbolism of his own to convey the original idea. The symbols by proxy became the subject matter and even so it is the manner of their treatment which is the source of the picture's power to touch off chain reactions in our imagination.

Attempts to rid painting completely of subject matter were of little interest to Picasso, although his work contains a wealth of purely visual delights. To prove that such pleasures are not absent, it is only necessary to isolate a detail and enjoy it for its abstract qualities. In one

of Picasso's studies for *Las Meninas,* for instance, there is a triangular patch representing the hair of one of the ladies in waiting to the Infanta. The qualities present in it that excite the eye are produced merely by green paint brushed thinly with sweeping curves on to white canvas. The mysterious depth and movement contained in the brush stroke has been achieved by a combination of chance and Picasso's knowledge of what he can do with the materials he uses. If this detail were cut out of its context and framed, it could, stripped of the subject to which it belongs, still give satisfaction though it would be of the kind which depends only on the arrangement of shapes and colours. When the detail is restored to its surroundings it becomes once more the flowing hair of a girl, green like grass and moving in sensuous undulations. You may ask, why should Picasso want the *menina*'s hair to look like grass? It is not certain that he does, but by such suggestions he widens the scope of his image, and his painting gains a new power over our emotions.

In his attachment to a subject, however distant, Picasso remains in spirit nearer to Velázquez than to those of the present generation who have become hostile to that quality in painting which has many names – subject matter, literary content, realism – and which he always uses as an asset to his work. In other ways, Picasso the rebel and the liberator also shows his appreciation of past achievements. In his technique we can often trace traditional styles that have been transformed by him. His contemporary versions are a kind of shorthand. They can be read as a translation into modern terms of more laborious methods. In his *Meninas* variations the bold movements of the brush of Picasso are the descendants of the careful modelling of Velázquez. They are as sensitive and deliberate, but they belong essentially to our century with its accelerated tempo and its apprehensions, rather than to that more contemplative age three hundred years ago. His work is addressed to the sensibility of the time in which he lived, a new perception which he has given to us and to the generations to come.

Some Paintings of 1958

There are few events that had more surely the power of dragging

Picasso from his work than a bullfight. The reason is clear. The bull-fight always provided him with new material. In 1958 at Whitsun this happened once again. Excited by an unusually brilliant performance and at the same time worried by the violent political crisis of 13 May that brought de Gaulle to power, Picasso was reminded once more of the fragile nature of life, and the picture he produced in this mood was one that shouted defiance. 'I painted this with four-letter words,' he said as he showed me a large canvas now known as *Still-life with Bull's Skull* (Plate XXVI, 1), in which the burning reds and yellows, a double reflection of the sun in the open window, and the monumental immobility of a horned skull in the foreground, produce a shock like a deadly explosion within the calm of a distant blue sky.

Other large paintings less turbulent in their atmosphere, such as *The Bay of Cannes* (Plate XXV, 4), were produced during the same summer. There were also several portraits of Jacqueline which reveal his continual tenderness for her, and a head of amazing sensitivity, *L'Arlésienne*[10] which he painted with pigeon feathers that lay thick on the floor of his studio. The liquid freshness with which the paint finds its place on the canvas with no sign of brush or knife seems due to an instant of complete spontaneity, but for his own record, and our en-lightenment, Picasso scored up along the side of the canvas a long tally of dates, showing that he started on 8 July and finished on 15 August.

[10] See Zervos, *Picasso*, Vol. XVIII, p. 83, No. 299.

14

Vauvenargues; Departure from Cannes:
Spanish Friends
(1959-61 and after)

Le Mont Sainte Victoire

Picasso once asked me at 'La Californie' if I liked his surroundings and without waiting for my reply added bluntly, 'Well, I don't.' The garden, in spite of some splendid trees, seemed to him artificial, and the architecture of the house, although it provided him with plenty of space and light to work in, still echoed the bourgeois vulgarity of 1900. In addition, the proximity of Cannes and its overcrowded beaches and the growing numbers of admirers and autograph hunters, had diminished its attraction for him. The daily visit to the beach had ceased to tempt him and he had become more impatient at the frequent interruptions by day and the noise of '*son et lumière*' repeating relentlessly the history of the islands opposite his windows at night.

In August 1958 Picasso once more took his place of honour at the bullfights in Vallauris, but he returned home without further festivities when it was over. When in October his friends prepared once more the banquet which by then had become a tradition, he decided at the last moment he could not face celebrations of this kind any longer and let them know that that year at least he did not intend to have a birthday. Leaving 'La Californie' abruptly with Jacqueline and Sabartés he disappeared until the menace had passed.

Pleasures had become torments and it was not surprising to hear Picasso talk frequently of moving to more remote surroundings, but none of his friends thought that he would easily abandon the amenities of 'La Californie'. It was natural therefore when one day he telephoned Kahnweiler saying 'I have bought le Mont Sainte Victoire' that this old friend, thinking of his love of Cézanne's landscapes, should reply,

'Congratulations – but which?' Picasso had to convince him that it was not a painting he had bought but a property consisting of more than 2,000 acres, nearly all of it forest, surrounding the ancient Château de Vauvenargues on the northern slope of the mountain. It had happened with vertiginous speed. At first sight he had been enchanted by the austere dignity of the ancient building, with its towers and robust masonry perched on rocks in the centre of a wild and beautiful valley. Its noble proportions and its rugged surroundings reminded him of a Spanish *castillo*, and its remoteness promised to make it the refuge he had dreamt of, far from the frivolities of Cannes. Not more than a week passed before Picasso found himself landlord of this great estate which carries with it the title of Marquis de Vauvenargues.

During the following winter while that bitter wind, the *'mistral'*, scourged the rocks and the pine forests with its icy whips, Picasso returned at intervals to see how the work of putting his new house in order was proceeding. The old caretaker, who had used her tongue with such efficiency in her attempts to bar his way when he first came to visit the property, opened the iron gates in great trepidation. 'Forgive me, Maître, for having been so rude,' she said, expecting those to be the last words before her dismissal. 'Not at all,' answered Picasso, 'you must always do that and even worse for the visitors.'

Once again Picasso had found space in which to expand. Removal vans arrived from Paris with his own paintings, and those that he had collected in the past by artists such as Le Nain, Cézanne, Matisse, Courbet, Gauguin, the Douanier Rousseau and many others. All of these had been hidden away for years and he greeted them as old friends released from prison. The bronzes from 'La Californie' arrived without their bases and were dumped along the drive just as they came out of the van. The long line of figures looked as though they had been drawn up ready to salute the arrival of their master. Furniture chosen in the antique shops of the neighbourhood, chiefly for its size and good solid workmanship, arrived to make the great whitewashed rooms habitable. If the chairs needed upholstery he had them covered with plain cloth and then painted them with designs which reflected the colours of a landscape dominated by the sun. He was also very pleased with his discovery of a ponderous nineteenth-century Henri II style sideboard

covered with elaborate carving which he placed in the dining-room. This piece, in company with his new dalmatian hound (Plate XXV, 6), found its way into some of the first paintings made at Vauvenargues. There was a common link between the haphazard scattering of black spots on the dog and the inept arrangement of the stylized carvings.

As usual when Picasso moved to a new place, his manner changed with his arrival. In the great salon, where the bust of a former marquis dominates the eighteenth-century overmantel, he began work on a new series of paintings. There were portraits of Jacqueline in violent reds, blacks and deep sombre greens with her features drawn with extraordinary economy and precision. To one of these he added significantly the inscription 'Jacqueline de Vauvenargues'.

In a series of still-lifes a lute and a large jar seem to court each other in a dance. The jar displays a new sign which might be called the signature of Vauvenargues. It is a sun-face with four curved limbs radiating from it in the manner of that ancient emblem, the swastika, or the astrological sign for Taurus with two horns added. The dominant colours, bottle green and reddish pinks, seem to have filtered in from the reflection of the sun on the bare limestone of the mountainside, the deep shadows of the pines, the lush grass of the meadows below and the ochre colour of the soil. There is water at Vauvenargues which two grotesque heads built into the masonry of the terrace spout into two great stone tanks, one on each side of the steps that lead up to the front door, a handsome feature designed by Portuguese masons in the sixteenth century. 'Portuguese or Spanish, it's all the same,' commented Picasso thinking probably of Velázquez and wishing to insist on the Iberian character of his new house.

The nobility both of the château and the landscape at Vauvenargues is such that the casual visitor, or more certainly a new owner, would be likely to become the victim of its grandeur, devoured by nostalgic thoughts about its ancient traditions, but Picasso entered as though it were his birthright, both as a peasant and a grand seigneur, and above all simply as an artist moving into a new studio.

For a while the influence of Vauvenargues revived in Picasso his most Spanish vein. When Kahnweiler warned him of the melancholy that could be overpowering in this lonely place, he replied calmly that since

he was born a Spaniard he was not frightened. In the spring of 1959, the first spent there, the paintings, whether they were portraits or still-lifes, echoed the severity of his native land and without doubt revived his earliest impressions of light and colour. There are also a few small landscapes of the village seen across the ravine, sheltering against the steep mountainside, which have nothing of the gentle restraint of French landscape painters and nothing easily recognizable of his great predecessor in this region, Cézanne.

But as Maurice Jardot remarks in his preface to the catalogue of the exhibition in Paris in January 1962, when over thirty paintings of this period were shown: 'The exaltation ceased suddenly: Picasso was to paint only four more pictures at Vauvenargues between 13 May and 24 June and only five during the years 1960 and 1961.'[1]

A Monument for Apollinaire

The tedious controversy between Apollinaire's friends and the authorities as to what would be the most appropriate monument to his memory[2] was finally resolved by the decision to accept Picasso's offer of the large bronze head of a girl, inspired by Dora Maar in 1941 (Plate XX, 3). All formalities and permits from official quarters were at last complete in the spring of 1959, and with due ceremony and genuine emotion a group of the poet's old friends, including Madame Apollinaire, André Salmon and Jean Cocteau, assembled to unveil Picasso's gift. The site chosen was the corner of the churchyard of St Germain des Prés facing the street, one of the shortest in Paris, which had been named 'rue Guillaume Apollinaire' a few years before. At last Picasso's tribute to the most eloquent and revolutionary friend of his youth stood modestly shaded by chestnut trees, backed by the walls of the old monastery and surrounded by children at play.

Figures and a Fountain

For several months Picasso had enjoyed making a series of sculptures

[1] *Peintures Vauvenargues 1959-1961*, Galerie Louise Leiris, Paris 1962.
[2] See p. 221.

which were to form a group of figures playing together (Plate XXV, 2). It was his intention that one of the figures was to function as a fountain in the same way as the Mannequin Pisse fountain in Brussels. They were originally constructed with batons of wood from packing-cases, empty canvas stretchers, broom handles and other scraps of material chosen from pieces lying about his studio. For many weeks these tall thin figures with tiny birdlike heads and angular gestures had stood around at 'La Californie', exchanging semaphore signals with each other. Then in the autumn of 1958 they reappeared cast in bronze and grouped as Picasso had intended but round an imaginary pool in the centre of the Galerie Louise Leiris. Later they were shown in an exhibition in New York where critics, excited by their originality and their comic stances, gave them an unusually enthusiastic welcome. Again, in the summer of 1960 they were exhibited more appropriately by the lake in Battersea Park in London.

Georges Salles had already shown his appreciation of what might have passed as frivolity by writing: 'All this would have been just slick, droll, carnivalesque if in the strangeness of these beings there had not been the throb of the most disturbing mystery: that of life.'[3]

More Exhibitions

In the early sixties there were many important exhibitions to add to the long record. Kahnweiler's unique position as an intimate friend and Picasso's dealer kept the Galerie Louise Leiris well stocked with a flow of work which could be shown to the public for the first time. Picasso's continuous output provided the material for five major exhibitions in the years 1959-62. In the first the entire series of the *Meninas* variations (see pages 418-24, Plate XXIV, 8) was shown, together with the landscapes with doves (Plate XXV, 10), those jubilant observations made from the balcony of his studio. The chronological hanging made it possible to follow the sequence of Picasso's thought and to enjoy, on the one hand, his playfulness in response to the subject matter – the child princess surrounded by her attendants – and on the other, the depth of

[3] G. Salles, *Quadrum*, 1958, pp. 4-10.

his insight into pictorial problems. It became clear that the series should not be considered only as a critical study of Velázquez's style but also as a panorama revealing new conceptions of time and space in relation to our vision.

Next came an exhibition of great vigour and gaiety, 'Forty-five engravings on linoleum', the result of experiments and discoveries that Picasso had made in the simple process of lino-cuts. With the aid of a young printer in Vallauris, whose craftsmanship became transformed by Picasso's powers of transmission, new methods of enriching this otherwise coarse technique were invented. We were presented with idyllic scenes: fauns, bulls and maidens dancing among upland pastures and swirling clouds, or the secluded intimacy of lovers.

Following this, in the autumn of 1960, there was an exhibition of drawings made during the two previous years. The main themes were the 'gallant *picadors*, favourites of the great ladies' and 'the encounter between the bull and the heavy horseman'.[4] Slender ladies with towering mantillas, witchlike peasant women and flamenco dancers surrounded the impassive *picador*, centre of all admiration, in an aura of flying skirts and provocative gestures. The drawings, masterly in their creation of movement and suspense, were once more a brilliant proof of Picasso's nostalgia for Spain and the ease with which he could communicate his passion to us. Never had the skill of his hand as a draughtsman and the invention of his wit been used with more cunning and with more success.

In 1962 two more exhibitions were added to this series. The first consisted of the paintings from Vauvenargues (1959-61) which I have already described and the second was a series of twenty-seven paintings begun at Vauvenargues and continued at the newly acquired mas Notre Dame de Vie. Picasso had once more taken a painting he admired and used it as a starting point of successive variations. This time he had picked the *Déjeuner sur l'herbe* of Manet, an event which could easily have taken place in the sunlight and shade of the water meadows of Vauvenargues (Plate XXV, 7). The composition of this landscape with figures had already been borrowed by Manet from Giorgione's

[4] Michel Leiris, Preface to Picasso catalogue, *Dessins 1959-60*, Galerie Louise Leiris, Paris.

painting in the Louvre, *La Fête champêtre.* But as usual the scene became increasingly transformed by Picasso's imagination, and except for the dominant greens the allusions to the original painting gave way to playful inventions. Manet's characters lived a new life improvised for them by Picasso.

It is not possible for me to mention here all the exhibitions that have taken place continually in many countries, but there are some major events that must not be forgotten. In the summer of 1959, thanks to the initiative of M. Gaston Defferre, senator and mayor of Marseille, an important selection of some sixty canvases covering all periods was shown in that city, the choice having been made by Mr Douglas Cooper with Picasso's cooperation. The day before the opening Picasso for once overcame his aversion to seeing exhibitions of his own work. He found among many paintings he had not seen for years the portrait of a woman he had painted in Madrid in 1901, which had spent many decades in the vaults of the Bellas Artes museum. So many years had passed that even he had forgotten the colour of the lady's skirt.

The following year, 1960, it was London that honoured Picasso with the most representative exhibition of his paintings that had yet been assembled. The Tate Gallery gave up more space than it had ever before allowed to a single artist and the 280 paintings, ninety of which were lent by the artist, included early works such as the *Girl with Bare Feet*, painted when he was fourteen, the *Demoiselles d'Avignon*, the great drop curtain for *Parade*, the entire *Meninas* series and ten superb canvases dating from 1900 to 1909, lent by the Russian Government. The response of the London public was overwhelming. Almost half a million visited the exhibition. Their reactions and those of the critics were in fact very different from the violent antagonism that had been aroused when the wartime paintings were shown only fifteen years before at the Victoria and Albert Museum. The press now acclaimed Picasso as a great genius and the Queen herself during a private visit spoke of Picasso as the greatest artist of this century. There was only one disappointment. In spite of the persistent encouragement of his friends, Picasso could not be persuaded to come to London. It was impossible to discover whether he dreaded more the acclamation and publicity that he was bound to receive or the formidable sight of his

whole life work presented to him in one great sequence. His own explanation however was summed up when he said 'Why should I go? I know them all, those paintings, I did them myself.'

A New Spanish Period

In his later years there was probably more Spanish spoken by Picasso than French, owing to a notable increase in visitors from Barcelona, Malaga and Madrid. Old friends such as Pallarés paid Picasso annual visits with his son, and Vidal-Ventosa kept in touch. Architects, poets, painters, publishers, dealers and museum directors came to pay their respects and to find ways in which they could interest Picasso in some project in Spain. The faithful and indispensable Sabartés for some years was active in finding support in Barcelona for the foundation of a Picasso Museum. He succeeded in obtaining the fifteenth-century palace of the de Aguilar family in the calle Montcada near the centre of the old part of the city where Picasso had spent his youth. In Malaga a plaque was placed on the house in the plaza de la Merced where Picasso was born and the installation in an ancient palace near by of a well-documented collection of Picassiana was also begun by Sabartés.

For years Picasso had had the habit of presenting to Sabartés a special signed copy of every print he made and these were added by his friend to the portraits, drawings and paintings he had received from Picasso over many years to form the first donation to the new museum in Barcelona. Sabartés's health had been deteriorating for some years but he was determined to see the work of his friend to whom he had been devoted for more than sixty years installed permanently in the city of their youth. It gave him great satisfaction to follow closely the progress of his ambitious project but when finally the museum was opened his weakened condition and failing health prevented him from being present. Soon after his death in February 1968 Picasso made a gift in his memory of the entire series of the *Meninas* paintings to the museum and he continued to set aside copies of his engravings still dedicated to Sabartés as though he were alive.

The difficulties in obtaining official consent from the Government for the establishment of a Picasso museum in Spain had been

considerable but by tact and determination Sabartés and his Catalan friends succeeded in building up the nucleus of a collection which it would have been scandalous to refuse and in negotiating the transfer of twenty early paintings, some of them given by Picasso and some acquired before the war, from the municipal museum in Barcelona. They also won the support of the municipality and persuaded the mayor to inaugurate the Museo Picasso.

Barcelona was always the city in Spain for which Picasso felt most sympathy and when a group of young architects asked him for designs for the decoration of a new College of Architecture that was being built in the old part of the city close to the cathedral, he agreed to help. The designs he produced were large line drawings inspired by the traditional Catalan dances and festivals in which he had taken part in his youth. They were drawn to scale, so that they could be reproduced on a wide band of concrete that extends across the façades of the building. The lines were incised into the surface by sandblasting – a technique perfected and executed by a young Norwegian artist, Karl Nesjar, who has since produced monumental sculptures and reliefs from Picasso's designs elsewhere in Europe and America. The decorations at the College of Architecture were unveiled in April 1962.

Picasso's new Spanish period had also led in 1960 to the publication by Camilo José Cela, himself a poet, of three fragments, the first to be printed in Castilian in Spain, from a long poem, '*Trozo de piel*', written by him during the winter of 1959-60, and for the first time since the Spanish war Picasso lent paintings from his studio to an exhibition in Spain. This took place at the Sala Gaspar in November 1960 and gave the people of Barcelona their first opportunity to see some thirty of his paintings representative of many different periods.

But perhaps the most convincing evidence of Picasso's sense of loyalty to Spain, or more precisely to Catalonia, came in March 1970 when it was officially announced that he had made an important donation of his early work, which had been in the keeping of his family and had therefore never left Spain, to the new museum in Barcelona. Later on I will speak of this in more detail.

A Secret Rendez-vous *and Public Celebrations*

When it was announced in reputable newspapers on 14 March 1961 that Picasso had married Jacqueline Roque, most of his friends, including those who had long wished that this might happen, believed it to be no more than a rumour. They were wrong. It was in fact on 2 March that the marriage had taken place without ceremony at the Town Hall in Vallauris, and for ten days no one but the communist mayor, a devoted admirer of Picasso, and two witnesses had any hint of what had happened. For once the flood of publicity and congratulations had been successfully kept in control.

Six months later however Picasso was to celebrate his eightieth birthday and for this occasion he decided to enter wholeheartedly into the festivities that had been planned for him. In spite of rumours that he was sick and confined to bed, which kept visitors at a respectful distance until the day arrived, he set out to enjoy it all to his full capacity.

The little town of Vallauris gave itself up to rejoicings on a scale which might be compared to a holy feast in Renaissance times. Four thousand invitations in the name of M. Paul Derigon the mayor were sent out, announcing events which began in Nice with a Festival of Music, Song and Dance. Among the performers were the Russian musicians Svyatoslav Richter and Leonide Kogan, Gloria Davey of the New York Metropolitan, Antonio the famous flamenco dancer, and other stars from various countries, such as the conductor Markevitch. In an atmosphere which remained intimate in spite of the 6,000 spectators and the profusion of distinguished guests, the acts and applause went on till early morning.

The following day, Sunday, Picasso arrived before noon in Vallauris escorted by helmeted motor-cycle police with white gauntlets. With difficulty a path was made through the crowd to enable him to visit an exhibition of fifty of his own paintings. They had been carefully selected by his friends so that he could again see pictures which had been hidden from him in museums and collections for many years. The streets were crowded with admirers of all descriptions. In addition to those who understood his greatness as an artist were many who loved him as a man. Groups of enthusiasts who had come from towns in the neighbourhood with guitars to serenade him found themselves shoulder

to shoulder with foreigners from all parts of the world.

At midday Picasso was honoured at a lunch by the sea where a hundred of his friends acclaimed him with speeches in various languages and great quantities of presents. By this time the road back to Vallauris had become so hopelessly blocked that a long detour had to be made so as to arrive in time for the bullfight that was given in his honour in the spacious place des Ecoles. The matadors were his famous friends Miguel Dominguín and Ortega. Four bulls were killed by them with full Spanish ritual and in deliberate contravention of French law.

The official programme came to an end in Cannes where a great reception at the Palm Beach Casino was followed by a display of fireworks fit for an emperor. After all this activity Picasso was still in splendid form. Throughout he had shown his appreciation and enjoyment of this amazing display of affection and admiration. When it came to an end he was loath to let his friends disperse. Several were obliged to cancel reservations so as to accompany him in further conviviality. Finally when they had all said good-bye he at once shut himself up in his studio and returned to his work.

The homage offered to Picasso was not only local. In various parts of the world it was a welcome pretext for tributes to be paid in the form of exhibitions and special numbers of magazines dedicated to him. In the USA celebrations began on his birthday with 'Bonne Fête Monsieur Picasso', an exhibition of more than 170 works lent by southern Californian collectors at the UCLA galleries in Los Angeles. In the following spring a remarkable event was organized in New York. Nine art dealers cooperated in presenting exhibitions in their galleries, all contributing to the same catalogue and covering chronologically Picasso's work since 1895, with a total of 310 exhibits. At the same time the Museum of Modern Art put on an all-summer showing of its great collection of his paintings and sculptures. This impressive tribute happened fifty years after Picasso's first one-man show in New York organized as a revolutionary gesture by Steiglitz and Steichen in the 291 gallery. In a half century the admiration for Picasso and his work had grown to phenomenal proportions.

While these events were bringing together magnificent displays of paintings, drawings, and sculpture in New York, it was announced in

Moscow on 1 May that Picasso had been awarded the Lenin Prize: a prize intended 'to strengthen the bonds of peace between all peoples'. The relationship between Picasso and Russian officialdom had always been equivocal. Although his affiliation to the French Communist Party and its respect for him, as well as his international fame, made him for many years a desirable asset, and in spite of the immense attraction that an exhibition of his paintings in Moscow in 1956 proved to be, there was always violent antagonism from official and academic quarters. In 1956 some fifty paintings on show had been borrowed from Picasso, thanks to the initiative of the poet Ilya Ehrenburg; the response of the younger generation was one of great curiosity mingled with admiration. It is said that the exhibition attracted about a million visitors. Yet five years later officialdom seemed not to have progressed. Mr Khrushchev and his suite greeted with scorn the 'decadent' art of Picasso when they visited the exhibit of his work in the French Exhibition in Moscow as recently as 1961. However, by placing the onus of his fame as a painter on the judgement of foreigners and praising his opinions and his conduct as a man, *Pravda* was able to explain the official party line in these terms: 'All people of good faith will welcome with enthusiasm the award of the Lenin Prize to Pablo Picasso, the celebrated painter and the great humanist, whose name is known to hundreds of millions of people. His work can be seen in the museums of almost all the capital cities in the world... For Picasso, painting can be likened, as he himself says, "to a weapon both of defence and of attack in the war against the enemy": and this enemy is fascism.'

In contrast to this I will quote the headlines of an interview published in *France-Soir* at the time of his eightieth birthday in which he is quoted as saying 'Love is the only thing that is worth while.' Whatever the means, Picasso in fact made his conquest of the world.

15

Le mas Notre Dame de Vie
(1961-70)

A New Refuge

For a brief period Picasso had two homes some fifty miles apart, or rather two places for work, very different in atmosphere: one comfortable but overrun by civilization, the other austere and solitary. When the stimulus of Vauvenargues began to fade in 1960 he returned to Cannes. But the constant expansion of the tourist trade was by now encroaching on the villa 'La Californie' itself. Gigantic apartment blocks rose up between it and the sea, cutting off the view and even menacing the privacy of the garden and the house itself (Plate XXV, 8). For a while Picasso watched the siege with curiosity; the tall red cranes perched high on the great towers that would soon make his life intolerable appeared in some large paintings of the view seen by night and day from his windows. He did not seem annoyed that the idyllic landscape with the islands which he had painted only three years before was slowly being blocked out. With characteristic willingness to see things from every angle he said, 'Who knows? - perhaps they are beautiful.'

However, as the overcrowding became intolerable another solution offered itself. A villa providing ample space, which formerly had been a Provençal 'mas' came into the market and was bought without hesitation by Picasso. Situated on a hill near Mougins, it had the advantage of being sufficiently isolated although it was only some five miles from Cannes. Unlike Vauvenargues it was already in good repair and its position, at the top of a hill, gave it an impregnability which 'La Californie' lacked. The slopes of the surrounding hills, covered with trees, vineyards and villages, stretched down to the sea on one side and

rose to the bare ramparts of the lower Alps on the other. The continuous growth of new villas and apartments along the coast was still sufficiently distant to be inoffensive. On the crest of the hill above the villa stands the ancient chapel of Notre Dame de Vie which appropriately gives its name to the property.

Sculpture: Intimate and Monumental

With new defences of his privacy well in control Picasso settled with assurance into the cool spacious rooms of Notre Dame de Vie with its terraces of olive and cypresses looking out towards the Esterelle mountains and the walled hill village of Mougins. The sculptures that never found their final positions at Vauvenargues were brought here and again without any attempt at display they were crowded together in the vaults of what had been the entrance hall, joined by others, big and small. Among these were fragile cubist sculptures, some in poor condition, that had been retrieved after years in storage. Above them was hung an immense circular collage of the drawings of a thousand schoolchildren made in honour of his eightieth birthday. A more unexpected intrusion was the arrival of a present from the Antibes Museum of two full-size casts of Michelangelo's slaves. Their bonds seemed all the more intolerable when compared to the revolutionary freedom of the sculpture that surrounded them.

Sculpture again became one of Picasso's chief preoccupations. New forms emerged from a method he had used in the early days of Cubism when he had made sculpture out of sheets of cardboard and tin. The surfaces were flat or curved like the sails of a ship and completed with drawing and colour. In cubist sculpture the subject was usually the guitar, but in the 1960s Picasso took more often for his inspiration the classical profile and flower-like eyes of Jacqueline (Plate XXVI, 5). But there were other subjects such as birds, dancing figures, gods, shepherds, mothers with their babies, great bearded heads and even a chair (Plate XXVI, 7). Lionel Prejger who undertook to translate these fragile maquettes into sheet-iron sculptures tells how the chair was first presented to him as a large sheet of brown paper on which a strange octopus-like shape had been drawn. 'That is a chair,' Picasso told him,

'and you see there an explanation of Cubism. Imagine a chair that has been run over by a steam-roller, well, it would produce something like that.'[1] Picasso then cut out the shape and folded the paper along lines he had already drawn and the result was indeed a chair.

One of the important factors in the new sheet-iron sculptures was the use of the empty spaces between the painted surfaces. These appear to contain invisible form, even more convincingly than the wire sculptures of 1928-9. The painting of the surfaces helped to aid this illusion. Picasso in fact had never been so near to uniting painting with three-dimensional sculpture, a development which came inevitably to him from the years he had spent working in ceramics which were also a combination of the two arts.

As usual, Picasso did not limit himself to one method. Other sculptures more like ceramics were modelled in clay and sent to Paris to be cast. Figures also were constructed with flat pieces of wood, humble objects such as spoons or forks sometimes making their heads or hands. It often happened that he used the rough surfaces of wood in which the grain or the marks of the saw could be preserved faithfully when the constructions were cast in bronze. This direct use of raw materials contrasted strongly with the sculptures modelled in clay with a degree of sensitivity, such as *Head of a Woman*, 1961 (Plate XXV, 9). Again there is the *Man Running*, 1960 (Plate XXVI, 4), which combines a surface as nondescript and as natural as a pool of mud with the irresistible likeness of a man getting into his stride.

The sheet-iron sculptures opened up new possibilities for which he had been in search since he began the drawings and paintings for monumental sculptures in 1929.[2] They could be enlarged to a much greater size. Casting in bronze of small modelled sculpture is unsatisfactory if not ludicrous when the scale is greatly increased, but this does not apply to the smooth surfaces of metal sheets. The success of the first attempt to enlarge faithfully the *Woman with Outstretched Arms*, 1961 (Plate XXVI, 3), from a figure 14½ inches high to a second version 72 inches high encouraged Picasso and the next step, made

[1] Lionel Prejger, 'Picasso découpe le fer', *L'Œil*, October 1961, No. 82, p. 29.
[2] See above, p. 266.

possible in 1963 by a technique devised by Karl Nesjar, resulted in the same sculpture being built in ferro-concrete to a height of 60 feet in Kahnweiler's garden at St Hilaire. This was the first of a number of the monumental sculptures in which Picasso's painted sheet-iron figures were enlarged and constructed with his approval. The process, devised and executed by Nesjar, necessitated a change from iron to concrete. The figure was built in reinforced concrete with an inner core of pebbles and a smooth finish to the concrete. Then, wherever required, the outer skin of the concrete was penetrated with a high power jet of sand so as to expose the darker and rougher surface of the pebbles. In this way Picasso's drawings could be faithfully reproduced. The first experiment in this technique had already been carried out by Nesjar on the walls of the College of Architects in Barcelona and the St Hilaire figure was then followed by monuments in many different places. There is one at the entrance to the harbour of Kristinehamn on the Swedish coast, a second in the courtyard of a school in Marseille and another, a gigantic head of Sylvette, in New York near Columbia University, large enough to be in scale with the skyscraper buildings that surround it and adding to them a note of gaiety and splendour (Plate XXVII, 9). There are others in Amsterdam and Stockholm.

The Chicago Picasso

The obstacle that had prevented the ambitious projects of 1930 being realized was the lack of rich admirers willing to produce the necessary funds. This had now disappeared. Picasso's work was eagerly solicited even by official bodies. In the spring of 1963 I was asked by a group of architects from Chicago to help them to approach Picasso with a view to obtaining from him a maquette which could be enlarged to gigantic proportions and set up in the piazza in the new civic centre then being built in the heart of Chicago. Realizing the importance of this proposal I accepted for once the difficult task of helping them to gain Picasso's interest. I warned the three architects who arrived with a large model of the site and photographs of its surroundings that although Picasso might be tempted to consider the project there was no certainty that he would carry it out. Fortunately Picasso showed signs of becoming

involved at once and told the delegation that he was honoured that the two cities famous for their gangsters, Marseille and Chicago, should be the first to ask him for monuments. A group of enthusiasts in Marseille had in fact proposed that he should make a large sculpture for the old port. But in spite of the interest he had taken I looked in vain for a new sculpture which could have any relationship to the Chicago project during my subsequent visits to Notre Dame de Vie. Picasso had proposed that they should make an enlargement of the wire 'space' sculpture of 1928 which would indeed have looked magnificent against the background of the enormous glass-fronted walls of the new law courts that were being built, but the architects were obstinate, they insisted on an entirely new piece and wished for it to be in metal rather than a concrete version such as Nesjar could produce.

After more than six months of inaction my own estimate of the chances of success had begun to wane although Jacqueline assured me he had not forgotten Chicago, but when I paid Picasso another visit in the following spring I was delighted to find two versions, almost similar, of a very powerful head in metal which was unlike any former sculpture I had seen. More than one feature gave it great originality. An elegant central strip which became the profile and contained forehead, eyes, nose, mouth and chin was connected by a series of rods to two larger opaque planes that suggested great coifs of hair and between them was an open gap which had the shape of a head in empty space. This gap seen through the rods gave the magic effect of a head within a head (Plate XXVII, 1).

I asked Picasso at once if he had Chicago in mind when he had conceived this unexpected and enigmatic sculpture. His answer was sufficiently encouraging for me to cable my friends and a few weeks later a delegation of five architects arrived in Cannes. At that time, however, as I had warned them could easily happen, Picasso was not in a mood to see visitors however important their mission might be and after more than a week of patient waiting they were all forced sadly but respectfully to return home, with the exception of one William Hartmann, who was determined that we should make another attempt a few weeks later.

Picasso's reasons for refusing to admit visitors were varied. It was

often due to an overwhelming desire to continue his work undisturbed but less frequently the cause was that he was seized by a fit of misery and self-criticism that immobilized him in utter despair. So violent were these crises that Zervos, who had witnessed this phenomenon over a period of many years, told me that it was not possible for this mood to last in Picasso for more than two or three days, otherwise its sheer violence would destroy him. By the time we returned the atmosphere had changed completely. We were at once welcomed into his studio and it became clear that the new head was likely to become the maquette for the Chicago monument. Nothing was however certain. Picasso insisted that he might want to alter it and demanded an unlimited period to contemplate what he had done. He seemed particularly uncertain about its base and also about the scale in relation to people moving around it with the immense vertical cliff of a skyscraper as its background. He also understood at once that if it were to stand fifty feet tall there would be serious problems, including wind stresses, that engineers alone could cope with.

Another year passed and the maquette still remained in the same place in the studio becoming increasingly hidden behind new paintings and sculptures as though it would never emerge into the daylight. At the end of April 1965 Hartmann returned and together we received a warm welcome but it was impossible to guess what would happen next. For two consecutive days we visited Picasso without mentioning the sculpture and were agreeably surprised when on the third day Jacqueline said to Picasso without warning 'Would you like it put out of doors?' A thorough investigation of the maquette then began. The head was set on the ground while Picasso found small toy models of Don Quixote and Sancho Panza, which turned out to be the size required to give the maquette the scale of the proposed monument, and Hartmann calculated the direction from which it would receive the midday sun, but instead of skyscapers for a background we had to content ourselves with olive trees and the low stone wall of the studio.

Picasso became very alert and determined to try out new positions for the head which we were already admiring as we looked down on it with its shadow cast on the gravel, realizing that people would often see it at this angle from the upper floors.

A tall iron cylinder was produced and set up with the maquette on top of a small cross-legged metal table. Hartmann then reminded us that the monument could be placed in a formal pool which suggested to Picasso the idea of making it a figure with long arms that could dangle in the water. Long straight pieces of wood were produced which turned out by chance to be the right length and Picasso rapidly cut out of cardboard two large clumsy hands which put everyone in good humour. Monsieur Thiola, the metal worker, who had cut and welded the steel maquette was then sent for. He listened eagerly to Picasso who explained with great simplicity how the limbs were to be made.

Next day the arms were ready. Thiola fixed them to the base of the maquette and the whole complex was again set up, this time beside Michelangelo's slaves in the studio. We gazed up at the head now balanced high above us on its cylindrical body with grotesquely thin arms dangling their enormous hands in the imaginary water. We laughed together at the surprisingly provocative effect this assemblage had produced and discussed the probable reactions of the people of Chicago about which Hartmann was unexpectedly sanguine. Picasso was enjoying it. The more extravagant the suggestion the more eagerly it was discussed. It was as though he were playing a game in which the rules had still to be made and he was determined to try anything out. At the same time he was continually asking our opinions and listening attentively to suggestions. Then suddenly the game was over. He decided – and it may be he had known it throughout – that the right solution was to place the head on the ground supported only by a low plinth. In this way it would be more accessible, more in touch with the people who were to live with it and its sheer height rising from the pavement of the piazza itself would become all the more impressive. The head would be more like a habitation than the remote crowning feature of a statue.

The maquette was then dispatched to Chicago where the architects and engineers concentrated on the problems that its achievement as a monument fifty feet high would involve; and in the summer of 1967 it was unveiled by the mayor of Chicago and William Hartmann in the presence of a vast crowd of spectators and the massed bands of the Chicago fire brigade (Plate XXVII, 2). One of the main concerns

inevitably had been the funds necessary for the construction of the monument and the payment to Picasso of at least a token fee. From the time of their first visit the architects had inquired tactfully what he would want as payment but Picasso had brushed this aside saying that he never bound himself by commissions and in any case the important point for him was to produce the sculpture rather than talk of money. The final result was that after three local charitable foundations, including the Art Institute of Chicago, had agreed to finance the project there was enough money to pay for the cost of construction and offer Picasso a generous fee. Hartmann returned to Mougins delegated by his friends to describe to Picasso the great ceremony with which the monument had been unveiled and tell him of the enthusiasm with which it had been welcomed not only by intellectuals and artists but by the people of Chicago themselves. They had been stimulated not only by its vast dimensions but also by the freshness and originality of its conception. There were long debates as to what it signified. Some claimed it was a bird, others the head of a woman but its ambiguity did not diminish the splendour of its form, a symbol of a new and poetic idea conceived in cor-ten steel, a material which was thoroughly in keeping with the mechanized city of which it was now the symbolic centre. There was however a danger that its effect might become diminished if with time it became too thoroughly integrated with the building against which it stood, which contains the same metal as its framework.

Picasso accepted modestly the congratulations that were offered but when Hartmann presented him with a cheque for $100,000 as a token of their gratitude he refused it categorically saying he wished the sculpture to be his gift to the people of Chicago. In this way it will remain as a unique monument to his greatness and his generosity.

The monument for Marseille on the contrary did not materialize. Those who promoted the idea and found a site by the old port had not the same flexibility in their ideas. Their insistence that it should be a sculpture in marble from the Mediterranean did not inspire Picasso. As a substitute however a great sand-blasted sculpture executed by Nesjar stands against the sky in the playground of a school.

Painting: The Artist and His Model and The Sabines

On his return to the comforts of Cannes in 1960 Picasso's interest in his surroundings shifted its focus. The brilliant contrasts between the hard white limestone of the Mont Sainte Victoire dappled with the shadows of pines and the luscious secluded water meadows at Vauvenargues had provided him with a setting for the variations on the *Déjeuner sur l'herbe,* but his thoughts then returned to an inexhaustible theme, the artist and his model, which had preoccupied him periodically for many years (Plate XXVI, 6). It was a subject which allowed him to express with great freedom his perpetual interest in the multiple significance of the female nude, the fascination she exerts over her companion and her archetypal relationship to the landscape itself. It also carries with it for Picasso a suggestion of the snare into which this situation may lead the over-zealous artist. He often presents the painter as a more or less ridiculous character absorbed in himself and his artistic hobby or even overcome by sleep rather than possessed by a passionate effort to interpret his enigmatic subject. The restricted, academic approach to this eternal problem and the banalities it can produce had already been examined as part of the theme of the sculptor's studio engravings of 1933 and in an even more devastating way in the 180 drawings of the winter of 1953-4. In the 'sixties it was developed with even greater freedom, an enjoyment of the pastoral surroundings which the artist is seen to have chosen for this task and more boisterous and at times more scathing humour.

But Picasso never confined himself for long to a single theme. In 1963 he painted a series of canvases, large and small, of a classical subject, *The Rape of the Sabines* (Plate XXVI, 9). which introduced again an element of violence but without the same pitch of anguish as *Guernica.* The hysteria of armed men and horses riding over the women and children who are their prize and their victims seems almost naïve in comparison to the impersonal horror of modern warfare. Some of these compositions of struggling figures, such as that in the Musée d'Art Moderne in Paris, have the nostalgia of scenes from Homeric battles but others, painted like *Guernica* in monochrome, are more sinister and centred on the magic power of the horse, a horse that charges with fury

towards us out of a turmoil of armed men and naked women bringing with it the overwhelming terror of a nightmare.

During this period Picasso found other more lyrical subjects, such as a nude girl playing with a black kitten (Plate XXVII, 3), boys eating water melons and an occasional landscape inspired by the view from the windows of Notre Dame de Vie. They demonstrate that Picasso was in no way losing his vigour nor his capacity to see every day the world around him with fresh eyes. There was also an increasing freedom in his use of paint which seemed at times to flow with complete spontaneity and yet miraculously had the power to evoke precise images. Michel Leiris, in his preface to one of the many exhibitions held during these years at the Galerie Louise Leiris, quotes a phrase that he found written by Picasso dated 27 March 1963 on the last page of a sketch-book 'sumptuously' filled with drawings. 'Painting,' he wrote, 'is stronger than I am, it makes me do what it wants.' In answer to this Leiris wrote

without doubt Picasso today does *what he wants* with an art which, on another level, compels him to yield to it. But is it not as though painting, having become life itself to him, more than ever makes him its vassal? Caught by the game of which he is leader, this artist of such rare stature that the term 'genius' belongs to him finds himself, somehow, expelled from himself by an art which becomes his master at the very same time he masters it. It is the ambiguity of such a situation, difficult to tolerate, which the brief and paradoxical confession of the 27 March 1963 seems to reflect, where that which appears as a victory to the eyes of others is presented as a defeat.[3]

The problem of the artist and his art comes as a direct consequence of the problem of the artist and his model but it is more fundamental and lies at the origin of all Picasso's painting in his last years. Now that he had outlived so many of his friends, those such as Braque, Cocteau, Reverdy, Breton, Giacometti, Zervos and Sabartés, all of whom had died within the last decade, he had, in the loneliness of old age, become more of a recluse. His work had become more completely the sole purpose of his life and at the same time the image of the outer world and of his inner self. Nourished by a richness of accumulated memories it was made fertile by his incredible ability to use whatever technique he

[3] Michel Leiris, *Picasso, Peintures 1962-1963*, Galerie Louise Leiris, Paris.

might choose. But to pretend that it is possible to decipher from his work the highly complex process of his thought, both logical and contradictory and the rich variety in his emotions and intellect would be presumptuous. The quotations of Eluard and Ribémont Dessaignes with which I began this book: 'I speak of that which helps me to live' and 'Nothing that can be said of Picasso is exact' still express the truth.

Drawings

There are unfailing pleasures and a great wealth of knowledge to be found in the drawings of Picasso. It is a medium which he used continuously with a flow of invention which never ceased. Drawing for Picasso is not merely a preparatory exercise as it is so often for other artists. When he draws his imagination never fails to provide him with a rich variety of themes and a multitude of characters who have been his familiars for many years. They present themselves to him, demand his attention and then act a charade for his entertainment and consequently for ours.

Picasso once showed me a drawing of a group of various members of a family who seemed to belong to a Balzac novel, but I expressed my surprise at finding that Jean Cocteau had slipped in among them. 'Yes,' said Picasso, 'I don't know how he got there, he came in without being invited.' It was easy to recognize Cocteau whereas with the others their presence seemed so real that I felt certain that I knew them but could not think of their names. This same sensation is usually aroused by the appearance of all Picasso's characters whether they be fauns, musketeers, urchins, old bearded shepherds, lawyers, clowns or above all women whether they be glorious in their nudity, dressed with the utmost frivolity or old, emaciated, and draped in rags. Among them there is often a small figure, aloof but watching with dark penetrating eyes. Never twice the same, he is sometimes old and wrinkled with the burden of having lived, sometimes young and malicious, but his persistent appearance in such intimacy suggests that he corresponds to the multifarious spirit of Picasso himself.

In his later work the old man, often made to look ridiculous, appears more frequently, sometimes as the ageing artist and at others as a senile

Peeping Tom. It would however be an absurd misjudgement should we limit these references to old age in the drawings to an admission of impotence, a supposition made by several critics at the time of the exhibition of the series of 347 engravings made by Picasso in the summer of 1968 (Plate XXVII, 10). Throughout the sequence of wildly erotic love scenes between Raphael and his model, La Fornarina, there is present in every engraving an old man sometimes crowned as the pope and at others with a dunce's cap. Critics who take the easy line of interpreting this figure as a symbol of the artist's impotence are biased or ignorant. Picasso draws as he thinks and as he lives. The whole drama of love, life and the inevitability of death is present due to his own participation in life, combined with an Olympian detachment. In latter years his imagery had never been richer and more universal nor had his technique ever been more vigorous and inventive. Every line or stroke of the brush was the signature of his inner being revealing the full scope of his emotions, an extended self-portrait surpassing the limits of time.

It is in his drawings also that we can appreciate best Picasso's ability to convey the infinite variety of expression in the human face. It is all the more interesting to find this quality at a time when talent for portraiture is neglected if not non-existent among most artists of this century. In the thousands of faces Picasso has drawn, each one has its personality and its own life. Those magic communications which flow between us through our eyes and facial expression become alive with a surprising economy of lines, smudges and dots. Their look can be penetrating or drowsy, savage or benign, bitter or laughing, quizzical or confident, lustful or saintly. It can be drawn with the realism of Ingres or stylized in geometric simplicity. Whichever method he chooses there is always a depth and a vitality in the expression which gives each face its unique character. His imagination provides us with an endless commentary on human nature.

A rare quality in Picasso's drawings and engravings which seemed to grow rather than diminish as he approached his ninetieth year was the firmness of his line in which no unwanted tremor or indecision is to be found. It is with a definitive line of the greatest purity that he gives form to an image on an empty sheet and brings to life the fleeting

expression of a face or the softness of flesh. This precision is however frequently allied to the exploitation of chance happenings, the smudge or blot that brings with it miraculously the imprint of life. The dimensions of the drawings never seem to interfere with their intensity. Picasso is equally at ease on very large sheets of paper and minute copper plates. He uses felt pens, thick crayons or needle points and pens used by engineers for precision drawings. Nor does the speed with which he draws or paints remain constant. When he embarked on the series of 347 engravings in the summer of 1968 he had the expert help of the brothers Piero and Aldo Crommelynck and the use of the press they had installed at Mougins. Even so they were hard put to keep pace with the speed of Picasso's output. But only a few weeks later Picasso adopted a different tempo, working repeatedly and for long periods on the same plate and examining patiently each proof that was brought to him before creating new effects. It would be difficult to find in the history of art a more extraordinary example of perfection and mastery of drawing in old age expressed with such variety and in such abundance.

Lino-cuts

Other techniques had continued to occupy Picasso. Intensive periods of painting were interspersed with other methods of expression. The banality of the lino-cut, a process which had first tempted Picasso in 1954, became exalted by his Midas touch to an art of great distinction. He discovered that by printing in strong colours from the same block, after cutting away the unwanted parts, he could overprint more economically and obtain a density of colour and texture which gave entirely new possibilities to the process as well as a subtle richness to the effects. To obtain these it was essential to see clearly from the start the consequences of each successive printing, because once the block had been altered by cutting away part of the surface there was no return. By this method he produced brilliant effects of light and darkness, rich arabesques and the wide expanses of sky and landscape. In general a lighthearted lyricism made possible by his new technique pervades the whole series (Plate XXV, 5).

On one occasion I found him with some large white sheets of paper

which had just been returned by the printer. Impressions in white printer's ink which were almost invisible had been taken on them from the block of a large lino-cut. This had not penetrated into the lines of a drawing incised in the lino which could still be seen faintly. Picasso, armed with a large pot of indian ink and a brush, asked me to accompany him and Jacqueline to an upstairs bathroom. With sweeping gestures he covered entirely each sheet of paper with the ink, and then handed them one by one to Jacqueline and myself to wash off under the shower. The result was astonishing. The black ink was almost entirely washed away from the surfaces protected by the white printer's ink, leaving only a grey uneven ground over the whole print, but it remained and stood out boldly where the indian ink had entered into the lines engraved in the linoleum. The process Picasso had invented was as simple as Columbus and the egg once you had seen it done and gave a unique and lively quality to the print. We now had before us a splendid image, a line drawing of a satyr struggling with a naked nymph. As I left I thanked Picasso warmly for being allowed to assist in the completion of this idyllic scene, saying that I enjoyed it all the more since in the picture the lovers seemed to be so ecstatically happy. To which he answered enigmatically with a smile 'Who knows?' (Plate XXVI, 8).

Engravings and Eroticism

Recently Jean Leymarie, whose untiring efforts had produced the great exhibitions in Paris in honour of Picasso's eighty-fifth birthday, said to him that his students wanted to know the difference between art and eroticism. 'But,' said Picasso with great seriousness, 'there *is* no difference.' Remembering the early sketchbook drawings made in Barcelona, his remark was consistent with his lifelong obsession for the female form. It continues to be apparent even when in 1907 he decided to abandon the 'indestructible' classical conception of female beauty and sublimate or distort the image of woman according to his choice. His uncompromising attack is explained by his assertion that fundamentally we love a woman rather than Venus and it is this that led him in search of a new realism in which the whole range of erotic reactions including

hate as well as love was to play a part. In the dismemberments and distortions that have followed, the question of the degree in which physical desire should play a part in his art never ceased to be of crucial importance. Since the art of Picasso is never abstract, even the most violent distortions have their origin in reality – and this is above all true when his subject is a confrontation between the sexes. In her preface to the English edition of the series of drawings made by Picasso in the winter of 1953-4 Rebecca West wrote: 'Anybody who looks at these pages [Plate XXIII, 4] and fails to realize that the model symbolizes sexual love must have led a dull life. But she stands for much more besides... The truth is that she symbolizes Nature: the living, visible and tangible world which we will hate to leave behind us when we die.'[4] Although Picasso chose to use in these drawings a more representational style than he had done in many of his paintings, his intention and his capacity to see deeper than the surface remained and continued to be present in the many erotic paintings, drawings and engravings he produced in later years. In the series of Raphael and La Fornarina (Plate XXVII, 7),[5] he goes far beyond the painting of Ingres from which the idea originated and handles the subject with Rabelaisian wit and relish, highlighting the physical nature of the artist's inspiration. Ignoring all conventional taboos the purpose of the embraces between these eager lovers becomes as clear as the scenes of copulation in the stone sculptures of the temples of Konarak.

There is an obvious reason why the eroticism of these engravings cannot be confused with commonplace pornography. The invention and unflinching candour of the drawing forces us to laugh, removing the image from the level of those who snigger from a sense of guilt to an admiration and enjoyment liberated from all ancient taboos. Picasso, by refusing to acknowledge a sense of sin, reinstates once more the natural virtue of the sexual act, innocent as the interlocking of male and female units in the hands of an electrician or the entrance of a badger into its hole in mother earth.

[4] *Verve,* Vol. VIII, No. 29-30. English edition, A. Zwemmer, 1954.
[5] Picasso, *347 Engravings 1968,* Galerie Louise Leiris, Paris, I.C.A. London and Museum of Modern Art, N.Y.

The artist has for centuries been required to draw a veil over, or adopt a substitute for, reality, but like Michelangelo, ancient Greek, Hindu and Far Eastern artists, Picasso was unable to tolerate such obvious hypocrisy. It is the nature of man to exist from head to foot as an integral being and an artist who has the power to do so should contemplate and represent him and his functions without shame as part of reality and as a celebration of our human condition. It is through the power of his poetic vision that in his old age, even more than in his youth, Picasso was able to banish hypocrisy and fear.

Unwelcome Ordeals

During the sixties Picasso sustained more than one attack on his equanimity. The least disturbing and most beneficial of them was an operation on his gall-bladder which took place at the American Hospital in Paris in December 1965. Just as the wedding had been held in complete secrecy, elaborate precautions were taken again so that he should not be disturbed by the press or by friends who might be too eager to console him. Picasso had known a full year before that he would have to submit sooner or later to an operation but he demanded that Jacqueline alone should be in the secret. When the time arrived even his son Paulo was told simply that he need not come to Cannes for his usual visit at the end of each month. As the only person allowed to know what was about to happen with all the risks involved, Jacqueline found her position very hard to bear.

Elaborately disguised, they boarded the night train for Paris at St Raphael rather than Cannes where he could easily have been recognized. At the hospital he was entered as Monsieur Ruiz and until the time that he was well enough to return to Mougins no one except Jacqueline and the surgeon, Dr Hepp, knew of his identity. This secrecy caused some resentment on the part of Paulo and his most intimate friends, but it was justified by the fact that his health was restored without any of the fatigue that even the most well-meaning visitors might have caused. He returned home delighted at the success of the operation in every sense.

A later event caused Picasso personal distress which probably left

lasting scars. In the autumn of 1964 Françoise Gilot published in New York, in collaboration with an American journalist, Carlton Lake, a book entitled *Life with Picasso*. It is her account of the years between 1943, when she first met Picasso, and in 1953, when she broke with him.

Even though she enters into her private life with Picasso in detail and narrates long conversations between them, Françoise Gilot does not reveal her motives in writing the book unless they are to warn other girls against his egotism. In his preface Carlton Lake speaks of his conviction that Françoise has an unusually accurate memory; 'total recall' is the term by which he describes it. His statement has weighed heavily in giving authenticity to the book just as the dedication 'To Pablo' on the flyleaf of the first edition had the effect of giving the impression that Pablo had been consulted. This dedication was removed from the French edition when in the following spring it was published in Paris.

Critics greeted the editions in America and England with mild disapproval of the indiscretion they saw in the public exposure of the private life of a great living artist by a disloyal former mistress, but almost without exception they praised the book for its revelations of Picasso's character and his inner thoughts set out in many long discourses.

Leaving aside the question of bad taste, it is above all on the accuracy of the conversations that the value of this book must depend. All those who knew Picasso agree that he never made speeches but let fall his most profound and surprising remarks in brief elliptical phrases which usually took the form of a paradox, or as ideas which he tested for his own satisfaction, punctuated by the interjection *'n'est-ce-pas?'*. So it is surprising to find in the book dissertations made by him rather in the style of a professor of art history. It was also strange to see with what trivialities and lack of understanding Picasso's closest friends such as Matisse, Braque and Paul Eluard could be dismissed. Picturesque accounts of the exploits of the Surrealists, such as the story of Michel Leiris's insulting behaviour to policemen, are highly imaginative and accounts of the actions of former friends of hers such as Kahnweiler, Madame Leiris and Madame Ramié savour of the animosity which is

directed in particular towards Jacqueline, to whom she had abandoned her place beside Picasso.

It had been usual for Picasso to disregard with Olympian detachment all criticism based on ignorance or deliberate misunderstanding of his way of living and his work. But in this case his reactions were instant and, for a short time, violent.

The French edition was first given widespread publicity by the publication of extracts in the magazine *Paris Match*, which provoked a protest signed by forty-four artists of distinction. They denounced the book for the 'evil quality' of the publicity it gave to private affairs and the impropriety of a mother laying bare to the public and to her children what should have been her most intimate and precious memories. The moral tone adopted is again irrelevant to the main issue of authenticity. But among the many comments published, Pignon made the following statement which owing to his long friendship and his knowledge of the unique way in which Picasso thought and expressed himself in conversation, carries much weight: 'This book also falsifies his language. Picasso never talked in the way he is reported to have done... it is grotesque, absurd.'[6]

It was unfortunate that the legal action taken by Picasso to suppress publication failed and tragic that the relationship between him and his children, Claude and Paloma, should have become so envenomed, apparently because of the book, that their estrangement from their father seemed to be complete.

For several years after their separation Françoise had agreed that the children should spend their holidays with their father. From 1954 onwards when Claude was six and Paloma four they were eagerly welcomed and tenderly looked after by Jacqueline, first at Perpignan and afterwards at 'La Californie'. To all appearances they were developing happily and able to accept a life shared between Françoise and her new painter husband Luc Simon in Paris and their father's household sustained by the warmth of Jacqueline's presence in Cannes. In order to ease the situation Picasso gave his name legally to both children. But after the legal action brought by Claude in 1969 against

[6] *Arts*, Paris, 28 April 1965.

his father in an attempt to assure his own inheritance there seemed no possibility that relations between them could ever be the same again.

Another event that caused Picasso considerable annoyance was the loss of the great rooms in the house in the rue des Grands Augustins where nearly thirty years before he had painted *Guernica* and where he continued to work tenaciously throughout the war. It was a great misfortune not only to Picasso but to posterity that André Malraux, who was at that time the minister responsible for the arts, was unable to prevent these splendid seventeenth-century rooms from reverting to municipal offices, since he had already shown his inclinations by declaring that so long as he lived Picasso would never be asked to give them up. However, through a succession of misunderstandings the possibility of a future museum in the place where Picasso had lived and worked in the heart of Paris was lost and he himself put to great inconvenience in the dismantling and rehousing of his possessions.

Homage to Picasso

During the 'sixties there were such a vast number of exhibitions of the work of Picasso in its many forms that it is impossible to give a full account of them all. There are some however that cannot be overlooked. The exhibition shown in Kyoto, Nagoya and Tokyo in May 1964 attracted enormous crowds. It contained 160 paintings, many borrowed from Europe and America and others lent by Japanese collectors. Among the visitors was Anastas Mikoyan, the First Deputy Premier of Soviet Russia, who happened to be in Tokyo at the head of a large cultural delegation. Having been asked if he was aware that Picasso was a member of the Communist Party Mikoyan answered 'of course I know and am proud of it . . . there are many great works in the field of the abstract. Many Soviet people are enjoying Picasso's works'. This revealed an attitude more encouraging than Khrushchev's only three years before.

In the same year an exhibition was organized with scholarly devotion at the National Gallery of Canada at Ottawa, while in New York the Spanish Government paid their first tribute by exhibiting several important canvases in their pavilion in the World Fair of 1964.

But understandably the greatest number of manifestations in honour of Picasso took place in 1966 in honour of his eighty-fifth birthday. The pace was set by Paris where five exhibitions opened simultaneously in November under the auspices of the Ministry of Cultural Affairs. A great exhibition of paintings took place at the Grand Palais. It brought together a well-chosen survey, from which *Guernica* was one of the few major works that were absent, and finished with twenty paintings chosen by Picasso from his work of the last three years. Very thorough exhibitions of sculpture, drawings and ceramics were shown across the street in the Petit Palais and graphic art was on view at the Bibliothèque Nationale. *'Picasso domine son siècle'* were the words with which Jean Leymarie began his introduction to the catalogue and there was no doubt that Paris was overwhelmed by the magnitude and the power of this great manifestation which Picasso himself, true to his tradition as a hermit, never saw.

It had not been easy for Picasso's friends, even with all the backing possible from André Malraux and the Ministry of Cultural Affairs, to gain the full cooperation of the artist. His impatience with exhibitions and the interference in his work that they brought put him in a cantankerous humour and it was only after critical moments of suspense that, with the help of Kahnweiler and Michel and Zette Leiris, Jean Leymarie found that a large quantity of work could finally leave Mougins for Paris. The section that needed the greatest cooperation and caused the most painful indecision on the part of Picasso was the sculpture. In the past his paternal feeling towards his sculpture had made it impossible to obtain more than a few pieces at a time for exhibition and almost all his production with the exception of those that had been sold as casts had remained in storage or more recently been crowded into his studio at Notre Dame de Vie. But after much persuasion he at last allowed his sculpture to go to Paris and even promised that it should travel afterwards to London and New York. This exhibition composed of more than 200 works came as a revelation. It was now possible to follow the development of Picasso's sculpture from the early modelled figures of the Blue period, through the cubist objects to the space sculptures in iron wire of 1930 and the hieratic bronze heads from Boisgeloup. Following these came the metamorphic

sculptures made during the war, coeval with the *Skull* and the *Man with the Sheep*. Later the painted figure constructions and the flat surfaces of the sheet-metal heads of Sylvette lead up to birds, shepherds, gods, goddesses and the portraits of Jacqueline which culminated in the maquettes for the monumental sculptures of St Hilaire and Chicago. Wit, invention and dexterity dominated throughout, freed of the two-dimensional restrictions of painting. No doubt remained as to the genius of Picasso as a sculptor and in their astonishment certain critics preferred him in this role.

The impact of the great exhibition in Paris was unprecedented. Crowds of Parisians and visitors queued for hours to gain admission and critics poured out their praise in innumerable illustrated articles. There were no shouts of disapproval as there had been in 1944. But as recognition grew and the anger of those who could neither understand nor stomach Picasso subsided so did the pitch of the ecstatic eulogies that had come so often from his admirers. Picasso had now taken his place in the eyes of the world among the great masters and, unlike many of them, had been given the highest honours during his lifetime.

16

Last Years
(1970-73)

El Entierro del Conde de Orgaz

On the 6 January 1957 Picasso embarked on a new literary fantasy. Writing in Spanish with coloured chalks, dating each contribution carefully and correcting mistakes emphatically, he continued to add to it when he was in the mood until with a decisive burst of energy on the 20 August 1959 he brought it to an end. Like most of his writings this work does not enter into any given category. It begins with the suggestion that it is to be a play rather in the style of *The Four Little Girls*. The dialogue opens between characters: 1,2 and 0 but on the date 12 January 1957 this manner is suddenly broken off with a note in French: 'On the stage the most complete emptiness...characters 0-00.' It is not until some months later that the fantasy begins again with the following announcement: '14.8.57. *Continuá el entierro del Conde de Orgaz*' ('Continuation of the funeral of the Count of Orgaz') but the invocation of El Greco's masterpiece in Toledo is used only to give a strong savour of Spanish tradition to all that follows. In his preface Raphael Alberti introduces the author thus: 'Here is the inventor of the entangled story or novel – of the entangled poem – of great entangled poetry – Pablo plants a sketch on the surface of a page and it grows into a whole population.'

For some years the manuscript of this strange invention lay fallow until in the winter of 1966–67, encouraged by the presence in Mougins of the brothers Crommelynck, Picasso made twelve copper-plate engravings to accompany the text and accepted the collaboration of a friend from Barcelona, the publisher Gustavo Gili, in making an edition which included not only the text, sumptuously presented and

with admirable typographic style, but also a fascimile of the manuscript and an additional unpublished engraving of 1939 as a frontispiece.[1]

The first finished copy that Picasso received was one that had been bound specially for him and delivered to Notre Dame de Vie in April 1970. His first act on its arrival was to adorn every blank page and much of the text with large and splendid drawings. He then dedicated this unique volume with its rare embellishments to Jacqueline.

Surprisingly the twelve engravings made specially to accompany the *Entierro* do not appear to have any direct relationship to the text. Among the characters who appear we find the grandee and recognize the naïve looks and weatherworn faces of the Spanish peasants but the figures that take the major roles are mythical – Venus, plump and provocative, jealously watched over by Cupid and a wild man sometimes threatening violently the tranquillity of a bourgeois family or sometimes overpowered and docile. The engravings describe graphically, and with great fluency, a story equally fantastic which runs parallel to the text but on a different plane.

A factor of great importance in the production of this work was the reappearance in Picasso's life of the Spanish poet Raphael Alberti. Born in Cadiz, he had been before the war a leader in the group of poets and artists who were decimated and dispersed by the Civil War. Among his closest friends were Federico García Lorca and Luis Buñuel and he had met Picasso during the 'thirties in Paris. After some twenty years of exile in the Argentine he returned to Europe and eventually settled in Rome. From there visits to Mougins were relatively easy and the reunion of the two Andalusians with so much in common sparked off a boisterous and fertile cooperation, stimulated by Alberti's enthusiasm for this 'language in vertigo. . . painting in vertigo' that he found in the *Entierro*. It at once became obvious that no one was better qualified to write the preface.

Feeling more detached in the world of literature Picasso did not find the same reasons for respect of style or rebellion in his writings that governed to some degree his career in the visual arts. It was in consequence easier for him to indulge in great unrestrained celebrations

[1] Picasso, *El Entierro del Conde de Orgaz*, Gustavo Gili, Barcelona, 1970.

of those things he found enjoyable in the vast resources of his imagination without diminishing the acuity of his attack on the absurdity and the false values that delude us often in our view of life. The *Entierro* has as its background his memories of his early life in Andalusia. It evokes the characters who impressed him as a youth by their traditions and their formality, or whom he saw standing solemnly round the dead Count in El Greco's version of the funeral. In imposing lists they are renamed, some with dignity and others as: Don Morcilla (Don Bloodsausage), Don Rato (Don Rat), Don Rugido (Don Roarer), Don Cano (Don Hoaryhead), but memories of the past appear more vividly in the family which invades the grotesque and 'entangled' theme – the flock of lecherous uncles, pious domesticated aunts, wayward girls and a multitude of doubtful ne'er-do-well cousins. All these are centred round the postman, his wife and an unsealed package without stamps which reappears occasionally as the elusive foundation stone of the whole story. 'This family', Picasso tells us on the last page, 'is an example to us and even today we come across many things, true and untrue, which must be taken into account so as to pass in review this *corrida* or primitive picture-postcard humanity.'

Alberti was not only fascinated by the richness of the imagery which is to be found in all Picasso's writings but also, in this case, by his use of language and his memory of the turn of phrase and flavour of Spanish as it is spoken in Andalusia. In the preface which is both illuminating and poetic in itself he claims that the author has created 'an invention without equal, a story or an entangled narration unique in the Castilian tongue'. He concludes by quoting from Picasso's text: 'And here ends the story and the fête. What happened not even the fool would know.'

Le Palais des Papes

A further demonstration of the undiminished vitality of Picasso took place in the summer of 1970. Yvonne Zervos, while paying a visit to Mougins with her husband during the previous autumn, had gained Picasso's consent for an exhibition of the paintings he had made during 1969. This production of one year amounted to some 165 canvases, excluding those that had already been sold, mostly large in size. In

addition forty-five drawings were to be included. The place they had in
mind for the exhibition was the Palais des Papes in Avignon, where on
the immense bare walls of the Chapelle Sainte Clementine and the
adjoining rooms, Yvonne Zervos had already organized an exhibition
including paintings by Matisse, Picasso, Braque, Kandinsky and Léger
in the summer of 1947. Unfortunately a few weeks later Yvonne died
suddenly, leaving Zervos himself to carry out this unique project before
he also died the following year. In spite of this tragic coincidence the
exhibition was one of the most convincing celebrations of human life
that has happened this century.

In spite of the grandeur of the surroundings and the unforgettable
traditions of papal magnificence the exhibition was displayed with a
complete lack of pretension. Picasso himself insisted that there should
be no frames. The canvases pinned to the bare masonry were spread
close together and often high above each other on the vast walls, giving
the effect of the fiercely coloured pages of the diary of a giant – a diary
that spoke of the intimate passion of Picasso who, to quote Emily
Genauer[1] 'at eighty-eight, is utterly and magnificently obsessed with
sex'.

Sex was indeed the dominant theme but although it was treated in the
majority of his latter works with continual reference to his love of
Jacqueline, its vigour and variety in Picasso's hands gave it the
significance of the universal life force (Plate XXVIII, 3 and 8). There were
nudes whose anatomies were composed with outrageous liberty which
recall archetypal references to nature, their genitals inviting as a cool
mountain valley and their breasts as tempting as ripe fruit (Plate XXVIII,
5). In their embraces and their copulation, man and woman become
melted into each other as one single being in the all-consuming act of
love. There was a brilliant series of the grandee, a scathing examination
of male vanity, in which Picasso's wit had never been more acute (Plate
XXVIII, 1 and 4). Pipe, sword, hat, beard, wig, ruff and robes of brilliant
colour are his attributes but often he is accompanied by Cupid perched
on the shoulder or cuddled on the knee. The painter also appears
closely entwined with his model, his brush or his male organ actually

[2] *New York Post,* 15 August 1970.

painting her bare flesh (Plate XXVIII, 8).

The selection of drawings of the same year was as astonishing as the paintings. Again sex was the prevailing motive and again the rich variety of styles and themes gave this section, in which youth and a gentle playfulness dominated, an irresistible fascination (Plate XXVII, 10). Among the *hidalgos* (Plate XXVIII, 1 and 4), dwarfs, sleeping girls and the wizened duenna, Harlequin made an unexpected reappearance, having dropped out of Picasso's repertoire with the portraits of Paulo in 1924 (Plate XXVIII, 2). But here he was no longer the elegant entertainer nor the wandering outcast of the Blue period. His attitude was truculent and the wand he carried had become a bludgeon which he flourished aggressively, threatening his timid pierrot-like companion. Picasso willingly admitted to me this change in the character of the new Harlequin but he did not offer an explanation; he merely insisted that the stick, which is also prominent in the harlequin of Cézanne's *Mardi Gras*, was traditional and not his invention.

The Great Collage of 1937 Becomes a Tapestry

The collage made in the winter of 1937-8 with the intention that Madame Cuttoli should have it made into a tapestry, as she had done with many other designs, proved for years to be a task too formidable to be tackled because of its size and the intricate detail of maps and wallpaper patterns that it contained (Plate XVIII, 6).

However, through the persistent devotion of Pierre Baudouin, the Gobelins state tapestry works, after two years and eight months' work, produced an admirable replica of the collage, in which every detail, even the ragged edges of torn paper, was faithfully reproduced. Baudouin was charged by the Government with the delivery of the tapestry to Picasso at Notre Dame de Vie as a present. It arrived one evening in June 1970 and was spread on the gravel in front of the house, since there was no wall big enough to hang it. From his balcony above Picasso admired with his friends the great skill with which more than thirty years after its creation the collage had taken the form for which it was intended. During the process of weaving the tapestry Baudouin had

brought some of the black and white photostats made for working purposes for Picasso to see. He was at once so pleased with the effect that at his suggestion the Gobelins factory offered to make a second monochrome version of the collage.

There was no doubt that Pierre Baudouin had scored a great success and had been placed in the important position of presenting the finished work to Picasso on behalf of the Government. It was in consequence a surprise to me to find when I visited Picasso the following day that a serious drama seemed to have arisen between them. As I entered I found Picasso seated at the round table which had been for years the centre of his business and social life, with Baudouin and Madame Ramié facing him; all three had tense expressions but particularly Baudouin who had become alarmingly pale. As I sat down Picasso turned to me with a letter saying in a provocative way: 'Here, you are a lawyer, read this.' The letter was the official statement of the gift of the tapestry to Picasso and the request that a second copy should be made which would remain the property of the State. All it needed was Picasso's signature. Saying I could see nothing particularly awkward in their request even though, as he knew, I was not a lawyer, I handed it back.

'No,' replied Picasso. 'It is I who am awkward. I am always being asked to sign and once I've done so they do what they like. No, I can't sign. They will make as many copies as they want to and I, what do I get? I've already given them quite enough by allowing them to make the tapestry.'

The situation was not promising. Baudouin and Madame Ramié both looked very worried; they knew that when Picasso was in an obstinate mood there was little hope of softening him, and Baudouin's reputation was at stake if he failed to return to Paris with the signature. He tried patiently to explain that only two more copies were to be made, one in colour for the State and the monochrome copy for Picasso himself, but as soon as it seemed to be undeniably clear Picasso would change the subject, only to return to it a few minutes later where he had begun.

Finally, after some half-hour's arguing and jumping from one subject to another, during which I had the impression that he was enjoying the agony he was causing in his friends, and the final rejection of the idea of

asking the advice of his solicitor because the solicitor might advise him to sign, Picasso said firmly: 'Very well, I shall ask Jacqueline to decide.' The question was put to her as she came into the room. She sat down quietly and answered: 'No, I shall not tell you what you ought to do. If I tell you to sign you will not sign, and vice versa. You have made fun of me in this way often enough.'

The game seemed to be lost. With Baudouin watching eagerly Picasso took up a piece of blue chalk saying, 'Well, I sign', and then found a succession of pretexts for not signing. Finally it all came to an end. The document was signed and pocketed by Baudouin who made his excuses for a rapid departure with Madame Ramié. I was now left alone with Picasso who turned to me with the delighted smile of a schoolboy who has succeeded in enraging his elders and said, 'You see – you are too young to understand.' I realized once more that life around Picasso was always kept by him in a state of tension and the role Jacqueline played was often extremely difficult, demanding at the same time firmness and tact. Later that day, she agreed with me that he had only been playing a game, perhaps at the expense of his friends, but also that it was necessary to be as robust as him in health in order to appreciate it.

It has always been said that to live with a genius is intolerable for any woman unless the perpetual aggravations that arise are not more than counterbalanced by love. There is no doubt as to the high degree of devotion that Jacqueline had for Picasso but she also knew that it was not enough to wait on him and sit at his feet in adoration. There was an increasing burden of responsibility for decisions being passed on to her. When Picasso himself failed to make up his mind she was often obliged to reassert her independence and pass back firmly the onus to him. There was a suspicion among those who wished to visit Picasso casually, as was possible in the past, that it was due to Jacqueline that they were refused, since frequently they had recognized her voice on the phone, but anyone who was present would know when the phone rang and some acquaintance asked to speak to Picasso or call on him, how unjust this accusation was. The quick mercurial changes that happened in Picasso's moods and often in his attitude towards those around him were often responsible for his refusal to see an old friend for weeks together and equally for the overwhelming charm of the welcome they

received when finally they entered. The stabilizing presence of Jacqueline had been a vital factor. She had learned through years of patient observation to know how to watch over his diet, keep order in the house, provide him with the variety of attentions he needed and remind him even of trivial details such as the time of the all-in wrestling on television which he watched eagerly, fascinated by the grotesque contortions in which athletes entangle each other. Her devotion imposed on her increasingly a life of seclusion in which the presence and charm of her daughter Cathy, and the visits of friends, kept open her only contact with the world at large. She had become not only the great lady of Notre Dame de Vie but the main influence in the continued life and vitality of Picasso himself while at the same time she remained the source of his inspiration.

The guests who were accepted attracted Picasso's interest for a variety of reasons. There were his old established friends and those who visited him, such as the Crommelynck brothers, Karl Nesjar, the poet Alberti, and publishers, photographers and architects who had a mutual purpose in some project in which they were helping him, and with them Picasso became deeply absorbed in technical matters. But there were others whose company was desired for their talent. The photographer Lucien Clergue, who had succeeded in obtaining some cooperation from Picasso in making a film, brought with him one summer evening the four gipsy guitarists from the Camargue, the Maniñas de Plata, and until early morning the house resounded with flamenco music while Picasso and Jacqueline handed round wine and food to their guests. But the strangest noise to be heard that night was the hollow scratching of Picasso's penknife as he signed the guitars of his enthusiastic guests.

It had now become rare for Jacqueline to succeed in persuading Picasso to leave his home. Occasional visits to restaurants near by and token visits to the dentist in Cannes were among the few excuses for an outing. Picasso had all he needed within himself and his home; he did not need to go out into the world and in consequence in the degree that he wished to tolerate it, the world came to him.

The Museo Picasso

There was evidence during the latter years of his life that the Spanish Government had begun to feel that they had much to gain if they could by a show of goodwill entice Picasso to return to Spain. Various gestures and overtures had been made, such as the inclusion of his work in the Spanish Pavilion at the United States World Fair in 1964 and again in the following year. A rumour was widely circulated in the press in the autumn of 1969 that the Spanish Government had at last succeeded in persuading Picasso to present *Guernica* to the new Museum of Modern Art in Madrid and that a gallery was being prepared to receive it, although this would have meant that the Government of Generalissimo Franco were prepared to accept the very painting which had so eloquently perpetuated his guilt. But no such transaction was contemplated by Picasso who repeated stubbornly that *Guernica* would only go to Spain when the Republic had been restored.

The announcement in the spring of 1970 of the important donation that Picasso was making to the Museo in Barcelona came as a surprise to many, although it was clear that the gift was made to the capital of Catalonia rather than to Madrid. It was not difficult however to understand the motives for this gift. The works consisted of rough sketches, painstaking art-school drawings from plaster casts, water-colours and notes for set-piece compositions as well as oil paintings, some of considerable size, and portraits of himself, his family and his friends. None of them had ever been outside Barcelona except those dating from the early years when he had lived in Corunna or visited Malaga and Madrid. There was also a separate group of pictures, dated 1917, painted when Picasso came to Barcelona with the Russian Ballet. All these had been stored with his mother and his sister in their apartment in the Paseo de Gracia and after their deaths Picasso's nephew Dr Vilató became their guardian.

In the spring of 1970 Picasso gave his permission for the transfer of the entire collection to the museum which had been founded by the diligence of Sabartés and had already been enlarged by adding the adjoining palace in the calle de Montcada. In addition there was still the intention of acquiring yet a third house to accommodate all the riches

that were to come. Great activity followed and by the end of the year the major part of Picasso's donations, which included the *Meninas* series and the hundreds of new arrivals, were already on view, hung and lighted with great skill in the appropriate surroundings of Catalan Gothic architecture. It is in consequence a delight to study a collection which is so intimate, so complete and so revealing of the accomplishments and development of Picasso's genius. There are drawings dating from 1890 when he was nine years old which bear out his claim that he never drew like a child. There is an immediate mastery of form and movement – the toreador in the arena is tossed convincingly into the air – there is action and emotion throughout, shown vividly in gestures and facial expressions and a sense of reality which could not be suppressed by the tedious exercises imposed on him by the art master. Though the influence of his father dominates so clearly in the early years, even set pieces such as *Science and Charity* (Plate I, 4) seem, now that they have been cleaned and well lit, to have already the touch of a master.

It is however in following the development of Picasso's powers as a draughtsman and the growth in his imagination seen in the drawings that most satisfaction can be obtained. It is clear that the pressures with which he was surrounded could have led him safely into the banality of a successful academic career. There are studies which show him coping with great competence with religious subjects and battle scenes but his exceptional talent appears in its most surprising form in the thousands of sketchbook drawings. Picasso drew as he breathed, the means he used were vehicles for his thought. Images were crowded into the same sheet, sideways, upside down or in whatever way the urgency of his desire to draw compelled him. Sketches from life, people, horses, birds, ships became invaded by creatures and caricatures drawn from his imagination and his exuberant sense of humour. There are studies of detail: eyes, hands, ears, and abrupt changes in style and scale which flood the paper. He had already mastered Impressionism, as can be seen from landscapes in oil and water-colours before 1900, and yet he did not abandon classical realism. New discoveries were then a means of enlarging his field of expression just as they continued to be to the end.

The group of later paintings are mostly late-cubist figures or still-life,

including a cubist portrait of a dancer, Blanquita Suarez, exceptional for the movement of the figure and the head which is an early instance of profile and full face combined together in a way that suggests the ambiguity in the face of the dancer on the left side of *The Three Dancers** of 1925 (see Plate XI, 2, and p. 250). Also there are three important works which are in other styles: first, *The Balcony,* a view, with a sky that resembles pointillist or fauve techniques, taken from the window of a studio near the port from which could be seen that landmark the Columbus Column. The composition of the painting, in which the column stands as the central feature surrounded by the tufts of palms, dominated by the yellow and red colours of the Spanish flag, is prophetic of the many versions of the open window with a table in the foreground painted mostly at St Raphael two or three years later (see Plate X, 5). A second painting is a beautiful portrait, rich in colour, of a girl known as *La Salchichona* because of her agreeably rounded figure and the entertaining way she pronounced this word meaning sausage. Her mantilla and blouse palpitate with rich colour applied in a form of pointillism but the most disconcerting feature is the disparity between her eyes, both beautiful in form but catching and giving out light differently. Finally there is a large drawing, unlike any other work in the group, of a dying horse bleeding to death in the arena, which in its proportions and its expression is a very moving picture. For study and profound enjoyment the Museo Picasso can now rank as one of the greatest in the world.

A New Language

It has been said that, with age, Picasso became self-sufficient and withdrawn into a world of his own. In an interview published at the time of the exhibitions organized in Paris to celebrate the artist's eighty-fifth birthday, Claude Lévi-Strauss is reported to have said of his painting: 'Rather than bring an original message it expends itself in a kind of fragmentation of the code of painting. An interpretation of a second degree: an admirable discourse on the pictural discourse much more than a discourse on the world.'[3] This has been quoted by critics

[3] *Arts*, Paris, 16-20 November 1966.
* also called *The Dance.*

influenced possibly by a reaction against the present widespread admiration for the genius of Picasso or at least as a caution to those who have in their enthusiasm become incoherent in their praise.

It would be beyond my capacity to embark here on an exhaustive critique of the vast mass of commentaries that Picasso has called forth, ranging from the unstinted applause of devotees to the vicious attacks of jealous enemies. There is indisputably in the work of his later years a freedom, a virtuosity which is dazzling in its invention but which may disappoint the critic who is looking for subjects of political significance and who remembers *Guernica* and the deep anguish that emerges from both the painting and the accompanying studies.

The question arises as to whether we should always demand from a work of art the same intensity of content related to a specific theme or whether the enlargement of our appreciation of life through a more varied, more detached and even cynical approach may not be in the long run as profound and as valid when it emanates from an intimate association with the reality of nature.

Paul Eluard claimed that the poet was not so much inspired as he who inspires others. In a similar way Picasso always had at heart the desire to provoke emotion, to enlarge sensibility and to cast light into hitherto obscure regions by the use of the painter's special prerogative, the use of his own language of colour, form, image or symbol. This became clear to me in a conversation I had with him at the time he decided to part with that great canvas he had kept beside him for nearly forty years, *The Three Dancers*. I had said that I could think of no other picture that had any real affinity to it except perhaps the *Crucifixion* of 1930 and therefore I understand its unique importance. 'However,' I added, 'one of the factors that makes *The Three Dancers* so interesting to me is that one sees in it the first traces of *Guernica*.' Picasso looked at me with surprise and answered: 'Perhaps, but of the two paintings I much prefer *The Three Dancers*. It is more a real painting – a painting in itself, without outside considerations.'

In spite of the occasions when war and human sufferings demanded from him a more categoric statement, Picasso had an unshakeable faith in his art and in his capacity to shape it so that it would convey its most potent message. In old age it was far from being a 'second

degree interpretation'. His work still contained ruthless inventions as astonishing as those of *The Three Dancers* dispersed in hundreds of paintings and drawings, such as those exhibited at Avignon, but he was less anxious to concentrate all he had to say into one work; in fact the flow of his eloquence could no longer be contained in one masterpiece.

This ardent revolutionary who began by destroying the current conception of painting became in his lifetime the great enduring eminence, the champion of that art which some people consider to be a dying form of expression but to which he gave new life and a new direction. He widened its scope by introducing a new sense of time. Octavio Paz in a comparison between Marcel Duchamp and Picasso says: 'Duchamp set up a vertigo of delay in opposition to the vertigo of acceleration', and continues:

Picasso is what is going to happen and what is happening. Speed permits him to be in two places at once, to belong to all the centuries without letting go of the here and now. He is not the movements of painting in the 20th century; rather he is movement become painting. He paints out of urgency and, above all, it is urgency that he paints: he is the painter of time. [4]

'He is movement become painting' suggests that Picasso has a special ability to liberate movement which has been frozen in painting and sculpture ever since the running deer were literally immobilized in the caves of Lascaux and the discobolus was caught at the moment of hurling his disc. Traditionally the visual arts have had the power to render movement in timeless, static form. But already in Cubism Picasso introduced a new sense of movement in the simultaneous viewing of the same object from different angles, which implied that the spectator was on the move – a formula which endowed painting with a form of spectator participation similar to that which is physically possible in sculpture. The new conception was carried further in the movement, violently emotional but derived from Cubism, of *The Three Dancers*. It reappears in those heads where profile and full face are combined, implying movement between the two positions and this is developed even further in the free displacement of features and limbs which forces on the spectator a new agility in his imagination. The

[4] Octavio Paz, *Marcel Duchamp or the Castle of Purity*, Cape Gallard Press, London, 1970.

former static representation of movement gives way to a more active process in our appreciation of Picasso's inventions.

But there are other ways in which Picasso has revolutionized the conceptions of movement and time. For him the arts depend fundamentally on their negation of time, a negation which involves a unity between past and present. It is the same unreasonable and yet unquestionable unity that exists in myths and dreams. History and myth are the nourishment required by Picasso in his prophecies. Paradoxically he belongs to all centuries and yet essentially he belongs to ours, in which the future is more than ever unpredictable and threatening. At no point in his work do we find him searching for finality. There is no final solution. 'Finish a work! Complete a picture? How absurd,' he once said to a friend. 'To finish an object means to finish it, to destroy it, to rob it of its soul, to give to it the *"puntilla"* as to the bull in the ring.'[5] But in spite of his insatiable ability to vary his style, each painting is closely linked to those coming before and after in such a way that although they exist in their own right they also form part of a group like separate scores in the orchestration of a symphony.

There are many instances which can illustrate this focusing of ideas around a central theme, beginning simply with the 'Alleluias',[6] the sheet of humorous drawings organized like a strip cartoon illustrating Picasso's arrival in Paris in 1904. Later his insistence that the studies for *Guernica* should be kept together with the painting finds further echoes in the Palais Grimaldi at Antibes where a group of paintings, drawings and sculpture of the period when he was working there in 1946 were donated to the town of Antibes on condition that they should never leave the building. The series of 180 drawings which were the outcome of the misery he lived through in the winter of 1953-4 exist as an organic entity and should be read as the diary of his season in hell. Again it was his hope that all the variations on Delacroix's *Femmes d'Alger* of 1955 should be kept in the same collection and the fact that this did not happen became a factor in prompting him to present the whole of the *Meninas* series to the new Museo Picasso in Barcelona. The most recent proof that he had a purpose in keeping together all

[5] Picasso, *Works 1932-1962*, Galerie Beyeler, Basle.
[6] See p. 93.

related work was the exhibition in 1970 of all the paintings of the previous year in Avignon.

Picasso's conception of the relationship of his work to time is augmented by his ability to enter into the person of mythical characters. We have already noticed the ease with which he could associate himself with Harlequin, the Minotaur and reincarnate characters of ancient Greece or legendary Spain with authentic conviction. Time for Picasso has an englobing quality which belongs more to an epoch when man was not chained to calendars and clocks, and it is in this sense that his work becomes timeless.

All this is due to the revolutionary sense of time that always belonged to Picasso and which became more firmly established in recent years. It is an act of subversion which completes the negation of art by the dissolution of time. It results 'not in a measureless eternity but a vivacity equally without measure'.

Once while he was showing some paintings to friends Picasso remarked: 'You see, like all Spaniards, I am a realist', but he did not go on to explain just what he meant by 'realist' nor, the more easily answered point, why Spanish realism could be more appropriate to him than any other kind. I have tried to point out that in spite of his admiration for Velázquez's ability to observe and portray the world around him, Picasso found an interpretation of reality in his variations on *Las Meninas* which involved a deeper and more contemporary criticism of the reality of time and space, a criticism which demands oscillation between an appreciation of the object itself and its negation, between fact and imagination. We cannot say what the real really is. It is only through the dialectical process adopted by Picasso that it can be explored, by a continuous oscillation between the real and the unreal, between positive and negative. It is in this that Picasso finds his closest affinity with his compatriots, Goya, Cervantes and Góngora. It is this that unites him with them in a fundamental negation of time.

Conclusion

The story of the life and work of Picasso will continue long after his death. His power of regeneration has made him 'the youngest painter in

the world' because he never allowed himself to become the victim of his own success. The invention of new styles and techniques saved him even in old age from a hardening of sensibility and a weakening of the emotions. In his life his affection for his friends and his enjoyment of simple pleasures remained undiminished. In the diversity of his work there is a constant, unifying strain due to the strength of his personality, the firmness of the decisions that finally put an end to vacillation and doubt, and in addition the unfailing accuracy of his visual memory.

Consistency and continuity persisted in his thought and his work. The love of life that urged him to question and probe appearances in his youth remained unchanged and there was no question of a softening in his challenge to the conventional ideas of morality or beauty. He was never the enemy of beauty and the champion of the hideous as some would have us think. He shows us the diversity of forms in which both beauty and ugliness reside.

In nature beauty and ugliness are inextricably partners and Picasso's art expresses this throughout his love of nature as a whole. His love of nature is not limited, it extends to qualities that are conventionally despised. It is there that he has often made his most astonishing discoveries. He is the scavenger who unearths from the mud abandoned riches and the magician who creates Venus out of empty space. He was born with the philosophers' stone in his hand. There is literal truth in attributing to him the touch of Midas since, in recognition of his powers, every time his pencil touches paper the slightest scribble can have its value in gold.

If he had wished to take advantage of the material wealth he created, he could have ranked among the richest men, but even such fame bears no comparison with the riches of the spirit that he produced with such abundant generosity and which is of a quality that justifies his having said: 'Each picture is a phial filled with my blood. That is what has gone into it.'

The fame of Picasso is now undisputed and will long be remembered. The virtue common to all great painters is that they teach us to see, but few have had a more compelling way of doing so than Picasso. His power has enchanted those who are susceptible and enraged those who resent being disturbed by his brilliance. Art itself should teach us to free

ourselves from the rules of art, and this is precisely what the art of Picasso, unaided by theories, has done. It has freed art and in consequence it has freed us of false conceptions, of prejudice and of blindness. There is reason also to be grateful for the violence that he has used, for in our time, when signs of apathy and despair are easy to detect, it is only a resounding and decisive passion that can succeed. As he himself has said: 'The essential in this time of moral poverty is to create enthusiasm.' Without the awakening of ardent love, no life and therefore no art has any meaning.

Postscript

With Picasso's encouragement I began to write this book in 1954. For years I was obsessed with the idea that I was in contact with a man so vital and enduring that his actual physical presence could never cease to illumine my life. The shock and implacable finality of the news on the morning of Sunday the 8th April 1973 that he had died at first seemed incredible – another of those diabolic jokes he delighted in inflicting on his friends to test their perception of the uncertainty of our human condition. Slowly I realized that the only consolation that remained was the knowledge that beyond death his work would live and his influence would endure.

Although during the last six months of his life Picasso had become more than ever a recluse, concentrating on his work and seeing rarely even his closest friends, to his last day the flow of inspiration continued. His mind was clear and his physique, except for increasing deafness, seemed unimpaired. It was only the ultimate failure of lungs and heart in his great old age that snatched him away from his devoted wife Jacqueline and extinguished the legendary black fire of his eyes.

As the news spread across the world it was accompanied by a wave of homage in which even those who had formerly sneered at his achievements joined in an appreciation of his overwhelming genius. The immediate problem that became uppermost among his friends was what form of ritual could be considered appropriate in France where Braque, only a few years before, had been given the honour of official recognition, a funeral with military pomp. Knowing that ceremonies of this kind corresponded so little to Picasso's personal desire, Jacqueline, whose devotion had helped to prolong his life, and the eldest of his heirs, his son Paulo, took charge. They decided that he should be

buried in the remote seclusion of the Château de Vauvenargues with the greatest possible privacy. Keeping the press and even intimate friends at a distance, the cortege set out before dawn on this final journey to the ancient house at the foot of the Mont Sainte Victoire. But although unhindered by crowds of mourners the elements took it upon themselves to waylay dramatically its progress. A heavy fall of snow covered the flowers already abundant in the Provençal spring and a violent thunderstorm announced their ulitimate arrival. It was not until snow ploughs had cleared the way and pneumatic drills had been summoned to pierce the rock at the foot of the stone steps that lead to the entrance of the *château* that Pablo Picasso was finally laid to rest, watched over by Jacqueline, Paulo and the small group of chosen friends. Even his children by Françoise, Claude and Paloma, had to content themselves with a distant view of the ceremony from the mountain above.

The portents that accompanied Picasso on his last journey through the olive groves, vineyards, forests and rocks were symptomatic of the widespread emotional disturbances that happened simultaneously to many of his friends. Jean Leymarie, who was then in Japan, was struck with an agony totally inexplicable to him until he heard the news on the radio. But it was Michel Leiris who described the effect of this event most eloquently in his recent book *Frêle Bruit*. He tells us how, while taking his habitual Sunday walk in the country with his dog, he found himself suddenly struck in the face by half frozen snow stinging his head so painfully that it reminded him of stories of old people buried in snow drifts; this was then accompanied by a violent clap of thunder which made his dog leap into the air with fright. Nearing home the sudden threat of a savage fight between his own pet dog and the neighbour's followed. Finally outside his house there was a shriek from a child as two cars in collision scarred each other's coachwork and his wife unexpectedly ran out to meet him with three words on her lips, 'Pablo is dead'.

'Two or three days later', Leiris writes, 'I was to read the conclusion of a newspaper article by an art historian devoted to the departed Picasso and inspired by the portentous character that this

overwhelming announcement acquired when heard over the radio. He evoked in a few lines the legend according to which the passing of the pagan era to the Christian era was signified by a voice crying forth from no determinable source – Pan, the great Pan is dead!

'The end of a world or the beginning of another? This, I also believe, is just what it means. And I tell myself. . . it is the world that belongs to us – to my wife and me as well as to many others from now onwards – that has just received the stab of the *puntilla*. As though in warning, a cascade of different noises had struck my ears:

> thunder,
> > furious barking,
> > > clatter of sheet iron,
> > > > cries.'[1]

The grave is now surmounted by a massive female figure in bronze, a work of his which dates from 1933 (Plate D, 2). Erect she stretches forward a strong right arm offering emphatically an elegant vase of classical shape. The head leans forward rising from a powerful neck and ample breasts. It is at the same time birdlike and suggestive of a large ripe fruit, in harmony with the mature female torso. Although this ponderous shape is undoubtedly a head, Picasso had added a minute face incised in the original plaster which is indicated only by two punctilios for eyes, a small straight slit for the mouth and a 'V' making a beaklike nose. It seems that this addition was an afterthought because a rough sketch of it has been found on an old envelope with 1934 as the postmark.

When Picasso first modelled this enigmatic figure at Boisgeloup, it seems improbable that it could have occurred to him that one day it would become his funeral monument but, as so often happens with the passing of time, his works gain added significance.

In 1937 he had the sculpture cast in cement and placed with one of the gigantic female heads of 1932 (Plate XIV, 1) as a dominating feature outside the Spanish Pavilion at the Paris International Exhibition

[1] Michel Leiris, *Frêle Bruit*, Gallimard, Paris, 1976.

which was to house as its central feature the great newly-painted mural *Guernica* (Plate XVII, 1). It is easy to find in the emphatic gesture of the figure holding the vase a parallel in the woman in the mural who reaches out from a window with a lamp to illuminate the dark scene of havoc below, but from the empty vase there now springs a flame which in the sketch of 1934 we find already suggested by some vertical lines that emanate from the vase.

There is an important painting of 1937, *Bathers with a Toy Boat* (Plate XVII, 5), the general atmosphere of which is different from *Guernica*. In the foreground two women play in the surf with a toy boat. But this apparently tranquil and innocent pastime is dominated by the appearance of a gigantic head which rises mysteriously from behind the calm of the horizon. It has an almond shape similar to the mock sun in *Guernica* and suggestive of the more rounded head of the bronze female statue. The features – eyes, nose and mouth – in the heads of the women and in the apparition are just as in the statue, all minute in scale, giving the figures by contrast gigantic proportions. In the painting there is also a hint of intimacy between the women and a sinister suggestion of spying from above by the lone giant of whom they apparently are unaware. In both the *Bathers with a Toy Boat* and the sculpture the acuteness of the expression in the faces is conveyed by the most rudimentary means, but in *Guernica* the drawing of the face of the woman with the lamp in profile is more explicit.

The memorial statue is undoubtedly well chosen. It combines many of the themes that are to be found in the great mural, in particular the woman stretching out with a lamp into the darkness and horrors of war. Today over the tomb of Picasso the sun of Provence with enduring ardour returns its radiance on the figure with the vase that harbours the light of truth.

Picasso died without leaving a will or instructions as to how he wished his wealth to be divided among his heirs. This included an enormous accumulation of his own works and paintings, sculptures and objects of all descriptions acquired by him or given to him by his friends. These and the quantities of letters, souvenirs and intimate documents that he had hoarded since his youth will take many years to classify before they

enter into the public domain; but since the French Government has allowed the estate duty amounting, it is said, to nearly 240 million francs, to be paid in works by the artist, the public will have access to a large part of his work. This splendid collection is to occupy the Hôtel Aubert de Fontenay, known as the Hôtel Salé, a noble seventeenth-century palace in the Marais which was in those days the aristocratic centre of Paris. The total value of the fabulous fortune to be divided between the state and six heirs has been estimated at 1,252,673,200 French francs, riches which left unchanged the man who earned them and in no way distracted him from his unique determination to pursue his muse.

Before his death there were events of importance that I have not until now been able to record. In 1971 in order to express to the city of Arles his appreciation for the entertainments, exhibitions and bullfights it had provided for him in recent years, Picasso presented to the Musée Réatu an important gift of drawings which now occupies a place of honour in seventeenth-century galleries overlooking a wide stretch of the waters of the fast flowing Rhône.

In Paris three exhibitions at the Galerie Louise Leiris followed in quick succession nourished by an unimpeded flow of work that came from Mougins. The first consisted of 194 drawings made between December 1969 and January 1971, many of which were in colour. In addition to new variations on the artist and model theme, Harlequin reappeared, sometimes in the aggressive mood of the paintings seen in the 1970 exhibition in Avignon, or else gaily courting an odalisque with a bouquet of flowers and enticing her to dance with him, or again flourishing his baton as though it had become a giant paint brush. The relationship between Picasso and his alternating moods and Harlequin seemed never to have been closer since the Minotaur, his other more bestial impersonation, had faded away.

A second exhibition in the same gallery followed in December of the next year. This time 172 drawings in black and white and in colour, made between November 1971 and August 1972, were shown. Here again there was astonishing variety in his play with female anatomy and his obsessive insistence on that flower of all seasons, her genitalia.

It was however in the drawings of heads, both male and female, archaic or modern in character, that the most illuminating expression of his inner thought was to be found. There are in particular three heads drawn on successive days in the height of the summer of 1972. All have a monolithic presence as though the head were a great boulder set against the sky, the crowning feature of a mountain ridge. The first is modelled in blue crayon, reminiscent of the Blue period and its melancholy reference to death, but the second has an even more dramatic link with the past. There is a self-portrait now in the National Gallery in Prague painted in 1907 at the age of twenty-six, which suggests revealing comparisons (Plate IV, 4). The painting emphasizes characteristics which, at the time, made Picasso unique, such as the blackness of his eyes that seemed to transfix everyone he met and the black mesh of hair that covered the right side of his forehead.

The indestructible appearance given to the second of the heads, drawn nine months before he died (Plate XXVIII, 9), becomes a symbol of his enduring influence. Like a great rock shaped as an inverted guitar, it stands defiantly on the mountain crest. The black mesh has gone, leaving a gap of the same shape. The angular nose in the painting has become a bulbous clownlike nose such as those of the masks he produced to make his friends laugh when they called on him, and the well-shaped mouth of his youth is now a row of angular tombstones. But the strangest transformation has taken place in the two large circles of the eyes which appear at first to be entirely empty. With humour and foresight, knowing how time could be made to work with him and for him, he has filled them on the white paper with white chalk which will only become visible as with age the paper darkens, bringing light back into the eyes, an allegory of his magic power to give sight, and an example of his ability to enlist the cooperation of time and its alchemical powers over matter. These two heads can be thought of more justly as self-portraits than the third, which is completely sculptural in appearance and closer to the giant heads modelled in plaster in 1931-32, and in consequence significant in the sense of continuity.

The third and last exhibition to be held during his lifetime at the Galerie Louise Leiris contained 156 recent engravings with prints that

showed the development of each successive stage in the plates as he worked on them. This made it possible to follow his inventions in technique and to realize how, with ruthless decision, he often obliterated effects that would have given complete satisfaction to other artists. The subject of many of the images was taken from a rare set of lithographs by Degas, much treasured by Picasso, of girls in the act of seducing distinguished clients in a brothel. Picasso admitted to Zette Leiris that of the three exhibitions the last gave him most satisfaction, probably because of its masterly technical achievements and also because it made visible the unsparing vigour with which he destroyed and recreated his own work.

After his death three more exhibitions were held during the same year, 1973. The first was organized by Jean Leymarie who gathered together the paintings already in the museums of France and obtained permission for the public to visit them without charge as a homage to Picasso. This was followed in May by an exhibition in Avignon, again in the Palais des Papes, which was open throughout the summer. Finally in September the French Communist Party, with the intention of paying tribute to their illustrious comrade, organized a well-chosen and well-staged exhibition as part of their annual fête in Paris. Works from Russia and Czechoslovakia were added to paintings lent by friends in France and recent canvases that had been given by Picasso to Jacqueline.

Of these exhibitions the most extensive and significant was the one held in the chapel of Pope Clement in Avignon. It was shown with the same simplicity and in the same great Gothic halls as the former exhibition of 1969. Planned before his death, he had insisted that none of his recent paintings should be omitted and in consequence the exhibition could be considered as his last will and testament, or rather a codicil to the great legacy he had left. Once more it contained a rare degree of invention and spontaneity although the colour was in general less high pitched, the eroticism less joyous and references to death more evident than in the previous Avignon exhibition. His inspiration was again drawn from human life around him and although there was the characteristic blending of tenderness with cynicism, of love with

anguish, there were also signs of impatience and an anxiety to express the intensity of his emotions in the short time still at his disposal. We were presented here with the *cri du cœur* of the dying artist, the almost daily revelations of his thoughts, his memories and his desires, disclosed with startling candour and an extravagant richness of invention. The diligence he had spent in handling his favourite medium, paint, throughout his life became evident in the exuberant boldness of his culminating endeavour showing paradoxically that Picasso, who has persistently been condemned as the painter who destroyed painting, should be the greatest exponent through revolutionary means of the plastic and poetic qualities of this art. Remembering the more formal achievements of early Cubism other influences appeared. With humour and passion he had created a style which should be called 'emotional' Cubism, so decisively had he broken to pieces the emotional imagery to which we were accustomed, and recreated a new vision.

In relation to the great legacy left to us by Picasso this celebration of his final achievement at the Palais des Papes was like the last stormy flash from the setting sun illuminating a troubled sky. There were in it signs of cynicism, pessimism and the unfathomable greatness of the unknown. The crowds of visitors appeared to be under a spell, disquieted and yet saturated by the personality of a prodigious genius, impregnated in spite of adversity with an overriding enjoyment of life and faith in humanity.

If, in spite of its unquestionable vitality the second Avignon exhibition happened in the shadow of his recent death, there was not long to wait before an event occurred that convinced the whole world of the immortality of Pablo Picasso.

It had taken more than five years to prepare but as soon as legal procedures permitted and agreements had been reached between his family and the State, an exhibition of a unique kind was opened in Paris at the Grand Palais. At once it drew overwhelming crowds and astonished even those who after years of study believed that they could assess reliably the magnitude and variety of his work.

In the autumn of 1979 the French Government was at last able to display the selection of paintings, sculpture, constructions, drawings,

collages, engravings and ceramics that they had chosen from the works that had remained in Picasso's possession and which they could claim for the nation in lieu of estate duty. This amounted to no more than a third of the vast hoard that remained to be divided among the six members of the family, his beneficiaries. Even so the catalogue listed no less than 691 exhibits ranging from *The Girl with Bare Feet* (Plate I, 2) painted in 1895 at the age of 14 to paintings dated 1972.

A rare virtue of this extensive display was its close association with its creator. The exhibits were all works that for one reason or another he had kept for himself when all else during his lifetime had gone out into the world. To follow through the galleries was to live with him through the discoveries, the loves, the anxieties, the influences, the delights and the triumphs of his long and intense life. The interchanges closely related between two-dimensional and three-dimensional art, between painting and sculpture, between colour and form, between reality and illusion, between humour and tragedy appeared with surprising clarity aided by the skill with which the exhibits had been arranged by Dominique Bozo the director of the new Musée Picasso. Never before had it been possible to see gathered together such an illuminating summary of the life-work of Picasso and realize so completely his influence on the art of this century of which every tendency was in some degree indebted to him. Equally evident was a continuous current of consistency in idea and image – a proof of his extraordinary visual memory and the coherence of his thought.

It was a surprise to find that he had kept beside him so many masterpieces. Some paintings, such as the *Crucifixion* (Plate XII, 7), *Still-life with Chair-Caning* (Plate VII, 10), *Girl Seated in a Red Armchair* (Plate XIII, 2), *Déjeuner sur l'herbe* (Plate XXV, 7), and the portraits of his loved ones, his children and himself had been lent to major retrospective exhibitions but there were many others that even his friends had never seen. Also, as Dominique Bozo tells us, it was extraordinary to find in all this treasure that there were so few unfinished or abandoned works. A large quantity of extremely fragile Cubist constructions that had been stored away emerged intact and brilliant in colour. This alone was astonishing and the revelation contained in the assemblage of all the sculptures, which he had kept

beside him as his favourite children, was deeply moving since it was possible to show many of the original sculptures composed of a motley of objects before they were cast. So vast was his output in drawings and engravings however that only a small selection could be shown and to see them the public had to wait patiently for a further revelation when the Musée Picasso opened its doors soon after the hundredth anniversary of his birth.

Undoubtedly there will be many more exhibitions in many parts of the world but as the exhibition of 'Picasso's Picassos' made clear, new surprises and further discoveries, material and spiritual, in the profound message of his work will continue to illuminate the future for countless years.

'Picasso is among those who Michelangelo said merit the name of eagles because they surpass all others and break through the clouds to the light and the sun. And today all shadow has disappeared. The last cry of the dying Goethe, "more light", ascends from his work sublime and mysterious.'

<div align="right">Guillaume Apollinaire</div>

Appendix

On three occasions impressive tributes were paid to the genius of Picasso before the hundredth anniversary of his birth in 1981. The French Government opened to the public a vast exhibition in the Grand Palais during the autumn of 1979, organized by Dominique Bozo, of the works that had been accepted in payment of the *droits de succession.*

A large part of this exhibition then travelled to the United States and was first shown at the Walker Art Center in Minneapolis before going in May 1980 to add to the most complete manifestation of the work of Picasso that had ever been assembled.

In New York the Museum of Modern Art had chosen to celebrate their fiftieth anniversary by emptying all three floors of their spacious premises and filling them with a magnificent display of the life work of the most fecund prodigy among the artists of this century. The organizers were able to borrow with discernment from collectors and museums all over the world adding to their own collection which already contained masterpieces such as 'Les Demoiselles d'Avignon', 'Guernica' (still on loan to them), the 'Girl with a Mandoline' and many others. Because of political friction however they failed to include the great paintings from the USSR.

The effect of this unprecedented manifestation covering more than eighty years of creative work was profound and widespread as was shown by the unparalleled crowds that visited the exhibition daily for four and a half months. Each period was treated thoroughly and with admirable perspicuity so that the richness of this brilliant panorama produced in the visitor a rare intensity of exhilaration.

Again on their return to Europe before the works belonging to the French Government were installed in the Picasso Museum arrange-

ments were made for them to be shown in Copenhagen and finally in London in 1981, a hundred years after his birth.

October 1980

Acknowledgements

In writing this biography I have drawn largely on information derived from books and conversations with friends of whom undoubtedly the most important was Monsieur Pablo Picasso himself. I am deeply grateful to him for his patience and cooperation during many days spent in his company and for the hospitality shown to me in Cannes by him and his wife Madame Jacqueline Picasso while I was at work on the early editions.

Other members of his family came to my aid from the beginning. I was greatly helped by the late Paulo Picasso and Claude Picasso the artist's sons, also by the late Señora Ruiz de Vilató his sister and her sons, the late Fin and his brother Javier Vilató, whose friendship I enjoyed for many years.

Among those who supplied me with valuable information and took special interest in my task were Jaime Sabartés and Daniel-Henry Kahnweiler. To them and to many other friends, some of whom sadly are no longer alive, thanks are due. I wish to mention in particular Alfred H. Barr, Jr, Clive Bell, Georges Braque, Pierre Baudouin, Jean Leymarie, Michel Leiris, Mme Dominique Eluard, Valentine Hugo, Manolo Hugué, Lady Keynes, Valentine Penrose, Zette Leiris, Fernande Olivier, Miss Alice B. Toklas, Mlles Dora Maar and Diane De Riaz, Man Ray, Baron Jean Mollet, Sir Herbert Read, Henri-Pierre Roché, Georges Salles, André Salmon, Tristan Tzara, Christian Zervos and Patrick Waldberg.

For continuous help and advice during the writing of the first version of the book I was most grateful to my late wife and to John Hayward, and also for help received from Mr and Mrs John Russell, Mrs Sonia Orwell and Mr and Mrs Terence O'Brien. In compiling the

illustrations I have been ably assisted by M. Teriade, the Galerie Louise Leiris and the Arts Council of Great Britain. In addition I wish to thank the many owners, both private and public, who have kindly allowed me to reproduce works from their collections. I must record my warmest thanks to Miss Joyce Reeves for the patience and devoted care she showed in putting my first manuscript in order and for recent help from MM Dominique Bozo and Pierre Daix as well as my gratitude to Roy Edwards and Gary Ness for their aid in helping me to revise and add to the text.

R.P.

February
1981

Selected Bibliography

The selection has been made on the basis of the relative importance, interest and availability of the works included. For a more complete bibliography up to 1946 see A. H. Barr, *Picasso: Fifty Years of His Art,* The Museum of Modern Art, New York, 1946, and two more up-to-date lists compiled by Inga Forslund in R. Penrose, *The Sculpture of Picasso,* The Museum of Modern Art, New York, 1967 and Pierre Daix, *Picasso,* Paris, 1964. For further detail the catalogues *Hommage à Pablo Picasso,* Ministère d'Etat, Affaires Culturelles, Paris, 1966, and *Pablo Picasso: A Retrospective,* Museum of Modern Art, New York, may be consulted.

Adéma, Marcel, *Apollinaire,* Heinemann, London, 1954.

Apollinaire, Guillaume, *The Cubist Painters,* English translation, Wittenborn, New York, 1944.

Apollinaire, Guillaume, *La Femme assise,* Gallimard, Paris, 1948.

Apollinaire, Guillaume, and Cerusse, Jean (editors), *Les Soirées de Paris,* Monthly Review, Paris, No. 18, 15 November 1913 to Nos. 26 and 27, July–August 1914.

Aragon, Louis, *La Peinture au défi,* Corti, Paris, 1930.

Argan, Giulio Carlo, *Scultura di Picasso,* Alfieri, Venice, 1953.

Arnheim, Rudolph, *Picasso's Guernica: The Genesis of a Painting,* University of California Press, Berkeley, 1962.

Barr, Alfred H., Jr, *Matisse: His Art and His Public,* The Museum of Modern Art, New York, 1946.

Barr, Alfred H., Jr, *Picasso: Fifty Years of His Art,* The Museum of Modern Art, New York, 1946.

Bataille, Georges, 'Soleil pourri', *Documents: Hommage à Picasso,* No. 3, 2ᵉ Année, Paris, 1930.

Bell, Clive, *Old Friends,* Harcourt, Brace and World, New York, 1957.

Berger, John, *Success and Failure of Picasso,* Penguin Books, Harmondsworth, 1965.

Bernier, Rosamond, 48, 'Paseo de Gracia', *L'Œil,* April 1955.

Billy, André, *Max Jacob,* Pierre Seghers, Paris, 1953.

Blunt, Anthony, *Picasso's 'Guernica',* Oxford University Press, 1969.

Blunt, Anthony, and Poole, Phoebe, *Picasso: The Formative Years,* Studio Vista, London, 1962.

Boggs, Jean Sutherland, 'The Last Twenty-five Years', in *Picasso: 1881-1973,* Paul Elek, London, 1973.

Boeck, Wilhelm, *Picasso Linoleum Cuts,* Thames & Hudson, London, 1963.

Boeck, W., and Sabartés, J., *Picasso,* Abrams, New York, 1955.

Bollinger, Hans, *Picasso for Vollard,* translated by N. Güterman, Thames & Hudson, London, 1963.

Boudaille, Georges, *Picasso, première époque: 1881-1906,* Paris, 1964.

Bowness, Alan, 'Picasso's Sculpture', in *Picasso: 1881-1973,* Paul Elek, London, 1973.

Bozo, Dominique, *Introduction* to Catalogue, Exhibition at Grand Palais, Paris, January 1980.

Les Musées de France, 1980.

Bozo, Dominique, 'The Picasso Legacy', *Introduction* to Catalogue: *Picasso From the Musée Picasso,* Walker Art Centre, Minneapolis, 1980.

Braque, Georges, and Vallier, Dora, 'La Peinture et nous', *Cahiers d'Art,* Paris, October 1954.

Brassaï, Jules Halasz, *Picasso and Co.,* preface by Henry Miller, introduction by Roland Penrose, Doubleday, New York, 1967.

Breton, André, 'Le Surréalisme et la peinture', *La Révolution surréaliste,* No. 4, Paris, 15 July 1925. Also published as a book by Brentano.

Breton, André, 'Picasso poète', *Cahiers d'Art,* No. 10, Paris, 1935.

Cahiers d'Art, Paris. Special numbers: 6, 1929; 8-10, 1936; 7-10, 1935.

Cirici-Pellicer, A., *Picasso avant Picasso,* Cailler, Geneva, 1950.

des Champris, Pierre, *Ombres et soleil de Picasso,* Gallimard, Paris, 1961.

Cocteau, Jean, *Le Coq et l'arlequin,* Editions de la Sirène, Paris, 1918.

Cocteau, Jean, *Picasso,* Stock, Paris, 1923.

Cooper, Douglas, *The Cubist Epoch,* Phaidon, London, 1971.

Cooper, Douglas, *Picasso: Les Déjeuners,* Thames & Hudson, London, 1963.

Cooper, Douglas, *Picasso: Theatre,* Abrams, New York, 1968.

Crastre, Victor, *La Naissance du cubisme,* Ophrys, Paris, undated.

Daix, Pierre, *Picasso,* Praeger, New York, 1965.

Daix, Pierre, and Boudaille, Georges, *Picasso 1900-1906,* Neuchâtel and Paris, 1966.

Daix, Pierre; Boudaille, Georges; and Rosselet, Joan, *Picasso. The Blue and Rose Periods, A Catalogue Raisonné of the Paintings,* Greenwich, Connecticut, New York Graphic Society, 1966.

Daix, Pierre, and Rosselet, Joan, *Picasso: The Cubist Years, 1907–1916, A Catalogue Raisonné of the Paintings and Related Works*, Boston, New York Graphic Society, 1979.

Dominguin, Luis, and Boudaille, Georges, *Picasso: Bulls and Bull Fighters (Toros y toreros)*, Abrams, New York, 1961.

Duncan, David D., *Picasso's Picassos: The Treasures of La Californie*, Harper, New York, 1961.

Duncan, David Douglas, *The Private World of Pablo Picasso*, Ridge Press, New York, 1957.

Elgar, Frank, and Maillard, Robert, *Picasso*, Praeger, New York, 1956.

Eluard, Paul, 'Je parle de ce qui est bien', *Cahiers d'Art*, Paris, 7 October 1955.

Eluard, Paul, *A Pablo Picasso*, Trois Collines, Geneva/Paris, 1944.

Eluard, Paul, *Selected Writings*, translated by Lloyd Alexander, Routledge & Kegan Paul, London, 1952.

Fagus, Félicien, *Gazette d'art*, quoted in *Cahiers d'Art*, Nos. 3–5, Paris, 1932.

Fry, Edward F., *Cubism*, Thames & Hudson, London, 1966.

Geiser, Bernhard, *Pablo Picasso: Fifty-five Years of His Graphic Work*, Abrams, New York, 1955.

Geiser, Bernhard, *Picasso: Peintre-graveur* (catalogue raisonné), second edition, Komfeld & Klipstein, Bern, 1955.

Gilot, Françoise, and Lake, Carlton, *Life with Picasso*, Nelson, 1965, and Penguin Books, London, 1966.

Golding, John, *Cubism: A History and Analysis 1907–1914*, Faber, London, 1969.

Golding, John, 'Picasso and Surrealism', in *Picasso: 1891–1973*, Paul Elek, London, 1973.

Gonzalez, Julio, 'Picasso sculpteur', *Cahiers d'Art*, II, Nos. 6–7, 1936.

Haskell, Arnold, with Walter Nouvel, *Diaghileff*, Gollancz, London, 1935.

Hugnet, Georges, 'Dada and Surrealism', *Bulletin of the Museum of Modern Art*, New York, November–December 1936.

Jacob, Max, *Correspondance*, Editions de Paris, Paris, 1953.

Jaffe, Hans L.C., *Picasso*, Thames & Hudson, London, 1964.

Janis, Harriet and Sydney, *Picasso: The Recent Years, 1939–46*, Doubleday, New York, 1946.

Jardot, Maurice, *Pablo Picasso: Drawings*, Abrams, New York, 1959.

Jarry, Alfred, *The Ubu Plays*, translated by Cyril Connolly and Simon Watson Taylor, Grove Press, New York, 1969.

Kahnweiler, Daniel-Henry, *Picasso: Dessins 1903–1907*, Berggruen et Cie., Paris, 1954.

Kahnweiler, Daniel-Henry, *The Rise of Cubism*, Wittenborn, Schutz, New York.

Kahnweiler, Daniel-Henry, preface to *The Sculptures of Picasso*, Rodney Phillips, London, 1949. (Photographs by Brassaï.)

Kahnweiler, Daniel-Henry, Questionnaire in *L'Œil*, No. 1, Paris, 1955.

Kahnweiler, Daniel-Henry, 'Introduction. A Free Man', in *Picassò 1881-1973*, Paul Elek, London, 1973.

Kaufmann, Ruth, 'Picasso's Crucifixion of 1930', *Burlington Magazine*, September 1969.

Kay, Helen, *Picasso's World of Children*, Macdonald, London, 1965.

Larrea, Juan, *Guernica*, Curt Valentin, New York, 1947.

La Souchère, Dor de, *Picasso in Antibes*, Lund Humphries and Pantheon Books, London, 1960.

Leiris, Michel, *Miroir de la tauromachie*, G.L.M., Paris, 1938.

Leiris, Michel, 'The Artist and His Model', in *Picasso: 1881-1973*, Paul Elek, London, 1973.

Level, André, *Picasso*, Crès, Paris, 1928.

Leymarie, Jean, 'Hommage à Picasso', Exposition au Grand Palais et au Petit Palais, *La Revue du Louvre et des Musées de France*, Paris, 1966.

Leymarie, Jean, *Picasso, Metamorphose et Unité*, Skira, 1971.

Lieberman, William S., *The Sculptor's Studio: Etchings by Picasso*, The Museum of Modern Art, New York, 1952.

Loeb, Pierre, *Voyages à travers la peinture*, Bordas, Paris, 1945.

Melville, Robert, *Picasso: Master of the Phantom*, Oxford University Press, 1939.

Minotaure Editions, Skira, Paris, 1933.

Mourlot, Fernard, *Picasso lithographe*, Vols. I and II, Editions du Livre, Monte Carlo, 1949 and 1950, Vol. III, preface by J. Sabartés, 1956.

Nicolson, Benedict, 'Post-impressionism and Roger Fry', *Burlington Magazine*, January 1951.

Olivier, Fernande, *Picasso et ses amis*, Stock, Paris, 1933.

d'Ors, Eugenio, *Picasso*, Paris, 1930.

Palau i Fabre, Josep, *Picasso en Cataluna*, Ediciones Poligrafa, Barcelona, 1966.

Parmelin, Hélène, *Picasso sur la place*, Julliard, Paris, 1959.

Parmelin, Hélène, *Picasso: Women, Cannes and Mougins 1954-1963*, translated by Humphrey Hare, Weidenfeld & Nicolson, London, 1965.

Parmelin, Hélène, *Voyage en Picasso*, Laffont, Paris, 1980.

Paz, Octavio, *Marcel Duchamp or the Castle of Purity*, Cape Galiard Press, London, 1970.

Penrose, Roland, 'Beauty and the Monster', in *Picasso: 1881-1973*, Paul Elek, London, 1973.

Penrose, Roland, *Homage to Picasso*, Lund Humphries, London, 1951.

Penrose, Roland, *Pablo Picasso: Four Themes*, The Folio Society, London, 1961.

Penrose, Roland, 'Picasso', *L'Œil*, October 1956.

Penrose, Roland, *Picasso*, Modern Sculptors, Zwemmer, London, 1961.

Penrose, Roland, *Picasso: Exhibition of Paintings,* Tate Gallery, London, 1960.

Penrose, Roland, *Picasso: Exhibition of Sculpture and Ceramics,* Tate Gallery, London, 1967.

Penrose, Roland, *Portrait of Picasso,* Lund Humphries, London, 1956.

Penrose, Roland, *The Eye of Picasso,* Collins, New York, 1967.

Penrose, Roland, and Wilenski, R. H., *Picasso,* 2 Vols. The Faber Gallery, London, 1961.

Picasso, Pablo, *Carnet catalan,* Facsimile of sketchbook of 1906. Preface and Notes by Douglas Cooper, Berggruen, Paris, 1958.

Picasso, Pablo, *El Entierro del Conde de Orgaz,* prologue by Rafael Alberti, Gustavo Gili, Barcelona, 1970.

Picasso, Pablo, *Le Déjeuner sur l'herbe,* preface by Douglas Cooper, Editions du Cercle d'Art, Paris.

Picasso, Pablo, *Le Désir attrapé par la queue,* N.R.F. Collection Métamorphose No. 23, Gallimard, Paris, 1949. Translated as *Desire Caught by the Tail,* by Roland Penrose, Calder & Boyars, London, 1970.

Picasso, Pablo, *Les Quatre Petites Filles,* Gallimard, Paris, 1968. Translated as *The Four Little Girls,* by Roland Penrose, Calder & Boyars, London, 1970.

Picasso, Pablo, *Toros y toreros,* Texte de Miguel Dominguín avec un étude de Georges Boudaille, Thames & Hudson, London, 1961.

Picasso, Pablo, *Trozo de piel,* Los Ediciones de los Papeles de son Armadans, Madrid - Palma de Mallorca, 1959.

Picasso, Pablo, Statements and Interviews:

(1) 'Picasso Speaks'. Interview with Marius de Zayas, *The Arts,* New York, May 1923. Reprinted by Barr in *Picasso: Fifty Years of His Art,* p. 270.

(2) 'Pourquoi j'ai adhéré au Parti Communiste'. Interview with Pol Gaillard, *L'Humanité,* Paris, 29–30 October 1944. Reprinted by Barr, *Picasso: Fifty Years of His Art,* p. 267.

(3) 'Picasso Explains'. Interview with Jerome Seckler, *New Masses,* 13 March 1945. Reprinted by Barr, *Picasso: Fifty Years of His Art,* p. 268.

(4) 'Picasso n'est pas officier dans l'armée française', *Lettres françaises,* 24 March 1945. Reprinted by Barr, *Picasso: Fifty Years of His Art,* p. 269.

Quinn, Edward, and Penrose, Roland, *Picasso at Work: An Intimate Photographic Study,* Doubleday, New York, 1964.

Ramié, Georges and Suzanne, *The Ceramics of Picasso,* Skira, New York.

Raynal, Maurice, *Picasso,* Crès, Paris, 1922.

Raynal, Maurice, *Picasso,* Albert Skira, Geneva, 1953.

Raynal, Maurice, 'Panorama de l'œuvre de Picasso', *Le Point,* XLII, Souillac (Lot) and Mulhouse, October 1952.

Read, Herbert, *Art Now,* Faber & Faber, London, 1933.

Read, Herbert, *Concise History of Modern Painting,* Praeger, New York, 1959.

Read, Herbert, *Concise History of Modern Sculpture,* Praeger, New York, 1964.

Read, Herbert, *The Origins of Form in Art,* Horizon, New York, 1965.

Read, Herbert, *The Philosophy of Modern Art,* Faber & Faber, London, 1951.

Read, Herbert, 'Picasso's *Guernica'*, *London Bulletin,* No. 6, 1938.

Reff, Theodore, 'Themes of Love and Death in Picasso's Early Works', in *Picasso: 1881–1973,* Paul Elek, London, 1973.

Richardson, John, *Picasso: An American Tribute* (catalogue), Public Education Association, New York, 1962.

Rosenblum, Robert, 'Picasso and the Typography of Cubism', in *Picasso: 1881–1973,* Paul Elek, London, 1973.

Roy, Claude, *La Guerre et la paix,* Editions du Cercle d'Art, Paris, 1954.

Rubin, William, editor, *Pablo Picasso. A Retrospective,* The Museum of Modern Art, New York, 1980.

Sabartés, Jaime, *Picasso: Documents Iconographiques,* Pierre Cailler, Geneva, 1954.

Sabartés, Jaime, *Picasso: Portraits et Souvenirs,* Louis Carré et Maximilien Vox, Paris, 1946.

Sabartés, Jaime, Preface to Mourlot, F., *Picasso lithographe.*

Salmon, André, *Souvenirs sans fin,* Gallimard, Paris, 1955.

Serna, Ramón Gomez de la, 'Le Toréador de la peinture', *Cahiers d'Art,* 1932, Nos. 3–5.

Soby, James Thrall, *Modern Art and the New Past,* University of Oklahoma Press, 1957.

Spies, Werner, *Sculpture by Picasso, with a Catalogue of the Works,* New York, Harry N. Abrams, 1971.

Sprigge, Elizabeth, *Gertrude Stein,* Hamish Hamilton, London, 1957. (Yale Collection Letters.)

Stein, Gertrude, *Autobiography of Alice B. Toklas,* Penguin Books, Harmondsworth, 1970.

Stein, Gertrude, *Everybody's Autobiography,* Random House, New York, 1937, and Heinemann, London, 1938.

Stein, Gertrude, *Picasso,* Scribner's and Batsford, London, 1938.

Sweeney, James Johnson, 'Picasso and Iberian Sculpture', *Art Bulletin,* 23, No. 3, New York, September 1941.

Tzara, Tristan, *Picasso et la poésie,* De Luca, Rome, 1953.

Uhde, Wilhelm, *Picasso and the French Tradition,* Weyhe, New York, 1929.

Vallentin, Antonina, *Picasso,* Albin Michel, Paris, 1957.

Vollard, A., *Recollections of a Picture Dealer,* Constable, London, 1936.

Verdet, André, 'Picasso es ses environs', *Les Lettres Nouvelles,* Paris, July-August 1955.

Verve, 'Couleur de Picasso', peinture et dessins de Picasso, textes de Picasso et de Sabartés. Vol. V, Nos. 19-20, 1948.

Verve, 'Picasso at Antibes', Vol. V, Nos. 19-20, 1948.

Verve, 'Picasso at Vallauris', Vol. VII, Nos. 25-6, 1951. Reissued with inserted English translations, Reynal, New York, 1959.

Verve, Suite of 180 drawings of Picasso, Vol. VIII, Nos. 29-30, 1954.

Zervos, Christian, *Catalan Art,* Heinemann, London, 1937.

Zervos, Christian (editor), *Cahiers d'Art.* Many volumes of this series contain important articles on Picasso, some of which are referred to above. See especially Nos. 3-5, 1932, and numbers for 1930-35 and 1945-6.

Zervos, Christian, *Picasso, Cahiers d'Art,* Paris, 1932-78. The monumental catalogue of Picasso's painting, sculpture and drawing with reproductions of most of his work.

Index